# Byzantine Women and Their World

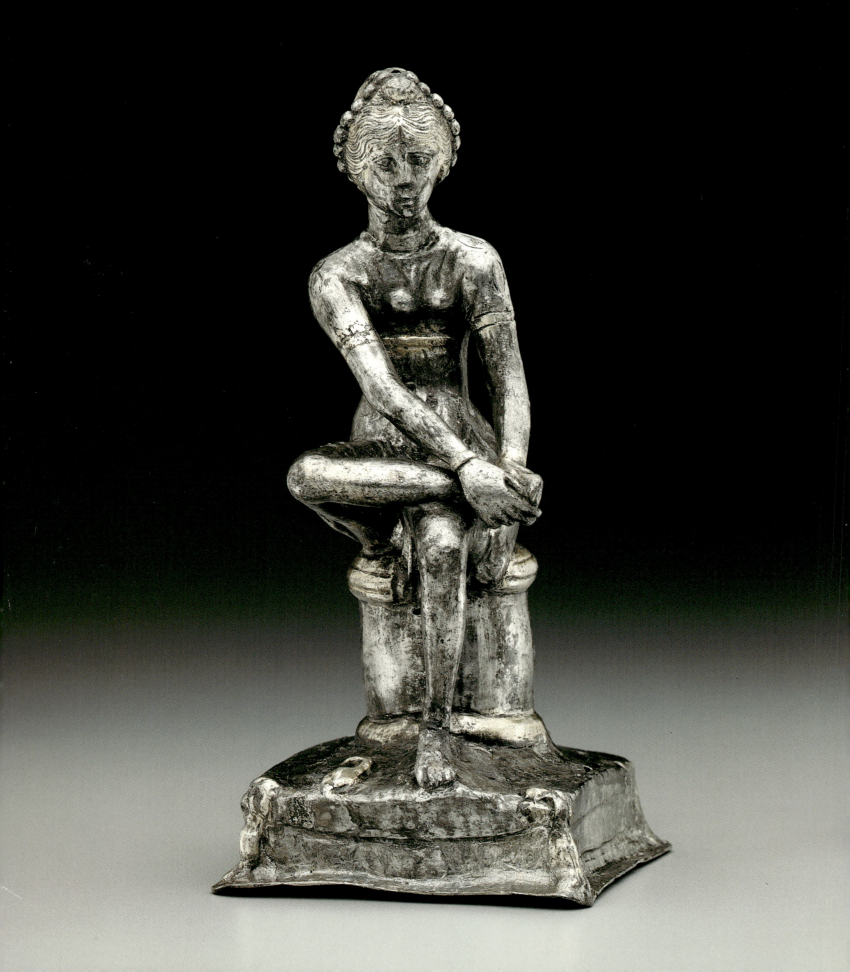

# Byzantine Women and Their World

Ioli Kalavrezou

WITH CONTRIBUTIONS BY

Angeliki E. Laiou

Alicia Walker

Elizabeth A. Gittings

Molly Fulghum Heintz

Bissera V. Pentcheva

HARVARD UNIVERSITY ART MUSEUMS, CAMBRIDGE
YALE UNIVERSITY PRESS, NEW HAVEN AND LONDON

*Byzantine Women and Their World* is published in conjunction with an exhibition organized by the Arthur M. Sackler Museum, Harvard University Art Museums, on view October 25, 2002–April 28, 2003.

This publication was funded by the Diane Heath Beever Fund, the Louise E. Bettens Fund, John F. Cogan, Jr., the J. F. Costopoulos Foundation, Jessie Lie Farber, the Goldman Sachs Foundation, the Florence Gould Foundation, the Gurel Student Exhibition Fund, George Hatsopoulos, John Hatsopoulos, Joseph Koerner, the Parthenon Group, Shelby White and Leon Levy, Liliane and José M. Soriano, and an anonymous donor.

Distributed by Yale University Press, New Haven and London

Library of Congress Cataloging-in-Publication Data

Kalavrezou, Ioli.
  Byzantine women and their world / Ioli Kalavrezou ; with contributions by Angeliki E. Laiou ... [et al.].
    p. cm.
"Published in conjunction with an exhibition organized by the Arthur M. Sackler Museum, Harvard University Art Museums, on view October 25, 2002–April 28, 2003"--T.p. verso.
Includes bibliographical references and index.
  ISBN 1-891771-28-0 (pbk. : alk. paper) -- ISBN 0-300-09698-4 (pbk. : alk. paper)
  1. Art, Byzantine--Exhibitions. 2. Women in art--Exhibitions. I. Laiou, Angeliki E. II. Arthur M. Sackler Museum. III. Harvard University. Art Museums. IV. Title.
  N6250.K27 2003
  949.5'02'0820747444--dc21

               2003001007

Produced by the Publications Department, Harvard University Art Museums

Evelyn Rosenthal, Head of Publications
Edited by Marsha Pomerantz
Designed by Katy Homans
Typeset in Centaur by Matt Mayerchak
Proofread by Joy Sobeck
Separations by Professional Graphics, Inc., Rockford, Illinois
Printed by Snoeck-Ducaju & Zoon, Ghent

# Contents

# Director's Foreword

We at the Harvard University Art Museums are committed to advancing the knowledge and appreciation of art through exhibitions and their attendant publications. Often these derive from seminars taught by our colleagues elsewhere in the university. *Byzantine Women and Their World* began life as one such seminar and, with the help of Andrew W. Mellon Internships awarded to graduate students, developed into an exhibition and a publication of the greatest originality and importance.

Ioli Kalavrezou, Dumbarton Oaks Professor of Byzantine Art at Harvard, led a curatorial team that comprised her students Molly Fulghum Heintz, Elizabeth Gittings, and Alicia Walker, as well as Amy Brauer, Diane Heath Beever Associate Curator of Ancient and Byzantine Art and Numismatics at the Arthur M. Sackler Museum.

We are deeply grateful for their work in bringing to fruition this complicated project, as we are to Angeliki Laiou, Dumbarton Oaks Professsor of Byzantine History at Harvard, for the essay she contributed to the catalogue, and to all the seminar students who wrote entries.

A topic as original as this one relies substantially on the evidence presented by means of the objects included in the study and, ultimately, from the resulting exhibition. Numerous lenders contributed generously to our project, none more than Harvard's Dumbarton Oaks, a sister institution with which we are most pleased to have cooperated. For their support of our efforts, we wish to thank especially Ned Keenan, director, and Susan Boyd, curator of the Byzantine Collection. For their generosity in lending prized objects from their collections we wish also to thank the directors and curators at the Indiana University Art Museum, Bloomington; the Malcove Collection, Toronto; the Menil Collection, Houston; the Metropolitan Museum of Art, New York; the Morgan Library, New York; the Museum of Fine Arts, Boston; the Museum of Fine Arts, Houston; the Nelson-Atkins Museum, Kansas City; the Princeton University Art Museum; the Royal Ontario Museum, Toronto; the Virginia Museum of Fine Arts, Richmond; the Walters Art Museum, Baltimore; and the Worcester Museum of Art, as well as private collectors.

We would also like to acknowledge the many funders who made possible the exhibition and its accompanying catalogue: the Diane Heath Beever Fund, the Louise E. Bettens Fund, John F. Cogan, Jr., the J. F. Costopoulos Foundation, Jessie Lie Farber, the Goldman Sachs Foundation, the Florence Gould Foundation, the Gurel Student Exhibition Fund, George Hatsopoulos, John Hatsopoulos, Joseph Koerner, the Parthenon Group, Shelby White and Leon Levy, Liliane and José M. Soriano, and an anonymous donor.

It is especially rewarding for me to be able to write the foreword to this catalogue, the last to be produced under my directorship at the Harvard Art Museums. I take great pride in our commitment to our scholarly and pedagogical achievements. And *Byzantine Women and Their World* is exemplary in this respect.

JAMES CUNO
*Elizabeth and John Moors Cabot Director*
*Harvard University Art Museums*

# Preface and Acknowledgments

Through artifacts and images, this exhibition presents the environment and concerns of women in Byzantine society. It grew out of a graduate seminar, "Women in Byzantine Art," that I offered in the Department of History of Art and Architecture at Harvard during the spring of 1999. The dynamic exchange that this topic generated in class discussion and the broad range of stimulating work that the students produced recommended the topic for further exploration in the form of an exhibition. The majority of the essays in this catalogue and much of the work presented in the object entries reflect the specific research interests of participants in the seminar.

The material for the exhibition was assembled from North American collections only, and as such provides a good sampling of the wealth of Byzantine art and artifacts in the United States and Canada. The planning took place at a time when many museums were rediscovering their Byzantine collections, largely in response to the great success of the 1997 exhibition at the Metropolitan Museum of Art, *The Glory of Byzantium*. For us, this was something of a mixed blessing. Many museums were eager to share their holdings, and we are proud that a large number of the works of art in this exhibition are published here for the first time. Other collections, however, having just reinstalled their own Byzantine displays, were unable to lend us their works. Several objects in well-known collections that would have contributed to the themes of the exhibition could not, regrettably, be included.

Recent scholarly publications on topics relevant to women's lives in Byzantium have made clear the great variety and wealth of this emerging subfield. Continuing interest has been demonstrated through the conference "Byzantine Women: The Everyday Experience," held at the University of California, Los Angeles, in April 2001, and the panel "Women and Byzantium" at the 28th Byzantine Studies Conference, held at Ohio State University in October 2002. This is the first time, however, that the topic of women in Byzantium is being studied through assembled works of art.

Each of the eight sections of the catalogue highlights a major theme that groups the objects in the exhibition. The sections, with their introductory essays, are not meant to be comprehensive. Rather, they are intended to stimulate further investigation of the issues raised and to indicate the vital role that art and material culture can play in studying the experience of Byzantine women.

This exhibition was three and a half years in the making. It drew from the talent and hard work of many individuals and the resources of numerous institutions. I thank all those who generously collaborated on this project. Without their expertise and willingness to help it would not have been possible.

I express my special thanks to the directors, curators, and administrative staff of the lending institutions, especially for their willingness to collaborate so generously with graduate students. The exhibition found a home in the Department of Ancient and Byzantine Art and Numismatics at the Harvard University Art Museums, and I am tremendously grateful to David Mitten, Amy Brauer, and Karen Manning for their daily support and unremitting patience. The Publications Department of the Museums, headed by Evelyn Rosenthal, provided expert guidance in the production of this catalogue; I would like to

thank especially Marsha Pomerantz, who tirelessly edited the entire text with great perception. Katy Homans, an independent designer, gave the book its elegant look. The catalogue stands as the permanent document of the temporary display at the Arthur M. Sackler Museum, and as such it is the appropriate place to recognize the outstanding work of the HUAM Exhibitions Department, headed by Danielle Hanrahan, whose keen eye and expert craft made it possible to realize in the gallery the ideas that emerged from my own and graduate-student research and that find expression in these pages. She was ably assisted by Peter Schilling and Steve Hutchison; Carolann Barrett of Publications edited the wall text. I am grateful also to Amanda Ricker-Prugh of the Registrar's Office for overseeing our contacts with lenders; Henry Lie, Tony Sigel, Nancy Lloyd, and intern Amy Jones of HUAM's Straus Center for Conservation, as well as independent conservator Dierdre Windsor, for preparing the objects for exhibition; and Katya Kallsen and Jay Beebe of the Digital Imaging and Photography Department for photographing HUAM objects for the catalogue. It is no exaggeration to say that this exhibition owes its success to the commitment of James Cuno, who from the beginning supported the project with great enthusiasm and always found the means to ensure its progress.

My warmest thanks go to the graduate students who, through their initial enthusiasm and support in the seminar and their research and contributions to the catalogue, have made this project possible. I would like to single out a few for their special assistance: Molly Fulghum Heintz, as an Andrew W. Mellon intern in the Museums, contributed to the initial phase of organization. Elizabeth Gittings and Alicia Walker, also Mellon interns, have been invaluable; without them the exhibition and catalogue would not have been realized. There has not been a day in the last two years when their continuous commitment and hard work did not bring us closer to our goal. Alicia's ability to see the larger picture and coordinate details at all times helped every one of us. Special thanks go also to Philip Maxeiner for his linguistic talents.

IOLI KALAVREZOU
*Dumbarton Oaks Professor of Byzantine Art History*
*Harvard University*

# Lenders to the Exhibition

Dumbarton Oaks Collection of Byzantine Art, Washington, D.C.
Cats. 8, 23, 47, 48, 50, 67, 97, 102, 123, 130, 131, 149, 150, 164, 182

Harvard University Art Museums
Cats. 2–7, 9, 15–22, 27, 29, 30, 32–46, 51, 55– 63, 66, 70, 74–78, 80–82, 84–86, 88–93, 96, 103, 104, 106–10, 113, 114, 119, 133, 134, 151, 153, 155–63, 169, 171–73, 181

Harvard University Department of the Classics, Alice Corinne McDaniel Collection
Cats. 10, 154

Indiana University Art Museum, Bloomington
Cats. 13, 14, 98, 99, 100, 101, 105, 121, 125, 146, 175, 176

The Malcove Collection, University of Toronto Art Center
Cats. 52, 54, 73, 94, 118, 140, 168

The Menil Collection, Houston
Cats. 124, 127, 166, 177, 185, 186

The Metropolitan Museum of Art, New York
Cats. 1, 11, 26, 64, 71, 132, 144, 165

The Morgan Library, New York
Cats. 69, 83, 174

Museum of Fine Arts, Boston
Cats. 12, 24, 31, 49, 72, 122, 139, 141, 152

The Museum of Fine Arts, Houston
Cats. 116, 120

The Nelson-Atkins Museum, Kansas City
Cats. 25, 68, 111

The Art Museum, Princeton University
Cats. 28, 79, 112, 167, 183

Private Collection
Cat. 115

Royal Ontario Museum, Toronto
Cats. 53, 65, 128, 129, 178, 179, 180

Virginia Museum of Fine Arts, Richmond
Cats. 135, 137, 138, 142, 145, 184

The Walters Art Museum, Baltimore
Cats. 87, 95, 126, 148, 170

Worcester Museum of Art, Worcester, Massachusetts
Cats. 117, 143, 147

# Contributing Authors

DA    Diliana N. Angelova

LD    Louis Demos

PD    Paul Denis

ADG    Anne Druckenbrod Gossen

EF    Emine Fetvacı

JF    Jennifer E. Floyd

ARG    Amy Rebecca Gansell

EG    Elizabeth A. Gittings

MFH    Molly Fulghum Heintz

JLH    Jennifer Ledig Heuser

DJ    Danielle Joyner

IK    Ioli Kalavrezou

AML    AnneMarie Luijendijk

BP    Bissera V. Pentcheva

HS    Helle Sachse

JKS    J. Kirsten Smith

AW    Alicia Walker

# Notes on the Catalogue

Measurements are in centimeters, and most are rounded to the nearest tenth; weights for coins and seals are exact. We use Greek rather than Latin spelling for the Byzantine period, with the exception of some names, such as Constantine, which have become standard in English; in most cases the *Oxford Dictionary of Byzantium* has been the reference.

The reign dates for empresses are frequently those of their husbands, since precise dates for empresses' reigns are often not known.

In the endnotes and bibliography, exhibition catalogues are cited by an abbreviated title and the date of publication; other catalogues are cited by author or editor and date.

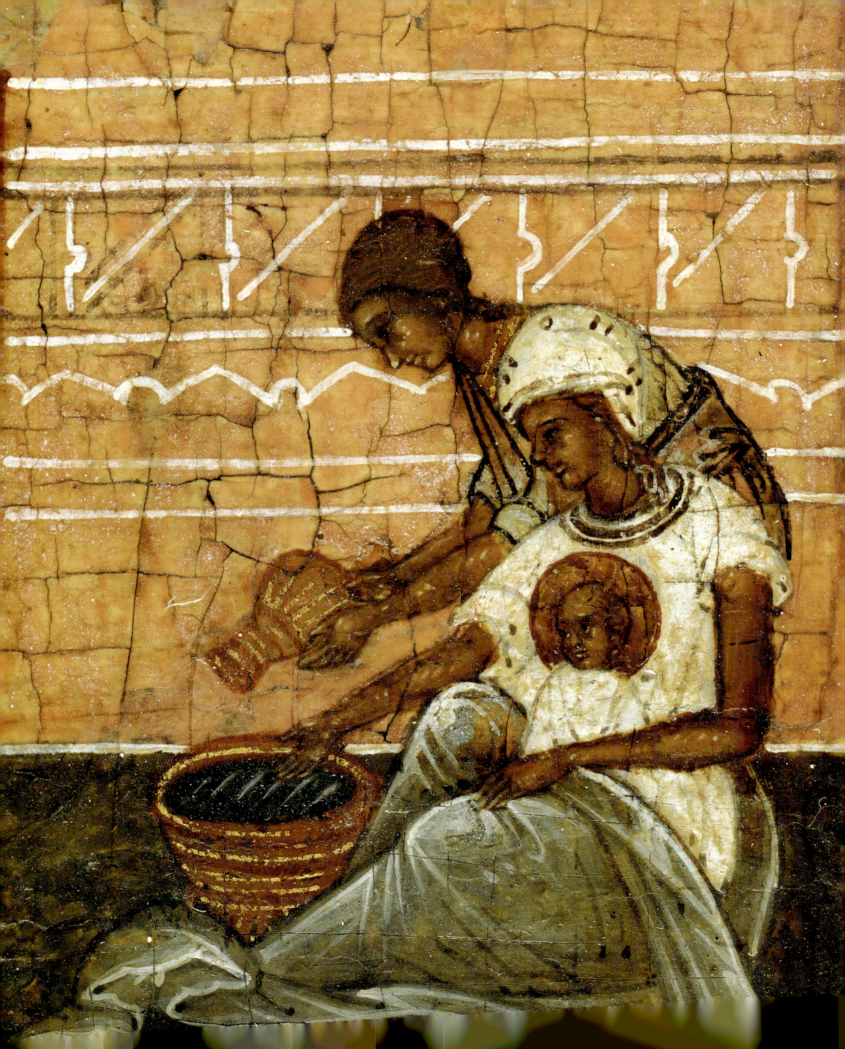

IOLI KALAVREZOU

# Women in the Visual Record of Byzantium

The modern perception of women in the medieval world has suffered from a lack of adequate textual sources and material evidence relating to women's lives. This historical silence has created a distorted view of the role of women in Byzantium.[1] The prevailing image is of women who dressed modestly, with their heads covered, and who were deprived of worldly experience, committed to bearing and raising children as their primary occupation, and confined to the home for most of their lives. As if this were not a negative enough impression of their existence, it is assumed that for the most part they were illiterate.[2] These perceptions are in need of correction. Byzantine women, even more than their counterparts in Western Europe, held a prominent, often powerful, and respected place in society.[3]

It should be acknowledged from the outset, however, that Byzantine society privileged males; regardless of any attempts to highlight and understand the social role of female individuals, the fact will remain that their status as citizens was inferior. For example, women were restricted by law from holding administrative office, whether in the Church, the state, or the army.[4] They were thus legally excluded from positions of power, and could not but come second in the social hierarchy.[5]

Despite recent research into the lives of Byzantine women, much remains difficult to assess. Since almost all chronicles, histories, and other accounts were recorded by men and for men, there is hardly any commentary devoted to the female experience.[6] Among the females mentioned in literature, aristocratic women have figured most prominently—and not always favorably—because of their prominence in society.[7] Their inclusion in the textual record is often the result of their unusual and outrageous behavior, which authors recount with relish. Such mention constitutes the exception and not the norm, and because of the paucity of information about less distinguished women, we still lack a clear image of female life. This is especially the case for women in rural populations, which accounted for a large part of medieval society.

With material assembled from everyday life, the exhibition *Byzantine Women and Their World* attempts to fill this gap: to bring the unexceptional individual within reach and to gain a better understanding of women's everyday experiences. To explore what it was like to be a woman in Byzantium, we must look at women's personal artifacts: their jewelry and clothes, their private icons, and the objects with which they chose to furnish their lives. A goal of this exhibition is to present not only the luxury objects of the aristocratic circles, for which Byzantium is famous, but also common objects, simply made and even trivial, that reveal details of life not considered worth recording.

Some aspects of the role of women in Byzantine society are known. Women's occupations in the typical household were not limited to cooking and cleaning, although these activities took up much of their daily life. It was the woman's responsibility to make sure that domestic necessities were taken care of. Cleaning and washing involved carrying water

to the house from the well or public fountain. Cooking and feeding the family required shopping for certain foods, usually fresh vegetables, at the market and either baking bread or buying it from public bakeries. Other activities outside the house included visiting nearby relatives and meeting other women to exchange news and gossip. Family ties were close, and women participated in decisions about marriages and child rearing.

Women also played a role in monitoring and maintaining the family's health, or *hygeia*, a concept that included both physical and mental well-being, which was vital to the family and the culture at large. Knowledge about health was put into practice through choices of food, water, plants, music, and dance, as well as mythological and other tales, which nourished body and soul. Were it not for women's daily application of this knowledge and wisdom, the culture might not have lasted as long as it did, and Byzantium would not have had such an influential role in history. A number of objects in the exhibition represent practices and traditions related to health.

Although depictions of females in visual sources are plentiful, they are rarely representations of actual contemporary women. Those recognizable as historical individuals are in most cases empresses and women from aristocratic circles (see fig. 9).[8] The fact that representations of such women are not as common as those of men is an indication of women's lesser status and fewer official rights.[9]

Any discussion of the representation of females in Byzantine society depends on the surviving visual evidence and must take into consideration the historical period of production of each object or work of art, since traditions and customs changed over time. Byzantium's cultural heritage was that of the classical and Roman world and its visual language clearly reflects this. The Greco-Roman repertoire of images and forms persisted in the Byzantine world, but within a Christian context that continued to develop and change during the thousand years of the empire. For example, public and private portraiture in sculpture continued until the sixth to seventh century, ending around the time of Iconoclasm, though this does not mean that statues disappeared all at once.[10] In Constantinople, for instance, a significant number of ancient statues remained on view in public places, especially the Hippodrome, and imperial portraits in sculpture continued to decorate public spaces for centuries.[11] Private portraiture in the exhibition includes several marble heads (cats. 24–27) that are likely portraits of aristocratic women who had themselves represented in the latest fashions and hairstyles, which were often dictated by the imperial women of the time.

The concept of portraiture was never lost, but in the period following Iconoclasm it was found only in low relief and in two-dimensional media such as painting, mosaic, and manuscript illustration. An earlier example of the last is the portrait of Anicia Juliana in the sixth-century Dioskorides manuscript, *De materia medica*, a facsimile of which features in the exhibition.[12] The surviving portraiture of the centuries after Iconoclasm continues to depict visible and powerful women, represented in the exhibition by a number of coins and seals, a sampling of the variety that developed over the centuries (see cats. 16a, 17a, 20b, 29a–33a, 40b, 46, 47).

Depictions of the "common woman" were primarily incidental and for the most part

come out of a biblical rather than secular context—namely, illustrated manuscripts or wall paintings in churches. From the illustrations of Old Testament narratives we can gain some sense of how women might have looked and what their activities in the domestic space involved. Most of these images come from Psalters and Octateuchs.[13]

Several depictions of childbirth—a most unusual and personal moment in a woman's life—appear in a series of Octateuchs produced in the eleventh and twelfth centuries. One example, in Vatican gr. 747, depicts Rebecca giving birth to Esau and Jacob (fig. 23).[14] She is shown twice in the scene: On the left she is seated, pensive and sad, next to her husband, who prays to God to make them fertile. There she is dressed in the manner familiar from most depictions of Old Testament and holy women—a long gown and a scarf over her hair—which was most likely similar to the type of dress that at least married women in Byzantium wore outside the home.[15] On the right Rebecca is shown in her home, without her head scarf, squatting with her legs parted, giving birth. Esau lies nearby and Jacob's head appears between her legs. It is remarkable that this very private moment is represented in such manuscripts, not only once, but in several episodes about noteworthy births. This suggests an openness and freedom of expression in matters of human emotion and intimate relationships, which find their strongest representation in art during the twelfth century. Depictions of such everyday domestic activities as taking care of a mother and her newborn proliferate during this period. Scenes of domesticity also occur in representations of famous births, such as those of John the Baptist and the Virgin Mary (cats. 70, 186).[16] These images show the bedchamber where the child has just been born. The midwife, easily identified by the white turbanlike scarf that holds her hair, is usually bathing the child with the assistance of a maidservant. The mother, still reclining on her bed, is attended by several young women, who present her with food and drink to help her regain her strength. Although they represent the births of holy figures, these images can be seen as depicting the everyday reality of such an event, since the artists of the time must have drawn upon the world around them for inspiration. Thus images of holy events give us a unique sense of Byzantine customs and of relationships among Byzantine women.

Another expression of the relationship between parents and a child in the home environment is found in illustrations in the two copies of the *Homilies of James Kokkinobaphos,* in Paris and the Vatican.[17] A number of scenes show the Virgin's parents, Anna and Joachim, caring for Mary during the first years of her life.[18] In the upper register of figure 1, for example, the high priests at a banquet, having passed the child around, finally hand her to Anna. In the register below, Anna is shown standing next to the little Virgin's crib and covering her with a blanket. She is shown a second time in the same register, seated at the end of the bed, tenderly embracing and kissing the girl as a female attendant looks on. Through this illustration we can visualize a Byzantine child's bedchamber as well as the types of bed and sheets that were used. The Virgin's sheet is beautifully embroidered at the head and foot with a kind of decorative motif that continues to be used to this day.

Another religious source for the representation of ordinary women, that gives us a sense of their manner and overall appearance is the scene of the Presentation of the Virgin in the Temple. The small Virgin is always accompanied by a procession of young

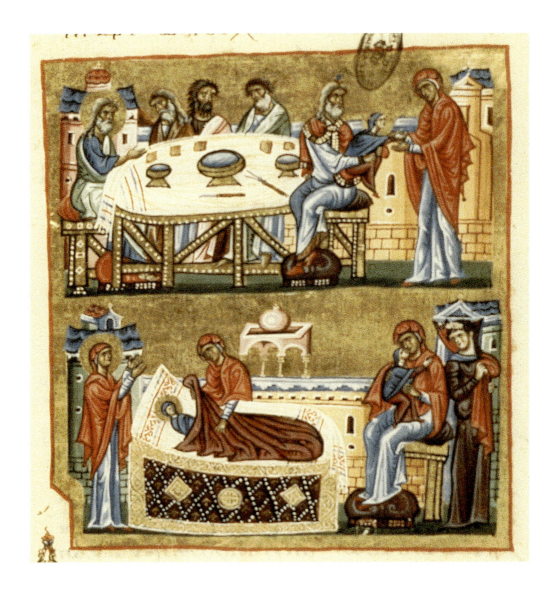

women carrying lighted candles. In a wall painting (c. 1290) by Manuel Panselinos from the Protaton on Mount Athos, this scene shows seven women in a variety of portrait types that can be considered typical of the period (fig. 2). All are young; some have their hair held back by white hair bands. Three have their heads covered in white scarves decorated with yellow stripes and white fringes and embroidery, the kind of head cover we have to imagine that women wore outside the home. All are dressed in reddish brown or purplish tunics topped by mantles in white or yellow. These are clearly not portraits of specific individuals, but representative types of ordinary young women.

In Byzantine art the contemporary secular environment thus finds expression through biblical and religious themes. The increase in images of contemporary life reflects a shift that occurred in the middle Byzantine period in female representation: the classical prototype was slowly abandoned in favor of a new, direct visual language that allowed women to be depicted in the context of their social and private lives. In the early period, the visual language of the classical world—its gods and mortals and their myths—was still used metaphorically to represent secular Byzantine subject matter. Examples in the exhibition

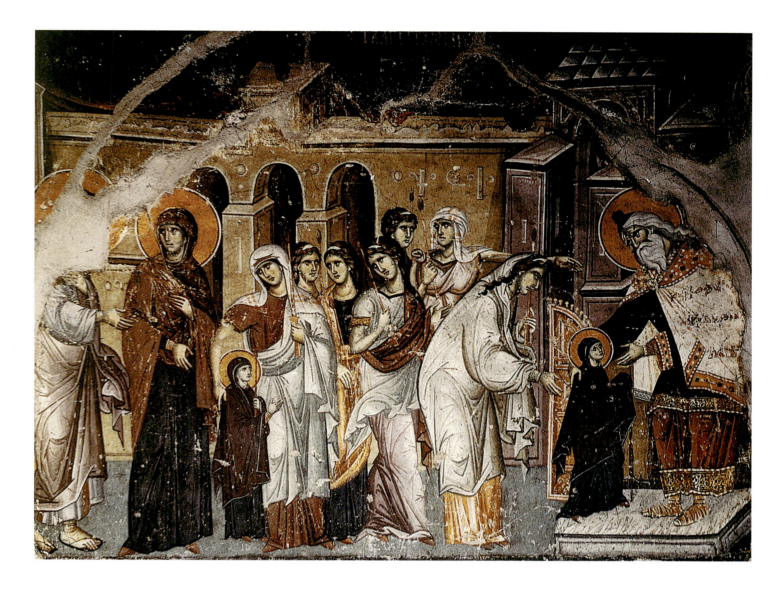

Fig. 2. The Presentation of the
Virgin in the Temple, c. 1290.
Fresco, attributed to Manuel
Panselinos of Thessaloniki.
Protaton Monastery, Karyes,
Mount Athos, Greece.

are objects such as the silver plate with Artemis hunting (cat. 97) and the lampstand with
Aphrodite (cat. 111). The figure of Aphrodite at her toilet, looking in a mirror and fixing
a lock of hair, was popular on female toilet articles and jewelry. That hint of coquetry is
also the motif on a most striking example of jewelry, a lapis lazuli shell pendant from the
sixth century (fig. 3), in the Dumbarton Oaks Collection.[19] A number of these famous
female figures from the classical past maintain some presence in the Byzantine period,
especially in literary texts, though they are seen less and less frequently in the visual arts
from the eleventh century onward.[20] Their endurance points to a familiarity with these
mythological characters and their power to express things feminine in a way that touched
the lives of Byzantine women.[21]

The eleventh century saw the introduction of the new visual language in secular
objects, in which contemporary women's roles and activities replaced the images of the
past, even if they sometimes had biblical references. What marks the figures as women of
their own times is their dress and their actions. Why this shift took place is not clear. It
may reflect changes in attitude toward the ancient past or less familiarity with mythology,

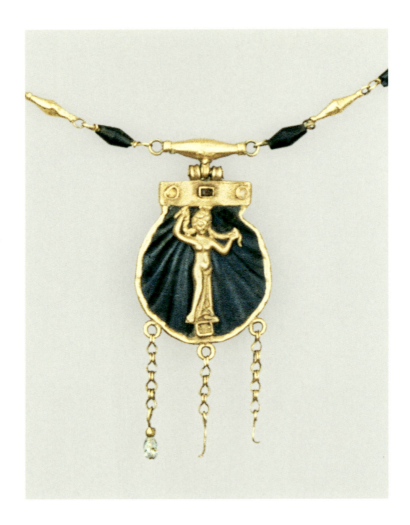

or it might have been the result of outside influences, Western or Eastern.[22] For example, female dancers appear in scenes of court entertainment, particularly on silver dishes; they also appear in Psalters, in depictions of Miriam dancing with her companions after the successful crossing of the Red Sea. Vatican Psalter gr. 752 (1058), for instance, presents one of the most striking contemporary images of women dancing.[23] They move in a circle, holding one another at the shoulder, displaying not only their rich and colorful silk dresses, sashes, and hats, but also the precise reverse step in the dance they perform. Their brocade dresses with long, wide sleeves tapering to points mark them as women of the court of this period. The artist here depicted the victory of the past as a victory of the present. He used contemporary imagery to refer to the past instead of classical imagery to represent the present, as was the custom in previous centuries. This new approach applied not only to aristocrats, such as these women dancing, but also to commoners, like the single dancer depicted on a plate in the Benaki Museum in Athens (fig. 16).[24]

Among the biblical figures that reflect Byzantine values and everyday activities are Adam and Eve, the archetypal couple whose encounter with God marked the life of all mankind. Depictions of them, found mostly on ivory boxes, go beyond the biblical narrative to show the couple toiling to survive outside Paradise. Eve plays a prominent role. She is shown working the earth with Adam, for example, on a box in the Cleveland Museum

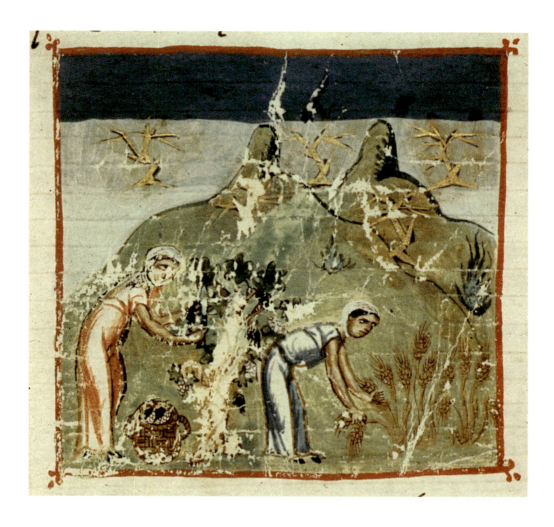

of Art, or on the plaque in the Metropolitan Museum of Art (cat. 71 comparative photo),
where the couple reaps grain and Eve carries a sheaf on her shoulder.[25] She is not depicted
spinning, an image that became traditional for Eve in the West, although spinning and
weaving were the kinds of work that Byzantine women did most frequently as their con-
tribution to the household (fig. 13).[26] Like Eve on this ivory box, women also worked in
agriculture, although that experience was hardly ever recorded. A rare image of women in
the fields—gathering grapes and harvesting grain—can be found, for example, in Vatican
Octateuch gr. 747 (fig. 4). The ivory casket scenes are unusual in that they show the cou-
ple sharing the burden instead of laboring in their separate domains. Eve assists Adam
even at the forge, by working the bellows as he hammers metal (cat. 71). This scene is
common on the ivory boxes, where in a few cases the personification of Ploutos (Wealth) is
shown seated between the couple, a suggestion that work can also bear fruit. The couple's
destiny was to work together in order to survive on earth; their well-being depended on
marital harmony and collaboration, which allowed them to overcome the difficulties that
a couple might encounter in life and to prosper. Since this type of box was for secular use
in the home, Eve sets an example here for every woman in Byzantium, taking a role equal
to her husband's within the family and assuming domestic responsibilities.

Among the late Byzantine representations of women that depart entirely from tradi-

tional figures, either classical or biblical, is that of a young contemporary woman with her lover.[27] Young couples are depicted on a number of silver dishes of the twelfth century as well as on ceramics, such as a famous dish from Corinth of a century later.[28] They usually appear on the inside of the dish, sitting together at the center. On two silver gilt bowls in Moscow, for instance, the young man is playing a harp as the woman sits beside him, listening and possibly singing along.[29] These depictions of courtship using contemporary figures are a significant departure from such earlier objects as the tenth-century Veroli casket, with its representations of famous couples from antiquity.[30] On the plate from Corinth, the couple is shown in a close embrace: the young woman, in a long skirt, sits on the lap of her lover, who is seated on a folding stool. The countryside is suggested by a plant and a jumping hare, which also symbolizes fertility and thus refers to their sexual relationship. This composition is one of the most "modern" images of Byzantine art, not only for its linear, abstract style, but also for a freedom of expression regarding relationships between men and women that is not usually associated with the medieval world.[31]

A close study of the visual record can begin to provide the kind of evidence still needed to enhance our understanding of Byzantine women. The range of images available—from Artemis to Eve, from empress to anonymous couples in love—gives us many different perspectives from which to examine their lives. And in this exhibition the variety of objects and artifacts—needle, comb, icon, necklace—supplies the tangible evidence for women's daily activities so rarely documented in text.

In the last few years new material has come to light from excavations and from storage rooms; a great number of objects were recently presented in the Thessaloniki exhibition *Daily Life in Byzantium*.[32] With such a rich body of evidence gaining notice, our perception of women in Byzantium can only continue to grow in clarity and depth.

1. For a general discussion, further bibliography, and some ways of recovering the practical reality of Byzantine women, see Herrin 1983.

2. On the education of boys and girls, see Kalogeras 2000, 212ff. On education in general, see Markopoulos 1989.

3. For recent research on women's place within Byzantine society, see Beaucamp 1990, 1992; Garland 1988; Herrin 1983; and Laiou 1981, 1985, 1992, and 2001.

4. Institutional offices for women in the Church outside monastic communities were confined to positions such as deaconess, but beginning in the sixth century, those positions, too, diminished (Herrin 1982, 72–73).

5. On the power of imperial women, see Hill 1997.

6. See Smythe 1997.

7. See, for example, Diehl 1906, 1908; Nicol 1994; Herrin 2000 and 2001.

8. See also Grabar and Manoussacas 1979, pl. 19 and fig. 110.

9. This essay represents an expansion of ideas introduced in my contribution to the catalogue of the Thessaloniki exhibition *Daily Life in Byzantium* (Kalavrezou 2002).

10. For a general discussion of these early surviving portraits of women, see ibid., 241–42.

11. See Elizabeth Gittings' essay "Women as Embodiments of Civic Life" in this volume.

12. Gerstinger 1965–70, fol. 6v.

13. The Octateuchs, the first eight books of the Old Testament, are a special group of manuscripts among the illustrated Byzantine texts. I believe they offer the stories and characters that form an alternative past, another history that fits well within the Byzantine Christian ideology and creates "epics" no longer connected with the pagan past.

14. See also Weitzmann and Bernabo 2002, fig. 355.

15. These portrayals offer no realistic representation of the female body. As Hutter has observed, the distinguished female forms present in earlier centuries were lost by the middle Byzantine period. She attributes this to theological developments, especially in relation to the icon (Hutter 1984). Most of these images come out of a religious context that is interested in illustrating narratives, not women.

16. For example, the birth of John the Baptist in Vatican MS urb. gr. 2, fol. 167v (*Liturgie und Andacht* 1992, 139–41). In this illustration, too, there is a careful depiction of the crib, next to the mother's bed, being prepared for the child after its bath. The crib is beautifully carved, with small arched cutouts on the sides and rockers for lulling the child to sleep. Unfortunately, few images of this kind survive.

17. For example, in the *Homilies of James Kokkinobaphos* (Stornajolo 1910, fols. 29r, 38v, 43r).

18. *Byzance* 1992, 361–62, cat. 272; Stornajolo 1910, 16, 17 (fols. 44v, 46v).

19. Ross 1965, cat. 12.

20. For example, the popular subject of Aphrodite's beauty is no longer found in the art of the middle Byzantine period.

21. References to ancient mythological figures, used in this eclectic way, are also found throughout the textual sources.

22. It also may result from the surviving evidence, which distorts our perception of the types of image that were used simultaneously, especially on secular objects, rather than successively.

23. De Wald 1942, vol. 3, pl. 54; *Glory of Byzantium* 1997, 206–7, cat. 142.

24. Representations of women dancers are found not only on luxury objects but also on everyday pottery. See Papanikola-Bakirtzi 1999, 155 and 161, cat. 335.

25. *Glory of Byzantium* 1997, 234–36, cat. 158.

26. Laiou 1986, vol. 1, 111–22. See also Molly Fulghum Heintz's essay, "The Art and Craft of Earning a Living," in this volume.

27. It is very possible that such themes were present in earlier centuries but that the surviving evidence gives a distorted image. The composition of the famous scene of David and Melodia in the Paris Psalter (Bibliothèque Nationale MS gr. 139) can be regarded as representing a couple, and it may derive from the classical tradition of such depictions, but thematically it does not yet represent a contemporary couple.

28. *Glory of Byzantium* 1997, 234–36, cat. 192. On ceramic plates, mainly from Cyprus and considered to be wedding plates, see Papanikola-Bakirtzi 1999.

29. Darkevich 1975, figs. 3, 4, 46, 47. Often such courtship scenes and those of hunting are regarded as derived from the epic of Digenes Akritas, but they could just as well be representations of the activities rather than known characters. See nn. 28 and 31.

30. Europa and Zeus, Aphrodite and Ares, and Phaedra and Hippolytus.

31. For a similar freedom of visual expression, see the wedding plates from Cyprus that depict couples in a close embrace, with their chests merged (Papanikola-Bakirtzi 1999).

32. Lefkos Pyrgos, Thessaloniki, October 2001–January 2002.

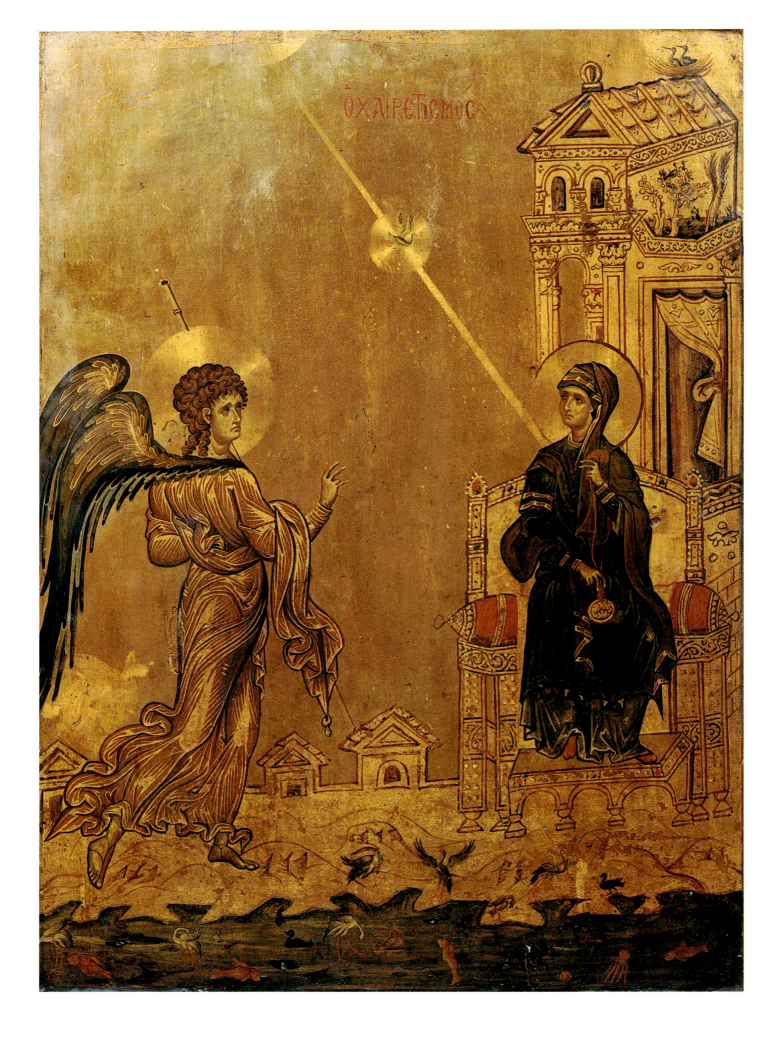

ANGELIKI E. LAIOU

# Women in the History of Byzantium

The image of Byzantium in scholarly as well as popular perception has long suffered from two historical accidents. The first is the fact that one of the greatest masters of English historical prose turned his unsympathetic attention to the history of Byzantium. Edward Gibbon's *The Decline and Fall of the Roman Empire*, with its memorable turns of phrase, has done a great deal to establish, especially in the consciousness of the English-speaking public, an image of Byzantium as a failed state, an obscurantist and superstitious society, a rigid and barbarous system traveling down the ages on a path of well-merited decline. The other historical accident is the one-sided information we have about Byzantine art and all it can tell us about Byzantine culture. For reasons that are easy to understand, the great majority of monuments and objects that have survived belong to the category of religious art. Although they include major masterpieces of the Middle Ages, they necessarily project a spiritual and cultural world that is incomplete. The study of those secular objects that have survived allows us to perceive different aspects of the culture of the Byzantine Empire: a sense of humor, an irreverence, a love of beauty, even a certain subversiveness. The existence of these objects reminds us that we would have seen a rather different and more complex society had more secular art remained.

A third element has also been of paramount importance in the elaboration of our image of Byzantium. When, in the course of the nineteenth century, Western Europe rediscovered its Middle Ages and with it the formative elements of its society and culture, the lands that had constituted the Byzantine Empire belonged to the Ottoman Empire, in whose political fate Western Europe was increasingly involved, and which was presented as in many ways the antithesis of Western civilization: exotic, underhanded, given to luxury and indolence—in short, "oriental." It was easy to project these same views and images back to the Byzantine Empire and contrast them with the reason and clarity of the classical past of Greece and the rational, capitalist present of Western Europe. The image of the Byzantine woman closeted in a quasi-harem and virtually invisible except when she emerged as a scheming and devious empress owes a good deal to this perception.

Today, Byzantinists know how much of this picture is wrong. Far from being a static, hieratic society hurtling headlong into disaster, Byzantium was vibrant, dynamic, ever changing—traits that were certainly part of its strength and that allowed the state to survive for more than a thousand years. Far from destroying ancient civilization, Byzantium treasured its monuments, ensured the survival of its texts, and incorporated part of its philosophy into the writings of the great fourth-century Church fathers. It was a world that was at times highly ordered and at other times unquiet and in flux; a world in which change took place on a bed of tradition, whether literary, institutional, or customary.

In this society, which looks patriarchal on the surface, women wielded great power. But it was power that manifested itself differently in different spheres, and normative

Fig. 5. Icon of the Annunciation, 12th century. Monastery of Saint Catherine, Mount Sinai, Egypt.

statements of powerlessness were pervasive, sometimes misleading scholars who have taken them at face value.

A pivotal change occurred in the Byzantine Empire in the seventh century, when the state lost its richest, most highly urbanized and most cultured regions—Egypt, Syria, Palestine, and North Africa—to the Arabs. Parts of Asia Minor were also lost for a time, while Constantinople itself came under sustained attack. In the Balkans there was a vast demographic change, with the influx of Slavic peoples, and of Bulgars into the area that today constitutes Bulgaria. A profound demographic crisis of a different type had occurred in the 540s as a result of the bubonic plague, which recurred through the second half of the eighth century. Cities shrank and the economy declined, as did intellectual activity. By the ninth century, however, Byzantium was in sustained recovery, as all indicators suggest. There was significant territorial expansion into Asia Minor and eventually into northern Syria and Armenia, as well as in the Balkans. The demographic curve was reversed as a population increase set in, to continue until the fourteenth century. The economy entered a phase of expansion, as did the cities. The cultural revival was virtually continuous, although with different phases, from the ninth through the fourteenth century, lasting in some areas into the fifteenth century. After the capture of Constantinople in 1204 by the participants in the Fourth Crusade, and despite the recovery of the city by the Byzantines in 1261, the state grew progressively weaker. Yet commerce thrived, and intellectual, cultural, and artistic activity was high in both quantity and quality, right down to the fall of Constantinople to the Ottomans in 1453. These changes necessarily affected the role of women as well: the lives of women were different in the eighth century from what they would become in the twelfth.

This discussion of women's roles focuses on the period from the ninth through the fourteenth century, with references to other periods. Like the exhibition this catalogue accompanies, it distinguishes between the public and private spheres, although the two interact in some important instances—for example, in the participation of women in economic life, and in the role of the female saint.

To the extent that by the public sphere we understand the exercise of political power, whether civil, military or ecclesiastical, it must be said that the participation of women was restricted by ideological norms as well as by the structure of power and authority. Ideological norms clearly and consistently posited that the proper realm for women's activities was the home—private, not public, space. Here as elsewhere practice did not necessarily follow ideology; but this was the case more in the marketplace than in the corridors of power. The Byzantine state was well organized and centralized, at least through the twelfth century. Authority devolved from the emperor to the civil officials and the army, who thus formed the hierarchy of political power. The institutional Church wielded political power of its own. From all of these centers of power and authority, with the notable exception of the palace, women were excluded by law and custom. By law they could not hold administrative office; by definition they were excluded from military office; they could not even bear witness except in matters touching on the intimate life of a woman.

In the secular Church, too, after the time of early Christianity, women were excluded

from office, certainly from that of priest or bishop. On the other hand, women could and did found and rule convents. For economic reasons, women founders of convents were frequently, although not always, members of the aristocracy. In the twelfth century and later, the monastery became for them an extension of the family, where they had control over everyday life. They even, up to a point, controlled the care of souls of the other nuns as well as of members of their family by deciding, for example, for whom and how often memorial services would be celebrated. The empress Irene Doukaina, who founded the convent of Kecharitomene, established in her foundation charter that after her death the convent would be ruled by her daughters, followed by her granddaughters, and in perpetuity by the female descendants of her eldest daughter, Anna Komnene. Given that convents also had important economic functions, the role of women in these institutions was both significant and multifaceted.

Women also played a role, and a significant one, in religious affairs. One of the most important movements of the middle Byzantine period, Iconoclasm, was eventually resolved through the actions of two empresses: Irene (cats. 18, 19), who restored the veneration of icons temporarily, and Theodora (cats. 35–37), whose disposition regarding the restoration of icon veneration proved final. A recent study has pointed out that by the time these events occurred (late eighth and mid-ninth centuries), traditions of feminine imperial authority had been so firmly established that women of the imperial family could exercise real power, whether in their own name, as wives, or as guardians of minor sons. Nor was the role of women in religious controversy limited to the early period, or to Iconoclasm. In the Palaiologan period (late thirteenth to mid-fifteenth century), women of the imperial family were actively involved in opposition to Michael VIII's policy of Church union with Rome (most notably, this was the case with his sister Eulogia and his two nieces, Theodora Komnene Raoulaina and Anna of Epiros). In the Palamist controversy,[1] Irene Choumnaina as well as, for a while, Irene Asanina, the wife of John VI Kantakouzenos, were publicly opposed to Palamism.

In the centralized Byzantine system of governance, women of the imperial family could play a determining role in public affairs. The case of the empress Theodora, wife of Justinian I (r. 527–65), is well known. It was said at the time that she and her husband played a political game, each of them ostensibly supporting a different faction, so that all important groups would think they had imperial patronage; but the imperial couple had secretly agreed upon this apparent disagreement. Theodora is also credited with saving the empire when, at a moment of acute crisis, as the emperor was preparing to flee Constantinople, she shamed him into staying by saying that she preferred to die dressed in the imperial purple. More directly, women ruled as empresses (for example, the eleventh-century Zoe and Theodora, cats. 20, 40), or as the mothers of minor or ruling emperors. A prime example of the latter is Anna Dalassene, to whom her son, Alexios I (r. 1081–1118), delegated full power and authority when he went on campaign. The empress Theodora (cats. 35–37), wife of Theophilos (r. 829–42) and regent for her young son, was a woman of intelligence, courage, and wit. She not only restored the veneration of icons while making certain that it would be done with a minimum of recrimination and reprisals, but she also

governed with wisdom and strength, organizing military campaigns and leaving a full treasury when she was overthrown.

Women saints straddled the public and private spheres. Saints' *vitae* stress their modesty, and some women attained sanctity through asceticism. Others, such as Saint Mary the Younger, became saints through the efforts of their families, who tried to turn a private cult into a public one. In any case, female saints, like male saints, were public figures to a greater or lesser extent. Female saints were most visible when they also happened to be empresses. But even saints from lower social strata had a public role, as miracle workers, for example. Furthermore, especially in the tenth century and after, women saints were distinguished by what one may call public virtues, primarily that of charity. Care of the poor was an activity that almost necessarily led to contact with people: Saint Thomaïs of Lesbos is an extreme example, for she is said to have roamed the streets and porticos of Constantinople at night, seeking out the poor to whom she would give alms. The funds for such charity came out of the private sphere, the household budget that women controlled, even if the saint had to suffer blows from her husband, as Thomaïs did, for "squandering" the money.

According to a powerful ideological tenet, the woman's world was the home and the family: in it her position was understood and mandated, within it her activities were sanctified, and in the institutions that constituted it she found safety and legal protection. The world of home and family was much vaster in the Byzantine period than it is in modern Western societies. Kinship relations were strong and extended certainly through the sixth degree of consanguinity (second cousins), in many instances through the seventh degree. Thus, people related to the seventh degree of consanguinity were, after the twelfth century, forbidden to marry, and intestate succession encompassed the seventh degree as well. Although the great majority of households consisted of nuclear families, extended households were also common. For economic reasons, such as the more efficient exploitation of agricultural plots that might otherwise have been divided, two or more siblings or even first cousins might live together. Parents of an advanced age normally lived with one of their children, and people from fragmented households—widowed sisters or orphaned nephews and nieces—found refuge in the households of their relatives. The family was a unit not only of reproduction and socialization, but also of economic activity. When the family was wealthy, the household was a rather important economic unit. And there, women came into their own.

A vivid portrait of the life of a woman in eleventh-century Constantinople emerges from the pen of Michael Psellos, intellectual and politician, who wrote two funeral orations, one for his daughter and one for his mother. His daughter, who died very young, is praised for her beauty: she was like a just-opened rosebud when a baby and developed into a beautiful young girl. Psellos describes her physical beauty in loving and elaborate detail. Her character was as beautiful as her body; she was mild, cheerful, affectionate toward her parents, and obedient to her mother, who was charged with her upbringing. Interestingly, Psellos insists on her intellectual qualities: she was quick and eager to learn, and she spoke clearly and articulately. At the same time, he says, she did not neglect the female occupation

of weaving, but divided her time between this activity and her studies. She was an expert weaver who made fine linen cloth and lovely figured silks. As is to be expected, she is also praised for her piety and her almsgiving. She was so perfect in every way that a number of men pressed their suit; but she died, breaking her parents' hearts, before she could marry.[2] For another daughter, Psellos later tried to get a husband, buying him a post in the imperial service as part of the dowry; the young man proved an unfortunate choice.

As for Psellos' mother, she is the model of a wife and mother. A somewhat austere figure, according to the writer, she spent her days at the work of the women's quarter, spinning and weaving. She was sober in her clothing, but not careless, so as not to appear unpleasant to her husband. She was a devoted mother, but not a learned woman: after having taught him his first letters, she sat with Psellos as he did his lessons, but was unable to help him further. She set great store on almsgiving, and was very pious. But for the rest, she did not concern herself with public affairs, "and did not want to know anything, either what took place in the marketplace, or what occurred in the Palace . . . or the affairs of her neighbors." After her daughter and then her husband died, she never left the house again, and lived the life of a nun, albeit at home. This text is a hymn to the virtues of the married woman and mother.[3]

Marriage was the institution for which the Byzantine woman of the middle period was groomed and within which she functioned (cats. 121–32). This statement sounds trite, but in fact it took some time for marriage to develop as the institution most valued by Church and state, and for the monogamous union in marriage to be adopted as the proper and blessed state for a woman.

Roman society had been a patriarchal one, in which authority within the family was vested in the father and/or the husband. Furthermore, the status of women in connection with male partners was socially differentiated. A proper and valid marriage necessitated the existence of dotal contracts. The institution of concubinage affected primarily poorer women, who had few rights regarding the property of their male partners; their status was much lower than that of married women, and their children had no rights regarding the father's property.

Important changes in this system were introduced by Justinian I, and with the *Ecloga*, the law code of the Isaurian emperors, issued in 741, the changes became massive and comprehensive. For one thing, the strictly patriarchal system was attenuated, since the *Ecloga* gave the widowed woman full authority over unmarried children, charging them with obedience and her with the right and obligation to bring up the children and arrange for their marriages. A number of important changes affected the institution of marriage. According to the *Ecloga*, dotal contracts were no longer required for a valid marriage. Instead, in a development that began under Justinian I, it was possible for poorer people to form a valid marriage on the basis of the consent of the contracting parties and their parents and a public recognition of their intent, effected either through the benediction of the Church or by proclaiming it in the presence of witnesses. By the time of Leo VI (r. 886–912), Church benediction was necessary for a Christian marriage. The net effect of this legislation was to facilitate the creation of the marriage bond between people of humble condition.

Just as important as far as women were concerned was the recognition in the *Ecloga* of a form of common-law marriage, whereby a long-term union constituted wedlock, with all the attendant property and inheritance rights. Both the *Ecloga* and Justinianic legislation that had taken some steps in the same direction saw and expressed the problem from the viewpoint of the woman: a man who had brought a free woman into his household, had had carnal relations with her, and had entrusted her with the running of his household was held to have contracted marriage with her. This legislation was probably connected with the Roman institution of concubinage, which it changed in ways favorable to the woman. The Roman concubine was now turned into a Christian wife, a great improvement as far as women of low status were concerned. This arrangement did not survive, however. Once benediction became necessary for a valid marriage, common-law marriage was no longer acceptable. As for concubinage, it was formally abolished by Leo VI (Novel 91), but in fact continued to be practiced.

The legislation of the *Ecloga*, with its flattening of social distinction and the strong support it gave to the institution of marriage, owed much to the influence of Christianity. The early Church had placed great value on virginity—life without carnal relations—and through its institutions had made it possible for women to live outside marriage. With time, however, the Church placed greater emphasis upon proper—Christian—marriage, which it sought to control. Indeed, much of the civil legislation concerning betrothal and marriage, impediments to marriage, divorce, and sexual relations outside marriage was indebted to Church teachings and to canon law. By the ninth century, the Church had fully accepted both marriage and the sexual relations it encompasses, so that the model of a good Christian woman now became the pious and charitable wife and mother. For women, therefore, there was an exalted role within marriage.

In practice, these developments also meant that a woman's life was under considerable control. Since marriage arrangements were made at a very young age, with simple betrothal (not recognized by the Church) possible at the age of seven, and marriage possible after the age of thirteen, actually taking place at fourteen or fifteen, very few women had a voice in choosing their own husbands. The choice was a matter of family strategy, within the confines of civil and ecclesiastical law. If a woman really detested her husband, there was little she could do about it, although in extreme cases women did invoke an implacable hatred of their husband to dissolve a marriage; this was not legally recognized as grounds for divorce, but it did work in practice. Obedience to the husband was expected, even though, here again, we find many instances where real life triumphed over ideology. Furthermore, although the Church, by supporting marriage as a freely contracted union, tended to stress the importance of the harmonious couple to whose formation man and woman contributed equally, it also accommodated the position that the woman was a temptress. Statements about women as a potentially polluting element recur over time—often, but not always, from the mouth or pen of ascetics. Such attitudes form a powerful undercurrent in the perception of women, and counterbalance to some extent the valorization of women as wives and mothers.

Women's position within the family was profoundly affected by Byzantine laws on the

devolution of family property, two aspects of which are of paramount importance. First, all children of a marriage, male and female, had a right to part of the family property; in the absence of a testament, the inheritance was to be equally divided among all the siblings. Property, then, was inherited through both the male and the female lines. Second, women normally received their share of the family property at the time of marriage, in the form of a dowry. Dowry property belonged to the woman in full ownership, although her husband had the right to administer it unless he proved incapable of doing so with probity. This property functioned under a special regime, which afforded it considerable protection from creditors, for example. It was the most stable part of the household property, since it could not be sold except in the most dire of circumstances. Women took on the administration of dowry goods when they were widowed; they also could and did own and administer other property, whether it came to them as a gift or was the result of their own labor.

The fact that women were property owners undoubtedly enhanced their importance within the household. This is most visible among the great aristocratic families. From the eleventh century onward, the aristocracy solidified its position through, among other things, successful and successive marriage alliances among its members; the alliance of the Komnenoi (cat. 47) and the Doukai (cats. 21, 41–44, 46) is only the most famous such arrangement. Power, property, and prestige traveled down the female line, whose members were quite as powerful as their husbands. Women of this class (and of other social groups as well) retained strong links with their family of birth, even after their marriage. The family of the Komnenoi again provides famous examples. It was the marriage of Alexios I and Irene Doukaina that sealed his alliance with the powerful Doukas clan, and allowed him to reach the throne. His wife is said to have supported the claims of their daughter Anna to inherit the throne at the expense of her brother, John II Komnenos. Anna herself retained such an affective link with her family that her seal bears the name Komnene, and not Vryennissa, her name by marriage. Her own daughter, Irene, preferred to identify herself through the line of her grandmother, and was known as Irene Doukaina. In peasant households as well, we occasionally find women who are identified through their birth family, and children identified through their mother's rather than their father's family. It may be that this occurred when the woman had married a man of lesser means than hers.

The institution of the dowry influenced women's lives in one other important respect. As in all societies where the dowry system prevails—where women bring property into the household—it served to reinforce the position that women should not work outside the home. Such work was thought to bring shame both on a woman's family of origin, for not providing a sufficient dowry, and on her husband, for failing to earn a sufficient living for his wife and children.

Every normative statement on the subject of a woman's place insisted that a good woman did not leave her house. Not only good bourgeois women and female saints, but all women were to stay within that protected space. From time to time, in the fourth century as in the fourteenth, this view was even incorporated into legal provisions regarding abduction or illicit intercourse. When such acts took place "in the wilderness," it was

assumed either that the woman was to some degree responsible because she did not stay within the protective environment (law of Constantine I on abduction, *Codex Theodosianus* 9.24) or, on the contrary, that she did not consent to the act, because in such a place even if she had objected she would not have been heard (Novel 26 of Andronikos II). The sight of women leaving the house and streaming into the streets was sometimes adduced as evidence of an upheaval so powerful that the world had turned upside down.

Potent as the ideology was, reality was quite different. In any case, the paradigm is class bound. Ideological norms such as those governing the parameters of a woman's life are created by the elite and are meant to apply primarily to the elite. In Byzantium, however, even the aristocracy did not follow the ideological norm, at least in the eleventh century and after. The empress Irene Doukaina followed her husband, Alexios I, on campaign, and other imperial wives or daughters ruled various cities in the fourteenth century. Aristocratic ladies held literary salons and freely consorted with men, in the eleventh century as in the twelfth and the fourteenth; Anna Komnene, with her circle of intellectuals who discussed philosophy, is a prime example. In my view, it was the families of bureaucrats and military men who aspired to higher social status that most treasured the norms and perhaps tried to apply them: this, at least, is the conclusion one draws from the works of the general Kekaumenos and the civil official Michael Psellos, both writing in the eleventh century.

For the vast majority of women, such conceits were unattainable. Women had to go out, whether to draw water, to work the fields, or to engage in other economic activities. Indeed, our sources from the fourth century onward make it quite clear that women had a considerable life outside the house. Their participation not only in agricultural labor but also in trade is well attested.

One of the most novel and exciting aspects of this exhibition is the attention given to "women at work." Such a rubric would have been impossible even a short time ago, for until recently scholars had little to say about women's labor, other than that women made cloth. The image of the good woman at her loom is omnipresent, in Byzantine literature as in art. This is the truly time-honored and sanctified female activity, going back in time to long before the Byzantine Empire was founded. The good woman of Proverbs 31:22 weaves cloth for her husband and herself; in the beautiful Sinai Annunciation of the twelfth century, the elegant Virgin is seen spinning (fig. 5; see also cat. 83).

Cloth making has all the elements of a proper female activity. It keeps the woman at home. It keeps her usefully occupied. It connects with another powerful ideological construct, that of the self-sufficiency of the household. Indeed, a number of sources insistently differentiate between engaging in this activity for the needs of the household alone and making cloth for the market; they consider the latter a lowly pursuit.

It is undoubtedly true that women engaged in cloth making; but so did men, and not only the workers who produced purple silks in imperial workshops. It is also true, however, that women worked in textiles not only for home production but also for trade; we even have some information that suggests the existence in the eleventh century of guildlike institutions whose members were women cloth workers. Women, we know, were

among the silk textile workers of the famous workshops of Thebes who were abducted by the Normans of Sicily in 1147. But women's work was certainly not confined to textiles.

In the search for information regarding women's labor, we are hampered by the ideological bias against it, which was so powerful that it is difficult to distinguish between reality and normative statement. This is particularly true about agricultural labor. Plowing was presented as men's work, and this was probably the case in reality. Herding, it seems, was also a male occupation, although contemporaries noted that Vlach women did engage in this activity. Women worked in the vineyards and at harvesting and threshing. We must imagine that they took care of the garden plots most Byzantine households possessed and that they raised barnyard animals, but information about this is lacking.

There is significantly more information about women in the marketplace. Unexpectedly, we find them there in the fourth century, and then again from the tenth century onward. Whether the hiatus reflects a lack of historical evidence, a decline in urban activities, or the reduced participation of women in those activities is not clear. Probably, as usual, all three factors apply. In any case, the presence of women in trade and business is unexpectedly strong, considering the powerful stereotype of the housebound woman and the fact that the open, boisterous, vulgar marketplace is the antithesis of the protected home environment. In the fourth century, women sold their wares (cloth is mentioned specifically) in the market at Constantinople, as Saint John Chrysostom attests. In the tenth and eleventh centuries, we find women involved in manufacturing cloth, trading in the market stalls, and investing in commercial real estate. Street hawkers, mostly of food, are attested in all periods, and in twelfth-century Constantinople, the irreverent poems of Ptochoprodromos speak of women selling food in butcher shops and elsewhere. In the late fourteenth century our sources proliferate. We find women who owned shops in Constantinople and women who managed them. Women invested in business and trade, as they had done in the sixth century, mostly with family members. Indeed, the shops were small, family-owned enterprises, and the family network was important in all economic activities. In that sense, women's roles in the economy lay between the public and the private spheres.

The world of the Byzantine woman was a rich and variegated one. The church, the home, the marketplace all formed a part of her life. But one must make essential distinctions. Female labor, although present, was despised, and the women who performed manual labor for others outside the household considered themselves unfortunate and were viewed by others as such. Although some institutional factors operated throughout the society (the dowry, for example), their effect and the power they conferred varied with a woman's class. In the end, it remains true that the fates of women very much depended on the dispositions made by males, notable examples to the contrary notwithstanding.

1. A mid-fourteenth-century religious controversy regarding man's ability to achieve communion with God and to experience God's uncreated grace.

2. Michael Psellos, "Επιτάφιοι λόγοι, Εις τήν θυγατέρα Στυλιανήν," in K. N. Sathas, Μεσαιωνική Βιβλιοθήκη, vol. 5 (Paris, 1876), 62–87.

3. Michael Psellos, "Επιτάφιοι λόγοι, Εις τήν μετέραν αυτοῦ," in Sathas, 3–62.

Beaucamp, J. 1990, 1992. *Le statut de la femme à Byzance (4e–7e siècle)*. 2 vols. Paris.

Diehl, C. 1906, 1948. *Figures byzantines*. 2 vols. Paris. [English: Bell, H. and T. de Kerpely, trans. 1963. *Byzantine Empresses*. London.]

Garland, L. 1988. "The Life and Ideology of Byzantine Women." *Byzantion* 58:361–93.

Gouma-Peterson, T., ed. 1995. *Bibliography on Women in Byzantium* 19. Wooster, Ohio.

————2000. *Anna Komnene and Her Times*. New York and London.

Herrin, J. 1983. "In Search of Byzantine Women: Three Avenues of Approach." In *Images of Women in Antiquity*, edited by A. M. Cameron and A. Kuhrt. London.

————2001. "The Imperial Feminine in Byzantium." *Past and Present* 169:3–35.

————2001. *Women in Purple: Rulers of Medieval Byzantium*. London.

James, L., ed. 1997. *Women, Men and Eunuchs: Gender in Byzantium*. London.

Laiou, A. 1981. "The Role of Women in Byzantine Society." *Jahrbuch der Österreichischen Byzantinistik* 31, no. 1: 233–60.

————1992. *Mariage, amour, et parenté à Byzance aux XI–XIIIe siècles*. Paris.

————1993. "Sex, Consent, and Coercion in Byzantium." In *Consent and Coercion to Sex and Marriage in Ancient and Medieval Societies*, edited by A. Laiou. Washington, D.C.

————1998. "Marriage Prohibitions, Marriage Strategies and the Dowry in Thirteenth-Century Byzantium." In *La transmission du patrimoine: Byzance et l'aire méditerranéenne*, edited by J. Beaucamp and G. Dagron. Paris.

————2001. "Women in the Marketplace of Constantinople (10th–14th Centuries)." In *Byzantine Constantinople: Monuments, Topography and Everyday Life*, edited by N. Necipoglu. Leiden, Boston, and Cologne.

Nicol, D. M. 1994. *The Byzantine Lady: Ten Portraits, 1250–1500*. Cambridge and New York.

Talbot, Alice-Mary, ed. 1996. *Holy Women of Byzantium: Ten Saints' Lives in English Translation*. Washington, D.C.

————1994. "Byzantine Women, Saints' Lives and Social Welfare." In *Through the Eye of a Needle: Judeo-Christian Roots of Social Welfare*, edited by E. A. Hanawalt and C. Lindberg. Kirkesville, Mo.

# Catalogue of the Exhibition

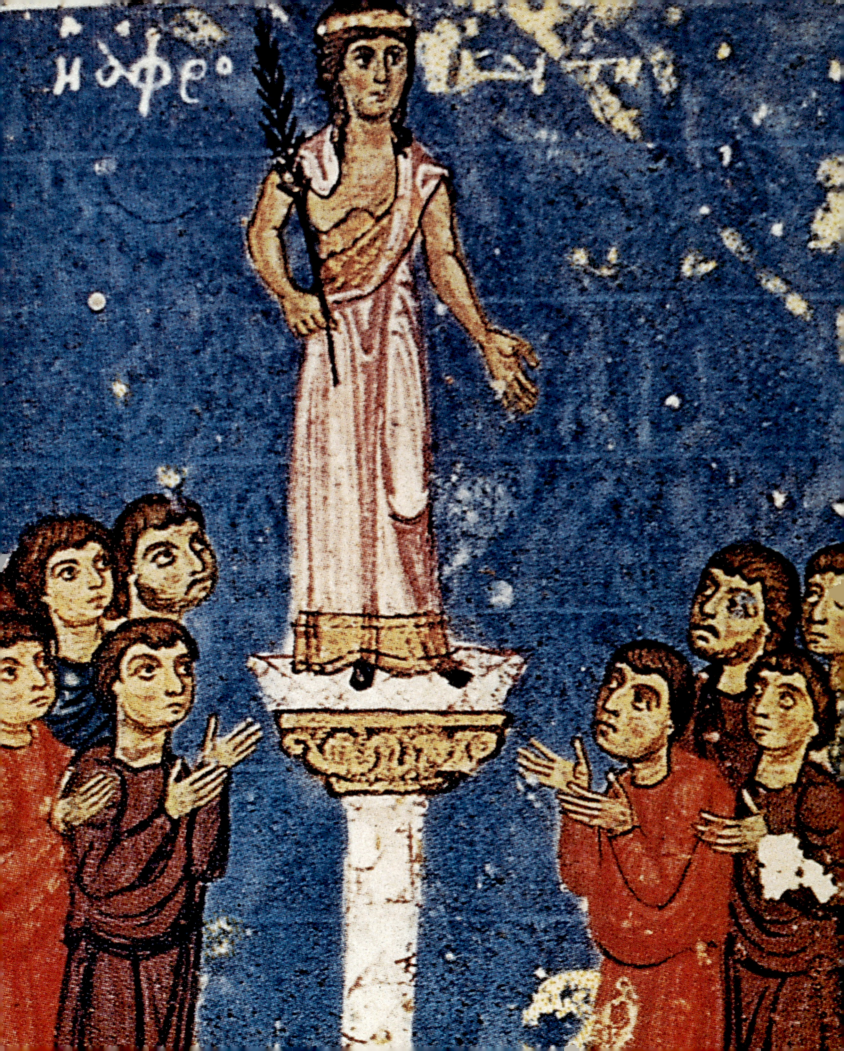

# CIVIC LIFE

**ELIZABETH A. GITTINGS**

## Women as Embodiments of Civic Life

Images of women had a prominent place in Byzantine civic life. Statues of goddesses, female allegories, and empresses dominated the public spaces of the early Byzantine city. Some were honored in spectacular parades involving the emperor, high officials, and citizenry, and their likenesses on coins circulated throughout the empire. The Virgin's image on icons and in churches and processions was the focus of later displays of civic piety, and depictions of the Virgin on coins replaced those of goddesses and allegories. With their majestic presence, these figures made female dignity an essential element in popular culture.

Among the figures from the early period were personifications of grand concepts such as Renewal, Magnanimity, and Foundation (Ktisis, κτίσις)—the last-mentioned depicted in a sixth-century mosaic pavement from a public building (fig. 6).[1] With her jewels and cornucopia—attributes of beauty, wealth, and abundance—and a tool for measuring length in her hand, Ktisis suggests the benefits of public works. Such female figures, elegantly corporeal and rooted in ancient tradition, were considered appropriate

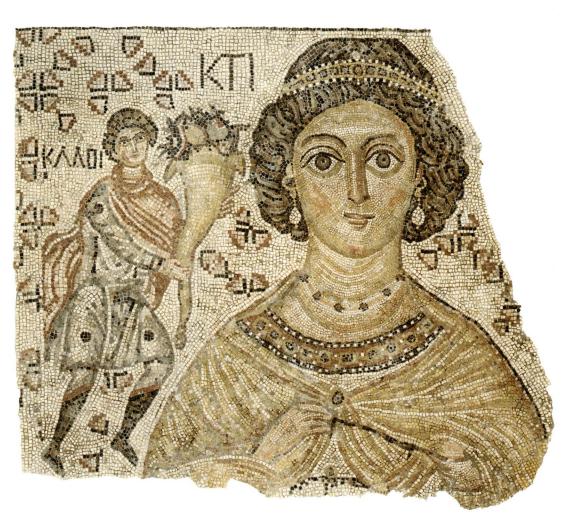

Fig. 6. The personification of Ktisis (Foundation) holds a measuring tool and receives a cornucopia. Mosaic floor fragment, 6th century. The Metropolitan Museum of Art, Harris Brisbane Dick and Fletcher Funds, 1998; and Purchase, Lila Acheson Wallace gift, and Dodge and Rogers Funds, 1999 (1998.69, 1999.99).

for the decoration of communal spaces such as reception halls, dining rooms, and church floors. Despite their pagan associations, they survived Byzantium's emergence as an officially Christian empire in the late fourth century.[2]

Tyche (Τύχη), the goddess or personification of a city's destiny and prosperity, was one of the most important early female personae.[3] Constantine established twin temples dedicated to the *tychai* of Rome and Constantinople in the new imperial capital he founded in 324 at the site of the ancient Greek city of Byzantium on the Bosporos.[4] He furnished the temples with appropriate cult statues: the Tyche of Constantinople was a reworked effigy of the goddess Cybele, known in Greek as Rhea, who had been venerated as the Tyche of Byzantium. She assimilated such attributes of this "Great Mother" as fertility, stability, and civic guardianship.[5] The second Tyche, brought from Rome, promoted the idea of the two capitals as counterparts, a major thrust of Constantine's official policy. In the words of the lawyer and historian Sokrates, "Having made her equal with Rome, the reigning city, and having given her the new name of Constantinople, [Constantine] prescribed by law that she be called a 'second Rome.'"[6]

Byzantines brought prestigious public offerings to the Constantinople *tychaion*. An inscription, perhaps from the early sixth century, found near the temple illustrates the popular belief in Tyche's influence in the lives of individuals: "Congratulations to you, Theodore, for having adorned the columned Temple of Tyche with such a wonderful work and having offered splendid gifts to gold-shielded Rome, she who made you consul and sees you three times prefect."[7] Numerous small-scale images of *tychai*, including statuettes in household shrines (cat. 1) and signet rings (cat. 8) and amulets worn on the body, invoked Tyche's help in personal matters and demonstrated civic pride and affiliation.

The cult of Tyche was closely associated with that of the emperor in early Constantinople. This auspicious nexus achieved spectacular form in the annual festival celebrating Constantinople's inauguration on May 11, 330. Chariot races were held in the Hippodrome. Escorted by troops in ceremonial dress bearing white candles, a gilt wooden statue of Constantine holding the city Tyche in his right hand was paraded on a cart around the racecourse.[8] Another statue of Tyche, named Anthousa (Blossoming), was venerated with hymns and acclamation below the great bronze statue of Constantine in the Forum, a large oval plaza where the inhabitants assembled for official ceremonies and announcements.[9] The golden parade effigy and statues of Constantine and Tyche in the Forum united the auspicious destinies of the emperor and his eponymous city—destinies to be shared not only by residents of the capital, but by all the empire.

As a principal allegory of the capital and empire, Tyche was soon assimilated into Christian ideas of triumph, primarily by association with the cross. Byzantines believed that the cross was a sign of both Christ's victory over death and the divine vision—a cross accompanied by a voice saying, "in this sign, triumph"—that inspired Constantine to defeat his pagan adversaries and found the Christian empire of "New Rome" in Constantinople.[10] The personified capital/empire is first depicted holding the *globus cruciger* on dynastic coinage that was struck in 430 in the name of the emperor Theodosios II but

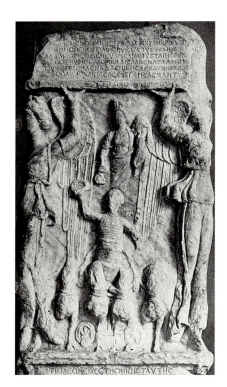

Fig. 7. Personifications of Nike (Victory) and the Tyche (Fortune) of the city of Nikomedeia surround the winning charioteer, Porphyrios. Base of a stele from the Hippodrome of Constantinople, c. 500. Marble. Archaeological Museum, Istanbul.

probably ordered by his powerful sister, the pious empress Pulcheria (cats. 7, 30).[11] In the early eighth century, a cross with the Tyche of the city flanked by statues of Constantine and his mother, Helena, stood on top of the Milion, the domed tetrapylon that marked the beginning of the city's main avenue and the point from which all distances in the empire were measured.[12] Thus, long after the end of paganism, Tyche was displayed in the center of the city as a vivid symbol of its divinely favored power and destiny.

The figure of the winged Nike (Νίκη), the female personification of victory, also conveyed the power of the Byzantine state and its rulers. Descending from the heavens or alighting on the globe of imperial dominion, she crowned emperors, consuls, or the personified capital/empire with the laurel wreath of victory (see cat. 6). The court poet Corippus described *nikai* suspended in the throne hall of the Sacred Palace above a gold, jewel-encrusted canopy "like the vault of the curving sky," heightening the aura of majesty as the emperor Justin II received a foreign embassy in 565.[13] Nike could also extend to more popular concepts of victory. Among the numerous Nike images in the Hippodrome were the voluptuous figures on the base of the circa 500 victory stele of Porphyrios, which was located on the *spina*, the course's central spine, and presided over chariot races and imperial victory celebrations (fig. 7).[14]

Like Tyche, Nike was first associated with the cross in the fifth century. On a solidus struck in 400–401 for the empress Eudoxia, wife of Arkadios, Nike inscribes a shield with the Chi-Rho, the monogram of Christ (cat. 29), recalling images known from drawings of the lost triumphal column Arkadios erected in Constantinople at about the same time. Nike holds a long, jeweled cross on a new type of solidus from the 420s, struck to celebrate Theodosios II and Pulcheria's endowment of a gem-studded gold cross on Golgotha, the site of the Crucifixion outside Jerusalem (cats. 30, 31, 33).[15] These imperial symbols and the monuments to which they relate mark the advent of a new concept of imperial victory that foregrounded the piety of the Byzantine ruler. Nike is the bearer of Christian triumph that made empresses and emperors God's representatives on earth and partners in redemption.

Effigies of ancient Greek goddesses were among the bronze and marble statues Constantine brought to his capital "from every province and city" in the empire, as the sixth-century chronicler John Malalas wrote.[16] A twelfth-century miniature illustrating the Epiphany homily of Gregory of Nazianzos (bishop of Constantinople 380–81) depicts crowds venerating figures of Aphrodite and Artemis, whose statues stood in the Forum of the early Byzantine capital (fig. 8). Addressing the evils of idolatry, the sermon and image attest to the prominence of recycled feminine images of power in the early urban landscape (see map, inside back cover).[17] The virgin goddess Athena was paramount among them. Like Tyche and Nike, she is evidence of the persistence of classical tradition, but her character was distinctly military. As a goddess of war, brandishing armor and the terrifying head of the Medusa she helped to defeat, Athena associated the capital and empire with her invincible strength.[18] Her upright stance and formal dress conveyed vigilance and gravity.[19] More than female, she united the characteristic excellence of both sexes, constituting a compelling public symbol.[20]

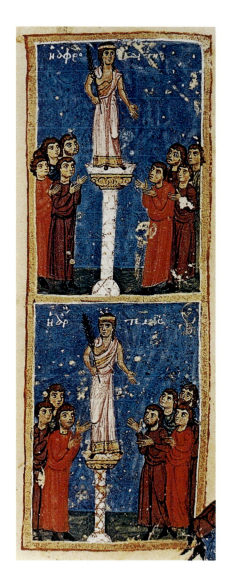

Fig. 8. Crowds venerate figures of Aphrodite, above, and Artemis, below. *Homilies of Gregory the Theologian,* 12th century. Mount Athos, Greece, cod. 6, fol. 164r.

The lineage and potency of the Athena statues was exploited through their placement in some of the most conspicuous loci of power in fourth-century Constantinople: the Forum of Constantine, the Senate House, and the Hippodrome. The most imposing of these statues was the nine-meter-high bronze Athena that stood on a column in the Forum. Paired with a sculpture of the sea-nymph Thetis, Athena dominated the entrance to the Senate on the north side.[21] Wearing a plumed helmet, a long, pleated dress, and a mantle-like aegis with the Gorgon's head, she extended her right arm southward toward the Sea of Marmara.[22] The colossal statue, said to have been made by Pheidias, was perhaps his bronze effigy of Athena Promachos (Foremost Fighter) from the Athenian acropolis.[23] Athena's towering presence was associated with magical power well into middle Byzantine times: in 1204 a mob destroyed the statue, believing that with her out-stretched hand Athena had beckoned the invading crusaders.[24] A second large statue of Athena, seated on a bronze chair, was installed above the imperial box in the Hippodrome, overlooking the *stama*, the pit where charioteers stopped to be crowned.[25]

Through the legendary wooden statuette of Pallas Athena known as the Palladion, sixth-century writers created a history associating Athena's image with the power and authenticity of Byzantine rule.[26] The miraculous figurine supposedly fell from the sky in Troy to safeguard the ancient city.[27] Malalas traces it from Troy to imperial Rome to Constantinople. Passing through the hands of heroes, kings, and emperors, it brought victory and prosperity to cities and rulers that possessed it.[28] The accrued power of the Palladion was transferred to the new Byzantine capital, as Malalas recorded: "Constantine took secretly from Rome the wooden statue known as the Palladion and placed it in the Forum he built, beneath the column which supported his statue. Some of the people of Byzantion say it is still there."[29] The Palladion, which had always gained force by being set apart and hidden, infused the Forum with an aura of potency that was made manifest in the annual festival held there.

To the public eye, Athena appeared to supervise imperial and civic processions, decrees, and the crowning of champions. Her magisterial presence is reflected in the small, lead-filled, bronze busts of the goddess used as counterpoise weights in the Byzantine marketplace from the fourth to seventh century (cat. 14).[30] Athena usually wears the plumed helmet and *gorgoneion*, attributes of the Forum statue emphasized by Byzantine chroniclers. Balanced on a *statera*, or steelyard, the busts were used to weigh heavy, inexpensive commodities such as fruits and vegetables.[31] All steelyards and weights had to be certified by the eparch, the city's chief administrator, and were to be regarded as indispensable and obligatory under penalty of law.[32] Athena's association with authority, advice, wisdom, and skill made her presence appropriate in this situation of inexact measurement.[33]

Empresses are also common in the corpus of contemporary bust weights, represented in a philosopher's pose that, like the Athena weights, suggests judiciousness (cats. 10–13). Byzantine emperors traditionally set standard measures, including the amount of grain a solidus would buy at granaries and the amount of free bread to be distributed to citizens by the state.[34] Empresses were also involved in the distribution of staples, through the establishment of bakeries and charity hospices.[35] With their array of jewelry and their

grave appearance, the empress weights perhaps represent the imperial guarantee of provisions and fair measures that ensured the basic standard of living which, from the time of Constantine, anchored the social contract between ruler and citizen. At several places in the capital, statues of Byzantine empresses contemporary with the weights, perhaps representing the same idea in monumental form, overlooked stairs where citizens received state bread doles.[36]

By the early eighth century, the perception of figures from the city's pagan past had changed. The author(s) of the *Parastaseis*, a text describing the city and monuments of Constantinople, had difficulty identifying statues of goddesses, even Athena, which suggests that these once-popular civic symbols were by then almost obsolete.[37] In the transition to a Christian society, the Virgin gradually emerged as the most prominent public figure, with protective powers that overlapped those of the old city goddesses. Coins, seals, icons, and amulets in this exhibition bear witness to the popular belief in the Virgin as a spiritual intercessor and civic guardian (see cats. 51, 52, 55, 59, 179, 180).

Empresses played a major role in establishing the prominence of the Mother of God, promoting her with churches, icons, and public ritual. During her sojourn in the Holy Land (434/5/8–39), the empress Eudokia (cat. 32) purportedly discovered in Jerusalem a portrait of the Virgin and Christ child painted from life by the evangelist Saint Luke,[38] and Byzantines regarded it as the most powerful image of the Virgin. Later tradition suggests that the icon was brought to Constantinople and deposited in the church the empress Pulcheria had founded around 450 at a home for the blind run by guides, or *hodegoi*.[39] Called the Hodegetria, or "The One Who Leads the Way," the icon became the focus of intense public devotion: Pulcheria instituted weekly evening vigils, processions, and liturgies associated with the Hodegon church and helped to establish the Virgin's feast days. Her initiatives fostered the new Marian cult in the capital.[40]

Pulcheria and the empress Verina (cat. 33), her successor, are credited with building the other two most important shrines of the Virgin in the capital: the Chalkoprateia, named after the busy coppersmiths' marketplace in which it was located, and the Blachernai, at the city walls.[41] Their patronage afforded the Virgin for the first time prominent sanctuaries within the city limits. Her most important relics were translated to these churches: the Blachernai received her veil or mantle, called the *omorphorion*, *maphorion*, or *pallium*, and the Chalkoprateia, her girdle, or *zone*.[42] The presence of these few precious remains of the Virgin's earthly possessions inspired the growth of her cult in the capital.[43] Verina and her husband, Leo I, endowed a magnificent shrine for the veil in the Blachernai. The relic, believed to bear traces of the milk with which Mary nursed her child, was deposited in a trifold, gold and jewel-encrusted reliquary.[44] The enthroned Virgin was depicted in mosaics on the ciborium above it, flanked by the imperial couple, their daughter Ariadne, and their grandson Leo II.[45] Processions of emperors and ecclesiastical officials visited both churches frequently from the seventh century onward.[46]

The relics and images of the Virgin in her shrines in the capital had a special significance for Byzantine women of all classes, since they were widely regarded as miraculous aids in conception and childbirth; in the hopes of conceiving a son, one unidentified

woman participated in the special liturgy every Friday at the Blachernai shrine, when the veil was lifted before the holy image of the Virgin in the apse.[47] A medieval legend mentions that an empress Anna, probably the daughter of Leo III (r. 717–41), visited the Blachernai while she was pregnant and gave birth soon after leaving the church.[48] Empresses and certain aristocratic women apparently had privileged access to Mary's relics: the birth of Theophano (empress c. 882–895/6), the first wife of Leo VI, was facilitated by a girdle brought from a church of the Theotokos (God-Bearer), which was tied around her mother's loins to ease the difficult labor (cat. 172).[49] The empress Zoe Karbounopsina (cat. 39), third wife of Leo VI, in 904 became pregnant with the long-awaited imperial heir after tying around her waist a cord that had been drawn around the edges of an icon of the Virgin at the church at Pege, just southwest of the city walls.[50]

Important icons and monumental images of the Virgin, such as the celebrated fifty-foot-high enthroned Virgin holding the Christ child on her lap in the apse of the Hagia Sophia, the cathedral of Constantinople and the main church of the state, gave her a vital presence in the capital of the middle Byzantine period.[51] Her prominence is reflected on numerous coins and on seals, which were used as personal marks on official correspondence; of all figures she is by far the most frequently represented (cats. 22, 46, 47, 54–56).[52] Theophano's seals, probably issued during her regency, in 863, are the earliest examples of a tradition of empresses' seals depicting the Virgin on the obverse and the facing bust or standing figure of the empress on the reverse.[53] Invoked by the inscription *Theotoke* (God-Bearer), the Virgin is shown as a haloed, bust-length figure with her hands open in an attitude of prayer and receptivity. This type, also the first image of the Virgin depicted on Byzantine coinage—on coins of Leo VI from 886 to 912 (cat. 57)—is perhaps based on the mosaic of the Virgin in the apse of the Blachernai, installed after Iconoclasm, in 843. As is clear from the sermon of the patriarch Photios dedicating the Hagia Sophia apse mosaic in 867, Byzantines perceived the maternal tenderness, humanity, and empathy of the Mother of God through her images, large and small, and found her the most appealing intercessor.[54]

Only a small number of other female saints are represented on seals.[55] An example in this exhibition is Theodora, perhaps the saint from Alexandria who was martyred under Diocletian, on a seal that belonged to Constantine, a twelfth-century metropolitan of Mytilene (cat. 23).[56] Like Theodora, the female saints on Byzantine seals are almost all early Christian martyrs (Anastasia, Irene, Euphemia, and Thekla; see cats. 67, 68, 183). They appear on the seals of clergy associated with Mytilene, Nikopolis, Chalcedon, and Seleukeia, cities that either honored them as patron saints or had shrines to them, evidence of these saints' importance in popular cult.[57] The only exception is Saint Sophia, who is depicted, sometimes attired as an empress, on the seals of imperial officials as well as clergy, some associated with the Great Church.[58] Sophia's presence perhaps reflects the special role of the cathedral in imperial ceremony and civic life.[59]

Throughout Byzantine history, ideal female figures fulfilled similar collective needs. Allegories of prosperity, luck, and victory, Tyche and Nike enhanced the prestige of the city and the effectiveness and authority of the emperor while purportedly improving the

fortunes of ordinary people. The Virgin, succeeding Tyche in the role of mediator, was accessible and merciful, protecting and providing for the needs of the city and its inhabitants. Athena, by contrast, was an aristocratic, unapproachable figure, an imposing symbol of the power and judiciousness of the state. Her role as the city's *palladion*, however, with miraculous powers of guardianship and strength, parallels that of the Virgin. These female emblems of city life offered privileged and ordinary persons alike ways of imagining civic identity, state authority, and communal security as a positive feminine presence.

1. Evans et al. 2001, 16.

2. Theodosios I issued an edict in 380 making Orthodox Christianity the official religion of the empire. Beginning in 391, he issued a series of strict laws prohibiting pagan sacrifice (*ODB* 1991, 2050–51).

3. Broucke 1994, 37–38. For statues of Tyche in early-eighth-century Constantinople, see Cameron and Herrin et al. 1984, 94–95, 102–3, 110–13, commentary 208, 215–18; Dagron 1984, 43–44, nn. 4, 9.

4. The double temples recall the Tyche temple built by the Roman emperor Maxentius, with its back-to-back *cellae* containing the cult statues of Venus and Roma. The Venus was later transformed into the Tyche of Constantinople, so that parallel double temples existed in both capitals (Vermeule 1959, 35).

5. Zosimus 1982, 38 (2.31). Cybele was honored as *Magna Mater* (Great Mother) by the Romans (Matheson 1994, 23–24).

6. Dagron 1984, 45. Sokrates' dates were fourth to fifth century. For Constantinople as *altera Roma*, see ibid., 46, quoting a letter of Optatianos Porphyrios written in 325–26.

7. For the date, see Cameron 1968, 19 and n. 3. The inscription was on the basilica, an old name for the arcaded part of the Augustaion containing the Tyche temples (Dagron 1984, 44, n. 5). "Rome" refers to Constantinople.

8. The festival was celebrated at least through the mid-sixth century (Malalas 1986, 175 [13.8]). At the climax of the festival, the small statue of Tyche was crowned; it was then placed in the Senate until the next year (Cameron and Herrin et al. 1984, 103; *Chronicon Paschale* 1989, 17–18 [Year 330]).

9. Cameron and Herrin et al. 1984, 219. After consecrating his statue, Constantine "made a bloodless sacrifice to God, and the Tyche of the city which had been restored and built and named after himself he called Anthousa" (Malalas 1986, 174 [13.7]).

10. Eusebios' *Life of Constantine* describes the vision of the cross as having taken place at the Milvian Bridge, near Rome, in 312, before and during the battle in which Maxentius was defeated, but early Byzantine authors placed the vision at the Forum and the Philadelphion, site of a sculpture of Constantine's sons on the Mese, Constantinople's main avenue (Cameron and Herrin et al. 1984, 192–93).

11. Holum 1982, 108–11.

12. Cameron and Herrin et al. 1984, 94–95, 208. The statue group was probably installed after Constantine's reign, since the story of the discovery of the True Cross by Helena was not current in his lifetime (ibid., 247).

13. Corippus 1976, 106–7.

14. A bronze statue of Nike also stood on the *spina* (Cameron and Herrin et al. 1984, 17, 218; Cameron 1973, 181, 184, 186).

15. Grierson and Mays 1992, 138.

16. Malalas 1986, 176 (13.13).

17. For a complete list of the statues described in the *Parastaseis*, see Cameron and Herrin et al. 1984, 48–51. For the effigies of Artemis and Aphrodite, perhaps taken from their temples on the acropolis of the city of Byzantium, that were installed at the Senate House in the Forum (a second Senate House existed in the Augustaion), see ibid., 66–69; 158–59, commentary 182. For the statues of Athena, see ibid., 104–5; 138–39, commentary 251.

18. The Byzantine sources mention her helmet, aegis, and *gorgoneion*, but not the spear or shield traditionally held by Athena Promachos (Jenkins 1947, 32–33).

19. Ibid., 31, citing Cedrenus.

20. *OCD* 1996, 201.

21. Cameron and Herrin et al. 1984, 182.

22. Jenkins 1947, 31, citing Cedrenus.

23. The Pheidian Athena in the Parthenon held a Nike in her outstretched hand; perhaps the Athena brought to Constantinople originally held a Nike or a spear, which would explain her position (*OCD* 1996, 1153; Jenkins 1947, 31, citing Arethas, Cedrenus, and Choniates).

24. Choniates records the statue's destruction in 1204. (Cameron and Herrin et al. 1984, 251; Jenkins 1947, 31).

25. Cameron and Herrin et al. 1984, 138–39, 174.

26. Malalas 1986, 174 (13.7); *Chronicon Paschale* 1989, 16 (Year 328).

27. The statue was still in Rome in 191 A.D. (*OCD* 1996, 1100–1101, citing Herodian 1.14.4).

28. Malalas 1986, 57, 59, 66, 88–91, 174 (5.43, 5.45, 5.52, 6.23–7.1, 13.7). The figurine or a replica of it had been the most auspicious attribute of Hadrian's statue of Tyche, considered a pledge of Rome's fortune and

28. (continued) magical guardian of the city (Vermeule 1959, 36, pl. 2, nos. 23, 24; pl. 3, nos. 1–5).

29. Malalas 1986, 174 (13.7); *Chronicon Paschale* 1989, 16 (Year 328).

30. For a comprehensive catalogue of bust weights, see Franken 1994.

31. Vikan and Nesbitt 1980, 32–33.

32. According to the circa 895 ordinances of the emperor Leo VI, probably based on earlier laws governing measures (Freshfield 1938, 211, 214).

33. *OCD* 1996, 202. The Athena weight in the present volume (cat. 14) lacks the *gorgoneion*.

34. Cameron and Herrin et al. 1984, 186–87.

35. Ibid., 189; Herrin 2001, 102.

36. A bronze statue of the empress Verina, wife of Leo I (r. 451–74), stood on a pillar near the church of Saint Agathonikos, above steps, perhaps those built by Constantine for the distribution of state bread (Cameron and Herrin et al. 1984, 92–93, 205). A statue of Arkadia, perhaps the first wife of the emperor Zeno (r. 474–75, 477–91) stood in the Topoi near the church of the archangel Saint Michael, close to steps that were also a distribution point (ibid., 94–95, 207).

37. Cameron and Herrin et al. 1984, 138–39, 251.

38. Theophanes dates the journey to the year 434/5 (Theophanes 1997, 143, n. 2). Ammianus Marcellinus dates it to 439. Kenneth Holum argues for the later date (Holum 1982, 185–88).

39. According to Cyril Mango, Pulcheria's association with the Hodegon is not mentioned before the ninth century (Mango 2000, 19).

40. Herrin 2000, 13, 19.

41. Mango argues that Verina, not Pulcheria, was responsible for building the two shrines—the reliquary chapel at the Blachernai before 475 and the Chalkoprateia after 472. He suggests that the *zone* is first mentioned in the early eighth century (Mango 2000, 19).

42. Herrin 2000, 14; Cormack 2000, 107–8.

43. Herrin 2000, 14.

44. Belting 1994, 36, n. 30.

45. Mango 1986, 34–35.

46. Berger 2001, 76, 79–87.

47. Herrin 2000, 19, n. 49.

48. Dagron 1984, 317, n. 13.

49. Cheynet and Morrisson 1995, 23; Kurtz 1898, 2, ll. 26–35; 3, ll. 1–3. The empress Theophano, sanctified after her death, is depicted on a lead *hystera* amulet, a popular type of charm women carried to promote the health of the womb; the representation suggests that she was also invoked as a holy intercessor in childbearing.

50. Garland 1999, 114, n. 52, citing the chroniclers Leo Grammatikos, Theophanes Continuatus, John Skylitzes.

51. Dedicated in 867, the mosaic illustrates the Virgin's prominence after the reinstatement of holy images, largely brought about through the efforts of the empresses Irene (r. 768–802; cats. 18, 19) and Theodora (r. 830–56; cats. 35–37) (Herrin 2001, 87–92, 202–13). For Patriarch Photios' sermon on the image, see Mango 1986, 187–90.

52. *ODB* 1991, 1859–60.

53. Theophano was married to the successive emperors Romanos II (r. 959–63) and Nikephoros II (r. 963–69) (Zacos and Veglery 1972, 65, cat. 72, pl. 21). Seals of Eudokia Makrembolitissa (r. 1059–71) also represent the orant Virgin (ibid., 80, cats. 89, 90). The next empress seals to depict the Virgin are much later, from the Palaiologan period (late thirteenth to mid-fifteenth century); on these, she is enthroned, holding the Christ child on her lap: the "Platytera" type (ibid., 114–15, cat. 122).

54. Kalavrezou 1990, 170.

55. Zacos and Veglery 1972, 1539, cat. 2733; Zacos 1984, 48–49, 226–27, cats. 41b, 404; Campbell 1985, 135, cat. 196.

56. *DOSeals*, vol. 2, 143, cat. 51.7.

57. Zacos and Veglery 1972, 767–70, cats. 1240, 1241, 1243–45; 786, cat. 1275; *DOSeals*, vol. 3, 132–35, cats. 77.1–9.

58. Zacos and Veglery 1972, 786, cat. 1275.

59. *DOSeals*, vol. 4, 139–40, cat. 55.13. The Sophia on seals is not the sixth-century empress of that name, but most likely the personification of Holy Wisdom, to whom the cathedral was dedicated. She was perhaps the inspiration for the legendary Saint Sophia of Milan, with her daughters Faith, Hope, and Charity (see *ODB* 1991, 1927); alternatively, she may represent Saint Sophia the Wonderworker (see *DOSeals* citation).

# 1 Statuette of a City Tyche

Byzantine, 4th–5th century
Bronze
H. 25.5 cm, w. 14.4 cm, d. 10.3 cm
The Metropolitan Museum of Art, Purchase,
Fletcher Fund, 1947, 47.100.40

COLLECTION HISTORY Collections of Mme.
Edouard Warneck, Paris, and Arthur Sambon,
Paris; said to have been found in Rome.

PUBLISHED *Early Christian and Byzantine Art*
1947, 57, cat. 205, pl. 35; *Middle Ages* 1969, cat.
26; *Age of Spirituality* 1979, 176, cat. 154;
*Spätantike und Frühes Christentum* 1983, 483–84,
cat. 85; *Obsession* 1994, 117, cat. 63; Bühl 1995,
126–27.

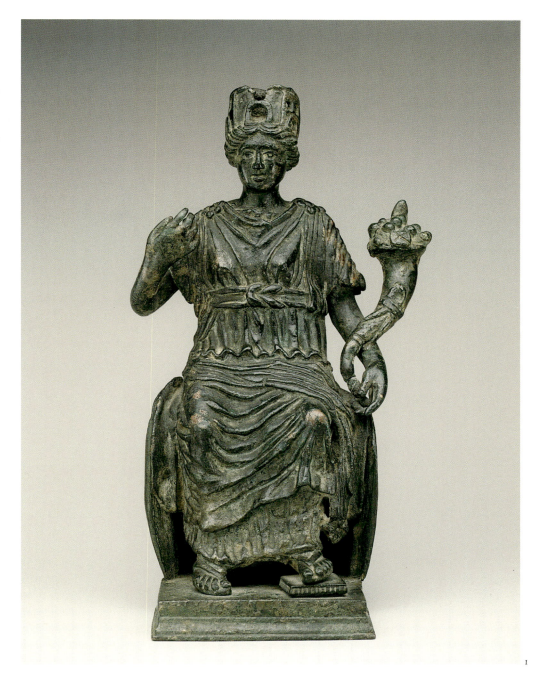

1

This hollow-cast bronze statuette represents a Tyche (Τύχη), the personification of a city,
its prosperity, and its destiny.[1] Seated on a throne with a low, curved back, she wears a
costume attesting to the ancient origins of her cult: a *chiton* (tunic); a *peplos* high-girt in
a Herakles knot and fastened at the shoulders by large, rosette-shaped *fibulae*; and a *palla*,
draped across her lap.[2] Her feet are clad in thong sandals with tapered soles, and the left
foot rests on a low footstool. The Tyche supports a cornucopia with her left arm and
originally held a long spear or scepter in her right hand, judging from its position and
the corresponding indentation on the base below.[3] Her rectangular silhouette and dense,
schematic drapery have been compared to those of late Roman bronze statuettes pro-
duced in Gaul.[4]

The Tyche's crown represents the main gate and walls of a fortified city, suggesting her role as a civic protector. With her mural crown, cornucopia, and staff, she corresponds most closely to personifications of Constantinople in early Byzantine official art.[5] Perhaps supporting a Western provincial origin for this bronze, close numismatic comparisons are figures of Constantinople on siliquae (silver coins) struck by Theodosios I and his co-*augusti* from 378 to 383 in mints such as Trier, London, and Aquileia. On these coins the personified capital is similarly enthroned and crowned, and holds a cornucopia in her left hand and a scepter in her right.[6] In Eastern coinage of the Theodosian period, the city is most often shown without a cornucopia, holding a spear or scepter and a globe (cats. 5–7).[7]

The cult of Tyche was promoted by the early Byzantine state. With its solemn frontality, this statuette was perhaps a personal souvenir or votive based on a cult statue of the Tyche of Constantinople that has since been lost. Such statues were donated to civic temples by the emperor: Constantine established adjacent Tyche temples in the new capital near the Augustaion, a large square next to the imperial palace, and furnished them with enthroned statues of the *tychai* of Constantinople and Rome.[8] The late-fourth-to-fifth-century historian Sokrates records that the emperor Julian (r. 361–63) offered public sacrifices at the temple of Tyche in the capital.[9] Theodore, a fourth-century consul and prefect, also endowed Tyche's temple.[10]

Despite her pagan origins, Tyche continued to be honored in the urban centers of early Christian Byzantium at least through the sixth century, probably for reasons of political expediency. In the culturally diverse cities of the time, she was an official symbol of communal identity and prosperity around which citizens could rally, whatever their religious beliefs.[11]   EG

1. The statue is made of multiple elements mechanically joined and soldered to one another. These include the throne, figure, cornucopia (two pieces), and arms. There is an old break and restoration across three fingers of the right hand. For the development and meaning of *tyche* (fortune or luck) and Tyche, see *Obsession* 1994.

2. On these classicizing garments of Roman dress, see Goldman 1994, 223, 228, 243.

3. Until 1914 the figure held a spear, removed because it was a restoration (*Middle Ages* 1969, cat. 26).

4. *Age of Spirituality* 1979, 176, cat. 154.

5. Kent 1978a, 105–13, nos. 9, 14–16, 20–22; *RIC*, vol. 8, 286, cats. 366–69; 288, cats. 383–87; 517, cat. 72; 525,

cat. 61; 585. Although Constantinople is usually depicted with one foot on the prow of a ship, other exceptions exist: Shelton 1981, 86–87, cat. 30, pl. 36; *Antioch* 2000, 116–17, cat. 2; Stern 1953, 124–44.

6. *RIC*, vol. 9, 25, cat. 55a, pl. 2, no. 13 (Theodosios I); 29, cat. 83c, pl. 2, no. 15 (Maximos); 47, cats. 24a (Gratian), 24b, pl. 4, no. 9; 99, cat. 25 (Theodosios I).

7. Grierson and Mays 1992, cats. 317, 442.

8. Zosimus 1982, 38 (2.31).

9. Dagron 1974, 44, n. 7.

10. Ibid, 44, n. 5.

11. Broucke 1994, 44.

## 2 Follis with Bust of Roma

Mint of Trier, 330–40
Bronze
Diam. 1.9 cm, wt. 2.46 g, reverse die axis
12 o'clock
Obv: clockwise from lower left, URBS ROMA
(City Rome)
Rev: in exergue, TR.S (mintmark of Trier,
workshop 2)
Arthur M. Sackler Museum, Harvard
University, Gift of George Davis Chase,
1942.176.1947x

COLLECTION HISTORY George Davis Chase
collection.

UNPUBLISHED[1]

## 3 Follis with Bust of Constantinopolis

Mint of Constantinople, 330–40
Bronze
Diam. 1.9 cm, wt. 2.91 g, reverse die axis
6 o'clock
Obv: clockwise from lower left, CONSTAN
TINOPOLI (Constantinople)
Rev: in exergue, CONS Z (mintmark of
Constantinople, workshop 7)
Arthur M. Sackler Museum, Harvard
University, Gift of George Davis Chase,
1942.176.1975x

COLLECTION HISTORY George Davis Chase
collection.

UNPUBLISHED

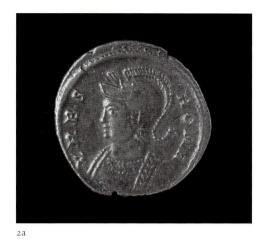

2a

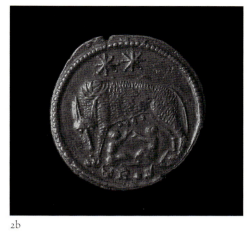

2b

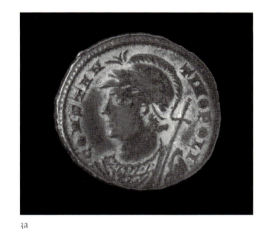

3a

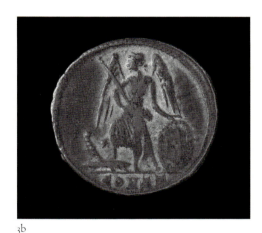

3b

# Personifications of Cities

These two folles (bronze coins) with the female personifications Roma and Constantinopolis on the obverse were struck to commemorate Constantine's dedication of the new capital of Constantinople in 330.[2] Profile busts of the two cities were juxtaposed on a series of bronze coins and related medallions issued between 330 and 347.[3] Minted widely with little variation, the special coinage established these female busts as standard symbols of the two major capitals of the nascent Byzantine Empire.[4] Emblems of power in an increasingly centralized state, they reflected and reinforced Constantine's official policies.[5]

The busts evoke the monumental public decoration of the new capital. With their helmets, they recall Athena, the ancient Greek warrior goddess and protector of Athens, and her Roman counterpart, Minerva. A colossal bronze statue of Athena, perhaps the one made by the classical Greek sculptor Pheidias for the Athenian acropolis, stood on a column at the entrance to the Senate House in the Forum of Constantine.[6] In addition, Constantine brought a cult statue of Roma from the old capital when he renovated the civic temple of the Tyche of Constantinople (cat. 1), promoting the idea of the two capitals as counterparts (cat. 4).[7]

The status of the two capitals and the relationship between them in this early period is a matter of debate.[8] Constantinopolis is identified as Νέα Ρώμη (New Rome) on contemporary coins, yet clearly defers to Roma on some issues.[9] Here (cat. 3) she holds a knobbed scepter and originally had a laurel crown (worn off) on her helmet.[10] These two attributes, which Roma lacks, suggest the hegemony of the new capital. Both cities, however, are sumptuously attired in accordance with their privileged status, wearing imperial mantles and tunics, Rome's (cat. 2) with jeweled and embroidered bands, and Constantinople's (cat. 3) with a pattern of jewels inside squares.

The reverse types emphasize the military supremacy of the Byzantine Empire and its role as heir to imperial Rome. The Roma follis, with a she-wolf suckling the twins Romulus and Remus, the mythical founders of Rome, and two ascendant stars representing their divine souls, honors the traditions and illustrious history of the old capital.[11] Constantinopolis is paired with the winged Nike, personification of victory, standing with her foot on the prow of a ship. Alluding to the city's location on the Bosporos, the image probably refers more specifically to Constantine's decisive naval victory over Licinius in 324, which led to the founding of his new capital in the same year.[12] Nike's shield and long, knobbed scepter suggest Constantinople's strength and position as ruling city of the empire. Assimilating Constantinopolis, Roma, Athena, and Minerva, these female busts emphasize the common Greco-Roman identity and auspicious destiny of the two cities.   EG

1. For the types, see *RIC*, vol. 7, 214, cat. 522 (Roma); 579, cat. 63 (Constantinopolis).

2. "Follis" follows the usage of *RIC*, vol. 7.

3. *RIC*, vol. 7, 719, under obverse legends CONSTANTINOPOLI and CONSTANTINOPOLIS, and 727, URBS ROMA. For the medallions, see Bühl 1995, 14–20, and Toynbee 1986, 178.

4. Bühl 1995, 13–14. For mints striking these types under Constantine, see Foss 1990, 283, cats. 87, 88a.

5. Increasing uniformity and central control of coinage is clear in the years 324–30, after Constantine became sole *augustus*. See *RIC*, vol. 7, 20–21.

6. On Athena statues in early Constantinople, see Cameron and Herrin et al. 1984, 104–5; 138–39, commentary 251.

7. Zosimus 1982, 38 (2.31).

8. For early Byzantine ideas of the two capitals, see Dagron 1974, 19–29, 45–60; Bühl 1995, 35–40.

9. Bühl 1995, 35–40.

10. The crown is clear on other coins of the same issue.

11. On stars, see *RIC*, vol. 10, 46.

12. The image of Nike standing on a ship's bow is expanded to include an entire flagship in contemporary URBS ROMA medallions, suggesting that the motif refers to the naval victory (Bühl 1995, 19).

## 4 Solidus of Constantius II with Roma and Constantinopolis

Mint of Arles, 355–60
Gold
Diam. 2.1 cm, wt. 4.63 g, reverse die axis
12 o'clock
Obv: clockwise from lower left, FL[AVIVS]
IVL[IVS] CONSTAN TIVS PERP[ETVVS]
AVG[VSTVS] (Flavius Julius Constantius
Eternal Augustus)
Rev: clockwise from lower left, GLORIA REI
•PUBLICAE (Glory of the State) ; on shield,
VOT[A]/XXX/MVLT[IS VOTIS]/XXXX
(vows of the 30th anniversary, with many
vows for a 40th anniversary); in exergue,
•KONSTAN (mintmark of Arles, workshop
3);[1] star
Arthur M. Sackler Museum, Harvard
University, Bequest of Thomas Whittemore,
1951.31.4.16

COLLECTION HISTORY Thomas Whittemore
collection.

UNPUBLISHED

## 5 Solidus of Valentinian II with Seated Constantinopolis

Mint of Constantinople, 383–88
Gold
Diam. 2.1 cm, wt. 4.49 g, reverse die axis
12 o'clock
Obv: clockwise from lower left, D[OMINVS]
N[OSTER] VALENTINI• ANVS P[IVS]
F[ELIX] AVG[VSTVS] (Our Lord Valentinian,
Pious, Fortunate Augustus)
Rev: clockwise from lower left, CONCORDI
AAVCCC E [or] Z [?] (concord of the three
*augusti*, workshop 5 or 7 [?]);[2] in exergue,
CONOB (mintmark of Constantinople,
refined gold [*obryzum*])
Arthur M. Sackler Museum, Harvard
University, Bequest of Thomas Whittemore,
1951.31.4.43

COLLECTION HISTORY Thomas Whittemore
collection.

UNPUBLISHED

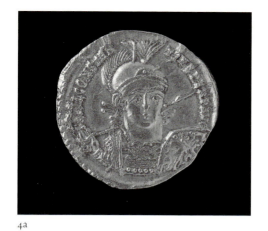

4a

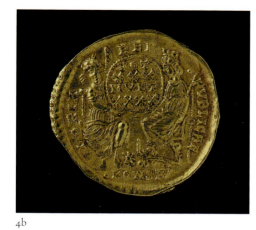

4b

5a

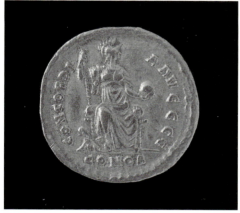

5b

The female personifications of Rome and Constantinople on these gold coins (cats. 4–7) are among the earliest Byzantine representations of the two major capitals of the empire.[5] Inflected by various attributes, the two figures are standard in subsequent official objects such as coins, medallions, statuary, and consular diptychs.[6]

The paired figures on the reverse of the earliest of these solidi (cat. 4b), which commemorates the thirtieth anniversary of the emperor Constantius II (*caesar* 324–37, *augustus* 337–61), emphasize the unity of the empire under his rule. The capitals of the Eastern and Western halves of the empire are seated at right and left, respectively, on a double throne with a high back, signifying the vast imperial dominion. At its center is the shield of Constantius, the "Eternal Emperor," whose long rule is celebrated by the inscribed numeral xxx. The coin was struck at Arles, in Gaul, where Constantius celebrated the anniversary on October 10, 353. The fine quality and detail of the reverse die suggest that special attention was given to the issue. The honors accorded the city included its renaming "Constantia," abbreviated in the mintmark.[7]

The reverse image recalls early Byzantine concepts of Constantinople as a counterbalance to Rome, a Second Rome, and a New Rome.[8] However, with her frontality and her position of honor on the left, Roma takes precedence over Constantinopolis, who is depicted in profile and looks toward her respectfully. Roma's prominence, in conjunction

## 6 Solidus of Theodosios II with Seated Constantinopolis

Mint of Constantinople, 408–19
Gold
Diam. 2.3 cm, wt. 4.49 g, reverse die axis
4 o'clock
Obv: clockwise from lower left, D[OMINVS]
N[OSTER] THEODO SIVS P[IVS] F[ELIX]
AVC[VSTVS] (Our Lord Theodosios, Pious,
Fortunate Augustus)
Rev: clockwise from lower left, CONCORDI
A AVCC Z (concord of the two *augusti*, work-
shop 7);[3] in exergue, CONOB (mintmark of
Constantinople, refined gold); star in left field
Arthur M. Sackler Museum, Harvard
University, Bequest of Thomas Whittemore,
1951.31.4.136

COLLECTION HISTORY Thomas Whittemore
collection.

PUBLISHED Grierson and Mays 1992, cat. 317.

## 7 Solidus of Pulcheria with Seated Constantinopolis

Mint of Constantinople, 442–43
Gold
Diam. 2.2 cm, wt. 4.49 g, reverse die axis
6 o'clock
Obv: clockwise from lower left, AEL[IA]
PVLCH ERIA AVC[VSTA] (Aelia Pulcheria
Augusta)
Rev: clockwise from lower left, IMP[ERA-
TOR] XXXXII CO[N]S•[VL] XVII• P•[ATER]
P•[ATRIAE] (Emperor, 42nd regnal year, 17th
consulship, Father of the Fatherland);[4] in
exergue: COMOB (mintmark of
Constantinople, refined gold)
Arthur M. Sackler Museum, Harvard
University, Bequest of Thomas Whittemore,
1951.31.4.159

COLLECTION HISTORY Thomas Whittemore
collection.

PUBLISHED Grierson and Mays 1992, cat. 442.

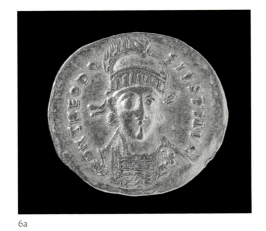

6a

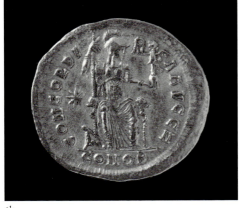

6b

7a

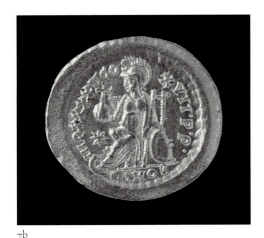

7b

with the surrounding inscription glorifying the state, suggests that she personifies both the city of Rome and the Byzantine Empire.[9]

Roma has a martial appearance often adapted in later personifications of Constantinopolis (cats. 5b–7b), which are frequently helmeted. Her helmet with crest and plume, and her spear, high boots, and bare right breast are attributes of an Amazon, the fierce female warrior of ancient Greek legend (see cat. 97).[10] She suggests the military power of the Byzantine Empire and of her emperor, Constantius, who is depicted on the obverse as a general, wearing a plumed helmet and cuirass, and holding a lance and shield with the image of a rider trampling an enemy. The assertion of military supremacy was critical during Constantius' reign as *augustus*, marked by war with Persia and the dynastic competitors he gradually eliminated after the death of his father, Constantine.[11]

On the three later solidi (cats. 5–7) Constantinopolis has appropriated the role of Roma, personifying both the empire and the city. On the coins of the emperor Valentinian II (r. 375–92; cat. 5b) and the empress Pulcheria (*augusta* 414–53; cat. 7b), she holds a scepter, instead of a spear, in one hand and an orb in the other, giving more weight to the city's status as the capital of the empire.[12] The division of the early empire into Eastern and Western spheres was intended to facilitate rule, and each part had its own supreme rulers, or *augusti*. The inscriptions on the reverses, associating Constanti-

nopolis with the concord of the Eastern and Western *augusti* (cats. 5b, 6b) and with the emperor as father of the empire (cat. 7b), reinforce the idea of Constantinople's primacy within and embodiment of a unified realm.

Early Byzantine Rome and Constantinople had numerous public buildings dedicated to the cults of divinities and personifications. The images of Roma and Constantinopolis on these coins may reflect aspects of lost cult statues. Roma's helmet, shield, and globe were attributes of a colossal effigy of the goddess installed in 307–12 by the Roman emperor Maxentius in his temple dedicated to Venus and Roma near the Coliseum in Rome.[13] The chronicler Ammianus records that the temple of the city goddess greatly impressed Constantius on his progress through Rome in 357.[14] Similarly, the paired figures on Constantius' solidus (cat. 4b) may reflect the seated cult statues of the *tychai* of Rome and Constantinople, which were arranged in adjacent temples in the Augustaion.[15]

Constantinopolis is given an orthodox Christian identity for the first time on the reverses of dynastic coinage struck in 442–43 for Pulcheria (cat. 7), her younger brother Theodosios II (r. 402–50), and their Eastern and Western co-*augusti*, male and female.[16] Here the figure of the city holds a globe, surmounted by either a victory or a cross, which sublimates her as a victorious and sovereign Christian capital. Pulcheria was probably responsible for the unprecedented prominence of the cross on dynastic gold issues struck during Theodosios' reign (cats. 30b, 31b).[17] The innovation evokes Pulcheria's acclamation as a "New Helena," a reference to the first Christian empress and imperial patron (see cats. 16, 120), who was credited with the discovery of the True Cross.[18]

Pulcheria is depicted in magnificent attire on the obverse (cat. 7a), wearing a pearl diadem, pearl necklace, hair jewels, tunic, and imperial mantle with epaulets, fastened at her right shoulder with a *fibula* with multiple pearl pendants. The Christian emphasis is stronger on almost all empress coins of the dynasty, many of which depict the Hand of God crowning similarly attired busts (cats. 29a–32a).[19] Like her vows of celibacy and spectacular patronage of relics and churches, Pulcheria's coins reinforce her political authority through public displays of piety.[20]　EG

1. For the type, see *RIC*, vol. 8, 221, cat. 238.

2. The workshop numeral is unclear; the triple *C* designates the co-*augusti* Valentinian II, Theodosios I, and Arkadios. For the type, see *RIC*, vol. 9, 230, cat. 67b.

3. The double *C* designates Theodosios II and Honorios.

4. Although Pulcheria's portrait appears on the obverse, the reverse inscription celebrates the anniversary of her brother Theodosios II, the senior *augustus;* on problems of chronology associated with the issue, see Grierson and Mays 1992, 146–47.

5. Rome remained under Byzantine control until the seventh century, when the Roman church began to disassociate itself from Constantinople because of doctrinal differences and to seek political control of Byzantine possessions in Italy (*ODB* 1991, 1808–9).

6. For example, a fifth-century ivory diptych in Vienna. See Coche de la Ferté and Ostuni 1981, pl. 21.

7. *RIC*, vol. 8, 200.

8. Zosimus 1982, 37 (2.31); *ODB* 1991, 1809–10; Krautheimer 1983 and Dagron 1974, 54–76, discuss the relationship between the two capitals.

9. As in the fifth-century ivory diptych (n. 6, above), in which a helmeted Roma is labeled *Imperium* and paired with Constantinopolis.

10. Vermeule 1959, 31, 101–3.

11. Zosimus 1982, 41–55.

12. Vermeule 1959, 45.

13. Fragments of the Maxentian statue indicate that it was more than three meters high and partially made of porphyry, the precious purple marble perhaps reserved for imperial use. Its appearance is known from coins of Maxentius (ibid., 35–44).

14. Ibid., 42.

15. Zosimus 1982, 38 (2.31).

16. Grierson and Mays 1992, 146, cats. 410–27, 441–42, 459, 834, 862, 872.

17. Holum 1982. These included Theodosios II's solidi of 423/4, the first coins to depict a Byzantine emperor holding the *globus cruciger*, a Christian emblem of imperial sovereignty, and the solidus type introduced in the 420s, with the reverse depicting Nike supporting a long, jeweled cross (cat. 31b). The Nike-and-cross image was predominant on solidi in the second half of the fifth century (see cat. 33b) (Grierson and Mays 1992, 138, 142).

18. The Council of Chalcedon (451) saluted Pulcheria as a "New Helena" (James 2001, 14). On Helena's discovery of the True Cross, see Drijvers 1992, 79–93.

19. Grierson and Mays 1992, cats. 441–42, 459, 834, 862, 872. On the meaning of the crowning hand, see Kalavrezou 1997a, 64.

20. Holum 1982, 103–11; James 2001, 152–55.

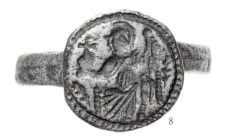

## 8 Ring with Personification of Constantinople

Constantinople (?), Byzantine, late 5th–6th century
Bronze
Diam. 2.5 cm
Dumbarton Oaks Collection, Washington, D. C., 1947.2.2286

COLLECTION HISTORY Said to have been found in Constantinople; gift of Gardiner Howland Shaw, Washington, D.C.

PUBLISHED Ross 1965, 53, cat. 59, pl. 41.

This ring consists of a seven-sided band supporting a circular flat bezel. Engraved on the bezel within a border of small dots is the figure of a seated woman wearing a Roman crested helmet and long robes draped diagonally across her lap. In her right hand she holds a globe surmounted by a cross and in her left, a staff or spear. On either side of her is a sheaf of grain. The imperial attributes of helmet, *globus cruciger*, and staff, in combination with grain as a reference to fertility, identify the woman as Constantinopolis, a personification of Constantinople. This blend of forceful ruling power with fertile abundance reflects a dual inheritance from the iconography of Nike, the Greek goddess of victory, and Tyche, the minor Greek deity associated with fortune and the protection of cities.[1] Found on imperial coins, seals, and diptychs, this visual conflation of goddess and personification represented and propagated imperial power.[2] Constantinople, dedicated in 330, replaced Rome as the capital of the Roman-Byzantine Empire. Images of Constantinopolis (cats. 1, 3a, 4b, 5b, 6b, 7b) evolved from and responded to the traditional iconography of Roma (cat. 2), the personification of Rome. Fourth-century depictions of Constantinopolis often included a cornucopia to emphasize the Eastern city's wealth (cat. 1); by the fifth and sixth centuries imperial attributes were more common (cats. 5b, 6b, 7b).[3]

Though this ring was previously dated to the sixth or seventh century, the circular shape and dotted border of its bezel suggest a slightly earlier date. The ring might have been worn by a man or a woman to demonstrate civic pride. Culling elements from traditional images of victory, power, and fertility, the image embodied and promoted the empire's strength and vitality.   DJ

1. Borromeo 1987, 79–95.

2. Toynbee 1951, 261–77.

3. For example, see the ivory diptych at the Vienna Kunsthistorisches Museum, in which Roma appears as a helmeted victorious warrior and Constantinopolis wears the traditional mural crown of Tyche and holds a cornucopia (Shelton 1979).

## 9 Solidus Weight with Moneta

Constantinople, c. 403–8
Bronze
Diam. 2.0 cm, wt. 4.49 g, reverse die axis
6 o'clock
Obv: clockwise, DDDNNNAAAVVVCCC
(Our Lords the Three Augusti)
Rev: clockwise from lower left, EXAC[IUM]
SOL[IDUM] SVB V[IRO] IL[LUSTRI]
IOHANNI COM[ITE] S[ACRARUM] L[ARGI-
TIONUM] (solidus weight issued under the
authority of the Illustrious Senator John,
Count of Sacred Largesse); in exergue, CONS
(mintmark of Constantinople); star in right
field
Arthur M. Sackler Museum, Harvard
University, Bequest of Thomas Whittemore,
1951.31.4.125

COLLECTION HISTORY Thomas Whittemore
collection.

UNPUBLISHED

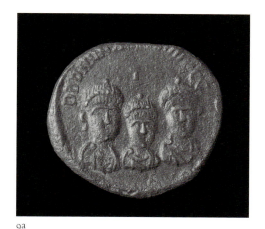

9a

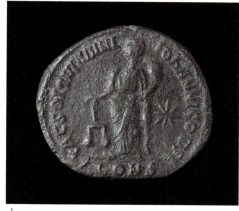

9b

The standing figure of Moneta, the female personification of the imperial mint and its policies, occupies the reverse of this early round exagium, a type of official solidus (gold coin) weight struck in Constantinople in the late fourth and fifth centuries.[1] Probably based on a standard imperial pound, weights like this one were introduced by the emperor Julian the Apostate (r. 360–63), in conjunction with a law establishing a *zygostates* (official weigher of solidi) in each city to detect clipped pieces that were hindering the fair exchange of gold coin.[2] On this weight, Moneta appears to hold her scale with an extended forefinger, in the manner depicted on the reverses of the earliest round exagia and prescribed by the Theodosian legal code of 438.[3]

Moneta is associated with the three facing draped and diademed busts of co-emperors on the obverse, probably Arkadios, Honorios, and Theodosios II, and the high-ranking financial official John, named in the inscription on the reverse.[4] The vast responsibilities of his office of *comes* included the administration of taxes, duties, mines, state-owned mills, and the mint of the capital, which issued coin weights such as this one.[5] With these associations and her cornucopia, symbol of abundance, Moneta personifies the wealth and assets of the empire. Her traditional assimilation with Juno, Roman goddess of married women and childbirth, perhaps added connotations of prosperity.[6]

Moneta's scales, also an attribute of Justicia, the goddess/personification of justice and a cardinal virtue of emperors, suggest the equity of the empire's rule and of fiscal administration. A similar idea is conveyed in contemporary counterweights in the form of empress busts holding a scroll (cats. 10–13). A classical attribute of intellectual judgment, the scroll perhaps signifies the careful supervision of trade by the state. Moneta's matronly garments, a long tunic and *palla* (cloak), strengthen the impression of the empire's propriety in the execution of monetary transactions. EG

1. The round series was probably struck only in Constantinople (*RIC*, vol. 10, 8). For the type, see Bendall 1996, 17–18, cat. 10a.

2. *RIC*, vol. 10, 8.

3. Bendall 1996, 17–19, cat. 1. Sections 12.7.1–2 of the Theodosian Code, a collection of imperial constitutions from the time of Constantine I, compiled under Theodosios II, deal with the proper way to hold the scale (*RIC*, vol. 10, 8).

4. The type of the standing Moneta holding a cornucopia and scales first appears on the reverse of coins struck by Domitian in 84 to celebrate his establishment of a new mint in Rome (Foss 1990, 92, cat. 25).

5. Bendall 1996, 13.

6. The first mint in Rome was located near the Temple of Juno Moneta, from which the word "money" derives (*OCD* 1996, 801).

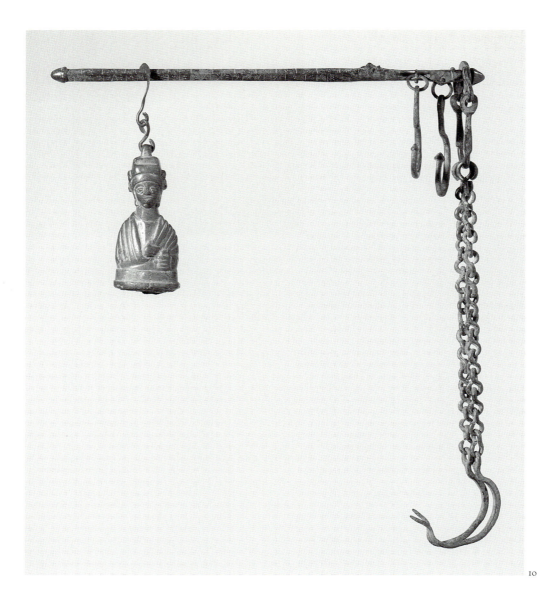

10, detail

10

## 10 Empress Bust Weight, Steelyard, and Collar with Chains

Byzantine, 5th century

Bronze

Collar and chains: l. 43.5 cm; bar: l. 39.5 cm; bust: h. 21 cm, w. 6 cm, wt. 1.441 kg

Arthur M. Sackler Museum, Harvard University, Loan from the Alice Corinne McDaniel Collection, Department of the Classics, Harvard University, TL31096A–C

COLLECTION HISTORY Purchased from Sotheby's New York, November 24, 1987; collection of Joseph Ternbach, New York, who acquired it from Elie Borowski, Basel, September 1969.

PUBLISHED *Ternbach Collection* 1981, 223–24, cat. 178; *Sotheby's New York* 1987, cat. 500; Franken 1994, cat. CA25.

In the marketplaces of the early Byzantine Empire, everyday commodities were weighed with the help of lead-filled bronze counterweights and a *statera*, or steelyard.[1] This type of balance allows a single object to offset loads several times its weight, with changeable suspension points along the bar acting as the fulcrum that divides the bar into two unequal arms. The steelyard in this exhibition has three fulcrum positions and two of its three original hooks. Each of the bar's three graduated scales, inscribed in Greek letters, corresponds to one of the fulcra. The fulcrum closest to the center of the bar, now missing and replaced by a small metal coil, would have weighed objects of up to thirteen pounds; the second fulcrum, up to thirty-four pounds; and the third, up to eighty-five pounds.[2] The merchant would have held the steelyard by one of the three fulcrum hooks and then suspended his goods on the twin hooks attached by chains to a collar at the end of the shorter arm. He would have measured their weight by placing a counterpoise on the longer, calibrated arm. Most of the weights preserved from the fifth to seventh century take the form of either an empress or the goddess Athena.[3] The five weights shown here (cats. 10–14) are therefore representative.

## 11 Empress Bust Weight and Hook

Byzantine, 5th century
Bronze
Bust: h. 24.2 cm, w. 11.5 cm., d. 7.1, wt. 2.29 kg; hook: l. 22.6 cm
The Metropolitan Museum of Art, Purchase, Gifts of J. Pierpont Morgan, Mrs. Robert J. Levy, Mr. and Mrs. Frederic B. Pratt, George Blumenthal, Coudert Brothers, and Mrs. Lucy W. Drexel, by exchange; Bequest of George Blumenthal and Theodore M. Davis Collection, Bequest of Theodore M. Davis, by exchange; and Rogers Fund, 1980, 1980.416a,b

COLLECTION HISTORY Collection of George Zacos, Basel, until 1980.

PUBLISHED *Late Antiquity to Late Gothic* 1990, 22, cat. 7, pl. 23; Franken 1994, 179, cat. CA58, pl. 98; *Mirror* 1999, 26–27, cat. 31; Evans et al. 2001, 16.

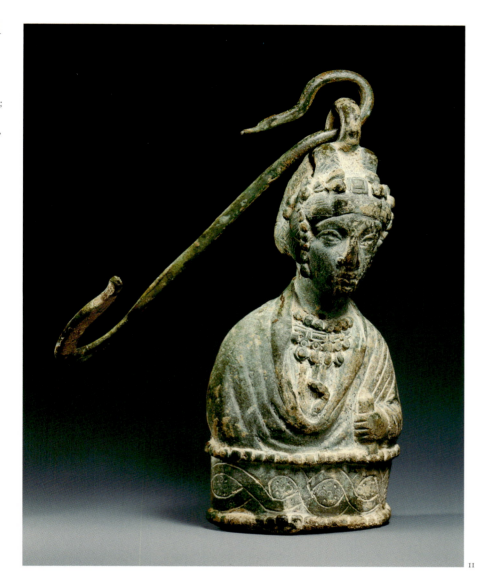

11

The empress weights share similar iconography, but differ in style and details. All feature a female figure wearing the imperial diadem, a necklace (except cat. 13), earrings, a garment tightly covering both shoulders, and a tunic. In her left hand the figure carries a small cylindrical object. In most cases (cats. 10, 12, 13), she holds the seam of her outer garment with her right hand, which rests within its fold. Cat. 11 is unique in depicting the empress's right hand making the gesture of speech, her hand pressed to her chest.[4]

Of all published weights, cat. 11 comes closest to a naturalistic portrayal.[5] The facial features, the multiple strings of the necklace, the stones of the diadem, and its two pendants are executed with great elegance. The careful rendering of the eyes is particularly interesting, as it differs considerably from that of the other four weights, all of which show variations of the typical late antique stare.[6] The folds of the garment and the left hand on cat. 11, however, are modeled with less precision.

Stylistically, all five busts exhibit to varying degrees a tendency toward simplification of three-dimensional forms. In cats. 12 and 14, accent is given to outlines and surface. The few important elements, such as the wide-open eyes, the scales of Athena's aegis, or the

## 12 Empress Bust Weight

Byzantine, 5th century
Bronze
H. 17.8 cm, w. 8.4 cm, d. 6.4 cm, wt. 3 kg
Museum of Fine Arts, Boston. William E.
Nickerson Fund, No. 2, 59.961

COLLECTION HISTORY Purchased by former
owner in Istanbul.

PUBLISHED *Ancient Art New York* 1961, cat. 315;
Comstock and Vermeule 1971, 440–41, cat.
644; *Romans and Barbarians* 1976, 177, cat. 194;
Franken 1994, 177, cat. CA46, pl. 94.

## 13 Empress Bust Weight

Byzantine, 6th century (?)
Bronze
H. 15 cm
Indiana University Art Museum, Burton Y.
Berry Collection, 76.61.2

COLLECTION HISTORY Burton Y. Berry
collection.

UNPUBLISHED

## 14 Athena Bust Weight

Byzantine, 5th century
Bronze
H. 14.5 cm
Indiana University Art Museum, Burton Y.
Berry Collection, 76.61.1

COLLECTION HISTORY Burton Y. Berry
collection.

UNPUBLISHED

stones of the diadem, appear prominent through relative enlargement. The counterpoise of cat. 10 and cat. 13 show a smoother treatment of the surface. Details of the diadem and the hairdo dissolve into their respective rounded shapes, and the faces are only sketched.

The bases of the weights can differ in shape, and the examples here are, again, representative. They can be oval or rectangular, straight or sloping, and are sometimes decorated. These differences seem to depend on chronology. As with most objects of unknown archaeological context, the chronology of the early Byzantine bronze weights has been established mainly on the basis of style and comparison to dated objects. The chronology for the empress bust weights runs between the late fourth/early fifth century and the mid-sixth century, whereas the Athena weights are dated between the fifth and seventh centuries.[7]

Cat. 14 is iconographically and stylistically similar to a fifth-century bust weight of Athena in the Metropolitan Museum of Art.[8] Both weights feature a female figure with a helmet over well-defined wavy locks, a *peplos*, and a shawl-like garment fastened over the left shoulder. This peculiar piece of clothing is a modified version of the aegis of snake scales, which usually covers both of Athena's shoulders and has a *gorgoneion*, the head of the Gorgon Medusa, in the middle. The base of cat. 14 is sloping, "double-decker," and incised with tendrils and circles, characteristics that point to the latter fifth century.[9]

The presence of imperial busts in the marketplace has been interpreted as an imperial guarantee of the fairness of commercial transactions.[10] The presence of Athena is thought to have invoked the goddess's wisdom—the quality that secured her longevity in Byzantine culture and her successful assimilation into Christian thinking.[11]

There is, however, a deeper symbolic connection between the empress and the goddess. On virtually every bust weight the empress carries in her left hand a small object identified as either a scroll or a *mappa*, a folded cloth that was one of the imperial attributes.[12] While the object could represent either of these, the scroll seems a more likely choice, since weights that show the cylindrical object in greater detail depict it as slim, straight, and compact.[13] The *mappa*, even in small-scale representations in this early period, is shown as a malleable, wrinkled bundle with fluffy ends.[14]

The gesture of the right hand also helps us to understand the significance of the female weights. The empress either makes a gesture of speech (cat. 11), or grasps the seam of her garment (cats. 10, 12, 13).[15] Both gestures are long-practiced conventions in the representation of learned individuals and imply that the empress, too, is exceptionally well educated. The gesture of speech in late antique/early Byzantine art is usually reserved for Christ, Church figures, and imperial officials; occasionally, for the Muses.[16]

The "sling" position of the right arm, in the presence of the scroll, makes another reference to learning: it reproduces a standard gesture of orators and personae who "love wisdom," such as philosophers, poets, Muses, or men and women showing off their learning.[17] The evidence from art and from written sources, however scarce, demonstrates that learnedness was one of the celebrated virtues of an empress.[18] The emperor Julian praises the empress Eusebia, wife of Constantius II (r. 337–61), for her wisdom.[19] A full-length statue of an early Byzantine empress, identified most commonly as Aelia Flacilla, wife of

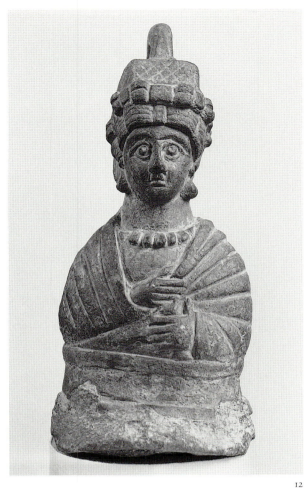

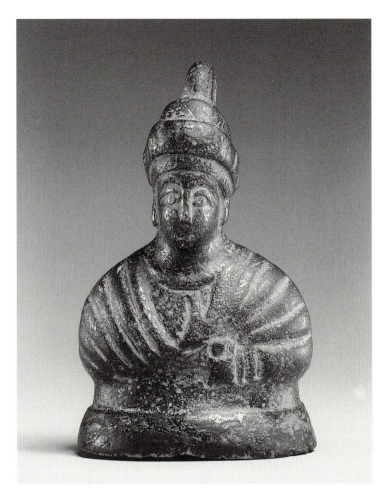

12

13

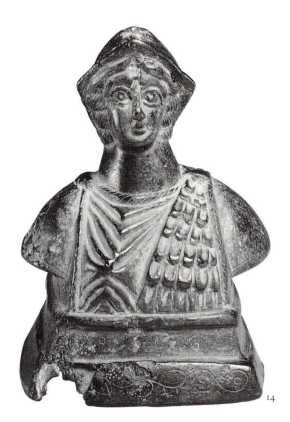

14

Theodosios I (r. 379–95), shows the *augusta* with a diptych or a writing pad in her left hand.[20] On some coins the same empress is shown as the personification of the well-being of the state holding a scroll.[21] The empress Eudokia (cat. 32), wife of Theodosios II (r. 402–50), delivered an encomium in Homeric hexameter on Antioch in the Senate of that city and took part in the reorganization of the university at Constantinople.[22]

Thus it may be inferred that empresses depicted on bronze bust weights, like the goddess Athena, stood as wisdom personified.[23] With their wide-open eyes suggesting both piety and watchfulness, they guaranteed by virtue of their wisdom the correct judgment in commercial transactions.[24]  DA

1. Kisch 1965, 56.

2. *Ternbach Collection* 1981, 223–24. On the mechanics and calibration of the steelyard, see Hill 1952, 54.

3. Norbert Franken's 1994 catalogue lists seventy-two empress bust weights and fifty-five Athena bust weights. To this corpus should be added the two unpublished Indiana bust weights (cats. 13, 14), one an empress and one Athena. The tendency to identify all helmeted female bust weights as representing Athena is problematic (Franken 1994, 100 and n. 210; Thomas 1987, 156), since some show a helmeted female with her right breast bare (Franken 1994, CB14-9, CB45), a convention for depicting Roma, the personification of the city of Rome.

4. Franken 1994, 97.

5. Its pearl-rimmed base is also unique (ibid., 97).

6. *Mirror* 1999, cat. 31.

7. Franken 1994, 92–93.

8. C. W. J. Eliot dates the New York Athena to 350–450 (Eliot 1976, 168). Franken sets the beginning of the chronology of early Byzantine Athena weights in the fifth century (Franken 1994, 94, CB9).

9. For a similar weight, see Franken 1994, CB10.

10. Franken 1994, 104–5. For the empress's presence in the market: McClanan 1997; James 2001, 117.

11. For the popularity of Athena in early Byzantium, see Thomas 1987, 156, and Franken 1994, 105. Athena was associated in Byzantine thought with wisdom and perhaps also just rule and protection from evil: W. Klaus (quoted in Franken 1994, 105) connects Athena to God's wisdom from Proverbs 8:1–36; significantly, wisdom is also the virtue by which "kings reign and rulers make laws that are just" (Prov. 8:15). The Gorgon's head, worn by Athena in some weights, remained a potent apotropaic device in later Byzantium (as on an ink box in Padua; see *Glory of Byzantium* 1997, 189); on the apotropaic properties of an Athena weight from Yassi Ada, see Russell 1995, 48. For Athena weights decorated with crosses: Thomas 1987, Abb. 10-1; *Rom und Byzanz* 1998, cat. 217; Franken 1994, CB 53.

12. Scroll: Franken 1994, 97; *mappa:* James 2001, 117 and nn. 20, 31, and St. Clair 1996, 153–55; for the *mappa* as an imperial attribute, Alföldi 1934, 34.

13. Franken 1994, CA 21, 47, 52, 55, 56, 58.

14. For instance, Kent 1978b, solidi of Theodosios II, nos. 747R, 748R. The same distinction between the *mappa* and the scroll is seen on ivories: the *mappa* on consular diptychs, Volbach 1976, nos. 5, 6, 8–13, 15, 21, 23, 24, 28, 31–33, 35. Exceptions are the diptychs of Anthemios and Anastasios, where the *mappa* is more compact but the texture of the fabric is clearly incised (ibid., 16–18). Scrolls: ibid., nos. 39, 47, 65, 108, 112, 122, 123, 132–33.

15. There are fifty-two examples (fifty-three with Indiana) of the seam gesture and eighteen of the speech gesture (Franken 1994, 97).

16. For instance, Christ on a Berlin ivory pyxis (Volbach 1976, no. 161; Zanker 1995, 304, fig. 165); the Carrand diptych with Saint Paul (Volbach 1976, no. 108; Zanker 1995, fig. 161 and comments 297); Muse on a sarcophagus (Ewald 1999, Tafel 20, 2).

17. For a discussion of this oratorical gesture, see Zanker 1995, 49; for plaques depicting poets with similar gestures, see Volbach 1976, nos. 69, 71. Other examples: a Muse on the diptych of Constantius (Volbach 1976, no. 34; Franken 1994, 110, n. 176); Saint Peter with sling gesture and scroll (Volbach 1976, no. 39); and the deceased with speech gesture and a scroll on sarcophagi in the Vatican and in Arles (*Age of Spirituality* 1979, figs. 53, 56).

18. James 2001, 12.

19. Julian 1962, vol. 1, 129: D.

20. *Age of Spirituality* 1979, cat. 20, pl. 1.

21. Anne Robertson interprets this posture as arms crossed on the breast, although a long scroll is clearly visible in the empress's hands (Robertson 1962–82, F.7, F.13, pl. 87).

22. Holum 1982, 117; Malalas 1986, nn. 194–95.

23. On the connections between empresses, goddesses, and imperial ideology in early Byzantium, see Angelova 1998.

24. This is also the intended meaning of the series of weights with a seated emperor.

## 15 Weight with Imperial Busts and Local Official

Egypt, Byzantine, March 16, 575
Bronze
H. 4 cm, w. 4 cm, d. 0.4 cm, wt. 78.46 g
Obv: left and right, ΓO/Γ (three ounces); in five lines, ΕΠΙ ΤΟΥ ΠΑΝΕΥ/ΦΗΜΟΥ ΚΑΙ ΕΥΦ/ΥΟCΤΑΤΟΥ CΤΡΑΤ/ΗΛΑΤΟΥ ΙΟΥΛΙΑΝȢ/ ΦΑΜΕΝΩΘ Κ. ΙΝΔ Η (in the time of the all-beneficent and best disposed [of men] Julian, commander in chief, on the 20th of Phamenoth, indiction 8th)
Arthur M. Sackler Museum, Harvard University, Bequest of Thomas Whittemore, 1951.31.4.1872

COLLECTION HISTORY Thomas Whittemore collection.

PUBLISHED Heintz 2000, 26–28.

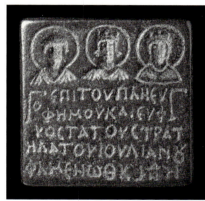

15

Three figures are depicted on the obverse of this square weight. The two imperial figures have been identified.[1] Justin II (r. 565–78) occupies the prime position, in the center, wearing a three-pronged crown with *pendilia* at the temples. The empress Sophia, the actual wielder of power at the time, appears on the right, just as she does on their bronze coinage, where the imperial couple is enthroned side by side in an unprecedented combination (cat. 34a).[2] Empresses had never before been represented in this way on the obverse of coins. On the weight, Sophia wears the same three-pronged crown as she does on coins. The third figure is not crowned, but has a halo, which makes it difficult to identify the figure with certainty.

Early Byzantine weights are very rarely dated to the year, much less to the exact day of their manufacture or issue.[3] It is even more unusual to encounter an example that reveals its region of origin, in this case Egypt, through the calendar system used in its inscription.[4] Also, as a rule, bronze weights from the time of Justin II and Sophia feature only the busts of the two rulers, with their monogram and a dating inscription.[5]

It has been argued that the third figure on this weight represents Tiberios, a young court notary who, on December 7, 574, was appointed junior emperor, or *caesar*, to govern in tandem with the senior ruler, Justin II.[6] The problem with this identification is that if he were the young co-emperor, he would be wearing a crown. The figure could perhaps be the provincial governor or high official who had the issuing authority for the weights.

The imagery on commercial weights of this type seems to vary considerably, suggesting that the weights were made regionally.[7] Justinian I (r. 527–65) issued a law in 545 that allowed, for example, the eparch (chief administrator of a city) or prefect to issue weights and measures for commodities, and the *comes sacrarum largitionum*, a high-ranking financial official, to issue weights for gold, silver, and other metals.[8] There were thus several weight-issuing authorities, from the emperor downward, including the *anthypatos* (governor of a special province) or proconsul. The variety of such authorities is evidence for the argument that a figure such as the one on the left in cat. 15 is the local authority, represented along with the emperor and empress. The inscription on the weight, which helps establish the date, identifies the figure as Julian the commander in chief, possibly a military governor, and draws attention to his presence through lavish praise.   IK

1. Heintz 2000, 26–28.

2. *DOC*, vol. 1, 204–17, pls. 50–52.

3. On the evidence for a 575 date, see Heintz 2000, 26–28.

4. Phamenoth is the fifth month of the Egyptian calendar.

5. Bendall 1996, 44–45, cat. 117.

6. For the identification of the figure as Tiberios, see Heintz 2000, 27. During the previous three years, Sophia had come to rule virtually alone because of her husband's declining mental health, and she prepared for his succession by hand-picking Tiberios to act as co-ruler under her close supervision (Cameron 1967

and 1975). Visual expression of Sophia's power during the reign of Justin II is found in joint representations of Justin and Sophia on ceremonial crosses, ivories, and lead seals, as well as on coins. See McClanan 1997, ch. 5: "The Empress Sophia: Authority and Conflict in Text and Image."

7. Bendall 1996, 14, also suggests that the great variety in design and technical expertise in weights indicates that there were numerous centers of production throughout the provinces.

8. Regarding the law, see ibid., 11–12. See 48–49, cat. 127, for a circular coin weight from about 565 with an image of the issuing authority, the eparch of Constantinople Zemarchos.

## 16 Follis of the Empress Helena with Securitas

Mint of Antioch, 325–26
Bronze
Diam. 1.9 cm, wt. 3.1 g, reverse die axis
6 o'clock
Obv: clockwise from lower left,
FL[AVIA]HELENA AVCVSTA (Flavia Helena,
Augusta)
Rev: clockwise from lower left, SECVRITAS
REIPVBLICE (Security of the State); in exer-
gue, S M ANT S (mintmark of Antioch,
workshop 2)
Arthur M. Sackler Museum, Harvard
University, Bequest of Thomas Whittemore,
1951.31.4.37

COLLECTION HISTORY Thomas Whittemore
collection.

UNPUBLISHED

## 17 Follis of the Empress Fausta with Spes

Mint of Ticinum, 325
Bronze
Diam. 1.9 cm, wt. 2.92 g, reverse die axis
6 o'clock
Obv: clockwise from lower left, FLAV[IA]
MAX[IMA] FAVSTA AVC[VSTA] (Flavia
Maxima Fausta, Augusta)
Rev: clockwise from lower left, SPES REI
PVBLICAE (Hope of the State); in exergue,
P U T (workshop 1, control mark, mint of
Ticinum)
Arthur M. Sackler Museum, Harvard
University, Gift of George Davis Chase,
1942.176.1905x

COLLECTION HISTORY George Davis Chase
collection.

UNPUBLISHED

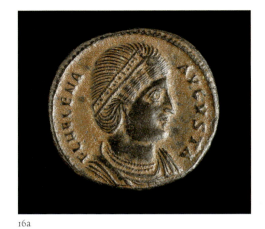
16a

16b

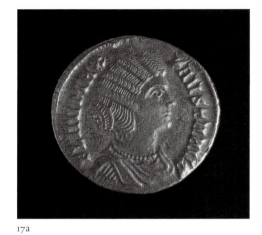
17a

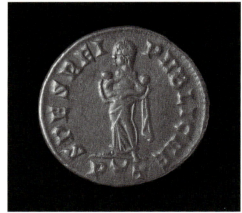
17b

# Helena and Fausta

These bronze coins were struck to commemorate the promotion of the empresses Helena, Constantine's mother, and Fausta, his wife, to the rank of *augusta* in 324.[1] They were granted that distinction, the highest imperial title for women, as part of the state celebrations following Constantine's victory over Licinius earlier that year (see cat. 3b).[2] The *augustae* were honored with a series of special gold and bronze coin issues bearing their portraits, Helena's associated with the female personification of state security (*securitas*) and Fausta's with the state's hope (*spes*) and health (*salus*). Coins of the two empresses were minted in far greater numbers than before 324, heralding them throughout the empire as protectors and pillars of the new Constantinian society.[3]

The obverse portraits represent the *augustae* as embodiments of imperial majesty, exalted through their sumptuous jewelry and implied physiognomic similarities to the emperor Constantine.[4] Both women possess the large, upward-gazing eyes of Constantine's official portraits, a resemblance that would have conveyed dynastic cohesion and stability.[5] Despite their identical titles, Helena alone is always depicted with a diadem on coins of the dynasty (cat. 16a), suggesting her seniority and higher status at court.[6] The empresses'

faces are somewhat individualized: the elderly Helena's is gaunt and has a sharp profile resembling her son's.[7] Her hair is gathered at the nape and drawn in a loop up the back of her head into a roll at the top, a contemporary hairstyle worn by elite women in the late third and early fourth centuries (see cat. 24). The more youthful Fausta (cat. 17a) has the delicate nose and chin familiar from her portrait sculptures.[8]

Fausta's follis recalls coins of the Roman empresses Livia (58 B.C.–29 A.D.) and Faustina the Younger (130–75 A.D.), on which they are shown as personifications of the similar state goals of health and fecundity.[9] The reverses of Fausta and Faustina's coins both depict the standing empress/personification holding her children (in this case, Constantine II and Constantius II) on either arm. Evocative of nursing, the image affirms the high value placed on motherhood and childbearing as roles for Roman and Byzantine imperial women.[10] Fausta's hair is parted in the center and pulled back in soft waves to form a tight bun at the nape. The style is retrospective, imitating portraits of Livia.

Fausta's name echoes the name of Faustina the Younger and her mother, the deified *augusta* Faustina the Elder (d. 141 A.D.), who was posthumously associated with the Roman mother-goddesses Juno and Ceres, as well as with Venus.[11] In much the way that the name Aelia and the portrait type of Aelia Flacilla, wife of Theodosios I (r. 379–95), were adopted as status symbols on coins of fifth-century empresses (see cats. 7a, 29a, 30a, 32a, 33a), Fausta's coins were perhaps designed to suggest her continuity with the two great Antonine empresses,[12] the wife and daughter of the Roman emperor Antoninus Pius (r. 138–61). The use of Antonine models is paralleled in her portrait sculptures (see cat. 25).

Livia, wife of Augustus, was the first Roman empress, as well as the first to be divinized and bear the title *augusta*, derived from her husband's name.[13] Faustina the Younger was granted the title when she bore the first of twelve imperial children.[14] Through her coin portraits, Fausta is perhaps compared with both Roman *augustae*, who were superhuman in stature: ideal matrons embodying all the female qualities desired by the state.   EG

1. For the types, Helena: *RIC*, vol. 7, 689, cat. 67 (Antioch=Antakya, Turkey); Fausta: ibid., 387, cat. 203 (Ticinum=Pavia, Italy).

2. After Helena and Fausta, the title was not used until 383 (Brubaker 1997, 69, n. 37).

3. Drijvers 1992, 41–42. For solidi of Helena and Fausta, see Foss 1990, 286, cat. 1; 287, cat. 1. For Fausta as *Salus Reipublicae* (health or welfare of the state), see *RIC*, vol. 7, cat. 300.

4. Stout 1994, 77, 93.

5. For coin portraits of Constantine, Helena, and Fausta: *RIC*, vol. 7, 694, cat. 96; 383, cats. 177, 182; 505, cat. 50; Giacosa 1977, pls. 60–63.

6. Drijvers 1992, 42. Conversely, Holum 1982, 33, and Alföldi 1963, 93, argue that Helena's band is not a diadem because it lacks a forehead jewel and ties in the back. Fausta is diademed in some issues: *RIC*, vol. 7, 331, cat. 294 (mint of Rome); 387, cat. 204 (Ticinum); 519, cat. 162 (Thessaloniki).

7. Helena was between sixty-seven and seventy-four years old when this coin was minted (*ODB* 1991, 909).

8. Fausta was perhaps twenty-seven when this coin was minted (Giacosa 1977, 76). For her possible portrait sculptures, see cats. 24 and 25 in this volume, as well as *Romans and Barbarians* 1976, 109–10, cat. 117; De Kersauson 1996, 524–25, cat. 250; St. Clair 1996, 150–52, n. 16.

9. Faustina the Younger was the wife of the emperor Marcus Aurelius and daughter of Antoninus Pius and Faustina the Elder (*I, Claudia* 1996, 59–60, cat. 8; 79, cats. 37, 38).

10. Ibid., 78–79, cat. 37.

11. Bergmann and Watson 1999; *I, Claudia* 1996, 77, cats. 34, 35.

12. On "Aelia," see James 2001, 127–28.

13. *I, Claudia* 1996, 53.

14. Ibid.

## 18 Solidus of Constantine VI

Mint of Constantinople, 792–97
Gold
Diam. 1.9 cm, wt. 4.39 g, reverse die axis
6 o'clock
Obv: clockwise from lower left, IPINH
AΓOVSZI (To Irene, Empress)
Rev: clockwise from lower left, COᴨSZAᴨ
ZIᴨOS ЬAS´ (Constantine, Emperor); Θ
(control mark)[1]
Arthur M. Sackler Museum, Harvard
University, Bequest of Thomas Whittemore,
1951.31.4.1117

COLLECTION HISTORY Thomas Whittemore
collection.

PUBLISHED *DOC*, vol. 3, 342, cat. 3 a.5.

## 19 Follis of Constantine VI

Mint of Constantinople, 792–97
Bronze
Diam. 1.8 cm, wt. 2.77 g, reverse die axis
6 o'clock
Rev: large, below central line, M (mark of
value=40 nummi); smaller, below, A (work-
shop 1); to left and right, X and N (date
formula)
Arthur M. Sackler Museum, Harvard
University, Bequest of Thomas Whittemore,
1951.31.4.1123

COLLECTION HISTORY Thomas Whittemore
collection.

PUBLISHED *DOC*, vol. 3, 346, cat. 7.5, pl. 14.

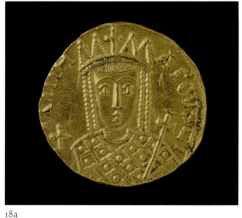

18a

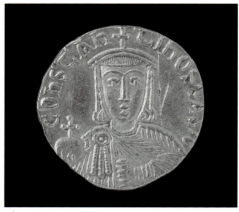

18b

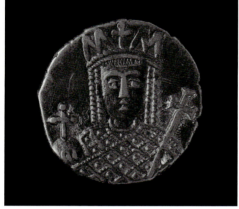

19a

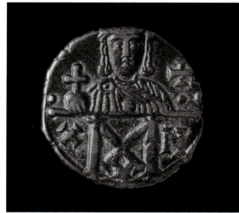

19b

# The Empress Irene

Coins were normally struck in an empress's name only when she ruled alone. When she married or her son reached adulthood, the privilege lapsed. Thereafter, her image and name appeared on coins only at the will of the senior emperor and were secondary to his.[2] Overturning tradition, Irene occupies the obverses of these two coins issued by her adult son and co-emperor Constantine, who is relegated to the reverse side. She alone wears the *loros*, and she bears the imperial insignia of the cross-scepter and *globus cruciger*. The emperor is clearly subordinate: he wears a less sumptuous *chlamys*, lacks the scepter of office, and is deprived of a beard, the Byzantine signifier of manhood.[3] On the solidus, Irene's name and title are in the vocative case, which means the issue is dedicated to her as the object of imperial acclamation, while Constantine's name and title are abbreviated and therefore ambiguous.[4] On the follis, he is half Irene's size.

Irene had been exiled for ordering the arrest of her son's advisers in a bid for power, and these coins were struck after her return.[5] Her regency had officially ended in the mid-780s, after which she had no right to appear on coins, much less surpass her son.[6] As co-emperor, former regent, and ruler credited with the restoration of holy images, however,

she had all the necessary qualifications for assuming control.[7] She became sole ruler by blinding Constantine in 797, and thereafter struck coins in her own name throughout her independent reign (792–802).[8] With her gold coins, she became the first Byzantine empress to issue money with her own portrait and name on both sides.[9] This new, feminized coin type promotes her as the only official ruler, an unconstitutional position for women which was nevertheless accepted.[10]

Irene's usurpation of the emperor's position on coinage is paralleled in her use of the male title Βασιλεύς Ρωμαίων καί αὐτοκράτωρ (Emperor of the Romans and Supreme Ruler) in the headings of two laws in her name.[11] She was the first empress in 150 years to be represented on coins and only the third in nearly three hundred years to strike gold coins in her name.[12] Her coin images, moreover, claim far more authority than those of her predecessors. They reflect her unsurpassed ability to override the state policy of male hegemony.  EG

1. By Constantine's reign, the final mintmark letters on most gold coins do not signify workshop numbers and are merely formulaic; see *DOC*, vol. 3, 77–78 and table 7.

2. *DOC*, vol. 3, 10.

3. On his coins, Constantine is never shown with a beard (ibid., 337).

4. Grierson 1982, 158.

5. The nineteen-year-old Constantine in 790 deprived Irene of her rank and confined her to the Palace of Eleutherios in Constantinople. In 792, in response to appeals, he restored her position as empress-mother and reinstated her at court (Herrin 2001, 92–93, n. 71, citing Theophanes).

6. Constantine was between twenty-one and twenty-five years old when this coin was struck (*DOC*, vol. 3, 11, 336). Throughout the 780s, Irene claimed the position of senior emperor over her son (Herrin 2001, 91).

7. Irene and Constantine presided over the Seventh Ecumenical Council in Nicaea, which restored icons; acclaimed as a new Constantine and Helena, they were granted a status similar to that of the saints (Herrin 2001, 87–89, 101).

8. Considered a merciful option in comparison with death, blinding was the normal punishment for conspiracy against the emperor and a common method of removing political rivals in Byzantium and the medieval West (Herrin 2001, 99).

9. For Irene's solidi, see *DOC*, vol. 3, 349–51, cats. 1.a.1–1c, pl. 15.

10. Garland 1999, 87–88.

11. The only comparable use of a male title occurred in the tenth-century West, when Theophano, a Byzantine aristocrat and widow of the emperor Otto II, signed acts using the male form *imperator* instead of *imperatrix* (Herrin 2001, 100–101); *DOC*, vol. 3, 11, suggests that Irene uses the female title *basilissa* (empress) on her coinage because *basileus* (emperor) would have made the contradiction of sex too obvious to be acceptable.

12. The previous empress to appear on coinage had been Martina (d. after 641/2), niece and second wife of the emperor Herakleios (r. 610–41). Ariadne (*augusta* c. 474–515), wife of the emperor Zeno and then Anastasios I, was the previous empress to strike gold coins in her name (*DOC*, vol. 3, 337).

## 20 Histamenon of the Empress Theodora

Mint of Constantinople, 1055–56
Gold
Diam. 2.6 cm, wt. 4.43 g, reverse die axis
6 o'clock
Obv: clockwise from lower left,
+ IΠXΠCΠCSX ΠCS ΠTIhΜ (Jesus Christ,
King of Those Who Rule)[1]
Rev: clockwise from lower left, + ΘЕОΔΥΡΛ
ΛΥΓΟVCΤΛ (Theodora Augusta); left and
right of Virgin's head, Μ̅ Θ̅ (Mother of God)
Arthur M. Sackler Museum, Harvard
University, Bequest of Thomas Whittemore,
1951.31.4.1586

COLLECTION HISTORY Thomas Whittemore
collection.

PUBLISHED *DOC*, vol. 3, part 2, 752, cat. 1 c.1.

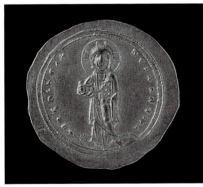

20a

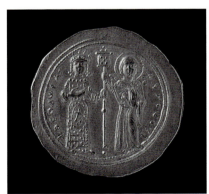

20b

Theodora's coins are the first to depict an empress standing beside the Virgin. On the reverse of this coin, the two women are depicted on the same level, wearing long robes. Their gestures are similar: with left leg extended, one hand holding the staff and the other in front of the chest, they venerate the standard that, with its cross design, is perhaps a symbol of the standing Christ on the obverse. Although the Virgin's hand is above Theodora's on the staff, signifying her superiority, the empress occupies the traditional position of honor on the viewer's left.[2]

Theodora minted a large number of these gold coins, saturating the marketplace with this evidence of her status as divinely favored sovereign and companion.[3] The coin illustrates the prominence of the Mother of God on currency in the middle third of the eleventh century (cats. 43a, 44a, 59a, 60a), partly because there were women sovereigns. Theodora ruled with her sister Zoe in 1042 and then alone in 1055–56 (see cat. 40).[4] Other official and public icons of the Virgin also proliferated, reflecting the expansion of her cult in Constantinople at this time.[5] On coins Mary always wears a long-sleeved tunic and a long, hooded mantle decorated with four pellets evoking a cross on her forehead and shoulders (cats. 43a, 44a, 57a, 58b, 59a–63a).[6] The Virgin's likeness thus became a standardized emblem of state authority.

These coins were struck when Theodora returned to the throne, taking a warship to the Great Palace to seize control when her late sister's husband, Constantine IX (r. 1042–55), became fatally ill and appointed a different successor.[7] Theodora and her coin images invite comparison to the Virgin, consolidating and legitimizing the sole rule that she chose, in the words of her contemporary Michael Psellos, "contrary to all belief and opinion."[8] Theodora won the support of the imperial bodyguard by using her piety and her status as a daughter born in the purple chamber of the palace, and thus the last legitimate heir to the Macedonian dynasty. Like Irene (cats. 18, 19) in the ninth century, she exercised the prerogatives of an emperor, issuing and signing laws as αὐτοκράτωρ (supreme ruler, masc.), and appointing clerics, a strictly male privilege.[9] The obverse epithet, "Jesus Christ, King of Those Who Rule," used by her ancestor Emperor Basil I the Macedonian (r. 867–86; cat. 38), underlines Theodora's status as heir to the dynasty he founded.[10]    EG

1. The spelling is corrupt (*DOC*, vol. 3, part 2, 752).

2. Alternatively, *DOC*, vol. 3, part 1, 110–11, suggests that the standard symbolizes Christ and that the order of precedence is correct for a three-figure coin design.

3. Penna 2000, 210–11; *DOC*, vol. 3, part 2, 748.

4. Carr 2000, 326–27.

5. Ibid., 325–34.

6. *DOC*, vol. 3, part 1, 170.

7. Garland 1999, 165–66.

8. Psellus 1966, 261. For Theodora's life, see Garland 1999, 136–67. Helena and Pulcheria, who were compared to the Virgin Mary, are precedents (James 2001, 14).

9. Garland 1999, 166–67. On Irene's titles, see Herrin 2001, 100.

10. *DOC*, vol. 3, part 1, 182.

## 21 Miliaresion with the Empress Maria

Mint of Constantinople, 1071–78
Silver
Diam. 2.2 cm, wt. 2.06 g, reverse die axis
12 o'clock
Obv: clockwise from lower left, ЄN TOVTω
NIKATЄ [MIX]AHΛ KAI MAPIA (Michael and
Maria triumph in this [sign of the cross])
Rev: five lines, upper part worn, MIXAHΛ/
KAI MAPIA/ ΠICTOI RA/CIΛHC Pω/MAIωN
(Michael and Maria, Faithful Emperors of
the Romans)[1]
Arthur M. Sackler Museum, Harvard
University, Bequest of Thomas Whittemore,
1951.31.4.1626

COLLECTION HISTORY Thomas Whittemore
collection.

PUBLISHED *DOC*, vol. 3, part 2, 811, cat. 6c.

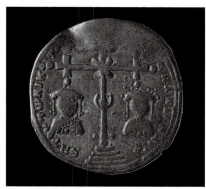

21a

21b

Maria was the daughter of King Bagrat IV of Georgia.[2] Her presence on her husband's coinage (see also cat. 44b) unusual for an empress, perhaps reflects her royal pedigree as well as diplomatic considerations. The coin design follows the precedent established by her mother-in-law, the empress Eudokia Makrembolitissa (cats. 41–43), under whose tenure the empress's bust took the place previously given to the junior emperor and successor on miliaresia (of 1059–67).[3] Maria's bust occupies the subordinate position on the right, opposite that of her first husband, Michael VII Doukas (r. 1071–78). Maria came to the throne through a diplomatic marriage to Michael, then a junior emperor.[4] Her noble birth, great beauty, and modesty ("She spoke only to her husband") were praised by the contemporary chroniclers Michael Psellos and Anna Komnene.[5] Maria's political skill is attested by her exceptionally long career at court, extending into the reigns of two subsequent emperors: her second husband, Nikephoros II Botaneiates (r. 1078–81), and her adopted "son" Alexios I Komnenos (r. 1081–1118).[6]

In schematic form, the obverse represents Maria and Michael flanking the cross. Veneration of the cross was a ritual that emperors performed repeatedly at stations on their procession through the palace and capital on high holidays.[7] The coin links the imperial couple's joint rule to the victories of Constantine, the first Christian emperor and the founder of the Byzantine Empire. His vision of the cross, accompanied by a voice saying, "in this sign, triumph," repeated in the obverse inscription, signified Constantine's holy mandate to rule, which brought about his victory over the Roman emperor Maxentius in 312 and the ascendance of Christianity.[8] The coin design recalls Byzantine processional crosses, with Michael and Maria's busts in the position of jewels or A and Ω pendants, reinforcing the idea of their piety and rule as part of a predestined Christian order.[9]   EG

1. The spelling is corrupt (*DOC*, vol. 3, part 2, 811, cat. 6c), and the first line is worn.

2. *ODB* 1991, 1298.

3. *DOC*, vol. 3, part 2, 765, 771, cat. 4, pl. 64. On the significance of Eudokia's miliaresia, see Kalavrezou-Maxeiner 1977, 311.

4. *ODB* 1991, 1298.

5. Psellus 1966, 372 (7.9–10); Comnena 1967, 102 (3.2). The quote is from Psellos.

6. Maria was only about ten years older than Alexios; the adoption was a political expedient (Garland 1999, 185).

7. For example, on the day of the Virgin's Nativity, the rulers venerated a cross at the porphyry column in the Forum of Constantine (Constantine VII 1967, vol. 1, 16). On the prevalence of veneration of crosses in the Great Palace and Hagia Sophia, see ibid., 5–8, 11–14, 19–20, 22–24, 26–27, 39.

8. *ODB* 1991, 550. Because of its pellets evoking jewels and its placement on steps, the cross probably also refers to the ex-voto jeweled cross set up by Constantine after his victory (Brubaker 1999, 153).

9. *Processional Crosses* 1994.

## 22 Seal of the Patriarch Athanasios with Enthroned Virgin

Constantinople, 1289–93 or 1303–9
Lead
Diam. 4.0 cm, wt. 42.1 g
Obv: left and right of Virgin's head, M̄P ΘV (Mother of God)
Rev: eight lines, +AΘANA/CIOC ЄΛЄW ΘV/ APXIЄΠICKOΠOC/ KWNCTANTINOV/ ΠOΛЄWC NЄAC PW/MHC KAI OIKȢMЄ/ [NIK]OC P̄PIAP/XHC (Athanasios, by the grace of God Archbishop and Ecumenical Patriarch of Constantinople, the New Rome)
Arthur M. Sackler Museum, Harvard University, Purchase, David M. Robinson Fund, 1999.60

COLLECTION HISTORY George Zacos collection; purchased from Spink and Son Ltd., Oct. 7, 1998.

PUBLISHED Zacos 1984, 48, cat. 41b, pl. 8; Spink Auction 1998, 19, cat. 24.

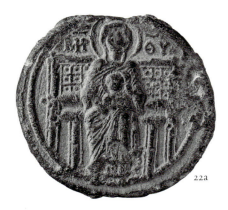
22a

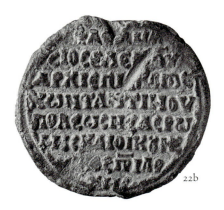
22b

# Lead Seals

Lead seals were used throughout the empire on documents, letters, and packages, including merchandise. The seal guaranteed that an item could not be opened until it reached its recipient. It served as both a lock and the signature of the sender. Official seals conveyed legal authority, while personal seals, with their iconographic choices, provided an expression of individual preference.

To apply a seal, a string tied around a letter or attached to a document was placed between two soft lead discs that were struck shut with a pliers-shaped implement called a *boulloterion*. As it pressed the seal closed, the *boulloterion* left an imprint on either side of the soft lead with an inscription and often an image that the owner had chosen. This type of lead seal had become standard throughout the empire by the seventh century. Until the eighth century, religious imagery on seals remained limited. A number of saints, male and female (Michael, Peter, Paul, Theodore, Irene, Anastasia), appeared on official seals. The most popular figure on seals, however, was the Virgin.

Usually the inscription on the obverse identified the owner of the seal by name and office. On the reverse were images that revealed some of the owner's interests in the realm of devotion and personal protection. Some individuals, usually those who were well known at least to their correspondents, used no identifying inscription. The lack of inscription also allowed the sender to remain anonymous to outsiders. An excellent example of this type was one of the wax seals of Anna Dalassene, powerful mother of the emperor Alexios I Komnenos (r. 1081–1118). We know from textual sources that it showed two religious scenes, the Transfiguration of Christ on one side and the Koimesis (Dormition) of the Virgin on the other. The example gives us a sense of her personal preferences in religious themes or scenes that she considered appropriate for seals, although we do not know the precise circumstances that led her to make her selection.

By the middle and late Byzantine period, seals carried a wide variety of religious themes and figures, but the image of the Virgin remained the favorite. Her many representations on famous icons provided models. Although her most important role was that of intercessor with Christ on behalf of mankind, the owner of a seal could choose to communicate other and more specific aspects of the Virgin: the heavenly queen, the devoted mother, the

guide and protectress. All but one of the seals in this exhibition (cat. 23) depict the Virgin Mary (cats. 22, 46, 47, 54–56). Their owners held a variety of positions of authority.

Cat. 22 is a fine example of seal engraving. It has a slight dent on the reverse, however, and the face of the Virgin is damaged. The owner of the seal was Athanasios I, ecumenical patriarch of Constantinople, who occupied the throne twice, in 1289–93 and 1303–9. A promoter of social reforms, he is well known from his correspondence, which survives.[1] On the obverse of his seal is an enthroned Virgin holding the Christ child on her lap. The wide back of the throne is decorated with squares and pellets that usually suggest pearls. After Iconoclasm the Virgin became a traditional motif on the patriarchal seals of Constantinople; emperors adopted the figure of Christ, sometimes enthroned, as the representative symbol on their seals. The Virgin seems a more appropriate theme for the patriarchal seals, since, like her, the institution of the Church and the patriarch, head of all clergy, serve as mediators or intercessors between the people and Christ.[2] Although the enthroned Virgin and Child first appear in the second half of the eleventh century, the wide-backed throne that Athanasios chose for this depiction is an iconographic detail introduced in the thirteenth century. IK

1. Maffry Talbot 1975.                    2. Kalavrezou 1990, 171.

## 23 Seal of the Metropolitan Constantine with Hosia Theodora

Mytilene (Lesbos), 12th century
Lead
Diam. 2.8 cm, wt. 20.9 g
Obv: left and right of the figure, vertical, with the last syllable, P and A, on either side of the name to form a cross, HOCIA ΘΕΟΔⲰΡΑ (Holy Theodora)
Rev: four lines, +KⲰNCTAN/TIN�8 CϤΡΑ/ΓICMA T�8 MH/TVΛINHC (seal of Constantine of Mytilene); cross above; two eight-rayed stars below
Dumbarton Oaks Collection, Washington, D.C., 58.106.12

PUBLISHED *DOSeals*, vol. 2, 143, cat. 51.7.

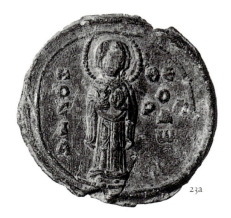

23a

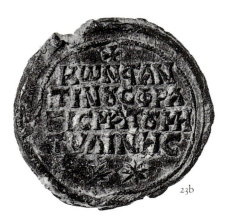

23b

On the obverse of this seal, Theodora stands facing the viewer, holding a martyr's cross in her right hand; her left hand is open in front of her chest in a gesture of prayer. Theodora has been identified as the Alexandrine woman who vowed to preserve her virginity for Christ and was martyred by the emperor Diocletian (r. 284–305). The seal belonged to the metropolitan Constantine of Mytilene in the twelfth century. Clearly the image on the seal was chosen because Theodora was the saint to whom the *metropolis* (cathedral) of Mytilene was dedicated. This is an example of a seal with a female saint other than the Virgin Mary.[1] IK

1. *DOSeals*, vol. 2, 143.

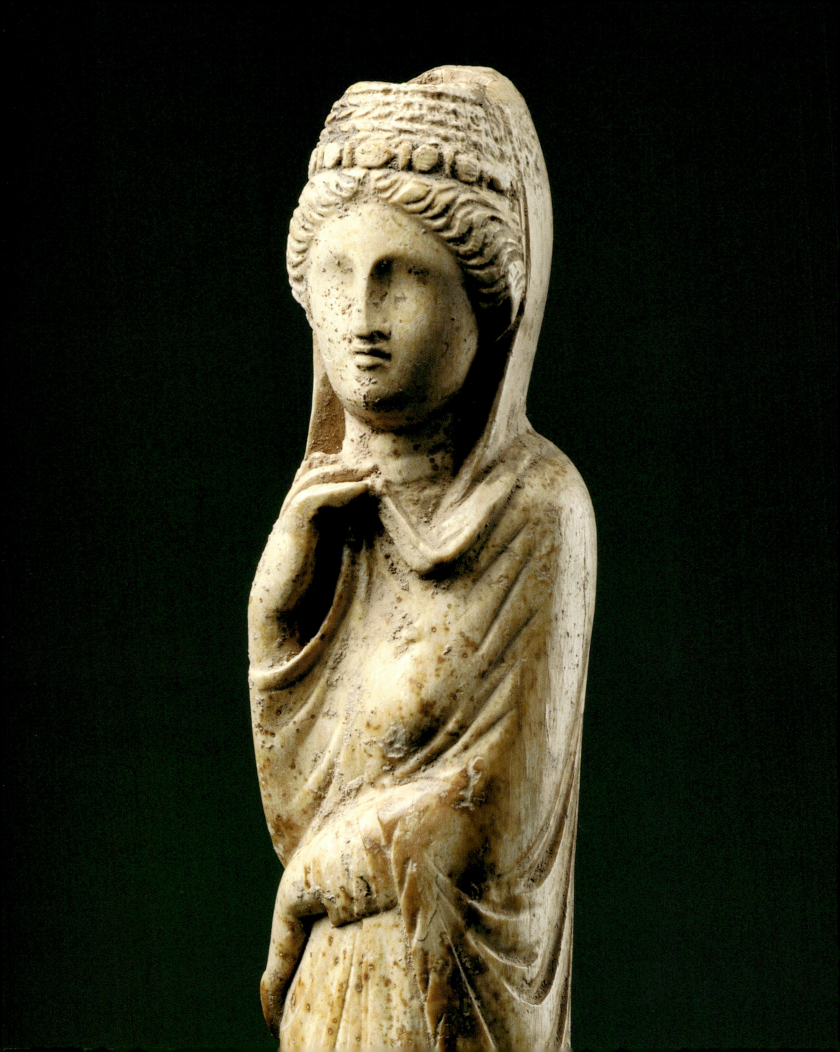

# ELITE WOMEN

ELIZABETH A.
GITTINGS

## Dignity, Power, and Piety

Women from imperial and aristocratic families had great influence in Byzantine society. In exceptional cases, such as that of the mid-eleventh-century empress Theodora, they ruled as autocrats, with little obeisance to male authority. Empresses were promoted in official art and ceremony as paradigms of virtue and emblems of the state. Elite women in general were among the greatest patrons, endowing charitable institutions, churches, relics, and icons. Admired and criticized, they had a liminal relationship to official power, sometimes in conflict with the patriarchal protocols of the court, the church, and the military.

The lack of a hereditary aristocracy in the early empire meant that elite women initially came from diverse social backgrounds, some humble and disreputable. Helena (cat. 16) was a *stabularia*, or tavern waitress, a position that often involved sexual servitude, before becoming the concubine of Constantine's father, the Roman emperor Constantius Chlorus (r. 293–306).[1] The learned Eudokia (cat. 32), wife of Theodosios II, was the daughter of a pagan philosopher from Athens, yet rose to dominate the imperial court in the 420s and 430s.[2] Theodora, wife of Justinian I (r. 527–65), was a former circus dancer and alleged prostitute.[3] Most empresses of the ninth to eleventh century, however, came from aristocratic Byzantine families with estates on the eastern frontier of the empire. A few were foreigners, such as the beautiful Maria of Alania (r. 1071–81; cats. 21, 44), daughter of King Bagrat IV of Georgia, one of the earliest of the diplomatic brides that were to become a common phenomenon from the thirteenth century onward in a reduced and increasingly fragmented empire.[4]

Most empresses came to the throne as teenage brides. Although the precise circumstances of accession are often unknown, one official method of selection was the "bride show," recorded through the late ninth century. The mother of a young emperor usually arranged the event, screening girls brought to the capital from around the empire. Noble birth, beauty, and moral character were prerequisites.[5] From the rural province of Paphlagonia, bordering the Black Sea, the iconophile Theodora (cats. 35–37) was selected in 829 as a wife for Theophilos in a bride show, primarily on the basis of her virtue. The experience of the ninth-century empress Theophano (cat. 172), who was examined in the bath, suggests that soundness of body and perhaps virginity were also determinants. Though they evoked the mythological Judgment of Paris (cat. 148), bride shows were probably political expedients, attracting the loyalty of ambitious provincial families and enabling imperial matriarchs to control access to their sons and cultivate the future favor of their daughters-in-law.[6]

Coronation was necessary before marriage, to validate an empress's accession to power. The earliest surviving description of the coronation of an *augusta*, a woman holding the official rank of principal empress, is probably based on that of Irene (cats. 18, 19), wife of Leo IV, which took place on December 17, 768.[7] The ceremony was held in the

Augusteos, the main reception hall in the oldest part of the Great (Imperial) Palace in Constantinople (see map, inside back cover).[8] There the co-emperors invested her with the primary insignia of office: the *chlamys,* or imperial cloak, and the crown, to which they attached *pendilia,* the long strings of pearls first depicted on coins of the fifth-century empress Licinia Eudoxia.[9] Afterward, the new empress was accompanied by the women of the court to the adjacent portico, named "The Golden Hand" for its sculpture of a blessing or crowning hand, possibly the hand represented on coins of the Theodosian empresses and their successors (cats. 29–32) to signify their investiture.[10] Finally, as the new empress stood on the terrace of the Tribune, she was acclaimed by representatives of the populace—factions of racing fans who staged the games in the Hippodrome.[11]

The extent to which the office of empress allowed participation in the business of state is a matter of debate. Although empresses were unique among women in being above the law, they did not all have equal opportunity, political aptitude, or status; elevation to *augusta* was at the discretion of the senior emperor.[12] It is clear, however, that Byzantines regarded female rule as an aberration, a "twisting [of] the thread of the purple robe." Because of this bias, elite women often wielded power through their male relatives. Even the few women who ruled alone and as regents, with absolute authority, were initially validated in relation to male rulers: Theodora's identity (cats. 20, 40) as the last member of the Macedonian dynasty founded by Basil I was sufficient to establish her alone on the throne in 1055. Irene, after the death of her husband, Leo IV, ruled as regent for their minor son, Constantine VI. When he reached adulthood, she blinded him to gain sole rule (797–802). Both Theodora and Irene appropriated the male positions and titles of *autokrator* (supreme ruler) and *basileus* (emperor).[13]

In rare cases, co-reigning empresses, and especially regents, took full control of the state: the fifth-century Pulcheria (cats. 7, 30), older sister of Theodosios II, and the sixth-century Sophia (cats. 15, 34), wife of Justin II, dominated these reigning emperors, who were incapacitated or simply weaker. The eleventh-century *augusta* and regent Eudokia Makrembolitissa (cats. 41–43) is the unique example of an empress who, because of her outstanding political abilities and the support of an extended and well-placed aristocratic family (Doukas), eclipsed two adult emperors with whom she ruled: her son Michael VII and her second husband, the general Romanos Diogenes.[14] Dowager empresses also had substantial authority. Anna Dalassene, mother of the emperor Alexios I Komnenos (r. 1081–1118), was entrusted with the regency by imperial edict and ruled for long periods while her son was out of the capital on military campaigns. As Alexios' daughter, Anna Komnene, put it: "He was in theory the emperor, but she had real power."[15]

Imperial women in more unconventional positions could also rise to power. Among them were mistresses, such as the striking Eudokia Ingerina (cat. 38), a lady at the court then dominated by the iconophile Theodora in the mid-ninth century. Eudokia was simultaneously the consort of two co-emperors, Michael III and the parvenu Basil I, and was crowned empress by Basil after he usurped the throne in 867. Skleraina, mistress of Constantine IX Monomachos (cat. 60), was introduced openly into the palace, and the empress Zoe, his wife and the imperial heiress through whom he had gained the throne,

Fig. 9. The widow Danielis
travels in a litter to meet the
emperor Basil I. Chronicle
of John Skylitzes, Siculo-
Byzantine, 12th century.
Biblioteca Nacional, Madrid,
Vit. 26-A, 102 Ra.

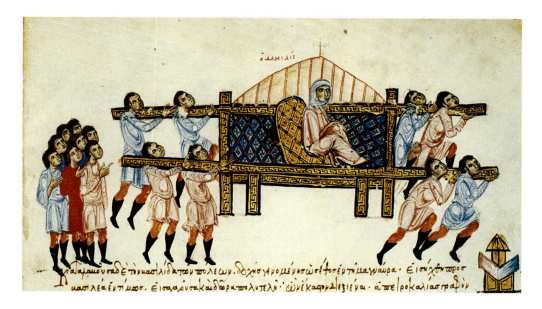

was forced to recognize her before the Senate as *sebaste*, a new title indicating kinship to
the empress or emperor.[16] Surprisingly, tenure as an empress was not always contingent
on bearing heirs. For example, the sixth-century Theodora; her successor, Sophia; and
the ninth-century Theophano (cat. 172) were not repudiated for failing to produce male
offspring, and the fifth-century Pulcheria used her virginity to legitimize her authority at
her brother's court by suggesting her similarity to the Mother of God.[17]

In addition to family relationships, wealth empowered elite women. Rich widows in
control of large fortunes could alter the political landscape. The ninth-century widow
Danielis from Patras, who owned a large part of the Peloponnesos, was the chief financial
sponsor of Basil I (cat. 38), bankrolling his meteoric rise from imperial horse trainer to
emperor. Danielis also gave Basil a spectacular gift of one hundred eunuchs, prized as
imperial servants, suggesting that her own estate was of a luxury and complexity approach-
ing the imperial standard.[18] She is depicted in a twelfth-century miniature, modestly veiled
and borne toward Basil in a litter (fig. 9). Many aristocratic widows had substantial cash
and assets, including land and shares in shops, and they frequently served as moneylend-
ers.[19] Dowager empresses had both vast personal holdings and access to state funds.
Constantine's biographer Eusebios notes that Helena had "authority over the imperial
treasury," and she personally owned a palace and baths in Rome.[20]

The depiction of imperial women on coins and in statuary and other official art
played a key role in promoting their authority. Large-scale portrait statues of empresses
were widespread in the early empire, erected by both state and local officials. They are
known from fragments such as heads (cats. 24–27) and inscribed bases, as well as epi-
grams and descriptions in later sources.[21] In the capital alone, more than thirty such stat-
ues are recorded in the early eighth century.[22] Alone and in dynastic groupings, they stood
high on columns, gates, and rooftops in the most prominent locations in the city.[23] The
prime venue was the Augustaion, a large plaza named after Constantine's mother, the
*augusta* Helena, whose statue had been erected by her son on a low porphyry column there.
Located between the Great Palace and the Hagia Sophia, the cathedral of the city, the

square contained numerous statues of emperors and empresses. Throughout the city exalted female figures, made of ivory, porphyry, bronze, and silver, rich materials that clearly marked the subjects as women of power, formed part of the fabric and idea of the ruling capital, creating an illustrious collective identity.[24]

The importance and the popular appeal of such empress statues are illustrated by reactions to the famous silver effigy of the fifth-century empress Eudoxia (cat. 29), which stood on a porphyry column in the Augustaion. Erected by the city prefect, it commemorated Eudoxia's acclamation as *augusta* and was dedicated "with applause and popular spectacles of dances and mimes, as was then customary on the erection of the statues of the emperors," according to the historian Sozomenos.[25] As patriarch of Constantinople, John Chrysostom (398–404) disapproved of the noisy, pagan consecration, a response that angered Eudoxia and supposedly led to John's removal from the capital.[26] The destruction of a statue in Antioch of the fourth-century *augusta* Flacilla (cat. 26), torn down by a mob in a 387 protest against new imperial taxes, was punishable as treason. These incidents suggest that, like the images of emperors, statues of empresses were invested with the authority of state.[27]

The standard of modest dress evident in surviving statues of elite Byzantine women, such as the popular image of the virtuous empress in the guise of Chastity (cat. 28), departs from the conventions of late Roman private portraiture, in which women were sometimes depicted as goddesses such as Venus, wearing little or no clothing.[28] The writings of the Church fathers and ascetics called for women to be modest in accordance with their supposedly inferior moral status (cat. 69).[29] For some elite women, such as the Roman aristocrat who became Saint Melania the Younger after giving her vast fortune to charity and living in poverty, modesty was not only a virtue but afforded a certain freedom, since it entailed a voluntary sacrifice of the trappings of high status.[30] Many elite women, however, delighted in luxurious display, wearing "long dresses bright with purple and rustling with gold," according to the fifth-century bishop Paulinus of Nola, who decried the practice. They also wore their hair uncovered and piled high, "structured and castellated with layers of ropes and interwoven locks" (see cats. 24–28).[31] Thus, while idealized images of modesty and chastity suggested the dignity, legitimacy, and goodness of women rulers, it is clear that their high status was also expressed through expensive attire and the freedom to wear and display it.

Many elite women had intellectual interests, and learning was promoted as a virtue of imperial women in official art and encomia.[32] Educated in all genres of literature, the empress Eudokia in 438 delivered an encomium of Antioch in ancient Greek verse before the Senate of the city, which honored her with gold and bronze statues.[33] Eudokia's poetic image of an ancient queen "sitting by the fireside with her attendant women, turning sea-purple yarn on a distaff" evokes the intimacy, splendor, and decorum of her own imperial court.[34] In her dynastic chronicle, the *Alexiad*, Anna Komnene's hauntingly beautiful image of her mother's hands as carved out of ivory conveys the grace and elegance of an empress with eloquence that speaks through the ages.[35]

But religious patronage was the greatest vocation of elite women. Among the earliest

converts to and patrons of Christianity were wealthy and aristocratic women, such as Thekla (cats. 67, 68) and Melania the Younger. Beginning in the fifth and sixth centuries, piety and philanthropy were increasingly promoted as virtues of imperial women, with Helena offered as the definitive role model. The first Christian empress and imperial patron, she was credited with the discovery of the True Cross during her pilgrimage to Jerusalem in 326, as well as the construction of the first church of the Ascension on the Mount of Olives and church of the Nativity in Bethlehem.[36] The empresses Pulcheria, Euphemia, Sophia, and Verina (cat. 33) were acclaimed as "New," "Second," or "Orthodox" Helenas.[37] Empresses publicly displayed their devotion through pious vows staged for maximum effect, the collection of holy relics, and the endowment of churches, ecclesiastical furnishings, and charitable institutions.

The piety and patronage of elite women were often linked to their dynastic ambitions. The powerful women of the Theodosian family, including Pulcheria (cats. 7, 30), Galla Placidia (cat. 31), and Anicia Juliana, commissioned sumptuous religious art to legitimize and advance their own political positions and those of their brothers, husbands, and sons. Before her subjects and the priesthood in 413, Pulcheria "devoted her virginity to God," as reported by a contemporary historian, and dedicated an altar with gold and precious stones in the Hagia Sophia, inscribing it "on behalf of her own virginity and her brother's [Theodosios II's] rule . . . so that they might be visible to all."[38] Two of Pulcheria's most important pious works were the construction of the church of Saint Stephen, the first Christian martyr, in the Great Palace and the translation of the holy relic of the saint's arm from Jerusalem.[39]

Some projects validated female dynasties over several generations. Daughter of the Western emperor Olybrios and last heiress of the Theodosian line, Anicia Juliana sponsored an ambitious church-building program in Constantinople with a strong dynastic emphasis.[40] An epigram carved in large letters around the nave and outside the narthex of her church of Saint Polyeuktos, built between 524 and 527 and decorated with variegated mosaics, marbles, gold, and mother-of-pearl, acclaimed her imperial pedigree and her role as the divinely ordained successor to her great-grandmother Eudokia (cat. 32), who had erected an earlier church on the same site. The epigram suggested that Juliana's work rivaled that of the greatest kings and emperors:

> What choir is sufficient to sing the work of Juliana, who, after Constantine, the adorner of his Rome, and after the holy golden light of Theodosios, and after so many royal ancestors, accomplished in a few years a work worthy of her family and more than worthy? She alone has conquered time and surpassed the wisdom of the renowned Solomon, raising a temple to receive God, whose glittering and richly wrought beauty even the ages cannot celebrate.[41]

The magnificent religious displays of female dynasts suggested that the imperial woman enjoyed a special relationship with God. Her pious works made her the mediator and revelation of God's favor toward her family and subjects.[42]

Some early imperial women displayed their power in association with their husbands, suggesting the partnership and mutual approval of emperor and empress before God.[43]

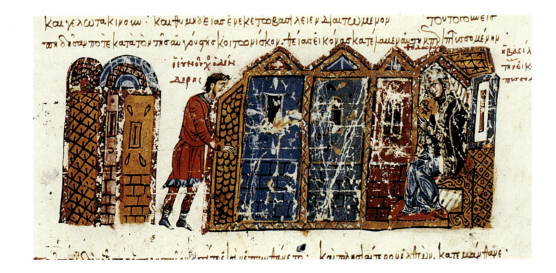

Although the sixth-century Theodora was criticized in her own time by the chronicler Prokopios for moral degeneracy, she was publicly promoted with Justinian in monuments in the Eastern and Western capitals. The two were depicted together in the center of the triumphal mosaics on the Chalke Gate, receiving homage from conquered kings; on the altar cloth of the Hagia Sophia, performing philanthropic acts; and in the famous mosaics flanking the apse in the church of San Vitale in Ravenna, bearing gifts of gold liturgical vessels.[44]

Charity was an official duty of empresses, who had special funds set aside for *solemnia,* or annual gifts to monasteries, and coinage struck for almsgiving (cat. 32).[45] Despite Theodora's early career as a circus performer and courtesan, she engaged in religious and philanthropic works as empress: she built churches in Antioch, hospices for the destitute, and a hotel for visitors in Constantinople, and, according to Paul Silentiarios, "sent to Jerusalem a very costly cross, set with pearls."[46] Her convent for penitent prostitutes in the capital and her possible influence on legislation against the entrapment of girls through illegal contracts suggest a real sympathy based on personal experience.[47] The patronage and public portraits of Justinian and Theodora united them in performance of the principal imperial virtue of piety, demonstrating their fitness to rule.[48]

The restoration of holy images by the empresses Irene and Theodora, in 787 and 843 respectively, is perhaps the greatest contribution of Byzantine women to ecclesiastical art. Both reversed the iconoclastic policies of their late husbands, Leo IV and Theophilos, apparently acting out of personal conviction. Irene venerated sacred images even during her marriage to Leo, who was reportedly horrified to find two icons in her possession and thereafter refused to have sexual relations with her.[49] The chronicler Skylitzes recounts how Theodora (fig. 10) used to send her five daughters to visit their grandmother, Theoktiste, who kept icons secretly hidden in a chest and brought them out to instruct her granddaughters in their proper veneration.[50] These empresses upheld the Orthodox faith in their own households and as the official religion of the empire, in opposition to powerful males in the family.

It has been argued that, because of their more secluded role in society and limited

opportunities in ecclesiastical life, women developed a closer relationship to icons.[51] This special association—the eleventh-century Zoe, for instance, was devoted to an icon of Christ that foretold the future through changes of color—is emphasized in numerous sources.[52] Many women are recorded as having icons, private chapels, and even large churches attached to their residences. Thekla (cats. 35, 36), the oldest daughter of the iconoclast Theophilos, built an exquisite little chapel dedicated to her patron saint next to her residence near the Blachernai church.[53] Elite women were also expected to care for the religious growth and maintenance of their children, providing them with icons, tutors, and spiritual mentors. Women's patronage of liturgical furnishings such as icons, crosses (cats. 48, 66, 67), and precious silver chalices (cats. 49, 50), often inscribed with their names, suggests that they sought greater access to divine liturgy through gifts.

The lifestyle of elite women was luxurious. Constantinople was replete with palaces, seasonal villas, and official residences belonging to imperial and aristocratic women. The most important was the *gynaikonites,* or women's quarters, of the Imperial Palace, apartments controlled by and adapted to the personalities of the women who lived there.[54] Far from being isolated, they were the locus of such diverse activities as palace conspiracies and assassinations as well as diplomatic receptions and religious observances. The women's chambers also included the *porphyra,* the birthing room, which was decorated entirely in purple, a color reserved for the imperial family: hence the title Porphyrogennetos (born-in-the-purple).[55] One of the separate women's palaces was that of the fourth-century Flacilla, wife of Theodosios I, which included a wardrobe of imperial insignia and a silver dinner service appropriate for an imperial reception, suggesting that some residences were self-sufficient satellite courts.[56] Within these residences, personal styles differed. The eleventh-century empress Zoe kept supplies of gold and exotic herbs to distribute to her acquaintances, while her sister, Theodora, was criticized for her parsimony.[57]

Ex-empresses were granted an imperial standard of retirement, receiving income from property as well as pensions and silk vestments appropriate to their rank.[58] In the middle and late Byzantine period, they increasingly patronized monastic churches, often retiring, by choice or under duress, from the court into the convent. The last official act of the empress Anna of Savoy (cat. 45), mother of John V Palaiologos, was a donation to the convent of the Anargyroi in Thessaloniki around 1360. She retired into a convent, taking the pious name Anastasia.[59] Like Anna, many who sought monastic life were widows probably seeking a refuge. Their motivations were dynastic as well as spiritual: the foundation of splendid churches and of communities where the empresses and their relatives could be received and eventually buried guaranteed all of them a glorious and perpetual appeal for their salvation.[60]

1. According to Ambrose, bishop of Milan, writing about a hundred years after Helena's death (Drijvers 1992, 15–16, n. 37); perhaps for this reason Constantine issued a law in 326 exempting tavern waitresses and their slaves from prosecution for adultery.

2. Holum 1982, 112–13.

3. Procopius 1981, 82–86 (9.1–9.27). Theodora was first Justinian's mistress; he later promoted her to patrician rank (ibid., 86).

4. There were long-standing diplomatic ties and marriages between the Georgian and Byzantine courts (Garland 1999, 180, n. 3). On the rise of the landed Byzantine families of Anatolia and the Eastern empire, see Angold 1984, 2–4.

5. Treadgold 1979, 409–10; Theodora was selected in 829 by the empress Euphrosyne as a bride for her stepson Theophilos. She chose Eudokia Dekapolitissa as a wife for her own son, Michael III, in 855 (Herrin 2001, 132–38; Garland 1999, 110). Beauty was a decisive factor in the selection of Eudokia by Pulcheria as a wife for her younger brother, Theodosios II, in 421; Theophano by the emperor Nikephoros I as wife for his son, Staurakios, in 807; Maria of Amnia by the empress Irene as a wife for her son, Constantine VI, in 788; and Theophano by the empress Eudokia Ingerina as a wife for her son, Leo VI, in 882 (Holum 1982, 112–13; Herrin 2001, 132–38, 170–73; James 2001, 53).

6. On Theophano's ordeal, see Treadgold 1979, 407–8; in some accounts, the bride is presented with an apple by her future husband, evoking the mythological Judgment of Paris. Because of such rhetorical elements, the historicity of bride shows has been challenged. See Vinson 1999, 31–60; James 2001, 53, n. 28.

7. James 2001, 52, nn. 20–22.

8. Constantine VII 1967, vol. 1, 26–27.

9. Herrin 2001, 60–61. *Pendilia* first appear on coins in the facing portraits of the *augusta* Licinia Eudoxia, daughter of Eudokia and wife of Valentinian III, emperor in the West (Grierson and Mays 1992, cat. 870. pl. 34). The *chlamys* is depicted on coins of all the Theodosian dynasty empresses.

10. On the Golden Hand and its possible representation on the empress coins, see Kalavrezou 1997a, 63–64.

11. One of the acclamations was: "He who has crowned you, Irene, by his own hand, keep you in purple for many years, for the glory and exaltation of the Romans" (Herrin 2001, 61–62, n. 16, citing Constantine VII Porphyrogennetos). The marriage followed in the nearby palace church of Saint Stephen, where the imperial couple received their *stephanoi*, or wedding crowns, from the patriarch, exchanged rings, and joined hands (ibid., 62, n. 17).

12. For the status of early empresses, see James 2001, 119–25. On the meaning of *augusta* and other female imperial titles, see Bensammar 1976, 243–91.

13. Herrin 2001, 100–101; on the "purple robe," see Talbot 2001b, ch. 1, 142, quoting the fifteenth-century Doukas.

14. Before his death, her first husband, Constantine X Doukas, appointed her regent for their three sons, although the oldest, Michael VII, was already an adult (Garland 1999, 169–71). On Eudokia's unusual power as ruler and the iconography of her reign, see Kalavrezou-Maxeiner 1977, 306–25.

15. Comnena 1969, 120 (3.7); Bensammar 1976, 270.

16. Psellus 1966, 180–85 (6.56–62).

17. James 2001, 59–82; Holum 1982, 145.

18. Tougher 1997, 168.

19. Laiou 2001, 269–70.

20. Brubaker 1997, 57.

21. The known civic dedications to empresses include two statue bases for sculptures of Flacilla, in Aphrodisias and Ephesus; a gold and a bronze statue of Eudokia in Antioch; and, in Constantinople, a bronze statue of Theodora, wife of Justinian, on a purple column in the court of the Arcadianae bath, statues of Sophia at the Baths of Zeuxippos and the Praetorium, and a silver statue of Eudoxia in the Augustaion (James 2001, 42–43).

22. Probably a fraction of what existed before large-scale public statuary was obsolete; the *Parastaseis*, an early-eighth-century description of the monuments of Constantinople, mentions 427 statues removed by Justinian I from the area of the Hagia Sophia and dispersed around the city (Cameron and Herrin et al. 1984, 48, 70–73).

23. Dynastic groupings were common, including Constantine and Helena with crosses, and empresses with their female relatives: Arcadia and Ariadne, wives of the emperor Zeno; Eudoxia with her daughters; and Sophia with her daughter Arabia and niece Helena (Cameron and Herrin et al. 1984, 48–51; Herrin 2000, 7).

24. The chronicler Prokopios mentions their highly polished surface. See Procopius 1971, 89–90 (1.11.6–10); on the Augustaion, see Cameron and Herrin et al. 1984, 262–63.

25. Herrin 2000, 7 and n. 11

26. Cameron and Herrin et al. 1984, 206–7.

27. James 2001, 41–42.

28. D'Ambra 1993b, 100–14. Chastity was traditionally associated with the moral matron and her demure occupation of weaving. Livia, the first Roman empress, was associated with chastity as an ideal wife and inspirational model for her subjects (ibid., 36). The fourth-century emperor Julian the Apostate compares the empress Eusebia, wife of Constantius II, to the personification of Chastity in an encomium: "Now when I first came into her presence, it seemed to me as though I beheld a statue of Chastity set up in some temple . . . so gentle and comforting was her utterance" (Julian 1962, 327).

29. Hill 1997, 77.

30. Gerontius 1984.

31. Paulinus 1975, 247–48 (poem 25.69–91).

32. Eusebia, wife of Constantius II, "honored the name of philosophy," according to the emperor Julian, and gave him "the best books on philosophy and history and many of the orators and poets" (Julian 1962, vol. 1, 319, 329). The empress Sophia, whose name means "wisdom," was called "energetic wisdom" and praised for her "calm judgment" (Corippus 1976, 85, 93 [preface, 20, and 1.290]).

33. Holum 1982, 115–17.

34. "Sea-purple" refers to the porphyry or purple dye made from the murex mollusk, one of the most expensive pigments on earth. The color it produced was reserved for the use of the imperial family in Byzantium (Holum 1982, 220, n. 12).

35. Comnena 1969, 110–11 (3.3–4).

36. Brubaker 1997, 58; Theophanes 1997, 42 (AM 5817, 27)

37. James 2001, 14.

38. Pulcheria also imposed a pledge of virginity on her younger sisters Arcadia and Marina to prevent them from marrying: "to avoid bringing another male into the palace and to remove any opportunity for the plots of ambitious men" (Holum 1982, 93, citing Sozomenos).

39. Holum 1982, 103, n. 111, citing the ninth-century chronicler Theophanes Confessor; Kalavrezou 1997a, 57–59.

40. Anicia Juliana was the great-granddaughter of Theodosios II and Eudokia, daughter of the Western emperor Olybrios, wife of the general Areobindos, and mother of the consul Olybrios.

41. Patton 1916, vol. 1, 8–11, (epigram 10).

42. James 2001, 43.

43. Ibid.

44. Mango 1986, 89, excerpting Paul Silentiarios, and 109–10, excerpting Prokopios. On Theodora's moral corruption, see Prokopios' *Secret History* 9.1–9.27.

45. Herrin 2001, 163.

46. James 2001, 43, n. 60, citing Paul Silentiarios; Garland 1999, 20–21, nn. 61, 62, 66, citing Malalas and Prokopios.

47. Garland 1999, 18.

48. James 2001, 43.

49. Talbot 2001b, ch. 6, 4.

50. Ibid., 4–5, n. 10.

51. Ibid., 5. Women could participate only in the lay parts of the liturgy in the Orthodox Church: the responses, the creed, and certain chants and prayers. As is the case today, they were forbidden access to the sanctuary (James 2001, 39).

52. Herrin 2001, 166–67. On Zoe's devotion to the icon, see Psellus 1966, 188 (6.66–67).

53. Herrin 2001, 229.

54. For example, Anna Dalassene transformed the *gynaikonites* into a kind of religious haven (Comnena 1969, 120–21 [3.7–8]). On the freedom of women at home, see Kazhdan 1998, 1–17.

55. Herrin 2001, 65. According to the chronicler Theophanes, it is named after the purple cloth distributed there by empresses to noblewomen on the winter solstice festival of Brumalia (Mango 1986, 165).

56. Magdalino 2001, 56, 67–68.

57. Psellus 1966, 185–86 (6.61–63).

58. Herrin 2001, 175.

59. Nicol 1994, 93–95.

60. The associated charitable institutions, such as hospitals, homes for the elderly, and food distribution centers, added to the general welfare (Talbot 2001a, 341).

## 24 Portrait Head, Perhaps of Fausta or Helena

Rome (?), late Roman or Byzantine,
1st quarter 4th century
Marble
H. 27.5 cm
Museum of Fine Arts, Boston, William E.
Nickerson Fund, 62.662

COLLECTION HISTORY Purchased Sept. 19,
1962, from Robert E. Hecht, Jr.; said to come
from Rome.

PUBLISHED Vermeule 1964, 339–40, pl. 106,
fig. 34; von Sydow 1969, 7, n. 19; *Art of the Late
Antique* 1968, cat. 15; *Ancient Portraits* 1970, cat.
24; Vermeule and Comstock 1972, cat. 83;
*Romans and Barbarians* 1976, 109–10, cat. 117;
Comstock and Vermeule 1976, 242–43, cat.
380; Bergmann 1977, 190–92, 196–97, pls. 55.1,
56.1; *Age of Spirituality* 1979, 21, cat. 14; Yegül
1981, 63–65, fig. 6; Vermeule and Comstock
1988, 116, cat. 380; Mandel 1988, 25, n. 173;
Hannestad 1994, 94, n. 133.

This life-size head of a woman with a pensive expression and elaborate hairstyle has been interpreted as a portrait of the empress Fausta, wife of the first Byzantine emperor, Constantine (r. 324–37), or of his mother, Helena.[1] Broken off at the neck, it probably belonged to a bust or full-length figure. The nose, chin, and edges of the hair are damaged. The surfaces of the stone have a light yellow or grayish brown patina.[2] The tight, deeply drilled arc of ringlets over the forehead and isolated, asymmetrical wrinkles between the eyebrows indicate a date soon after the Tetrarchic period (293–305).[3]

The aloofness and the hairstyle suggest the prerogative, resources, and high status of an imperial woman. The woman's hair is drawn back and interwoven with false locks in a net rendered through crosshatching; the luxury of artificial hair indicates her wealth and privilege.[4] The hairpiece is folded over the top of the head to form a broad roll—the *Scheitelzopf* style worn by empresses of the late third and early fourth centuries.[5] The semicircle of curls framing the face, reminiscent of portraiture of the Flavian dynasty (69–96 A.D.), may be a conscious reference to these Roman imperial ancestors of Constantine.[6] Helena (cat. 16a) and Fausta (cat. 17a) both add the name Flavia to their coin inscriptions, reinforcing their dynastic right to rule.

Helena wears the *Scheitelzopf* hairstyle on coins struck to commemorate her elevation to *augusta*, principal empress, in 324, when she was probably in her seventies.[7] However, she is most often depicted with a hairband or diadem, and her features are much sharper than those of this head, with its softly modeled flesh.[8] The square jaw, full cheeks, and small mouth with powerfully molded upper lip recall portraits of Fausta, whose age would suit this head. She was approaching her mid-thirties when she, too, was promoted to *augusta* in 324; she was put to death for treason and an alleged affair with her stepson, Crispus, in 326.[9] The youthful appearance may be a stylistic choice, alternatively, reflecting the increasing preference for more idealized and abstract forms in early-fourth-century portraiture.

The features suggest that the personal character of the subject has been subordinated to emphasize dynastic resemblance. The winglike, knitted eyebrows with distinct hairs and the large, heavy-lidded eyes with an upward, contemplative gaze, incised irises, and drilled, crescent-shaped pupils are also found in numerous portraits of members of Constantine's family.[10] Several comparisons for this head are known: an example in the Palazzo dei Conservatori in Rome, not as finely carved, but with a similar hairstyle and physiognomy, has been identified by several scholars as a portrait of the same woman.[11] Dated around 290, a second head with a similar hairstyle, gaze, and lips exists in the Schloss Fasanerie in Fulda.[12] The possibility of multiple copies suggests that this head was commissioned as an official portrait.[13]   EG

1. Helena or Fausta: Vermeule 1964b, 339; Comstock and Vermeule 1976, 243, cat. 380. Helena: von Sydow 1969, 7, n. 19; *Ancient Portraits* 1970, cat. 24. Fausta: *Age of Spirituality* 1979, 21, cat. 14; *Romans and Barbarians* 1976, 109–10, cat. 117.

2. The marble is from quarries near Luna, Italy (Carrara).

3. Von Sydow 1969, 7, n. 19, suggests a date around 300. For a Tetrarchic head with ringlets done in a similar technique, see *Spätantike und Frühes Christentum* 1983, 413–14, cat. 31. Similar expression lines are also found in Manner portraits of the last quarter of the third century (Bergmann 1977, 187, pl. 53, figs. 1, 5).

4. Fejfer 1999, 146.

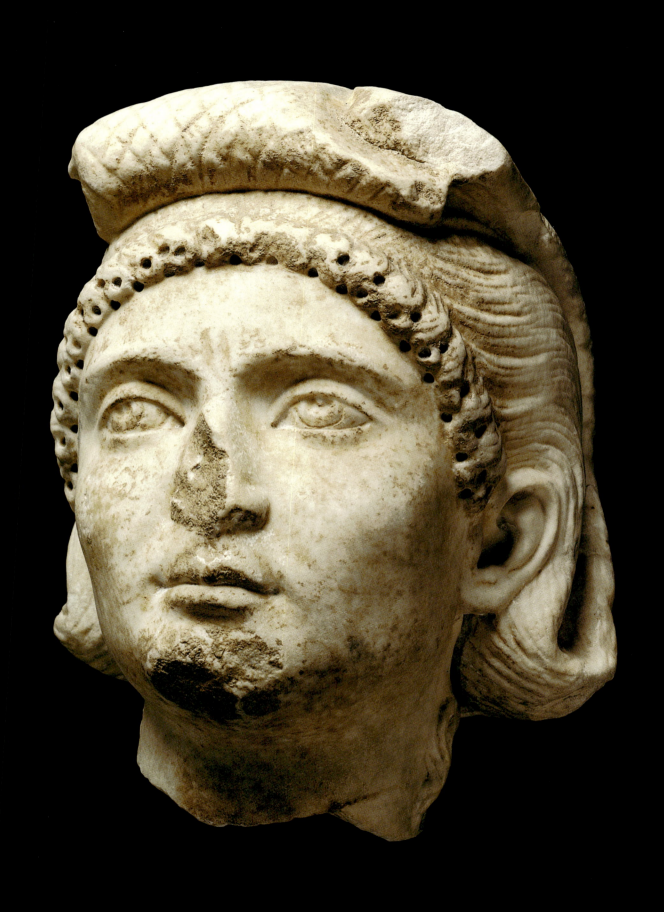

5. As on coin portraits of the Roman empresses Ulpia Severina, Magnia Ulpia, and Galeria Valeria (Bergmann 1977, 180).

6. *Ancient Portraits* 1970, cat. 24, citing Vermeule.

7. Bensammar 1976, 271.

8. For Helena's sharp features, see her statue in the Capitoline Museum (Fittschen and Zanker 1983, 35–36, cat. 38, pls. 47, 48). For folles with portraits of Helena and Fausta, see *RIC*, vol. 7, 384–85, cat. 191, and 446–47, cat. 187.

9. Compare Calza 1972, pl. 86, figs. 301–4; pl. 88, figs. 311–12.

10. For dynastic comparisons, see Delbrueck 1933, 112–13, 121–22, 125, 166–67, pls. 28, 29, 37–39, 61, 66, 67; Bergmann 1977, pls. 55.5, 56.5, 60.5, 60.6; De Kersauson 1996, vol. 2, 524–25, cat. 250.

11. Vermeule 1964b, 339, and Bergmann 1977, 192, n. 780.

12. Von Heintze 1968, 79–80, cat. 53, pls. 88, 89, 135, 136.

13. Fejfer 1999, 138.

## 25 Portrait Head of a Young Woman

Byzantine, Constantinian, after 320
Pentelic marble
H. 27.3 cm, w. 21.6 cm, d. 15.2 cm
The Nelson-Atkins Museum of Art, Kansas City, Missouri (Purchase: Nelson Trust) 34-200

COLLECTION HISTORY Purchased by Harold Parsons, agent for the Nelson-Atkins Museum, from the dealer Zoumboulakis of Athens.

PUBLISHED Vermeule 1964, 105, 131, fig. 35; Vermeule 1974b, 318–19, fig. 10; Vermeule 1981, 374, cat. 324.

Carved from white marble with some streaking on the sides, this life-size portrait head of a young woman is conceived in the round, with the back of her elaborate, braided hairstyle carefully rendered. Broken off at the base of the neck, the head was probably originally attached to a bust or full-length figure. It has been dated alternatively to the Constantinian period (324–63) or the Antonine (138–92).[1] The large eyes with their remote expression, the stiff features, and the aquiline nose, recalling the profile of the empress Fausta on coins of circa 320–26 (cat. 17a), suggest that the subject is a woman of Constantine's family. Because of its youthful appearance, the head has been proposed as a portrait of a daughter of Constantine and Fausta, perhaps Helena the Younger, who would have been an adolescent in the 320s.[2]

The head is slightly angled. The heavy-lidded eyes, incised irises, crescent-shaped pupils, and winglike, almost joined brows with hairs clearly articulated are among the features shared by numerous sculpted images of members of Constantine's house.[3] With their physiognomic resemblance, real or contrived, such portraits played a key role in transmitting a message of dynastic unity and stability in early Byzantine cities. Perhaps this head belonged to a statue in one of the many Constantinian family groups.[4] Single honorific busts of early Byzantine empresses are also recorded in official decoration, for example in the Senate House of the capital.[5]

The tightly wrapped tower hairstyle is retrospective. Popularized by the Roman empress Faustina the Elder (r. 138–41), wife of Antoninus Pius, it was revived by the women of Constantine's family, with variations appearing in a number of life-size portrait heads and other sculptures of the period (cat. 28).[6] The hair is parted in the middle, flowing back in waves partially covering the ears. The small, high, oval nest is built up from thick plaits secured in the back by a vertical braid. Two twisted strands meet behind the head to stabilize the base of the nest.[7] Like the sensitive modeling of the face, the hairstyle perhaps represents an early phase of Constantinian classicism, increasingly evident in the time of the sons of Constantine, when models were sought in the refined style of the Antonines.[8]

Although the braid nest is much flatter, a Louvre head identified as Fausta (dated 307–26) has features close enough to those of this head to be a juvenile portrait of the same woman.[9] In both cases, the exaggeration of the ocular zone, with its enlarged eyes

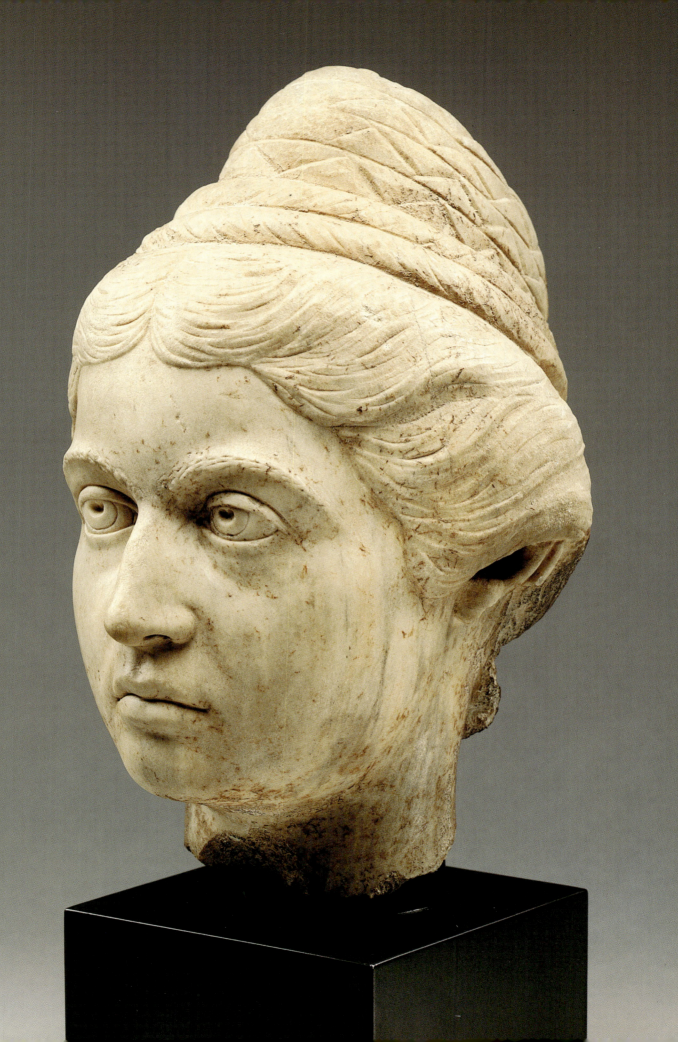

and especially the thick brows, distinguishes the heads from Antonine portraits with similar hairstyles. The back of the hair also differs in the fourth-century portraits, with the vertical braid beginning lower, at the base of the head.[10]

Perhaps the women of Constantine's family were portrayed with this towering hairstyle to signify their superior morality and status by alluding visually to the deified Faustina the Elder, memorialized in official propaganda as an ideal imperial wife, mother, and goddess.[11] Elite naming practices in the early Byzantine Empire followed a similar pattern, using a "status nomen" to imply eminence and honor by association.[12] It is tempting to interpret Fausta's appropriation of imperial Antonine hairstyles—the braid nest as well as the loose chignon she wears in coin portraits (cat. 17a)—as complementing her onomastic connection with Faustina the Elder and Younger.[13]  EG

1. Vermeule 1964a, 105; Vermeule 1974, 318, cat. 10; Vermeule 1981, 374, cat. 324.

2. Vermeule 1974, 318, cat. 10; Vermeule 1981, 374, cat. 324.

3. For dynastic comparisons, see Delbrueck 1933, 112–13, 121–22, 125, 166–67, pls. 28, 29, 37–39, 61, 66, 67; Bergmann 1977, pls. 55.5, 56.5, 60.5, 60.6; De Kersauson 1996, vol. 2, 524–25, cat. 250.

4. Twelve Constantinian family groups are recorded in Constantinople in the early eighth century (Cameron and Herrin et al. 1984, 48–51).

5. James 2001, 42.

6. The style originated in the last years of the empress Sabina (r. 117–136/7) and was copied in numerous portraits of Antonine women. For heads of the Constantinian period with the style, see Vermeule 1981, 374, cat. 324 (a daughter of Fausta and Constantine); *Romans and Barbarians* 1976, 110, cat. 118 (Constantia, half-sister of Constantine); De Kersauson 1996, vol. 2, 524–25, cat. 250, and Bergmann 1977, 197–99, pl. 61, nos. 1, 2 (the youthful Fausta). Vermeule 1981, 374, also mentions a replica of cat. 25 on the London art market in 1973.

7. For a close parallel to the coiffure in an Antonine head at the Capitoline Museum, see Fittschen and Zanker 1983, 77–78, cat. 102. The interpretation of the hairstyle as retrospective is controversial (St. Clair 1996, 151, n. 18).

8. For the classicizing style in the Metropolitan Museum head of the emperor Constans (r. 337–40), see Yegül 1981, 66.

9. De Kersauson 1996, vol. 2, 524–25, cat. 250 (Louvre no. 4881). For Fausta with a similar hairstyle on coinage, see Delbrueck 1933, 86, pl. 11, no. 1 (3).

10. The nest is lower, resembling a braided bun, cap, or turban, in most sculptures of the period. In the late fourth century, it widens and often flares out. See *Rom und Byzanz* 1998, 75–78, cat. 3; Von Heintze 1968, 84–85, cat. 56, pls. 94, 95; and Inan and Alföldi-Rosenbaum 1979, vol. 1, 309–10, cat. 306.

11. Bergmann and Watson 1999, 8. The tradition of adopting imperial hairstyles as emblems of morality dates back to Livia (d. 29 A.D.), Augustus' wife, considered "the living embodiment of the emperor's moral ethos" (*I, Claudia* 1996, 53, cat. 1).

12. Fausta and Helena use the family name Flavia in their coin inscriptions, emphasizing the imperial ancestry of the Constantinian house and its blood claim to the throne (Salway 1994, 137–40). Many Byzantine imperial women were named after predecessors, such as Helena or Eudokia, to whom they were related or with whom they wished to be associated. The acclamation "New Helena" follows a similar logic (James 2001, 14).

13. For portrait heads of Faustina the Younger with the chignon, De Kersauson 1996, vol. 2, 248–49, cat. 110; 254–55, cat. 113. For coins of Fausta with a similar hairstyle, Delbrueck 1933, 86–87, pl. 11, nos. 2, 4, 5; *RIC*, vol. 7, 384–85, cat. 191.

## 26 Portrait Head in the Type of Flacilla

Constantinople (?), Byzantine, c. 380–90
Marble
H. 27.2 cm (face 11.1 cm), w. 15.5 cm, d. 17 cm
The Metropolitan Museum of Art, Fletcher
Fund, 47.100.51

COLLECTION HISTORY Collections of Baron
Max von Heyl, Darmstadt; Dr. H. N.
Calmann (on loan to the Museum für Kunst
und Gewerbe, Hamburg, in the 1930s), and
Joseph Brummer, New York.

PUBLISHED Delbrueck 1933, 202–3, pls.
99–101; *Early Christian and Byzantine Art* 1947,
23, cat. 5, pl. 7; Harrison 1953, 70–71; Von
Sydow 1969, 93–95; Von Heintze 1971, group
III.4, 73–76; *Age of Spirituality* 1979, 290–91,
cat. 269.

Carved from fine-grained white marble, this slightly under life-size head represents a dig-
nified woman with delicate features. The rough tab below the neck was meant for inser-
tion into a bust or figure and would not have been visible. The area of exposed neck
is consistent with the collar of a tunic.[1] The flesh of the face and front of the neck is
smooth, finely modulated, and highly polished.[2] The back is duller, suggesting the sculp-
ture was intended for a niche or display against a wall.

The face is slender and ethereal. Beneath thin brows, the almond-shaped eyes gaze
ahead and slightly upward with a remote expression. The upper lid is heavy, the pupils
crescent shaped, and the irises convex, articulated with a wide groove. The inverted trian-
gular contour of the head and the proportions and form of the features, including the
rosebud mouth and the eyes and brows sloping down at the outer edges, are consistent
with the court style of the emperor Theodosios I (r. 379–95).[3] The reduced scale and
high finish are paralleled in a full-length statuette in Paris often identified as the empress
Aelia Flavia Flacilla, wife of Theodosios.[4] The delicate profile is reminiscent of coin like-
nesses of Flacilla and other Theodosian empresses (see cats. 7a, 29a, 30a, 32a), although
the broken nose weakens the comparison.[5] The portrait style, elaborate coiffure, and lack
of a diadem, featured in all known images of Flacilla, suggest that the head instead repre-
sents a contemporary woman of rank.

In contrast to the face, the turbanlike, "round plait" hairstyle is schematically ren-
dered with rough chisel work and a matte finish: a wide fringe of ribbed, grooved waves
frames the face, almost covering the ears, and is surmounted by a high, thick band com-
posed of two twisted strands of equal size wrapped around the top of the head. A flat,
vertical braid runs from the nape of the neck over the top of the head. Perhaps intro-
duced in portraits of Helena, the hairstyle is worn by numerous imperial women of the
fourth and fifth centuries, including Constantine's half-sister Constantia (d. c. 330) and
Flacilla, in sculptures and coins, as well as by the generic empresses in steelyard weights
(cat. 13).[6]

The rigid, complex coronet of hair, requiring the substantial labor of a hairdresser,
suggests the nobility and high status of the subject, as well as the formal context for
which her portrait was intended. Although Christian writers admonished Byzantine
women to be modest and cover their heads in public (cat. 69), elite women often wore
their hair piled high, visible under veils (cat. 28), or uncovered in ostentatious display.[7]
The hairstyle of this head was popular with women of the high senatorial aristocracy:
Serena, the adopted daughter of Theodosios I and wife of the consul Stilicho, wears it in
a diptych of 400, as does Projecta on the fourth-century silver Esquiline casket (fig. 20).[8]
The hairstyle was perceived as a signifier of luxury and seduction; in a wedding speech
in the early fifth century, Bishop Paulinus of Nola warns his son's daughter-in-law against
it as excessive and un-Christian: "You must not seek with foul purpose to delight even
your own husband by thus adding inches to your person."[9]

As a possible allusion to Flacilla, the hairstyle may also imply exceptional female
moral superiority in addition to high status and exclusivity. Praised as "an undefiled mon-
ument of chastity" and "harmonious mixture of all the virtues," the pious empress was a

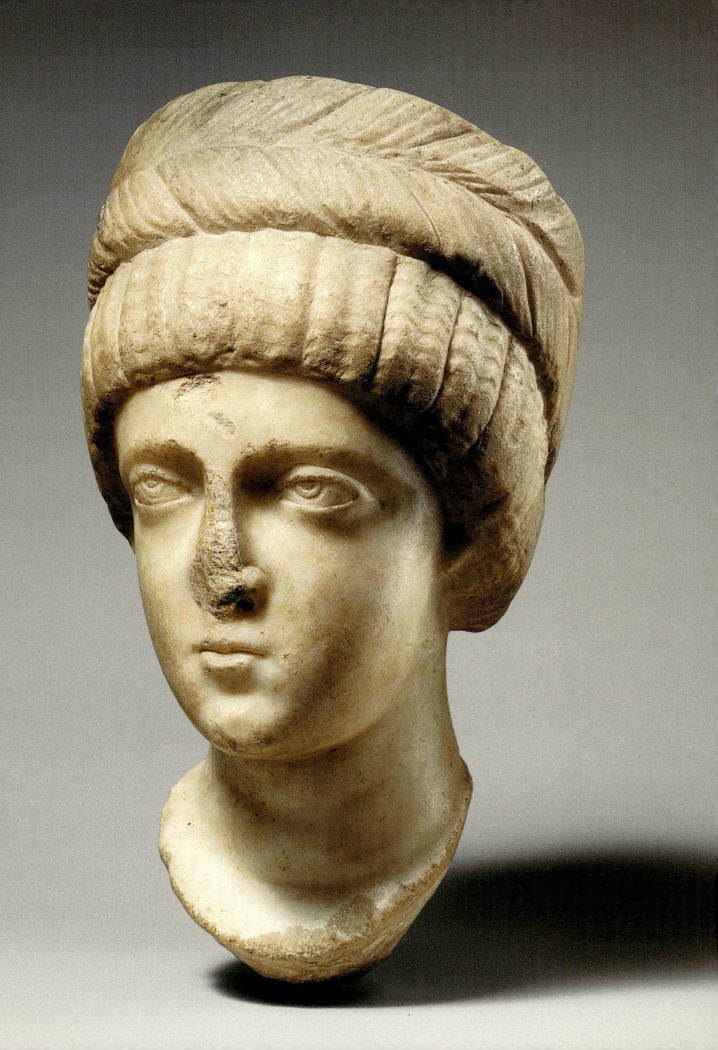

role model for elite women of her time.[10] Flacilla's coin portraits, the first to represent an empress wearing the imperial mantle and three-pendant *fibula*, insignia formerly reserved for the *augustus* (supreme ruler, masc.), were imitated by fifth-century empresses, who also adopted her family name, Aelia (cats. 29a–33a).[11] EG

1. Delbrueck 1933, 202.

2. The sixth-century historian Prokopios describes the brilliant, burnished surfaces of public sculptures in the capital; this head attests to a similar, earlier aesthetic (Procopius 1971, 88–89 [1.11.6–7]).

3. Kiilerich 1993, 19–29.

4. James 2001, 26–41.

5. Delbrueck 1933, 101, pl. 23.

6. Fittschen and Zanker 1983, vol. 3, 35–36, cat. 38, pls. 47, 48; Delbrueck 1933, 49–51, 86, 169–71, 173–74, figs. 19, 20, pls. 11, 23, 69, 70, 72.

7. Like Roman women (see Bartman 2001, 5), who were also criticized for wearing their hair loose in public, by early Church fathers such as Tertullian and Jerome (Clark 1993, 116). See the essay "Adorning the Body, Neglecting the Soul?" in this volume.

8. Delbrueck 1933, 50, 234–36, pl. 124.

9. Paulinus 1975, 248, 399–400, n. 1.

10. Holum 1982, 23, quoting Gregory, Bishop of Nyssa's 385 funeral oration on Flacilla.

11. Ibid., 34. The empress Galla Placidia (*augusta* 421–50) uses the name only on her Eastern coinage.

## 27 Head of a Female Figure, Possibly an Empress

Early Byzantine, c. 375–400
Marble
H. 27 cm
Arthur M. Sackler Museum, Harvard University, Gift of the Hagop Kevorkian Foundation in memory of Hagop Kevorkian, 1975.41.112

COLLECTION HISTORY Kevorkian collection.
PUBLISHED Vermeule and Brauer 1990, 158, cat. 146.

This head, traditionally dated to circa 325–425, has been associated with a group of six late antique marble portraits of imperial women (see cat. 25).[1] However, it displays a more marked resemblance to the face of a marble statuette in Paris identified as the empress Aelia Flacilla, wife of Theodosios the Great (r. 379–95).[2] In the fifth century, there was a resurgence in the production of female portraiture, both within and outside of imperial circles.[3] The proposed narrowing of the date of this piece to circa 375–400 places it on the cusp of this efflorescence (see also cat. 26).[4]

This head and the Paris statuette share not only the deep indentations over the eyes and tiny thin-lipped mouth, but also the rounded cheeks and jaw and the combination of upturned eyes and downward-sloping brow.[5] Cat. 27 is rendered more awkwardly, as is apparent from the back view—perhaps evidence that it was produced more quickly or displayed less prominently than the Paris statuette.

Despite the great similarity in style of the facial features of the two works, the current state of the hairstyle of cat. 27 is markedly different: the rough carving of the hair indicates extensive recutting, most notable over the forehead, but apparent throughout.[6] Indeed, the flattened, schematic nature of the hairstyle contrasts not only with the hair of the Paris statuette, which is raised higher off the forehead in a smooth mass crowned by a squarish topknot and diadem, but also with the soft rounding of cat. 27's own facial features. Here we find the greatest evidence for recutting, whether ancient or more recent. Rather than the shallowly carved fringe that now curls across the forehead, the geometrically scratched sausage-like plaits in the back, and the highly unusual headdress, the original coiffure of this head was more likely a raised cap of hair similar to that of the Paris statuette. Indeed, despite the reworking, some of the original shape is apparent in the high headdress and in the heavy twists of hair that fall down over the ears. Even the band, with its deep grooves and stylized back bow, betrays some of the original composition: it

26

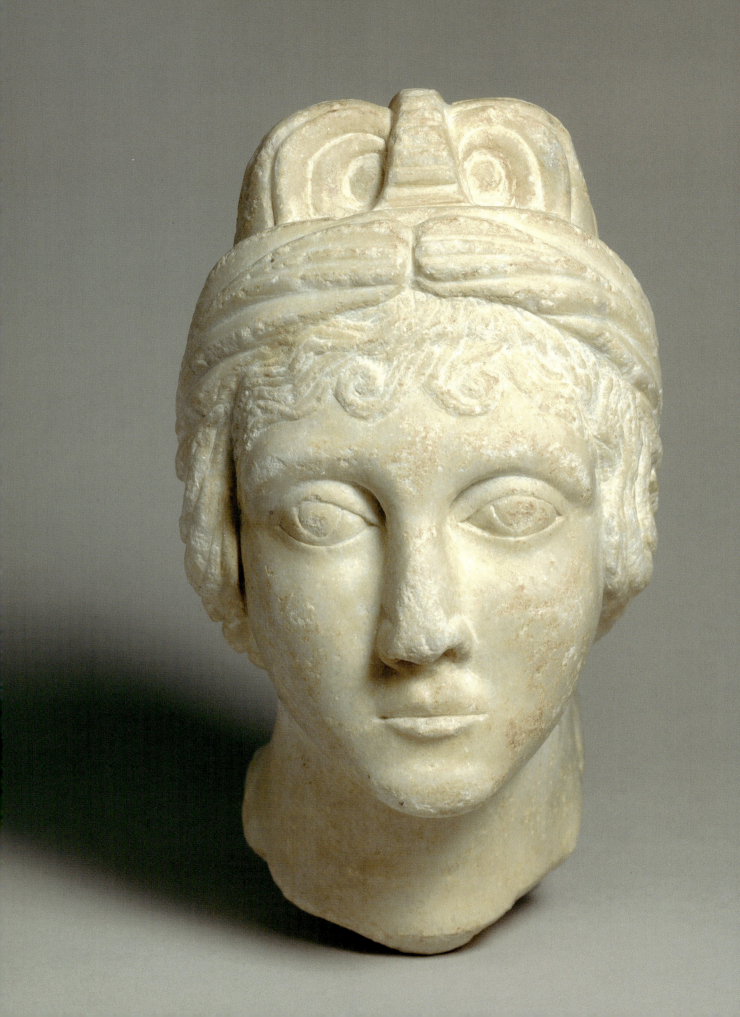

has a deep center part reminiscent of the Paris statuette's hair and once may have been the jeweled diadem that identified its wearer as someone of imperial importance (see cat. 28).[7]

Cat. 27 may indeed represent an empress; the slight upward gaze of her eyes speaks of power rather than the feminine modesty encouraged by Christian ideology, and the squared shape created by her hairstyle recalls that of the fifth-century bronze steelyard weight of an empress also in the Harvard University Art Museums collection (cat. 10). In any case, this portrait represents a young Byzantine woman of high rank, possibly an empress herself, or perhaps, as was common in Roman and Byzantine tradition, someone emphasizing her elite status by emulating the appearance of one (cat. 26).[8]  JLH

1. Including portraits in Boston (Comstock and Vermeule 1976, 122, cat. 188), the Hermitage (Vostchinina 1974, 192–93, cat. 79), Perge (Inan and Alföldi-Rosenbaum 1966, 198, cat. 273, pl. 150), Chicago (*Age of Spirituality* 1979, 289–90, cat. 268), Aphrodisias (Inan and Alföldi-Rosenbaum 1966, 179, cat. 241, pl. 133, figs. 3, 4), and Kansas City (Vermeule 1974b, 318–19, cat. 10, figs. 10, 10a). Most recently, the Chicago head has been dated to the time of Hadrian (r. 117–38) (*I, Claudia* 1996, 173, cat. 128) and to the second half of the fourth century (*Daily Life* 2002, 379–80, cat. 464; see St. Clair 1996, 150–51 for a discussion of the similarity between hairstyles of these two periods). The closest visual parallel to cat. 27 is the one in the Hermitage (which has a tentative imperial identification), but its presentation is much more angular. The growing interest in late antique portraiture calls for a reevaluation of the works in this group and their relationship to one another.

2. For the Paris statuette, see *Age of Spirituality* 1979, 26–27, cat. 20, pl. 1. Aelia Flacilla was inaugurated as *augusta* in 379 and died in 386; the Paris statuette is possibly posthumous, but unlikely to have been made before 379 (ibid., 27). Weitzmann dates the Paris statuette to 380–90; Roman portraiture has traditionally been dated very precisely, based on the emulation of imperial fashions (ibid., 26–27).

3. Ibid., 286.

4. Cat. 27 is carved in the round out of sand-colored marble. Broken off at the base of the neck, it was perhaps originally attached to a bust or a full-length figure. The neck was restored just under the chin; as a result, it does not line up evenly with the head. The resin used to piece the neck and head together is non-soluble, making re-repair difficult. The gap is filled with a dark-colored adhesive.

5. The roundness of the cheeks and jaw of cat. 27 may be an effort to capture the youth of the subject or a more specific reference to a Hellenistic portrait type revived in Constantinian art (St. Clair 1996, 151). The face shows abrasions, especially on the tip of the nose.

6. The recutting of the head (and particularly the hair) is borne out by the appearance of fluorescence under UV light (Harvard University Art Museums conservation file, 1975.41.112).

7. Only female members of the imperial family who had been granted the title of *augusta* were allowed to wear the diadem. Constantine started this tradition, which began to appear in imagery about 324 (St. Clair 1996, 151).

8. In Byzantium as well as in ancient Rome, portraits of private individuals, women as well as men, tended to emulate those of imperial rank, which makes identification difficult (*Age of Spirituality* 1979, 286).

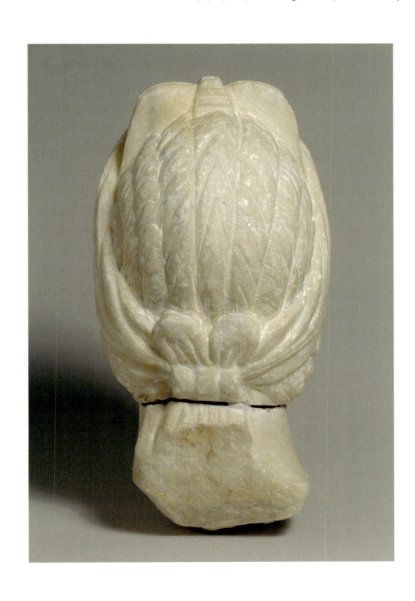

27

## 28 Statuette of an Imperial Woman

Northern Syria (?), Byzantine, 4th century
Bone
H. 19.7 cm, diam. at base 3.3 cm
The Art Museum, Princeton University,
Museum purchase, Caroline G. Mather Fund,
y1989-22

COLLECTION HISTORY Said to come from
northern Syria or southeastern Turkey.[1]

PUBLISHED St. Clair 1996, 147–62.

This statuette of an imperial woman personifies the virtue of chastity. The figure is delicately carved, from two hollow bone pieces joined below the hips, leaving marrow cavities open at the top and base.[2] It may also have been gilded and polychromed, with the eyes painted in.[3] The upper body is accentuated with curved forms and softly modeled flesh. The lower body is more linear, although the contours of the legs are suggested beneath the flattened folds of the garments. The feet protrude below a slightly pooled hem, and the platform sandals and drapery falling behind give the sense of a column or base. The tall, slender profile and frontal plasticity are paralleled in late-fourth-century public statuary.[4] The distinctive fringe of the mantle suggests an origin in the Eastern provinces.[5]

The hair is parted in the center, flowing in waves to the ears, with three or four plaits wrapped around the head to form a nest. Originating in the time of the Roman empresses Sabina (r. 117–36/7) and Faustina the Elder (r. 138–41), this hairstyle was revived by the women of Constantine's family, adopted in their sculpted (cat. 25), painted, and numismatic portraits.[6] The broad braid nest of this statuette is characteristic of later versions of the style in the fourth century.[7]

The figure wears a jeweled diadem, reserved for women of the imperial family granted the highest female rank, *augusta*.[8] A similar diadem, with round pearls or gems set in squares, was introduced on coinage celebrating Helena's elevation to *augusta* in 324 (cat. 16a), suggesting a *terminus post quem* for the statuette. The diadem suggests that it may represent one of the five known fourth-century *augustae*: Helena (cat. 24); Constantine's wife Fausta (r. 324–26; cats. 24, 25); Domnica, wife of the emperor Valens (r. 364–78); Flacilla, first wife of Theodosios I (r. 379–95); or Galla, his second wife.[9] Alternatively, as with empress bust weights (cats. 10–13) and diademed female personifications such as Ktisis, or Foundation (fig. 6), she may not represent a specific empress, but an abstract idea—in this case chastity—with imperial attributes enhancing her power and status.[10]

Constantinian empresses were widely represented in the guise of virtues in public and domestic art and literature of their time (cats. 16b, 17b).[11] The pose of this figure, standing in *contrapposto* with one hand raised to her veil and the other hugging her waist, is associated with sculpted personifications of chastity.[12] Although their arm positions are reversed, she recalls a life-size statue of Chastity identified as a portrait of Fausta.[13] Both sculptures subsume the empress's individuality in an idealized image, presumably because it was important to portray her as possessing the virtue in question.[14]

Julian the Apostate's panegyric to Eusebia, wife of the emperor Constantius (r. 337–61), illustrates the pervasiveness of Chastity as a trope for fourth-century empresses: "Now when I first came into her presence, it seemed to me as though I beheld a statue of Chastity [ἄγαλμα σωφροσύνης] set up in some temple."[15] Julian then compares Eusebia to Penelope, the modest wife of the classical Greek hero Odysseus and a popular Byzantine paradigm for a chaste woman shunning public life, "holding up before her face her shining veil"—a phrase that evokes the gesture of this figurine.[16]

Chastity was probably an appealing image for an empress, since the figure was identified with the moral matron and her demure occupation of weaving, connected with the domestic lives of ordinary women.[17] The model goes back to Livia, wife of Augustus and

the first of the Roman and Byzantine imperial women to be associated with Chastity as an inspirational model for their subjects.[18]

This statuette and related public sculptures suggest that the empress in the guise of Chastity continued to be an important moral exemplum in early Byzantine public and private life.   EG

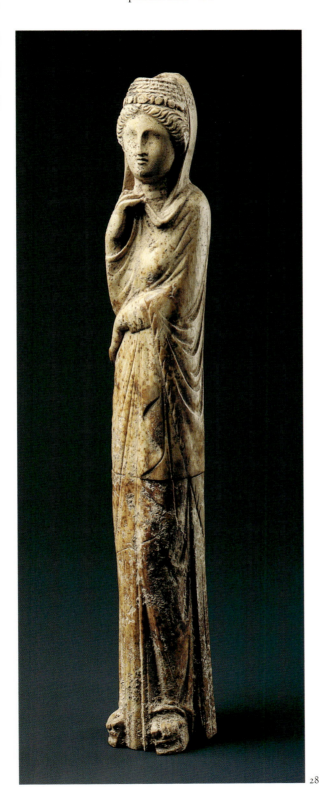

28

1. St. Clair 1996, 162.

2. The cavities were probably closed by bone plugs (ibid., 148).

3. For female bone figures of similar style, size, and provenance, see Sotheby's New York 2001, 166, cat. 301; *Romans and Barbarians* 1976, 57, cat. 76; St. Clair 1996, 148–49.

4. For example, the contemporary public portrait statues at Aphrodisias in Caria have a similar columnar silhouette (Smith 1999, 160, 165).

5. The fringe occurs only in late Hellenistic freestanding statues and funerary reliefs of Chastity from the eastern regions of the Roman Empire (St. Clair 1996, 148, 152–53).

6. For marble heads identified as women of Constantine's family with a similar hairstyle, see: Vermeule 1981, 374, cat. 324; *Romans and Barbarians* 1976, 110, cat. 118; De Kersauson 1996, 524–25, cat. 250; Bergmann 1977, 197–99, pl. 61, cats. 1, 2.

7. For a much larger head with a veil and similar braid crown, see Von Heintze 1968, 84–85, cat. 56, pls. 94, 95. In late-fourth-century sculptures, the braid nest frequently flares out rather than tapering. See Inan and Alföldi-Rosenbaum 1979, vol. 1, 309–10, cat. 306, and vol. 2, pl. 216, 1–4.

8. On the development and significance of the diadem in coin issues, see *RIC*, vol. 7, 43–45.

9. For a list of *augustae*, see the appendix in this volume, "Byzantine Empresses." On the title and rank of *augusta*, see Bensammar 1976, 271.

10. James 2001, 115–17; Campbell 1984, 58.

11. For example, the female personifications of wisdom, beauty, health, and youth, also wearing a diadem and veil over a high crown, in the ceiling frescoes of the imperial residence at Trier, have been interpreted as portraits of Fausta (Simon 1986, 26–37, 39–44).

12. Called Sophrosyne (Greek) and Pudicitia (Latin), the personification of chastity was a common statue type in antiquity. This statuette recalls the Saufeia variant, named after a first-century B.C. statue from Magnesia (St. Clair 1996, 149).

13. Ibid., 150–52, n. 16.

14. James 2001, 37.

15. Julian 1962, vol. 1, 326–27. Chastity, piety, philanthropy, and marital devotion are mentioned as the cardinal virtues of Byzantine empresses in fourth- and fifth-century encomia (James 2001, 11–16).

16. Julian 1962, vol. 1, 338–39.

17. D'Ambra 1993b, 79.

18. Ibid., 36.

## 29 Solidus of the Augusta Eudoxia

Mint of Constantinople, 400–401
Gold
Diam. 2.0 cm, wt. 4.49 g, reverse die axis
6 o'clock
Obv: clockwise from lower left, AEL[IA]
EVDO XIA AVC[VSTA] (Aelia Eudoxia
Augusta)
Rev: clockwise from lower left, SALVS REI
PVBLICAE (Health of the State); on shield, ✗
(Christogram); in exergue, CONOB (mint-
mark of Constantinople, refined gold)
Arthur M. Sackler Museum, Harvard
University, Bequest of Thomas Whittemore,
1951.31.4.126

COLLECTION HISTORY Thomas Whittemore
collection.

PUBLISHED Grierson and Mays 1992, cat. 273,
pl. 11.

## 30 Solidus of the Augusta Pulcheria

Mint of Constantinople, 422–29
Gold
Diam. 2.2 cm, wt. 4.49 g, reverse die axis
4 o'clock
Obv: clockwise from lower left, AEL[IA]
PVLCH ERIA AVC[VSTA] (Aelia Pulcheria
Augusta)
Rev: clockwise from lower left, VOT[A] XX
MVLT[IS VOTIS] XXX (vows of the 20th
anniversary, with many vows for a 30th
anniversary); in exergue, CONOB (mintmark
of Constantinople, refined gold); star in
upper left field
Arthur M. Sackler Museum, Harvard
University, Bequest of Thomas Whittemore,
1951.31.4.157

COLLECTION HISTORY Thomas Whittemore
collection.

PUBLISHED Grierson and Mays 1992, cat. 438,
pl. 17.

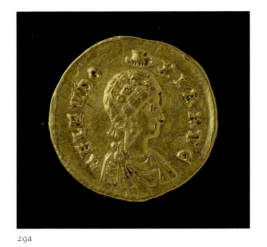

29a

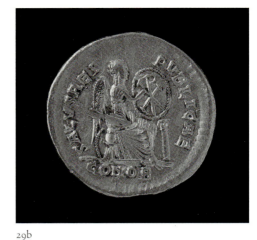

29b

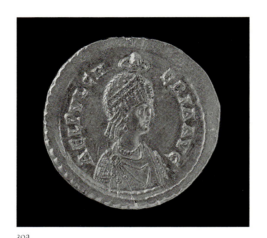

30a

30b

# Theodosian Dynasty Empresses

With their standardized obverse profile busts, these fifth-century gold coins of the Theo-
dosian empresses (cats. 29–32) suggest the stability and security of the dynasty's rule.[1]
The prominence of this line of women rulers is unequaled on Byzantine coinage, where
empresses are only sporadically represented. Commemorating their elevation to *augusta*,
the rank of principal empress, or, in the case of Galla Placidia, to the throne as regent
(r. 423–39), the coin types of these empresses are remarkably consistent across time and
geographical boundaries.

Compared with coin portraits of the Constantinian empresses Helena (cat. 16a) and
Fausta (cat. 17a), those of the Theodosian empresses include more signs of elite status: an
array of jewelry, a more elaborate headdress, and the imperial *chlamys*, fastened with a *fibula*
with three pendants. The mantle and *fibula* of this type had formerly been reserved for
an *augustus*, the senior emperor, who was supreme ruler.[2] The four busts are based on coin
portraits of the empress Aelia Flavia Flacilla, wife of Theodosios I (r. 379–95), founder of
the dynasty; she was the first empress to be depicted in this court costume, on coins com-
memorating her elevation to *augusta* in 379. Flacilla's delicate profile, broad, jeweled diadem,

and hairstyle with a vertical braid drawn up over the back of the head are copied. Along with Flacilla's portrait type (cat. 26), successive fifth-century empresses also adopted her family name, Aelia, as an honorific implying female distinction and dynastic exclusivity.[3]

The coins of Aelia Eudoxia, wife of Arkadios (r. 395–408), are the first to represent an *augusta* crowned by the Hand of God (cat. 29a), a device repeated on solidi of later fifth-century empresses (cats. 30a–33a).[4] Virtually confined to empresses' coins, this emblem of divine investiture gave the *augustae* an overt sacral authority paralleling that of the emperor. The motif may refer to the portico in the Great Palace called "The Golden Hand," where *augustae* were officially acclaimed just after their coronation.[5] In addition to her coins, official portrait sculptures of Eudoxia were distributed throughout the provinces in honor of her elevation, even in the West, sparking the protest of the Western emperor, Honorios (r. 395–423).[6] Like the new signs of distinction on these coins, the incident illustrates the change in policy that occurred during the Theodosian period: Byzantine empresses were promoted to a degree unprecedented in official Byzantine art and ceremony.

Apart from the *Manus Dei*, Eudoxia's solidi repeat the main type of Flacilla, her mother-in-law, with Nike on the reverse inscribing a shield with the monogram of Christ (cat. 29b).[7] The solidi of the two empresses are traditionally associated with their role in child-bearing, as the mothers of imperial children[8] whose birth Nike records as a triumph of the Christian empire. Eudoxia's coin (cat. 29) was probably struck while she was pregnant with the future emperor Theodosios II (r. 408–50), who was her only male child.[9] Her first two children were daughters, named Flacilla and Pulcheria after their paternal grand-mother and aunt, emphasizing, like their coinage, the continuity of the generations.[10]

Fecundity, however, may not be the reason certain empresses were granted the title of *augusta* and represented in coinage.[11] Eudoxia's and Flacilla's prominence may simply reflect their power and high status.[12] Raised by a wealthy family connected to the court in Constantinople, Eudoxia had a longstanding alliance with the eunuch Eutropios, chief of the imperial household, and great influence over her "sluggish" husband, Arkadios.[13] Flacilla was renowned for her piety, a quality her granddaughter, Aelia Pulcheria (*augusta* 414–53, cats. 7, 30), later used to consolidate her own authority. Pulcheria's earliest coins, which copy this Nike type of Flacilla and Eudoxia, also celebrate her as the "Health of the State," although she took a vow of celibacy and had no children.[14] Thus, the type cannot be specifically related to motherhood.

Eudoxia's contributions to the empire went beyond providing heirs. Her most impressive achievement was the endowment of a massive cruciform basilica in Gaza, including in its interior thirty-two green marble pillars "shining like emeralds."[15] Completed after her death, the church was dedicated as the Eudoxiane, in her memory.[16] Her solidus probably has a more general meaning, celebrating her as the bulwark of the imperial family and state.

Nike holds a long, jeweled cross on the reverse of the coins of Pulcheria (cat. 30) and Galla Placidia (cat. 31). The type commemorates the monumental gold, jeweled cross erected "under the influence of the blessed Pulcheria" at the site of the Crucifixion outside Jerusalem in 420.[17] The solidus type is dynastic, struck throughout the empire in the 420s in the names of the Eastern and Western *augusti*, emphasizing their solidarity.

## 31 Solidus of the Augusta Galla Placidia

Mint of Ravenna, 426–30
Gold
Diam. 2.2 cm, wt. 4.41 g, reverse die axis 12 o'clock
Obv: clockwise from lower left, D[OMINA] N[OSTRA] GALLA PLA CIDIA P[ERPETVA] F[ELIX]AVC[VSTA] (Our Mistress Galla Placidia, Eternal, Fortunate Augusta); on right shoulder, ☧ (Christogram)
Rev: clockwise from lower left, VOT[A] XX MVLT[IS VOTIS] XXX (vows of the 20th anniversary, with many vows for a 30th anniversary); to left and right of Nike, R V, and in exergue, COMOB (together, mintmark of Ravenna, refined gold); star in upper left field
Museum of Fine Arts, Boston. Anonymous gift in memory of Zöe Wilbour (1864–1885), 35.627

PUBLISHED *Romans and Barbarians* 1976, 162, cat. C143.

## 32 Tremissis of the Augusta Eudokia

Mint of Constantinople, 423–42
Gold
Diam. 1.4 cm, wt. 1.49 g, reverse die axis 6 o'clock
Obv: clockwise from lower left, AEL[IA] EVDO CIA AVC[VSTA] (Aelia Eudokia Augusta)
Rev: in exergue, CONOB (mintmark of Constantinople, refined gold)
Arthur M. Sackler Museum, Harvard University, Bequest of Thomas Whittemore, 1951.31.4.162

COLLECTION HISTORY Thomas Whittemore collection.

PUBLISHED Grierson and Mays 1992, cat. 472, pl. 18.

31a

31b

32a

32b

A strong personality who dominated the court of Theodosios II, her younger brother, Pulcheria was probably responsible for the prominence of the cross on the coinage of his reign.[18] She used her piety to increase her power, elevating herself above ordinary women with public vows of celibacy, ecclesiastical patronage, and church-building in the capital, including the church of Saint Stephen and the Virgin's shrines at Hodegon and Blachernai (map, inside back cover).[19]

Galla Placidia's obverse inscription, including the epithet "Eternal Fortunate" or "Pious Fortunate" used by Roman emperors, honors her status (unique among these empresses) as senior ruler in the West from 423 to 439, regent for her young son Valentinian III.[20] This coin was struck in Ravenna, the Byzantine capital in northern Italy, soon after Placidia (*augusta* 421–450) and her children were restored to the Western throne in 425 by armies sent by Theodosios II. The only surviving daughter of Theodosios I's second wife, Galla (d. 394), Placidia was the half-sister of the emperors Arkadios and Honorios and a contemporary of her powerful relative Pulcheria.

With Helena (cats. 16, 24) and Pulcheria, Placidia ranks as one of the greatest ecclesiastical patrons in history. She built several churches in Ravenna. Among them was San Giovanni Evangelista, which she decorated with sumptuous mosaics, devoting the apse to an ensemble tracing the lineage of the Theodosian house back to Constantine. Placidia's

mantle is the only one in this group with a Christogram (cat. 31a), often depicted on the cloaks of contemporary emperors, emphasizing the divine sanction of her sovereign rule. Solidi of the same type were struck simultaneously in Western mints for her daughter Justa Grata Honoria, celebrating her elevation to *augusta* in 425 at the young age of seven or eight. Honoria's mantle, however, has a simple cross instead of the Christogram, distinguishing her rank from her mother's.[21]

The small tremissis of Aelia Eudokia (*augusta* 423–60) with a cross in a wreath on the reverse (cat. 32b), is a type struck throughout her reign, and was probably used for almsgiving.[22] Philanthropy was promoted as one of the main vocations of Byzantine empresses, and similar coins were issued by virtually all fifth-century *augustae*.[23] Daughter of a pagan philosopher from Athens, Eudokia, born Athenais, was selected as a wife for Theodosios II in a bride show organized by his sister Pulcheria, who was impressed with her beauty and intellect. Converting to Christianity, she was baptized Eudokia and in the 420s and 430s became the most powerful woman at court, temporarily displacing her sister-in-law.[24] Accused of an affair with one of Theodosios' closest advisors, she left the capital around 443 for the Holy Land, where she lived for nearly twenty years, retaining her title and maintaining a small palace and court in Bethlehem.[25] She kept some measure of authority, hearing the petitions of her subjects and issuing decrees, including one allowing Jews to pray at the ruins of the Temple of Solomon, in contradiction of her husband's policies.[26]

Eudokia was probably the most learned of all early Byzantine empresses. She wrote several poetic works, including a collection of verses inspired by Homer and a metrical paraphrase of part of the Bible.[27] Her rhetorical skills were evident during a pilgrimage to Jerusalem in the company of Saint Melania the Younger (383–439), when she addressed the Senate of Antioch; seated on a throne decorated with gold and precious stones, she delivered an encomium of the city in Homeric verse and was honored in return with statues of gold and bronze.[28] She was also a great Christian patron: she supposedly brought back to Constantinople the famous Hodegetria icon, believed to be an authentic portrait of the Virgin and Child painted from life, and she acquired relics of the protomartyr Stephen for the church of Saint Lawrence in the capital. In Jerusalem, she built an episcopal palace as well as hostels for pilgrims, the poor, and the elderly, and restored and fortified the city walls. Her most sumptuous gift was an enormous bronze cross weighing three tons, raised to the top of the church of the Ascension on the Mount of Olives.[29]

Like the emperors, these empresses of the Theodosian family were promoted in official art and ceremony as bearers of divine authority and as partners in redemption. The coinage of some, such as Eudoxia and Eudokia, predates the birth of an heir, but not of female children. This suggests that daughters were more important to dynastic succession than previously believed.[30] The prominence of the Christianized Victory on the coins of these empresses presents their rule, philanthropy, and imperial motherhood as triumphs of the Christian state.   EG

1. The profile bust is standard in this period for representing the dignity of an *augusta*; emperors are usually depicted frontally and in military dress on contemporary coinage.

2. Holum 1982, 34.

3. Aelia was the name of Flacilla's aristocratic family from Spain. The Western empresses Galla Placidia and Licinia Eudoxia (*augusta* 439–55?) also bear the name on coins struck in the East (Holum 1982, 22, n. 62). The Constantinian empresses and Flacilla herself (Aelia Flavia Flacilla) used "Flavia" in the same way, alluding to the Roman imperial dynasty.

4. Including the Western empresses Galla Placidia and Justa Grata Honoria (*augusta* 425–49?) (Holum 1982, 129–30, fig. 14). Rare on fourth-century coins, the *Manus Dei* appears on the earliest coinage of Arkadios, struck for his coronation, but is subsequently restricted to the coins of the Theodosian empresses and their immediate successors Verina (*augusta* c. 457–84; cat. 33a) and Zenonis (*augusta* 476–76) (Holum 1982, 66; James 2001, 105).

5. Kalavrezou 1997a, 63–64. The portico was named "The Golden Hand" after the sculpture of a hand, perhaps blessing or crowning, installed there. Although the earliest description of an empress's coronation is from the ninth century, the portico was in the original part of the palace attributed to Constantine, so the Theodosian empresses might have been acclaimed there after being crowned (Constantine VII 1967, vol. I, 6 [1.25]; Constantine VII 1939, vol. 2, 16–23 [50], 33).

6. Holum 1982, 66.

7. For the type on Flacilla's coins, compare *RIC*, vol. 9, 225, cat. 48.

8. Implied in Holum 1982, 30–32, and Grierson and Mays 1992, 133.

9. James 2001, 119.

10. Holum 1982, 53.

11. James 2001, 119–25.

12. James's argument is supported by the existence of coins depicting Flacilla standing with the same legend, "Health of the State"; unlike Fausta, she is not shown with children, when this would have been easy and was the traditional way of commemorating imperial fecundity. See *RIC*, vol. 9, 302, no. 17, pl. 16, 9.

13. Holum 1982, 51–53, 50, quoting the fourth-to-fifth-century bishop Synesios of Cyrene.

14. Grierson and Mays 1992, 152, cat. 436.

15. Mark the Deacon 1913, 84.

16. Ibid., 92.

17. Holum 1982, 103, n. 11.

18. Grierson and Mays 1992, 152.

19. Holum 1982, 103–11; James 2001, 152–55.

20. Holum 1982 130, suggests *Perpetua Felix* (Eternal, Fortunate).

21. Ibid., 130, fig. 14.

22. Grierson and Mays 1992, 156.

23. Ibid., 231, cat. 831.

24. Holum 1982, 112–13, 130–32.

25. Ibid., 176–77.

26. Ibid., 217–18.

27. Grierson and Mays 1992, 155.

28. Holum 1982, 186.

29. Ibid., 219.

30. Eudoxia probably received the title after bearing two daughters, but before bearing the male heir. Eudokia was elevated in 423 after bearing Licinia Eudoxia (James 2001, 119–25).

## 33 Solidus of the Augusta Aelia Verina

Mint of Constantinople, 457–74
Gold
Diam. 2.0 cm, wt. 4.49 g, reverse die axis 6 o'clock
Obv: clockwise from lower left, AEL[IA] ЧERINA AVC[VSTA] (Aelia Verina Augusta)
Rev: clockwise from lower left, VICTORI AAVCCC (Victory of the three co-*augusti* Verina, Leo I, and Zeno); in exergue, CONOB (mintmark of Constantinople, refined gold); star in right field; pierced
Arthur M. Sackler Museum, Harvard University, Bequest of Thomas Whittemore, 1951.31.4.182

COLLECTION HISTORY Thomas Whittemore collection.

PUBLISHED Grierson and Mays 1992, cat. 593, pl. 23.

33a

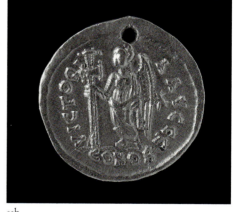

33b

Verina's solidus imitates the long-cross type struck in the 420s for the Theodosian empresses (cats. 30b, 31b). Their influence on their immediate successors is evident in the coinage of Verina and her Western contemporary, Euphemia (r. 467–72), both of whom adopted the Theodosian dynastic nomen Aelia and the profile portrait type with imperial diadem, mantle, *fibula*, and modified *Scheitelzopf* hairstyle.[1] However, Verina's strong, some-

what gaunt features are distinctive, a marked contrast to the delicate profiles on her predecessors' coins (cats. 7a, 29a–32a). Her appearance evokes the formidable, independent character for which she is known. Historically she was overshadowed by the Theodosian women, and her contributions to female autonomy and religious patronage are perhaps underestimated.

Wife of the emperor Leo I (r. 457–74), this long-reigning *augusta* (457–84) played a major role in the political life of her time, orchestrating military campaigns and imperial appointments. A relative of the Western emperor Julius Nepos (r. 474–80) and of Odoacer, a contemporary Gothic leader, she was perhaps prepared by her social background to deal with the court.[2] Verina's personal ambition was most evident after her husband's death in 474. She expected to rule as regent for her grandson, Leo II, but his father, Zeno, husband of her daughter Ariadne, was proclaimed emperor instead. Verina succeeded in overthrowing Zeno briefly, planning to marry her lover, Master of Offices Patrikios, and raise him to the throne.[3] She was imprisoned in an Isaurian fortress for her role in the failed conspiracy.[4] Once freed, she crowned Zeno's rival, Leontios, on her own authority. In a remarkable rescript issued in 481/2, she left no doubt that she considered herself supreme ruler:[5] "We, Aelia Verina, the Augusta, to our magistrates and Christ-loving people, greeting. Know that since the death of Leo of divine memory, the empire is ours. . . ."[6]

Verina was perhaps the leading imperial sponsor of the Virgin's cult during the late fifth century. She is credited with building the two most important churches of the Virgin in the capital: the Blachernai, which housed the miraculous relic of Mary's veil, and the Chalkoprateia, which later received the girdle Mary was purported to have worn while giving birth to Christ.[7] Leo and Verina furnished the Blachernai with a precious gold-and-jewel casket for the veil, depicting themselves and their family flanking the enthroned Virgin in mosaics on the ciborium above it.[8] The shrine and votive image set a precedent for generations of empresses, who made the Blachernai the special focus of their devotion.[9]  EG

1. For Euphemia's solidus, see Grierson and Mays 1992, cat. 933. Verina also copied the type with a seated Nike inscribing a shield, introduced by Flacilla (ibid., cat. 598, pl. 23).

2. James 2001, 61.

3. *ODB* 1991, 2160.

4. Isauria was a remote mountainous district in southern Asia Minor, considered the edge of the empire. The emperor Zeno, Verina's son-in-law, was an Isaurian chief. These tribal warriors formed the core of the imperial army in the fifth century (*ODB* 1991, 1014).

5. Grierson and Mays 1992, 170.

6. James 2001, 73–74. n. 74, quoting Theophanes and others.

7. Mango 2000, 19.

8. Mango 1986, 34–35.

9. Herrin 2000, 25–27.

## 34 Follis of Justin II and Sophia

Mint of Constantinople, 574–75
Bronze
Diam. 3.1 cm, wt. 13.19 g, reverse axis 6 o'clock
Obv: clockwise from lower left, D[OMINVS] N[OSTER] IVST[I] NVS P[ER]P[ETVVS] AVC[VSTVS] (Our Lord Justin Eternal Augustus)
Rev: at center, M (mark of value=40 nummi); within M, E (workshop 5); at left, vertical, and right of M, ANNO X (year 10 of Justin's reign); in exergue, CON (mintmark of Constantinople); cross above
Arthur M. Sackler Museum, Harvard University, Bequest of Thomas Whittemore, 1951.31.4.550

COLLECTION HISTORY Thomas Whittemore collection.

PUBLISHED DOC, vol. 1, 212, cat. 38e.I, pl. 51.

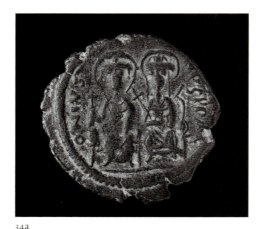

34a

34b

With this follis type, Sophia became the first Byzantine empress to be represented enthroned with the emperor on the obverse of coins.[1] This remarkable innovation in official imagery reflects Sophia's leading role in imperial politics and fiscal policy during Justin's reign (565–78).[2] The coin was struck the year Justin was found incompetent by reason of insanity. Tiberios, count of the imperial guard, was appointed *caesar*, but Sophia continued as *augusta* and was de facto ruler of the empire.[3]

Although Justin occupies the position of honor on the left, Sophia's presence as co-ruler, on the same level and scale as her husband, is unprecedented in early Byzantine coinage. Her bust on a unique weight (cat. 15), alongside busts of Justin and another official, also stresses her partnership in rule. The joint rulership of emperor and empress, an unusual official theme, was emphasized in other public imagery of Justin's reign: in Constantinople, statues of Justin and Sophia stood together in front of the Praetorium and at the Deuteron Palace and commemorated victory over the Persians.[4] Additional statues of Sophia, accompanied by her family, were erected at the harbor of Sophia and at the Milion, the great tetrapylon marking the central crossroads of the capital.[5]

The Milion sculptures, depicting Sophia with her daughter and niece, constituted a public display of female dynastic power at the symbolic epicenter of the empire. Sophia was the niece of the empress Theodora, wife of Justinian I (r. 527–65), and her prestige in court predated Justin's reign; their marriage facilitated his ascent to the throne.[6] Corippus calls Sophia "the sharer of your rule" in his poem addressed to Justin on his accession, suggesting her early influence.[7] The public unity of emperor and empress, obvious in Justin and Sophia's coinage, statuary, and the silver cross they sent to Rome, may be influenced by similar representations of Justinian and Theodora.[8] The image of co-rulership on this coin may reflect not only Sophia's authority, but also the tradition of a female dynasty that wielded significant authority in two successive reigns. EG

1. Introduced by the emperor Anastasios in about 498, the large-denomination follis traditionally depicted the bust of the emperor alone on the obverse (Sear 1974, 12). The only precedents for joint representation are fifth-century imperial marriage solidi depicting *augustae* standing with their husbands, but these were not regular issues.

2. DOC, vol. 1, 195.

3. Sophia's most impressive diplomatic achievement was perhaps her successful appeal to the Sasanian emperor Khusrau which, with a payment of 45,000 solidi, brought about a truce with the Persians until 575. Justin's aggressive policies toward the Sasanian

Empire had been disastrous, resulting in a significant loss of Byzantine territory (*DOC*, vol. 1, 195).

4. James 2001, 42–43, nn. 56, 57, citing *The Greek Anthology* and the Syriac historian John of Ephesus.

5. Cameron and Herrin et al. 1984, 48–51.

6. Cameron 1975.

7. Corippus 1976, vol. 4, 86.

8. For the silver cross in the Vatican with portraits of Justin and Sophia flanking the Lamb of God, see

Rice 1959, pl. 71. Prokopios describes a mosaic at the Chalke Gate, the main vestibule of the Great Palace in Constantinople, depicting Justinian and Theodora in the center, flanked by the Senate, with defeated Goths and Vandals before them (James 2001, 43, n. 58). Justinian and Theodora were also represented together on the altar cloth of the Hagia Sophia, performing philanthropic acts (ibid., n. 60, citing Paul Silentiarios).

## 35 Solidus with Theophilos, Theodora, and Daughters

Mint of Constantinople, late 830s
Gold
Diam. 2.1 cm, wt. 4.41 g, reverse die axis
6 o'clock
Obv: clockwise from lower left, ΘΕΚ´ ΘΕΟΡ´ ΘΕ´ (Thekla, Theophilos, Theodora); two crosses above
Rev: * ANNA SANTASIA (Anna, Anastasia); pellet between heads, cross above
Arthur M. Sackler Museum, Harvard University, Bequest of Thomas Whittemore, 1951.31.4.1174

COLLECTION HISTORY Thomas Whittemore collection.

PUBLISHED *DOC*, vol. 3, part 1, 428, cat. 4, pl. 22.

## 36 Solidus of Theodora as Regent

Mint of Constantinople, 842–43(?)
Gold
Diam. 2.0 cm, wt. 4.49 g, reverse die axis
7 o'clock
Obv: + ΘΕΟΔΟ RA ΔΕSPVTISA (Theodora, Mistress)
Rev: •MIXAHL S ΘΕCLA (Michael and Thekla)
Arthur M. Sackler Museum, Harvard University, Bequest of Thomas Whittemore, 1951.31.4.1208

COLLECTION HISTORY Thomas Whittemore collection.

PUBLISHED *DOC*, vol. 3, part 1, 461, cat. 1a.1, pl. 28.

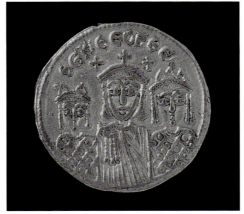
35a

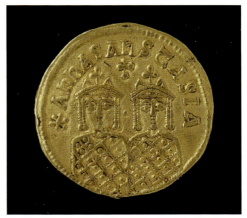
35b

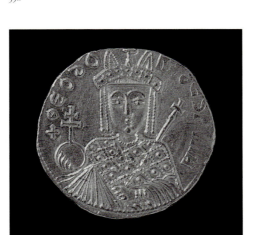
36a

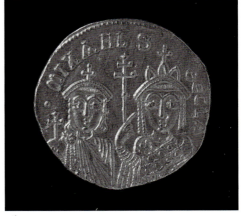
36b

# Theodora and Her Family

Empresses are unusually prominent on the coinage of the iconoclast emperor Theophilos (r. 829–42), which reveals that, in the absence of male heirs, daughters were sometimes promoted to ensure the continuity of the dynasty. Cat. 35 is a rare solidus that includes portraits of his wife, the empress Theodora (fig. 10), and three of their five daughters.[1] The daughters' presence on the coin and their imperial costume, the *loros* and crowns with

## 37 Solidus of Theodora and Michael III

Mint of Constantinople, c. 843–56
Gold
Diam. 2.0 cm, wt. 4.42 g, reverse die axis
6 o'clock
Obv: IhSЧX RISZOS* (Jesus Christ)
Rev: partially obscured, + MIXALHS ΘE
OƆORA (Michael and Theodora); cross in
upper field, pellet between them
Arthur M. Sackler Museum, Harvard
University, Bequest of Thomas Whittemore,
1951.31.4.1209
COLLECTION HISTORY Thomas Whittemore
collection.
PUBLISHED *DOC*, vol. 3, part 1, 463, cat. 2.2,
pl. 28.

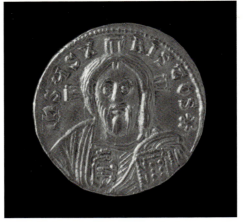

37a

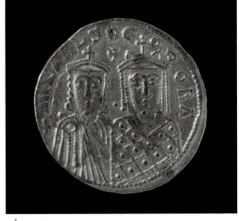

37b

*pendilia*, suggest that all received the rank of *augusta*. However, the oldest child, Thekla, is given priority over her sisters. She is depicted on the obverse, to the left of her father (center) and her mother, whose larger size and more elaborate crown distinguish her as the senior *augusta*. Although there is no space for the rulers' titles, the order of seniority is indicated by position, with each person identified by an abbreviated name.[2] This coin predates the birth of the couple's only male child to survive, the future emperor Michael III.

When Theophilos died, in 842, Theodora began her fourteen-year rule as regent for their son, Michael, then two years old. She issued coins such as cat. 36, with herself on the obverse, holding the insignia of seniority, a cross scepter and a *globus cruciger*, a globe surmounted by a patriarchal cross. Michael's secondary status is marked by his position on the reverse and his lack of a beard, the Byzantine signifier of manhood. Thekla, the only daughter included on the regency coinage, is depicted in the subordinate place to his left. However, she is larger, holds an overbearing patriarchal cross, and points to herself in a dramatic gesture of self-affirmation. Thekla's prominence suggests she was officially a co-ruler.[3] The abundant early solidi of Theodora's regency are often overstruck on earlier coins, suggesting that a large initial issue was put in circulation quickly to publicize Michael's accession and thereby circumvent rivals.[4]

Theodora is best known for her role in the permanent restoration of holy images on March 11, 843, reversing Theophilos' policy of iconoclasm only fourteen months after his death. Cat. 37 suggests Theodora's role as a champion of icons as well as her dynastic commitment.[5] Although she came from a rural Paphlagonian family, with little preparation for the role of empress, she was politically subtle enough to succeed in promptly restoring the use of icons while preventing the bishops from condemning her late husband's memory, through which she and her children derived their legitimacy.[6] Theodora reintroduced Christ's image on coins, the main obverse type during her regency. The image, a bust of Christ with his right hand raised in blessing, is perhaps a copy of the famous icon of Christ over the Chalke, the bronze gate of the imperial palace, that was said to have been destroyed under iconoclasm and replaced by Theodora with a new mosaic of the standing Christ.[7] She also brought to the capital the relics of famous

iconophiles, including those of her predecessor, the empress Irene (cats. 18, 19).[8] On this coin, Theodora yields pride of place on the left to her son, but her authority is emphasized by her larger size and position in the foreground. Michael's lack of a beard marks his youth and junior status.

Theodora's regency ended in 856, when Michael ordered the murder of the eunuch chamberlain Theoktistos, her closest ally at court. Like many medieval imperial women, Theodora and her daughters were forced to enter convents and thus eliminated as potential rivals. Theodora retained her title and some autonomy; she withdrew to the family monastery in Gastria, where the imperial women had traditionally maintained a patrician residence.[9] Thekla, however, continued to have political ambitions, reemerging in court life as the mistress, temporarily, of Michael's new co-ruler and soon-to-be usurper, Basil I.[10]

While Michael is remembered as a weak, dissipated ruler, Theodora was immortalized as a Byzantine saint soon after her death.[11] She is commemorated annually on the Feast of the Triumph of Orthodoxy, the first Sunday in Lent, when her life is read in Orthodox churches and her icons displayed for veneration.[12]   EG

1. Absent are their fourth child and deceased heir, Constantine (d. 835); their fifth, Maria (d. c. 839); sixth, Pulcheria (presumably not yet born); and youngest, the future emperor Michael III (b. 840).

2. *DOC*, vol. 3, part 1, 415–16.

3. Ibid., 454. Michael's youth and the high mortality rate among the siblings would make Thekla's continued co-rulership logical.

4. Ibid., 455.

5. Ibid., 208–9.

6. Theodora perhaps invented the story of Theophilos' deathbed repentance to redeem him: he supposedly kissed a small icon hanging from the neck of the chamberlain Theoktistos (Herrin 2001, 202, 205).

7. *DOC*, vol. 3, part 1, 454; Garland 1999, 102–3. On iconophile devotion to the Chalke icon and its possible destruction by Leo III, see Talbot 2001b, ch. 6, 5, n. 14.

8. Herrin 2001, 213–14.

9. Ibid., 176, 234–35.

10. Ibid., 228–29.

11. Perhaps under the emperor Leo VI (r. 886–912), who was probably the son of Michael III, not of Basil I, who was officially his father (Talbot 1998, 355–56).

12. Herrin 2001, 238–39.

## 38 Solidus of Basil I with Eudokia Ingerina

Mint of Constantinople, 868(?) or 882(?)
Gold
Diam. 1.9 cm, wt. 4.4 g, reverse die axis
6 o'clock
Obv: clockwise from left, +bASILIOS
AЧGЧSZ'b' (Basil, Augustus, Basileus)
Rev: clockwise from left, partially obscured,
COПSZAПZ' S EVƆOCIA* (Constantine,
Eudokia); cross in upper field between figures
Arthur M. Sackler Museum, Harvard
University, Bequest of Thomas Whittemore,
1951.31.4.1219

COLLECTION HISTORY Thomas Whittemore
collection.

PUBLISHED *DOC*, vol. 3, part 2, 489, cat. 3.1.

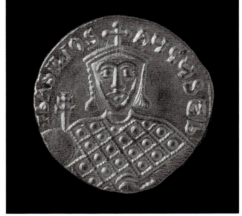

38a

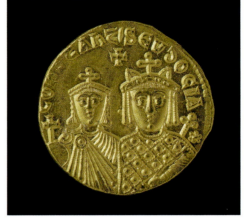

38b

## 39 Solidus of Zoe Karbounopsina as Regent

Mint of Constantinople, 914–19
Gold
Diam. 2.1 cm. wt. 4.4 g, reverse die axis
7 o'clock
Obv: clockwise from left, + IhS XPS REX
REGNANTIЧM* (Jesus Christ, King of Those
Who Rule)
Rev: clockwise from left, COПSZAПZ' ZΩH
EП X'Ʊ b' R' (Constantine, Zoe, in Christ,
Emperors of the Romans); pierced
Arthur M. Sackler Museum, Harvard
University, Bequest of Thomas Whittemore,
1951.31.4.1332

COLLECTION HISTORY Thomas Whittemore
collection.

PUBLISHED *DOC*, vol. 3, part 2, 542, cat. 2.2,
pl. 36.

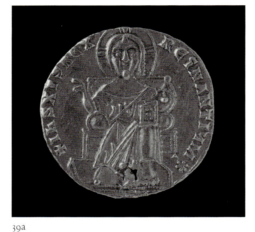

39a

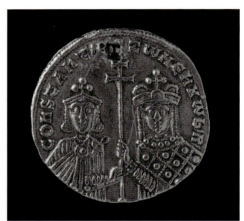

39b

## 40 Tetarteron of Theodora as Sole Ruler

Mint of Constantinople, 1055–56
Gold
Diam. 1.9 cm, wt. 4.0 g, reverse die axis
6 o'clock
Obv: in left and right fields, IC̄ X̄C (Jesus
Christ)
Rev: clockwise from left, + ƟEOΔΩ I ΛVΓOV
(Theodora, Augusta)
Arthur M. Sackler Museum, Harvard
University, Bequest of Thomas Whittemore,
1951.31.4.1435

COLLECTION HISTORY Thomas Whittemore
collection.

PUBLISHED *DOC*, vol. 3, part 2, 753, cat. 2.2,
pl. 62.

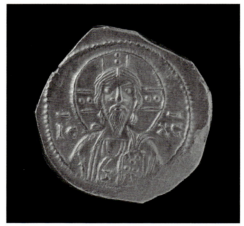

40a

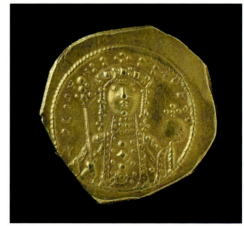

40b

# Macedonian Dynasty Empresses

The reverse of cat. 38 depicts Eudokia Ingerina, the first empress of the Macedonian dynasty, next to Constantine, her first-born son. Although he occupies the position of honor on the left, Constantine has the beardless face of an adolescent and stands in the background. Her image is larger and overlaps his, suggesting her precedence. The emperor Basil I (r. 867–86), founder of the dynasty, perhaps struck the coin in memory of his beloved son and wife, who had died in 879 and 882 respectively.[1] Basil, depicted on the obverse, was said to be inconsolable over his son's death. Despite his famous vigor, he did not remarry after Eudokia died, perhaps out of devotion to her memory.

It was highly unusual for a Byzantine empress to be depicted on coinage. The single recent precedent had been the iconophile Theodora, who, with her daughters, was included only on rare ceremonial solidi (cat. 35) during the reign of her husband, Theophilos (r. 829–42). Theodora also appeared on issues of her regency (r. 842–56, cats. 36, 37), but Eudokia never ruled as regent, only as empress-wife. Cat. 38 is rare and relatively unworn, like other coins of the same small issue, suggesting it had a special commemorative purpose. If so, Eudokia would be one of only two Byzantine empresses to be honored with a posthumous portrait on coinage.[2] Alternatively, the type may mark Constantine's coronation in 868, but this does not explain Eudokia's presence.[3]

The noble and beautiful daughter of Inger, perhaps a Viking in imperial service, Eudokia is said to have been one of the most seductive empresses in history.[4] Her shamelessness displeased the dowager empress Theodora, whom she served at court, but Eudokia nevertheless consorted simultaneously with two emperors.[5] Michael III, Theodora's son and heir, arranged for her marriage of convenience to his co-emperor Basil, so that Eudokia could remain accessible to Michael as his mistress after he was forced to marry another woman chosen by his mother.[6] When Basil murdered Michael in 867 to gain the throne, Eudokia was crowned *augusta* and ruled with him for fifteen years. Unfortunately, their earlier unconventional relationship created dynastic problems. Their son Constantine and his younger brother, the future emperor Leo VI (r. 886–912), were born while Michael was still alive. Basil considered Constantine to be his son and Leo to be Michael's. Eudokia's response to what became a serious family conflict is unclear. She did take an active interest in Leo's affairs, arranging a bride show and selecting the pious Theophano (cat. 172b), a relative of hers, to be his wife. Leo praises his mother as beautiful and aristocratic in his funeral oration for Basil.[7] However, one of Leo's first official acts as emperor was to collect Michael's remains and bury them with imperial honor in the church of the Holy Apostles.[8] This suggests that he believed Michael was his father; it is unlikely that he would have admired the woman who was complicit in his death.[9]

Cat. 39 is a rare solidus that was perhaps struck in 914, when the empress Zoe Karbounopsina, widow of the emperor Leo VI, began her difficult six-year rule as regent for their son Constantine VII (r. 913–59).[10] Zoe and Constantine are depicted on the reverse, with the boy in the place of precedence, affirming his accession, no doubt to fore-

stall the formidable military rivals who sought his throne.[11] Zoe's hand is above his on the patriarchal cross, establishing her authority. Constantine's long, triangular face and slender proportions, mature for his age (between eight and thirteen), recall portraits of his father Leo (cat. 57b). The obverse type copies a design introduced by Basil I, representing the enthroned Christ above the emperor's throne in the Chrysotriklinos, the main audience hall of the Great Palace.[12] These visual references emphasize the position of Zoe and her son as the rightful heirs of the Macedonian dynasty.

Zoe was a strong-willed ruler who fought for her own position and her son's inheritance. Expelled from the palace in 913 by a board of regents headed by her old political adversary, the patriarch Nicholas Mystikos, she was forced to enter a convent. Nevertheless, she succeeded in recovering the regency after eight months, ruling in the face of tremendous opposition. Her regime ended in 919, when the admiral Romanos Lekapenos entered the capital and assumed command of the palace guard. Romanos consolidated his position by marrying his daughter to Constantine, now almost fourteen. Zoe was accused of trying to poison Romanos and was permanently exiled in 920 to the monastery of Saint Euthymia in Petrion, where she took the name Sister Anna.[13]

Like Eudokia Ingerina, Zoe Karbounopsina (of the coal-black eyes) was a physically striking noblewoman at court who began her imperial career as the mistress of an emperor. As Leo's concubine, she gave birth in 905 to Constantine, his long awaited and only male heir. The patriarch Nicholas bargained to have Zoe expelled from the palace in return for baptizing the boy as an imperial heir in the Hagia Sophia. Leo soon married her anyway, in an uncanonical marriage that sparked the famous "tetragamy" crisis. Their marriage, Leo's fourth, was considered anathema by the Church; the emperor was officially disgraced, forbidden by the patriarch to enter the Hagia Sophia.[14] After Leo's death in 912, Zoe retaliated. According to a contemporary chronicler, she sent fifty swordsmen into the patriarch's chamber, "running all about hither and thither, and with their fearful aspect and arms to terrify him."[15]

The last ruler of the Macedonian dynasty, Theodora (r. 1055–56; cats. 20b, 40b) was the only empress of her line to rule alone as *autokrator*, the male title of emperor and supreme ruler that she adopted; she was the first woman since Irene (sole ruler 797–802, cats. 18, 19) to do so.[16] Theodora was the only empress in Byzantine history to exercise supreme rule without ever having been married and without obeisance to male authority. Since Byzantines considered it "improper" for a woman to govern, Theodora's career is extraordinary.[17] She is depicted on this gold coin full-face, with a stern expression, imposing in her jewel-encrusted regalia—an image that perhaps consciously paralleled depictions on coins of her immediate predecessor, the emperor Constantine IX Monomachos.[18] Although she was in her seventies when she inherited the throne, Theodora took full control of her ancestral office, as the chronicler Michael Psellos relates:

> She herself appointed her officials, dispensed justice from her throne with due solemnity, exercised her vote in the courts of law, issued decrees, sometimes in writing, sometimes by word of mouth. She gave orders, and her manner did not always show consideration for the feelings of her subjects, for she was sometimes more than a little abrupt.[19]

Theodora's blood claim to the throne apparently gave her the authority to rule as *autokrator*. When she had ruled briefly before, in 1042, with her sister Zoe, the two were proclaimed *autokrators* by the people in a unique historical case, confirming their possession of total power.[20] Theodora's ambition is suggested by her involvement in two revolts during the reign of Romanos Argyros (r. 1028–34), her sister's husband; her temporary exile to a convent by the jealous Zoe; and the popular acclaim that brought her back to the throne with her sister. As sole ruler she openly took on a male role, wielding authority in all areas of government. In particular, her appointment of clerics, considered a masculine privilege, angered many, including the powerful patriarch Michael Keroularios. Exercising her prerogative, she simply refused to meet with him. Like her great-grandfather Constantine VII and her uncle Basil II, she used the title Porphyrogennetos (born in the purple chamber of the Great Palace) on her coinage, invoking her great imperial pedigree to consolidate her power. She died in the palace after a digestive illness, waiting until the last moment to appoint a successor.[21]　EG

1. *DOC*, vol. 3, part 2, 481.

2. Constantia, half-sister of Constantine I, was commemorated on coins struck after her death in 330. See *Romans and Barbarians* 1976, 110, cat. 118.

3. *DOC*, vol. 3, part 2, 481.

4. Eudokia was also a member of the Martinakioi family (Garland 1999, 110).

5. The empress Theodora (regent 842–56) and her advisor Theoktistos were concerned over Michael III's liaison with Eudokia "on account of her impudence and shamelessness" (Garland 1999, 104, quoting the tenth-century chronicler Leo Grammatikos).

6. Herrin 2001, 224–25.

7. Garland 1999, 110.

8. Ibid., 109.

9. Ibid., 110.

10. Gold issues may have been suspended afterward until the 920s (*DOC*, vol. 3, part 2, 533).

11. Leo Phokas, commander of the army, and Romanos Lekapenos (r. 920–44), admiral of the fleet (*DOC*, vol. 3, part 2, 527).

12. *DOC*, vol. 3, part 2, 533.

13. Ibid., 527; Garland 1999, 124.

14. Garland 1999, 114–15.

15. Ibid., 120, citing the anonymously written *Life of Euthymios*, about the patriarch of Constantinople 907–12.

16. Ibid., 167.

17. Psellus 1966, 262 (6.3–5).

18. *DOC*, vol. 3, part 2, cat. 3.2, pl. 58.

19. Psellus 1966, 261–62 (6.3–5); Garland 1999, 166.

20. Bensammar 1976, 290.

21. Garland 1999, 143, 161, 166, 167 n. 30.

## 41 Histamenon of Eudokia Makrembolitissa as Regent

Mint of Constantinople, 1067
Gold
Diam. 2.6 cm, wt. 4.45 g, reverse die axis 6 o'clock
Obv: clockwise from lower left, +IhS XIS RCIX RCSN ΛNTIhIΠ (Jesus Christ, King of Those Who Rule)
Rev: clockwise from lower left, +ΠIX ЄЧ ΔK KѠNS (Michael, Eudokia, Constantius); double-struck
Arthur M. Sackler Museum, Harvard University, Bequest of Thomas Whittemore, 1951.31.4.1610

COLLECTION HISTORY Thomas Whittemore collection.

PUBLISHED *DOC*, vol. 3, part 2, 783, cat. 1.1.

## 42 Marriage Histamenon of Eudokia and Romanos IV

Mint of Constantinople, 1068–71
Gold
Diam. 2.6 cm, wt. 4.38 g, reverse die axis 6 o'clock
Obv: clockwise from lower left, KѠN ΠX ANΔ (Constantius, Michael, Andronikos)
Rev: clockwise from lower left, +PѠΠANS ЄVΔ ƵΛIIΛ (Romanos and Eudokia); to left and right of Christ's head, I͞C X͞C (Jesus Christ)
Arthur M. Sackler Museum, Harvard University, Bequest of Thomas Whittemore, 1951.31.4.1611

COLLECTION HISTORY Thomas Whittemore collection.

PUBLISHED *DOC*, vol. 3, part 2, 790, cat. 1.5.

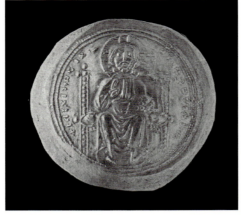

41a

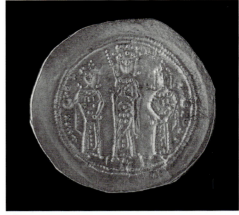

41b

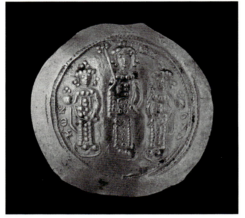

42a

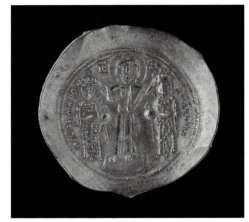

42b

# Empresses of the Doukas Dynasty

The death of the emperor Constantine X Doukas in 1067 left the dynamic Eudokia Makrembolitissa "as ruler . . . with the totality of power" and regent on behalf of her three sons.[1] From the first issue of her regency, cat. 41 depicts the empress in the central position on the reverse, an elegant, stately figure wearing a *loros* and crown covered with jewels, and holding the long scepter of senior office. Her sons flank her in the background, as they did in imperial audiences, holding the *globus cruciger* as a sign of their legitimate rule. Eudokia clearly takes precedence over them, despite the fact that an empress was not normally in the line of succession and her portrayal never became a requirement in official imagery. Her unusual authority is attested by the fact that her son Michael, at left, was no longer a minor. In spite of this, her husband had requested that she be given complete control of the government after his death, in association with Michael and Constantius, her first and third sons;[2] he probably believed that only through her would the new Doukas dynasty survive on the throne. Eudokia joins Helena (cats. 16, 24), Irene (cats. 18, 19), and Anna of Savoy (cat. 45) as the only Byzantine empresses to remain on coins after their adult sons became emperors. Here she occupies the histamenon, the most valuable denomination of the empire.

## 43 Tetarteron of Eudokia and Romanos IV

Mint of Constantinople, 1068-71
Gold
Diam. 1.9 cm, wt. 4.05 g, reverse die axis
6 o'clock
Obv: clockwise from lower left, +ΘΚΕ ROHΘ (God-Bearer, Help); to Virgin's left and right, M̄P ΘV̄ (Mother of God)
Rev: clockwise from lower left, +Iω MANS CVΔKRI (Romanos and Eudokia)
Arthur M. Sackler Museum, Harvard University, Bequest of Thomas Whittemore, 1951.31.4.1612

COLLECTION HISTORY Thomas Whittemore collection.

PUBLISHED *DOC*, vol. 3, part 2, 791, cat. 3.3.

## 44 Tetarteron of Michael VII Doukas and Maria of Alania

Mint of Constantinople, 1071–78
Gold
Diam. 1.8 cm, wt. 4.0 g, reverse die axis
6 o'clock
Obv: clockwise from lower left, + ΘΚΕ ROHΘ (God-Bearer, Help); to Virgin's left and right, M̄P ΘV̄ (Mother of God)
Rev: clockwise from lower left, +MI XAHΛ SM PA (Michael and Maria); worn die
Arthur M. Sackler Museum, Harvard University, Bequest of Thomas Whittemore, 1951.31.4.1623

COLLECTION HISTORY Thomas Whittemore collection.

PUBLISHED *DOC*, vol. 3, part 2, 808, cat. 4.2.

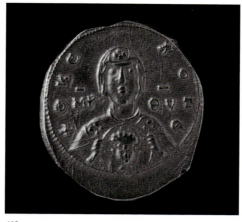
43a

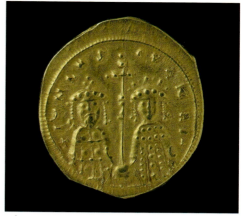
43b

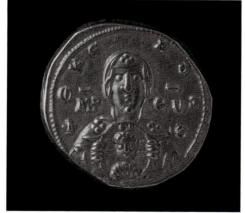
44a

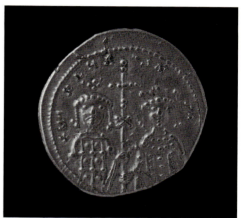
44b

Eudokia's career marks the ascendancy of the great Anatolian families among the elite of the capital. She was the niece of the patriarch Michael Keroularios, and her husband, scion of the aristocratic Doukas family, had been president of the Senate before becoming emperor in 1059. Eudokia was also a patron of the Byzantine imperial chronicler Michael Psellos, the tutor of her son and heir Michael VII (r. 1071–78). Psellos describes Eudokia as a lady of "noble birth, great spirit, and exceptional beauty." He also praises her modesty as a regent: "Neither in the imperial processions nor in her own clothing was there any mark of extravagance."[3]

Eudokia's personal qualities were truly impressive. She was learned and authoritative—in addition to being fertile, bearing seven imperial children by Constantine X. Yet her husband apparently feared that after his death her ambition might threaten the Doukas dynasty. He placed her in the difficult position of taking a public oath, in the presence of the patriarch, a church synod, and the Senate, on pain of anathema, not to remarry and to exclude anyone other than his brother, the *caesar* John Doukas, from participation in her government.

Eudokia's political power gave her license. Rather than ceding the throne to her adult son, Michael, which would have been the accepted procedure, she decided under pressure

from the court to break her oath and remarry, choosing the much younger Romanos Diogenes, a general, whom Psellos suggests she believed she could control. Romanos was introduced discreetly into the palace on New Year's night in 1067. He was presented to Michael VII and to Psellos, who feared the consequences of the choice. The next morning, Romanos married Eudokia and was crowned and acclaimed *autokrator* (supreme ruler, masc.) in the Hagia Sophia, the cathedral of the capital. The reverse of cat. 42, a histamenon, commemorates the marriage and double coronation, an unusual theme in official art. Christ crowns the new imperial couple, investing them with the sacred authority of office and sacrament. Romanos is given the senior position at left, but husband and wife are equal in size and both hold the *globus cruciger*, suggesting their partnership and joint rule. Eudokia's sons, however, are privileged. They occupy the obverse, with Michael in the central position. Psellos suggests that Romanos had agreed in writing to "be a subject, not a ruler": in short, to protect the dynastic rights of Eudokia and her sons.[4] Their prominence on this coinage, especially the presence of Andronikos Doukas, right, whom Michael crowned as co-emperor, suggests that Romanos deferred to their authority. Eudokia widely used the double-coronation theme, which also appeared on seals and diplomatic ivory panels of Romanos' reign, to publicize her continued supremacy and that of the Doukas dynasty.[5]

Eudokia's power during Romanos' reign (1068–71) is illustrated by the striking image on the reverse of cat. 43, a tetarteron. Romanos is technically in the position of precedence at left, but the couple's hands are clasped together at the same level on the staff of the cross scepter, affirming Eudokia as his equal and co-ruler. It is likely, however, that she actually superseded him: on a contemporary pattern for a tetarteron, she and not Romanos occupies the obverse. These coins explicitly represent Eudokia as the bond with and legitimizing factor of her second husband's government.[6]

Eudokia had two sons in quick succession with Romanos, who crowned them, weakening the political position of the Doukai. Hostility from the powerful Doukas faction in the government and military was a negative factor at the battle of Manzikert, contributing to the disastrous Byzantine defeat and Romanos' capture by the Seljuq Turks on August 19, 1071. Eudokia called a conference; it was agreed that Romanos, alive or dead, should be ignored and that rule should pass once again to the empress and her sons. Although Michael had great respect for his mother, Romanos had sent a letter to her from exile, a potential threat to Michael's security that could not be ignored. The *caesar* John Doukas finally intervened, arranging for Michael to be proclaimed emperor. Eudokia was deposed and sent to her convent of Piperoudion on the Bosporos, along with Romanos' two sons, who were stripped of their imperial rank.[7]

The tetarteron of Michael VII and Maria of Alania, his wife (cat. 44), is based on that of his mother and Romanos (cat. 43). Both feature the Virgin Nikopoios (Victory-Maker, the Virgin holding a medallion of Christ before her chest) on the obverse and busts of the imperial couple next to one another on the reverse, holding a long cross scepter between them. However, Michael (at left) is clearly the senior ruler, with his hand above his wife's on the staff of office. Daughter of the Georgian king Bagrat IV, Maria

probably married Michael before the death of his father in 1067. They had a son, Constantine, born in 1174, who was made co-emperor at an early age.[8] Maria is also depicted on miliaresia of Michael (cat. 21a). In preceding centuries, the consorts of emperors had rarely been represented on coins. Michael was undoubtedly influenced by the example of his mother, Eudokia, under whose tenure the empress's bust replaced that of the junior emperor on miliaresia of his father, Constantine; she was also highlighted during her regency (cat. 41b). Maria's prestigious royal lineage and the need to promote her for diplomatic reasons may also have been a factor in her inclusion.

One of only two foreign-born eleventh-century empresses, Maria may have lived in Constantinople as a young girl, perhaps as a diplomatic hostage at the court of the empress Theodora (cats. 20b, 40b).[9] Psellos praises Maria's beauty and modesty, and the chronicler Anna Komnene, daughter of the emperor Alexios I Komnenos (r. 1081–18) describes her as breathtaking.[10] When Michael VII abdicated the throne and was forced into religious life, Maria married his successor, the older general Nikephoros Botaneiates (r. 1078–81). She is also represented with Nikephoros on his silver coinage, publicizing her as co-ruler and legitimizing his accession.    EG

1. Psellus 1899, 243 (1.10–12).

2. For Eudokia as supreme ruler, see Psellus 1966, 345 (7.1–2); on the iconography of Eudokia's reign, see Kalavrezou-Maxeiner 1977, 317; for a history of Eudokia's career, see Garland 1999, 168–79.

3. Psellus 1966, 345 (7.1–2).

4. Ibid., 348–49 (7.6–9).

5. Kalavrezou-Maxeiner 1977, 318.

6. Garland 1999, 175.

7. Psellus 1966, 356–57 (7.13–17).

8. Garland 1999, 180.

9. The other is Aikaterina, daughter of John Vladislav, ruler of Bulgaria, and wife of the emperor Isaak I Komnenos (r. 1057–59).

10. Psellus 1966, 372 (7.9–10); Comnena 1969, 107 (3.2).

## 45 Assarion of Anna of Savoy and John V Palaiologos

Mint of Thessaloniki, 1351–54 (?)
Bronze
Diam. 1.9 cm, wt. 2.24 g, reverse die axis 7 o'clock
Arthur M. Sackler Museum, Harvard University, Bequest of Thomas Whittemore, 1951.31.4.1957

COLLECTION HISTORY Thomas Whittemore and Osman Bey collections.

PUBLISHED *DOC*, vol. 5, part 2, cat. 1192, pl. 62.

45a

45b

Anna of Savoy's presence on the reverse of this rare coin, probably struck just after her son reached adulthood, demonstrates her authority and influence during his reign. Ruling as regent from 1341 to 1347, the Italian-born dowager empress won the support of the patriarch and other high officials and succeeded in keeping her political rival, Grand Domestic John Kantakouzenos, from the capital. The empire fell into civil war and Anna

was forced give the Byzantine crown jewels to the Venetians as security for a loan. She was eventually compelled to come to terms with Kantakouzenos, who was crowned senior emperor in 1347.[1]

Anna stands on the reverse, to the right of her son, John V Palaiologos, who occupies the position of honor. She holds a trefoil-headed scepter of imperial office and he a *labarum,* indicating their joint investiture in power. Dowager empresses are seldom depicted on Byzantine coins and even more rarely after their sons reach majority. The other exceptions are Helena (cats. 16, 24, 173) in the early fourth century, Irene (cats. 18, 19) in the late eighth century, and Eudokia Makrembolitissa (cats. 41–43) in the eleventh century. After the recovery of Thessaloniki from the Zealots, a local rebel group that had set up a regime there, and her son's unsuccessful attempt to wrest power from Kantakouzenos, Anna was given sole rule of the empire's second city, which she governed from 1352 to 1365. Although minting was not a usual privilege of the rulers of Byzantine appanages, Anna's position as *autokratorissa* (supreme ruler, fem.) allowed her to strike large numbers of bronze coins in Thessaloniki.[2] After her son finally became senior emperor in 1354, she continued to mint coins; they depicted her on what may have been the obverse, in full regalia, holding a model of the city.[3]

Contemporary writers view Anna's career with the characteristic Byzantine ambivalence toward female rulers: The fifteenth-century historian Doukas attacks her regency, likening the empire in female hands to "a weaver's shuttle spinning awry and twisting the thread of the purple robe," implying that handiwork and not rule was the proper vocation of women.[4] However, Anna's rule at Thessaloniki, whose patron saint, Demetrios, is featured on the obverse of this coin, is praised in other sources: Nicholas Kabasilias, a native of the city, lauds her for restoring tranquillity to her portion of the empire.[5]

Anna was a patron of both the city and the Church. An inscription on the acropolis of Thessaloniki commemorates her gift of a gateway in 1355. She donated a splendid psalter, preserved on Mount Athos, to the Hodegon monastery in Constantinople in 1346. Her last known official act was a donation to the convent of the Anagyroi in Thessaloniki around 1360. She retired to a convent, taking the pious name Anastasia. Though she was Catholic by birth, she is honored as a champion of Orthodoxy in the Synodikon of Orthodoxy and in a list on Mount Athos of worthy leaders of the Church and state.[6]   EG

1. Philip Grierson agrees with S. Bendall's attribution of the coin to the period of Thessaloniki's recovery from the Zealots, after Anna's regency ended (*DOC,* vol. 5, part 1, 175–76, 186).

2. John was demoted to a less prestigious governorship in Thrace. Anna, but not her son, was listed in the imperial acclamations when Matthew Kantakouzenos was crowned emperor in 1353 (ibid., 197–98). In the late Byzantine period, the empire was more decentralized, administered as a series of separate fiefdoms.

3. Bendall and P. J. Donald suggest that the side with Anna's portrait is the obverse (Bendall and Donald 1979, 248-53, cats. 3–7). Grierson suggests that the side with John V's portrait is the obverse (*DOC,* vol. 5, part 1, 198–99).

4. Talbot 2001b, ch. 1, 142.

5. *DOC,* vol. 5, part 1, 197–98.

6. Nicol 1994, 93–95, nn. 33, 34, 38.

## 46 Seal of Anna Doukaina, Sebaste

Byzantine, c. 1068–before 1136
Lead
Diam. 3.0 cm, wt. 24.6 g
Obv: in upper field to left and right of Virgin, MP ΘV (Mother of God)
Rev: metrical, four lines, – + –/ ΘKЄ ROHΘ/ ANNH CЄR´/CTH TH ΔV/KAINH (Mother of God, help Anna Doukaina, *sebaste*)

Arthur M. Sackler Museum, Harvard University, David M. Robinson Fund, 1999.63

COLLECTION HISTORY Collection of George Zacos, purchased from Spink and Son Ltd., Oct. 7, 1998.

PUBLISHED Spink Auction 1998, 40, cat. 77.

46a     46b

This seal most likely belonged to Anna, the daughter of Andronikos Doukas. Her sister Irene Doukaina became the wife of the emperor Alexios I Komnenos (r. 1081–1118), who granted Anna the title of *sebaste*, a distinction he introduced for his female relatives by blood or marriage, when she became his sister-in-law.[1] She married George Palaiologos, a high-ranking general, in 1081, and died between 1118 and 1136.[2] Anna chose to depict on her seal the Virgin Blachernitissa, the image of the Virgin with raised arms and a medallion with the Christ child suspended before her. This iconographic type of the Virgin had become popular in the eleventh century (see cats. 54, 55) and was used by both men and women.[3] IK

1. Angold 1984, 4.

2. Polemis 1968, 74–75; Spink Auction 1998, 40.

3. Pentcheva 2000, 34–56. For further examples of this type on seals see Zacos 1984, cats. 419, 578, 581, 620, 806, 823, 838. These seals date from the last third of the eleventh century. See also Sode 1997, 183, cat. 357, pl. 15, for a damaged seal of the same type.

## 47 Seal of Maria Komnene

Byzantine, mid-12th century
Lead
Diam. 3.2 cm, wt. 21.0 g
Obv: to left and right of the Virgin, MP ΘV; vertically, H/ A/Γ/I/CO/PITI/CCA (Mother of God of the Holy Soros [reliquary])
Rev: metrical, in six lines, +/ CKЄΠOIC KO/MNHN ΠAIΔ AN/[Δ]PO NIKV KOPH/ [CЄ]RAΨOKPATH/ [Π]OPΦVPAVΓ/MAPIAN (protect the purple-lustrous Maria Komnene, child of Andronikos, daughter of the *sebastokrator*)

Dumbarton Oaks, Washington, D.C., 1958.106.522

COLLECTION HISTORY George Zacos collection, Basel.

PUBLISHED Zacos and Veglery 1972, cat. 2733a, pl. 186.

47a     47b

This seal belonged to Maria Komnene, niece of the emperor Manuel I Komnenos. She was the oldest daughter of Andronikos Komnenos, *sebastokrator*—a title reserved for the emperor's oldest brother. Her first husband was Theodore Dasiotes, who was captured in 1143 by the soldiers of the sultan Masout of Ikonion. She then married John Kantakouzenos, who was killed in the battle of Myriokephalon in 1176. Since she is mentioned in the inscription in relation to her father, she was probably not yet married when the seal was made, and it should be dated before 1143. On the obverse the Virgin is represented in full length,

facing left, with her arms extended in prayer. This iconographic type of the Virgin, the Hagiosoritissa, probably reproduces an original image from the Soros chapel of the Blachernai church in Constantinople, which housed a reliquary containing the Virgin's mantle.[1] The Virgin Hagiosoritissa is an unusual type and not often found on seals.   IK

1. *ODB* 1991, 1929, 2171.

## 48 Votive Cross

Syria-Palestine, Byzantine, 6th–7th century
Bronze
H. 18.4 cm, w. 15.1 cm
Obv: + ΥΠЄΡ/ ϹΥΝΧΟΡ/ЄϹЄΟϹ Π/ΑΡΑΠ-
ΤΟ/ΜΑΤΟΝ Λ/ЄѠΝΤΙΑϹ (for forgiveness of the sins of Leontia)
Dumbarton Oaks Collection, Washington, D.C., 69.75

COLLECTION HISTORY Hayford Peirce collection, New York; gift of Mrs. Hayford Peirce to Dumbarton Oaks, December 1969.

PUBLISHED *Processional Crosses* 1994, 90–95, cat. 9, fig. 33a, b; *Cradle of Christianity* 2000, 90.

This cross, although in good condition overall, is missing the bottom of the lower vertical arm. It also has a small crack in the lower right corner of the intersection and is slightly bent. The three complete arms flare slightly and their points end in small discs. According to the inscription on the lower portion, the cross was a gift of Leontia in an appeal for forgiveness of her sins. Just above the dedicatory inscription, a saint on a pillar is depicted without an inscription to identify him; judging from his appearance, he may be Saint Symeon the Elder. The presence of a stylite saint near the inscription suggests that the cross was given to a church dedicated to Saint Symeon or another stylite. The cross has been dated to the sixth to seventh century and placed in the Syria-Palestine area because of its stylistic and paleographic features.[1]

The front of the cross is decorated with a number of additional holy figures, all engraved. On the upper vertical arm Christ is shown standing, holding the gospel book in his left hand and blessing with his right. At the intersection is a depiction of the Annunciation to the Virgin, with the angel approaching from the right. Mary is standing, still holding the skein of yarn she has been spinning out of wool pulled from a basket. This scene is flanked by figures on the left and right arms. The figure on the left is most likely John the Baptist, or the Forerunner, the prophet who recognized the Messiah. He stands in his typical pose, with his right arm raised and his index finger pointing toward Christ. On the right a high priest holding a censer and wearing bells on the fringe of his mantle is possibly Aaron, whose sprouting rod has become a typological symbol for the Virgin.[2] An amphora containing three sprouting branches, placed between Saint John and the scene of the Annunciation, should be regarded as another symbol of the Virgin Mary: she is the vessel from which the Word Incarnate will sprout. The representation of the Virgin Mary here, especially in the Annunciation scene, emphasizes the reality of the Incarnation and thus the Passion and Death of Christ on the cross, which bring salvation to mankind. The iconographic theme was thus most appropriate for the gift of Leontia, who was asking for salvation.

The reverse of the cross has three concentric circles around a dot, placed precisely at the intersection of the arms. These circles, often seen as apotropaic symbols, are frequently found on crosses as well as on other bronze and bone objects.[3]   IK

1. *Processional Crosses* 1994, 90.

2. For a discussion of the possible identities of these figures, see ibid., 92–95.

3. *Art and Holy Powers* 1989, 5–7.

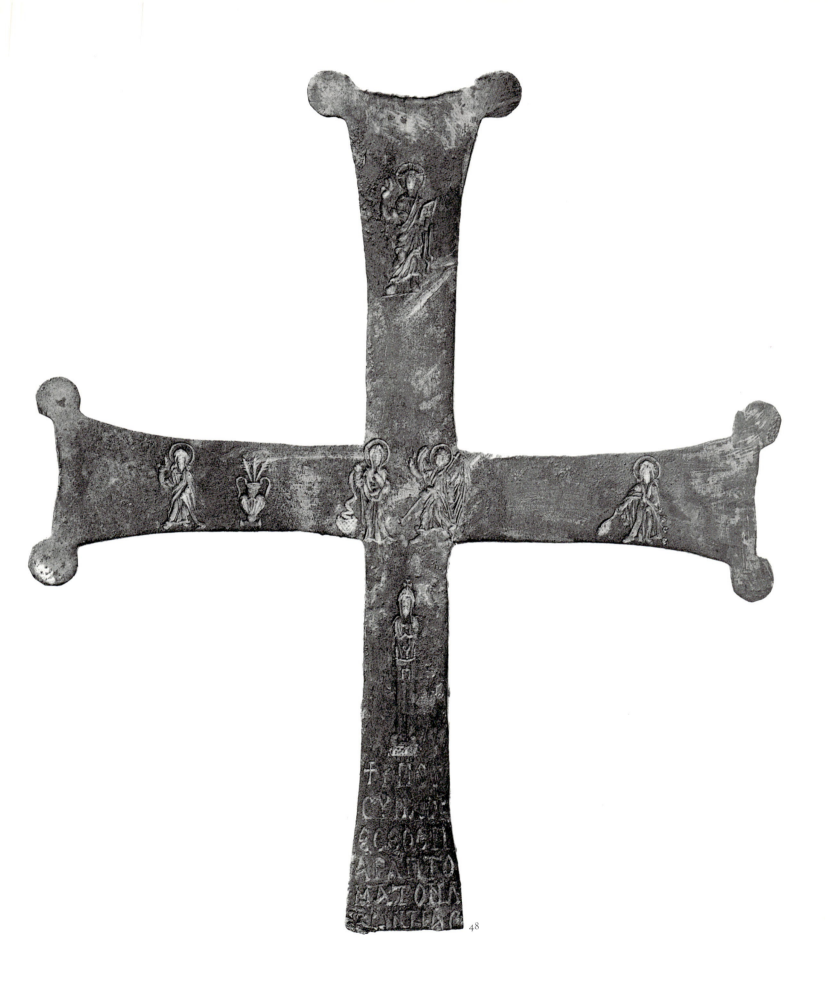

48

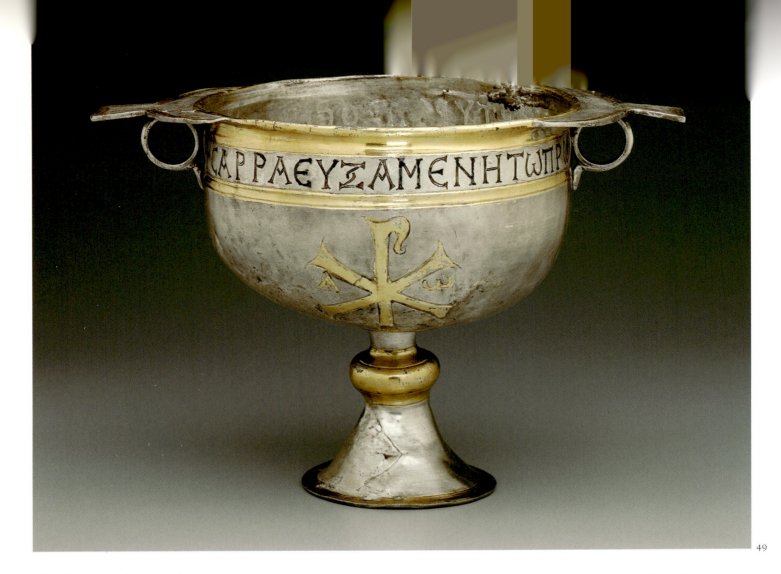

## 49 Chalice Dedicated by Sarra

Syria, Byzantine, early 6th century
Silver with niello inlay and gilding
H. (max.) 18.0 cm, w. (max., at handles)
26.6 cm; w. (bowl) 16.0 cm
Inscription: + CAPPA ЄVZAMЄNH TⳜ
ΠΡⳜTO MAPTVPI ΠΡOCHNЄΓKA
(I, Sarra, having prayed, offered [this] to the
First Martyr)
Museum of Fine Arts, Boston. Edward J. and
Mary S. Holmes Fund, 1971.633

COLLECTION HISTORY Purchased by the
Museum of Fine Arts from Robert E. Hecht,
Jr., December 8, 1971.

PUBLISHED *The Rathbone Years* 1972, 64, cat. 47;
Dodd 1974, 15, 25; *Romans and Barbarians* 1976,
193–94, cat. 225; *Age of Spirituality* 1979, 608,
cat. 543; *Silver from Early Byzantium* 1986,
246–47, cat. 73.

Large gold Christograms (combinations of the first two letters of ΧΡΙCΤΟC, *Christos*) mark the front and back of this chalice, signaling its likely use as a container for the wine of the Eucharist. An alpha and an omega hang from either side of the upper arms of the cross, representing Christ as the beginning and the end of all things.[1]

The niello inscription between the handles reveals a woman, Sarra, as the patron and donor of the work. She offered the vessel to Stephen, the first martyr and first deacon.[2] The dedication of this offering to him exploits the confluence of symbolic and actual sacrifice associated with him. Through the gift of this chalice, Sarra heightened her participation in the central Church ritual of sacrifice.

The chalice was found alongside a paten datable to the reign of Anastasios (498–518).[3] Although the exact findspot is a matter of speculation,[4] the discernible facts of the production of the chalice can suggest its meaning. The choice of a prominent inscription to commemorate the female patron, along with the display of a central Christian symbol, documents the ability of a woman of means to penetrate the male-controlled ritual of Communion and to preside as a patron over that collective experience. JKS

1. Rev. 1:8.

2. Acts 7:57–60 and 6:5.

3. Dodd 1974, 25.

4. *Silver from Early Byzantium* 1986, 246.

## 50 Chalice Dedicated by Anthousa and Ardabarios

Syria (?), Byzantine, 5th century
Silver
H. 19.4 cm; diam. 18.6 cm, with cross handles 27.4 cm
Inscription: across handles, +VΠЄР ЄVXHC ANΘOVCHC+ (in fulfillment of a vow of Anthousa); +VΠЄР ЄVXHC APΔABOVPIOV+ (in fulfillment of a vow of Ardabarios)
Dumbarton Oaks Collection, Washington, D.C., 59.66

COLLECTION HISTORY Gift of Mr. and Mrs. Robert Woods Bliss, 1959; acquired in the Near East (purchased by George Zacos).
PUBLISHED Ross 1962, 4–5, cat. 5, pl. 4; *DO Handbook* 1967, no. 56; Demandt 1986, 113–17.

Across the handles of this classically shaped silver chalice run a pair of inscriptions, one indicating that the chalice was dedicated in fulfillment of a vow by Anthousa and the other that it was dedicated in fulfillment of a vow by Ardabarios. The two were probably a wife and husband who joined together in this offering, either in return for a benefit received or in anticipation of one for which they hoped. Multiple crosses on the handles, two framing each inscription and one punctuating each tip, signal the Christian affiliation of the couple, who likely offered the chalice to a church.

A family of consuls bearing the name Ardabarios is attested in the fifth century in Byzantium. A woman by the name of Anthousa appears in the *Life of Isidore*, the biography of a contemporary scholar written by his colleague Damaskios and preserved by the ninth-century patriarch Photios in his *Bibliotheca*, a compilation of texts by pagan and Christian authors. Clues within the story have led to the identification of Anthousa's husband as Ardabarios Junior, consul in 447.[1] Anthousa's family traced its roots to Pelops, the great-grandfather of Orestes, while Ardabarios was a Goth. According to the story, Anthousa consulted an oracle to learn the fate of her husband, who was away on a Sicilian campaign. The prophecy, which Anthousa interpreted from the movement of clouds, was the accurate prediction of his death. This chalice can be seen as a chance memorialization of the marriage.   JKS

1. Demandt 1986.

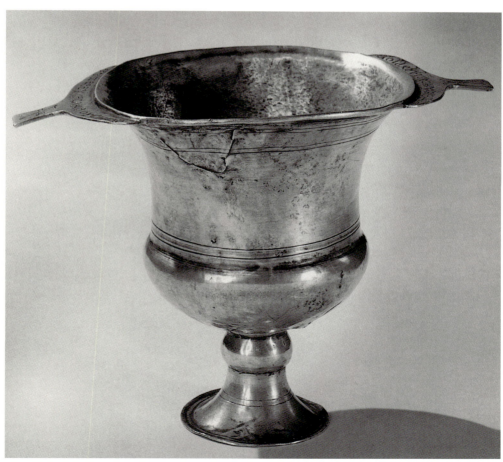

50

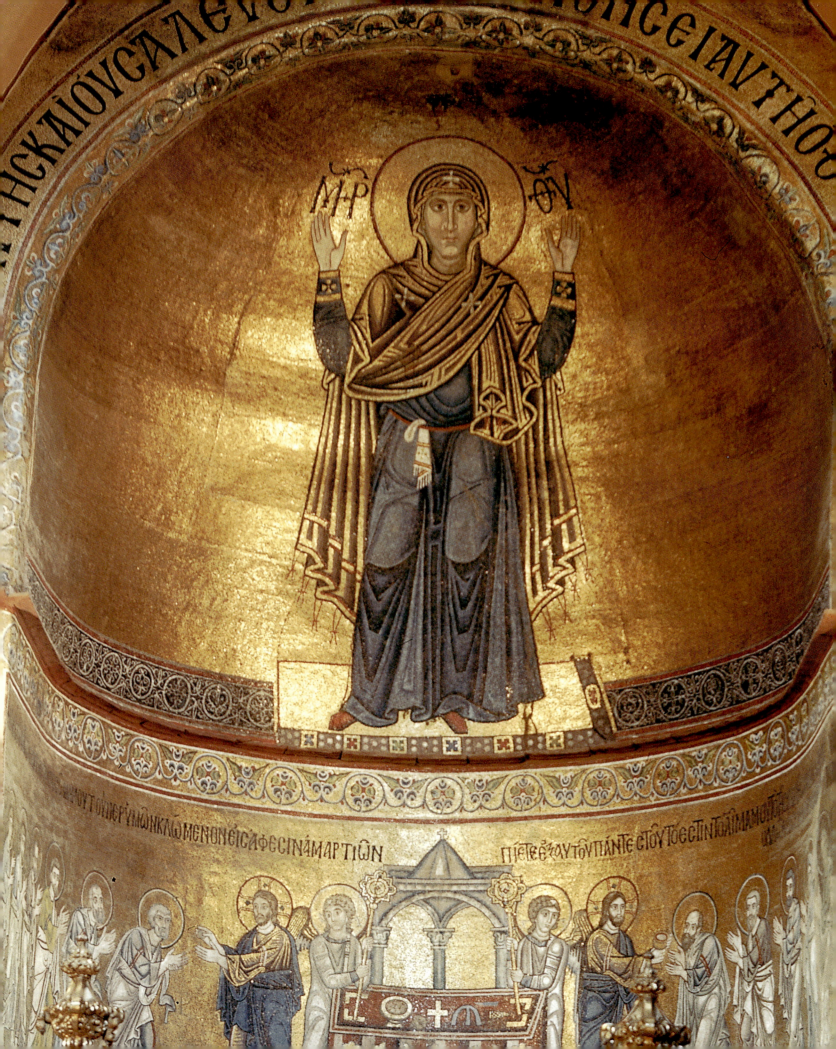

# PUBLIC DEVOTION

BISSERA V.
PENTCHEVA

## The Virgin of Constantinople: Power and Belief

Although recent generations have perceived Mary as a delicate and tender Virgin, Byzantines saw her as a woman of power. Among her many epithets were *Meter Theou*, Mother of God; *Panagia*, All-Holy One; and *poliouchos*, city protector.[1] Mary in Byzantium inherited the faculties of ancient goddesses of war and protection, such as Athena and Tyche, or of motherhood, such as Isis and Cybele.[2] She came to be perceived as the general of the Christian armies and the protector of the empire and its capital, Constantinople. Her role is clearly expressed in the opening verses of the "Akathistos," a sixth-century hymn addressed in thanksgiving to the Virgin and still sung today in Orthodox churches on the fifth Saturday of Lent:[3]

> *To you, our leader in battle and defender,*
> *O Theotokos, I, your city, delivered from suffering,*
> *address hymns of victory and thanksgiving.*
> *Since you are invincible,*
> *free me from all kinds of danger*
> *that I may cry to you:*
> *"Hail, bride unwedded."*[4]

The verses introduce the idea of Mary's invincibility into a hymn that was essentially about the Annunciation and the Incarnation. The "Akathistos" thus created a model for Mary's power in war that rested on her paradoxical virginal motherhood. Unlike Athena, the Byzantine Virgin was never depicted in military attire, brandishing a spear and a shield. Instead, the images carried into battle depicted her as a mother with the Child in her arms (fig. 12), or as a lone figure praying on behalf of her people.[5]

A number of holy women were the focus of intense public devotion in the Byzantine world. Churches dedicated to female saints such as Euphemia, Anna, and Thekla (cats. 67, 68, 183) gave the public access to a network of sacred female patrons.[6] Their *vitae* and medieval legends described outstanding virtue and nurturing qualities that predisposed them to act selflessly for the welfare of individuals and society. Some female saints, such as Theodora (cat. 23), Marina (cats. 184, 185), Melania, and the empress Theophano (cat. 172), were seen as facilitators of childbirth and reproductive health.[7] None of these saints, however, exerted an attraction as broad and deep as that of the Virgin Mary, and none was considered to possess comparable powers.

The cult of the Virgin emerged in Constantinople after the Council of Ephesus in 431, which confirmed Mary's title of *Theotokos*, Bearer of God. The recognition of her divine motherhood made the Virgin the focus of public devotion, promoted by the imperial family.[8] In the tumultuous times of Avar and Arab invasions, and especially during the Avar siege of 626, Mary came to be perceived as the supernatural defender of

Fig. 11. The Virgin Blachernitissa, 1043. Apse mosaic, Church of Hagia Sophia, Kiev, Ukraine. © Artephot/R. Percheron

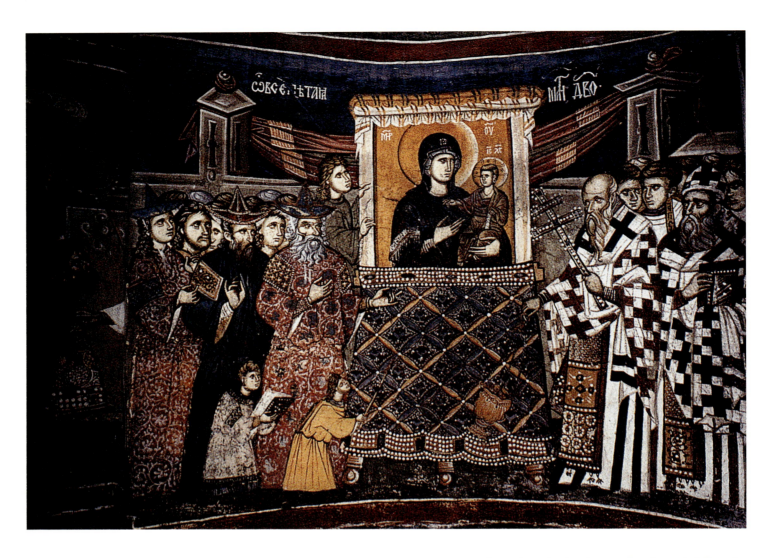

Fig. 12. Representation of the Icon of the Virgin Hodegetria. Verse 24 from the cycle of the Akathistos Hymn, late 14th century. Wall painting, Markov Manastir, Macedonia.

Constantinople.[9] In seventh-century texts, she is described as having fought and defeated the enemy at the sites of her two sanctuaries outside the walls of Constantinople: the Pege and the Blachernai.[10] The victory was celebrated at the Blachernai, and that church thus became associated with Mary's power in war. Here the emperors came to pray before embarking on military expeditions.[11]

After the Avars were repulsed, the emperor Herakleios expanded the city walls to encompass the Blachernai. The church was thus the last stronghold in the city for emperors going off to war, and the first sight for barbarians approaching the capital. Although the church has not survived, inscriptions known to have been in the mosaics of its interior reveal how the Byzantines perceived this sanctuary:

*Here they who are set up to rule over the earth [the Byzantine emperors] believe that their scepters are rendered victorious. Here the patriarch, ever wakeful, averts many catastrophes in the world. The barbarians attacking the city, on only seeing Her [the Virgin] at the head of the army bent at once their stubborn necks.*[12]

The inscription proclaims the belief that the Virgin at the Blachernai brings victory to emperors and death to barbarians. Both effects were elicited through the dutiful perform-

ance of the weekly liturgical service organized by the patriarch. Inscriptions in Byzantium were not silent texts; their potency was activated as the words were pronounced aloud in the liturgy.[13] The Blachernai inscription thus functioned as a publicly performed prayer to the Virgin.

The power of the Virgin in the Blachernai was identified with three physical elements: a holy spring, relics, and images. The waters of the spring, or *louma*, received the emperor on Fridays.[14] Yet these springs were also perceived to have brought about the destruction of enemies, as recorded in another inscription:

> *Here are the fountains of purification from the flesh, here is redemption of errors of the soul. There is no evil circumstance, but from Her [the Virgin] gusheth a miraculous gift to cure it. Here, when She overthrew the foe, She destroyed them by water, not by the spear. She hath not one method of defeat alone, who bore Christ and putteth the barbarians to flight.[15]*

The waters both purify the soul and "cleanse" the city of its enemies.

The second physical element identified with the Virgin's power in war was the relic of her robe, or *maphorion*, kept in the Soros chapel at the Blachernai (see cat. 47).[16] Starting in the middle Byzantine period, this relic was believed to have brought about the death of enemies. In a sermon, the patriarch Photios described the role of the robe in the 860 Russian siege of Constantinople:

> *When, moreover, the whole city was carrying with me her raiment for the repulse of the besiegers and the protection of the besieged, we offered freely our prayers and performed the [litany. . . .] Truly is this most-holy garment the raiment of God's Mother! It embraced the walls, and the foes inexplicably showed their back; the city put it around itself, and the camp of the enemies was broken up as at a signal; the city bedecked itself with it, and the enemies were deprived of the hopes which bore them on. For immediately as the Virgin's garment went around the walls, the barbarians gave up the siege, and broke camp, while we were delivered from impending capture and were granted unexpected salvation.[17]*

The robe of the Virgin is here perceived to have embraced the walls and saved the city from imminent disaster. A similarly poetic image of the *maphorion* protecting the Byzantines is offered by a vision of Saint Andrew the Fool, a "created saint" who supposedly lived in the fifth century and whose feast day was May 28.[18] A late-ninth- or tenth-century text describes how, in the fourth hour of the night, the Virgin appeared in the Blachernai church like an empress with an entourage—an escort of angels resplendently dressed in white and gold:

> *After the prayer she approached the sanctuary, praying there on behalf of the standing crowd. Then, with the end of the prayer, unwrapping her* maphorion, *which was carried on her all-pure head like a bright light, with gracious dignity, she took it in her hands. And, oh, great and awesome occurrence! She placed it above the whole crowd of standing people.[19]*

The vision of the Virgin spreading her *maphorion* over her people remains an image of unfailing protection.

It is quite likely that the figure of the Virgin in the apse of the Blachernai church also

alluded to the power of the *maphorion* and was associated with Mary's role in war. Indirect evidence offered by texts, Byzantine coins (cats. 60a, 63), and the mosaics in the Hagia Sophia of Kiev (fig. 11) suggests that the image in the apse of the Blachernai revealed Mary as a full, standing figure, spreading her cloak by extending her arms to the sides in a gesture of intercession.[20] The Blachernai mosaic was probably executed immediately after Iconoclasm, in 843, and prompted a series of copies, one of them in the palatine church of the Virgin of the Pharos, restored in 864. Here the Virgin is described as "stretching out her stainless arms on our behalf and winning for the emperor safety and exploits against the foes."[21] The text clearly identifies the iconography and its meaning: victory for the emperor.

A similar presence of the power of the Blachernai Virgin can be discerned in the iconographic copy in the apse of the church of Hagia Sophia in Kiev, built in 1037–46.[22] Here, too, the Mother of God stands full length, with arms lifted to the sides in prayer, spreading her *maphorion* over her people. The inscription on the face of the arch, a variation on Psalm 45(46):5–6, reads: "God is in the midst of her [understood as the city or the Virgin], she would not be shaken, God will help her when the morning dawns."[23] Paired with the image, the text can be seen to allude to both the city and the Virgin, who would always be protected by God. Mary's unfailing power is clearly linked here to the Incarnation: God is in her midst. It is from this source that Mary derives her power in battle.

The apse mosaic at the Blachernai, along with the relics and the holy spring, thus offered a material expression of the site's association with the military power of the Virgin. Eventually an icon, identified as the Blachernitissa, was promoted in that church and became the object Byzantine emperors took with them into battle.[24] The image most likely copied the mosaic representation of the Virgin in the apse: a standing figure with arms raised in prayer and spreading the *maphorion*, as exemplified on the silver issues of three eleventh-century sovereigns: Constantine IX Monomachos (r. 1042–55; cat. 60a), Theodora (r. 1055–56), and Michael VI (r. 1056–57). In all three cases, the image is identified with the name Blachernitissa, evoking the military might of Mary at the Blachernai.[25]

By associating his image with the figure of the Virgin of the Blachernai, even a weak emperor could present himself as strong. This is the message conveyed in the visual propaganda of Constantine IX Monomachos, who never set foot on a battlefield. Mary was often described as a fighter and ally, a *summachos*, which echoed in his family name: Monomachos means "Lone Fighter." The association of names is clearly revealed in the inscription, rhythmic with repetition, on a Marian icon the emperor owned: Τὴν ἀκαταμάχητον, ὦ Μονομάχε, ἐν ταῖς μάχαις ἔχων με σύμμαχον μάχου (Oh Monomachos, fight on, having me, the invincible, as co-fighter in the fights).[26] The emperor's verbal association with the Virgin of Blachernai found visual expression on his silver issues. The Blachernai image of the standing Mary appears on the obverse of his coins, while on the reverse Constantine IX Monomachos is portrayed in military attire, holding a scepter and a sword (cat. 60b).[27]

The same military propaganda figures in the mosaics of the monastery of Nea Moni,

which Constantine IX built to celebrate his accession to the throne. They play on the idea of imperial victory elicited through the powers of the Virgin. A copy of the Blachernai image of Mary standing with arms spread in prayer appears in the apse of the new church, while another image of the Mother of God surrounded by military saints decorates the vault of the narthex.[28]

The Blachernai's location next to the walls and its function as a sentinel of the city gave rise in the thirteenth century to the perception of Mary herself as the unassailable wall (τῆς βασιλείας τὸ ἀπόρθητον τεῖχος). The most eloquent visual expression of this idea is offered by the coins of Michael VIII Palaiologos (r. 1259–82) and his successors. Here the image of the Blachernitissa with arms lifted in prayer is contained within the walls of the city (cat. 63a). The juxtaposition suggests that just as the body of Mary has remained pure and intact *in partu* and *post partum*, so the city will survive upheaval unscathed.

In the eleventh and twelfth centuries the dominance of the Blachernai as the site of Mary's power in war was challenged by the emergence of a new Marian cult center, the Hodegon monastery, founded by guides for the blind, with its icon the Hodegetria, "The One Who Leads the Way" (fig. 12).[29] It shows the Virgin holding the Christ child in her left arm and gesturing toward him with her right hand. Weekly processions with the Hodegetria were perceived as a symbolic reenactment of the entrance of the Virgin, at age three, into the Temple.[30] Just as she was ushered into the Temple, the Hodegetria was brought to the altar at the culmination of the urban procession. This strong public presence of the icon resulted in its gradual immersion in the life of Constantinople and in historical memory.

By the mid-eleventh century the Hodegetria had been integrated into the procession for the annual Feast of the Akathistos. On the eve of Saturday of the fifth week of Lent, people carried icons from Hagia Sophia to the Blachernai. On their return, they stopped at the Chalkoprateia, a shrine named for its location in the coppersmiths' market.[31] Once the Byzantines began carrying the Hodegetria, they developed a new belief crediting that icon with the victory over the Avars.[32] Thus the Hodegetria subsumed some of Mary's protective and military powers originally associated with the Blachernai and came to be perceived as the *poliouchos,* or city protector. Whenever the city was besieged, the memory of the Hodegetria's purported appearance on the city walls was reenacted by bringing the icon there again. For instance, in 1186 the emperor Isaakios II Angelos (r. 1185–95) carried the Hodegetria up to the top of the walls to summon divine support and the allegiance of the people of Constantinople against the usurper Branas.[33]

In the Palaiologan period this rite was enacted more frequently because of the constant threat of invasion by the Ottoman Turks. The Hodegetria was usually brought to the Chora monastery, just within the city walls, which assumed the protective functions of the Blachernai in this period. A Palaiologan sermon describes how, in 1421, the Hodegetria was brought to the city walls, and how, after it repelled the attack, it was returned to its sanctuary at the Hodegon:

*The great and high priest of the* oikoumene *and all the royal priesthood,*[34] *the emperor and his sons, the leaders of the leaders, and all the chosen people,*[35] *monks and laymen, old and young, virgins and widows, and married women, as many natives as foreigners, the entire abundant crowds of your Christ-named and holy people, walked in procession singing hymns of victory and carrying candles as your icon [the Hodegetria] returned from the place of the living [the Chora monastery] to the Hodegon monastery, surrounding it [the icon] in a circle. The church [the Hodegon] greatly rejoiced, having received her icon, and proudly proclaimed to all, saying: "My glory exalts the Lord, who gave me a victory-bringer, an invincible and unconquerable general, the strengthening of my decrees...."*[36]

The final rite with the Hodegetria was performed just before the fall of Constantinople to the Turks in 1453. The icon was brought to the Chora monastery again to solicit the Virgin's protection of her city. When the Turks broke through the walls, they captured and destroyed the panel.[37] Yet the legend of the Hodegetria and her protection of the city, exemplified by the memory of the Avar siege, lingered in the minds of Orthodox Christians.

The model of the Hodegetria as protector triggered the development of new cult practices in the Eastern Orthodox world. The best example is the Vladimirskaya icon. A Byzantine panel brought to Kiev in the twelfth century, it had come to be perceived as the protector of Moscow by the sixteenth century.[38] The two Russian icons in this exhibition (cats. 51, 52) offer a visual narrative of how this happened. The power of the Vladimirskaya, activated in a procession, purportedly compelled the Mongols to abandon their 1395 siege of Moscow; the trope recalled the tradition of the Virgin appearing on the walls of Constantinople in 626.[39]

The perceived manifestation of Mary's protection of Constantinople evolved over time until the Hodegetria icon became accepted as the most potent conduit to her might. Viewed as the palladium of the city, the panel initiated the tradition of establishing Marian icons as city protectors in the Eastern Orthodox world. Like the Hodegetria, these panels were carried in procession at times of distress, as the faithful beseeched them for help. The memory of the Virgin of Constantinople lived on in them, and with it, the belief in Mary's unfailing protection.

1. Kalavrezou 1990, 165–72; Cormack 1997, 38–39.

2. Benko 1993; Limberis 1994.

3. Trypanis 1968; Wellesz 1955–56; Limberis 1994; Peltomaa 2001. Although the last two authors date the hymn to the early fifth century, a sixth-century date conforms more closely to the historical development of Marian devotion. The question requires further study. *A-kathistos,* "not seated," refers to the fact that the faithful stood while singing the hymn.

4. Peltomaa 2001, 3 (modified).

5. Pentcheva 2001.

6. The most famous of all sanctuaries in Chalcedon was that of Saint Euphemia, martyred in 303; the fourth-century shrine was the site of the Ecumenical Council of 451. A church of Saint Euphemia also existed in the Hippodrome in Constantinople. On Thekla's shrine and cult, see Egeria 1981, 23.5; Davis 2001.

7. In the sixth-to-seventh-century life, Maria/Marinos, the transvestite nun, is wrongly accused of impregnating an innkeeper's daughter. "He" voluntarily accepts severe punishment and raises the child in the monastery (Constas 1996, 1, 9–12). Marina was later assimilated to the late-third-century virgin saint known as Marina, Pelagia, or Margaret of Antioch, honored as the patron saint of childbirth in the late medieval West (Weitzmann-Fiedler 1966, 17–48). Melania and Theophano lent their girdles to women in difficult labor (Clark 1984, 73; Herrin 2000, 26, n. 70).

8. Constas 1995; Mango 1998 and 2000.

9. Cameron 1981, 205–34, with a revision of the argument in Pentcheva 2002. The Avars were a nomadic people who appeared in the mid-sixth century on the steppe north of the Black Sea.

10. Pertusi 1960, 182–83; Makk 1975, 79–82, 87–90, 95–96; *Chronicon Paschale* 1989, 180.

11. Comnena 1969, 395; Carr 2000.

12. Patton 1960–63, vol. 1, 52–53.

13. Papalexandrou 2001.

14. Constantine VII 1829, vol. 1, 554 (2.12).

15. Patton 1960–63, vol. 1, 54–55.

16. Carr 1997 and 2001; Cameron 1979.

17. Photius 1958, 102–3. For the Greek text see Müller 1883, vol. 5, 169–70. See also Belting-Ihm 1976, 43ff.

18. *BHG* 115z–117k; *PG* 111, 848–49; Rydén 1982.

19. *PG* 111, 848–49. Author's translation.

20. Without offering any evidence, Kondakov presents the same conclusion: Kondakov 1914–15, vol. 2, 55–123, esp. 57. See also Belting-Ihm 1976, 49–50, and Belting-Ihm 1992, 63.

21. Photius 1958, 188 (translation); *PG* 102, 572 B (Greek).

22. Lazarev 1966; Kondakov 1914–15, vol. 2, 72 ff.

23. ὁ θεὸς ἐν μέσῳ αὐτῇ, οὐ σαλευθήσεται· βοηθήσει αὐτῇ ὁ θεὸς τὸ πρὸς πρωί (Rahlfs 1975).

24. Attaleiates 1853, 152–53. The icon is mentioned in connection with the trial of a soldier accused of stealing a donkey. The emperor Romanos IV Diogenes (r. 1068–71) is criticized for meting out harsh punishment.

25. For other Marian images originating at the Blachernai and hence called Blachernitissa, see cats. 46 and 54–56.

26. Lampros 1911, 7. Author's translation.

27. *DOC*, vol. 3, part 2, 746–47 and pl. 59, nos. 7, 8; 753, 758 and pl. 62, no. 3. The same image type and name are reproduced on the silver coins of Theodora (r. 1055–56). The earliest example of the type, without the name Blachernitissa, appears on the gold coins of Emperor Leo VI (r. 886–912).

28. Maguire 1992.

29. Angelidi and Papamastorakis 2000; Pentcheva 2001, ch. 2–4.

30. Pentcheva 2001, ch. 3.

31. Ševčenko 1991.

32. Pentcheva 2002.

33. Choniates 1984, 209–10.

34. "All the royal priesthood": I Peter 2:9.

35. "All the chosen people": Psalm 44:13.

36. Bryennios 1768–84, 409–10. Author's translation.

37. Ducas 1839, 288.

38. Anisimov 1928; Miller 1968, 657–70; Miller 1995, 239–73.

39. *Chronicon Paschale* 1989, 180.

## 51 The Icon of the Virgin of Vladimir with the Story of Its Miracles

Russian, 18th–19th century
Tempera on wood panel
H. 71.8 cm, w. 55.3 cm, d. 3.8 cm
Fogg Art Museum, Harvard University,
Bequest of Philip M. Lydig, 1930.43

UNPUBLISHED

## 52 The Icon of the Virgin of Vladimir Met at the Gates of Moscow

Russian, 17th century
Tempera on wood panel
H. 31 cm, w. 27.3 cm, d. 2.5 cm
University of Toronto, Malcove Collection,
M 82.117

COLLECTION HISTORY Purchased from À la Vieille Cité, Paris, December 1965.

PUBLISHED Campbell 1985, 271, cat. 369.

The icon of the Virgin of Vladimir was a Byzantine panel brought to Kiev in the late twelfth century,[1] after the Kievan princes expanded their domain northwest, into present-day Russia, and made the city of Suzdal their northern capital. Prince Andrei Bogoliubskii ("Lover of God"; r. 1157–76) established Vladimir, near Suzdal, as his permanent seat of power. He marked the transition by transferring the icon of the Virgin there from Kiev; hence the icon's new name, Vladimirskaya. At the end of the fourteenth century the icon was supposedly brought to Moscow; it was moved there permanently by the sixteenth century, when it came to be perceived as the city's protector. The reception of the icon in Moscow marked the last stage in a geographic succession of power: the Vladimirskaya validated Moscow's claims to be the legitimate heir of Byzantium, Kiev Rus, and Suzdal. Cat. 52 illustrates the arrival of the Vladimirskaya at the gates of Moscow in 1395, while cat. 51 offers a pictorial narrative of the legends associated with the icon. The Vladimirskaya, depicted at the center of cat. 51, shows the Virgin holding Christ in her right arm. The Child lovingly reaches out to embrace his mother, pressing his cheek to her face, as she lifts her left hand toward him in a gesture of prayer.

The function of the Vladimir icon as the protector of Moscow followed the tradition of the Hodegetria icon in Constantinople. Although the Virgin was perceived as the supernatural defender of the Byzantine capital as early as the sixth century, her help was at first believed to be manifested through her actual presence in battle. Only toward the end of the tenth century did Mary's intervention begin to be associated with her icons, and by the middle of the eleventh century her power in war was attributed to the Hodegetria in particular. That icon, from the Hodegon monastery, founded by guides for the blind, was carried on the city walls when the city was under siege and paraded in imperial triumphal processions and at weekly liturgical services.[2]

In addition to sharing the function of the Hodegetria, the Vladimirskaya copied one of its important iconographic features: Mary's hand, palm up. Her gesture both beseeches the Child and offers him to the viewer. It thus expresses the sacrifice of the Virgin, who has overcome her motherly love for the sake of the world. The power of her gesture is even more poignant in light of the infant's embrace.

In cat. 51 the Vladimirskaya image is framed by a series of scenes narrating the miracles the icon performed and the process through which it came to be regarded as the protector of Moscow. The sequence reads from left to right by row, starting at the top; except for the top frieze, each image is identified by a brief inscription in Russian. The following scenes are represented: 1. Saint Luke painting the icon of the Virgin; 2. angels carrying the icon to Constantinople; 3. the icon brought from Constantinople to Kiev; 4. the icon placed on the high altar of the Vyshgorod monastery in Kiev; 5. Prince Andrei Bogoliubskii taking the icon to Suzdal; 6. the icon curing the wife of the servant Nicholas; 7. the construction of the church of the Virgin in the city of Vladimir; 8. the miracle of the Golden Gate in Vladimir, in which the gate fell on a crowd of people, but the Virgin kept them from harm; 9. the miracle of the victory over the boyars, or feudal lords; 10. the vision of Prince Vsevolod Iurievich, Bogoliubskii's brother, who saw the icon hovering in the sky and was reassured of the auspicious outcome of his military expedition to the

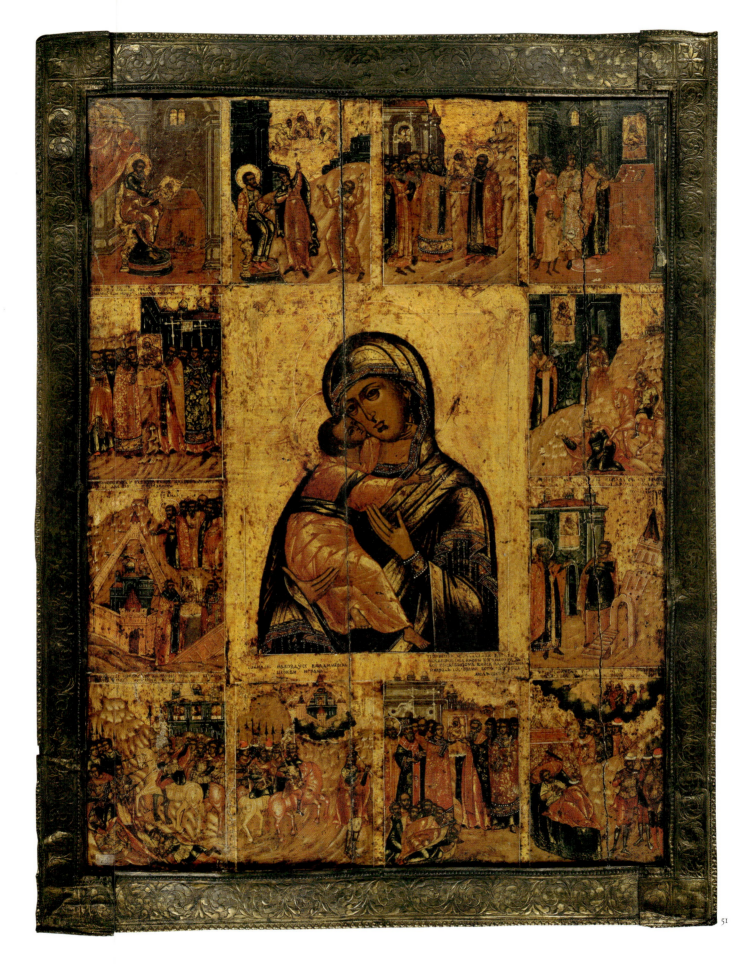

north; 11. the icon brought from Vladimir to Moscow in 1395; 12. the Virgin appearing to Tamerlane in a dream and forbidding him to attack Moscow.

The written tradition of the Vladimirskaya, finalized in the seventeenth century, triggered the rise of pictorial representations of the story. During the same period a network of annual urban processions developed the link between the miraculous icon and its chosen city, Moscow. The processions took place on May 21, to commemorate extensive repainting of the icon and the addition of a revetment in 1514; on June 23, to celebrate the deliverance of the city from the Tartars under Khan Ahmed in 1480; and on August 26, the date the icon arrived in Moscow in 1395. On each occasion, the Vladimirskaya, among other icons, was carried across town in a procession led by the patriarch and the city's secular head. These public rituals symbolically linked the city's history of trust in the Vladimirskaya with a plea for continued protection:

> *Today the glorious city of Moscow shines brightly, receiving the rays from your icon as from the sun, oh Mistress. Around her [the Vladimirskaya] we assemble today and beseech you, crying out to you: "Oh, extremely miraculous Mistress, Mother of God, pray on our behalf to Christ our Lord, who is merciful because he became incarnate in you, to deliver the city and all the cities and states of the Christian world from foreign invasions and to save our souls."*[3]

Cat. 52 shows the encounter between the Muscovites and the Vladimirskaya in 1395. The panel at the front of the procession (left) represents the Vladimirskaya, although the image is reversed, possibly because a pricked cartoon, used in the post-Byzantine production of icons, was flipped.[4] The original icon most likely depicted the procession as moving from left to right and featured the correct image of the Vladimirskaya.   BP

1. Anisimov 1928; Guseva 1995.

2. Pentcheva 2001, ch. 1–4.

3. Poseljanin 1993, 288.

4. Vassilaki 2001.

52

## 53 Conical Seal Stamp

Byzantine, c. 850–75
Silver
H. 1.9 cm, diam. 2.8 cm
Inscription: +ΘΚΕ ROHΘH ΓΡΗΓΟΡHO
MONAXON (God-Bearer, help Gregory the
Monk); as cruciform monograms, ΘTOKE
(God-Bearer); ROHΘH (Help)
Royal Ontario Museum, Toronto, Canada;
Gift of R. E. Hindley and the Reproductions
Fund of the ROM Foundation, 995.130.1

UNPUBLISHED

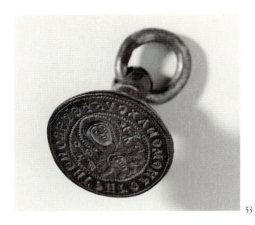 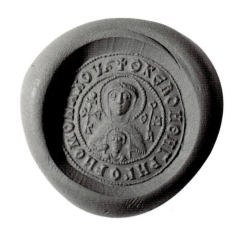

53

Two joined spheres form the handle of this stamp, with the top one pierced for the suspension ring. The sealing side is engraved with a type of the Theotokos (God-Bearer) image that, by the eleventh century, had gained the additional epithet Nikopoios (Victory-Maker). The Virgin is shown as a frontal bust holding with both hands a medallion displaying a frontal bust of the Christ child.[1] The inscription, on the perimeter of the image, is framed by a beaded border, and a cruciform monogram fills the field on either side of the Virgin.

After the end of Iconoclasm, in 843, the Virgin Mary's importance and popularity greatly increased. An image of Mary was one of the most important vehicles through which a person could pray, publicly or privately, for her help.[2] The Theotokos Nikopoios, held in high esteem from the late sixth century, was believed to have brought about miraculous victories when emperors carried it into battle.[3]

The image of the Theotokos Nikopoios on cat. 53 and on related lead seals suggests how this icon may have looked during the second half of the ninth century, in its earlier style.[4] A century later, Basil II (r. 976–1025) attributed his 989 victory over the general Bardas Phokas to a similar icon of Mary that he carried into the fray.[5] He honored the victory-making icon by placing a representation of it on a silver commemorative coin struck the same year.[6] The image of the Nikopoios continued to be used on seals and coins well into the eleventh century.[7] Beginning in the mid-ninth century, it underwent stylistic changes, and the accompanying inscriptions and monograms also varied.[8] However, the all-important iconographic scheme of a frontal bust of Mary holding a medallion with a frontal bust of the Christ child remained constant.

Conical stamps and signet rings with the Virgin's image, often accompanied by abbreviated prayers, were common in the middle Byzantine period (see also cats. 177–79). Titles are unusual on these small stamps, suggesting that the perishable wax seals they produced were used in private correspondence.[9] The monk Gregory probably found the qualities of this icon most appealing when he sought divine help to achieve his own personal victory over sin and thus ensure eternal salvation for his soul.  PD

1. She is nimbed and wears a *maphorion* (veil) decorated at its center with four pearls in the shape of a cross, as well as a *chiton* (tunic). Christ has a cross nimbus and wears a *chiton* and *himation* (mantle).

2. Maguire 2000, 279–89; Carr 2000, 325–37.

3. Likhacev 1936, 474–75; Sendler 1992, 156.

4. See, for example, Laurent, vol. 1, 713, cat. 908; 720, cat. 914; *DOSeals*, vol. 1, 131–32, cat. 48.2 (eighth-ninth century).

5. Grierson 1963, 114–16.

6. *DOC*, vol. 3, part 2, 631, cats. 19.1–4.

7. Zacos and Veglery 1972, 1449–52, cat. 2678; *DOC*, vol. 3, part 1, 171–72.

8. Seibt 1985.

9. *ODB* 1991, 1860. The Pseudo-Kodinos (anonymous author of the fourteenth-century *Treatise on the Dignities and Offices*) states that the emperor used wax seals only when writing to his mother, wife, or son (Zacos and Veglery 1972, 5).

## 54 Seal of Leon Skleros

Byzantine, 2nd half 11th century
Lead
Diam. 3.2 cm
Obv: M̄-P ΘV (Mother of God)
Rev: – ✳ –/ + ΘΚΕ ΡΟΗ/ΘΕΙ ΤⱲ CⱲ Δ.[ΟΥΛⱲ]/ ΛΕΟΝΤΙ ΜΑ/ΓΙCΤΡⱲ S ΠΡΕ/ΤⱲΡΙ ΤⱮ ΟΨΙ/Κ ΤⱲ CΚΛΗ/–ΡⱲ– (Mother of God, help your servant Leon Skleros, Magistros and Praitor of the Opsikion)
University of Toronto, Malcove Collection, M82.235b

COLLECTION HISTORY Lillian Malcove collection.

PUBLISHED Campbell 1985, 135, cat. 196.

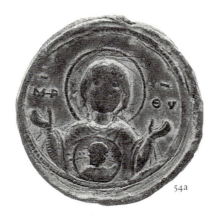

54a

54b

This seal, according to the inscription, belonged to Leon Skleros, who held the honorific title of *magistros* and the office of *praitor* (judge/tax collector) of the Bithynian *thema* of Opsikion.[1] It is in good overall condition. There is a small chip on the reverse, however, and on the obverse the Virgin's face is worn. The obverse shows the Virgin orant, in her intercessory role. The image here, however, is enriched with the depiction of the Christ child on a medallion that appears suspended in front of her chest. This is a new eleventh-century image of the Virgin and Child that seems to have become popular because of its connection to a repeated miracle in the church of Blachernai in Constantinople.[2] It was probably perceived as the most powerful image of its time.   IK

1. There are several extant seals belonging to the same Leon Skleros, who came from a distinguished Byzantine family (Seibt 1976, 87–88, fig. 12; Oikonomides 1972, 294, 323, 344, 348).

2. See Pentcheva 2000, 34–56, and Pitarakis 2000.

## 55 Seal of the Protoproedros of the Dikaspoloi

Byzantine, 11th century
Lead
Diam. 3.3 cm, wt. 28 g
Obv: M̅P Θ̅V (Mother of God); vertical, on either side of figure at right, Θ/N/I/K/O/Λ/A/O/C (Saint Nicholas)
Rev: metrical inscription in eight lines, – • –/ + O TωN / ΠPOEΔPωN / ΠPωTOC ωN / ΔIKACΠOΛω[N] / ΦPYPYC VM[AC] / TIΘHMI Tω[N] / ΓEΓPAMME / –NωN– / – (I, the first *proedros* of judges, place you [Virgin, saints depicted] as guards of all that has been written [court documents sealed with this])
Arthur M. Sackler Museum, Harvard University, Purchase, David M. Robinson Fund, 1999.62

COLLECTION HISTORY George Zacos collection, purchased from Spink and Son Ltd., London, October 7, 1998.

PUBLISHED Zacos 1984, 330, cat. 687, pl. 68; Spink Auction 1998, 39, cat. 74.

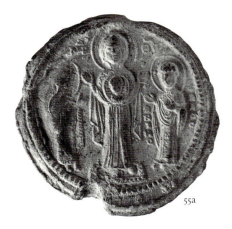

55a

55b

This is a seal of extremely high quality. Unfortunately, it has a small chip at the edge, and part of its surface on either side is flattened. On the obverse the Virgin is represented as the Blachernitissa, the new eleventh-century type (compare cat. 54).[1] She is flanked by two saints addressing her in prayer. This composition is the ultimate depiction of prayer (*deesis*), in which two saints acting on behalf of the owner intercede with the Virgin Mother, who in turn intercedes with Christ. Because of surface damage on the obverse, however, the identity of the saint on the left is not known. On the right is Saint Nicholas in three-quarter view, with hands uplifted.

Although the owner provides us with his position and title—he was a high-ranking judge—he does not mention his name. It may have been Nicholas, since one of the saints praying for him on the obverse is Saint Nicholas, whose name is also spelled out completely.   IK

1. Pentcheva 2000, 34–56. For further examples of this type on seals see: Zacos 1984, cats. 419, 578, 581, 620, 806, 823, 838. They date from the last third of the eleventh century.

## 56 Seal of Constantine Keroularios

Constantinople, 2nd half 11th century
Lead
Diam. 3.2 cm, wt. 20.3 g
Obv: on either side of medallion, IC XC (Jesus Christ); vertical, left, Θ/N/I/K.[O]/ΛA/O/C (Saint Nicholas); vertical, right, Θ/MI/NO/ KA/ΛΛ../../ ΛA/Δ.[OC] (Saint Menas Kallikelados); center, in six lines, + / K̄Є / RO / HΘЄI / TѠ CѠ / ΔΘΛѠ / K̄ѠN (Lord, help your servant Constantine)
Rev: on either side of medallion, M̄P Θ̄V (Mother of God); vertical, left, Θ/ ΔH/MH/ TP./O (Saint Demetrios); vertical, right, Θ/Π/ΛN/TЄ/ΛЄ/HM (Saint Panteleimon); center, +K̄Є / RO /HΘЄI / TѠ CѠ / ΔΘΛѠ / K̄ѠN (Lord, help your servant Constantine)
Arthur M. Sackler Museum, Harvard University, Purchase David M. Robinson Fund, 1999.61

COLLECTION HISTORY George Zacos collection, purchased from Spink and Son Ltd., London, October 7, 1998.

PUBLISHED Zacos 1984, 226–27, cat no. 404, pl. 42; Spink Auction 1998, 37, cat. 67.

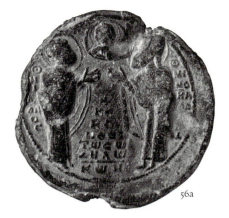

56a

56b

Although this seal is cracked on the reverse, along the shaft, its overall condition is good. Attention has been paid to the depiction of the saints' garments, which show great variation. The seal is unusual in having figural representations on both sides: four saints, two on each side, pray for the owner of the seal, named Constantine. On the obverse Saint Nicholas and Saint Menas Kallikelados pray to Christ, who is depicted in a medallion above them. On the reverse Saint Demetrios[1] and Saint Panteleemon, a medical saint, address the Virgin, also depicted in a medallion above. In her role as intercessor, she raises her arms in prayer.

On a similar seal with some of these saints, Constantine, nephew of the patriarch Michael Keroularios (patriarch 1043–58), is identified as the head of the imperial appeals tribunal. The choice of saints and other similarities suggest that cat. 56 was owned by the same Constantine. Considered a high official *(megas droungarios tes viglas)*, he was the first non-imperial person to be honored with the title *sebastos,* which usually indicated a blood relationship to the imperial family.[2] His seal is clear evidence of the Virgin's popularity. It was not enough for Constantine to have two saints addressing Christ on his behalf; he wanted the additional image on the reverse, where the Virgin, assisted by two more saints, appeals to Christ yet again for Constantine's well-being.   IK

1. Possibly the damaged inscription can be read as "Saint Damian," which would mean the two saints on the reverse have a medical connection.

2. *ODB* 1991, 1124–25.

## 57 Solidus of the Emperor Leo VI

Mint of Constantinople, 886–908
Gold
Diam. 1.9 cm, wt. 4.2 g, reverse die axis
7 o'clock
Obv: + MARIA +; to left and right of Virgin,
M̄R̄ Θ̄ϒ̄ (Mother of God)
Rev: clockwise from left, LEOII EII CRIStO
ЬASILEϒS ROMEOII (Leo, in Christ Emperor
of the Romans); plugged
Arthur M. Sackler Museum, Harvard
University, Bequest of Thomas Whittemore,
1951.31.4.1256

COLLECTION HISTORY Thomas Whittemore
collection.

PUBLISHED *DOC*, vol. 3, part 2, 512, cat. 1b.3.

## 58 Histamenon of the Emperor John I Tzimiskes

Mint of Constantinople, 969–76
Gold
Diam. 2.1 cm, wt. 4.39 g, reverse die axis
7 o'clock
Obv: clockwise from lower left, +IhS XIS
REX REGNANTIIIM (Jesus Christ, King of
Those Who Rule)
Rev: clockwise from lower left, +ΘEOTOC
ЬOHΘ' IW ƏESP (God-Bearer, help the ruler
John); above Virgin's head, MΘ (Mother of
God)
Arthur M. Sackler Museum, Harvard
University, Bequest of Thomas Whittemore,
1951.31.4.1413

COLLECTION HISTORY Thomas Whittemore
collection.

PUBLISHED *DOC*, vol. 3, part 2, 593, cat. 2.1.

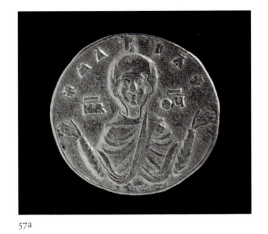

57a

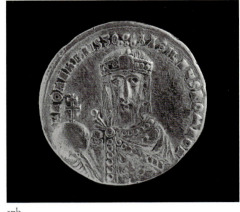

57b

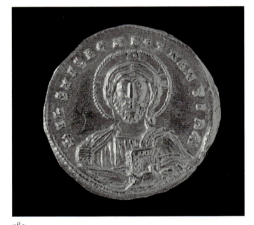

58a

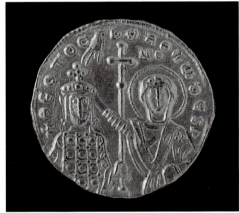

58b

# Coins with the Virgin

Although the image of the Virgin had been introduced on imperial seals in the sixth century, her representation did not appear on coins until the early tenth century. The first issues were the gold coins of Emperor Leo VI (r. 886–908). During the tenth and eleventh centuries, Marian images became more common on gold and silver coinage, and by the twelfth century they were also found on bronze. The issues of the late tenth and eleventh centuries introduced the greatest diversity of Marian image types and the most evocative inscriptions. From the late eleventh to the thirteenth century the Virgin frequently appeared on the obverse of coins as an enthroned figure,[1] or standing in a position of prayer, with a medallion of Christ on her chest. The presence of the Virgin on the coins conveyed a political message: a belief that the rule of the emperor depicted on the coins would remain intact and unblemished through the protection of the Virgin and the example of her inviolate body.

Cat. 57a shows the image of the Virgin that was the first to appear on Byzantine coins. She is depicted with her arms outstretched in the gesture of prayer. Her identification as *Meter Theou*, Mother of God, is probably one of the earliest examples of this epithet.

## 59 Miliaresion of the Emperor Romanos III Argyros

Mint of Constantinople, 1030 (?)
Silver
Diam. 2.6 cm, wt. 2.17 g, reverse die axis
6 o'clock
Inscription: from obverse to reverse,
+ΠΑΡΘΕΝΕ COI ΠΟΛΥΑΙΝΕ// OC ΗΛΠΙΚΕ
ΠΑΝΤΑ ΚΑΤΟΡΘΟΙ (Much-praised Virgin, he
who places hope in thee will prosper in all
things); obverse, left and right, M̄ Θ̄ (Mother
of God)
Arthur M. Sackler Museum, Harvard
University, Bequest of Thomas Whittemore,
1951.31.4.1573

COLLECTION HISTORY Thomas Whittemore
collection.

PUBLISHED *DOC*, vol, 3, part 2, 719, cat. 3a.1.

## 60 Miliaresion of the Emperor Constantine IX Monomachos

Mint of Constantinople, 1042–55
Silver
Diam. 3.1 cm, wt. 2.83 g, reverse die axis
6 o'clock
Inscription: clockwise from lower left, obverse
to reverse, +ΔΕCΠΟΙ ΝΑ CⲰΖΟΙC//
ΕVCΕΡΗ ΜΟΝΟΜΑΧΟΝ (Mistress, save the
pious Monomachos); obverse, left and right,
M̄P Θ̄V (Mother of God)
Arthur M. Sackler Museum, Harvard
University, Bequest of Thomas Whittemore,
1951.31.4.1581

COLLECTION HISTORY Thomas Whittemore
collection.

PUBLISHED *DOC*, vol. 3, part 2, 746, cat. 7a.1,
pl. 59.

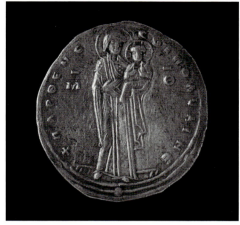

59a

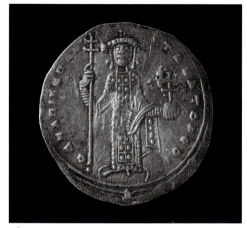

59b

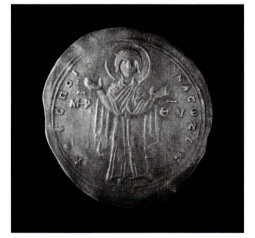

60a

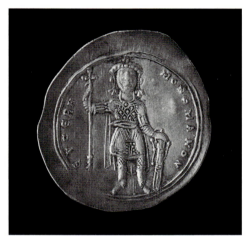

60b

Leo VI may have chosen this iconographic type in the hope that the Virgin would inter-cede to secure him an heir.

The iconography of cat. 58b, the Virgin placing her hand on the crown on the emper-or's head, directly addresses the issue of the legitimacy of John Tzimiskes' succession to the throne. He killed the previous emperor, Phokas (r. 963–69), and then modified the iconography of the coinage issued by his predecessor. Phokas had used an image of Mary and the emperor holding the scepter together. Tzimiskes chose a more potent gesture: the Virgin vouching for the legitimacy of his rule by placing her hand on the symbol of imperial power.

The issue with the Hodegetria type, Mary holding the Child in her left arm and gesturing toward him with her right (cat. 59a), is associated with the Syrian campaign of Romanos in 1030. On this occasion the emperor is reported to have carried with him an icon of the Virgin as general of the Christian armies. It is significant that the representa-tion of the Mother of God is addressed in the inscription as *parthene,* meaning "virgin." Mary's power in war rested in her virginal motherhood, and the coin, by pairing the image of the mother with an address to the virgin, expresses this duality. It is quite likely that

## 61 Aspron Trachy Nomisma of the Emperor Andronikos I Komnenos

Mint of Constantinople, 1183–85
Electrum
Diam. 3.2 cm, wt. 4.20 g, reverse die axis
6 o'clock
Inscription: clockwise from lower left, obverse
to reverse, +ΘΚΕ ΡΟ ΗΘΕΙ// ΑΝΔΡΟΝΙΚω
ΔΕСΠΟΤΗ: (God-Bearer, help the ruler
Andronikos); obverse, left and right, M̅P̅ Θ̅V̅
(Mother of God); reverse, left and right of
Christ, I̅C̅ X̅C̅ (Jesus Christ)
Arthur M. Sackler Museum, Harvard
University, Bequest of Thomas Whittemore,
1951.31.4.1806

COLLECTION HISTORY Thomas Whittemore
collection.

PUBLISHED *DOC*, vol. 4, part 1, 347, cat. 2a.1.

## 62 Aspron Trachy Nomisma of John III Doukas, Emperor of Nicaea

Mint of Magnesia, 1248
Electrum
Diam. 3.0 cm, wt. 2.67 g, reverse die axis
5 o'clock
Obv: left and right in upper field, M̅P̅ Θ̅V̅
(Mother of God); left and right on back
of throne, Δ Ρ (sigla for date, 1248)
Rev: obscured, usually two columns, Iω̅
ΔΕСΠΟΤΗС Ο ΔδΚΑС (John Doukas, ruler)
Arthur M. Sackler Museum, Harvard
University, Bequest of Thomas Whittemore,
1951.31.4.2104

COLLECTION HISTORY Thomas Whittemore
collection.

PUBLISHED *DOC*, vol. 4, part 2, 493, cat.
24a.2, pl. 31.

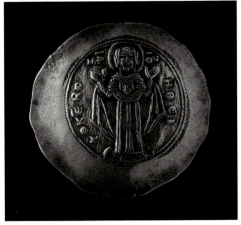

61a

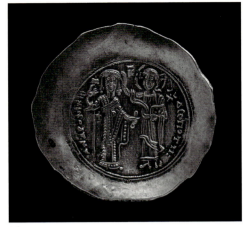

61b

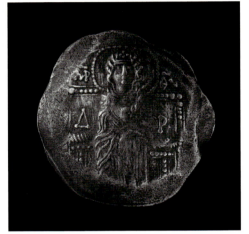

62a

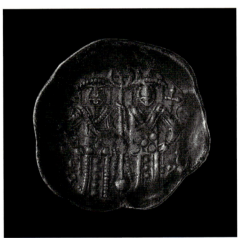

62b

this representation of the Virgin was credited with securing victory for emperors; in the case of Romanos, he lost the campaign but came out of it alive.

The image of the Virgin on cat. 60a most likely reproduces the apse mosaic of the Blachernai church. The copy harnesses the powers of the Virgin of the Blachernai in the service of the emperor, whose battle attire emphasizes the coin's military associations. Although Constantine IX Monomachos (r. 1042–55) never took part in battle, he used the rhetoric of images for what he lacked in deeds. The emperor also justified his military images with his family name, Monomachos, "Lone Fighter."

The Virgin orant with the hovering medallion on cat. 61a is an image type that had become extremely popular by the late eleventh century, possibly through its associations with a miraculous icon at the Blachernai church. The preeminence given to the Virgin on the coins of Andronikos is clear when compared to the issues of Tzimiskes (r. 969–76) or of Romanos III Argyros (r. 1028–34). It is the Virgin who stands on the obverse, while the image of Christ crowning the emperor is relegated to the reverse.

Cat. 62a, which shows a majestic image of the Virgin seated on a broad, jeweled, high-backed throne and holding the nimbate head of the Christ child on her lap, emphasizes

## 63 Hyperpyron of the Emperor Andronikos II Palaiologos

Mint of Constantinople, 1282–94
Gold
Diam. 2.7 cm, wt. 4.13 g, reverse die axis
6 o'clock
Obv: between castles, Ⱨ Ⱥ (sigla of
Andronikos II)
Rev: left, top to bottom in column,
+/ΑΝΔ/ΡΟΝΙΚ/ѠC ЄΝ X̅Ѡ̅ ΔЄCΠΟΤΗ/C
Ο ΠΑ/ΛΑΙΟ/ΛΟΓ/Ο΄ (Andronikos, ruler in
Christ, Palaiologos); to right of Christ, I̅C̅ X̅C̅
(Jesus Christ)
Arthur M. Sackler Museum, Harvard
University, Bequest of Thomas Whittemore,
1951.31.4.1913

COLLECTION HISTORY Thomas Whittemore
collection.

PUBLISHED *DOC*, vol. 5, part 2, cat. 221,
pl. 14.

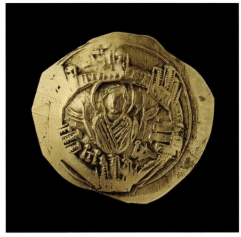

63a

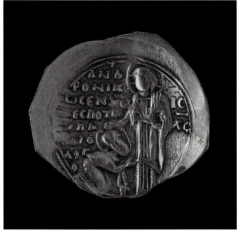

63b

the richness of Byzantine tradition in a time of great crisis for the empire. Constantinople's fall to the crusaders in 1204 had led to political fragmentation and rivalry for control. John III Doukas (r. 1221–54) ruled the strongest of the successor empires from its capital of Nicaea.[2] The enthroned Virgin, a type frequently found on patriarchal seals (cat. 22a), suggests Nicaea's role as the seat of the patriarchate, which had also been forced to relocate there.[3] John's right to the throne is emphasized on the reverse, where he is depicted as sharing rule with Constantine (r. 324–37), the founder and first emperor of Byzantium. They hold between them a long standard with a cross, evoking the sign in Constantine's vision that promised the empire's victorious Christian destiny. Expressing both anxiety and hope, this coin is a poignant emblem of Byzantine persistence.

The coin of Andronikos II Palaiologos (r. 1282–1328; cat. 63) reproduces a model created by the founder of the Palaiologan imperial dynasty, Michael VIII Palaiologos (r. 1259–82). The obverse image of the Virgin surrounded by city walls gives pictorial expression to the belief in Mary as unassailable fortress (cat. 63a). The crusaders had occupied Constantinople and ruled over much of the territory of the Byzantine Empire from 1204 to 1261. With this image, the dynasty that entered Constantinople after that period of Latin occupation negotiated a new idea of rule that rested on the support of the Virgin. The unsullied Virgin framed by walls expressed the hope that renewed Byzantine rule over Constantinople would preserve the city from harm.  BVP

1. First introduced on the post-reform (1092–1118) coinage of Alexios I Komnenos (r. 1081–1118). Under the reform, several denominations of debased metal (called *trachea* by contemporaries) had been in circulation. They were strikingly different from normal coins in being concave rather than flat (Grierson 1999, 2).

2. The coinage of the Empire of Nicaea was struck in Magnesia, whose walls guarded the mint and treasury (Foss 1996, 65).

3. Ibid.

## 64 Ostrakon with Hymn to the Virgin

Egypt, Byzantine, 580–640
Pottery fragment and ink
H. 27.2 cm, w. 17.1 cm
Inscription, in Greek: + Mary Mother of God, the ever Virgin, has borne for us today Emmanuel, both God and Man. "Lo, the Virgin shall conceive and bear us a son, and they shall call His name Emmanuel, which is interpreted as 'God is with us.'" Him did a virgin's womb conceive without intercourse. A virgin conceived, a virgin was with child, a virgin was in travail, a virgin brought forth and remained a virgin; before bearing, virgin, and in bearing, virgin, and after bearing, virgin. + The Metropolitan Museum of Art, Rogers Fund, 1914 (14.1.198)

PUBLISHED Winlock et al. 1926, 316, no. 600, pl. 14.

This pottery fragment is inscribed with a *troparion*, a short hymn, addressing the Virgin. Its main theme is the wondrous birth of Christ Emmanuel from a virgin mother, with the paradox repeated as a refrain. The *ostrakon* was found with a few others on a sleeping mat in a monk's cell in the monastery of Epiphanios in Thebes. The archaeological remains show that the cell collapsed, and the monk who owned the *ostrakon* must have left it behind just before that event.[1] The fragment is another example of the great devotion to the Virgin Mary, the veneration of her purity of body and soul, that pervaded Byzantine society. The monk's own prayers probably included this hymn to the Virgin.   IK

1. Winlock et al. 1926, 316, no. 600.

## 65 Votive Cross

Syria-Palestine, Byzantine, 6th–7th century
Bronze
H. 24 cm, w. 16.5 cm
Inscription: + ΑΓΙΑ / ΕΚ[Κ]ΛΕCΙ/Α ΠΡΟC/ΔΕΞΕ/ΙΟΥΛΙ/ΑΝΟΝ+ (Holy Church, receive Julian)
Royal Ontario Museum, Toronto, Canada; Gift of the Government of Ontario and the ROM Membership, 986.181.38

PUBLISHED *Processional Crosses* 1994, 96–99, cat. 10, fig. 34a, b.

This type of cross is often identified as processional because of the tang on the lower vertical arm, which was meant to secure the cross to a pole or church furnishing.[1] The arms of the cross are nearly equal in length and flare slightly. The upper vertical arm and the horizontal arms have points that end in small discs. The cross is decorated front and back with concentric circles at the end of each arm; on the back an additional pattern of concentric circles has been engraved at the intersection.

Several figures are engraved on the front. On the upper vertical arm, Christ stands holding the Gospels and extending a blessing with his right hand. Below him, at the center of the cross, are a Virgin and Child on a lyre-back throne, surrounded by an incised circle. On each of the horizontal arms an angel with cross-staff in hand turns toward the Virgin and Child as guardian. On the lower vertical arm is a votive inscription in which Julian asks to be taken into the Church. The invocation to the "Holy Church" is unusual, but in the pre-Iconoclastic period the Virgin seated on the lyre-back throne and holding the Christ child might still have been seen as a metaphor for the Church.[2] This cross, like cat. 48, is thus a contribution to the decoration of a church, given in the hope of salvation for the soul. In this case the church was most likely dedicated to the Virgin, since she features prominently at the center of the cross.   IK

1. For the popularity and use of these crosses see *Processional Crosses* 1994; *Rom und Byzanz* 1998, 61–71.

2. *Processional Crosses* 1994, 98.

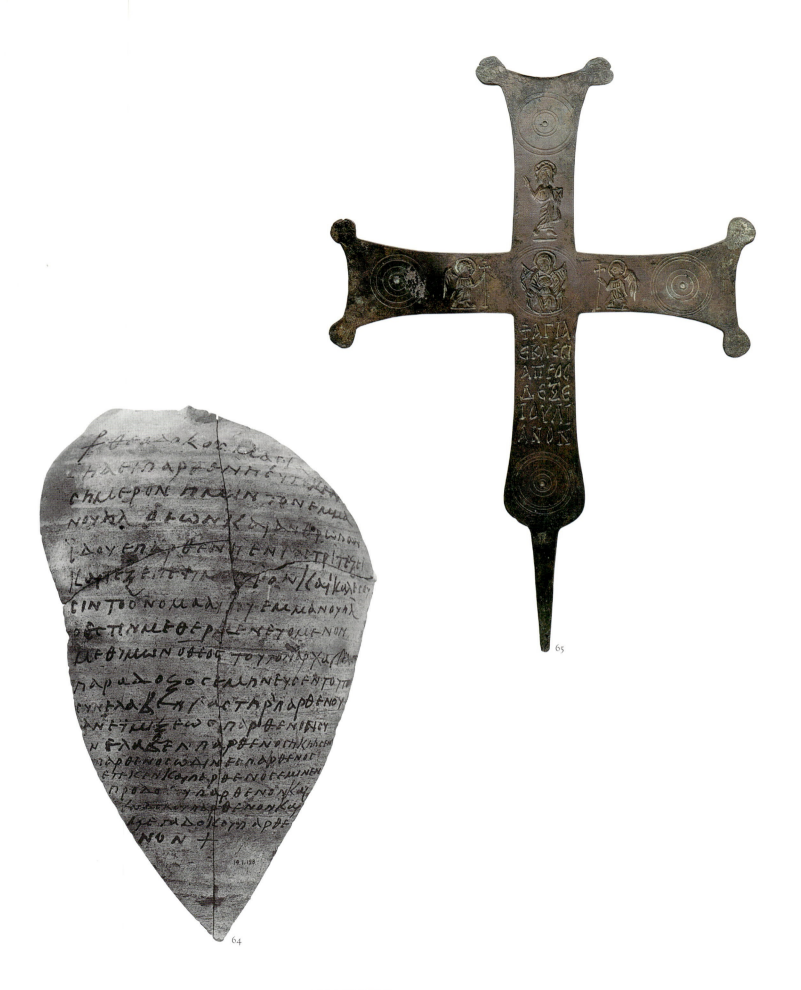

65

64

## 66 Pectoral Cross-Reliquary with Saints

Byzantine, 9th–12th century
Bronze
H. 10.7 cm, w. 6.7 cm
Inscriptions: front top, Ι ΑΓΙΑ Θ/ΕΟΤΟ/ΚΟС
(Holy God-Bearer); bottom, Ο ΑΓΙΟС ΠΕ/
ΤΡΟС (Saint Peter); back top, Ο ΑΡΧ/ΙСΤΡΑ/
ΤΙΓΟС (the high general=Saint Michael)
Arthur M. Sackler Museum, Harvard
University, Gift of Nelson Goodman,
1995.1150
COLLECTION HISTORY Nelson Goodman
collection.

UNPUBLISHED

This bronze cross consists of two parts, front and back, that form a narrow container in which a relic may have been kept.[1] Such crosses, probably easily affordable, were commonly used for personal protection and have been found in large numbers throughout the empire—in Greece, Asia Minor, Egypt, and Serbia.[2] This cross was worn suspended from a chain around the neck, which passed through a metal hoop connected to the top by a hinge. The reliquary was closed at the bottom with a pin that passed through the metal bosses; one boss and the pin are now lost.

The cross is decorated on both sides with the same crudely incised figures. Within a medallion at the center is a bust with hands extended in front of it. The lower part of the vertical axis displays a standing angel. Inscriptions at the top and bottom identify the otherwise generic figures: on the front (cat. 66a), the Virgin labeled as Holy Theotokos (God-Bearer), and below her, Saint Peter; on the back (cat. 66b), Saint Michael, referred to by the inscription as *archestrategos*.

It is not clear whether crosses of this type were made for men or for women. Their large size might suggest they were for men, but the iconography would just as easily have suited women. Cat. 66 may have belonged to a man by the name of Peter, since Saint Peter appears on the front. The Virgin Mary, however, is represented here as the primary intercessor. AB/IK

1. It is not clear what kind of relic was kept in this cross. The relatively humble material, bronze, suggests that the sacred object within was likely not of great value: perhaps a piece of cloth soaked with holy oil or myrrh that had been placed next to a relic and thus made holy itself.

2. For example, *Daily Life* 2002, 502–3, cat. 688; see also Pitarakis 1996.

66a

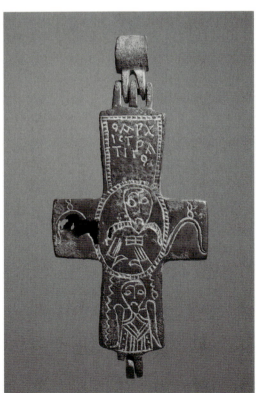

66b

## 67 Cross with Prayer to Thekla

Byzantine, 7th century (?)
Bronze
H. 7.7 cm, w. 6.2 cm
Inscription: vertical axis, ΑΓΙΑ/ ΘЄΚ /ΛΑ/ ВО/НΘН/ CVΜ/ΙΟΝΙ/ఠ Κ͞, CV/ΝЄCΙ/ΟV Κ͞; horizontal axis, ΜΑΡΙΑ Κ͞, ΘЄΚΛΑ (Holy Thekla, help Symionios and Synesios and Maria and Thekla)
Dumbarton Oaks Collection, Washington, D.C., 52.5

COLLECTION HISTORY Collection of Mrs. George D. Pratt, New York; gift of Mrs. Pratt, March 1952.

PUBLISHED Ross 1962, 58, cat. 67, pl. 40; *Pilgrimage* 1982, 44–45, fig. 37; Warns 1986, 104–5; Schurr 1997, 215.

Still embedded in the lead that once attached it to a column or wall, this cross displays an incised bust above a dedicatory inscription. Crosses incised in each serif multiply the potency of the object. The inscription reads first down the vertical axis and ends with the conjunction *kai*. That connects to the horizontal segment, which skips the vertical column at the intersection, as indicated by the reversed parentheses. The inscription appeals to Thekla to come to the aid of two men, Symionios and Synesios, and two women, Maria and Thekla. The names of the women have case endings that differ from those of the men. The bust at the top of the cross, a veiled orant figure, represents Thekla, to whom the prayer is addressed.

The last supplicant bears the name of the saint to whom the group appeals for intercession (see also cats. 68, 183). Thekla gained some popularity in Byzantium as a name for women, including the name of both the mother and the daughter of the ninth-century emperor Theophilos. At the end of the fourth century, the Cappadocian father Gregory of Nyssa claimed that his sister Macrina had Thekla as a secret name.[1] The four names inscribed here most likely represent a family that offered this cross as an ex-voto by attaching it to the physical structure of a church.   JKS

1. Maraval 1971, 2.

67

## 68 Medallion of Thekla Bound to Two Beasts

Egypt, Byzantine, 5th century
Limestone
Diam. 64.8 cm
The Nelson-Atkins Museum of Art, Kansas City, Missouri (Purchase: Nelson Trust) 48-10

PUBLISHED Buschhausen 1962–63, 148; *Romans and Barbarians* 1976, 201–3, cat. 236; *Age of Spirituality* 1979, 574–75, cat. 513; Nauerth and Warns 1981, 31–34; Schurr 1997, 212; *Antioch* 2000, 226–27, cat. 116.

The roundel depicts Thekla, a supposed disciple of Paul.[1] She is flanked by two angels and two beasts, and the entire group is encircled by a laurel wreath. She wears an ankle-length skirt. Between her exposed breasts a harness connects to a rope that wraps around her waist and binds her to a full-maned lion on the left and a collared lioness, with her teats visible, on the right. The angels hover, with palms facing outward in the gesture of prayer. Incised crosses mark their chests. The angels direct their eyes to the right, while the lions stride toward the edges of the roundel, turning their heads back to look at the central figure.

Seduced by Paul's teachings, Thekla set off on an adventure, following him and escaping her fiancé and other suitors along the way. Her devotion to Paul and resulting rejection of other men led to multiple trials in which she overcame fire, lions, bulls, and even seals. In the late fourth century, the pilgrim Egeria visited Thekla's shrine in Asia Minor. After praying there, she and her companions read the entire account of Thekla's acts.[2] In the next century, a local cleric rewrote Thekla's story and composed an account of the miracles that occurred at her shrine.[3] Her cult by then had spread across the Mediterranean from Asia Minor to Egypt, where this limestone medallion was made, and beyond.[4]

In its composition, this rendering of Thekla's flirtation with martyrdom recalls conventional early Christian representations of trials, such as Daniel in the lion's den or Susannah among the predatory elders. In keeping with a detail from her *vita*, however, Thekla's hands are tied behind her back rather than extended in prayer as they are in other visual models (see cats. 67, 183). The angels act as her surrogate.

This architectural relief likely adorned the wall of a sacred space, and was probably both enticing and awe inspiring to followers of her cult. Her voluptuous form challenges notions of Christian propriety. What was perceived as her great beauty in this depiction underlines the magnitude of her sacrifice for faith. The relief resonates with the story of one of her trials, in which her naked body elicited weeping from the local governor. JKS

1. "The Acts of Paul and Thekla" is translated in Schneelmelcher 1965, vol. 2, and McDonald 1983.

2. Egeria 1981, 122 (23.5).

3. Dagron 1978.

4. Davis 2001; Cooper 1995.

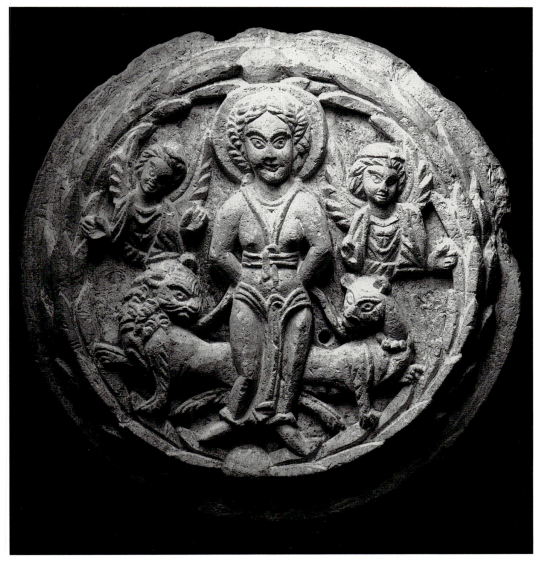

ΑΠΕΛΘΟΥΟΥΔΕΝ ΠΛΗΝ ΤΟΥ ΔΙΚΤΟΥ Ο ΗCΘΙΕΝ ΚΑΙ ΗΝ
ΕΠΙ ΙΩCΗΦ ΤΩ ΠΡΟCΟΠΩ ΤΑ ΡΗΜΑΤΑ ΤΟC Ο ΠΗΡΟΓ
ΤΩ ΝΟCΑΛΑ ΑΜΑΡΤΗCΟ ΜΑ ΕΓ ΕΠΑΝ ΤΟΙΩΝ ΤΟΥ ΕΥΑ
ΗΝ Ο ΒΑΔΕ ΑΛΛΠ ΔΙΩC ΠΟ ΗΜΕΡΑΝ ΕC ΗΜΕΡΑC
ΚΑΙ ΟΛ ΩΝ ΗΝ ΤΟΥ CΕΝΑ ΧΤΗ ΙΟ ΝΟC ΟΥ ΔΕΙΝ ΜΕΤ ΗΝ
ΤΟΥ ΧΥ ΕΙΠΟΝ ΕCΟ ΛΑΥΤΗ · ΕΓΕΝΕΤΟ ΔΕ ΤΟΙ ΟΛΥΤ
ΤΡΙ CΗ ΝΙΚΑ ΕΙCΗΛΘΕΝ ΙΩCΗΦ ΕΙC ΤΗΝ ΟΙΚΙΑΝ
ΠΟΙ ΟΝ ΤΑ ΤΑ ΕΡΓΑ ΑΥΤΟΥ ΚΑΙ ΟΥΘΕΙC ΤΩΝ ΕΝ ΤΗ
ΕΝ ΙΚΕΙ ΕΑΩΝ ΕΠ ΤΑC Ι ΑΥΤΟΝ ΤΩΝ Η ΜΑ ΤΟΥ
ΕΝ ΑΛ ΑΒΕ ΤΟ ΙΜ ΠΟΝ ΤΙ ΑCCΥΝΗ ΤΗΚΑΤΑ ΛΙ Π
ΤΑ ΙΜΑ ΤΙΑCΙ ΠΑ ΤΟ ΧΕΙΡ ΟCΕΙ ΛΑΥΤΗ ΤΗC ΕΦΥΓΕΝ ΚΟ
Ο ΞΩΙΛΑ ΔΕ ΤΟ ΩΙΙ ΚΑΙ ΙΠΟ Λ ΕΠΟΙΟ CΕΙ ΔΕΝ Ο ΤΙ Η
ΚΑΙ ΦΕΛΙΝ ΗΝ Τ ΙΜΑΤΙΟΝ ΑΥΤΟΥ ΕΠ ΤΑC ΧΕΡCΙΝ
ΑΥΤΗC ΚΑΙ ΜΑ ΤΑ Ι ΑΥΤΟΝ ΚΑΙ ΕΞ ΗΛΘΕΝ ΕΞΩ Η CΘ

# WORK

MOLLY FULGHUM
HEINTZ

## The Art and Craft of Earning a Living

Regarding her occupation, a woman of the Byzantine Empire had few choices. Girls were expected to marry young, have children, and take care of their families and households. If a young woman had no dowry or no one to arrange a suitable marriage for her—a task usually entrusted to the parents—she might decide to dedicate her life to God and enter a convent.[1] A woman could also earn a living as a midwife, a wet nurse, or a seamstress; occasionally, primary sources attest to female innkeepers, cooks, and bathhouse keepers. Barring these possibilities, women resorted to acting, dancing, or prostitution, which were common although less socially acceptable ways for an otherwise destitute woman to support herself.

Aside from female saints, the women described in the greatest detail by Byzantine authors are empresses and aristocrats. Although they had a certain amount of freedom, these women were held to very much the same standards as average women in Byzantine society: modesty, piety, and self-control were traits of an ideal woman.[2] To preserve their modesty, young unmarried women rarely went out in public alone, and married women who did not have jobs outside the home left the house only for specific reasons, such as to go to the market, to church, or to the baths (cat. 69). By the middle Byzantine period, it was thought appropriate for women, when they did go out, to cover their heads.[3]

Byzantine women generally received less education than men, but they were not necessarily illiterate. Aristocrats were more likely to have a good education; a notable example is the twelfth-century chronicler Anna Komnene (1083–c. 1153/4).[4] Primary sources that discuss women should be used with caution, since they often have a religious bias, and they may exaggerate for rhetorical effect. Through a patchwork of primary texts, art, and artifacts, however, a picture of how an average Byzantine woman spent her time begins to emerge.

The main goal of marriage in Byzantium was to produce children. Infertility was viewed as a catastrophic problem within a marriage, and sources describe a variety of medical and miraculous remedies for the condition. A woman having difficulty conceiving might invoke the story of Abraham's wife Sarah, who became pregnant late in life (cat. 174). In a parallel story from the New Testament, Elizabeth, Mary's cousin, became pregnant with John the Baptist long after having been diagnosed as barren. One can imagine an older woman who wished to have a child turning to an icon of the Nativity of John the Baptist or the Virgin to ask for help (cats. 70, 186).

A woman about to give birth often relied on the expertise of a midwife and the help of other women, such as the nursemaids depicted on the icons with birth scenes (cats. 70, 186) and in a manuscript painting of the birth of Jacob and Esau from a twelfth-century Vatican Octateuch (fig. 23).[5] Midwives probably gained their knowledge through experience and common sense rather than formal education. Midwifery may not have been a full-time job, especially if the woman lived in a small town or village. Writing

Fig. 13. Joseph fleeing Potiphar's wife, with domestic scene of women tending children and spinning. Vienna Genesis, Syria or Palestine (?), 6th century. Österreichische Nationalbibliothek, Vienna, cod. theol. grec. 31, fol. 16r.

in the fourth century, Eunapios of Sardis tells the story of a midwife who was also the hostess of a wine bar; one night, as she was in the middle of serving drinks, she was called away to deliver a baby.[6] Midwives also dealt with gynecological issues other than birth; women sought their advice on irregular bleeding or general illness.[7] A text on gynecology written between the sixth and twelfth centuries is signed "Metrodora" (who, from the feminine ending of the name, would seem to be female). The essay discusses various conditions that might affect the womb, tests for virginity, how to falsify virginity, and how to beautify the face and body with cosmetics.[8] It contains evidence that convent hospitals had female doctors.[9]

Motherhood was valued in Byzantium, and several authors describe their mothers with respect and affection. By the middle Byzantine period, the Virgin Mary was portrayed as an ideal mother and officially called by the epithet *Meter Theou*, Mother of God.[10] As early as the sixth and seventh centuries in Byzantine Egypt, a popular type of the Virgin was the Galaktotrophousa, which depicted Mary nursing the Christ child. Echoing the iconography of the Egyptian deity Isis nursing Harpocrates, the Galaktotrophousa imagery seems to have been too explicit or intimate to become widely accepted throughout the empire.[11]

Byzantine mothers breast-fed their children or employed the services of a wet nurse for the first few years of a child's life.[12] When children grew a little older, their mothers taught them Bible stories or rudimentary grammar. Later, girls would stay at home with their mothers and learn how to run a household, while boys might attend private lessons in grammar and other subjects. In the eleventh and twelfth centuries, girls may have had more access to a limited formal education.[13] Often mothers played an aggressive role in arranging their children's studies. The eleventh-century writer Michael Psellos mentions his mother's dedication to giving him an excellent education.[14]

A woman's second most important function, after child care, was running the household. Large houses often had an area designated as the *gynaikonites*, or "women's quarters," a series of rooms where women carried out their duties and spent most of their time.[15] Wealthy households employed servants or had slaves whom the woman of the house would oversee on a daily basis. Not only was a woman responsible for monitoring the food supplies and the cooking, but she also was in charge of the household furnishings and keeping her family clothed. Some Byzantine women also engaged in agricultural chores, such as working in the fields, harvesting crops, and gathering olives and other produce that they sold at the market (cat. 71).

To produce textiles for everyday use and simple clothing, women spent a great deal of their time spinning and weaving. These were not only practical tasks; they were regarded as the only "proper" pastime for a woman.[16] When a notable woman did not spin and weave regularly, Byzantine authors were quick to point that out. For example, Anna Komnene, probably one of the most educated women in Byzantine history, was said to have "exchanged the distaff and spindle for learning."[17]

Spinning and weaving have long been the preferred activities for the ideal female, from Penelope in Homer's *Odyssey* to the good wife in the Book of Proverbs.[18] Roman

funerary inscriptions, as well as imagery on grave steles and tombs, reflect the importance of associating the woman of the house with spinning and weaving. This is exemplified in the Phrygian stele in this exhibition (cat. 73), depicting a woman's weaving implements in relief. The Virgin, the ultimate female role model in Christianity, is held to the same standard: in scenes of the Annunciation in Byzantine art she is often shown spinning (see cat. 83), and apocryphal stories about her life describe how, as a young girl, she was given a skein of purple wool to weave the curtain that demarcated the Holy of Holies at the Temple in Jerusalem.[19] A folio from the sixth-century Vienna Genesis conveys the message in a less subtle way (fig. 13). The scene opposes "ideal" women spinning and taking care of children (upper register, right; lower register) with Potiphar's wife, who attempts to seduce Joseph (upper register, left).[20]

The *vitae* of many female saints refer to their virtuous spinning and weaving. The ninth-century Saint Theodora of Thessaloniki "set her hands to the spindle; and preparing and spinning the very coarse fibers of flax that had been rejected, and the useless wool tossed into the dung heaps, she would make bags."[21] The tenth-century Saint Thomaïs of Lesbos "put her whole hand to the spindle. She worked skillfully and artfully to weave on the loom fabrics of various colors. . . . Her hands labored for the sake of the poor and wove tunics for the naked."[22] These were the examples Byzantine women were compelled to follow if they wished to please God.[23]

Women were also involved with textile production on a professional level.[24] In the early Byzantine period, women worked in male-run silk factories, although they seem to have been confined to spinning.[25] In a short treatise titled "On the Female Festival of Agathe," Psellos briefly describes a procession and celebration that took place annually on May 12 in Constantinople.[26] It has been suggested that because the female participants were divided into categories of carders, spinners, and weavers, they might have been professional cloth makers, possibly even members of a guild. This hypothesis seems to be supported by the tenth-century *Book of the Eparch*, a legal text codifying the rules and regulations of the Constantinopolitan guilds under the supervision of the city's prefect. Chapter VII discusses regulations applying to the raw silk dressers, "whether men or women."[27]

While weaving was a job performed by both men and women, spinning historically remained a female activity performed in the home. The loom was a standard piece of domestic furniture,[28] used for weaving the household linens and clothing. Not only did spinning and weaving confine a woman to the physical space of the home, but their products, which included curtains for the windows and doorways, further circumscribed her space. While large-scale tapestries for wall hangings may have been produced in weaving workshops run by men, smaller, tapestry-woven textiles may have been produced by women who worked at home (cats. 80–82, 89–96, 161–63).

In the early Byzantine period, vestiges of the old Roman Empire heavily influenced many aspects of life. For example, despite protests from the Church, women still attended popular spectacles at the theater and chariot races in the hippodrome, and they were also among the performers there. Female dancers, often shown with billowing veils, may be seen on the obelisk base of Theodosios I (r. 379–95) *in situ* in the former Hippodrome of

Fig. 14. Dancer performing before the imperial family (detail). Pyxis, mid-14th or early 15th century. Ivory. Dumbarton Oaks Collection, Washington, D.C., 36.24.

Constantinople and on the sixth-century victory stele of the charioteer Porphyrios.[29] They also performed at civic festivals and imperial celebrations, even in the late Byzantine period, as depicted on an ivory pyxis thought to commemorate the installation of John VII Palaiologos as emperor in Thessaloniki around 1403 (fig. 14).[30]

The silver statuette of the seated dancer in this exhibition is a poignant representation of a female entertainer (cat. 72). Often slaves, actresses and dancers were considered to be a low class of women who could have a corrupting influence on society. As one scholar points out, any woman on public display was thought to be sexually available. This even included barmaids.[31] Female performers participated in the mime skits that were commonly part of theatrical shows; the skits often had erotic overtones or included lewd gestures and situations.[32] Those who participated in mime were frequently labeled prostitutes (pornai), even though this was not necessarily the case.[33]

Female performers apparently worked on a "freelance" basis as well, when the wealthy hired them to perform at private parties.[34] A letter composed by Artemisia of Philadelphia survives on a third-century papyrus:

> To Isidora, castanet dancer, from Artemisia of the village of Philadelphia. I wish to engage you with two other dancers to perform at the festival at my house for six days. . . . You will receive as pay 36 drachmas for each day, and for the entire period 4 artabas of barley and 20 pairs of bread loaves. And whatsoever gold and ornaments you may bring down, we will guard these safely; and we will furnish you with two donkeys when you come down to us and a like number when you go back to the city.[35]

Entertainers who were highly sought after could become wealthy themselves. One such was Pelagia, a famous actress (mimas) from Antioch, who eventually converted to Christianity and later became a saint.[36] Notably, any female entertainer who left the stage was required by law to convert to Christianity. Apparently, authorities saw this as a way to stifle latent immoral impulses that could endanger society.[37] Finally, in the seventh century, the Council in Trullo banned "public dances by women which are able to cause much impurity and harm."[38] In fact, the public perception of acting and dancing was so negative that, despite cases of financial success, it was sometimes difficult to recruit new members for theatrical troupes.[39] It may be for this reason that many entertainers were slaves or their descendants, who were compelled to perform.

Slaves were often prisoners of war or those born in captivity. Literary evidence concerning female domestic slaves in the Roman period indicates that they performed daily tasks, such as spinning and weaving, under the supervision of the woman of the house, and the same seems to have been true in Byzantium.[40] In images from the period, female slaves or servants most often appear in the company of an aristocratic woman, helping her with her toilet, such as on the Projecta casket in the British Museum (fig. 20), or assisting with childbirth, as in the icon of the Nativity of John the Baptist (cat. 70). Legally, slaves could not marry, because they owned no property; however, a partnership (contubernium) between male and female could be acknowledged by their owner.[41] While Christian authors such as the fourth-century bishop Saint Gregory of Nazianzos condemned slavery, it was common in Byzantium until the late period.[42]

Some women in Byzantium supported themselves in ways that were defined by sex. The law differentiated several categories of sexual relationships between men and women. Adultery was both a legal and a religious issue in Byzantium, and was often the subject of ecclesiastical authors and priests, who condemned sex outside the union of marriage. In general, there was a double standard for men and women concerning adultery: "a married woman was an adulteress if she had any male sexual partner other than her husband; whereas a man was an adulterer, whether or not he was himself married, only if his partner was a married woman."[43] Several emperors were reported to have had mistresses, the best known of whom is Skleraina, the companion of Constantine IX Monomachos (r. 1042–55).[44] The daughter of a nobleman, Skleraina was given the title of *sebaste*, which usually indicated a blood relationship to the imperial family, and was invited to live in the palace with the emperor and his wife, the empress Zoe.

Concubinage, a stable sexual relationship between a man and a woman usually of a lower class, was also common in Byzantium. Often this involved cohabitation and in practice was indistinguishable from marriage. The question of property and titles due the children of concubines was debated in Byzantine law.[45]

Although their legal status was different, concubines (*pallakai*) and prostitutes (*pornai*) were sometimes equated in religious texts.[46] Prostitutes appear frequently in primary sources, and while this may attest to the widespread nature of prostitution in Byzantium, the converted prostitute may also be understood as a literary topos, based on the model of the conversion of Mary Magdalene in the New Testament. For example, Pelagia, the famous actress in late antiquity who converted to Christianity, is called "Pelagia the Harlot" in the early-eleventh-century *Menologion* of Basil II. Helena, the mother of Constantine the Great (r. 324–37) and later a saint, was supposedly a prostitute at her father's inn before her marriage. Roadside inns were notorious haunts of women of ill repute.[47]

The fact that most women had limited education precluded them from holding positions that required refined reading and writing skills. While aristocratic women often administered estates and managed large properties, the job of an average woman was to manage the day-to-day running of the home.

1. Garland 1988, 366–67.

2. Ibid., 371–74.

3. Kekaumenos, the eleventh-century author of the *Strategikon* (a manual of advice), was an advocate of strict standards for female behavior (Garland 1988, 369–72).

4. Anna Komnene, who wrote the *Alexiad*, a history of the reign of her father, the emperor Alexios I Komnenos (r. 1081–1118), is one of the best-known Byzantine female authors.

5. The Octateuch, composed of the first eight books of the Old Testament, circulated as a separate volume from the ninth or tenth century.

6. Clark 1993, 69; Eunapius 1952, 463.

7. Clark 1993, 69.

8. Patlagean 1987, 618–19; Metrodora 1953.

9. Miller 1985, 15, 201, 214.

10. Kalavrezou 1990, 168–72.

11. Ibid., 166.

12. Clark 1993, 45, 87.

13. Garland 1988, 368.

14. Kazhdan and Epstein 1985, 123.

15. Garland 1988, 382. Evelyne Patlagean states that for the Byzantine home "the segregation of women was the first principle of interior design" (Patlagean 1987, 573).

16. Michael Psellos, in his essay on his daughter Styliane, notes that weaving was one of her "most important" tasks (Garland 1988, 368).

17. See George Tournikos' funeral oration for Anna Komnene (Garland 1988, 379).

18. Weaving has been considered "women's work," as Elizabeth Barber demonstrates, since prehistoric times, and the notion that a virtuous woman spins and weaves is also ancient (Barber 1994, 185–88).

19. Mary receiving the wool is depicted in mosaic in the narthex of the Chora church in Constantinople (Underwood 1966, pls. 130–34).

20. Throughout the Middle Ages, the motif of weaving could also have had an ambiguous or negative meaning, reflecting the belief that women could be crafty or even witches, reciting spells that, as the women wove, were "trapped" in the cloth (Tatar, 1987, 106–33).

21. Talbot 1996, 200.

22. Ibid., 303–4.

23. Nicholas Constas discusses "domiciled female passivity" of women in the Christian world; while the imagery of the Virgin and holy women weaving may have done nothing directly to confine women to their traditional domestic roles, it reinforced existing ideas of what constituted appropriate behavior (Constas 1995, 186).

24. Quenemoen 1996, 157.

25. Lopez 1945, 6.

26. Laiou 1986, vol. 1, 111–22.

27. Ibid., 116; Koder 1991, ch. 4–8. In the Roman period, however, professional spinners (*quasillariae*) were not allowed to form a guild.

28. See Clark 1993, 30–39.

29. Cameron 1973.

30. Oikonomides 1977, 330–31; alternatively, Weitzmann dates the pyxis to circa 1355 and suggests that it represents the Kantakouzenos imperial family (Weitzmann 1972, vol. 3, 77–82, cat. 31).

31. Clark 1993, 29.

32. Webb 1997, 121.

33. Ibid., 123. A well-known account of a performer/prostitute is that of Theodora, who was an entertainer before her marriage to the emperor Justinian (r. 527–65). The sixth-century author Prokopios describes Theodora as a prostitute who had a talent only for stripping. He goes to extreme lengths to describe her lascivious nature and her multiple sexual partners, even accusing her of bewitching the emperor (*Secret History* 9.1–30). It may be argued that this is a highly rhetorical text meant to portray Theodora in the worst possible light. In another book, a straightforward account of buildings in Constantinople, Prokopios describes a palace converted into a convent by Justinian and Theodora (*Buildings* 1.9.2–9). Named "Repentance," it was specifically for reformed prostitutes (Clark 1993, 30–31; Webb 1997, 128).

34. Webb 1997, 129.

35. *Art and Holy Powers* 1989, 222, citing W. L. Westerman and C. J. Kraemer.

36. Clark 1993, 31, 129.

37. Ibid., 29–30.

38. Webb 1997, 130.

39. Clark 1993.

40. A. Wallace-Hadrill describes how the mistress of the house doled out a *pensum*, a daily portion of wool, to be woven by each slave girl. A house in Pompeii bears a graffito with the names of each slave girl and the size of her *pensum*. "The slave girl working late into the night by lamplight to finish her *pensum* is a cliché" (Wallace-Hadrill 1996, 112).

41. Clark 1993, 34.

42. Kazhdan and Epstein 1985, 9–10.

43. Clark 1993, 29.

44. In the ninth century, the emperor Leo VI was notorious for his philandering (ibid., 35).

45. Beaucamp 1990, 195–200; Clark 1993, 31.

46. Patlagean 1987, 602.

47. Clark 1993, 29–31.

69

## 69 Homiletic Fragment Advising Women on Public Conduct

Egypt, before August 30, 823[1]
Parchment leaf
H. 33.9 cm, w. 25.3 cm
The Pierpont Morgan Library, New York.
Gift of J. P. Morgan (1867–1943); 1924. MS
M.579

COLLECTION HISTORY Found in 1910 in a
cache of manuscripts excavated at the site
of the Monastery of Saint Michael at
Sôpehes, near contemporary Al-Hamuli in
the Fayum, Egypt; purchased in Paris in 1911
for J. Pierpont Morgan from Arthur Sambon,
agent for an owners' consortium including J.
Kalebdian.

PUBLISHED Depuydt 1993, vol 1., 165–66,
cat. 83.

A page from a lost parchment codex, this fragment of an unidentified homily was reused
to paste down the overleaf inside the cover of an early ninth-century lectionary, a book
of scriptural passages, sometimes accompanied by sermons, used on feast days. The only
decorations are a lower band and rectangular headpiece of knotted rope interlace (upper
right), below which the surviving text of approximately thirty-four lines is arranged in two
columns on the recto of the ruled folio. The text is in Sahidic, the dialect spoken by the
Copts, the Egyptian Christian minority of Egypt, in the Byzantine and Islamic periods.
The script is Greek, primarily uppercase, with upright letters. The literary style and
content of the homily suggest that it derives from the Church fathers and was probably
translated from the Greek, like most other Coptic texts.

Partially based on Proverbs 9:13–17, the homily reflects the widespread Byzantine
belief that women were of inferior moral status and more fallible than men. It addresses
first men, then women, in the second person, exhorting them to avoid contact with
persons of the opposite sex in the streets and baths.

The woman "openly visible in the streets, spending time with the passersby," is portrayed as promiscuous, tempting men "straight in their ways" to engage in illicit sex. "Run far away and do not delay at her place, and do not fix your eyes upon her," the homilist admonishes. In contrast, women who "wish to become faithful" are advised to be monogamous and dress modestly: "Please your husband only, and cover your head in the streets so that your female beauty become dark."[2] The text underlines the standard comportment of married Byzantine women, who wore mantles over their heads in public and were encouraged to leave the house only when necessary—for example, to attend church or to bathe.[3]

Most early Byzantine cities had κοινά λουτρά (public baths) that were open to women. Some were ἀνδρόγυνα λουτρά (coed baths)[4] and some, such as the small one near the Baths of Zeuxippos in Constantinople, were for women only. In Egypt there is evidence of several large double baths that served pilgrims and had separate facilities for men and women.[5] Although the homily does not forbid women to bathe, it strongly warns against common bathing as immodest: "Remove yourself so as not to wash yourself together with virgin young boys. For it is a disgrace that a faithful woman should wash herself with men. For if a woman covers her face, hiding herself from unknown young lads, how can she take a bath with men?"

The Church fathers considered women more susceptible than men to carnal temptation, but their level of tolerance varied: The Pseudo-Clemens recommended that chaste women bathe around ten o'clock in the morning to avoid "many eyes," but not at midday because the bath would be full at that time.[6] The existence of coed baths led John Chrysostom to prohibit women from bathing, condemning them, especially widows, who tended to linger in the baths with men, as a stain on the pure Church.[7] He faulted mothers for allowing their daughters to wear cosmetics and to bathe frequently, and deplored the female practices of gossiping and flaunting gold jewelry in the bath.[8] In his stern address to virgins, Athanasios of Alexandria warned: "Do not go needlessly to the bath if you are healthy and, in order to wash yourself, do not submerge your entire body in the water if you are sanctified to God."[9] Bathing for medicinal purposes was, however, acceptable.

The prescriptive character of this homily fragment, also pronounced in the writings of the Church fathers, and the large number of baths open to women, suggest that women actively participated in the vibrant bathing culture of the early Byzantine period.   EG

1. The *terminus ante quem* is provided by the colophon of Morgan Library M162, in which this leaf was used as a pastedown (Depuydt 1993, vol. 1, 165–66, cat. 83).

2. Ibid.

3. Clark 1993, 108–9; Chrysostom cites the attendance at bath and church as among the few occasions on which a chaste woman is permitted to leave the house (Berger 1982, 40, n. 39). For headdresses worn by Byzantine women, see Emmanuel 1995.

4. The Greek Church father Clement of Alexandria (second-to-third century) criticizes the κοινά λουτρά, and Palladios, bishop of Helenopolis in Bithynia (fourth-to-fifth century), mentions the ἀνδρόγυνα λουτρά (Berger 1982, 41). Around 475, Constantinople

had nine large public baths and 153 private baths (ibid., 28–29).

5. At Abu Mena and Menuthis in Canopus (ibid., 33, 43).

6. Ibid., 39, 42, n. 54.

7. Ibid., 41, n. 49.

8. Ibid., 39, nn. 35, 36; 60; 218. The reproach is not specifically Christian; Libanios, the fourth-century pagan orator of Antioch, also mentions the chattering of a woman as she returned from the bath (ibid., 40, n. 38).

9. Ibid., 39, n. 34.

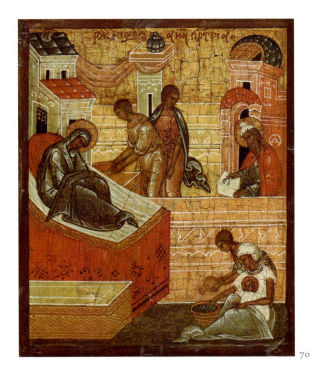

70

## 70 Icon of the Birth of John the Baptist

Russian, Novgorod School, late 15th
century (?)
Tempera on wood panel
H. 13.3 cm, w. 10.8 cm
Inscription, in Russian: The Nativity of
Saint John Prodromos
Fogg Art Museum, Harvard University,
Bequest of Thomas Whittemore, 1951.31.26

COLLECTION HISTORY Thomas Whittemore
collection.

PUBLISHED *Russian Icons* 1988, cat. 8.

This small panel represents the birth of Saint John the Baptist (Luke 1:57–66). The life of John has several parallels with that of Christ, whom he prefigures in the Gospels (hence the epithet Prodromos, or Forerunner).[1] Elizabeth, a kinswoman of the Virgin Mary, was advanced in age. Her husband, Zacharias, received a visit from the archangel Gabriel, who told him that his wife, despite her years, would soon conceive a son who "will be great before the Lord" (Luke 1:15). At the Annunciation of Christ's birth, the same angel told Mary about Elizabeth, who "in her old age has also conceived a son" (Luke 1:36).

Saint John is depicted in the right foreground of the composition, as a tiny baby in the lap of the midwife, who prepares to bathe him with the assistance of a second woman. John's mother sits on a bed at left, while his father sits at right beyond a low wall and writes in a book. Also beyond the wall are two other female attendants. In the background, filling the upper portion of the composition, are buildings with slanted and domed tile roofs and a central column festooned with drapery.

Against a gilded background the icon is painted in bright blue, red, orange-red, green, pinks, and olive skin tones. Facial features and minor details are clear and precise for such a small panel, suggesting comparisons with painted miniatures in Byzantine manuscripts.

The style of the icon places it in the Russian Novgorod School of the second half of the fifteenth century.[2] Its size suggests that it was used in a private context. The story of Elizabeth's conception at an advanced age, the subject of birth in general, and the representations of women in this scene may have resonated with the Byzantine viewer. For us, the icon offers information about the activities of women at home and depicts the work of the midwife (see also cat. 186).   MFH

1. Isaiah 40:3 ("A voice cries: in the wilderness, prepare a way for the Lord. . . .") is often interpreted as foreshadowing the birth of John.

2. Natalia Teteriatnikov dates the icon to the end of the fifteenth century (*Russian Icons* 1988, cat. 8).

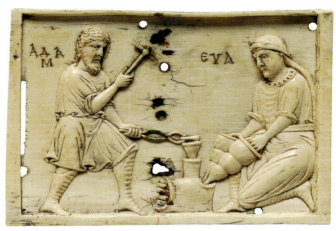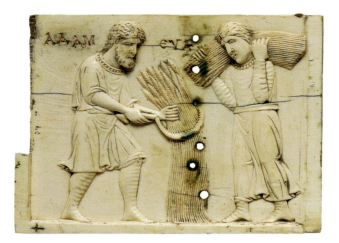

71

## 71 Plaque with Adam and Eve at the Forge

Constantinople (?), Byzantine, 11th–12th
century
Ivory
H. 6.7 cm, w. 9.8 cm
Inscription: left, AΔA/M (Adam); right, ЄVA
(Eva)
The Metropolitan Museum of Art, Gift of
J. Pierpont Morgan, 1917 (17.190.139)

COLLECTION HISTORY G. Brauer, Paris 1909.
PUBLISHED Goldschmidt and Weitzmann
1930, vol. 1, 54–55, cat. 93; *Glory of Byzantium*
1997, 234–36, cat. 158; Evans et al. 2001, 52;
Kalavrezou 2002, 245, fig. 8.

This high-quality ivory plaque of Adam and Eve toiling at the forge (left) was originally
part of the exterior decoration of a box showing scenes from Genesis. Three other panels
have been recognized as belonging to the same ensemble.[1] The panel that is closest in size
and theme, also in the collection of the Metropolitan Museum of Art (right),[2] depicts
Adam and Eve harvesting. Both these panels show the couple surviving by the sweat of
their brow after their expulsion from Paradise.

In cat. 71, Adam holds a piece of iron on the forge and is about to strike it to give it
shape. Eve, her hair covered, kneels close to the fire, working the bellows with both hands.
The figures are labeled. In assisting at the forge, Eve participates in work not usually per-
ceived as a woman's domain; she is not shown spinning, the activity that was most typical
of a woman's role in the Byzantine household.

Everyday activities were rarely depicted with contemporary figures in Byzantine art,
but such activities can be identified indirectly: Adam and Eve have become the representa-
tive couple whose destiny, to work for their survival and well-being on earth, depends on
their cooperation.[2] As examples of the difficulties a couple encounters in life, these scenes
suggest that marital harmony is achieved through collaboration in hard work. IK

1. *Glory of Byzantium* 1997, 234–36, cat. 158.

2. The Metropolitan Museum of Art, Gift of J.
Pierpont Morgan, 1917 (17.190.138).

3. A number of ivory boxes depict the story of Adam
and Eve. The cycle begins with their life in Paradise
and proceeds to their fall, their expulsion,
and scenes of labor that are not part of the biblical
narrative.

## 72  Seated Dancer

Eastern Greece, Roman-Byzantine, late
4th century
Silver and gold
H. 12.0 cm
Museum of Fine Arts, Boston, Frederick
Brown Fund, 69.72

COLLECTION HISTORY Mathias Komor
collection.

PUBLISHED Vermeule 1971, 404, figs. 55–56;
Vermeule 1974a, 33–34, cat. 97; *Romans and
Barbarians* 1976, 115, cat. 124; Museum of
Fine Arts, Boston, 1981, cat. 18; Cahn and
Kaufmann 1984, 320; *Trésors d'orfèvrerie* 1989,
261, cat. 223; *I, Claudia* 1996, 89–90, cat. 53.

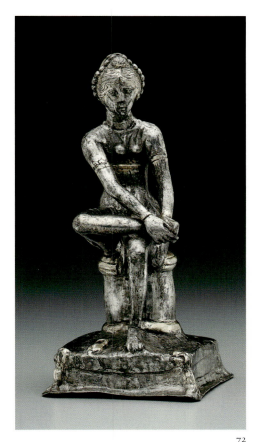

72

This silver statuette represents a woman seated on a stool. Her right ankle rests on her left knee, and she holds her right foot in both hands. Bands around her upper arms, wrists, chest, and slippers are rendered in gold. She wears a thin, tight tunic that is gathered at the waist and extends to mid-thigh. Circles delicately incised at the top of each shoulder represent the clasps of her tunic. Her hair, also gilded, is pulled back from her face, gathered at the top of her head, and secured by a circle of beads. The rounded stool rests on a small platform; its cushion and base are inlaid with gold, as are the lion-headed ornaments at the corners of the base.

The gold jewelry and revealing costume of this figure indicate that the statuette depicts a professional dancer. In the Byzantine world, dancing, both as a pastime and a profession, was a predominantly female activity.[1] Women danced to celebrate important occasions, such as marriages or festivals, and professional dancers took to the stage of the theater and the hippodrome in public performances or were hired as entertainers for private parties.[2] Church writers and imperial laws criticized dancing, particularly by women in public, but the frequency of censorious references to female dancers bespeaks the widespread popularity of these performances.[3] Byzantine works of art indicate that female dancers were also an integral part of legitimate public events such as imperial appearances (fig. 14), and presumably the same women performed at sanctioned and unsanctioned spectacles.[4]

Although a select number of female performers may have grown wealthy through their art—for example, the dancer Pelagia, who later became a saint—the majority of these women would have made very modest livings and were generally of low social status.[5] Indeed, because they appeared minimally clad and heavily adorned in public, dancers were seen in the same light as prostitutes.[6]

This statue is a rare representation of a working woman preparing for her job. Pagan texts relished and Christian texts condemned the lewd gestures and erotic movements of the dance.[7] But sitting in repose, this figure does not elicit erotic associations. The sympathetic portrayal focuses instead on the woman's humanity, thereby contrasting with the image of professional dancers conveyed by contemporary laws and religious texts.  AW

1. For discussion of the "gendered nature" of dance in Byzantium, see Webb 1997, 125–26.

2. For discussion of a contract for a private dance performance, see Webb 1997, 129–30, and Westermann 1924, 134–44. For a reference to women dancing in civic and guild festivals, see Laiou 1986, vol. 1, 113, 122.

3. Webb 1997, 122–23, 131–35; Magoulias 1971, 246–52.

4. Examples of such works are the fourth-century marble base of the obelisk of Theodosios I that still stands on the *spina* of the Hippodrome in Istanbul and an eleventh-century enamel crown of Constantine IX Monomachos (r. 1042–55), in the Magyar Nemzeti Múzeum, Budapest, Hungary (99/1860), as well as

(see fig. 14) the fourteenth-century ivory pyxis depicting an emperor and his retinue, in the Dumbarton Oaks Collection, Washington D.C. (36.24).

5. For the *vita* of Pelagia, see Petitmengin 1981, 23–37; Brock and Harvey 1987, 40–62.

6. Magoulias 1971, 246–52; Petitmengin 1981, vol. 1, 23–37; Procopius 1966, 82–85. As Webb notes, however, "the frequent assimilation of performers to prostitutes (*pornai*) appears as a way of expressing moral disapprobation rather than as a statement of fact about the status of performers" (Webb 1997, 123).

7. Webb 1997, 122–23; Fear 1996, 178–79.

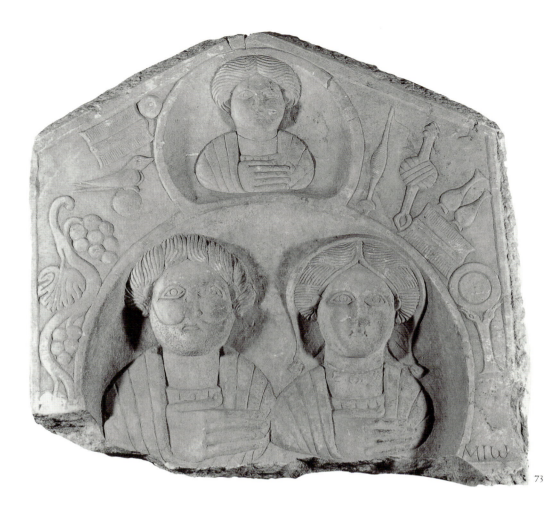

73

## 73 Gable of a Funerary Stele with Family and Domestic Implements

Asia Minor, Late Roman, 230–40
White marble
L. 47 cm, w. 42 cm, d. 7 cm
Inscription: MIѠ [incomplete]
University of Toronto, Malcove Collection,
M82.323

COLLECTION HISTORY Collection of Dr.
Lillian Malcove.

PUBLISHED Campbell 1985, 21–23, cat. 17.

This late Roman stele depicts a family with its implements of daily life. Representations of a woman and her husband occupy an abbreviated roundel on the upper portion. Above them is a smaller roundel possibly depicting the couple's daughter. The hair of both females is parted in the middle and pulled to the back of the head. The woman's hairstyle is more elaborate, with sections layered in waves on either side.[1] She wears a ribbon ornament or hair net that covers the hairline and the central part,[2] and a short veil ending in tassels covers her head. Her jewelry consists of small teardrop earrings and a necklace with round and ivy-leaf-shaped pendants. The smaller female above wears only a simple incised necklace. Each of the three figures is dressed in a tunic and a cloak in which the right arm is cradled. The oversized right hand of each is exposed and held against the chest.[3]

Objects relating to the figures are carved in relief around the roundels. A variety of personal and domestic implements occupies the area to the right of the woman. Included are a spindle connected by an incised thread to a distaff, perfume bottles, a comb, and a mirror with a handle decorated with duck heads. The spindle and distaff indicate that spinning and weaving probably occupied a large portion of the woman's time.[4] The motif of the noble female spinning and weaving is an ancient one, represented by Penelope in the *Odyssey* and later, in Christian art, by Mary spinning at the Annunciation (cat. 83).[5] The other implements all relate to grooming and to the image of a well-to-do household.

A weaving comb similar to the one depicted on the stele is included in this exhibition (cat. 79). To the left of the smaller bust in the upper roundel, a bird seated on a ball, a comb, and possibly a piece of fruit represent the world of children in general and identify the child as a girl. Birds were common pets for women and children in the Roman period.[6] To the left of the husband is a vine, indicating a possible link with viticulture.

The stele is one of a large group of funerary steles produced in Phrygia during the Severan period and known as *Türstein*, or steles with doors.[7] The similarity of the objects depicted on the stele to the images and objects gathered in the exhibition suggests that, for women, the arrival of Christianity may have had little impact on quotidian routine. Spinning and weaving represented a woman's work and contribution to the household. The perfume, combs, and jewelry depicted here all played a role in the daily life of Byzantine women. More significant, the wife and mother in cat. 73 is the same size as her husband, indicating that her role in the family unit was equal in importance to his. In Byzantium, however, although women may have continued to run the household, their role was not acknowledged in the same highly visible way that it was in the Roman period.  MFH

1. A similar hairstyle is found on a statuary head possibly depicting Lucilla, the wife of the emperor Lucius Verus (r. 161–69 A.D.). The head was found near Phrygia and dates to 165–85 (Vermeule 1978, 119).

2. A similar type of headdress appears on a stele from Palmyra dating to the late second century A.D. (*Romans and Barbarians* 1976, fig. 61).

3. Parallels for this type of dress may be found on contemporary Roman funeral monuments (Kleiner 1977, fig. 87).

4. In the Roman period, the funerary monuments of women often dipicted wool baskets, symbolizing the life of a virtuous woman who provided for her household. If there was no room to represent spinning and weaving implements on a grave marker, the inscription *lanam fecit* (she spun) was added.

5. A first-century A.D. Roman stele from Este depicts a distaff and spindle (D'Ambra 1993a, fig. 37). For a discussion of Penelope as the model of the ideal female and the related weaving frieze on Domitian's Forum Transitorium, see D'Ambra 1993a, 109, and D'Ambra 1993b.

6. Campbell 1985, 24.

7. For a complete discussion of these steles, see Waelkens 1986.

## 74 Spindle

Roman (?), 1st–4th century
Bone
Shaft: l. 16.6 cm, diam. 0.9 cm; disc: diam.
3.2 cm
Arthur M. Sackler Museum, Harvard
University, Transfer from the Peabody
Museum of Archaeology and Ethnology,
Harvard University, 1978.495.73
UNPUBLISHED

## 75 Needle

Roman (?), 1st–4th century
Bone
Shaft: l. 10.15 cm, diam. 0.55 cm; eye: l. 0.7 cm,
w. 0.25 cm
Arthur M. Sackler Museum, Harvard
University, Transfer from the Peabody
Museum of Archaeology and Ethnology,
Harvard University, 1978.495.76
UNPUBLISHED

## 76 Needle

Roman (?), 1st–4th century
Bone
Shaft: l. 8.75 cm, diam. 0.75; eye: l. 0.9 cm,
w. 0.2 cm
Arthur M. Sackler Museum, Harvard
University, Transfer from the Peabody
Museum of Archaeology and Ethnology,
Harvard University, 1978.495.77
UNPUBLISHED

## 77 Needle

Roman (?), 1st–4th century
Bone
Shaft: l. 9.75 cm, diam. 0.55 cm; eye: l. 0.85 cm,
w. 0.2 cm
Arthur M. Sackler Museum, Harvard
University, Transfer from the Peabody
Museum of Archaeology and Ethnology,
Harvard University, 1978.495.78
UNPUBLISHED

## 78 Needle

Roman (?), 1st–4th century
Bone
Shaft: l. 7.7 cm, diam. 0.3 cm; eye: l. 0.6 cm,
w. 0.15 cm
Arthur M. Sackler Museum, Harvard
University, Transfer from the Peabody
Museum of Archaeology and Ethnology,
Harvard University, 1978.495.79
UNPUBLISHED

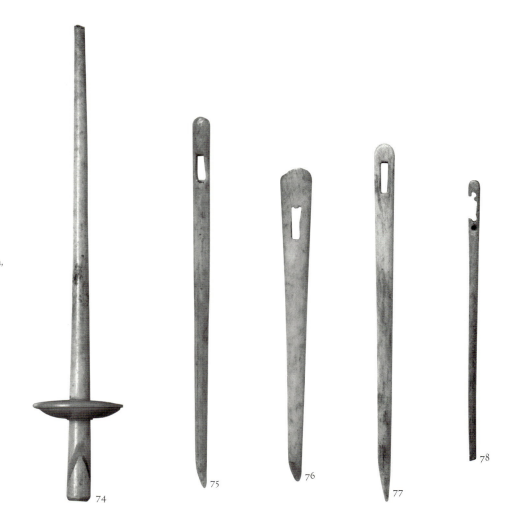

Byzantine spinning and sewing implements were not very different from those of the ancient world. The development of the drawloom in the early Byzantine period was a great advance for weaving technology, but basic tools such as the spindle for spinning thread and needles for sewing cloth remained the same. The implements were often made from the strong bones of cattle or oxen. This spindle (cat. 74) consists of a shaft with a V-shaped slit at the top for attaching thread and a disc (whorl) at the bottom that acted as a weight to help twist the fiber. The spinner twisted the spun thread around the spindle until the spindle was full, and the thread became a skein for weaving.[1] Spindles were usually made of wood; whorls were made of a variety of materials, including wood, stone, bronze, terracotta, or bone. Several bone spindles and whorls similar to cat. 74 have been found at sites in Greece and at Dura-Europos.[2]

Polished to a smooth finish, the bone needles have a rectangular eye and are sharpened asymmetrically to a point. Needles were also made of other materials, such as wood and iron, and varied in their fineness.[3] Weaving implements, including books of needles, were often found in women's graves in Egypt.[4]

Weaver's combs were also found in graves and in houses from the early Byzantine period.[5] With their small, shallow teeth, the combs were used to pack down woven threads

## 79 Weaver's Comb

Egypt, Coptic, 10th–11th century
Wood
L. 25.3 cm, w. 13.8 cm, d. 2.0 cm
The Art Museum, Princeton University, Gift
of Charles Rufus Morey, y1946-79

PUBLISHED *Byzantium at Princeton* 1986, 55–56,
cat. 24.

on a loom. They are usually made of wood and are rectangular in shape. In the center of cat. 79 is the figure of a standing woman holding a cross before her chest with both hands. She wears a crown similar to the type worn by Tyche figures (see cats. 1, 4b).[6] She is flanked by two columns carved in spiral shapes; each column is grasped by a naked angel flying toward the center and holding a wreath encircling a cross. It is not clear who is represented here. The Christian symbolism is emphasized. MFH

1. Rutschowscaya 1990, 25.

2. *I, Claudia* 1996, 93, cat. 60, and 157, cat. 103; *Daily Life* 2002, 370, cats. 447, 448.

3. *I, Claudia* 1996, 157, cat. 104.

4. Rutschowscaya 1990, 29–30.

5. Ibid.; Rassart-Debergh 1997, 106. See also *Beyond the Pharaohs* 1989, 13, for a group of weaving implements, including a comb, taken from a windowsill of a house in Karanis, Egypt.

6. For a fifth-century hair comb with a seated Tyche, see *Daily Life* 2002, 462–63, cat. 631.

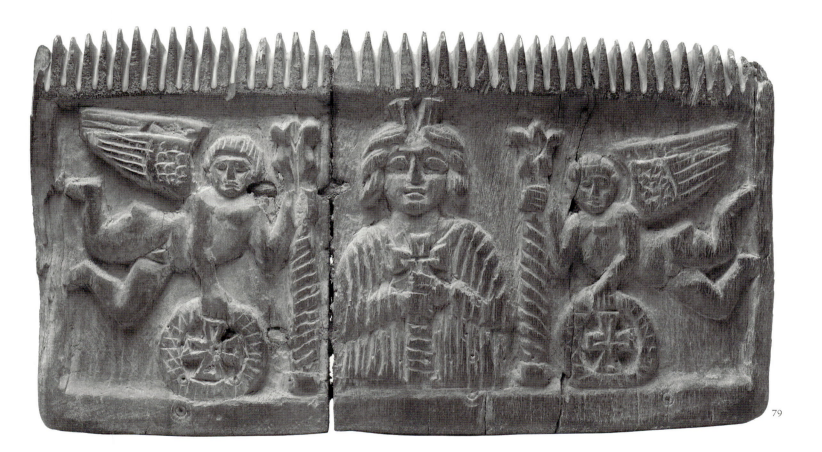

79

## 80 Textile Fragment with Flourishing Vine

Egypt, Byzantine, 5th–6th century
Wool
L. 16.5 cm, w. 16.5 cm
Arthur M. Sackler Museum, Harvard
University, Gift of Denman W. Ross, 1917.110

COLLECTION HISTORY Denman W. Ross
collection.

UNPUBLISHED

This fragment is a good example of an all-wool textile, which allows for extensive use of brightly dyed yarn as a background. The use of red here may be compared to that in the Louvre's "Sabine shawl," where panels depicting mythological scenes, putti, and animals are placed against a deep red background.[1] Cat. 80 also may have been part of a shawl or winter garment.

In the roundel, a stylized and symmetrical vine with large leaves and grape clusters grows from a volute krater with a footed base. The flourishing-vine motif depicted in the roundel is common in Byzantine textiles. Often, the vines bear fruit and are tended by putti.[2] The vine has a long tradition in textile production; in early classical examples it is associated with Dionysos and may symbolize fecundity. In Christian iconography, the vase with a flourishing vine is often associated with the rite of baptism: the vase represents the body, and the vine, the rebirth of the soul. The flourishing vine was also used to refer to Christ, who preached, "I am the true vine, and my Father is the husbandman" (John 15:1).  MFH

1. The color reconstruction of this textile is shown in Rutschowscaya 1990, 94–95.

2. Ibid., 91.

80

81

## 81 Roundel with Multicolored Ivy Leaves

Egypt, Byzantine, 7th–8th century
Wool and linen
L. 16.5 cm, w. 16 cm
Arthur M. Sackler Museum, Harvard
University, Gift of Denman W. Ross, 1917.111

COLLECTION·HISTORY Denman W. Ross
collection.

UNPUBLISHED

This fragment is a good example of the range of colors available to weavers in the early Byzantine period. While some Coptic textiles have lost their vibrant colors through burial in tombs or extensive exposure to light, many remain surprisingly bright. Most dyes used in Coptic textiles are colorfast, and their stability allows a revealing glimpse of color preferences in clothing and home decoration.

Wool fiber accepts dye more readily than linen fiber, and the majority of decorative tapestries produced in Egypt have a dyed-wool weft and a natural-linen warp. The weaver of the roundel used a range of colored yarn, including pink, red, yellow, orange, green, and several shades of blue, in addition to bleached white. Most dyes were derived from plant materials, although a red dye was often made from the eggs of the *kermes*, an insect found on the Mediterranean coast. Another type of red dye, known as "lac dye," was made from red resin produced by an insect that lives on trees in India. This type of dye began to be used more frequently in Egypt following the Arab invasion, when trade to the north was interrupted.[1]

This roundel may have been used to decorate a linen tunic or shawl. Its design of leaves and vines and its multicolor border are typical of later Coptic textiles, which often emphasize color and repeated abstract motifs.[2] These differ from the two-tone coloring and figural motifs commonly found on earlier Egyptian Byzantine clothing. The change in taste may have been influenced by the newly established Arab culture in Egypt. MFH

1. Rutschowscaya 1990, 27–29.       2. Du Bourguet 1964, 355, cat. G34, and 458, cat. G287.

## 82 Eight-Pointed Star Tapestry

Egypt, Byzantine, 4th century
Wool and linen
Diam. 28 cm
Arthur M. Sackler Museum, Harvard
University, Gift of the Hagop Kevorkian
Foundation in memory of Hagop Kevorkian,
1975.41.13

COLLECTION HISTORY Hagop Kevorkian
collection.

UNPUBLISHED

This tapestry panel in the shape of an eight-pointed star composed of two squares, one superimposed on the other and rotated, is an excellent example of both geometric decoration and the use of a "flying shuttle." Motifs such as this one are very common in textiles produced in Egypt in the third and fourth centuries,[1] although eight-pointed stars within a circle are more common than the star motif standing alone.[2] The background is usually dark purple wool, and details are rendered in bleached wool or linen thread. In the intricate technique of the flying shuttle, often used for such detail, an extra thread is added on top of the weft to create the design against the purple ground: the shuttle "flies" across portions of the warp instead of weaving in and out.[3] The high contrast in colors and the fineness of the pale thread yields a very delicate effect.

In this piece, a central roundel contains a pattern of diamonds and circles. Stylized vines grow out of the roundel into each point of the star, and white threads fill in the background. This decorative panel may have been used on clothing, such as a shawl. MFH

1. Du Bourguet 1964, 54, cats. A10 and A11, and 78, cat. B131; Kendrick 1920, vol. 1, cat. 204.

2. Rutschowscaya 1990, 48.

3. Ibid., 32–33.

82

## 83 The Annunciation

Touton, Fayum, Egypt, Coptic, 913/4
Parchment
H. 35.1 cm, w. 26.8 cm
Inscription, in Coptic: above figures, "The Holy Virgin/ Gabriel bringing glad tidings"; between figures, "Hail woman full of grace, the Lord [is] with you" (Luke 1:28)
The Pierpont Morgan Library, New York. Gift of J. P. Morgan (1867–1943); 1924. MS M.597

COLLECTION HISTORY Produced at the Monastery of the Virgin in Apa Silvanus (Selbane), Egypt; found in 1910 at the Monastery of Saint Michael, near Al-Hamuli (Sôpehes), Egypt; purchased in Paris in 1911 for Pierpont Morgan.

PUBLISHED Cramer 1964, 143, cat. 25, pl. 69; Leroy 1974, 55, 103, 204, pl. 35; Urbaniak-Walczak 1992, 167–69, cat. 23; Depuydt 1993, vol. 1, 205–7, cat. 107, pl. 10; L'art copte 2000, 185, cat. 199.

The Virgin Mary, nimbed and wrapped in a purple cloak, sits on a throne, facing front. She raises her left hand toward her face, perhaps in a gesture of surprise. In her right hand she hold a spindle and distaff; to her left sits a basket with three additional spindles. On the right side of the page stands the archangel Gabriel, carrying a staff in his left hand and turning slightly toward the Virgin. Nimbed and draped in a mantle, he raises his right arm in her direction; his right hand is positioned in a gesture of speech. As indicated by the inscription, he announces to the Virgin that she will be the mother of Christ. The image introduces the subsequent texts in the manuscript: Demetrios of Antioch's "Homily on the Incarnation" (fols. 1r–45v) and Cyril of Jerusalem's "Homily on the Virgin Mary" (fols. 46r–74v).[1]

Spinning and weaving featured throughout ancient and medieval times as symbols of female discipline and morality. The Virgin Mary is often shown at the Annunciation in the act of spinning, a perennial reminder of her industriousness and virtue.[2] This image might also have served, however, as a reminder of the Virgin's unique authority in the Christian world order. Proclus, the fourth-century Constantinopolitan cleric and confidant of the empress Eudokia, invented a metaphor for the Virgin, calling her womb a textile workshop in which God wove the tapestry of Christ's body.[3] The Virgin's flesh was "the interlocking warp thread" of this textile.[4] This metaphor elevated the quintessential female activity of textile production to the most sacred and noble act of Christian history.[5] The Virgin spinning at the Annunciation could have been interpreted as a symbolic foreshadowing of the immaculate conception and a reminder of the Virgin's unique authority as the bearer of Christ.   AW/IK

1. Depuydt 1993, vol. 1, 205.

2. This iconography appears as early as the fifth century at the church of Santa Maria Maggiore in Rome, where a basket of yarn appears next to the enthroned and spinning Virgin (Constas 1995, 181, n. 38).

3. Ibid., 180–83.

4. Ibid., 182.

5. Citing the writings of John Chrysostom, Constas argues that early Church fathers used such metaphors to make theology understandable and to imbue even the most mundane objects with spiritual value (ibid., 193).

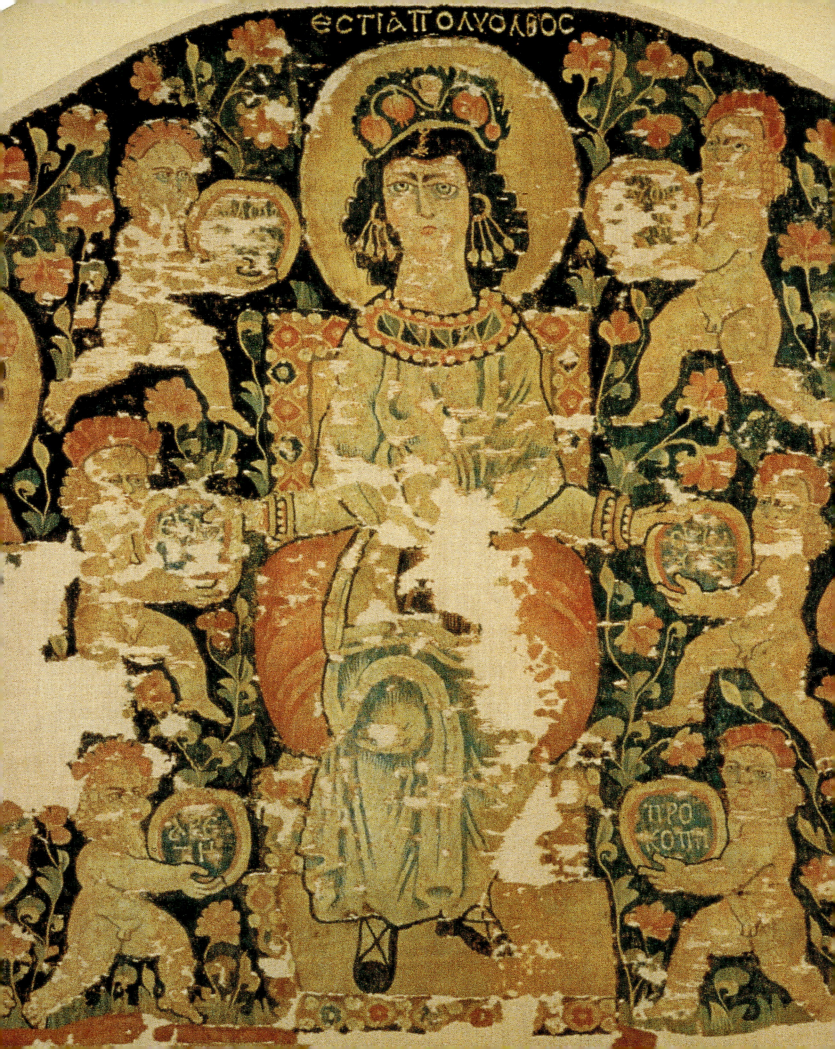

# HOME

ALICIA WALKER

## A Space "Rich in Blessing"

Although Byzantine women were not sequestered in the home, the public realm was a primarily male domain, and the domestic sphere was under the purview of women. The late-fourth-century Church father John Chrysostom offered a detailed explanation for this division:

> In general our life is composed of two spheres of activity, the public and the private. When God divided these two He assigned the management of the household to the woman, but to the man He assigned all the affairs of the city, all the business of the marketplace, courts, council-chambers, armies, and all the rest. A woman cannot throw a spear or hurl a javelin, but she can take up the distaff, weave cloth, and manage everything else well that concerns the household. She cannot give an opinion in the council, but she can give her opinion in the household. Often, indeed, whatever her husband knows of household matters, she knows better.[1]

Elite women—empresses and members of the aristocracy—had the opportunity to wield power in public forums, but even they were frequently censured.[2] The majority of Byzantine women exercised authority only within the bounds of their home. While Chrysostom considered the domestic sphere inferior to the civic, he nonetheless recognized a woman's jurisdiction in household matters.

Evidence for the seclusion of Byzantine women from public view exists, but such citations appear predominantly in reference to wealthy women and usually serve to demonstrate the family's affluence and the women's virtue.[3] These references might be understood as indicative of a social ideal embodying the value of chastity and modesty for women, and especially young women, but an ideal that was enforced only in extreme situations, if at all.[4] Indeed, compelling evidence suggests that both upper- and lower-class women were involved in activities outside the home.[5] The ninth-century Saint Mary the Younger lost a certain amount of her freedom upon moving from a town to a city: while living in a small town, she had daily traveled to the local church to pray, but upon moving to the city, she prayed at home. This change in behavior might be understood as a topos of modesty; she remained within her home in "the populous city" so as to avoid coming "into the sight of one and all, native and foreign."[6] Alternatively, it may indicate that life in urban centers required then, as it does today, a different set of cautionary practices, or that Saint Mary's relatively high social standing imposed certain limitations on her freedom. In contrast, the middle-class tenth-century Saint Thomaïs of Lesbos, who lived in Constantinople, traveled freely and independently to the churches of that city as well as around the marketplace.[7]

A marked transition in the character of feminine sanctity occurred in the ninth century with the emergence of the "holy housewives," a group of pious women who replaced the early Byzantine model of the female saint as repentant prostitute or ascetic virgin with a mother-wife, who fulfilled her marital duties while remaining an exemplary Christian, particularly in matters of philanthropy and prayer.[8] Saint Mary the Younger, for example,

was noted for her "good housekeeping" in tandem with her religious devotion and good works.[9] Her *vita* explicitly states:

> *Although she was a woman, although she was married and bore children, nothing hindered her in any way from finding favor with God: neither the weakness of [female] nature, nor the annoyances of wedlock, nor the needs and cares of child-rearing. To the contrary, it was these things which gave her the occasion to find favor [with God], and thus proved that those who believe and claim that such things form an obstacle to virtue are foolish and create pretexts for sins.[10]*

In the *vitae* of holy housewives, spousal and motherly devotion were revered as aspects of saintly virtue.

The specific duties of the wife within the home were outlined by John Chrysostom as follows:

> *A wife has only one duty, to preserve what we have gathered, to protect our income, to take care of our household. After all, God gave her to us for this purpose, to help us in these matters as well as in everything else. . . . [S]he can raise children well, which are the greatest of treasures. She can discover the misbehavior of the maids and oversee the virtue of the servants. She can free her husband from all cares and worries for the house, the store-rooms, the wool-working, the preparation of meals, the maintenance of clothing.[11]*

As Chrysostom notes, the woman's role centered on processing the raw materials provided by men: food was turned into meals, wool into thread and cloth, children into virtuous and productive adults.[12] The tools that facilitated these tasks—spindles for making thread (cat. 74); needles for sewing textiles (cats. 75–78); plates, jugs, and vessels for making and serving food (cats. 97–104); icons and prayer books for instructing in religion and morality (cats. 115–19)—all testify to the daily activities of Byzantine women.

Although the early-third-century Church father Clement of Alexandria expressed great disdain for physical adornment, he made an exception for housewives wearing a gold seal ring to carry out household duties, including the regulation of domestic goods (cat. 123).[13] Containers of foodstuffs were sealed with wax, clay, or pitch, and an impression was made as a guard against pilfering: a broken seal signaled that some of the contents had been stolen.[14] Especially in homes where servants or slaves were kept, the mistress would need to be vigilant against petty theft. The continuation of these practices may be gleaned from the *vita* of Saint Mary the Younger; when her husband suspected her of infidelity and profligacy, he assigned a servant girl to oversee the household storeroom, a domestic duty he apparently no longer trusted Mary to execute.[15] Ceramic containers used for storing goods (cats. 103–4) would have been common ware in a Byzantine kitchen; the residue of seals on some of these containers provides a physical record of the Byzantine wife's domestic duties.

The use of a family seal might also be authorized to a woman in order to carry out official duties on behalf of a male relative. Fifth-to-sixth-century letters preserved in papyrus from Byzantine Egypt record correspondence between wives and their absent husbands and attest to the concerns of early Byzantine households. From these documents,

we learn of a host of business transactions that a wife or mother might execute in the absence of her husband or son, all of which might easily have required the use of a family seal: accepting payments, paying debts, receiving goods, interacting with couriers and other middlemen, negotiating with tax collectors.[16] These documents suggest that the stark division between public and private roles proposed for men and women by John Chrysostom was not entirely reflective of everyday reality. There were limits, however, to the authority exercised by a female relative; for example, letters tell of a woman imploring her husband to return home to cultivate their land, or a man advising his mother to seek assistance if she is unable to resolve the claim of a debt.[17]

The home played a role in the economic life of the family in other ways as well. Producing cloth, food, and other necessities for the family's use allowed the household to remain economically independent.[18] But women, especially widowed women, who had no other means of support, might turn to weaving and sewing for others as a socially acceptable means of providing for their families.[19] Textiles—worn on the body and hung in public and private spaces—attest to the domestic and professional labor of women.

Household objects lend some sense of the variety and abundance of material from Byzantine homes.[20] As a space largely under the control of women, the home provides a physical record of their predilections and preoccupations.[21] Creating an environment that promoted good luck and domestic bounty ranked among the responsibilities of the household mistress. Images of women bedecked with jewelry and fine clothing (cats. 84, 92) or carrying baskets overflowing with fruit or flowers (cat. 85) frequently adorn domestic objects. Some figures are identified by inscription as personifications of the earth, Ge, or Gaia, but others are anonymous. These "wealth-bringing" figures connoted abundance and prosperity, shedding blessings on the homes they adorned.[22] Images of plants and animals would also have endowed a house with the bounty of nature (cats. 91, 96).

In some cases, pagan deities and personifications decorated furnishings, textiles, and tablewares found in Byzantine homes. The goddess Hestia, keeper of the hearth, was the foremost guardian and benefactor of the home. A well-known sixth-century textile in the Dumbarton Oaks Collection illustrates this personification—inscribed "Hestia Polyolbos" (Hestia Rich in Blessings)—and vividly depicts symbols of the bounty and happiness she encouraged: wealth, joy, praise, abundance, virtue, and progress (fig. 15).[23] Nereids, female sea nymphs and the daughters of the sea god Nereus, or maenads, the wild female devotees of Dionysos, the god of wine, appear as images of fertility, sensuality, and revelry on bone plaques that would have decorated wooden furniture and boxes (cats. 85–88). A muse accompanies Apollo, the god of music, on a textile fragment that once adorned a pillow, wall hanging, or item of clothing (cat. 95). A female warrior, possibly Artemis, the goddess of the hunt, appears on a silver plate (cat. 97). Representations of specific deities might have been appropriate to particular spaces in the home: Aphrodite, the goddess of love and beauty, for example, would have been a fitting guardian for the bedroom or dressing room (cat. 111). These personages of Greco-Roman myth and culture abound on objects from the early Byzantine world and suggest a different conception of female identity and Byzantine culture from the one promoted by Church writers.

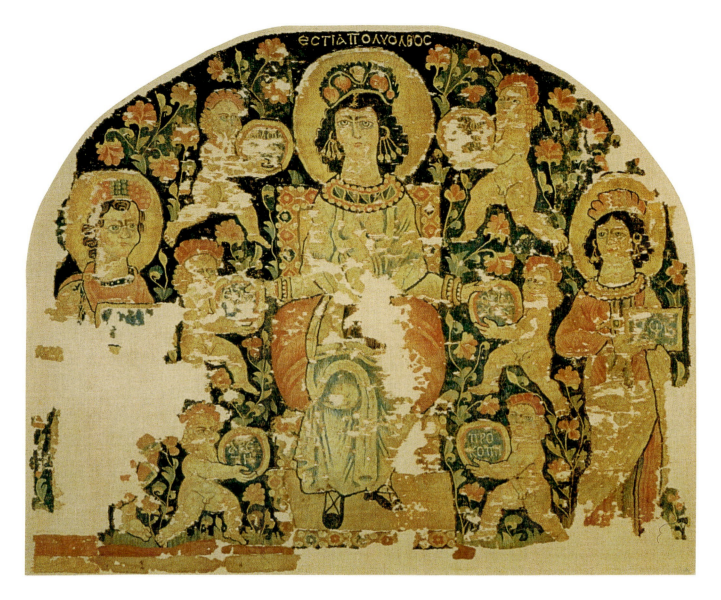

ECTIA ΠΟΛΥΟΛΒΟC

Fig. 15. Tapestry hanging show-
ing Hestia Polyolbos. Egypt,
first half of 6th century. Wool,
1.13 x 1.377 m. Dumbarton Oaks
Collection, Washington, D.C.,
29.1.

That the classical world continued to be a source for domestic decorative themes is appar-
ent from the twelfth-century commentaries on canon law by Theodore Balsamon in which
the author censures Byzantine aristocrats for decorating their homes with statues of
erotes, the winged minions of the goddess Aphrodite.[24]

In the middle and later Byzantine period, images of natural bounty continued to
appear on ceramic vessels and plates, although more comic and aggressive scenes of
animal combat often replaced the peaceful, idyllic scenes of the early Byzantine period
(cats. 99, 100). Middle Byzantine epics also grew in popularity as a source for decorative
motifs. In particular, depictions from the story of the half-Greek, half-Arab border lord
Digenes Akritas found their way into ceramic wares (cat. 102).[25] The female characters in
the Digenes Akritas story offered new types to add to the old cast of personages from
Greco-Roman and Christian narratives. The protagonist's spouse embodied the virtuous
housewife, while the Amazon queen Maximo, bested by Digenes in both battle and sex,
represented the aberrant female.[26] A thirteenth-century ceramic plate depicting a dancing
girl (fig. 16) shows another example of popular imagery from the middle Byzantine era

and indicates a new generic motif of good will and grace that replaced the anonymous female busts of earlier household objects (cats. 84, 92).

Christian symbols were not limited to the church, but appeared in domestic contexts as well. Lamps of bronze or ceramic, and metal polycandela and coal shovels, some decorated with crosses, are attested by archaeological evidence from early Byzantine homes.[27] The cross served as a protective device—much as an image of a pagan deity might—to guard the peace and prosperity of a household.[28] Some homes included prayer corners where small icons were installed to facilitate personal prayer (cats. 115–20). The *vita* of Saint Mary the Younger notes that although the saint did not have an icon corner, she prayed at home to an icon of the Virgin.[29] Lamps or polycandela adorned with Christian symbols (cats. 107–9) would also have been appropriate in these spaces.

The Byzantines continued the Greco-Roman practice of censing the home, to enhance the aesthetic experience of domestic space and to ward off evil and attract good.[30] Since ancient times, bad smells had been associated with sickness and death; incense and other aromatics were believed prophylactic and curative.[31] They were employed, for example, to keep insects away from storerooms, furniture, linens, and doorways.[32] A late antique text, *The Book of Medicines,* instructs the user to take the *kahîna* root "and go to the house or the church, and place it in the hollow of the head of the door." Accompanied by prayers and incense from the church, this fragrant root could serve a variety of aims, from protecting against devils to ridding a woman of an unwanted pregnancy to safeguarding ships and homes.[33] A fourth-century businessman cited incense among the substances in a package he was sending to his wife; incense figures alongside olives, honey, thread, and cloth as an essential item for that affluent Byzantine household.[34]

Fig. 16. Vessel depicting a dancing girl, 13th century. Glazed ceramic, Paphos, Cyprus. Benaki Museum, Athens, 13609.

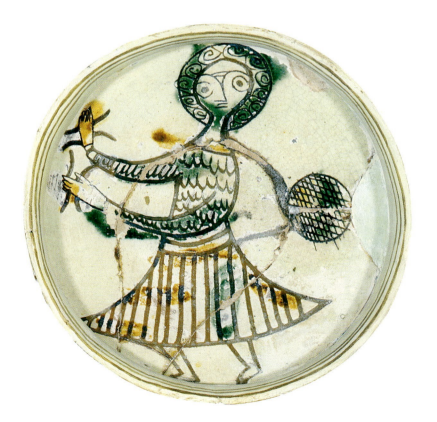

The role of incense as an enhancement of prayer is well illustrated by the *vita* of Saint Symeon the Younger. A miraculous healing is recounted in which the spirit of the saint makes a house call to cure a young man possessed by a demon; the youth sees the saint in a vision and instructs his father to throw incense on the fire and pray to Saint Symeon.[35] Two incense burners in this exhibition represent the secular and religious needs that incense could serve: one, adorned with images of sacred sites in the Holy Land (cat. 113), could have hung in a prayer corner, enhancing the pious devotions of the inhabitants; the other, in the shape of a woman's head (cat. 112), might have connoted the eastern origin and exotic luxury of the substance burned within it.

As caretakers of the home, women not only provided for their husbands and children, but also assisted in the maintenance of the domestic economy. In selecting the objects and materials that adorned their homes, they drew from both pagan and Christian traditions to generate an optimum level of blessing and prosperity for the household. While the male-dominated civic realm was a more visible sphere of activity, the home was nonetheless essential to the cultural identity and smooth functioning of Byzantine society.

1. Chrysostom 1986, 96–97. For middle Byzantine sources reflecting similar values, see Kazhdan 1998, 10–13.

2. See for example, Michael Psellos' criticism of the empress Theodora (Psellus 1966, 261).

3. Kazhdan 1998, 2–8. Based on evidence from the ninth to twelfth century, Kazhdan asserts that the existence within the home of separate women's quarters, a γυναικεῖον, cannot be proved (ibid., 6–8).

4. Ibid., 4–5, citing Angold 1995, 433.

5. Laiou 1981, 246–49.

6. Laiou 1996, 260.

7. Halsall 1996, 262. On this topic, see also Kazhdan 1998, 16.

8. Patlagean 1976, 620–23.

9. Laiou 1996, 257.

10. Ibid., 254.

11. Chrysostom 1986, 96–97.

12. Beaucamp 1993, 186–90.

13. Finney 1987, 182, citing Clement of Alexandria, *Paedagogus* 3.57.1.32–33.

14. Vikan and Nesbitt 1980, 10.

15. Laiou 1996, 264.

16. Beaucamp 1993, 190–91.

17. Ibid., 191.

18. Laiou 1981, 245. See also *Art and Holy Powers* 1989, 143.

19. Beaucamp 1993, 193–94.

20. On the late antique and early Byzantine home, see *Art and Holy Powers* 1989.

21. Like all matters pertaining to Byzantine women, material and physical evidence for the Byzantine home is scarce and often indirect (Kazhdan 1998, 1–2). Several archaeological sites have, however, yielded important information. They include Anemourion, Turkey (Russell 1982a); Sardis, Turkey (Foss 1976, 43–44); and Karanis, Egypt (Gazda and Royer 1983). See also Kazhdan 1998, 8–10.

22. See "Women Who Bring Wealth," in *Art and Holy Powers* 1989, 13–14.

23. *DO Handbook* 1955, 155, no. 301.

24. Saradi 1995, 31.

25. Notopoulos 1964.

26. *Glory of Byzantium* 1997, 271, cat. 192.

27. Excavations in Anemourion, for example, yielded fragments of polycandela from Byzantine houses (Russell 1982a, 137). Excavations of a sixth-century house in Sardis yielded a polycandelon, an ember shovel decorated with a cross, and an incense burner (Foss 1976, 43–44, fig. 21a, b), while excavations in the Byzantine shops produced a bronze lamp with a cross motif and an incense burner (Crawford 1990, 98, figs. 566, 568, 570).

28. *Art and Holy Powers* 1989, 32.

29. Laiou 1996, 260.

30. "In the House" and "Powers of Fragrances," in Caseau 1994, 117–22 and 194–226. See also n. 28, above.

31. Caseau 1994, 203–4.

32. Ibid., 214.

33. Ibid., 211.

34. Beaucamp 1993, 186.

35. Vikan 1995, 572–73.

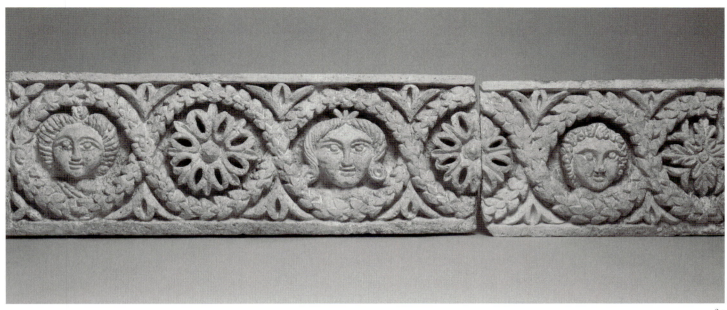

## 84 Architectural Frieze with Portraits in Medallions

Bawit (?), Egypt, Byzantine, early 5th century
Limestone
H. 32 cm, l. 143 cm
Arthur M. Sackler Museum, Harvard
University, Gift of the Hagop Kevorkian
Foundation in memory of Hagop Kevorkian,
1975.41.47

COLLECTION HISTORY Hagop Kevorkian
collection.

PUBLISHED *Pagan and Christian Egypt* 1941,
cat. 53.

This frieze, which decorated the lintel of a building, possibly a house, features a looped ivy garland that forms six medallions: three that frame portraits of women alternate with three that frame rosettes. The rosette on the right is different from the other two, and the piece is broken along the right edge, indicating that the original frieze most likely continued and included at least one and possibly two or more portrait heads.[1] Although the three portraits are carved in the same rough manner, with flat, stylized heads and large, bulging eyes, they are quite distinct from one another. Each woman wears a different hairstyle, and the shape, size, and expression of each face is unique.

Because the frieze lacks an inscription and the portraits have no identifying visual attributes, it is impossible to know who these women were. They may have been local residents, perhaps members of the family that built the structure this frieze once decorated. It is more likely, however, that they functioned as anonymous symbols of bounty and fertility, a theme commonly associated with images of women in Nilotic scenes in Egyptian Byzantine art.[2] The leafy garlands, blooming rosettes, and dense composition of the piece support the latter interpretation. Indeed, though there is nothing to identify these women as maenads, the garlands have a thick, vinelike quality often associated with Dionysian abundance, a popular theme of Byzantine art, especially in Egypt.[3]   JLH

1. A companion limestone relief has the same pattern of garlands and rosettes, but instead of portraits, the florets alternate with pineapple-like fruits (Arthur M. Sackler Museum, Harvard University, 1975.41.46). For wooden friezes from Byzantine Egypt showing comparable floral and fruit motifs, see Rutschowscaya 1986, cats. 419, 446, 447.

2. *Art and Holy Powers* 1989, 13–15; *Rich Life* 1999, 27–29; and cats. 85–88 in this volume.

3. See *Rich Life* 1999, 88.

## 85 Plaque with a Woman Carrying a Basket

Egypt (?), Byzantine, c. 400–640
Bone
H. 9.2 cm
Arthur M. Sackler Museum, Harvard University, Gift of Beatrice Kelekian in memory of Charles Dikran Kelekian, 1984.651

COLLECTION HISTORY Kelekian collection.
UNPUBLISHED

## 86 Plaque with a Maenad

Egypt (?), Byzantine, c. 400–640
Bone
H. 11.9 cm
Arthur M. Sackler Museum, Harvard University, Gift of Beatrice Kelekian in memory of Charles Dikran Kelekian, 1984.653

COLLECTION HISTORY Kelekian collection.
UNPUBLISHED

## 87 Plaque with a Maenad

Egypt (?), Byzantine, 4th or 5th century
Bone
H. 9.0 cm, w. 5.0 cm
Gift of Mr. and Mrs. Nelsen Gutman, The Walters Art Museum, Baltimore, Maryland (71.1097)

COLLECTION HISTORY Henry Walters collection; Joseph Brummer Gallery, New York, 1931; Walters Art Museum, 1942.
PUBLISHED Randall 1985, cat. 148.

## 88 Plaque with a Nereid

Egypt (?), Byzantine, c. 400–640
Bone
W. 9.7 cm
Arthur M. Sackler Museum, Harvard University, Gift of Beatrice Kelekian in memory of Charles Dikran Kelekian, 1984.649

COLLECTION HISTORY Kelekian collection.
UNPUBLISHED

These bone panel fragments would most likely have enhanced household objects for everyday use. Carved bone plaques were a common addition to wooden furniture and boxes, decorating the family's—but especially the woman's—realm.[1] The shape of a plaque sometimes indicates the type of object it originally adorned. Cat. 85, for example, is curved and hollowed out in the back and likely covered the leg or back of a couch or chair.[2] Although bone panels were luxuries, they were more economical than the ivory panels preferred in imperial and elite Byzantine circles. The skill deployed in carving panels varied greatly: cat. 85 shows unrefined, chunky modeling in the face, despite the high relief of the piece, while cat. 87 is deftly carved and almost classical in shape and style.

The themes of fertility and plenty that abound in these panels recur throughout the Byzantine period in imagery inherited and adapted from the Greeks and Romans. Cat. 85 features the most essential image of plenty: a full basket.[3] The roughness of the carving and the wear of age have muted the details of the composition, but the basket-bearer's torso and head are still legible; her arm rises out of the broken left edge and in her right hand she holds ribbons attached to the basket that she cradles in her left arm.[4] Her head is turned so that she looks over her left shoulder, a detail that emphasizes the curved shape of the fragment, as does the high relief of the carving. Despite this three-dimensionality, the figure's pose, especially the angle of her head, is awkward.

Cats. 86 and 87 depict dancing maenads, female devotees of the Greek god Dionysos. The Dionysian dance remained popular in Byzantine art well after Christianity had become the official religion of the empire.[5] Although in the classical and Hellenistic periods maenads were represented as women gone out of control, by the Byzantine period the revelries of Dionysos were more commonly associated with fertility and plenty. Only one arm, the greater part of the belly, the pubic region, and the legs of the figure remain on cat. 86.[6] The maenad's right leg is crossed over her left, a typical position for figures engaged in the Dionysian dance.[7] The figure is carved in very low relief, but the abstracted nature of the pose, with the dancer's belly forced out in front of her, creates a sense of motion, an impression enhanced by the smoothness of the carving. A slight indentation above the navel emphasizes the roundness of her belly, drawing attention to her fecundity. The wavy lines in the background are difficult to interpret; one at the bottom of the fragment could represent a very thick vine, referring again to Dionysian abundance.

Cat. 87 is broken near the top of the figure's thighs, leaving the upper body, with the exception of the hands, intact.[8] The figure is finely carved, with her head thrown back, her hair cascading in waves, her arms raised, and her torso thrust forward; the style of carving creates very smooth, rounded forms.[9] From her pose and lack of costume (she carries only a light piece of drapery as a shawl) we can identify her as a maenad lost in Dionysian revelry.[10] Her youthful appearance—the fullness of her figure and the apparent firmness of her flesh—emphasizes her sensuality and potential fertility. This type of imagery shows that qualities condemned by Christian writers, such female sensuality, were still depicted and celebrated in certain contexts, offering an opposing feminine ideal to which Byzantine women might aspire.

88

Cat. 88 shows a swimming Nereid, or sea nymph, one of the daughters of the sea god Nereus.[11] The plaque is broken, and only the left arm and face of the figure are preserved, but her pose, the elongated shape of her "swimming" arm, and the drapery that flies up behind her identify her as a Nereid.[12] Her face is simple and somewhat rough in style; its large eye sockets, rounded outline, and long nose are similar to styles in contemporary Egyptian Byzantine sculpture. Her hair, parted in the middle, flows back behind her head—a gesture of movement recalling the waves of the sea or, more specifically, the Nile. Nilotic water scenes are prominent in both bone plaques and textiles from late antique Egypt, again as indicators of fertility and plenty.[13] Because Nereids are often paired with a Triton (male sea deity), scholars have proposed that Nereids that appear alone represent "an undercurrent of domestic liberation."[14] If that is the case, it seems likely that this connotation, like the pagan overtones of the Dionysian dance, was muted as the imagery became a familiar motif. Although naked female revelers were found in the decoration of furnishings throughout the house, these images were particularly apt for objects women used.  JLH

1. Randall 1985, 94–95, cat. 148. For a box adorned with maenad plaques, see Randall 1985, 107, cat. 135 and pl. 44.

2. In fact, this figure may have acted as a support for a larger structure, such as a chair or a bench, much like a classical caryatid.

3. *Rich Life* 1999, 27–29 and 38–39. Although some scholars may interpret this basket-bearer as part of a Dionysian retinue, the basket itself is filled with oval objects that appear much too large to be grapes, suggesting a more general interpretation of plenitude.

4. This bone panel is weathered and decaying at the top. It is broken on the right side and the bottom.

5. According to Eunice Maguire, the dance "remains an expression of well-being and liberation throughout the Byzantine period" (*Rich Life* 1999, 88).

6. This bone fragment is broken at the top and the left; a thin border on the right indicates the original edge of the panel.

7. For a textile example, see *Rich Life* 1999, 94, cat. B1.

8. This bone fragment is broken at the left and on the bottom. A squared-off corner at the upper right indicates an original edge.

9. The thrown-back head is a sign of ecstasy in the dance, leading to this maenad's distinction as an "ecstatic dancer" (*Rich Life* 1999, 91). For a piece similar in style of carving, see Gonosová and Kondoleon 1994, 196–97, cat. 63.

10. The shawl-like garment does not appear to be the "cross strap" apparent in many Egyptian Byzantine weavings (*Rich Life* 1999, 123, cat. B25, and 90–91). For a textile with similar shawl-like drapery, see ibid., 108, cat. B12.

11. This bone panel is broken at the left side. The bone shows a slight bowing and there is a dark brown discoloration in the upper middle of the piece.

12. For examples of other Nereids with drapery, see *Age of Spirituality* 1979, 171–72, cats. 150, 151. For an example of a Nereid carved in a similar style, with the same elongated arm and drapery, see Randall 1985, 92–93, cat. 142, and 106, pl. 42. It is also horizontal in orientation.

13. For an example of a textile with a Nereid and dancers, see *Rich Life* 1999, 97, cat. B3.

14. Ibid., 133–34. This theory would make it even more likely that this particular panel adorned an object intended for private use by a woman.

## 89 Textile Fragment with Jeweled Border

Egypt (?), Byzantine, 4th–6th century
Wool and linen
L. 47 cm, w. 17 cm
Arthur M. Sackler Museum, Harvard
University, Bequest of Marian H. Phinney,
1962.81

UNPUBLISHED

## 90 Textile Fragment with Braid Motif

Egypt (?), Byzantine, 4th–6th century
Wool and linen
L. 44.5 cm, w. 17.8 cm
Arthur M. Sackler Museum, Harvard
University, Gift of the Hagop Kevorkian
Foundation in memory of Hagop Kevorkian,
1975.41.21

COLLECTION HISTORY Hagop Kevorkian
collection.

UNPUBLISHED

## 91 Textile Fragment with Leaf Motif

Egypt (?), Byzantine, 4th–6th century
Wool and linen
H. 27.5 cm, w. 13.6 cm
Arthur M. Sackler Museum, Harvard
University, Gift of Denman W. Ross, 1924.87

COLLECTION HISTORY Denman W. Ross col-
lection.

UNPUBLISHED

These pieces represent the variety of designs found on wall hangings in Byzantine Egypt. Distinguished by their brightly colored wool yarns, textiles from this period offer a glimpse into the decoration of interior space in the early Byzantine world. Geometric designs were common for borders and backgrounds, but textile compositions often featured themes from nature, mythology, and religion.

Cat. 89, the most elaborate of the three pieces, depicts a cross at the left edge and fruit baskets at the center and right, all against a red background; birds and vegetal motifs flank each element. The textile employs decorative motifs typical of the period, such as a jewel border. The type of border represented in this piece — with blue, pink, and green gemstones and four white pearls in a square setting — is common on textiles.[1] Borders such as this one can define architectural forms, frame inscriptions, or frame a scene, as may be the case in cat. 89.[2] Jewel borders are also common in other media from the early Byzantine period, such as mosaics and manuscript illuminations.

The birds in cat. 89 all differ in coloring and features. The damaged cross at the left edge is gold and covered in jewels, and interspersed with its arms are tiny white faces with features added in black. No attributes identify the heads. The basket in the center of the fragment holds pink fruit with leaves; at the fragment's right edge only an outline of another basket is visible. Based on this arrangement, it appears that the cross may originally have been at the center of this register, with two more baskets filling out the left side.

Cat. 90 represents an elaborate braid motif, similar to the guilloche (twisted strands) pattern that is very common in larger textile pieces from the early Byzantine period. Both types of design are found on a large hanging depicting Dionysian themes at the Abegg Stiftung in Riggisberg, Switzerland, where they decorate the arches and columns of an arcade.[3] The braid on cat. 90 follows a straight line, indicating that it may have formed an architectural element, such as a column, represented within the textile, or simply func-tioned as a border to the composition as a whole.

Cat. 91 has the shape of a large leaf. The textile appears to have been cut away from its original background and attached to a piece of linen at a later date. The bright green leaf encloses four circles outlined in white and containing orange veins against a deep blue background; the thick stem is in two shades of green. Similar shapes on other textile frag-ments have been identified as "shrubs" or even the "Tree of Life."[4] The orange and blue circles may represent fruit, possibly figs. The shape of the fragment is also reminiscent of the head of a *thyrsos*, the staff carried by Dionysos or maenads in scenes of revelry.[5] The *thyrsos* shape also appears on clothing as decoration.[6] Its scale, color, and design suggest that this fragment was part of a large wall hanging; this motif might have appeared in a repeating pattern.   MFH

1. See, for example, Rutschowscaya 1990, 65.

2. *Beyond the Pharaohs* 1989, cat. 128.

3. Rutschowscaya 1990, 84–85.

4. Rassart-Debergh 1997, 146, fig. 185, and 151, fig. 203.

5. Dionysian themes and nature in general were popu-lar subjects for large hangings produced in Egypt. See *Rich Life* 1999, 88.

6. Ibid., 105, cat. B9.

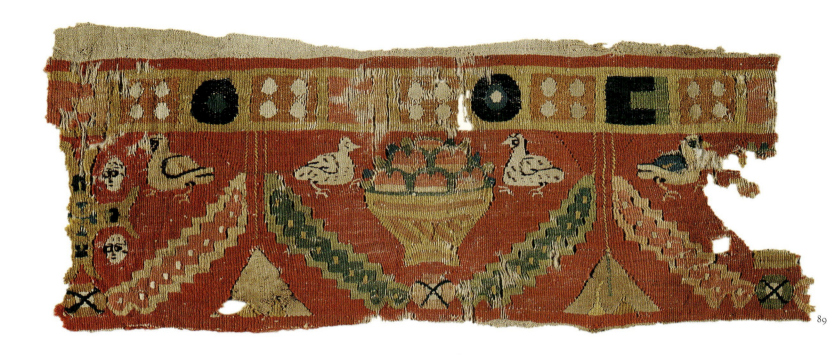

89

90

91

92, detail

92, detail

## 92 Fragments of a Textile Hanging with Female Busts

Egypt, Byzantine, 5th–6th century
Wool and linen (?)
H. 10–18 cm, combined preserved l. 107 cm
Arthur M. Sackler Museum, Harvard
University, Gift of the Hagop Kevorkian
Foundation in memory of Hagop Kevorkian,
1975.41.23

COLLECTION HISTORY Hagop Kevorkian
collection.

PUBLISHED *Pagan and Christian Egypt* 1941,
cat. 186.

Conservators have reassembled fragments of this tapestry-woven textile, which depicts five female portrait busts—four gazing to the right and one to the left—interspersed with stylized pink and green palmettes.

The busts, representing well-dressed women, may have been intended to evoke ideas of privilege and prosperity.[1] Such female figures are frequently found on textiles used to clothe the body and decorate the home; they not only embodied good fortune, but also were thought to attract it. While a single propitious female figure was a common motif on tapestry elements of clothing, the lack of a finished decorative border around each bust and the consistent orientation of the eyes in four of the five figures make it more likely that these come from a larger tapestry hanging.[2] All the women are dark-haired and wear pale gold veils or headdresses (possibly nimbi), earrings, necklaces, and elaborate, colorful robes. The robes vary, however, in motif—flowers or dots—and each woman registers a somewhat different expression. The most prominent feature of the faces is the eyes, with arched brows. In the four women who look to the right, eye color alternates between blue and brown.

It is not possible to tell exactly whom the busts represent, if anyone specific. Repetition of maenads was common in Dionysian scenes, and representations of muses also feature multiple female figures. The lack of identifying inscriptions or special attributes suggests that the heads were meant simply to evoke the idea of privilege. Based on the women's dress, the tapestry seems to have had an overall secular theme and most likely hung in a domestic space. The hanging was woven to be viewed from both sides and could well have served as a curtain separating two spaces.   MFH

1. *Rich Life* 1999, 135–38. Under Justinian (r. 527–65), sumptuary laws enforced in Constantinople restricted the display of wealth by men. Women, however, were allowed to wear luxurious fabrics, including patterned silks (Lopez 1945, 11).

2. If these heads were arranged around a larger scene, they may have looked similar to a hanging with a religious subject, the sixth-century tapestry of the Virgin Enthroned in the Cleveland Museum of Art, in which the Virgin with Christ is surrounded by the busts of Apostles (Rutschowscaya 1990, 135). Although more abstract in style, the Harvard fragments may also be compared to a linen-and-wool hanging in the Metropolitan Museum of Art showing Dionysian busts (Rutschowscaya 1990, 88). The busts, also with eyes of varying color, are in roundels and arranged in facing pairs.

92

## 93 Tapestry Roundel with Eros and Horse

Egypt (?), Byzantine, 6th century
Wool and linen
H. 5.6 cm, w. 6.2 cm
Arthur M. Sackler Museum, Harvard
University, Gift of the Hagop Kevorkian
Foundation in memory of Hagop Kevorkian,
1975.41.9

COLLECTION HISTORY Hagop Kevorkian
collection.

UNPUBLISHED

In this miniature tapestry roundel, an eros riding a horse appears against a dark blue background. The center top and bottom edges of the roundel have deteriorated, but a red-and-natural wave border is still legible.[1] The eros is woven in tan wool; his body is unmodeled, although the outline of his right leg and foot are gracefully contoured. Two large black eyes dominate his face. In his left hand, he holds a red and beige leaf; his right hand is stretched behind him. A tan shape curves around his neck: a cape, or possibly stylized wings. The horse is woven in natural wool with tan highlights and a tan mane, tail, and hooves. Its mouth is open and its eyes are clearly rendered in black. The horse raises its two front hooves in a gallop.[2] Although the figures are rendered in a summary manner, their expressive gestures and dynamic stance create a lively vignette.

Erotes were the attendants of the goddess of love and beauty, Aphrodite, and her son, Eros. Erotes frequently appeared independently of their divine patrons on early Byzantine domestic objects and clothing. Sometimes associated with fertility and bounty, particularly when depicted in Nilotic scenes, erotes were also comic characters whose playful antics suggested a joyful and carefree life.

A comparable tapestry roundel showing a riderless horse in the Walters Art Museum, Baltimore, formed part of a wall hanging.[3] Cat. 93 might also have been one of multiple miniature roundels decorating a curtain or wall hanging.[4]　AW

1. The running wave pattern appears on a circa mid-fourth-century tunic panel at the Metropolitan Museum of Art (89.18.151; *Beyond the Pharaohs* 1989, 267, cat. 181) as well as a sixth-century tapestry roundel at the Museum of Fine Arts, Boston (55.577; ibid., 157, cat. 66).

2. Comparable horse-and-rider figures are found on a sixth-to-seventh-century tapestry panel at the Museum of Fine Arts, Boston (35.87; ibid., 158, cat. 67) and a fourth-to-fifth-century tapestry panel in the collection of the Victoria and Albert Museum, London (Kendrick 1920, 66, cat. 62, pl. 14). In both examples, the rider pulls his arm back in a manner similar to that of the figure in cat. 93.

3. The Walters Art Museum roundel (83-461) is dated to the sixth century and, although larger in format, shows a comparable, but somewhat more finely modeled horse (*Beyond the Pharaohs* 1989, 139, cat. 48).

4. For a tapestry weave element that was probably applied to a curtain and is of comparable size to cat. 93, see *Rich Life* 1999, 54, cat. A11.

93

94

## 94 Tapestry Band with Female Bust

Egypt, Byzantine, 6th century
Wool
L. 25 cm, w. 6.5 cm
University of Toronto, Malcove Collection,
M82.44

COLLECTION HISTORY Delacorte Gallery,
New York.

PUBLISHED Campbell 1985, cat. 199; *Art and Holy Powers* 1989, 51, cat. 4.

Busts of unidentified women are common on Byzantine Egyptian textiles. Many of these women, often richly dressed and nimbed, may represent good fortune.[1] The busts are usually surrounded by lush vegetal motifs and are found on hangings for interior spaces (cat. 92) and even on clothing.[2] The most striking feature of the woman on this textile fragment is her large, expressive eyes, which gaze to the left. She has curly black hair surrounding a square face with a small mouth and a dimpled chin. A jeweled headpiece, drop earrings, and the jeweled collar of her tunic indicate that she is a woman of wealth and status. Stylized palmettes and acanthus leaves fill in the left and right background. All these characteristics of the composition allow the woman to be identified as a generic representation of prosperity.

The graphic style of the textile is very similar to that of other well-known pieces produced in Egypt, such as the Hestia Tapestry at Dumbarton Oaks (fig. 15), and it has been argued that this fragment may even have been made in the same workshop at a slightly later date.[3] However, it has also been noted that textiles with both warp and weft of wool, such as this one, were not commonly produced in Egypt during the fifth and sixth centuries, suggesting that the piece may have been imported in antiquity.[4]

Companion pieces in the Brooklyn Museum of Art and the Montreal Museum of Fine Arts support the hypothesis that these fragments were originally part of a larger frieze that served as the border of a hanging.[5]   MFH

1. *Rich Life* 1999, 135–38.

2. Campbell 1985, 138; for an example from clothing, see *Rich Life* 1999, 160, cat. C18.

3. Campbell 1985, 139.

4. Thompson 1971, 20, cat. 5.

5. Campbell 1985, 138–39. The Brooklyn Museum piece (38.684) is Thompson 1971, cat. 5; the unpublished Montreal Museum piece is 952.Dt.38. Thompson also cites a similar fragment in the Museum of Fine Arts, Boston (30.685).

## 95 Textile Roundel with Apollo and a Muse

Egypt, Byzantine, 5th–6th century
Wool and linen
H. 48 cm, w. 51 cm
Acquired by Henry Walters, The Walters Art Museum, Baltimore, Maryland (83.466)
PUBLISHED *Pagan and Christian Egypt* 1941, cat. 195; *Beyond the Pharaohs* 1989, cat. 41.

This tapestry roundel could have decorated a household textile, such as a pillow or curtain, or even a piece of clothing, such as a shawl.[1] A double frame, consisting of an outer circle and an inner square, surrounds the representation of a couple. Between the circle and square on each of the four sides is a flowerlike ornament flanked by two smaller discs, which imitate jewelry.[2] Inside the square, on the left, against a lighter background, stands a nude male figure who rests his left arm on a lyre atop a pedestal.[3] His right arm bends at the elbow and the back of his hand touches his head. A mantel hangs from his shoulder. The man turns toward the female figure, who wears a black dress with yellow stripes, a bright red skirt, and red shoes. She inclines her head toward her companion, but her body faces the viewer. She raises her right hand as if waving at the man. Flowers surround the couple.

The lyre and the nudity of the male figure suggest that he is Apollo, patron of the arts.[4] Judging from Apollo's raised arm, the weaver of this textile probably had in mind a particular iconographic type of the god in which he either caresses or bends over his lyre while lifting his right hand over his head.[5] An ivory plaque dating from the fifth to sixth century exemplifies this type.[6] It features Apollo in the center surrounded by the Muses with their attributes. In the ivory, Apollo rests his left arm on his lyre and raises his right arm above his head. Clio, the Muse of history, appears to the right, carrying a tablet. Although the woman in the textile does not hold a tablet, her posture recalls that of Clio.

If this identification of the figures on the textile roundel is correct, Apollo with one Muse would have implied the presence of all the Muses. Such an image would have associated the home it adorned with culture and learning.[7]   DA

1. See, for instance, the fifth-century shawl of Sabina in *Age of Spirituality* 1979, cat. 112.

2. A similar border and design appear in a textile fragment in De Moore 1993, cat. 57.

3. The man's legs are awkwardly positioned, with both knees bent; this is probably the result of a mend in the textile.

4. This identification was suggested along with others (Orpheus and Eurydice, mythical lovers), but not explored further from an iconographic point of view (*Beyond the Pharaohs* 1989, 131–32, cat. 41). The identification of Orpheus and Eurydice is unlikely because in examples of that scene, Orpheus is typically surrounded by animals, wears a Phrygian cap, and is fully clothed.

5. *LIMC* 1981–97, s.v. "Apollon": 199, 210, 211, 209, 215, 222, 227.

6. The plaque is now in two pieces. See Volbach 1976, cat. 70, Tafel 70, and *Age of Spirituality* 1979, cat. 243.

7. Although "men of the Muses"—poets and playwrights—are shown in the company of Muses (see Volbach 1976, cats. 34, 69, 71), women alluded to their erudition by embodying a Muse. For instance, a fourth-century silver box from the Esquiline Treasure (fig. 22) is covered by a domed lid decorated with eight of the Muses, each identified by her respective attribute. The top of the lid represents a woman without attributes, possibly the owner of the container, shown as a ninth Muse (see also *Age of Spirituality* 1979, cat. 309).

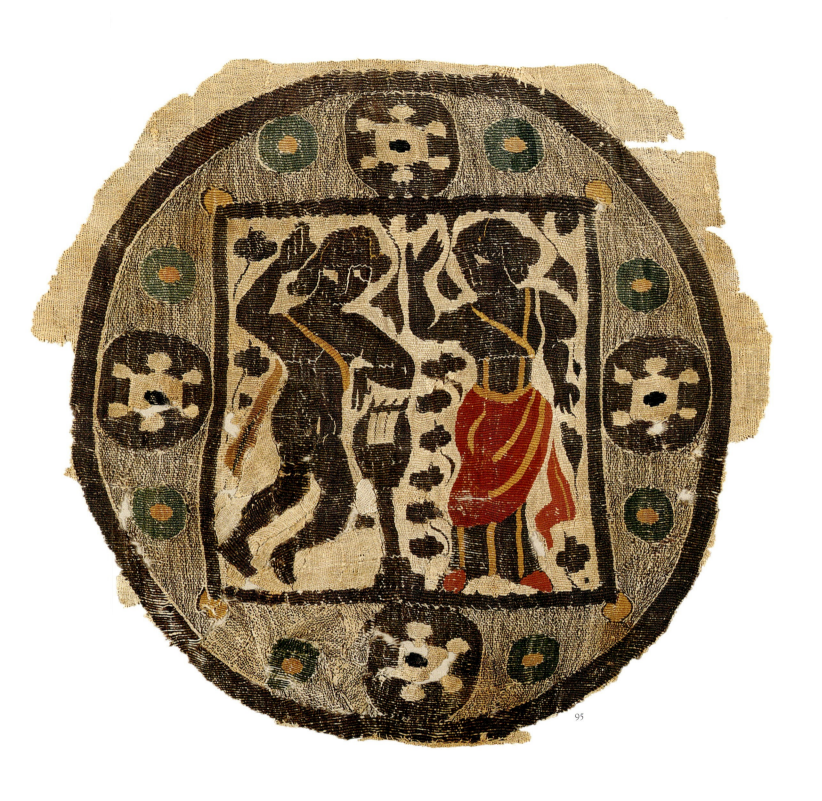

95

## 96 Textile Panel with Duck

Egypt (?), Byzantine, c. 6th century
Wool and linen
H. 12 cm, l. 11.5 cm
Arthur M. Sackler Museum, Harvard
University, Gift of Charles Bain Hoyt, 1931.39
UNPUBLISHED

This panel could have adorned a household object, such as a curtain or pillow, or a garment. It is woven with a weft of dyed and natural wool on a warp of natural linen, and the surrounding plain-weave linen is still intact. In the central square are alternating blue, green, and yellow rosettes, natural lilies, and natural buds against a red background. Within this frame, a thin natural border encloses a duck, which faces left and stands on a stylized branch. The duck is rendered in natural linen with red details; its wings are folded and it raises one foot as if to waddle forward. The medley of bright colors and the diversity of forms on this panel would have made it a particularly striking addition to the object it adorned.

It has been suggested that ducks, a type of game that could be procured even during the lean winter months when other animals were scant, might represent that season or, more generally, sustenance in times of scarcity.[1] This symbol of bounty would have conveyed good tidings to the wearer or household it adorned.   AW

1. *Art and Holy Powers* 1989, 10. Ducks appear, for example, around a winter scene in the late-fifth-to-early-sixth-century mosaic pavement in the narthex of the Large Basilica at Heraklea Lynkestis, Macedonia (Maguire 1987, 36, fig. 49). Ducks are also common attributes for personifications of winter (Dunbabin 1999, pl. 34) and sometimes symbolize the hunt (Du Bourguet 1964, vol. 1, 29, and 75, cat. B25).

96

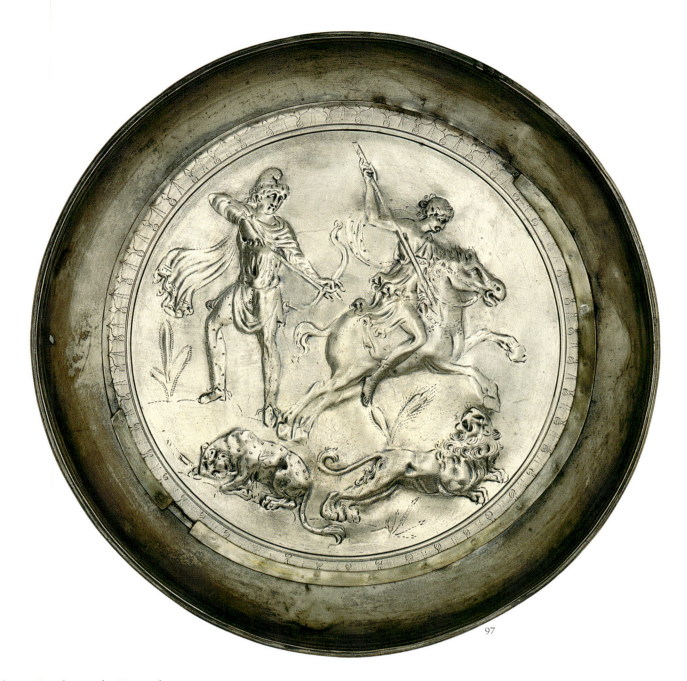

97

## 97 Silver Dish with Female Rider

Constantinople, Byzantine, 5th century
Silver
Diam. 28 cm
Dumbarton Oaks Collection, Washington,
D.C., 47.12

COLLECTION HISTORY Purchased in 1947
from Joseph Brummer Gallery, Inc., New
York, August 15, 1947.

PUBLISHED *Dark Ages* 1937, 34, cat. 72; *Early
Christian and Byzantine Art* 1947, 83, cat. 373;
*Bulletin of the Fogg* 1947, 225; Weitzmann 1960,
48–49; Ross 1962, 3, cat. 4, pls. 2 and 3; *DO
Handbook* 1967, 15, no. 55; *Romans and Barbarians*
1976, 179–80, cat. 203.

The silver dish is decorated with a hunting scene in repoussé. The huntress has been
interpreted as the female deity Artemis or as an Amazon, a legendary female warrior.[1] The
woman rides a galloping horse and is about to strike a lion with her spear. Her male com-
panion aims his arrow at the same beast. In the lower left a spotted feline, probably a
leopard, lies wounded. The scene does not come from any specific narrative, but the male
figure, based on the shape of his hat, has been identified as a Phrygian or a Trojan. The
alliance of Troy with the Amazons further supports the identification of the female figure
as an Amazon.[2]

The plate is dated to the fifth century on stylistic grounds.[3] Greco-Roman represen-
tations survived in secular objects well into the middle Byzantine period, and in earlier
centuries luxury objects in particular followed the visual vocabulary and mythology of
the classical world.[4] This continuity comes as no surprise, considering the social context

in which such objects were created. Asia Minor in the fifth and sixth centuries was still being converted to Christianity,[5] and the cult of Artemis, for example, appears to have survived until the sixth century.[6]

This plate was most likely used in an elite household. The motif is especially relevant because hunting was a favorite pastime of the Byzantine court. Furthermore, in the early Byzantine period, festive receptions were the places to flaunt one's classical education and wealth,[7] qualities that the owner of this plate might have sought to convey. In the ensuing centuries, the use of silver seems to have shifted from the private realm of the aristocracy to that of the Church, a transition accompanied by the demise of classical motifs on silver objects.[8]

The female type depicted here—a mounted huntress, whether Artemis or an Amazon —is not seen frequently in later Byzantine objects.[9] The popularity of this motif may have declined because it could not be reconciled with the new ideals of female behavior. The negative conception of the female warrior or hunter is evident in the epic romance *Digenes Akritas*, which was probably compiled in the twelfth century but reflects earlier, oral traditions.[10] The fate of the Amazon queen Maximo might indicate how some elements of classical mythology were interpreted differently in the middle Byzantine period: though Maximo is a brave fighter, Akritas kills her because her beauty has led him to sin. Maximo is thus condemned as promiscuous and headstrong, and is juxtaposed with Digenes Akritas' chaste and passive wife, a more suitable model for middle Byzantine women.   EF

1. Ross 1962, 3, cat. 4.

2. Weitzmann 1960, 48–49, and Ross 1962, 3.

3. Ross 1962, 3.

4. Kalavrezou 1997a and Kalavrezou-Maxeiner 1985c, 167–68.

5. Trombley 1985, 352.

6. Ibid., 334–35.

7. Elsner 1998, 105–6.

8. Elsner 1995, 259–70.

9. Some early examples include fourth- and fifth-century silver from Ephesus (*Age of Spirituality* 1979, 132–33), and fifth- and sixth-century textile fragments from Egypt (ibid., 134–35, and *Art and Holy Powers* 1989, 149).

10. For an English translation of *Digenes Akritas*, see Mavrogordato 1956.

98

## 98 Silver Bowl

Byzantine (?), 11th–13th century
Silver, gilding
H. 29.9 cm, diam. 14.7 cm
University of Indiana Museum, Burton Y.
Berry Collection, 76.35.42

COLLECTION HISTORY Burton Y. Berry
collection.

PUBLISHED *Highlights from Berry* 1979, 46,
cat. 49; Rudolph 1995, 305–7, cat. 94.

During the early Byzantine period, silver was common for both domestic and ecclesiastical objects, but by the middle Byzantine era it was generally restricted to ecclesiastical use.[1] The lack of clearly Christian iconography on this bowl, however, leaves open the possibility that it was used in a secular context. Its decoration consists of abstract, overlapping petals surrounded by a gilded rim featuring a vine scroll with blossoms. The damage at the center of the bowl suggests that a medallion, now lost, was originally mounted there.

A silver bowl with identical overlapping petal decoration in the Kiev Museum of Historic Treasures has an intact central medallion showing an inscribed roundel inside a square with corners ornamented by vegetal motifs.[2] In between these motifs are cutout griffins.[3] The highly embossed and enameled decoration on the Kiev plate makes it unlikely that it would have been used as a serving platter; it was most likely a presentation plate in an aristocratic household, and cat. 98 probably had a similar use.   EF

1. On Roman and early Byzantine silver and its aristocratic and liturgical uses, see Elsner 1995, 259–70.

2. Rudolph 1995, 305–7, cat. 94. For the Kiev plate see Ganina 1974, fig. 105, and Bondar and Makarova 1975.

It is also possible that the medallion on the Kiev plate was a later addition.

3. Rudolph 1995, 306–7.

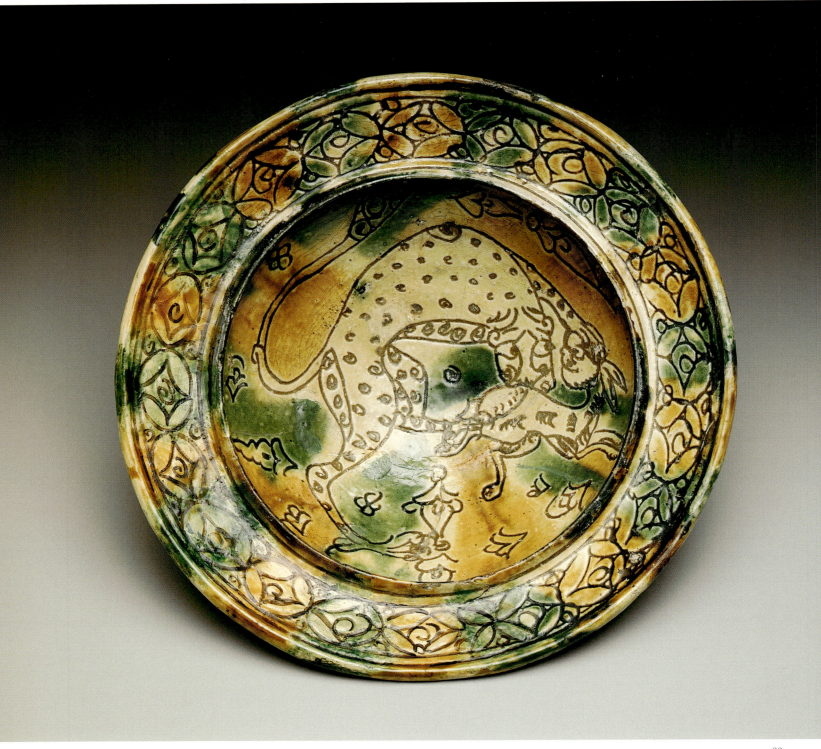

## 99 Bowl with Incised Leopard Attacking a Rabbit

Byzantine, late 13th–early 14th century
Glazed clay
H. 8.3–8.6 cm, diam. 22.9 cm (rim)
Indiana University Art Museum, 77.14

COLLECTION HISTORY Purchase, Frankfurt
art market.

UNPUBLISHED

## 100 Plate with Incised Bird

Byzantine, 12th century
Glazed clay
H. 4.6 cm, 1.1 cm (base); diam. 22.7 cm (rim),
9.1 cm (base)
Indiana University Art Museum, Burton Y.
Berry Collection, 69.117.2

COLLECTION HISTORY Burton Y. Berry
collection; said to be part of a group from
an Aegean shipwreck.

UNPUBLISHED

## 101 Plate with Incised Geometric Design

Byzantine, 12th century
Glazed clay
H. 2.7 cm (max.), 1.0 cm (base); diam.
20.8 cm (rim), 8.8 cm (base)
Indiana University Art Museum, Burton Y.
Berry Collection, 70.72.2

COLLECTION HISTORY Burton Y. Berry
collection; said to be one of a group from
an Aegean shipwreck.

UNPUBLISHED

Objects of humble material were at times richly embellished. These three ceramic dishes were decorated with *sgraffito*, a technique in which incised lines and scrapings in the slip expose the darker clay beneath. Each dish is finished with a glaze. On cat. 99, the glaze enlivens the surface with orange and green color, which is not, however, correlated with the outlined figures. On cats. 100 and 101, the white slip and glaze give the otherwise dull clay an appealing sheen, enriching the mundane medium with a reflective surface reminiscent of more valuable materials.[1]

Cats. 99 and 100 show that scenes from nature remained popular during the middle and later Byzantine periods. The animals depicted, however, are not the peaceful, idealized flora and fauna of the early Byzantine world. Rather, both scenes relate to animal combat. In cat. 100, a bird with curved beak, sharp talons, and alert stance evokes a powerful and dangerous animal of prey, perhaps a falcon. A meandering tendril provides an irregular frame.[2] The detailed rendering of feathers on the bird's chest, shoulders, and wings and the overall naturalism of the representation demonstrate that even in this less valuable medium of ceramic, expressive design and faithfulness to nature were appreciated.

Cat. 99 depicts a leopard, identified by its spots, attacking a rabbit, identified by its long ears. Unlike the bird with its proud demeanor, these animals engage in a comedy of role reversal, with the leopard shyly hiding behind the rabbit's rump instead of biting into it. The rabbit returns the leopard's timid glance with a bemused smile. Although the leopard grabs the head of his prey in one forepaw, the rabbit seems undeterred, striding away from the large cat. Anthropomorphizing humor is a common feature of middle Byzantine ceramics: animals frequently smile, and predator and prey do not always interact as nature would dictate.[3] The richly speckled green and orange pigments and the finely glazed surface, as well as the shape of the bowl, recall a group of ceramic vessels known as Port St. Symeon Ware, which originated from the eponymous port town of Antioch, Syria, that flourished during the Crusader period, about 1097–1268.[4]

Cat. 101 represents a different type of ceramic decoration, an intricate geometric design. Here, a highly stylized leaf at the center of the dish is surrounded by concentric bands of waves or stylized vines. Although simple, the highly regular and expertly balanced design rivals the aesthetic achievement of the more complex decoration on the rabbit-and-leopard plate. The white pigment of cat. 101 is enhanced by a rich glaze that recalls a finer and more expensive material, ivory,[5] while the border designs and central emblem recall the incised and repoussé work of luxury silver.

Ceramic wares like these were typical in middle to late Byzantine households. They are found everywhere in the empire and contrast with the repertoire of classicizing imagery that is more often associated with Byzantine art (cats. 85–88, 97). AW

1. On middle Byzantine ceramics, see E. Maguire 1997.

2. A middle Byzantine ceramic plate decorated with a similar bird is found in the Metropolitan Museum of Art (Evans et al. 2001, 57). However, cat. 100 displays greater attention to detail in rendering the bird's feathers, and its body is stocky, unlike the elongated form of the Metropolitan bird.

3. A middle Byzantine plate in the Metropolitan Museum of Art shows a smiling fish, for example (ibid.).

4. Compare with examples discussed in Ševčenko 1974, 356–57, esp. bowl no. 2, fig. 10.

5. Evans et al. 2001, 57.

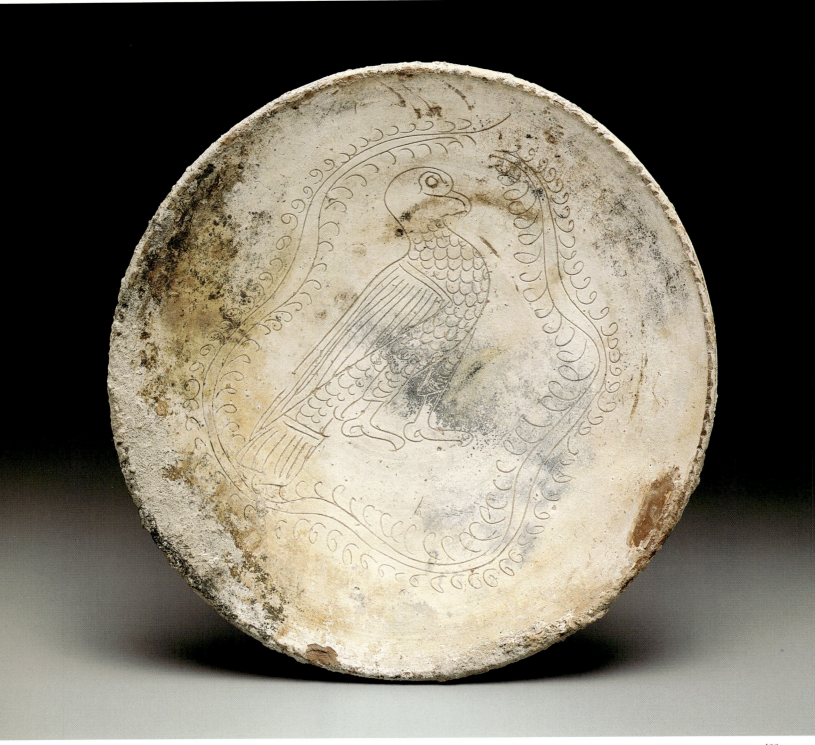

## 102 Two-Handled Ewer with Animal and Human Figures

Greece or Syria (?), Byzantine, 13th century
Glazed ceramic
H. 26 cm
Dumbarton Oaks Collection, Washington, D.C., 58.92

COLLECTION HISTORY Purchased from G. Zacos.

PUBLISHED Rice 1966, 212–14, figs. E, 4, and 5, no. 5; *DO Handbook* 1967, no. 307; Boyd 1979, 40, no. 2G1.

This inexpensive ceramic ewer would have made a lively addition to the household wares of a Byzantine home. The vessel is divided into four registers, and the second register from the top is interrupted by a handle on each side. The first and fourth registers are decorated with abstract motifs: a guilloche pattern at the top and thick strokes of white paint on an unglazed background at the bottom.

The second and third registers feature animal and human figures, all roughly equal in size. The third register on one side features four animals and a Scylla-like creature. All of the figures face left except for a jackal, standing to the left of center, who faces a lion. To the lion's right strides a quadruped with a deer-like head; its body is rendered awkwardly, so that it seems to run on its forelegs while its atrophied hind legs dangle uselessly. To the left of the jackal stands a bird with long, curved tail plumes. To the left of the bird hangs a scroll-like branch, which separates the bird from a creature with the upper body of a man and the multilimbed lower body of a squid or octopus. The figure recalls Greco-Roman mythological beasts of the sea, like Scylla; it wears an elaborate hat or crown with a scroll motif and holds its hands in front of its chest. A vertical line with a thin, ladder-like design separates this figure from the creatures on the opposite side of the vessel. The lion and jackal in the third register stand almost directly under a small tree that marks the center of the second register; another lion prances to the left of the tree and a bird waddles to the right.

The opposite side of the vase displays what appears to be a unicorn at the right of the third register; a single, short horn protrudes from the center of its head. The unicorn faces left, toward a man in a three-pronged crown who raises his right hand. The man, too, faces left, toward a highly stylized tree. On the other side of the tree stands another mythological beast, probably a harpy, half-woman, half-bird. A hanging leaf separates the siren from a quadruped with a feline body and a lizard's head. Three figures appear in the second register on this side. At the right, a man and woman face one another; each raises both hands toward the other (detail, following page). Their gestures may indicate speech or the initiation of an embrace. A stylized tree at the woman's left separates her from an unidentifiable quadruped, possibly a deer. Abstract bud motifs float in the background of the second and third registers. The vibrant green and orange glazes splashed onto the surface of the first three registers do not conform precisely to the figural or geometric designs.

The figures do not appear to be drawn from a specific story, nor do they establish any narrative sequence. The man and woman on one side of the second register recall the epic story of Digenes Akritas—a popular source for Byzantine ceramic decoration—and may represent the hero and his wife.[1] Rather than conveying a narrative sequence, however, this image recalls the general themes of heroism and romance that are essential to the epic. But the two figures could equally represent an anonymous couple, perhaps epitomizing the human world in contrast to the world of fantasy and nature represented by the accompanying creatures. Similar couples appear on contemporary Byzantine ceramic plates that scholars have argued represent brides and grooms. Such figures embrace one another intimately; the woman typically wears a long braid or scarf that projects from her head.[2]

Several of the beasts on this vessel exhibit human qualities: the lion in the second

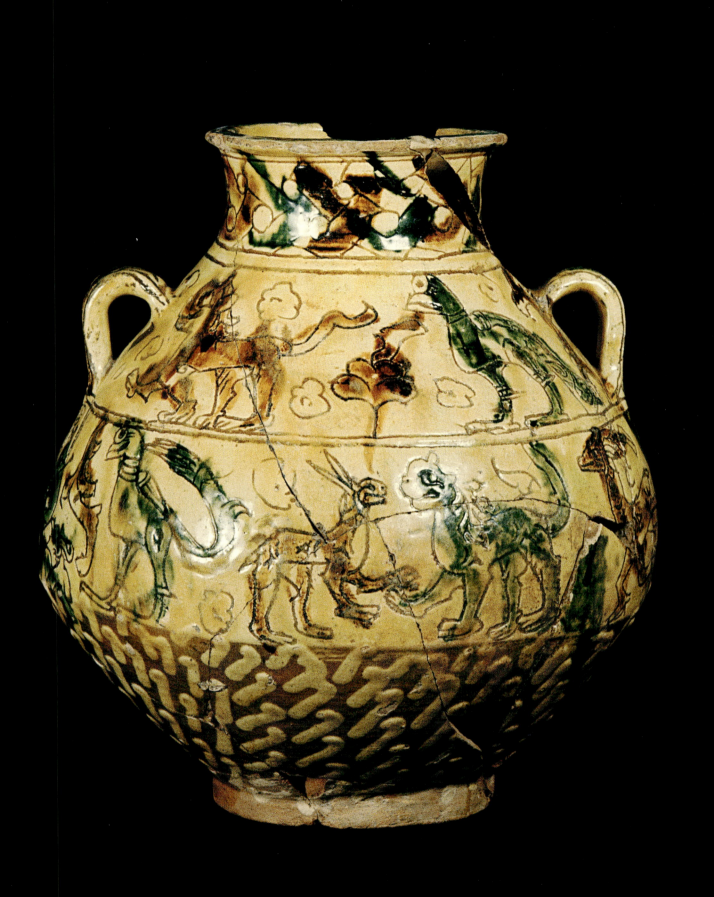

register smiles,[3] while the half-feline, half-lizard creature in the third register displays a menacing scowl. The lion and jackal at the center of the third register on the opposite side recall compositions in the illustrated medieval Islamic story *Kalila wa Dimna*.[4] The tale abounds in anthropomorphic animals, who talk and plot with one another and are frequently depicted with emotional expressiveness. A connection to Islamic themes and narratives is not unlikely for this piece; thirteenth-century Byzantine ceramics frequently draw from Islamic motifs or Islamicized versions of Greco-Roman mythological beasts.[5] The harpy figure in the second register, for example, originates in ancient Greek and Roman art, but here wears a scrolled crown similar to those that feature commonly in figural decoration of Islamic ceramics and manuscripts.[6]

The vivid, stylized representations of humans and animals found on this ewer are typical of middle Byzantine ceramic decoration of the twelfth to fourteenth century. The fanciful animal figures lend the piece a playful and amusing air. AW

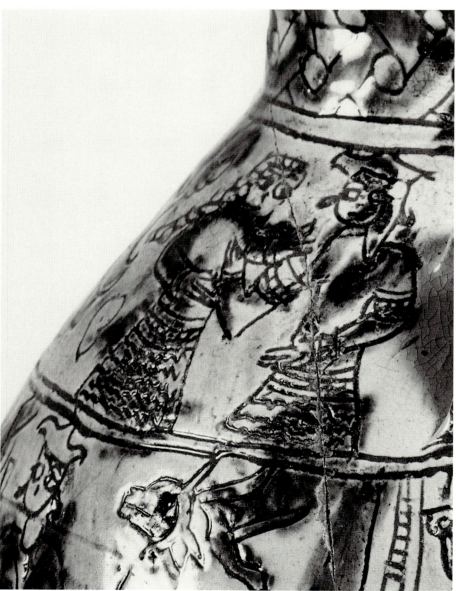

102, detail

1. Frantz 1940–41, esp. 87; Notopoulos 1964.

2. Papanikola-Bakirtzi and Iakovou 1997, 145, cats. 78, 79. In these examples, however, the man wears a short skirt and no crown.

3. Comparable lion figures also appear alone on Byzantine ceramic plates. Rice proposes a circa eleventh-to-twelfth-century Persian source for these feline types (Rice 1966, 216–17, nos. 11, 12, figs. 13, 14).

4. Compare, for example, the probably Syrian early-thirteenth-century manuscript in the Bibliothèque Nationale, Paris, MS ar. 3465, esp. f. 49v (Ettinghausen and Grabar 1987, 377, fig. 397).

5. Rice 1966, 209–17; Ševčenko 1974.

6. Rice 1966, 210.

## 103 Two-Handled Amphoriskos

Bodrum (?), Turkey, Late Roman/Byzantine, c. 300–600
Ceramic
H. 29 cm, w. 16.7 cm
Arthur M. Sackler Museum, Harvard University, Louise M. Bates and George E. Bates, 1992.256.184

COLLECTION HISTORY Bates collection.

UNPUBLISHED

## 104 Jug

Heliopolis (now Baalbek), Lebanon, Byzantine, 600–630
Ceramic
H. 19.5 cm
Arthur M. Sackler Museum, Harvard University, Gift of Professor and Mrs. George E. Bates, 1990.87

COLLECTION HISTORY Acquired by George E. Bates c. 1959.

PUBLISHED Bates 1968, 67.

Ceramic vessels were integral to the lives of late antique and Byzantine women, filling household needs in the kitchen and at the table.[1] Amphorae were the most common storage vessels in the Greco-Roman world, and their sturdiness and utilitarian construction made them essential to the Byzantine household as well.[2] Small amphorae like cat. 103 were called *amphoriskoi* (singular, *amphoriskos*).[3] This example has grooves incised horizontally across its body, very likely to prevent slippage when it was held or carried.[4]

Byzantine amphorae were stacked upright on ships and used for transporting and storing such staples as oil, wine, honey, fruit, and fish paste.[5] Small amphorae may well have been used for luxury items purchased and consumed in small quantities. Because they did not have flat bases, amphorae used in households were placed in wooden or metal stands with round sockets.[6]

In addition to sewing, weaving, cleaning, laundering, and child rearing, Byzantine women were responsible for food preparation and storage.[7] Ceramic vessels were used

103

to keep food and drink from spoiling, as well as to secure provisions against vermin.[8] Amphorae were ideally suited to both tasks. They were usually stopped with wooden plugs fastened with fabric or leather around the rim, or with shards of other ceramics, and then sealed with clay to make them airtight.[9] The seals were sometimes stamped with impressions or ink.[10] Cat. 103, which could have served as a storage vessel or as a container at the table, has a stain on the inside of its neck that may represent residue from dye applied to its stopper.[11] Some amphorae were used as rubbish bins.[12]

Ceramic vessels also served as storage containers for household valuables. Cat. 104, a wheel-made globular ceramic jug with one applied handle, would have originally been used for serving liquids,[13] but when excavated it contained a hoard of 272 sixth- and seventh-century folles and one half-follis, heavy bronze Byzantine coinage.[14] Coin hoards tend not to reflect great wealth, but rather hasty storage in emergencies (particularly wartime) of a treasury that was not recovered; this hoard may have been deposited shortly before the Arab invasions in 635.[15]   LD

1. Nikolakopoulos 1989, 317.

2. The name *amphora*, which means "that which can be carried on both sides," derives from the two handles by which it was lifted ("Storage and Security," in *Art and Holy Powers* 1989, 87).

3. *Amphoriskoi* usually measured less than a foot (ibid., 88). For a comparable *amphoriskos*, see ibid., 102.

4. Bakirtzis 1989, 73.

5. Ibid., 77.

6. Ibid. A fourth-century floor mosaic from the Piazza Armerina villa in Sicily depicts the use of glass *amphoriskoi* as containers for the wine served at an elegant hunt picnic ("Storage and Security," 88).

7. Talbot 1992, 126.

8. "Storage and Security," 87.

9. Bakirtzis 1989, 76–77.

10. Winlock et al. 1926, 80.

11. The purple-pink stain on the interior neck of cat. 103 does not extend into the inner body of the vessel. The stain may have been formed by the impression of sealing materials (usually mud, pitch, plaster, or terracotta) with stamps dipped in pigment, usually red dye (Winlock et al. 1926, 80). The dye may have seeped through the sealing material and discolored the inner neck, or the sealing material may have sunk too low into the amphora, causing the dye to rub on the inner neck. Polarizing light microscopy conducted by Narayan Khandekar at the Straus Center for Conservation, Harvard University Art Museums, suggests that the dye is of organic origin, and UV/visible spectroscopy by the Museum Research Laboratory, Getty Conservation Institute, points to a shellfish source.

12. Bakirtzis 1989, 77.

13. Morgan 1942, 28.

14. Bates 1968 14, 67.

15. Howgego 1995, 88.

104

<div style="text-align: right">105</div>

## 105 Glass Flask with Inscription

Byzantine, 4th century
Glass
H. 12.7 cm
Inscription: ΥΓΕΙΑ (health)
University of Indiana Museum, Burton Y. Berry Collection, 72.2.8

UNPUBLISHED

This small vessel has a spherical body with a short funnel neck and a flared rim. The blown glass is a clear light green. The upper part of the body has an incised crosshatch pattern, and a similar design of angular lines decorates the lower body, around the base. On the plain space of the circumference an inscription in large double-outline Greek letters spells ΥΓΕΙΑ (health). The flask is typical of a group of blown-glass vessels with engraved Greek inscriptions that spell out abstract nouns; others are "joy" and "grace."[1] An almost identical flask in the British Museum has the word ΚΥΡΙΑ inscribed on it, which might mean "power," but also "for the lady" or "for the mistress."[2] It is not clear what the specific use of these flasks was, but, judging from their inscriptions, which suggest certain mental and physical conditions, the fluids contained in them were intended to bring about a healthy or happy state.   IK

1. Buckton 1994, 40–41, cat. 17.

2. For the British Museum flask (BM, M&LA 1962, 12-2,1) with the word ΚΥΡΙΑ, see Harden 1963, 27–28, pl. 8.

## 106 Polycandelon

Egypt or Eastern Mediterranean, Byzantine,
6th–8th century
Cast bronze
Diam. 23.3 cm, l. of chains 36 cm
Arthur M. Sackler Museum, Harvard
University Gift of the Hagop Kevorkian
Foundation in memory of Hagop Kevorkian,
1975.41.145

COLLECTION HISTORY Hagop Kevorkian
collection.

UNPUBLISHED

## 107 Polycandelon

Bawit (?), Egypt, Byzantine or Coptic,
7th–10th century
Leaded brass
Diam. 57.4 cm
Arthur M. Sackler Museum, Harvard
University, Gift of the Hagop Kevorkian
Foundation in memory of Hagop Kevorkian,
1975.41.137

COLLECTION HISTORY Hagop Kevorkian
collection.

PUBLISHED *Pagan and Christian Egypt* 1941,
cat. 86.

Cat. 106 consists of a bronze disc with a sawtooth edge; it is suspended from three bronze chains that attach at one end to three rings soldered to the disc and at the other to a suspension hook.[1] The disk has a geometric openwork design with seven round lamp openings, one at the center and six in the outer circle. Small conical glass beakers filled with oil and ignited by a wick would have been placed in these openings.[2] Radiating from the central opening are six pairs of spokes. In three pairs the spokes are connected by a crosspiece; the openings between the spokes in the other three pairs are partially filled. Interspersed with the six peripheral round lamp openings are additional spokes connecting the central and outer circles. The pairs of inner spokes with the spaces partially filled are reminiscent of the Christ monogram, but the design of this polycandelon combines several decorative types that have lost some of their original detail and have developed into abstract shapes.[3] Cat. 107 consists of a wide, flat bronze ring with twenty-one round openings.[4] They would have held candles, as confirmed by a residue of beeswax.[5] Three bronze suspension rings are soldered to this ring. The large Greek cross at the center is soldered to the outer ring.

Until the eighth century polycandela were widely used as lighting devices in churches and homes.[6] One such polycandelon includes an inscription featuring a female name, indicating that it was commissioned by a female patron or acquired by a woman as part of her household furnishings.[7] The cross-shaped decoration of cat. 107 would make it an appropriate lighting device for a church or perhaps for a home in which the inhabitants sought the protective and auspicious power of the cross.[8] HS

1. The Egyptian origin of cat. 106 is supported by an almost identical example, now in Berlin, from an Egyptian monastery (Wulff 1909, 211, cat. 1005, pl. 48). A similar but more elaborate polycandelon is in the Malcove Collection, Toronto (Campbell 1985, 58).

2. Bouras 1982, 480; Mango 1986, 90; Crowfoot and Harden 1931, 200–201.

3. The central spokes of a comparable but more elaborate polycandelon in Berlin represent a Christogram with the loop of the rho as well as an alpha and omega (Wulff 1909, 211, cat. 1010, pl. 48). Comparison with other polycandela suggests that the double bars with crossbars in the inner circle of cat. 106 may derive from the letter alpha. See, for example, a polycandelon in the Walters Art Museum, Baltimore (Verdier 1960, 2).

4. An identical piece in the Louvre has been attributed to an Egyptian context (Bénazeth 1992, 166).

5. This analysis was conducted by Eugene Farrell, Straus Center for Conservation, Harvard University Art Museums.

6. *Art and Holy Powers* 1989, 57.

7. This piece is in the Louvre (Schlumberger 1895, 178).

8. According to conservation analysis, the pattern of corrosion on cat. 107 indicates that this piece was stacked with other, similar pieces, which suggests that it may have been used in a church setting, where multiple polycandela were needed.

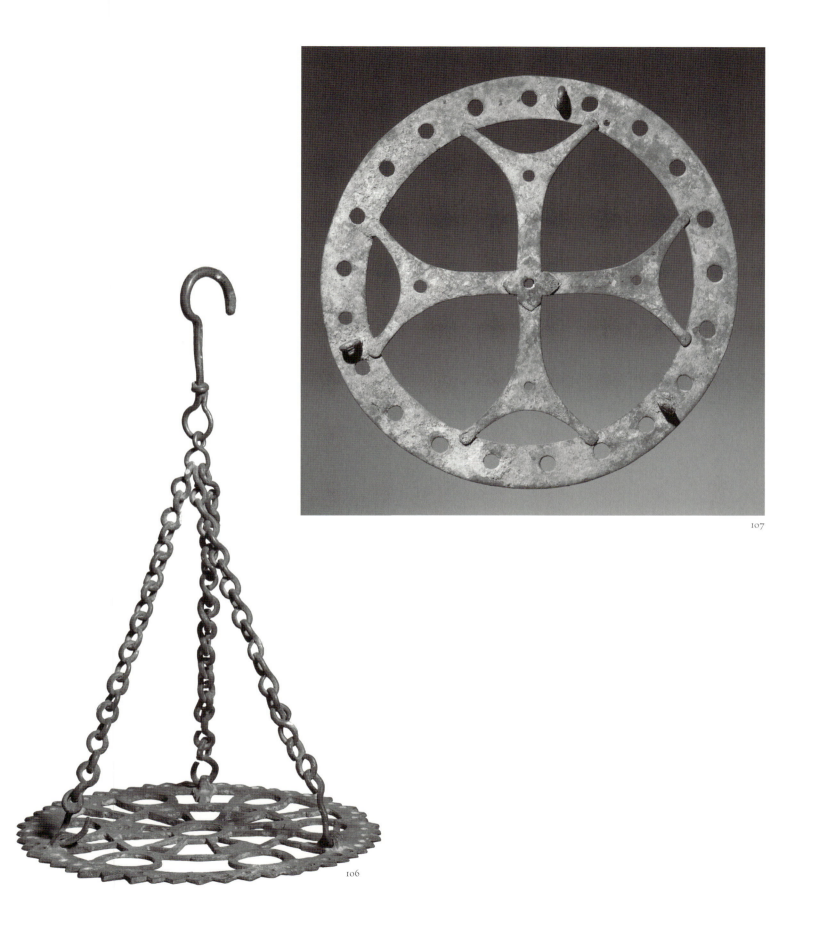

106

107

## 108 Lamp

Karpathos, Greece, Byzantine, c. 5th–7th century
Bronze
H. 10 cm, l. 15 cm, w. 5.2 cm, diam. of foot 4 cm
Arthur M. Sackler Museum, Harvard University, Gift of Mrs. A. Kingsley Porter, 1957.68

COLLECTION HISTORY Collection of Mrs. A. Kingsley Porter.
PUBLISHED *Early Christian and Byzantine Art* 1947, 64, cat. 250, pl. 38.

## 109 Lamp

Eastern Mediterranean, Byzantine, 6th–7th century
Bronze
H. 9.8 cm, l. 10 cm
Arthur M. Sackler Museum, Harvard University, Gift of the Hagop Kevorkian Foundation in memory of Hagop Kevorkian, 1975.41.138

COLLECTION HISTORY Hagop Kevorkian collection.
PUBLISHED *Pagan and Christian Egypt* 1941, cat. 89.

## 110 Lampstand

Eastern Mediterranean, Byzantine, 6th–7th century
Bronze
H. 24.6 cm
Arthur M. Sackler Museum, Harvard University, Gift of the Hagop Kevorkian Foundation in memory of Hagop Kevorkian, 1975.41.141

COLLECTION HISTORY Hagop Kevorkian collection.
PUBLISHED *Pagan and Christian Egypt* 1941, cat. 89.

Oil lamps were widely used in Byzantium in both domestic and religious settings. From excavations we know that lamps were the most common household furnishing until the seventh century, when they were largely replaced by candles.[1] In churches, lamps were hung above altars and in front of icons as votives, and they served as lighting devices for worship and study. Many homilies and theological essays of the Byzantine period use lamps as metaphors for the soul.[2]

Byzantine lamps range from the strictly utilitarian to vessels elaborately adorned with designs of crosses or animals and with precious stones. Clay lamps were the least expensive and most ubiquitous, while bronze and silver lamps appeared in aristocratic households and ecclesiastical settings.[3] Though some lamps were hung from above, both these examples were placed on the pricket of a lampstand.

The body, handle, lid, and hinge pin of cat. 108 were cast separately. The bulbous body has a flared base with a tapering rectangular indentation for the pricket of a stand. The lip of the spout and the lid are each incised with a circle. The lid tapers to a rounded finial. The handle is shaped like a cross with end beads decorating each of the upper three arms and a finger ring at the base.[4] Like cat. 108, cat. 109 is cast; it consists of a bulbous body and shell-shaped, hinged lid.[5] Its handle is also in the form of a cross with flared arms. A finger grip is soldered to the back of the cross. The base of the lamp forms a shallow disc with an indentation that received the pricket of a stand. The spout is unusually large. The cross decoration of the handles on these lamps does not necessarily indicate that they were used in a church. Objects in the home were frequently decorated with the cross, a symbol that was thought auspicious and protective on both domestic and ecclesiastical objects.[6]

The cast-bronze stand (cat. 110) consists of three separate pieces: a saucer and pricket; a flared, baluster-turned shaft; and a tripod base. The flared base terminates in three down-turned knobs and is supported by lion's-paw feet.[7] The saucer and pricket are joined to the middle piece by a screw. The presence of the screw, as well as the fact that the saucer and base are decorated with incised circles while the shaft is decorated with raised circles, suggests that the pieces were not made together and may have been assembled at a later date. The stand supported a lamp on its pricket. Lampstands varied in height from twenty-five centimeters to more than a meter. The shortest were intended for tables or wall niches, and the tallest were placed on the floor. This stand would have been well suited for placement on a table or in a niche.[8]   ADG

1. Mango 1982, 254; Soren 1985, 52.

2. *Art and Holy Powers* 1989, 58.

3. Ibid. and Gonosová and Kondoleon 1994, 175.

4. See Ross 1965, cat. 31, for a similar cruciform handle, and cat. 35 for a similar finial.

5. Cat. 109 is covered in a mottled dark-brown patina, and the spout displays corrosion. The body is dented near the lip of the basin.

6. A lamp bearing a cross ornament was also uncovered in a Byzantine shop at the site of Sardis, Turkey, again attesting to the use of cross-adorned lamps in a secular context (Crawford 1990, 98, figs. 567, 568, 570).

7. The tripod base and flared shaft are similar to other eastern Mediterranean examples from the fifth to seventh century (Gonosová and Kondoleon 1994, 259). Ross compares a similar stand in the Dumbarton Oaks Collection and attributes it to Syria (Ross 1965, 38). Chronological attribution of the group stems from the inscriptions on stands from the Hama excavations (Gonosová and Kondoleon 1994, 259).

8. The lampstand is covered in a mottled dark-brown patina.

108

109

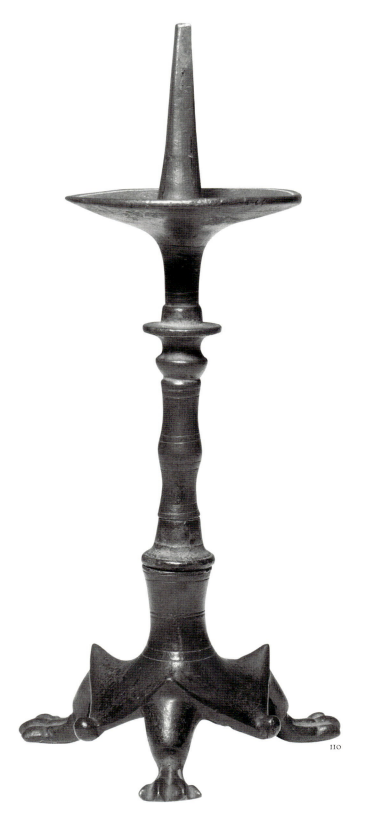

110

III Lampstand with Aphrodite

Egypt, Byzantine, 5th–6th century
Bronze
H. 50.2 cm
The Nelson-Atkins Museum of Art, Kansas
City, Missouri (Purchase: Nelson Trust) 58-5

COLLECTION HISTORY Collection of J. P.
Morgan, Sr.; Nelson Gallery of Art, 1958.
PUBLISHED Nelson Gallery Foundation 1959,
47; Ross 1959; *Age of Spirituality* 1979, cat. 318;
*Beyond the Pharaohs* 1989, cat. 51, pl. 17; *Art and
Holy Powers* 1989, 180, and 182, fig. 45.

This stand has a pricket at its top that would have held a lamp. The dish below the pricket was designed to catch oil drippings. The pillar of the lampstand takes the form of Aphrodite, the goddess of beauty and love. She is naked from the waist up, and her lower body is wrapped in a tight garment with angled striations that emphasize the curves of her hips, thighs, and buttocks. In her right hand she holds a disproportionately large perfume or cosmetic applicator, which she points toward her face while she gazes into a mirror. At the base of the stand, Nereids and icthyocentaurs frolic.

Scenes of Aphrodite at her toilet appear on objects associated with early Byzantine women (see fig. 3); the presence of her image on this object suggests that the owner of the lampstand was a woman. Although short lampstands were portable and could have been moved throughout the house, the theme of this object makes it a particularly appropriate furnishing for a woman's dressing room. The Nereids at the base entwining amorously with the ichthyocentaurs perhaps foreshadow the intimate encounter for which Aphrodite—and possibly the owner of the stand—prepared.

The association of Aphrodite with love and marriage in classical and late antique literature has led scholars to identify this lampstand as a wedding gift. According to this interpretation, the Nereids deliver presents for the bride to Aphrodite, who prepares to attend the nuptials.[1] While marriage certainly offers one social context for the production and use of objects featuring Aphrodite iconography, this lampstand would not have required such an impetus for its production. Rather than deliver wedding gifts, the Nereids may simply assist Aphrodite at her toilet, presenting the necessary tools. If that is the case, they might mirror the attendants who aided the female owner of this lampstand in her own preparations.    AW

1. Ross 1959, 2–4. Ross bases his argument in part on comparison of the lampstand with the fourth-century Projecta casket (fig. 20) which he asserts depicts the preparation of the bride for her marriage, the preparation of Aphrodite to attend the marriage, and the bearing of gifts—including a lampstand—by the guests. An alternative reading questions the identification of the casket as a wedding gift, interpreting the scene as a procession to the bath (Shelton 1981, 26–28).

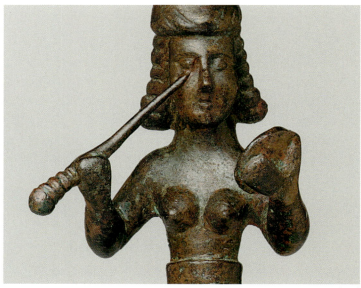

III, detail

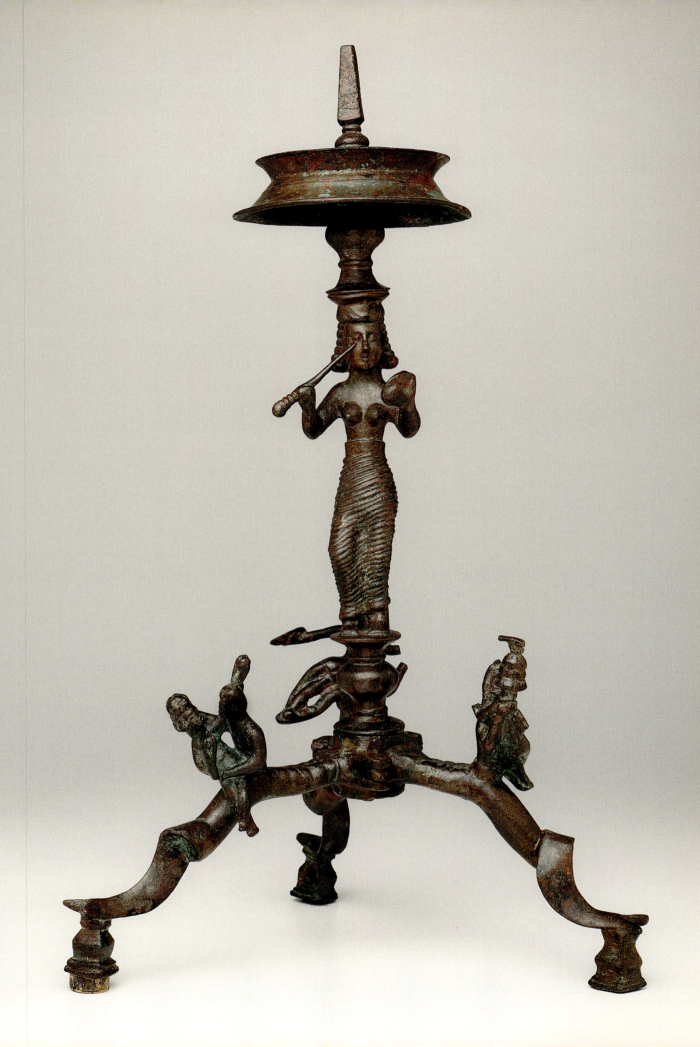

## 112 Incense Burner with the Queen of Saba (?)

Egypt, Byzantine, 4th–6th century
Bronze
H. 25.5 cm, w. 7.5 cm
The Art Museum, Princeton University,
Museum purchase, y1933-5

COLLECTION HISTORY Said to come from
al-Mawsil in northern Iraq.

PUBLISHED *Early Christian and Byzantine Art*
1947, cat. 275; *Byzantium at Princeton* 1986, 75,
cat. 53; *Beyond the Pharaohs* 1989, cat. 17.

This bronze incense burner is cast in the form of a female head with large, heavily out-lined eyes, a pointed nose, and a small mouth. The figure wears a Phrygian cap and elaborate jewelry, evidence of a taste for exoticism in the decoration of a common household furnishing. The incense burner consists of three parts: the neck and head resting on three small feet; the hinged, hat-shaped lid with a front closure; and the chain attachment on top. Small and portable, it could be hung, carried, or set down to give off fragrant smoke.

With its ridged rim, scrolled tip, and smoke holes suggesting spots, the lid represents a leopard-skin Phrygian cap, an attribute widely used to identify figures of Eastern origin in late antique and early Byzantine art.[1] Women wearing Phrygian caps, dangling earrings, and pearl necklaces adorn several other domestic incense burners and lamps from early Byzantine Egypt.[2] Their special association with vessels in which perfumes were burned, as well as Asiatic royalty and incense gifts, evokes the Queen of Saba (Sheba), the biblical ruler of southern Arabia who astounded the court of Solomon with presents of gold, precious stones, and an unparalleled abundance of aromatic spices.[3] Saba would be a logical subject for an early Byzantine censer; most incense was imported from southern Arabia and is generally associated with the region in contemporary sources.[4] The third-century Church father Tertullian refers to incense merchants as "Sabaeans" and confesses, "If the smell of any place offends me, I burn something from Arabia."[5]

In Byzantine chronicles, the Queen of Saba is identified with the Cumaean Sibyl.[6] Described as πάνυ ἐπ᾽ ἀγχινοίαι τε καὶ σοφίαι καὶ πολυπειρίαι διαβόητος (exceeding in sagacity and wisdom and experience), Saba possessed gifts of prophecy and knowledge that perhaps also gave her image auspicious meaning.[7] The adornments of this head—pearls, earrings, and fillet—suggest great wealth and far-flung resources, befitting the sibyl-queen and perhaps expressing hope for household prosperity. Favorable connotations may also be implied by her likeness to female personifications of health and plenitude on other Egyptian Byzantine domestic furnishings. Similar female heads exist on vessels identified as pitchers for a woman's toilet, such as the fine silver-inlaid example from the fourth-century Esquiline Treasure.[8] Perhaps this type of incense burner was also made for women's apartments, which the late-fourth-century Greek Church father Gregory of Nazianzos associated with "outpourings of costly perfumes."[9] The censer evokes the application of jewelry and cosmetics often depicted as part of a woman's toilet. The overstated outline of the eyes clearly imitates kohl, the traditional eyeliner of Egypt, known, like incense, for its beautifying and protective qualities.[10] As the Queen of Saba, whose beauty entices Solomon in medieval legends, the censer may also allude to the notoriously seductive power of airborne fragrances.[11] They were used liberally in bed-rooms and on the wedding night, which, in the words of the fifth-century poet Claudian, was enhanced by "burning censers wafting strong scents."[12] Alternatively, this ornate female censer is a fitting personification of εὐωδία, a sweet scent that offers and fosters pleasure, health, prosperity, and piety in the home.[13]   EG

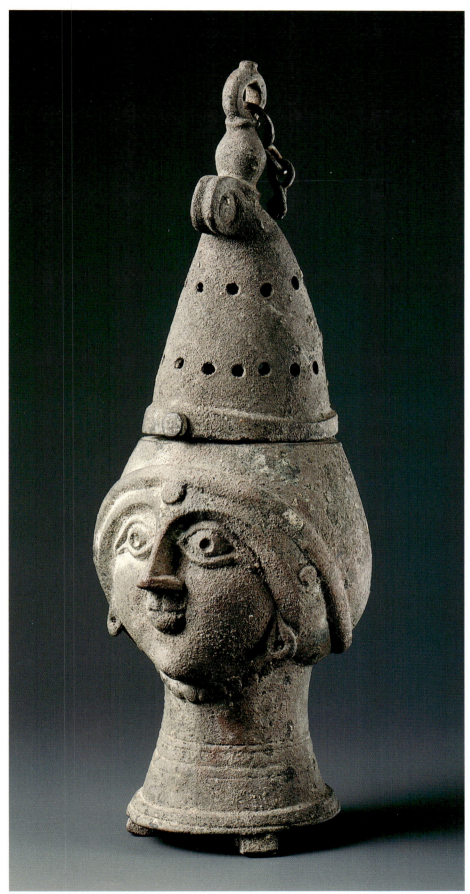

1. Among them are maenads, the Magi, the Phrygian hero Aeneas, and the Persian hero Mithra (Webster and Brown 1997, pl. 25; Goldman 1966, 159, photo 20a).

2. See a female-head censer (*Early Christian and Byzantine Art* 1947, 68, cat. 276) and a female cymbalist from an Egyptian Byzantine bronze lamp (Badawy 1978, 329, and 332, fig. 5.25). Crosses are added on top of triangular caps in two other female-head censers (Wulff 1909, cat. 97, and *Art and Holy Powers* 1989, cat. 136), on which both holes and incised circles may suggest spots of a leopard-skin cap.

3. I Kings 10:10–12; in Hamartolos 1904, vol. 1, 200, George the Monk describes the gifts given by Saba.

4. Caseau 1994, 20–21, 29.

5. Ibid., 119, n. 8; 179–80, n. 292, citing Tertullian, *De Corona militis,* 10.5.

6. Krauss 1902, 120–31.

7. Hamartolos 1904, vol. 1, 201 (author's translation); Krauss 1902, 120–31.

8. Shelton 1981, 26, 84, cat. 18, pl. 32; Bénazeth 2000, 212, cat. 257; Wulff 1909, 216, cat. 1035.

9. Caseau 1994, 130, n. 75, citing Gregory of Nazianzos, "On His Brother, St. Caesarius."

10. Caseau 1994, 37.

11. The Queen of Saba and Solomon are lovers in early medieval Arab and postbiblical Jewish sources (Khoury 1992; Lassner 1993, 167–68, 175, 181, 199–201, 212). On the seductive power of fragrance, see Caseau 1994, 123–33. Byzantine images of Aphrodite wearing a Phrygian cap may also allude to the erotic potential of incense. See *Age of Spirituality* 1979, 140, cat. 118.

12. Caseau 1994, 121, 158–59, n. 208, citing Claudian, *Epithalamium* 208–10.

13. Liddell and Scott 1991, s.v. "Εὐωδία."

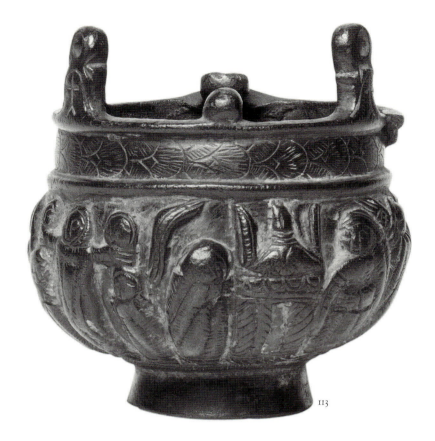

113

## 113 Lamp/Incense Burner with Scenes from the Life of Christ

Palestine, Byzantine, 7th–10th century
Bronze
H. 8.3 cm, diam. 7.5–8.1 cm
Arthur M. Sackler Museum, Harvard
University, Gift of the Hagop Kevorkian
Foundation in memory of Hagop Kevorkian,
1975.41.140

COLLECTION HISTORY Hagop Kevorkian
collection.

PUBLISHED *Early Christian and Byzantine Art*
1947, 69, cat. 282.

This object, which could have functioned as either a lamp or an incense burner,[1] is cast in bronze and rests on a slightly flared foot. Its rounded sides depict five scenes from the life of Christ—the Annunciation, Nativity, Baptism, Crucifixion, and the Women at the Tomb—rendered in high relief. A section of the object is missing from the upper edge, and a crack extends above the Nativity scene. Additional incisions decorate the outer lip, foot, and base of the suspension rings, and a six-petal rosette is incised in the underside. The object would have hung from chains attached to its three suspension rings, one of which is bent inward.

It was common in the home, as in the church, to light an oil lamp before icons, and at certain hours or on particular days to burn incense, which was considered a propitiatory offering.[2] Keeping a light burning before the household iconostasis was usually the responsibility of the women of the home. The scented smoke, rising to heaven with a person's prayers, would encourage the invoked saint to intercede on the supplicant's behalf, a tradition described in the story of Zacharias in Luke 1:8: "According to the custom followed by the priests, he was chosen by lot to burn incense on the altar. So he went into the Temple of the Lord while the crowd of people outside prayed during the hour when incense was burned." The Bible story demonstrates the efficacy of the incense, for an angel then appeared and announced that his wife Elizabeth would give birth to a son who should be named John.   DJ/IK

1. Vikan 1984, 70–71.

2. Excavations of the Byzantine phase of the city of Sardis, Turkey, yielded evidence of the use of incense burners in secular contexts, both in a home (Foss 1976, 43–44, fig. 21a, b) and in a shop (Crawford 1990, 98, figs. 566, 570).

## 114 Miniature Codex Containing "Oracles" in Sahidic

Egypt, Byzantine, c. 6th century (?)
Vellum
L. 7.5 cm, w. 6.9 cm
Arthur M. Sackler Museum, Harvard
University, Gift of N. R. Kelekian, 1984.669

UNPUBLISHED

This miniature codex is composed in Sahidic, the classical Coptic dialect. It consists of six quires with a total of eighty pages. The text is written in a neat hand and laid out so that each pair of facing pages comprises one textual unit. In the left margin of each left page is a simple decoration.

The codex contains thirty-eight Christian "instant oracles"[1] under the title *The Gospel of the Lots of Mary, the Mother of the Lord Jesus the Christ.* It is one of four Coptic manuscripts[2] that contain such a collection, usually referred to as *Sortes sanctorum;*[3] examples exist in other languages as well. The oracular responses, which could be obtained by throwing dice, are general in nature—advice to those seeking peace and strength in the face of adversity, suffering, and death. Several responses call upon the reader to be patient and persevere, and not to doubt, but to trust in God. The language is reminiscent of biblical literature, especially the Book of Psalms. The codex contains a disputed text, however, and divination by casting lots is a practice condemned in ecclesiastical literature.

Approximately sixty miniature codices are known, seven written in Coptic and the others in Greek. Comparable to pocket books today, they were intended for private use and could serve various functions.[4] The owner of this book might have been a traveling diviner, for whom the small format would have had two advantages: it was convenient to carry and easy to hide.   AML

1. So called by Pieter W. van der Horst (Van der Horst 1998).

2. See Van Lantschoot 1956.

3. See Klingshirn 2002.

4. Eric Turner defines a miniature codex as one that is "less than 10 cm. broad" and lists fifty-five such codices (Turner 1977, 22, 29–30). Recent finds have expanded this number. For an insightful discussion of miniature codices and their uses, see Gamble 1995, 235–36.

## 115 Icon Pendant with Saint George

Byzantine, 14th century
Bronze
H. 5.5 cm (6.3 with boss), w. 5.3, d. 0.3 cm
Inscription: Ο ΑΓΙΟC ΓΕWΡΓΙΟC (Saint George)
Private collection

COLLECTION HISTORY Purchased in Alexandroupolis in 2000.
UNPUBLISHED

The small, almost square bronze plaque depicts Saint George killing the dragon. The saint occupies the center of the composition, riding his horse from left to right, and is identified by a vertical inscription in large, raised letters on the left side of the plaque. He wears a short tunic and cuirass, although their decorative details are not recognizable. His shield is visible behind his right arm, and his right foot is in a stirrup. While his lower body is depicted in profile, his torso and head are turned toward the viewer. This frontal position is common with riding figures; they hold the spear in their right hand and the reins in their left.[1] On this icon, however, Saint George holds the spear with both hands as he thrusts it into the gaping jaw of the dragon, which lies at the horse's feet. At the right, on elevated ground in front of the horse, a winged figure strides toward the saint, offering a wreath. The iconographic tradition of this motif has a long history, going back to Roman imperial images of triumph and *adventus* scenes.[2] The motif is found again in the Palaiologan period (late thirteenth to mid-fifteenth century), the date of this Saint George plaque. Another example from the period is a steatite icon in the Walters Art Museum, Baltimore, in which a flying victory/angel figure offers Saint George a wreath.[3]

Icons with military saints started to become popular during the eleventh century. During the following centuries these saints were increasingly depicted as riders, especially on what can be identified as privately owned icons. Cat. 115 has a small boss at the top, which suggests that it was meant to be hung or, most likely, worn around the neck. Although the wearer would have been a male, the pendant has been included in the exhibition as an example of a talismanic icon that a household could possess.   IK

1. For example, on a small fourteenth-century steatite icon in Florence (Kalavrezou-Maxeiner 1985a, cat. 125) or a mid-thirteenth-century painted icon in the British Museum (Buckton 1994, 176, cat. 191).

2. The most famous example is the sixth-century Barberini five-part ivory panel in the Louvre (*Byzance* 1992, cat. 20).

3. Kalavrezou-Maxeiner 1985a, cat. A-9.

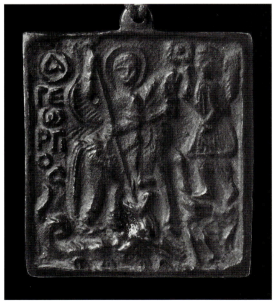

115

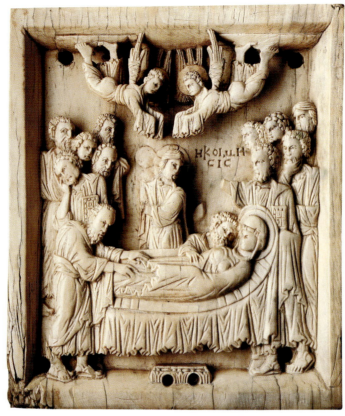

116

## 116 Icon with Koimesis of the Virgin

Constantinople, Byzantine, mid-10th century
Ivory
H. 10.6 cm, w. 8.7 cm, d. 1.3 cm
Inscription: H ΚΟΙΜΗCΙC (The Dormition [of the Virgin])
The Museum of Fine Arts, Houston; Museum purchase with funds provided by the Laurence H. Favrot Bequest, 71.6

COLLECTION HISTORY Ernst Kofler-Truninger, Lucerne, Switzerland, 1946; purchased by the museum March 27, 1971.
PUBLISHED Schrader 1970, cover and fig. 3.

## 117 Icon with Koimesis of the Virgin

Constantinople, Byzantine, 11th century
Ivory
H. 11.8 cm, w. 16.5 cm
Worcester Art Museum, Worcester, Massachusetts, Museum purchase, 1942.43
PUBLISHED Goldschmidt and Weitzmann 1934, 57, no. 110.

Representations of the Koimesis, or Dormition of the Virgin, appeared late in Christian iconography, most likely during the ninth century, after the end of Iconoclasm. The scene became a popular image in church decoration and on icons, probably because of the increasing attention given to the Virgin in general during this period.[1] Along with a selection of important moments from the life of Christ, the Dormition was one of the standard scenes in the Dodekaorton, the depiction of the twelve major feasts of the Church. In churches this scene was usually placed on the west wall above the door and could be seen by people exiting the naos.

The Koimesis became popular on private icons, not only for its representation of the Virgin but also for its more general depiction of death and its visual promise of the salvation of mankind. For private icons, which were set up in the home, the most common images were of the Virgin; there were also portraits of patron saints of family members, and narrative scenes, which included the Nativity and the Crucifixion as well as the Koimesis. The popularity of the Koimesis is evident from the large number of ivory icons, such as these two examples, that survive from as early as the tenth century. A rare use of the theme is found on a gold ring (cat. 182).

The Koimesis recalled scenes that were familiar to Byzantines from their own lives. It was common to mourn the dead in a similar setting in one's home. What we see in these representations is the Virgin lying on a bier, usually with her head toward the left; only in the early examples is her head to the right. She is surrounded by Apostles grouped at either end of the bier. Distinct figures are Paul at the foot of the bier, touching her legs; Peter at the head, swinging a censer; and John on the far side, bending toward her. Christ,

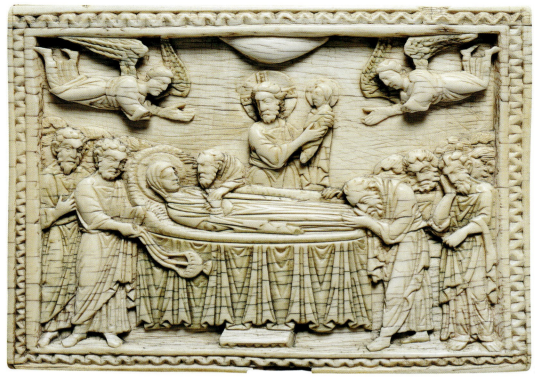

117

the tallest figure, stands at the center behind the bier and holds Mary's soul in the form of a child in his arms. Two angels descend, one on either side of Christ, ready to accompany her soul to heaven.

The presence of Christ with the soul of the Virgin in his hands and the accompanying angels spells out in visual terms the hope for resurrection, for a resting place for the soul in heaven, and for the salvation of mankind. With it also comes the recognition that great tribute is being paid to a woman. The Virgin Mary is surrounded by a group of men who, with abiding respect, mourn her death. Her son takes care of her now, as she took care of him when he was a child. There is no doubt that the roles are reversed: Christ with her soul in his arms recalls the familiar image of Mother and Child.

In cat. 116 the Virgin lies with her head to the right, an iconographic detail that indicates a tenth-century date. Unfortunately, Peter's censer and the small figure of the soul in the hands of Christ have broken off, and only the halo is still visible. The expression of grief on the faces of the Apostles is emphasized by their hand gestures. Their intimacy and personal love for the Virgin are expressed by John's placing his hand at her waist and by Paul's touching both her knees.

Cat. 117 is unusual among ivory icons because of the horizontal orientation of the tooth. Also unusual, though not unique, is the decorative frame, most likely a sign of the icon's later date. In this icon the group of Apostles is arranged horizontally, so that only a few faces are visible. Paul bends at the foot of the bier to kiss the Virgin's feet, and John, looking intently at her face, has grasped her hand. Peter swings a censer. Sadness and mourning are expressed by the figures' bowed heads.   IK

1. Kalavrezou 1990.

## 118 Icon of the Virgin and Child

Serbian or Cretan, 15th–16th century
Gesso, fabric, paint on wood
H. 22.0 cm, w. 18.5 cm, d. 2.5 cm
University of Toronto, Malcove Collection,
M82.108

COLLECTION HISTORY H. Wohl collection;
Lillian Malcove collection, 1961.

PUBLISHED Campbell 1985, cat. 341.

This icon represents the Virgin Mary holding the Christ child in a close embrace.[1] The child, wearing a white tunic under a golden-yellow *himation* (outer garment), sits in the crook of his mother's left arm. Her left hand supports his back while her right hand touches his shoulder. The child stretches out both arms toward his mother, reaching up to her *maphorion* (veil) with his right hand.[2] The sole of the child's right foot is visible, and he is about to lose his sandal, which is barely held in place by one lace. Christ has thrown his head back, the Virgin inclines her head toward her left, and their cheeks touch. Under the dark blue, gold-embroidered *maphorion* that covers her head and shoulders, the Virgin wears a blue tunic also finished in gold at the wrist. A halo is punched around her head into the otherwise plain background.

118

The child's enthusiastic embrace presents a stark contrast to the Virgin's pensive and sad gaze. Her expression suggests that she foresees her child's death on the cross.[3] That death is also prefigured by Christ's pose, with his arms outstretched and head thrown back. The icon, however, is far from being simply a projection of events to come. The intimate relationship between Virgin and Child emphasizes her role as a mother. From the second half of the ninth century onward, the human and maternal aspects of the Virgin became increasingly important.[4] In a highly influential homily, George of Nikomedeia, a deacon of the Hagia Sophia in Constantinople, explains this newly conceived role of the Virgin as Christ's own doing.[5] According to the gospel, the already crucified Christ declares the Virgin to be the mother of John, his disciple, and John the son of the Virgin. George of Nikomedeia, taking this one step further, puts words into Christ's mouth that make the Virgin the mother of all his disciples and therefore, in the broadest sense, the mother of mankind.[6] From literary sources such as this one the new maternal theme found its way into art, and, beginning in the eleventh century, icons depicting the mother and child in a tender embrace became widespread.[7] One of the most prominent examples is the Virgin of Vladimir, a copy of which is featured in this exhibition (cat. 51).

Although nothing is known about the patron or origin of this icon, its size suggests a context of private devotion. The emotionalism of the Virgin might have been particularly appealing to a female patron who could identify with this grieving and loving mother.   HS

1. Long ascribed a Serbian provenance (Campbell 1985, cat. 341), the icon may nonetheless have a different origin. The particular image in which the child has his arms spread far apart and is about to lose one of his shoes has been traced to Crete, where this type of icon was probably created in the fifteenth century (Hadermann-Misguich 1983, 13–15). This rare and extreme version of the Virgin Eleousa (compassionate) or Glykophilousa (sweet kissing), has been called the Virgin Kardiotissa, a reference to the monastery of the Kardiotissa, southeast of Heraklion, Crete, where a copy of the icon was kept (ibid., 14). Because the term Eleousa can be applied to icons of many different types, the post-Byzantine term Glykophilousa more clearly refers to icons featuring mother and child in a tender embrace (Grabar 1975, 30; Tatić-Djurić 1976, 259–67; and Belting 1994, 281).

2. On the origins of the *maphorion*, see Carr 2000, 327.

3. Belting 1994, 285.

4. Vassilaki and Tsironis 2000, 453.

5. Kalavrezou 2000, 42.

6. Ibid.

7. Images of this type can be found as early as the seventh century (Nordhagen 1962, 353). Hans Belting points out, however, that this does not indicate that the iconography was used continuously; rather, it was "rediscovered" during the eleventh century (Belting 1994, 284).

## 119 Icon of Saint Paraskeve (Saint Friday)

Russian School, 16th century
Tempera on wood panel
H. 19.4 cm, w. 18.2 cm
Fogg Art Museum, Harvard University,
Bequest of Thomas Whittemore, 1951.31.16

COLLECTION HISTORY Thomas Whittemore
collection.

UNPUBLISHED

This icon with the portrait of a female saint has no defining attributes or inscriptions to secure an identification. The saint's costume, however, a white *maphorion* (veil) with black trim, a green head covering, and a red robe or tunic, is characteristic of Saint Paraskeve in medieval Russian icons. She is depicted only from the shoulders up. Her long oval face has delicately rendered features, with heavy eyes and an aquiline nose. A halo is lightly inscribed around her head. Although some traces of gilding are still visible, most of it has been lost, and with it, probably, an inscription identifying the saint. Her face is original, but the rest of the panel has been repainted, and a crackle varnish was used to make the surface look aged.

*Paraskeve* (παρασκευή) is a feminine noun meaning "preparation." It is also the name of the fifth day of the week, Friday, specifically in reference to Good Friday, the day of the Crucifixion.[1] Saint Paraskeve is sometimes shown with the implements of the Crucifixion, in which case she may be interpreted as personifying the Crucifixion itself.[2]

A number of female saints with the name "Paraskeve" existed in the East, and their lives are difficult to disentangle.[3] Saint Paraskeve the Elder, eulogized by John of Euboea

119

and Constantine Akropolites, lived in the second century and supposedly converted the emperor Antoninus.[4] Saint Paraskeve the Younger lived in the middle Byzantine period; she was an ascetic whose relics worked miracles. Paraskeve thus became known as a healing saint and is sometimes depicted holding a vessel of curative tonic.[5] Saint Paraskeve from Ikonion was known as the "great martyr" in Russia.[6] Nicknamed Petka, she became a popular subject in the late fifteenth century for icons from the Novgorod School; she is often depicted holding a cross and dressed in the white *maphorion* of a nun and a red robe.[7] In Russia, Saint Paraskeve was the protector of trade and merchants. She was also the patron saint of spinners, weavers, virgins, and domestic life,[8] which made her an important holy figure for women. The small size of the icon indicates that it was used privately in the home.   MFH/IK

1. The earliest known representation of Saint Paraskeve (in this case, holding instruments of the Passion) is in the illustrated homilies of Gregory of Nazianzos (Halkin 1966).

2. Walter 1995, 753.

3. Bakalova 1978, 175–79. Saint Paraskeve of Epivatos has a very complicated history; her relics were moved at least five times, finally ending up in Iassy, Romania, in 1641.

4. *ODB* 1991, 1586.

5. Talbot Rice 1963, 31, pl. 16. In this early-fifteenth-century icon for Novgorod, Paraskeve wears a jeweled robe and a crown over her white *maphorion*; she holds a small ewer in her left hand and a cross in her right.

6. "Paraskeve of Epibatai" and "Paraskeve of Iconium," in *ODB* 1991, 1585.

7. Paraskeve is most often depicted with Saint Anastasia. For representations of Paraskeve with other saints, see Lazarev 1981, cats. 27, 28, 43.

8. Lazarev 1996, 53; Onasch 1957, 129–41.

## 120  Icon Triptych with Feast Scenes

Greece, Cretan School, 2nd half 16th century
Tempera and gold leaf on wood
H. 30 cm, w. 22.8 cm (closed)
Inscription: [. . .] ΧΕΙΡ ΙѠΑΚΕΙΜ [. . .]
ΟΔΙΑΚΟΝΟ [. . .] (?) (by the hand of Joachim the Deacon)
The Museum of Fine Arts, Houston; Gift of Miss Annette Finnigan, 37.28

COLLECTION HISTORY M. Segnedakis; purchased from Theodore Zoumboulakis, Athens, Greece, by Annette Finnigan in 1935–36.

PUBLISHED Barns 1991, 26.

This icon, when closed, seems to be a single rectangular panel of wood, but its construction is more complex than it appears at first sight. Two wings, painted on both sides, fold into receding arches in the central panel that correspond to them in shape and size. Unlike most icons, the triptych does not hang, but stands on a base like an altarpiece. Its small size suggests that it was set up in a home, at a private iconostasis, rather than in a church. With its high-quality painting and gold leaf on all panels, it must have been costly to produce. An inscription on the base attributes the paintings to "Joachim the Deacon." The last word, however, seems to be in a different hand. The piece is of particular interest for this exhibition because it shows the place of the Virgin in the Christological cycle, emphasizes the role of Saint Helena, and includes a rare appearance of Saint Julitta, all on an icon used in the home for private devotion.

When open, the triptych depicts from left to right the twelve major feasts of the Church calendar, the Dodekaorton, with four scenes on each panel. The Dodekaorton begins with the Annunciation to the Virgin and usually ends with the Koimesis, her Dormition. Here, however, the sequence of the scenes has been changed slightly so that each panel can also be viewed as an independent thematic unit. Within each panel, the scenes present themselves in a different order: the left wing suggests a clockwise reading, and the central and right panels suggest horizontal and vertical juxtapositions. The left wing begins with the Annunciation, then the Nativity, followed at bottom right by

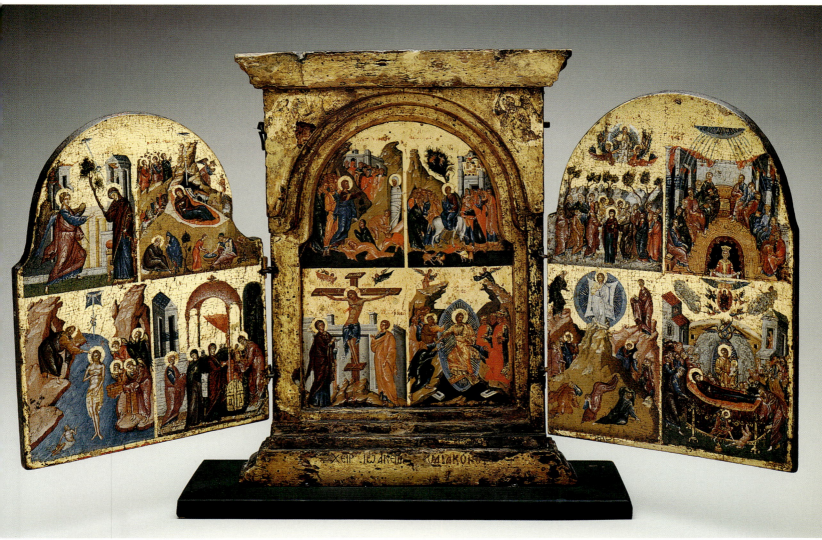

Christ's Presentation to the Temple. It ends with his Baptism by John Prodromos (the Forerunner) at bottom left. These four scenes represent moments from Christ's early life when his role as the Savior was first recognized. The Virgin Mother, in a dark blue garment and a dark red *maphorion* with gold trim, figures prominently in three of them.

The central panel focuses on the theme of Christ's Passion, Death, and Resurrection. The subject is introduced with the scene of the Raising of Lazarus. Then comes the Entry into Jerusalem, usually the first scene of the events of the Passion. The Crucifixion is depicted at bottom left, and beside it is the Anastasis, the Resurrection and the raising of the dead from the underworld. With these four scenes, the possibility of salvation and rebirth is made visible.

The right wing depicts the divine as it manifested itself to man. At bottom left is the Transfiguration, the moment when Christ's divine nature was made visible to his three disciples. At top left is the Ascension, showing Christ carried heavenward by angels. At bottom right is the corresponding scene of the Virgin's death, the Koimesis, and the ascent of her soul to heaven (see also cats. 116–17).[1] Surrounded by the Apostles, bishops,

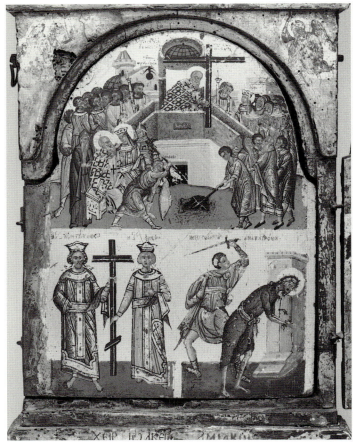

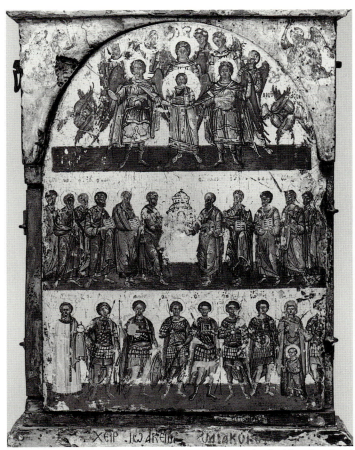

120, detail, left wing closed

120, detail, right wing closed

and a large crowd, the Virgin lies on a bier, with Christ standing at her side and holding her soul, shown as a small child, in his arms. He is surrounded by divine light, and within the mandorla a host of angels waits to accompany him when he conveys her soul to heaven. At the top of this quadrant, above the earthly scene, the Virgin herself rises to heaven amid divine light and angels. The representation of a bodily resurrection of the Virgin was not part of the Byzantine tradition. It was a popular theme in Western medieval art, however, and when the Venetians occupied Crete, it entered the iconography of the Cretan School of painting. The cycle closes with the Pentecost at top right, depicting the moment when the Divine Spirit descends upon the Apostles and selects them to preach Christ's teachings to the world.

The painting on the backs of the two wings is not of the same high quality as that of the other panels, and is most likely by a different hand. With the first (left) wing closed, the panel displays three scenes. At the top under the arch the Finding of the Cross and its Exaltation are combined into one scene. In the foreground two men excavate the remains of the cross. Legend has it that Helena, the mother of Constantine the Great, on her trip to the Holy Land discovered the True Cross, for which she was declared a saint. She is depicted in this scene seated at left with Makarios, bishop of Jerusalem, observing the discovery, gesturing toward the cross and talking. The Exaltation of the Cross, a feast celebrated by the Church on September 14, is depicted in the background. The bishop, at the

top of the ambo, raises the large cross and presents it to Helena, who stands on the steps at right. Priests and deacons holding candles stand on the steps at left. The composition derives from the liturgical ceremony for that feast day, on which the priest raises the cross and presents it to the congregation.[2] It is most unusual, however, to see that composition incorporated into the scene of the Finding of the Cross. It is even more remarkable to see Saint Helena participating in the ceremony, standing on the steps of the ambo, and the bishop turning toward her with an exaggerated gesture to present the cross.

In the scene below at left, Helena, this time with her son Constantine, is again represented as a saint in the traditional iconography. The two stand on either side of the True Cross, each holding it with one hand and gesturing toward it with the other. They wear the imperial *loros* and crowns, and inscriptions above their heads identify them. An interesting detail is found on Helena's *loros:* in the shield panel the instruments of the Passion have replaced the traditional cross. The scene at lower right on this panel is the decapitation of John the Baptist, who stands with his hands tied and bends forward, about to receive the blow.

The exterior of the right wing, visible when the triptych is closed, shows the Synaxis (Gathering) of the angels, Apostles, and saints to celebrate the Triumph of Orthodoxy, the official return of images to the Church. In the top register, three archangels at the center, surrounded by other angels and seraphim, hold a large medallion with a bust of Christ. Below them Peter and Paul, flanked by other Apostles and evangelists, hold a church building, symbolizing the foundation of the Church. The bottom register contains frontal representations of nine saints: six military saints (George, Demetrios, Theodore Stratelates, Theodore Tyron, and two whose names are illegible) joined by Saint Stephen the Protomartyr and, surprisingly, Saint Julitta and her young son Saint Kyrikos, both of whom were martyred under Diocletian.[3] This combination of saints is unusual and might refer to members of the family who bore those names. It is also conceivable that the last three, all early martyrs of the Church, were chosen for this icon because they represent not only both genders, but also a man, a woman, and a child, a family grouping.

Although the name of the painter is mentioned, there is no information about the owner of the icon. Because of the emphasis given to Saint Helena, however, it is likely that the icon was commissioned for a woman, possibly one with that name.   IK

1. The Koimesis composition follows to a large degree the iconographic tradition adopted by Andreas Ritzos. In his icons the large mandorla of light that surrounds Christ is filled with a host of angels in grisaille.

2. See, for example, the illustration of the Exaltation of the Cross in the lectionary of Dionysiou, MS 587, fol. 119v (Pelekanides 1973, vol. 1, 193, fig. 239).

3. In the Protaton Monastery on Mount Athos is a fifteenth-century icon dedicated solely to Saint Julitta and Saint Kyrikos; see *Treasures of Mt. Athos* 1997, 96, cat. 2.31.

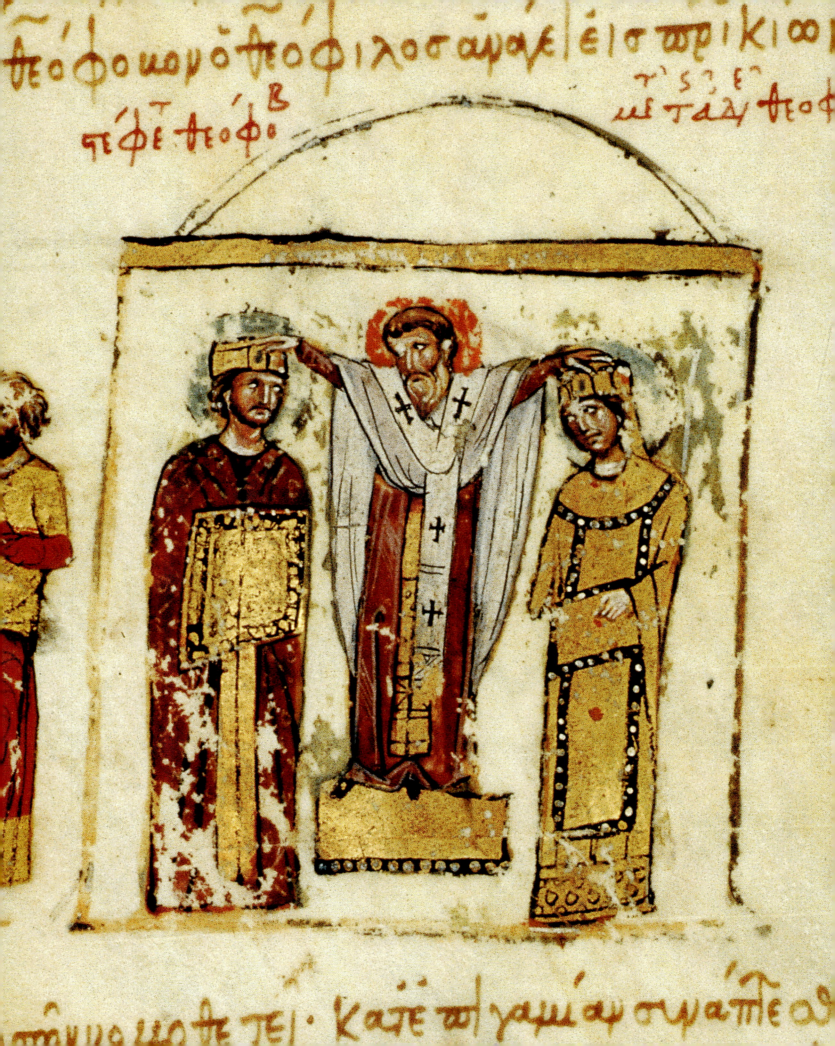

# MARRIAGE

ALICIA WALKER

## Wife and Husband: "A Golden Team"

Early Byzantine stories of female saints' lives celebrated the penitent prostitute and the consecrated virgin, but these moral extremes, although great fodder for hagiography, did not represent the average Byzantine woman's life experience.[1] It is fair to say that married life was considered the norm in Byzantium.

A model Byzantine union was one in which husband and wife were a "golden team," as the parents of the early tenth-century Saint Thomaïs of Lesbos were described.[2] This partnership of equals is expressed visually on early Byzantine marriage jewelry (cats. 121–22, 132). Harmony (ὁμόνοια) was the ideal state of marriage, as conveyed by the inscription that frequently appears on Byzantine marriage rings (cats. 121, 128–30) and belts (cat. 131). Marital cooperation is featured more literally in a set of middle Byzantine ivory plaques that depict Adam and Eve at the harvest and the forge; Eve assists her husband in his daily tasks, carrying wheat and pumping the bellows (cat. 71 and comparative image).[3]

Marriages were typically made between individuals of equal social status. Indeed, the emperor Justinian I (r. 527–65) was forced to enact a special law to permit his union with the lower-class Theodora, a former Hippodrome performer.[4] Marriages might involve the exchange of significant wealth in the form of dowries and bridal gifts. Among the social elite, marriages offered a means of contracting family alliances that could yield great political and financial benefit. A Byzantine groom—even one of relatively modest means—typically gave his fiancée jewelry, as reported in an early Byzantine letter written by a man to his soon-to-be mother-in-law in which he speaks of a ring and pearl that were to be delivered to the bride.[5] The bracelets, earrings, and necklaces featured in this exhibition (cats. 135–47), as well as ivory boxes displaying reliefs of mythological scenes (cat. 148) or vignettes from the story of Adam and Eve could have served appropriately as wedding gifts.

During the eighth and ninth centuries, "bride shows" were held to select the mates for eligible Byzantine imperial men.[6] In the contest of 830, organized by the empress Euphrosyne for the benefit of her stepson Theophilos, Euphrosyne gave Theophilos a golden apple to present to the woman of his choosing. Symeon the Logothete reports that when Theophilos approached the aristocrat Kassia, he admired her beauty, adding, "Yet through a woman evils came to man," a reference to man's downfall at Eve's provocation. Kassia retorted, "But through a woman better things began,"[7] a reference to the Virgin Mary and the birth of Christ. Kassia alienated the prince's affections by the demonstration of her superior wit—and protofeminism—and Theophilos chose another contestant as his bride.

Weddings were celebrated with great pomp. Chariot races and performances at the Hippodrome, events to which the populace was invited, usually marked imperial marriages.[8] The fourth-century theologian Saint John Chrysostom criticized the great expense and

215

debauchery associated with early Byzantine wedding ceremonies, claiming, "Camels and mules behave more decently than some people at wedding receptions!"[9] He particularly derided the singing of pagan and illicit songs: "Nowadays on the day of a wedding people dance and sing hymns to Aphrodite, songs full of adultery, corruption of marriages, illicit loves, unlawful unions, and many other impious and shameful themes."[10] A fourth-century belt buckle (cat. 132) and a sixth-to-seventh-century gold belt (cat. 131) attest to the popularity of pagan imagery in the visual culture of Byzantine marriage; each displays images of Greco-Roman gods and heroes in conjunction with the decidedly Christian representations of the married couple.

Bride and groom were luxuriously attired at the wedding. For women, elaborate jewelry and fine clothing were requisite; even the most schematically rendered Byzantine marriage jewelry takes care to represent the tailored garments as well as the earrings and necklaces of the bride (cats. 123, 132). An early fourteenth-century wall painting at the church of Saint Nicholas Orphanos in Thessaloniki depicts the Marriage at Cana, showing the bridal couple seated at a banquet table and attired in sumptuous clothing (fig. 17). The bride wears a white gown with red florettes and colorful, bejeweled shoulder ornaments, as well as a crown with two pearled *pendilia* (pendant ornaments), a headpiece that recalls those worn by the brides depicted on some Byzantine marriage jewelry.[11]

It was not until the early tenth century that marriages were required to be solemnized in a church, and the exact ceremony for the Byzantine rite prior to this date is unknown. General description of early Byzantine wedding celebrations comes, however, from the *vitae* of consecrated virgins, whose dedication to Christ is often considered a metaphoric marriage. A particularly detailed example from the life of the fourth-century Saint Martha most likely parallels the preparative rituals for the wedding that were practiced

in that era, including an elaborate process of bathing, perfuming, and clothing the bride; the arrival of the groom; and presentation of a ring and crown to the bride.[12]

Elements of the ceremony may also be gleaned from representations of Byzantine marriages in art. Crowns are a constant feature in marriage imagery from all periods of Byzantine culture. They appear on marriage rings, schematically rendered and typically suspended above the heads of the bride and groom (see cats. 127, 129), and can also be seen in manuscript representations of middle Byzantine marriages in the twelfth-century Siculo-Byzantine version of John Skylitzes' chronicle (fig. 18), in which the ninth-century aristocrat Theophobos and the sister of the emperor Theophilos receive crowns from the patriarch.[13] The joining of hands, or *dextrarum junctio,* of bride and groom also features in the Skylitzes illuminations. This symbolic union of the bridal couple through the clasping of their right hands persisted from Roman times and is frequently represented on Byzantine marriage jewelry (cats. 121–22, 131, 132) as well as on a circa seventh-century silver plate showing the marriage of the Old Testament King David to the daughter of King Saul, Michal (fig. 19). It is unclear whether Byzantine marriage rings and belts were part of the wedding ceremony or were exchanged informally as tokens between bride and groom. A seventh-century text that describes the marriage of the emperor Maurice, in which the priest crowned the couple and joined their hands, makes no mention of an exchange of rings.[14] The sixth-century *vita* of Saint Alexius speaks of the saint's presenting his wife with a marriage ring and belt in the privacy of the marriage chamber, again suggesting that these objects did not factor into the marriage ceremony.[15]

Fig. 18. The marriage of Theophobos to the sister of the emperor Theophilos, crowned by the patriarch. Chronicle of John Skylitzes, Siculo-Byzantine, 12th century. Vellum. Biblioteca Nacional, Madrid, cod. 5-3, no. 2, fol. 53v.

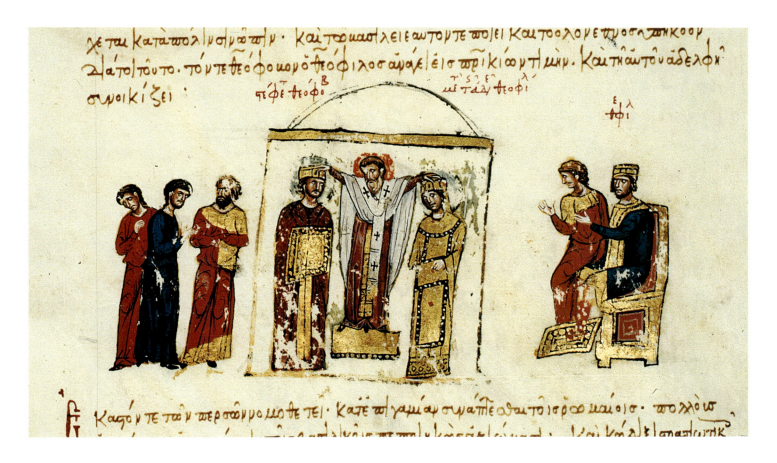

The legal age for girls to marry was set by the eighth-century law code, the *Ecloga*, at thirteen, and marriage usually took place during the early teen years.[16] This age was probably set in consideration of childbearing potential, as parenthood was considered the natural concomitant of marriage.[17] The provision in the *Ecloga* that a husband's impotence was grounds for divorce indicates the necessity of childbearing to the Byzantine institution of marriage.[18] In eleventh-century and later wills, Byzantine women proclaim their children as the joy of their lives; barren women speak of their infertility with great shame.[19] The infertility suffered by Thomaïs of Lesbos' parents was described as "iron collars laid upon them and binding them all around" and a "disgrace."[20] The importance of childbearing is further attested by the abundance of extant amulets for the promotion of healthy conception and parturition, such as the Holy Rider and Chnoubis amulets in this exhibition (cats. 165–73). Marriage belts worn by early Byzantine brides were frequently inscribed "health" (ὑγίεια; see cat. 131), which may express a wish for successful conception and childbirth.[21]

Erotic love features as a primary theme of medieval Greek novels, in which the overpowering emotions and sexual exploits of amorous couples are sometimes described in explicit terms.[22] Officially, however, physical love fell within the purview of marriage, and monogamy was certainly the rule.[23] The *vita* of the ninth-century Saint Mary the Younger presents her as the exemplar of wifely virtue when she responds, upon being accused of adultery with a slave: "I have known no man's bed but yours, O sweetest husband, to whom I was lawfully wed . . . [and] with whom alone I have had intercourse. I would happily have abstained even from that if it had been possible and if divine law had permitted it. But I know that I am not mistress of my body, but that you are my head."[24]

Saint Mary's final comment indicates that the purported ideal of Byzantine marriage

as a partnership of equals was not necessarily the reality. Indeed, in the *Ecloga*, adultery appears as a reason for divorce if committed by the wife, but not if committed by the husband.[25] The same law code made clear a wife's secondary status within the marriage union: "The Maker of All who created out of the uncreated did not, as He might have done, fashion woman in the same way as man, but made her out of man."[26] A certain degree of female subservience, in which the wife was "of one mind with her husband," characterized even the successful marriage of the parents of Saint Thomaïs.[27]

Byzantine law protected women within marriage, particularly with regard to the inalienability of their dowries,[28] but in most matters, the Byzantine wife was subordinate to her husband. A rather shocking indication of the subjugation of wives is the topos of domestic abuse in the *vitae* of middle Byzantine "pious housewives." The husband of Thomaïs of Lesbos beat her to discourage her from distributing family assets as alms to the poor.[29] And Saint Mary the Younger, whose husband physically attacked her for purported slander against him and alleged adultery with a male slave, eventually died from her injuries.[30] While exaggerated abuse at the hands of a husband served the hagiographic expediency of illustrating the extreme suffering and virtue of these women, the recurrence of the theme in saints' lives suggests that the problem was one to which an average Byzantine wife might relate. Men, however, were not always the dominant partner. The hen-pecked husband was a standard feature in the middle Byzantine comedic repertoire, in particular the poems of the twelfth-century author Ptochoprodromos,[31] and certain Byzantine empresses were lampooned for exerting undue influence over their husbands.[32] But the fact that such behavior elicited comments of a censorious and comic nature indicates that female dominance in marriage was considered outside the norm.

Early Byzantine couples sometimes explained instances of discord in marriage as the result of demonic interference. A sixth-century papyrus fragment cites a couple from Antinoöpolis in Egypt—the husband a baker, the wife the daughter of a merchant—who filed for a divorce because, despite their best intentions, "[we] suffered from a sinister and wicked demon which attacks us unexpectedly from we know not whence, with a view to our being separated from one another."[33] In the circa fifth-century magical treatise *The Testament of Solomon*, two demons—Modabeel and Katanikotaeel—are identified as disrupters of marital unions, and one scholar has suggested that Byzantine marriage rings were intended to guard the marriage union from these troublesome spirits.[34] The inscriptions on Byzantine marriage rings may have had even more specific magical connotations in the protection of marriage. Late antique magical treatises prescribed spells and amulets to protect the harmony of a marriage. For example, one recipe calls for the cooked heart of a bird, which, "if it should be given secretly to a woman in food or drink, works as a love charm on her towards the man. And when both wife and husband are discordant with one another or one with the other, if they should consume the heart in food or drink as described, then they will turn their hate to harmony."[35] Byzantine marriage rings that evoked harmony through inscriptions could have echoed, perhaps intentionally, the language and mechanism of pagan love magic.[36]

The question remains of what happened to women who lived outside the cultural

norm of married life. In some cases, impoverished women who could not afford dowries would become prostitutes or entertainers.[37] Some women ran their own households; for example the sixth-century Saint Theodore of Sykeon lived with his mother, aunt, and grandmother.[38] Although these women were prostitutes prior to Theodore's birth, their fortunes changed after his arrival, and the economic success of a hotel that they owned allowed them to give up their morally compromising profession. Monastic life was a persistent ideal for both women and men in Byzantium, and consecrated virgins could enter a convent rather than marry. Aspiration to enter the convent at a young age is a common topos in stories of female saints' lives. Especially in the middle and later Byzantine era, wealthy widows would frequently retire to convents, where, accompanied by their entourage, they could devote themselves to prayer, assist with the complex administration of a convent and its holdings, or continue their worldly pursuits within the protected walls of the nunnery.[39]

A preference for marriage, however, prevailed. Nowhere is this better indicated than in the *vita* of Saint Thomaïs, in which she prescribes to a woman with a cancer in her breast the following tonic: "If you wish to regain your health, avoid abnormal and filthy fornication. Do away with your passion for this and take a lawful husband, and you will quickly obtain a cure."[40] Even Saint Thomaïs, who suffered so tragically at the hands of her husband, was used to promote marriage as the proper path for a Byzantine woman.

1. See for example, the *vita* of Melania the Younger, a fourth-century aristocrat who renounced her worldly wealth and, along with her husband, devoted herself to a life of philanthropy and extreme asceticism, including sexual abstinence (Gerontius 1984). The late fourth-century Saint Pelagia (Brock and Harvey 1987, 40–62) and the early Byzantine Saint Mary of Egypt (Kouli 1996) were both repentant prostitutes. On the changing character of the Byzantine female saint from the early to middle period, see Laiou 1982, 198–99.

2. Saint Thomaïs' own marriage was, however, disastrous, for her husband "did not devote himself to her as a companion but as an opponent, not as a helpmate but rather as an enemy" (Halsall 1996, 303).

3. Judging from the extant sources, however, it was quite unusual for women to assist in the grain harvest (Laiou 1981, 248–49).

4. Procopius 1981, 89 (10.3). Consciousness of family lineage and reputation became increasingly important in the eleventh century and later, as the concentration of marriages among elite families attests (Laiou 1981, 250–53). Restrictions against marriages of individuals of different social status were loosened, however, in the eighth-century law code the *Ecloga* (Laiou 1993, 126).

5. Barns and Zilliacus 1960, 104–5. According to the letter, the pearl, if not the ring and the pearl, was to be applied toward the purchase of perfumes, presumably in preparation for the wedding.

6. Treadgold 1979. Other scholars have questioned the historicity of the imperial bride shows (Rydén 1985 and Vinson 1999, esp. 37, 46, 49, and 60).

7. Treadgold 1979, 402–3.

8. Garland 1990b, 10. Simocatta 1986, 34 (1.10).

9. Homily 12, "On Colossians 4:18," in Chrysostom 1986, 74.

10. "Sermon on Marriage," in Chrysostom 1986, 82–83.

11. Mavropoulou-Tsioumi notes that the bridal couple wears imperial dress (1986, 35). The frequency with which figures on Byzantine marriage rings wear crowns and other apparently imperial garments may indicate the appropriation of imperial-like costumes by brides and grooms.

12. Martha combated the proposals and threats of persistent suitors with her faith that Christ was her bridegroom:

> He will indeed come in glory, riding on the chariot of the clouds, accompanied by the angels and powers of heaven, and all that is appropriate for his wedding feast; he will shake from the dust the bodies of all those who are betrothed to him, wash them in the dew of heaven, anoint them with the oil of gladness, and clothe them in the garment of righteousness, which consists of glorious light; he will place on their fingers rings as the surety of his grace, while on their heads he will put a crown of splendor, that is to say, unfading glory. He will allow them to sit on his chariot—the glorious cloud—and will raise them up into the air, bringing them into the heavenly bridal chamber that has been set up in a palace not made by hands, but built in Jerusalem the free city on high (Brock and Harvey 1987, 70).

13. Grabar and Manoussacas 1979, 45, no. 127, fig. 56.

14. Simocatta 1986, 33 (1.1).

15. Amiaud 1889, 12–13, and Ross 1965, 39.

16. Freshfield 1926, 72.

17. Laiou 1981, 234 and 236.

18. Freshfield 1926, 78–79. For a synopsis of Byzantine laws pertaining to divorce, see ODB 1991, 640–41.

19. Laiou 1985, 66–67.

20. Halsall 1996, 300.

21. ODB 1991, 1305–6.

22. On the morality of sexuality within the relationships of protagonist couples in the medieval Greek novels, see Garland 1990a. On the consequences of abduction and rape in these texts, see Laiou 1993, 198–218.

23. On laws governing sexual relations and the punishment for illicit behavior, especially in the Ecloga, see Laiou 1993.

24. Laiou 1996, 263.

25. Freshfield 1926, 78–79. Angeliki Laiou notes, however, that in the Ecloga, a man who has sexual relations with an impubert girl, or has sex with a woman of marriageable status but refuses to marry her or is denied marriage to her by her parents, is punished by civil law, while his partner is not (Laiou 1993, 122–24 and 167–74). She notes, however, that informal punishment—in the form of shame and loss of social status—should be assumed for the woman. On earlier and later Byzantine laws relating to the abduction of women and extramarital sexual relations, see ibid., 141–45.

26. Freshfield 1926, 78.

27. Halsall 1996, 299.

28. On laws and court cases pertaining to women and marriage from the eleventh to fifteenth century, see Laiou 1981; on the dowry specifically, see 237–41.

29. Halsall 1996, 305–7 and 313–15.

30. Laiou 1996, 265–66.

31. Prodromus 1910.

32. Garland 1990b, 14.

33. Brown 1978, 10.

34. Maguire 1996, 150.

35. Hermes Trismegistus 1976, 197.

36. Walker 2002, 62–65.

37. After the death of her father, Theodora became a circus performer and, according to the sixth-century court historian Prokopios, a prostitute. Much later, after becoming empress, she founded a monastery called Repentance, which was devoted to the reformation of prostitutes (Procopius 1981, 124 [17.3]; 82–83 [9.1–15]).

38. Dawes and Baynes 1948, 88.

39. On middle and late Byzantine convents as loci of economic activity and the different provisions for aristocratic women within nunneries, see Laiou 1981, 242 and 246; Laiou 1982, 199; and Laiou 1985, 75–76.

40. Halsall 1996, 313.

## 121 Gold Ring with Clasped Hands

Roman/Byzantine, c. 3rd–4th century
Gold
Diam. 1.9 cm
Inscription: OMONOIA (harmony)
University of Indiana Museum, Burton Y.
Berry Collection, 65.87.31

COLLECTION HISTORY Burton Y. Berry
collection.

UNPUBLISHED

## 122 Gemstone Ring with Clasped Hands

Byzantine, c. 5th century
Sardonyx, gold
Diam. of gem 1.0 cm
Inscription: OMONOIA (harmony)
Museum of Fine Arts, Boston, Gift in mem-
ory of Robert E. and Julia K. Hecht, 63.1555

COLLECTION HISTORY Private collection.
PUBLISHED Babelon 1897, cat. 346; *MFA Annual
Report* 1963, 38; Boardman 1968, cat. 79; *Romans
and Barbarians* 1976, cat. 202.

The *dextrarum junctio*, or clasping of right hands, represented a pledge of faith that was used throughout the Roman period, in both the political and personal realms. Its link with the Roman marriage ceremony continued, with minor adaptations, into the early Christian period.[1] Cat. 121, a continuous thin, hammered gold hoop, depicts a pair of clasped hands and the inscription OMONOIA. Cat. 122 is a gold band with a sardonyx cameo bezel. The gem has been carved so that the clasped hands, the inscription OMONOIA, and a fillet above the hands all appear in white, contrasting with the black of the background. The hand on the left can be identified as that of the wife by its smaller size and the bracelet at the wrist.[2] Overall, cat. 122 is more elegant and of higher quality.

The iconography and inscriptions on these rings demonstrate no particular religious affiliation, and their owners could have been either Christian or pagan. The inscription in the lower field of the bezel of each ring conveys a wish for concord between husband and wife. During the Roman period, various pagan deities and personifications were thought to bring harmony to the marriage union; in the early Christian period, Christ assumed the role as *pronubis*, or guardian over marriage, and marital concord came to be understood as a blessing from God. The conversion of harmony from a pagan to a Christian concept dates from the fourth to fifth century, the period when these rings were produced.[3] The transitional character of this era may explain the lack of specifically pagan or Christian iconography in the rings. In contrast, sixth-to-seventh-century Byzantine marriage rings make clear the origin of divine blessing through the pairing of the inscription OMONOIA with a cross or a bust of Christ (see cats. 128–30).

These early Byzantine rings convey the message that marital union is a pledge between equals. Whether Christian or pagan, they indicate a persistence of the Roman ideal that a wife is a companion and partner, not a possession.[4]    JLH/IK

1. Kantorowicz 1960, 4, and Denis 1995/1996, 21. Denis cites a denarius issued around 202–5 by the Roman emperor Caracalla as a precedent for the clasped-hands imagery, but earlier Etruscan and Roman imagery features the *dextrarum junctio* representing the marriage bond (Brilliant 1963, 35, fig. 1.56, and 45, fig. 1.78). This imagery was distinctly different from the Greek marriage gesture, in which the man grasps the arm of the

woman and actively "takes" her (Kunisch 1997, vol. 2, Tafel 98, no. 300).

2. *Romans and Barbarians* 1976, cat. 202.

3. Kantorowicz 1960, 10.

4. Vikan 1990, 153. See also marriage rings with profile bust portraits in this volume, cats. 123–25.

## 123 Seal Ring with Facing Busts

Constantinople (?), Byzantine, late 4th–early 5th century
Gold
Diam. of band 2.5 cm
Inscription: in retrograde, ΑΡΙϹΤΟΦΑΝΗϹ ΟΥΙΓΙΛΝΤΙΑ (Aristophanes, Vigil[a]ntia)
Dumbarton Oaks Collection, Washington D.C., 47.18

COLLECTION HISTORY E. Guilhou collection, Paris; purchased from Joseph Brummer Gallery, New York, August 15, 1947.
PUBLISHED De Ricci 1912, cat. 829; Sotheby's London 1937, cat. 457; *Bulletin of the Fogg 1947*, 233; *Early Christian and Byzantine Art 1947*, cat. 502; *DO Handbook 1955*, no. 166; Ross 1965, cat. 50; *DO Handbook 1967*, no. 193; Walker 2001, 151, fig. 9.1.

## 124 Seal Ring with Facing Busts

Constantinople (?), Byzantine, 4th century
Bronze
Diam. of band 2.3 cm
The Menil Collection, Houston, X490.744

COLLECTION HISTORY Thought to have been acquired from George Zacos in Istanbul; collection of J. J. Klejman; purchased by John and Dominique de Menil, 1964.
UNPUBLISHED

## 125 Marriage Ring with Facing Busts

Byzantine, late 4th–early 5th century
Gold
Diam. of band 2.2 cm
Inscription: MAPIAC (of Maria)
University of Indiana Museum, Burton Y. Berry Collection, 76.86.19

COLLECTION HISTORY Burton Y. Berry Collection.
UNPUBLISHED

Each of these rings bears two busts in profile, one of a man and one of a woman, the generic representation of bride and groom. The figures in each pair are of comparable size, expressing the importance of both partners to the union, a tradition in attitude and representation carried over from Roman times.[1] Each figure is rotated slightly so that the shoulders are in three-quarter view but the face is in profile, a posture that emphasizes the intimacy of their gazes.

On cat. 123, a small cross centered above the heads represents the couple's Christian affiliation. The inscription, which awkwardly wends around three sides of the square bezel, provides the names of the couple, Aristophanes and Vigilantia.[2] The bride, on the left, wears an elaborate hairstyle, a beaded necklace, and drop earrings.[3] Her husband has his beard closely shaven and his hair combed forward. The pair appear quite elegant, with aquiline features and long necks. Cat. 124 has no cross or inscription, but a crudely incised border of beaded lines frames the couple.[4] The erosion on the surface of this ring suggests that it was worn for many years. The execution of the image is simpler and less delicate than that of cat. 123, and its material, bronze, is less valuable. On cat. 125 the couple is more naturalistically proportioned: the man is slightly taller than the woman. Still, the husband and wife face one another as partners. The inscription, MAPIAC, is the genitive form of a woman's name, "of Maria," indicating her ownership of the ring. The cross here is more prominent than the one on cat. 123.

The reversal of the inscription on cat. 123 indicates that it was used as a seal.[5] According to the early Christian writer Clement of Alexandria, women were permitted to wear only jewelry that aided in domestic duties; one such object was the seal ring, usually a

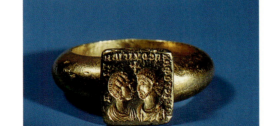

123

124

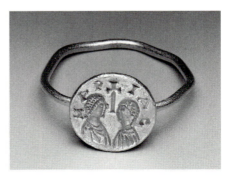

125

copy of the husband's seal.[6] Clement specifies that these rings could be used to mark wax or clay seals on household containers to prevent theft of provisions by servants. The diameter of each ring may seem more appropriate for a man's finger, but Byzantines wore rings on their finger joints, requiring a slightly larger size than would be typical for a woman.[7]

In Roman and Byzantine art, the left side of the composition was the more privileged position, which, in marriage jewelry, was generally reserved for the husband. The function of cats. 123 and 124 as seals, however, would explain their atypical arrangement: when the seal was impressed, the image of the husband appeared in the more prominent position.[8] Cat. 125, with its forward-reading inscription, was not a seal, and the husband appears on the left in the bezel.

Overall, the iconography and function of these rings suggest that marriage in the early Byzantine world was — or at least was represented to be — an emotional bond and practical partnership between two equal individuals.   JLH

1. This bust-length profile pose originated in imperial imagery, in which it emphasizes the equality and camaraderie of co-emperors (*Age of Spirituality* 1979, 38–39, cats. 31, 32). Coins with busts of facing imperial couples do, however, appear sporadically during the Roman period (*I, Claudia* 1996, 56–57, cat. 5, and 66, cat. 19).

2. For the date and provenance of this ring see Ross 1965, 48–50, cat. 50. The contrast between the elegant carving of the busts and the omission of letters and awkward spacing of the inscription suggests that the inscription might have been added to the ring in order to personalize the object for this couple's use.

3. A ring in the Museum of Art and Archaeology at the University of Missouri, Columbia, shows a woman wearing a similar hairdo (*I, Claudia* 1996, 177, cat. 135). A marriage ring in the British Museum displays a markedly similar bezel image but has no inscription (Buckton 1994, 47, cat. 27). Ross suggests that the similarity — especially in the portraits of the man — could indicate that the two rings were made at the same time, one for the husband and one for the wife (Ross 1965, 50, cat. 50). The explanation Ross finds less convincing — that the rings were kept in stock and engraved with names when a particular couple wanted to personalize them — is more likely and also accounts for the awkward execution of the inscription in cat. 123.

4. Vikan associates this ring with Constantinople (Vikan 1992b, cat. R25).

5. For a similar interpretation of a reverse inscription, see Gonosová and Kondoleon 1994, 40, cat. 5.

6. Finney 1987, 182.

7. Ibid., 183.

8. A close compositional parallel to these rings, a second-to third-century marriage necklace in the Metropolitan Museum of Art features a bust-length imperial couple, with the man on the left (*I, Claudia* 1996, 151, cat. 92).

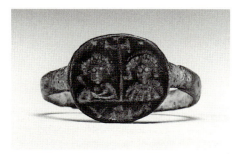

126

## 126 Ring with Busts Flanking a Cross

Byzantine, 5th–7th century
Bronze
Diam. of band 2.0 cm
Inscription: VΓIA (health)
The Walters Art Museum, Baltimore,
Maryland, Museum Purchase, 1992 (54.2954)

COLLECTION HISTORY Steinberg Auction,
1991; Edward J. Waddel, Gaithersburg, Md.,
1992.

UNPUBLISHED

## 127 Ring with Busts Flanking a Cross

Byzantine, 8th century
Bronze
H. 2.9 cm, w. 2.5 cm, d. 1 cm
Inscription: VΓI (health)
The Menil Collection, Houston, X490.754

COLLECTION HISTORY Purchased from a
New York antiquarian, 1964.

PUBLISHED Vikan 1990, 151, and 154–55,
cat. 14; Walker 2001, 159–60, fig. 9.8.

These low-cost bronze rings imitate the iconography of more valuable fifth-to-seventh-century gold marriage rings.[1] Although cat. 127 is severely abraded, cat. 126 clearly shows the subject matter of these two rings: a pair of frontal busts representing a man and a woman, most likely a husband and wife. In cat. 126 the husband appears on the left and the wife on the right; in cat. no 127, a seal ring, the positions are reversed. Each couple flanks a cross; in cat. 127, the cross has a slanted horizontal bar.[2] Two half-circles suspended above the couple in cat. 127 may represent crowns on the heads of the bride and groom during the marriage ceremony.[3] The exergue of cat. 127 is eroded, but the remains of an inscription, which possibly spells a variation of ὑγίεια (health), are visible. This same inscription is more legible on cat. 126.

A key difference between these base metal rings and their gold prototypes is found in the inscriptions: gold marriage rings are typically inscribed ὁμόνοια (harmony), not ὑγίεια (health). The significance of "health" as a marital blessing is attested, however, by an inscription on each of the two central medallions of a sixth-century Byzantine gold marriage belt (cat. 131): ЄΚ ΘЄOV OMONVA XAPIC VΓIA (from God harmony grace health). These wishes for health may be related to conception and childbirth, since the belt is worn in the area of the reproductive organs.[4]

It is possible that bronze marriage rings inscribed "health" also expressed wishes for successful childbirth.[5] Perhaps the presence of this inscription on base metal rings implies greater anxiety regarding health, including pregnancy, among less affluent people. Alternatively, these rings may have been used with another purpose in mind, perhaps obtained by a man or woman to improve the condition of a sick spouse. In this case, the less expensive material might be indicative of the temporary use of the rings, while the gold rings inscribed OMONOIA would have provided long-term protection for the lasting harmony of the marriage.    AW

1. Vikan 1990, 150–51, n. 45, figs. 12, 13, 17. Cat. 127 has been dated to the eighth century based on its compositional and stylistic affinity with lead seals of Leo III (r. 717–41) (Vikan 1992a, part 1, 114), but gold marriage rings of this general iconography are usually dated earlier, ranging from the fifth to the seventh century. Several sixth-century devices with the general iconography of frontal busts flanking crosses show an equal resemblance to the bezel image (Zacos 1984, 130–31, and pl. 27; Zacos and Veglery 1972, part 1, 212, cat. 130, and pl. 32).

2. Although the busts found on Byzantine marriage rings are sometimes suggestive of portraits in their detail, rings of both gold and base metal were mass produced, and the busts likely reflect stock types.

3. For Byzantine marriage crowns, see Walter 1979 and Drossoyianni 1982.

4. Vikan 1984, 69 and 83; *ODB* 1991, 1306.

5. Vikan 1990, 154–55.

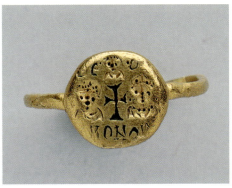

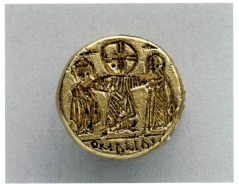

<div align="center">128                                    129</div>

## 128 Marriage Ring with Christ and Couple Flanking Cross

Byzantine, 6th–7th century
Gold with niello inlay
Diam. 1.5 cm; diam. of bezel 1.1 cm
Inscription above: ΘΕΟ (from God); below: OMONOIA (harmony)
Royal Ontario Museum, Toronto, Canada;
Gift of the Government of Ontario and the
ROM Membership, 986.181.3

PUBLISHED Denis 1995/1996, 19 and 20.

## 129 Marriage Ring Bezel with Bride and Groom Flanking Christ

Byzantine, 6th–7th century
Gold
Diam. 2.5 cm
Inscription: OMONOIA (harmony)
Royal Ontario Museum, Toronto, Canada;
Gift of Joey and Toby Tanenbaum, 994.220.37

PUBLISHED Denis 1995/1996, 19 and 21.

Although the details of iconography and inscription vary somewhat in these rings, they share two essential elements: the image of a man and a woman in the presence of Christ and/or a cross, and the inscription OMONOIA (harmony). Rings of this type have been identified as marriage rings. They represent the bride and groom, who appear in bust form in cat. 128 and full length in cat. 129. In the former, the couple flanks a cross, above which is suspended a bust, probably of Christ;[1] in the latter, the body of Christ—identified by his cruciform halo—takes the form of a cross, and he places one hand on the shoulder of each spouse. In both rings, the bride and groom are schematically rendered, but in cat. 128 marks of elite status are still discernable: he, on the left, wears a cloak (*chlamys*) held at the shoulder by a pin (*fibula*); she, on the right, wears a necklace and earrings.

It is uncertain in what ceremony, if any, these rings would have been employed. Prior to the promulgation of the early tenth-century Novella 89 by Emperor Leo VI (r. 886–912), Byzantine marriage ceremonies were typically held in the home rather than a church, and no standard marriage rite existed. Crowns, rather than rings, were the essential tokens of the Byzantine marriage act. Theophylact Simocatta's seventh-century description of the marriage of Maurice (r. 582–602) does not mention rings, but notes that a priest "took the royal pair's hands, joined them to each other, and blessed the emperor's marriage with salutations of prayer. And indeed he set the crowns on the royal heads."[2] Some marriage rings, such as cat. 129, have schematic representations of marriage crowns, a reference to this rite.[3] It is possible that marriage rings were exchanged informally, as tokens of engagement or as gifts between bride and groom. In the sixth-century *vita* of Saint Alexios, for example, the groom gave his bride a ring and a belt in a private exchange carried out in the nuptial chamber.[4]

Certain aspects of Byzantine marriage iconography derive from Roman conventions, and in both traditions, the iconography of marriage closely resembled the official imagery of imperial art and coins.[5] The image of a couple blessed by Christ first appeared in Byzantine art on a solidus of 451 that celebrated the marriage of the Theodosian empress Pulcheria (r. 414–53) to the general Marcian.[6] Furthermore, Byzantine marriage medallions and rings typically depict husband and wife in equal size, a convention that may refer to an ideal of equality within marriage that was inherited from the Romans, although it should be noted that the bride is almost always allocated the subordinate position, on

the right. In Byzantine marriage imagery, however, Christ officiates over the union of bride and groom, which is sealed by his cross.[7] The inscription flanking the bust of Christ in cat. 128 makes clear that the harmony of the marriage is "from God" ($\theta\varepsilon o \hat{v}$).[8]

Early Byzantine marriage rings served not only as tokens of union but also as amulets that helped to protect and preserve the relationship of husband and wife.[9] As indicated by the inscription, the role of these rings was to safeguard the harmony of the marriage.  AW

1. Denis 1995/1996, 20.

2. Simocatta 1986, 33 (1.1).

3. The crowning of bride and groom was a Roman tradition that acquired Christian symbolism as the couple's triumph over carnal desire (Walter 1979, 89–90).

4. Amiaud 1889, 12–13, and Ross 1965, 39.

5. Reeksman 1958 and Kantorowicz 1960.

6. Zacos and Veglery 1960, 73–74.

7. Kantorowicz 1960, 4–7.

8. Denis 1995/1996, 20.

9. Gary Vikan has argued that the Byzantine marriage rings served as amulets for healthy procreation (Vikan 1984 and 1990). For an alternate interpretation of the amuletic properties of marriage rings, see Walker 2001 and 2002.

## 130  Octagonal Marriage Ring

Constantinople (?), Byzantine, 7th century
Gold
Diam. 2.3 cm
Inscription in the exergue: OMONVA (harmony); around the edge of the bezel: KVPIE BOHΘI TOVC Δ8Λ8C COV ΠETP8 S ΘEOΔOTIC (Lord help Thy servants Peter and Theodote);[1] around the edges of the band: EIPINHN THN EMHN AΦIHMH VMHN / EIPHNHN THN EMHN ΔHΔΩME VMHN ("My peace I leave with you / My peace I give to you" [John 14:27]).
Dumbarton Oaks Collection, Washington D.C., 47.15

COLLECTION HISTORY Baron Pichon collection, Paris; E. Guilhou collection, Paris; purchased from Joseph Brummer Gallery, New York, August 15, 1947.

PUBLISHED Schlumberger 1862, 67–69; *Pichon Catalogue* 1897, cat. 26; *Sotheby's London* 1937, cat. 460; Chatzidakis 1939–43, 201–2, cat. 80; *Early Christian and Byzantine Art* 1947, cat. 514; Cecchelli 1947, 55–56; *DO Handbook* 1955, 195; Kantorowicz 1960; Ross 1965, 58–59, cat. 69; *DO Handbook* 1967, no. 205; *Age of Spirituality* 1979, cat. 446; Kitzinger 1980, 151, fig. 13; Vikan and Nesbitt 1980, 20, fig. 42; Vikan 1982, 43, figs. 35 a–c; Vikan 1984, 83–84; Vikan 1990, fig. 26; Maguire 1996, 147–50, figs. 127–30; *Mother of God* 2000, 232–33, fig. 181; Walker 2001, 153–54, fig. 9.5; Walker 2002, 61–63, fig. 4.4.

The eight-lobed bezel of this ring shows a bride and groom flanking a pair of haloed figures who bless the couple. Inscribed in the exergue is OMONVA (harmony); the legend around the edge of the bezel invokes divine aid for "Peter and Theodote," most likely the groom and bride, and includes an excerpt from the Book of John. The band of the ring is octagonal, and on seven of its eight sides are highly schematic images from the life of Christ: the Annunciation, the Visitation, the Nativity, the Presentation, the Baptism, the Crucifixion, and the Women at the Tomb.

Byzantine marriage rings not only commemorated the marriage union, but also served as amulets to protect it. The word OMONVA expresses wishes for marital concord, while the inscriptions around the edges of the bezel and band invoke divine assistance and cite the inherently protective words of biblical passages. The scenes from the life of Christ were no doubt meant to empower the ring with additional force to assure the harmony of the relationship.[2] The octagon is a common shape for Byzantine amulets, rings in particular.[3]

The iconography of the bezel also visualizes divine protection of husband and wife. The figure at center left, who crowns the groom, is Christ, as indicated by his cruciform halo, but the identity of the second figure is uncertain. It could be the Virgin Mary, whose aid is sometimes invoked by inscriptions on Byzantine marriage rings.[4] Alternatively, the figure might represent a personification of the Church. In early Christian writings, the Church was understood metaphorically as the bride of Christ. In his treatise "How to Choose a Wife," the fourth-century bishop John Chrysostom expanded on Saint Paul's dictum, "Husbands, love your wives as Christ loves the Church" (Ephesians 5:26), advising:

*Even if your wife sins against you more times than you can count, you must forgive and pardon everything. If you marry a surly woman, you must reform her with gentleness and kindness, as Christ did the Church. . . . Just as the woman was fashioned while Adam slept, so also, when Christ*

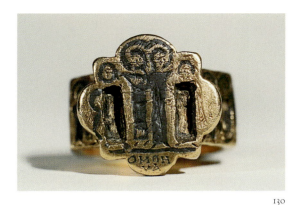
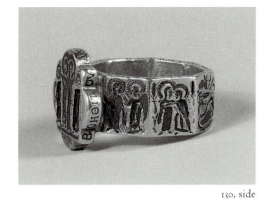

130                                                           130, side

*had died, the Church was formed from his side. As the bridegroom leaves his father and comes to his bride, so Christ left His Father's throne and came to His bride.*[5]

If interpreted as the Virgin, then this figure represents, along with Christ, a protector of the marriage union; if interpreted as a personification of the Church, then Christ and the female figure stand more as exemplars for the newlywed couple.[6]

The elaborate iconography and valuable material of this ring indicate the affluence of its owner.[7] It is impossible to know if the ring belonged to a man or a woman, but the depiction of a female figure in the company of Christ on the bezel suggests an effort to appeal to a female audience.   AW

1. Up to the seventh century, Byzantine invocations often render personal names in the genitive, as here. The sense is that the Lord is asked to be the help "of" Peter and Theodote. I thank John Nesbitt for this clarification.

2. Kitzinger 1980 and Vikan 1984, 65–83. Vikan has argued for a specific association of the Christological cycle with medicinal properties and, in the case of marriage rings, with a concern for successful childbirth (Vikan 1984, 83–84). For alternative interpretation of the amuletic intent of the rings, see Walker 2001 and 2002.

3. Vikan 1990, 161.

4. Ibid., 160.

5. "How to Choose a Wife," in Chrysostom 1986, 90–94, 96. In a marriage poem written for his son, the fifth-century bishop of Nola, Paulinus, also referred to this metaphor when he wrote, "the great sacrifice by which the Church gave herself in marriage to Christ" (Kantorowicz 1960, 13).

6. Kantorowicz 1960, 13; Vikan 1990, 160, n. 117. Kantorowicz argued that the second figure combines the Virgin and the Church to embody both bride of Christ and heavenly Queen, but, as his textual and visual evidence indicates, a merging of the Virgin and the Church typifies later Western medieval thought and offers no direct support for an early Byzantine conflation of the two (Kantorowicz 1960, 11–13).

7. A ring similarly decorated with scenes from the life of Christ on its octagonal band and a bride and groom blessed by Christ on the bezel was found in a seventh-century archaeological context in Syracuse, Sicily, and has been associated with the Byzantine emperor Constans II (r. 641–48) (Ross 1965, 59; Cecchelli 1947). Cat. 130 may also originate from the imperial circle.

## 131 Marriage Belt with Bridal Couple, Christ, and Pagan Deities

Antioch or Constantinople (?), Byzantine, late 6th–early 7th century

Gold

L. 75.5 cm; diam. of small plaques 2.5 cm; diam. of large plaques 4.8 cm

Inscription: ЄΧ ΘЄΟV ΟΜΟΝVΑ ΧΑΡΙϹ VΓΙΑ (from God harmony grace health)

Dumbarton Oaks Collection, Washington, D.C., 37.33

COLLECTION HISTORY Purchased from Bustros (Beirut) through Royall Tyler (Paris), January 1938; Mr. and Mrs. Robert Woods Bliss collection.

PUBLISHED Segall 1941, 13; Swarzenski 1941, 78; *Bulletin of the Fogg* 1945, 108, 117; *DO Handbook* 1955, no. 190; Grierson 1955, 57–60; Ross 1957, 258; Kantorowicz 1960, 1–16, fig. 1; Ross 1965, 37–39, cat. 38, pls. 30–32 and A; *DO Handbook* 1967, no. 184; Wander 1973, 102, fig. 18; *Age of Spirituality* 1979, 283–84, cat. 262; Vikan 1982, 4–35, fig. 26; Mango 1984, 21–29, fig. 6; *ODB* 1991, 1306; Walker 2001, 154, fig. 9.5; Walker 2002, 66–67, fig. 4.5.

The belt consists of twenty-one small medallions and two large medallions connected by links. The large medallions, at either end of the chain, form the front of the belt and are joined by a clasp from which two leaf-shaped charms are suspended. The smaller medallions display busts that have been identified as Dionysian revelers or pagan gods.[1] The two large medallions echo the iconography of fifth-century imperial marriage solidi.[2] They show the bride and groom flanking Christ, who presides over the *dextrarum junctio*, the joining of hands to commemorate the marriage union (see cats. 121, 122). The inscription, which curves around the figures, invokes God to bring the couple harmony, grace, and health.

While the large medallions feature a clearly Christian conception of marriage—with Christ acting as *pronubis,* or guardian, over the union—the smaller medallions draw from pagan iconography. As with the belt buckle in this exhibition (cat. 132), the combination demonstrates the persistence of pagan traditions in the culture of early Byzantine marriage. Here, the representation of Dionysian figures echoes the epithalamia of the sixth-century Byzantine poet Dioskoros of Aphrodito. In his "Epithalamium for Count Callinicus and Theophile" (c. 570), Dioskoros writes, "Dionysos attends the summer of your wedding, bearing wine, love's adornment, with plenty for all,"[3] and, in the "Epithalamium for Isakios," "Easily protecting garlanded Dionysos and the Nile with his many children, may God grant a noble marriage free from the destruction of others."[4] In the first citation, Dionysos revels in honor of the newlyweds, while in the second, the Christian God and the pagan deity are mentioned in tandem, with God taking precedence.

The pagan iconography on this early Byzantine marriage belt brings into question its function in Christian ceremony. Marriage belts seem to have been exchanged informally, perhaps being given to the bride as part of her dowry or as a gift from her husband. The tremendous value of this belt, however, makes clear that it was intended for display. If the belt was worn during a Christian ceremony or in any other situation in which pagan imagery was inappropriate, the smaller medallions on the chain could have been easily concealed under a garment while the larger medallions, with their Christian imagery, remained visible.

It has been argued that the inscription "health" on this belt relates to wishes for successful conception and childbirth.[5] Indeed, marriage belts were most likely worn by

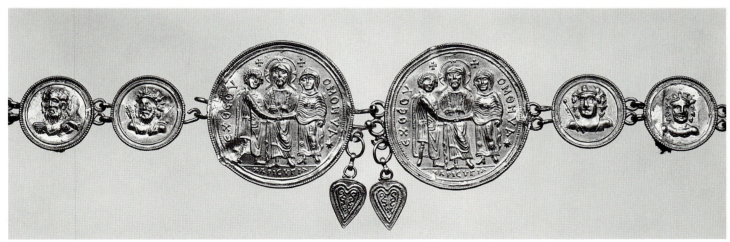

131, detail

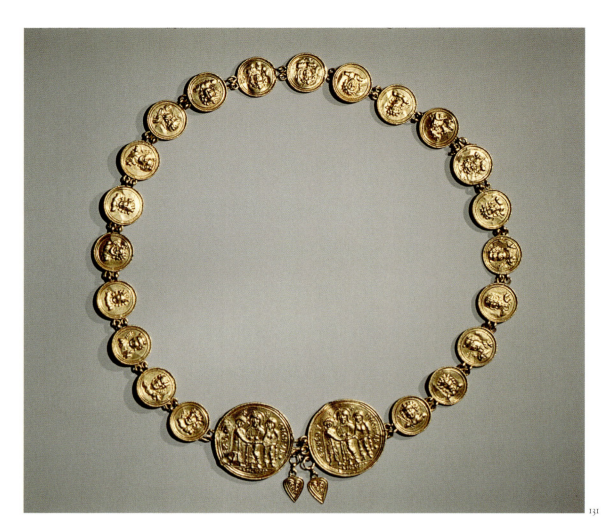

women, and in an area of the body that was of obvious relevance to reproduction. Belts are also cited as miraculous devices that aided women during difficult labor. For example, in the *vita* of the ninth-century Saint Theophano, the saint's father helps her mother by retrieving a belt that hung over an icon of the Virgin in a local church and placing it on his wife's loins, thereby facilitating the saint's birth.[6] In the fifth-century *vita* of Saint Melania the Younger, a woman whose unborn child has died in her womb is unable to expel the fetus. Saint Melania ties her belt around the woman's hips, enabling her to release the stillborn child.[7] Worn at the wedding rather than during childbirth, the belt depicted here would have served as an amulet, invoking both pagan and Christian deities to bless the marriage with harmony and fertility.   AW

1. Marvin Ross identifies six different Dionysian figure types (Ross 1965, 37); Josepha Weitzmann-Fiedler identified the figures as Dionysos, Hermes, Poseidon, and Asklepios (*Age of Spirituality* 1979, 283–84, cat. 262).

2. Kantorowicz 1960, 8; Zacos and Veglery 1960.

3. MacCoull 1988, 89.

4. Ibid., 111–12.

5. *ODB* 1991, 1306. A similar sixth-century marriage belt in the Louvre also refers to health in its inscrip-tion: ΥΓΙΕΝΟΥСΑ ΨΩΡΙ ΘΕΟΥ ΧΑΡΙС (Wear in good health/From God grace). The Paris belt displays the same iconography as cat. 131: on the large medallions, bride and groom are flanked by Christ, who presides over the *dextrarum junctio*; on the twenty smaller medallions, Dionysian figures and, in this case, profile figures identified as Tyche or Fortuna are featured (*Byzance* 1992, 133, cat. 89).

6. Kurtz 1898.

7. Gerontius 1984, 73.

## 132 Belt Buckle with Bridal Couple, Bellerophon, and Chimera

Rome (?), Byzantine, 4th century
Gilded copper alloy
L. 4.9 cm, w. 4.0 cm
Inscription: obverse, in upper field, ☧ (Chi-Rho, Christogram)
The Metropolitan Museum of Art, Purchase, Rogers Fund and Alastair Bradley Martin Gift, 1993 (1993.166)

COLLECTION HISTORY Michael Ward, Inc., New York, 1993.

PUBLISHED *Mirror* 1999, 25, cat. 28; Walker 2002, 67–68, fig. 4.6.

132

Worn by a man, this belt buckle displays a decorative motif that resembles one found on marriage belts worn by early Byzantine women. On the obverse stand a bride and groom joining hands in the *dextrarum junctio*. Their elite social status is indicated by their elaborate costumes: he wears a tunic adorned with *segmenta* (decorative tapestry panels) and a *chlamys* (mantle) gathered at the shoulder with a *fibula* (pin); she wears an ample, full-length tunic with *clavi* (decorative tapestry bands) running down the front. The bride's hair is gathered on top of her head. A Chi-Rho (the abbreviation of Christ's name in Greek) between the couple identifies their union as Christian. On the reverse, the Greco-Roman hero Bellerophon rides his mythical winged horse, Pegasus, who tramples the hybrid beast Chimera beneath his hooves.

Like the marriage belt (cat. 131), this buckle combines Christian and pagan imagery in celebration of the marriage union. Scholars have argued that Byzantine images of Bellerophon represent a visual allegory of Christ as a "new Bellerophon."[1] But Bellerophon may have held more specific meaning in the context of marriage. Bellerophon's battle against the Chimera was an appropriate theme for marriage jewelry because it was his triumph over this beast that won him the hand of the Lycian princess.[2]

In epithalamia (marriage poems) by the sixth-century poet Dioskoros of Aphrodito, Bellerophon features as a prototype for Byzantine grooms. In the "Epithalamium for Count Callinicus and Theophile" (c. 570), Dioskoros writes of the bridegroom, "your young body has surpassed prize-winning Bellerophon,"[3] and in the "Epithalamium for Patricia and Paul," he compares Paul to the pagan hero: "godlike in his grace, like Bellerophon, a desired bridegroom."[4] The bride is also equated with ideal pagan figures: Dioskoros calls Theophile "an enviable Ariadne," a reference to the wife of the Greco-Roman god Dionysos.[5] Early Christian women were also compared with pagan deities in art. A fourth-century silver casket found in Rome depicts a husband and wife, Secundus and Projecta, on the lid with an inscription that exhorts them to "live in Christ." The sides of the casket, however, show an image of Projecta at her toilet below a representation of Aphrodite bathing; the two women sit in comparable poses, and each twists a strand of her hair, making explicit the visual analogy of Christian wife and pagan goddess (fig. 20).[6]

While marriage regulations outlined in the eighth-century law book the *Ecloga* identify Adam and Eve as paradigms of Christian marriage,[7] early Byzantine poetry used classical figures to celebrate the heroic virtue of the groom and the physical beauty of the bride, topoi mirrored in the visual rhetoric of early Byzantine marriage art. AW

1. Hanfmann 1980, 85–87, with earlier bibliography.

2. *Mirror* 1999, 25.

3. MacCoull 1988, 89.

4. Ibid., 82.

5. Ibid., 89. Dionysos and Ariadne feature in early Christian versions and revisions of Greco-Roman myths, such as the fifth-century epic tale the *Dionysiaca*, by Nonnos of Panopolis (Nonnos 1962–63, vol. 3, 403–5 [47.419–69]).

6. See Shelton 1981, 27–28; 72–75, cat. 1; and pls. 2 and 11.

7. Freshfield 1926, 78.

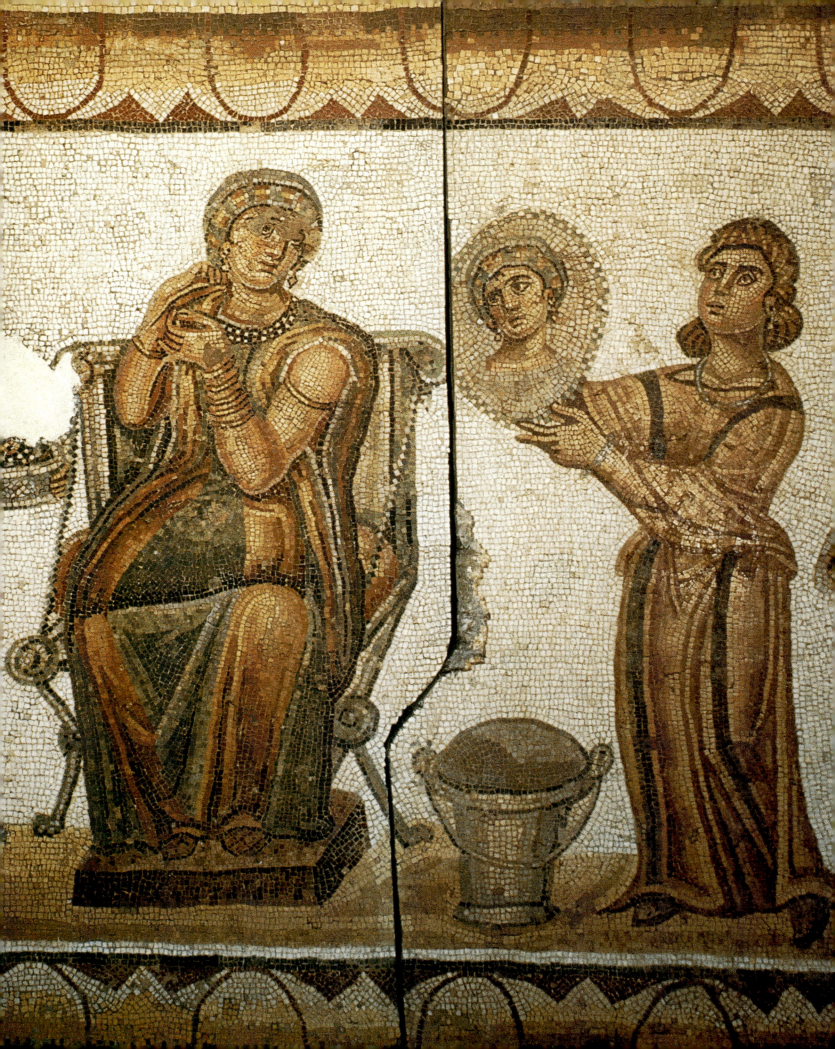

# ADORNMENT

ALICIA WALKER

## Enhancing the Body, Neglecting the Soul?

Early Christian Church writers, from Saint Paul to Clement of Alexandria, Tertullian, and John Chrysostom, strongly criticized the wearing of makeup, jewelry, luxurious clothing, and elaborate coiffures. Anti-adornment attitudes persisted in Christian writings throughout Byzantine history. The *vita* of the tenth-century Saint Mary the Younger, for example, states that the virtuous Mary believed "the [best] ornament was its absence. . . . [S]he rejected adorning herself with gold and [costly] array, following the wise exhortation of the holy Paul."[1] But the frequent appearance of Aphrodite-Venus, the Greco-Roman goddess of love and beauty, on objects of female adornment and household accoutrements indicates that women held ideals of female beauty that strongly contradicted the dictates of Christian writers (cats. 111, 140, 148, 150). No object better demonstrates this connection than a well-known fourth-century silver casket in the British Museum, on which an image of the owner, the Christian woman Projecta, mimics the gestures of Aphrodite at her toilet (fig. 20). With her voluptuous, nude body and long, flowing tresses, Aphrodite evinces less frequently recognized aspects of Byzantine female identity: sensuality and seductiveness.

Christian and secular ideals of female beauty did intersect to some degree. Both traditions praised symmetry of features, proportionality of body parts, and ivory or snowlike skin.[2] Christian rhetoric, however, discouraged the use of artificial means to hide natural deficiencies or to enhance favorable attributes. For example, rather than rouging her face, Saint Mary the Younger was "flushed with the proper glow of modesty."[3] Yet even natural beauty could be seen as a potential liability. In her poem "Woman," the ninth-century aristocratic nun and poet Kassia reveals an ambivalent attitude toward female beauty, considering attractiveness an undesirable trait, although still preferable to homeliness:

> It is not good for a woman to be beautiful;
> for beauty is distracting;
> but if she is ugly and ill mannered,
> without distraction it is twice as bad.
> It is moderately bad for a woman to have a radiant countenance
> yet beauty has its consolation;
> but if a woman is ugly
> what misfortune, what bad luck.[4]

It was this "misfortune" of ugliness that no doubt inspired Byzantine women to paint, drape, and adorn their bodies to improve on nature.

As is so often the case in the study of Byzantine culture, our impression is limited by the sources available. While few documents address the issue of women's beauty in the direct manner of Kassia's poems or the tracts of early Church fathers, a number of

233

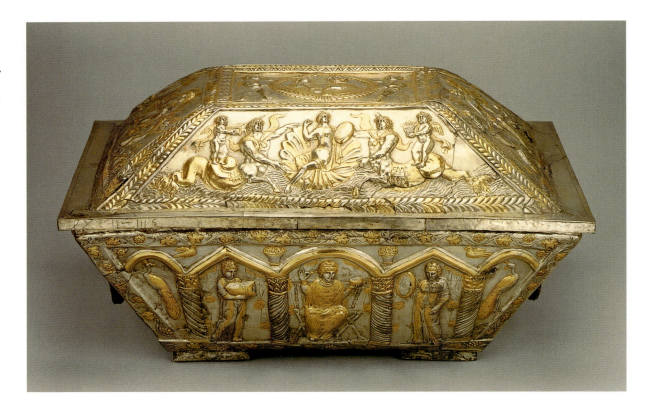

Fig. 20. Aphrodite and Projecta. The Projecta casket, 4th century. Gilded silver, 55.9 x 43.2 x 28.6 cm. The British Museum, London, BM M&LA 66, 12-29, 1.

sources—particularly early and middle Byzantine saints' lives and middle Byzantine imperial histories—do give us indirect comments. The greatest evidence for the importance of female adornment, however, comes from the material record. Extant items of jewelry, fragments of clothing, tools for applying cosmetics, and containers for perfumes all speak of the importance grooming and adornment held for Byzantine women and Byzantine society more broadly. No doubt the frequency of admonition against adornment can be taken as a sign of its ubiquity.[5]

Women who wore cosmetics and jewelry were typically described in early Byzantine sources as seeking to attract male admirers and were derisively compared with prostitutes. While some women did expend this effort for monetary profit, others sought merely to secure the affections of a spouse. The fifth-century *vita* of Saint Thekla tells of a man who came to loathe his wife after she damaged her face by using a poisoned beauty product. Saint Thekla aided the woman, instructing her to buy soap sold at the entrance to the saint's church and to wash her face with it. This sanctified cleanser reinstated the woman's attractiveness, reviving the affections of her husband.[6] Indeed, the third-century Church father Clement of Alexandria, who otherwise strongly condemned the use of cosmetics by women, made exceptions for cases in which a wife needed to regain the devotion of her spouse.[7]

Clement mentions the materials used for women's makeup, which included white lead, charcoal, and, intriguingly, "the droppings of crocodiles."[8] Containers used for keeping cosmetics were made from a variety of materials, including glass (cats. 156, 157), metal (cat. 155), ivory (cat. 148), bone (cat. 154), and wood. A lampstand with a figure of Aphrodite (cat. 111) depicts the goddess holding a wandlike tool, most likely a makeup or perfume applicator, to her face. Material evidence shows that Byzantine women used similar sticks

or spoons of bone (cat. 153), ivory, and metal. Perfume bottles, a comb, and a mirror, represented alongside weaving implements in a late antique funerary relief (cat. 73), show that beauty tools and cosmetic containers were as essential to female identity as the spindle and the weaving comb, ancient symbols of female virtue and diligence.

Hair was the focus of many commentaries on women's adornment, and great pains were taken to delineate acceptable bounds for its arrangement.[9] While luxuriant, long, and well-kept tresses were celebrated as a mark of virtuous femininity, women were advised to keep their hair covered in public.[10] Wild, unkempt, or exposed hair was a mark of licentiousness.[11] When the late-fourth-century prostitute—and, later, saint—Pelagia neglected to cover her head in public, her behavior was described as a perversion of her sex: "Then she went by with her head uncovered, with a scarf thrown round her shoulders in a shameless fashion, as though she were a man; indeed in her haughty impudence her garb was not very different from a man's apart from her makeup and the fact that her skin was as dazzling as snow."[12]

Clement of Alexandria advised women to gather their hair with a simple pin at the base of the neck and derided those who employed "hairnets of all different sorts, elaborate styles of hair-do, numberless arrangements of their locks, costly mirrors to keep adjusting their looks—all that they may ensnare men dazzled by appearances like senseless children."[13] Canon 96 from the late-seventh-century Council in Trullo censured women who wore their hair in a seductive manner and the stylists who created these coiffures.[14] Yet early Byzantine portrait statues depicting elite women show that elaborate hairstyles were indeed worn (cats. 24–27).[15] Hair was arranged with the aid of combs and pins, and these objects were sometimes ornamented with the emblems of beauty that women sought to imitate, whether the goddess Aphrodite (cat. 150) or an elaborately coifed but anonymous woman (cat. 149). From Clement, we know that wigs and hair extensions as well as hair dye were also employed in the early Byzantine era.[16]

The necessity of adornment to the social identity of early medieval women is exemplified by a mosaic from a fifth-century private bath in Sidi Ghrib, Tunisia: it represents a woman at her toilet, assisted by servants (fig. 21).[17] She sits on an elaborate chair, dressed in ample robes and adorned with a rich necklace, multiple bracelets, and jeweled earrings. As she arranges her tresses, one attendant holds a mirror and another presents a container that—although obscured by damage to the mosaic—appears to hold jewelry. Objects of the bath surround them: on the right are pails, a pitcher, and a domed vessel that may have held perfumes; on the left is a large, open coffer in which clothing is piled. A pair of slippers is neatly arranged in the upper corner, while a large, bowl-like object, possibly the lid to the container held by the attendant, lies in the lower corner. The mosaic was a pendant to a scene of the departure for the hunt.[18] While the male domain was epitomized by the pursuit of animals in the wild, the woman's realm was the home, and her activities centered on preening, presumably for male delectation. As on the Projecta casket, this representation of a woman admiring herself was juxtaposed with an image of Aphrodite at her toilet, situated across the hall in the main apse of the bath.[19]

The stereotype of women's love for fancy clothing and other adornments is also

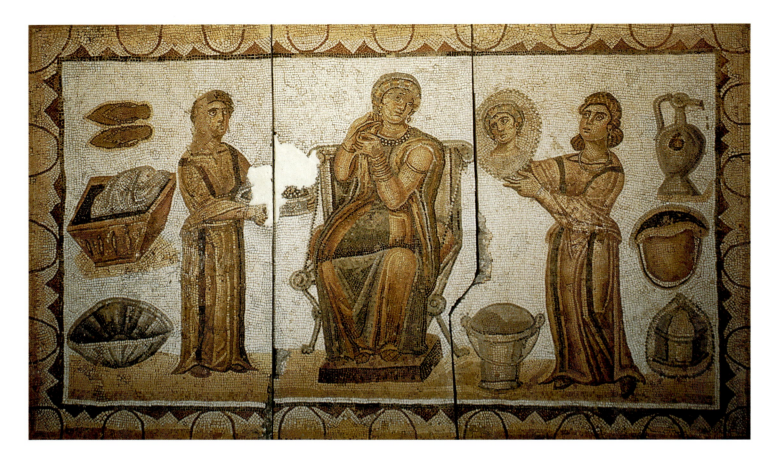

Fig. 21. A lady adorning
herself, 5th century.
Mosaic, Sidi Ghrib,
Tunisia. Bardo Museum,
Tunis.

found in the writings of the eleventh-century courtier and historian Michael Psellos,
who noted that the empress Zoe "affected scorn for the beautiful dresses of her rank,"[20]
a characteristic that he considered even "more surprising" than her disinterest in the quin-
tessential female pastimes of weaving and spinning.[21] His comment also raises the point
that clothing and ornaments were important indicators of social status in the Byzantine
world.[22] Courtiers' positions were denoted by the type of robes and finery they were
allowed to wear, garments that were often gifts from the emperor. Certain luxury materials
such as silk, purple dye, and precious stones were both financially inaccessible and con-
trolled by the state; only individuals of designated rank were allowed these extravagances.[23]
Status was expressed through the style of the objects; to be *à la mode*, whether in imitation
of a traditional type (cat. 144) or through adoption or adaptation of a foreign style
(cat. 145), seems to have been as important in Byzantine fashion as it is today.

Some sense of the personal possessions of an affluent middle-class Byzantine woman
can be gathered from the *vita* of Saint Mary the Younger.[24] Upon her death, Mary's hus-
band searched for her personal belongings, but, unbeknownst to him, she had long since
given these valuable items away to the poor: "[T]he husband opened her coffers and, . . .
finding [the coffers] empty, he ordered the young slave girl to be brought to him, and
asked her where her mistress's ornaments were, the earrings of pearls and precious stones,
and the gold ring, the multicolored silk dresses."[25] Necklaces, earrings, bracelets, and rings
made of gold, silver, pearls, and precious stones (cats. 135–47) both enhanced a woman's
beauty and conveyed her elevated status. People of lower economic standing adorned their

bodies according to their means, substituting silver or bronze for gold. Jewelry of lesser value often imitated the style and design of more expensive types (compare, for example, cats. 126 and 128, 123 and 124). Luxurious fabrics such as silk covered the bodies of the wealthy, while elaborate tapestry panels of wool weave enlivened the simple linen tunics accessible to individuals of more modest means (cats. 158–63).

The decorations chosen for clothing and jewelry varied from natural themes of animals and plants to pagan images of maenads, the female followers of Dionysos, or deities, such as Aphrodite.[26] The potential immorality of luxurious jewelry or clothing was in some cases mitigated by the use of Christian symbols, such as the cross (cats. 138, 176); the grapevine (cat. 141); and images of saints (cat. 183), Christ, and the Virgin Mary (cats. 177–79, 182). Decorations on both jewelry and clothing may have been intended to protect or bring good luck to the wearer: a knot or a cross was thought capable of repelling evil spirits (cats. 160, 176), while the auspicious image of a fruit-filled basket or a generously adorned woman (cats. 143, 161) was displayed to bring similar bounty to the user.[27]

Perfume also served not only to adorn but to protect the body.[28] As Michael Psellos explains, "perfumes give off a vapor which drives away evil spirits and which at the same time invokes the spirits of the just."[29] A fourth-century silver box for perfumes decorated with images of the Muses (fig. 22) was found in the same cache as the Projecta casket.[30] Both portable containers parallel the boxes depicted on the mosaic from Tunisia. Small glass bottles (cats. 156–57) holding perfumes and body oils were placed inside the Muse casket; such glass vessels could also be used independently.

A most likely exaggerated account of the total effect that some women sought and all Church fathers feared is described in the *vita* of Saint Pelagia.[31] While still an infamous actress and prostitute in Antioch, she was observed in the street by a group of monks:

> *This prostitute . . . was sitting prominently on a riding donkey adorned with little bells and caparisoned; in front of her was a great throng of her servants and she herself was decked out with gold ornaments, pearls, and all sorts of precious stones, resplendent in luxurious and expensive clothes. On her hands and feet she wore armbands, silks, and anklets decorated with all sorts of pearls, while around her neck were necklaces and strings of pendants and pearls. . . .*
>
> *As this prostitute passed in front of us, the scent of perfumes and the reek of her cosmetics hit everyone in the vicinity. . . .To put it briefly her appearance incited everyone who set eyes on her to fall in love with her. . . . Her beauty stunned those who beheld her, captivating them in desire for her.[32]*

The images of women portrayed in saints' lives were certainly sensationalized, and average women no doubt shied away from the extremes of adornment that Pelagia was said to have displayed. Some idea of the more modest image that ordinary women sought is conveyed by portraits from burials in late antique Egypt (cats. 133–34). These representations show women delicately coifed and wearing minimal jewelry, usually simple earrings and a necklace. The colors of their faces are enhanced, but to natural effect. Perhaps they heeded the Christian rhetoric that viewed Pelagia's artificial beauty as a moral trap: "[H]er ornaments . . . were a baited snare for all who beheld her, a stumbling block leading to perdition."[33]

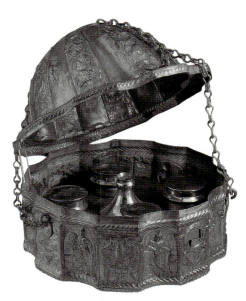

Fig. 22. The Muse casket, 4th century. Silver, h. 26.7 cm, diam. 32.7 cm. The British Museum, London, BM M&LA 66, 12-29, 2.

In the *vitae* of repentant prostitutes like Pelagia, however, the reformed female saint does not merely adopt the costume of a more modest Byzantine maid or matron. Rather, she turns to a regime of extreme asceticism in order to further distance herself from her former life. Pelagia, for example, traveled to Jerusalem, where the physical trials to which she submitted herself gave her the appearance of a eunuch, and she became known by the male name Pelagios:

> [H]er astounding beauty had all faded away, her laughing and bright face that I had known had become ugly, her pretty eyes had become hollow and cavernous as the result of much fasting and the keeping of vigils. Indeed the whole complexion of her body was coarse and dark like sackcloth, as the result of her strenuous penance. The whole of Jerusalem used to call her "the eunuch," and no one suspected anything else about her; nor did I notice anything about her that resembled the manner of a woman.[34]

Pelagia's rigorous asceticism exemplifies how Christian writers promoted moral virtue over physical attractiveness; her spiritual triumph is equated with the loss of femininity.[35] Kassia likewise promoted spiritual beauty over physical attractiveness in her poem "Beauty":

> One should prefer a drop of luck
> than great beauty.
> It is better to possess grace from the Lord,
> than beauty and wealth that does not gain grace.[36]

Women's spiritual virtue was sometimes conveyed through metaphors of physical grace and adornment. Saint Mary the Younger was described by her brother-in-law as "most beautiful both in appearance and in soul, so that her inner beauty is reflected in the beauty of her body."[37] The tenth-century Saint Thomaïs of Lesbos, who suffered at the hands of her husband, bore her living martyrdom as an ornamentation of her soul:

> [S]he clothed herself all over with the blows from the aforesaid Stephen [her husband] as with a garment of salvation. . . . She adorned herself with wounds as with pearls, with hurts as with most precious stones; she was embellished by thrashings as with golden [coins], and henceforth presented herself as a queen clothed and arrayed in divers colors before the Ruler of All. She was adorned by insults as with expensive earrings, her beauty was enhanced by the beatings.[38]

Such physical and emotional mortification was, however, by no means the norm.

In contrast to the interdictions of Church fathers and the ascetic models of female saints that textual evidence promotes, the extant material record shows that Byzantine women prized jewelry, clothing, and cosmetics as both aesthetic enhancements and indicators of worldly status. While the Byzantines promoted and commended feminine virtue and modesty, a well-groomed and handsomely dressed woman still represented an equal, if different, model of female achievement.

1. Laiou 1996, 260.

2. Expressing the predilection for pale skin, Michael Psellos writes of the empress Zoe, "her whole body was radiant with the whiteness of her skin" (Psellus 1953, 115 [6.6]); Anna Komnene describes her mother, the empress Irene: "Her face shone with the soft light of the moon" (Comnena 1969, 110 [3.3]) and "her hand . . . was ivory turned by some craftsman into the form of fingers and hand" (ibid., 110–11 [3.3]). On the appreciation of symmetry and proportion of body parts: Kassia, in her poem "Beauty," states, "First comes beauty of countenance, and then a well-proportioned body and limbs" (Kassia 1992, 120–21); Psellos writes of the empress Zoe, "If you marked well the perfect harmony of her limbs, not knowing who she was, you would have said that here was a young woman" (Psellus 1953, 115 [6.6]), but he is less complimentary regarding Zoe's sister, whose "head was small, and out of proportion with the rest of her body" (ibid.); Anna Komnene writes of her mother, the empress Irene, "She stood upright like some young sapling, erect and evergreen, all her limbs and the other parts of her body absolutely symmetrical and in harmony one with another" (Comnena 1969, 110 [3.3]).

3. Laiou 1996, 257.

4. Kassia 1992, 120–21.

5. Art and Holy Powers 1989, 159–60, 181–84, and Finney 1987, 183, n. 12.

6. Dagron 1978, 401–3.

7. Clement notes, however, that she is better off regaining his attentions through the attraction of virtuous behavior than through the application of paints and jewelry (Clement of Alexandria 1954, 245 [3.11]).

8. Ibid. 205 (3.2). In his discussion of cosmetics, Clement quotes numerous ancient writers, including Menander, Antiphanes, Aristophanes, and Alexis (204–6 [3.2]).

9. Emmanuel 1995, 770–71, and "Grooming," in Art and Holy Powers 1989, esp. 183–84; Clement of Alexandria 1954, 248 (3.11).

10. Clement of Alexandria 1954, 188 (2.10). See also Emmanuel 1995, 772–73, and Kazhdan 1998, 15.

11. Kennell 1991 and Kazhdan 1998, 15.

12. Brock and Harvey 1987, 42–43.

13. Clement of Alexandria 1954, 207–8 (3.2) and 248 (3.11).

14. Trombley 1978, 7.

15. Emmanuel 1993–94. For a discussion of women's hairstyles in the Roman world as signs of status and individual identity, see Bartman 2000.

16. Clement of Alexandria 1954, 248 (3.11).

17. National Museum of Carthage, Tunisia, D5. Ennabli 1986, 42–46, pl. 14. Slim 1996, 155, fig. 116.

18. Ennabli 1986, 44–46, pl. 14.

19. Ibid., 5–6, and 44, pl. 4.

20. Psellus 1953, 137 (6.64.)

21. On spinning and weaving as the model industries of women, see Laiou 1981, 243–45.

22. On clothing see Clement of Alexandria 1954, 180–89 (2.10 and ch. 11). On jewelry, see ibid., 190–98 (2.12), and "Jewelry," in Art and Holy Powers 1989, 159–60.

23. For example, the ordinances in the ninth-century Book of the Eparch on control of silks and purple-dyed fabric (Freshfield 1938, 16–17 and 25–26).

24. She lived in a small city and her husband was a military officer who had received a promotion following his successes on the battlefield (Laiou 1996, 239, 259).

25. Ibid., 267.

26. "Clothing," in Art and Holy Powers 1989, 139–43.

27. Ibid.: "Knots and Interlaces," 3–4; "Women Who Bring Wealth," 13–14; and "Christian Designs," 16–32.

28. On the erotic potential of perfumes and the early Church fathers' admonitions against their use, see Caseau 1994, 123–32, and "Grooming," in Art and Holy Powers 1989, esp. 181–82. On the apotropaic properties of perfumes in the antique and early Christian worlds, see Caseau 1994, 210–18.

29. Psellus 1953, 188 (6.66–67).

30. Shelton 1981, 75–77, no. 2, pls. 12–17.

31. The bishop Nonnos is awestruck by Pelagia's intense devotion to her toilet, which, he argues, must have far surpassed the efforts he or his monks undertook in their veneration of God (Brock and Harvey 1987, 44).

32. Brock and Harvey 1987, 42–43. After Pelagia's conversion, she donates her jewelry and clothing for the benefit of the Church (ibid., 55). Casting off the baubles of femininity, a common topos in the stories of saints' lives, symbolized the renunciation of worldliness, for example in the lives of Saint Mary the Younger (Laiou 1996, 260–61) and Saint Thomaïs of Lesbos (Halsall 1996, 306).

33. Brock and Harvey 1987, 43.

34. Brock and Harvey 1987, 60.

35. On the theme of "transvestite nuns," see Constas 1996.

36. Kassia 1992, 120–21.

37. Laiou 1996, 256.

38. Halsall 1996, 307, 308. I thank Bissera Pentcheva for this reference.

## 133 Portrait of a Woman with Earrings

Antinoöpolis, Egypt, Late Roman, 2nd century
Encaustic on wood
H. 35.3 cm, w. 22.5 cm
Arthur M. Sackler Museum, Harvard University, Gift of Denman W. Ross, 1923.60

COLLECTION HISTORY Denman W. Ross collection.

PUBLISHED Hanfmann 1964, 306, pl. 46; Thompson 1982, 5, fig. 6; Pintaudi 1985, 95; Doxiadis 1995, 113, fig. 85; Cuno et al. 1996, 116–17.

This funerary portrait of a woman is a fine example of the high quality of naturalism that can be achieved with encaustic, a mixture of pigments and hot wax applied to a gesso-primed wood panel.[1] The encaustic technique enabled the artist to create exceptional depth in the modeling of the face while giving the skin its translucency. Clearly this is the portrait of an individual, a rather young woman with a long, oval face, large eyes, prominent ears, and a small chin. Her hair is carefully combed back, leaving a row of tiny curls to frame the forehead. She wears only a simple pair of earrings, and not the necklace of gold or colored stones that often accompanies them. From the small, thick hoop through the ear a golden lozenge hangs, with a pendant pearl attached. Although modest, these earrings are quite noticeable, since the gold glitters and the pearls are glossy, reflecting light.

The lively expression of the portrait also results from the contrast between the earth tones of the face and the saturated purplish blue of the woman's dark tunic. This contrast is heightened by the stark white of her undergarment, which defines the tunic's neckline. The brightness of the undergarment helps bring out the white line of reflected light on her nose, the whites of her eyes, and even an impression of moisture in the eyes, especially her right one.

The effectiveness of this portrait is in its naturalism, which the artist achieved through a subtle treatment of details in the coloring and shading of the flesh tones of the face and neck. The high quality of his craft allows the viewer to discern the makeup the woman had applied: touches of rouge on her cheeks, light brownish red eye shadow giving emphasis to her dark eyes, and light pink color on her lips.   IK

1. The unusual shape of the panel, which widens at the bottom, is typical of portraits found in Antinoöpolis. It would have conformed more easily to the shape of the body or mummy to which it was attached (Thompson 1982, 5).

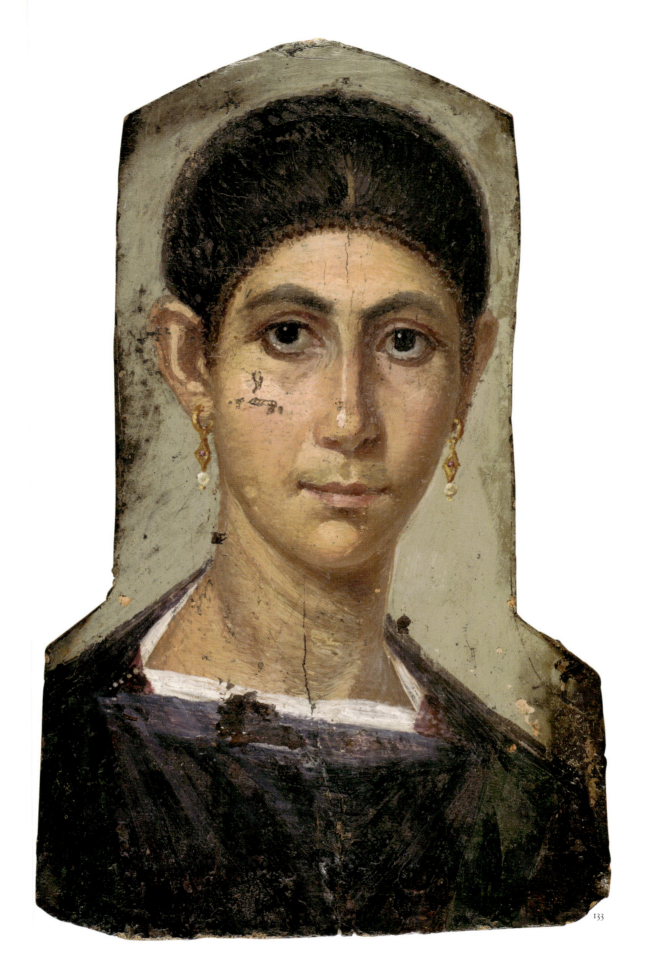

133

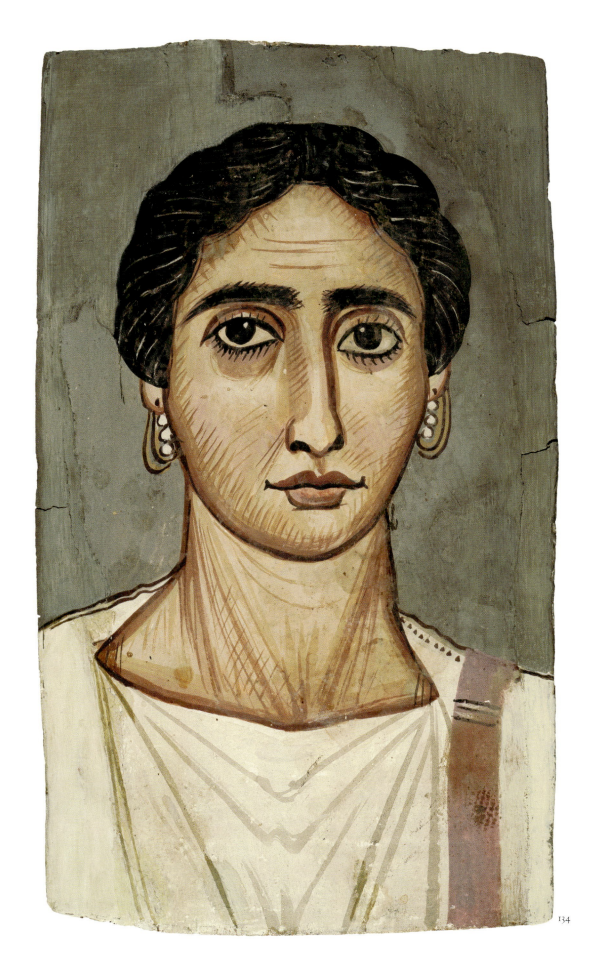

134

## 134 Portrait of a Woman in a White Tunic

Egypt, Byzantine, 4th century
Tempera on wood
H. 32.4 cm, w. 19.1 cm
Arthur M. Sackler Museum, Harvard
University, Gift of Mrs. John D. Rockefeller,
Jr., 1939.111

COLLECTION HISTORY Theodore Graf collection; Sotheby's sale 1931, listed as discovered in Rubayat, Fayum; Joseph Brummer Gallery, New York, 1933.

PUBLISHED Sotheby's London 1931, cat. 22, 1; Drerup 1933, 44, and 62, pl. 17a; *Pagan and Christian Egypt* 1941, 16, cat. 5, pl. 5; *Early Christian and Byzantine Art* 1947, cat. 674, pl. 87; Hanfmann 1964, 312, pl. 49; Parlasca 1966, 270; Thompson 1982, 21; Pintaudi 1985, 147.

This Fayum portrait of a woman is painted in tempera rather than using the encaustic, or wax, technique popular in portraits of this type. The use of tempera sometimes indicates a later date, and in this case the portrait has been dated to the early fourth century.[1] The woman's orientation is almost completely frontal, and she gazes into the distance instead of at the viewer. Her hair is dark, parted in the center, and pulled back in neatly arranged strands, highlighted in white. Her forehead is marked by a few horizontal lines, which give her a slightly worried expression. She wears hoop earrings with three small pearls attached.

What makes this portrait atypical is the simplicity of the woman's clothing and adornment. She is dressed in white, which is very unusual in depictions of women;[2] most are shown wearing tones of maroon, deep red, and purple. Men, however, are commonly depicted in white tunics. This contrast suggests that dress and color had a specific significance. Interestingly, the women dressed in white usually wear less jewelry than others, and they almost never wear necklaces. In two such portraits, from the first and second centuries, the women have their names and what seems to be the name of a profession written on their tunics. One reads "γραμματική" (schoolteacher).[3] Since white was the color worn by philosophers and other educated men, it is possible that this more austere appearance was the mark of an educated woman. A woman's dress and adornment thus identified her place in society not only in economic terms but perhaps also professionally.   IK

1. Thompson 1982, 270. Fayum portraits, painted on wood panels, take their name from the region in northern Egypt where a large number of such images have been found.

2. Doxiadis 1995, in which most of the known Fayum portraits are illustrated, has only three women in white tunics. See, for example, 25, 51, 65, 152, 156, 176.

3. Ibid., 51, pl. 33. The second is hard to decipher: 152, fig. 98.

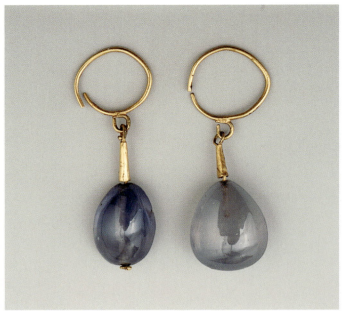

135

## 135 Drop Earrings

Early Byzantine, 5th–6th century
Gold, sapphires
H. 5.33 cm
Virginia Museum of Fine Arts, Richmond,
The Adolph D. and Wilkins C. Williams
Fund, 67.52.12.1/2

COLLECTION HISTORY De Clerq–De Boisgelin
collection, Paris.

PUBLISHED De Ridder 1911, 146, pl. 3, cat. 872;
Ross 1968, 15, fig. 9; Gonosová and Kondoleon
1994, 80, cat. 20.

These drop earrings are simple but elegant in design; each features a gold hoop, which would have passed through the ear, and a pendant that hangs from a small ring soldered to the bottom of the hoop.

A gold wire, a small gold cone, and a pear-shaped, pale-blue sapphire form each pendant. The earrings are not, however, identical: each is of irregular shape, and the sapphires are suspended in different ways. One earring (67.52.12.1) has a half-drilled sapphire attached to the wire with an adhesive, while the other has a fully drilled sapphire secured by a wire passing through the stone and coiled at the end.[1] In Byzantine jewelry the first technique is typically used for mounting pearls.[2] The second method of suspending precious stones is common in both Byzantine and ancient jewelry.[3]

The pear-shaped pendant form is extremely common. Earrings of this type, as well as more complex pieces of jewelry featuring similar pendants, were worn by women throughout the Mediterranean and in northern Europe.[4] Roman examples have been dated as early as the second century A.D.[5] Although in such earrings the pendants are usually pale sapphires, other precious and semiprecious stones were used.[6]

The gable of a funerary stele in this exhibition (cat. 73) represents a woman wearing pear-shaped pendant earrings, which is evidence of the popularity of this form of personal adornment.   JF

1. The irregular sizes of the sapphires and the different systems of suspension may indicate that the stones were reused (Gonosová and Kondoleon 1994, 80).

2. See the double ring in this volume, cat. 142.

3. Gonosová and Kondoleon 1994, 80–81.

4. Ibid.

5. Petrie 1927, 13, cat. 211.

6. De Ridder 1911, 145–46, pl. 3, cats. 865–83; for another amethyst example, see Petrie 1927, 13, cat. 211.

## 136 Basket Earring

Byzantine, 10th–11th century
Gold
H. 2.8 cm
Virginia Museum of Fine Arts, Richmond,
The Adolph D. and Wilkins C. Williams
Fund, 67.52.16

COLLECTION HISTORY De Clercq–De Boisgelin
collection, Paris.

PUBLISHED De Ridder 1911, vol. 1, 296,
cat. 1628, pl. 3; Ross 1968, 30, fig. 45; Gonosová
and Kondoleon 1994, 94, cat. 29; *Glory of
Byzantium* 1997, 246, cat. 169.

## 137 Basket Earring

Byzantine, 10th–11th century
Gold
H. 3.1 cm
Virginia Museum of Fine Arts, Richmond,
The Adolph D. and Wilkins C. Williams
Fund, 67.52.17

COLLECTION HISTORY De Clercq–De Boisgelin
Collection, Paris.

PUBLISHED De Ridder 1911, vol. 1, 296–97,
cat. 1629, pl. 3; Ross 1968, 30, fig. 44;
Gonosová and Kondoleon 1994, 94, cat. 28.

These two unpaired but similar earrings are of a type known as basket earrings, which were popular throughout the Byzantine Empire from the sixth through the thirteenth century. Early examples are decorated with twisted wire and figure-eight designs, whereas later variations are characterized by more complex filigree and granulation and the addition of attached ornamental elements such as knobs and studs.

Cat. 136 (not in the exhibition) is decorated on each of four sides and the bottom by a filigreed hemisphere. The ear wire and hinge are attached to the top, which is flat and decorated with openwork circles and a central granule. The center of each hemisphere is punctuated with a knob. Four raised and granulated triangles fill the corner spaces on each side. One of the side hemispheres, crude and undecorated, is possibly an ancient repair.[1]

Cat. 137 is composed of three circular elements interspersed with three triangular elements on the sides and a convex triangular element on the bottom. The circular sections consist of a plain hemisphere ringed by a filigree band in a pattern of figure eights. The center of each hemisphere is decorated by a two-part knob. The triangular sections are decorated with the same filigreed figure-eight design. Three studs separate each circular element and there is a protruding cylinder on the bottom. The ear wire and hinge are attached to a top piece.[2]

Although there is no way to know the exact identity of the owners of these earrings, the valuable material and high-quality craftsmanship indicate the users' affluence. The earrings continue the long tradition of personal adornment that was so prevalent during the Byzantine Empire.   AB

1. Gonosová and Kondoleon 1994, 94, cat. 29.

2. The construction, style, and design characteristics of these earrings are similar to those adopted by the Islamic Fatimid gold workshops of the eleventh to thirteenth century (Jenkins and Keene 1983, 70–71). Similar examples are found in the Stathatos Collection, Athens (Amandry 1963, 287, cat. 220 and fig. 178); Dumbarton Oaks, Washington, D.C. (Ross 1965, 93, cat. 134, pl. 65); the Staatliche Kunstsammlungen, Kassel (Naumann 1980, 49–50, cat. 109, pl. 21); and the British Museum.

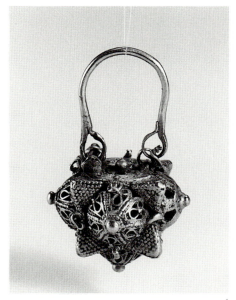

136

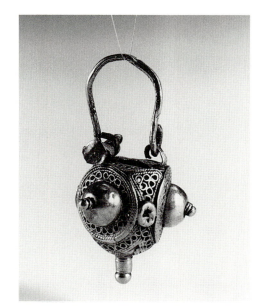

137

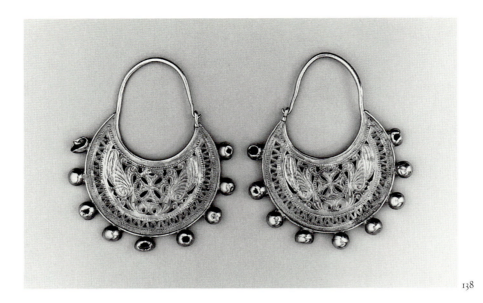

138

## 138 Peacock and Cross Earrings

Constantinople (?), Byzantine, 6th–7th century
Gold
H. 5.7 cm, w. 4.2 cm
Virginia Museum of Fine Arts, Richmond, Arthur and Margaret Glasgow Fund, 66.15.7.1/2

PUBLISHED Ross 1968, 20–21, fig. 20; *Age of Spirituality* 1979, 315–16, cat. 290; Steenbock 1983, 27–28, fig. 3; *Art and Holy Powers* 1989, 170, fig. 95; Gonosová and Kondoleon 1994, 86–87, fig. 24.

Each of these crescent-shaped, openwork gold earrings is embellished on its outer border with nine applied gold globules. The interior depicts a pair of peacocks facing a flared cross enclosed in a circle above swirling trefoils; the entire grouping is contained within punched-dot-and-triangle borders.

The iconography of the earrings holds both pagan and Christian connotations. Roman mythology associated peacocks with Hera, queen of the gods, and peacocks were believed to bear empresses to heaven at their apotheosis. The Romans viewed the annual regeneration of the peacock's plumage as a symbol of immortality. In Christian Byzantium, the symbolism shifted to Christ's resurrection and to eternal life, while still retaining regal associations.[1] George of Pisidia, deacon of the Hagia Sophia in the seventh century, gives evidence of the mixed significance of peacocks. He praises their adornment of gold and emerald, the colors of emperors, and links them to Christianity by naming them the most beautiful embellishment of God's creation: "How could anyone who sees the peacock not be amazed at the gold interwoven with sapphire, at the purple and emerald green feathers?"[2] In this pair of earrings, regal and religious symbols embellish an object of personal adornment, associating the wearer with imperial grandeur and Christianity.

Similar earrings found buried in tombs with coins suggest a seventh-century date for this pair.[3] Its geographical attribution is less clear; while the form and iconography appear in examples from Constantinople, Sicily, Cyprus, Syria, Hungary, and Egypt, the complexity of the design suggests the sophisticated workmanship of Constantinople.[4]  ADG

1. *Art and Holy Powers* 1989, 11.

2. From *The Hexaemeron*, 1245–92, quoted in ibid. Also Frendo 1984, 159.

3. Orsi 1924, 398, and Ross 1968, 22; see also Ross 1965, 68.

4. Gonosová and Kondoleon 1994, 87, and Ross 1968, 21.

## 139 Earrings with Dedication

Early Byzantine, late 4th century
Gold, sardonyx
L. 2.0 cm
Inscription: ΤΗ ΚΑΛΗ (to the beautiful one)
Museum of Fine Arts, Boston, Gift in
memory of R. E. and Julia K. Hecht, 66.318a;
Museum of Fine Arts, Boston, Helen and
Alice Colburn Fund, 66.318b

COLLECTION HISTORY Purchased from Bank
Leu & Co., Zürich, June 1, 1966.

PUBLISHED *MFA Annual Report* 1966, 54;
Vermeule 1971, 403, figs. 49, 50.

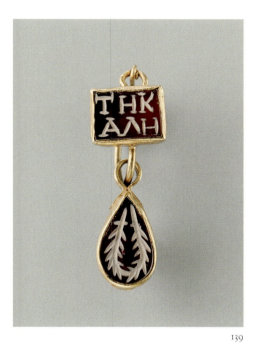

139

These gold earrings inlaid with sardonyx intaglios (only one of the pair is illustrated here) may have been a wedding gift from a bridegroom to a bride.[1] Each has an upper square stone inscribed ΤΗ ΚΑΛΗ (to the beautiful one, fem.) with letters grouped to fit the space, and a teardrop-shaped pendant engraved with an open wreath. Carved down to the white layer of the stone, the inscriptions and wreaths are striking against the reddish orange surface.[2] Sets of jewelry and individual rings with inscribed wishes for harmony, health, grace, and blessing (cats. 126–30) were often presented to brides or exchanged by nuptial couples in the early Byzantine period.[3]

The engraved wreaths may refer to the στεφάνωμα (crowning with wreaths), an essential part of the Roman and Byzantine marriage ceremony, originally an informal civil rite held in the home.[4] Other objects with depictions of wreaths, including finger rings, medallions, and chests, have been interpreted as wedding gifts or marriage souvenirs.[5] The inscriptions καλή (beautiful, fem.) and καλός (beautiful, masc.), which occur in ancient Greek literature and on vases dedicated by older male lovers to courtesans and youths, had erotic connotations known in the Byzantine period.[6]

The earrings evoke the epithalamium (prose or verse celebrating a marriage) by the fifth-century poet Dracontius, in which the bride's loss of virginity on her wedding night is symbolized by the color and brilliance of a red jewel:[7] "Let her shine scarlet with the red-tinged pallor of a jewel and unite in her cups Sardinian [bitter] and Sitifian [sweet] drugs."[8] The poem and the inscription on the earrings both celebrate the bride's beauty and sexual compliance as wifely virtues. Such values reflect the unequal power relations predicated on the youth and virginity of most early Byzantine brides.[9]   EG

1. On sardonyx, see Ogden 1982, 108–9.

2. Perhaps part of a set, the earrings were found with a pendant of gold, glass paste, and garnet (Vermeule 1971, 403).

3. On early Byzantine marriage rings, see Vikan 1984, 65–86; Vikan 1990, 145–63. For similar inscriptions on Roman jewelry, see Richter 1971, cats. 402–4.

4. Couples were originally crowned with garlands, and in later periods with a marriage crown of precious metal (*ODB* 1991, 1306–7).

5. Deppert-Lippitz 2000, 60–62, figs. 7.2, 7.3; Henig 1993, 32, fig. 2.6; Kantorowicz 1960, 9, n. 42 and fig. 10.

6. For καλή on ancient Greek vases, see Robinson and Fluck 1937, 1–2. The erotic meaning of the word is clear in the *Souda*, a tenth-century Byzantine lexicon in which καλή is used to describe the proverbial prosti-tute Rhodapois, whose beauty makes her more expensive than other women (Adler 1928–38, 191).

7. The epithalamium was traditionally composed by or on behalf of a male friend of the bridegroom, and sent close to the wedding night. In some cases, as here, it is a metaphorical imagining of the erotic events of the night and can be sexually suggestive (Ariès and Duby 1987–91, 618–19).

8. Roberts 1989, 34–36, citing Blossius Aemilius Dracontius, *Romulea* 7.42–47. Sardinian herbs are described in Virgil's *Eclogues* 7.41 as bitter, and Dracontius implies that herbs from Sitifia (in ancient Mauretania) are sweet. The adjectives also refer to the respective origins of the bride and groom (Roberts 1989, 35, n. 49).

9. Most brides were in their teens (Clark 1993, 13–15).

## 140 Earring in the Shape of a Female Nude

Egypt, Byzantine, 4th–5th century
Gold
L. 4 cm, w. 1.3 cm, d. 1.2 cm
University of Toronto, Malcove Collection,
M82.228

COLLECTION HISTORY Purchased from André
Emmerich Gallery, New York, September
1963.
PUBLISHED Campbell 1985, 110, cat. 137.

This single gold earring takes the shape of a nude female figure with voluptuous round hips, high breasts, narrow shoulders, and attenuated arms. Her hair is braided and pulled back from her broad, calm face. She stands on a rectangular pedestal from which a ring is suspended for the attachment of a pendant. Enormous spirals on either side of the face are possibly coils of hair with bead decoration, ear reels, or exaggerated stud earrings.[1] A barely visible indentation in the lower part of the pubic area was probably intended to emphasize the figure's femininity. Such attention to the pubic area, combined with a wide lower body and short legs, is characteristic of representations of nude females on objects, especially textiles, produced in the fourth to fifth century.[2]

The figure probably represents Aphrodite, or possibly one of the Nereids, the sea nymphs who often accompanied her.[3] Either would convey contemporary notions of female beauty, sex appeal, and fertility. However, evidence from other beauty accessories, such as boxes, pins, and jewelry, suggests that during the early Byzantine period Aphrodite was more commonly represented on items associated with women's adornment. These objects create visual parallels, subtle or direct, between the woman owner or user and the goddess (fig. 20; cats. 143, 144, 150).[4] If the female nude is Aphrodite, the earring would have been a playful suggestion that the woman wearing it was as beautiful and desirable as the goddess of love herself.   DA

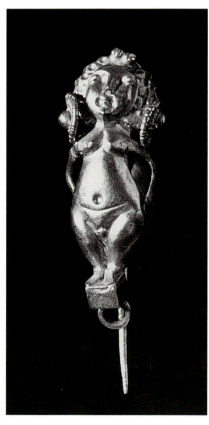

140

1. For stud earrings, see Williams and Ogden 1994, cat. 51.

2. See, for instance, dancers on a textile cover from Sheikh Abada, Egypt, and a limestone relief with Daphne from the same site (Wessel 1965, pl. 19 and fig. 40); two Nereids on a relief from Ahnas, Egypt (Du Bourguet 1971, 88); and Campbell 1985, cat. 137. A similarly proportioned female figure, identified as Aphrodite, is found in a third-to-fourth-century mosaic in Rudston, England (Dunbabin 1999, 100, fig. 99).

3. *LIMC* 1981–97, s.v. "Néréides." See also cat. 111 in this volume. Hellenistic and Roman earrings with figural representations depict erotes and victories (Williams and Ogden 1994, 97, cats. 20–21, 49, 50, 63; Siviero 1954, cats. 150–52, 154–59).

4. Associations between the female owner and the goddess can be assumed for two silver pins, probably belonging to the Christian woman Projecta, that terminate with representations of the nude Aphrodite. One presents her removing her sandal; the other shows her with a mirror (Shelton 1981, cats. 46–47). A later example, a late-sixth-to-seventh-century gold and lapis lazuli pendant, depicts the goddess of love in the nude, standing and arranging her long tresses (fig. 3).

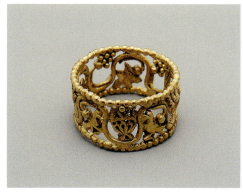

141

## 141 Openwork Ring

Byzantine, c. 550–650
Gold
Diam. 1.7 cm, width of band 0.9 cm
Museum of Fine Arts, Boston, Gift of Mary
B. Comstock, 1987.272

COLLECTION HISTORY Acanthus, New York.

UNPUBLISHED

Two bands of soldered gold beads frame this delicately sculpted openwork ring. A vase flanked by birds constitutes the central element of the composition; grapevines fill the remaining area. The small size and fine workmanship make this ring especially well suited for use by a woman.

Motifs of birds, vases, and tendrils were common decorative elements in early Byzantine art. The specific motif of the grapevine, however, also conveyed Christian symbolic meaning. Wine was thought to be transubstantiated into the blood of Christ during the Christian liturgy and was ritually administered as a symbol of human redemption through Christ's death.[1] If a Christian symbolism was intended for this ring, then the birds may be doves, symbols of the Holy Spirit and salvation.

The second-to-third-century bishop of Alexandria, Clement, preached that Christians, especially Christian women, should not wear jewelry. He did, however, approve of the use of a single gold ring by the matron of the house, and he specified appropriate decorative emblems, including the dove, for such a ring.[2] If the luxurious material and intricate decoration of this ring caused the wearer to fall short of ideal standards for Christian modesty, the iconography of her ornament, at least, promoted Christian values.

There is, however, another interpretation of this decorative theme. Many empresses, and perhaps women more generally, were compared to grapevines, and their offspring to grapes, the fruit of the vine.[3] Perhaps this ring—an object of female adornment, as indicated by its size—was intended as a symbol of divinely blessed fertility. AW

1. Clement of Alexandria commented on this symbolism in his treatise *Christ the Educator (Paedagogus)*: "[T]he product of the vine is wine; of the Word, blood. Both are saving potions: wine, for the health of the body; the other, blood, for the salvation of the soul" (Clement of Alexandria 1954, 16 [3.15]).

2. Ibid., 246 (3.11); Finney 1987, 184.

3. See, for example, the poetic inscription around the frame of the portrait of the ninth-century empress Eudokia, in the homilies of Gregory of Nazianzos, which compares her to a grapevine and her imperial children to the grapes (Brubaker 1994, 152, n. 34, fig. 7).

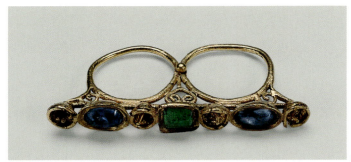

142

## 142 Double Ring

Yakhmour, Syria (?), Early Byzantine,
5th–6th century
Gold, emerald, sapphires
W. 4.9 cm; w. of hoops 3.7 cm; inner diam. of
hoops 1.6 cm; h. 2.2 cm
Virginia Museum of Fine Arts, Richmond,
The Adolph D. and Wilkins C. Williams
Fund, 67.52.9

COLLECTION HISTORY De Clercq–De Boisgelin
collection, Paris.

PUBLISHED De Ridder 1911, 399, pl. 5, cat. 2112;
Ross 1968, 14, fig. 7; Gonosová and
Kondoleon 1994, 46–47, cat. 7.

This double-hoop finger ring has a bezel with seven box settings. Pale-blue oval sapphires flank the central rectangular emerald. Round settings with protruding pins separate the sapphires from the emerald and are also located at either end of the bezel. Originally, these settings held half-drilled pearls, secured by an adhesive material. A gold wire shaped in a figure eight forms the finger hoops.

The hoops of this ring are small, roughly equivalent to a modern size 5.5. Double rings in other collections are the same size or smaller, which suggests that women and children wore them. This particular ring was originally part of the De Clercq Collection, formed in Syria.[1] The materials used suggest that the jeweler may have relied on east-west trade routes: Byzantine jewelers frequently used sapphires from Ceylon and emeralds from Egypt.[2] The ring has been dated to the early Byzantine period based on stylistic affinities and the use of multiple, multicolored stones.[3] The original owner was likely a fifth-or-sixth-century woman living in Syria.

Several of these rings have been found in funerary contexts, leading scholars to conclude that double rings are a type of funerary jewelry.[4] In some parts of the Byzantine Empire laws prohibited the burial of bodies decorated with more than one gold ring.[5] This proscription might have been circumvented by the use of a double or even triple hoop ring;[6] the practice would allow for greater ornamentation of a woman's body without violating the law. There is, however, no reason to conclude that double rings were not worn by living women as well: funerary art frequently depicts the deceased wearing jewelry popular among living women in a given period.[7]   JF

1. The collection includes eight other double rings; all have interior diameters equal to or smaller than that of this ring, which De Ridder measures at 1.75 cm (De Ridder 1911, 397–99, cats. 2104–11). The British Museum has three double rings with interior diameters of 1 cm to 1.9 cm (Marshall 1907, 137–38, cats. 840–42, pl. 21, fig. 114). For a list of double rings in other collections see Gonosová and Kondoleon 1994, 46, n. 2.

2. See Ross 1968, 12.

3. Anne Marie Lévêque argues that this style was most popular in the fifth and sixth centuries; later, an interest in openwork (interasile) ornamentation predomi-nated (Lévêque 1997, 79). See also Gonosová and Kondoleon 1994, 47; Higgins 1980, 184.

4. Gonosová and Kondoleon 1994, 46–47; Segall 1938, 115, cat. 169.

5. See Ross 1968, 12.

6. There are triple hoop rings in the Benaki Museum, Athens (Segall 1938, 114–15, pl. 36, cat. 169) and the British Museum (Marshall 1907, 157, pl. 25, cat. 983).

7. C. C. Edgar, for instance, dates one mummy mask that shows a double ring to a period in which the earrings the woman is wearing were popular on coin portraits of living women (Edgar 1905, xvii).

## 143 Bracelet with the Personification of Charis

Eastern Mediterranean, Byzantine (?),
c. 500 A.D. (?)
Gold sheets over fill material
Diam. 4.9 cm
Inscription: ΧΑΡΙϹ (grace)
Worcester Art Museum, Worcester,
Massachusetts, Stoddard Acquisition Fund,
2001.87

COLLECTION HISTORY Hesperia Arts
Auction, Ltd., New York, 1990.
PUBLISHED Hesperia Arts Auction 1990,
cat. 73.

## 144 Bracelet with Bust of Athena

Rome, Byzantine, c. 5th century
Gold
Diam 6.3 cm
The Metropolitan Museum of Art, New
York, Gift of J. Pierpont Morgan, 1917,
17.190.2053

COLLECTION HISTORY J. Pierpont Morgan
collection.
PUBLISHED Age of Spirituality 1979, 308–9,
cat. 282.

Each of these bracelets depicts the bust of a woman from Greco-Roman mythology, demonstrating the degree to which Greco-Roman figures persisted as powerful elements within Byzantine secular culture. In particular, female personifications and goddesses from pagan lore offered a wealth of feminine ideals to which Byzantine women could aspire.

The bracelet inscribed ΧΑΡΙϹ (Charis) features a woman in frontal bust form, encircled by multiple bands of a roundel frame.[1] Her curly hair is partially covered by a cap. She wears hoop earrings with pendants, a necklace composed of nine beads of equal size, and a pleated gown that falls over her shoulders and gathers at the chest, outlining her breasts. Her knobby chin protrudes slightly between her thick neck and fleshy cheeks.[2] Her elaborate hairstyle, carefully rendered jewelry, generously cut garment, and corpulence connote wealth, plenty, and good fortune.

The inscription ΧΑΡΙϹ[3] is also found on a variety of late antique objects: marriage rings,[4] coin weights,[5] love amulets,[6] and mosaics.[7] In simplest translation, χάρις means grace, and it is the term used for the Graces, female personifications of the Greco-Roman world who fostered natural bounty and human artistic creativity as well as the pleasures that accompany both.[8] In the Byzantine world, the term connoted a range of meanings, from divine grace—especially when accompanied by the term θεοῦ (from God)—to charm or physical attraction.[9]

Since the inscription and imagery on cat. 143 lack any religious associations, the most likely meaning for χάρις on this object is attractive force or charm, and the female bust is probably a personification of this characteristic. Her elaborate adornments and carefully rendered breasts recall representations of Aphrodite, goddess of love and beauty.[10] The bracelet bestowed attractive qualities on the woman who wore it and affirmed her appeal.

Cat. 144 presents a more sober image of a female figure, again in bust form, but here depicted only to the top of the shoulders.[11] In contrast to Charis's somewhat bloated visage and overall corpulence, this figure presents a trimmer countenance. Like the Charis bust, the figure on cat. 144 wears earrings and a necklace, this one formed from teardrop pendants. She also wears a four-cornered cap with beaded protrusions at the front, back,

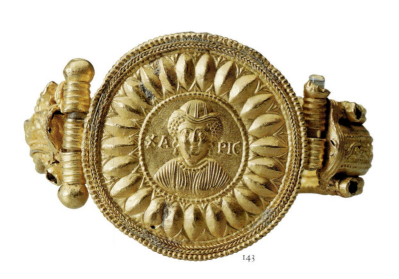

143

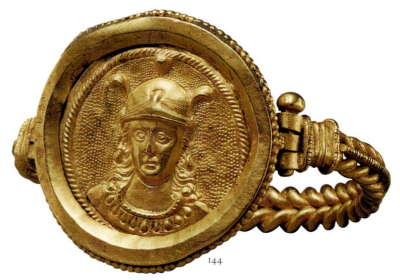

144

and sides. Although jewelry is not a typical attribute of Athena, the figure's headdress, a helmet, supports her identification as the virgin goddess of wisdom and battle.[12] Early Byzantine objects depicting the Judgment of Paris (cat. 148) evidence the continued familiarity of Athena and her distinction as an alternative female ideal to the goddess of beauty and love, Aphrodite.[13] Like cat. 143, cat. 144 endows and reflects the wearer's virtues, in this case wisdom and virginity. Although each bracelet promotes female ideals, the qualities represented by Charis and Athena are diametrically opposed.   AW/IK

1. The Charis medallion is elaborately framed by a series of beaded, vegetal, and braided roundels. The band of the bracelet is decorated with a tendril motif bordered by a thin row of beads at top and bottom and thick braids of gold at the outer edges. This tendril pattern appears on another gold Byzantine bracelet, dated c. 550, which shows an imperial quadriga (carriage drawn by four horses) on its central medallion (Ross 1965, 4–6, pl. 6, cat. 2a, and Lepage 1971, 18–19, cat. 32). A bracelet almost identical to cat. 143 appeared on the art market in 2000; its current location is unknown.

2. The rendering of the Charis figure is unusual. Her swollen face finds some parallel in the rounded visages of the bride and groom on circa sixth-century marriage-belt medallions (cat. 131). In addition, the groom's coiffure of tight curls, rendered in small beads, approximates the hair of the Charis figure.

3. A date of circa sixth century for cat. 143 is supported by paleographic comparison: a similar X — resembling a tilted cross — appears in the inscription of the sixth-century marriage belt (cat. 131).

4. For marriage rings inscribed XAPIC see Wamser and Zahlhaas 1998, 218–19, cat. 320. For marriage rings inscribed ΘΕΟV XAPIC, see Spieser 1972, 127, fig. 18, and Ross 1965, 7, cat. 4e, and 57–58, cat. 68.

5. Wamser and Zahlhaas 1998, 156, cat. 184; *Beyond the Pharaohs* 1989, cat. 84; and Bendall 1996, cats. 50, 66, 74.

6. Bonner 1950, 48, and Winkler 1991, 218–20.

7. Piccirillo 1993, 24–25, 53–54, fig. 5.

8. *LIMC* 1981–97, s.v. "Charis, Charites."

9. An association of χάρις with physical attraction is supported by the appearance of the word on a love amulet depicting Aphrodite; see n. 6 above.

10. The Graces, associated with Aphrodite, assisted at her toilet (Harrison 1986, 191–92). In a mid-sixth-century mosaic in Madaba, present-day Jordan, three women, each labeled XAPIC, tend to erotes, the winged offspring of Aphrodite (Piccirillo 1993, 25).

11. The background field of the medallion in cat. 144 is finely stippled; the bust of Athena is simply framed by an inner roundel of twisted gold surrounded by a smooth beveled frame, with a border of beads at the exterior circumference. The band of the bracelet consists of thick, twisted gold rods with a beaded filament running between them.

12. Although Athena is often designated by her aegis, a sheepskin worn over her shoulder (cat. 13), or the emblem of the Gorgon's head across her chest (*Age of Spirituality* 1979, 132–33, cat. 110, and 225, cat. 202), she is also identified by her martial attributes, such as a shield, a spear, or, as in cat. 144, a helmet (ibid., 225, cat. 202; and cat. 148 in this volume). Alternatively, the figure in cat. 144 could be identified as a personification of Rome, who also appears with martial attributes, including a helmet. Early Byzantine personifications of cities appear in a variety of media, including ivory, bronze (cat. 1), and gold. A sixth-to-seventh-century gold medallion depicting a personification of Constantinople wears a necklace and earrings that resemble those of the figure in cat. 144 (Ross 1965, 32, cat. 33).

13. See *Age of Spirituality* 1979, cats. 115, 116.

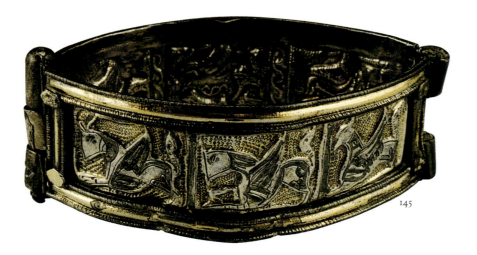

145

## 145 Bracelet with Animals in Relief

Balkans (?), Byzantine or Byzantine-inspired, late 11th–12th century
Silver, gilt, niello
H. 2.4 cm, diam. 7.2 cm
Virginia Museum of Fine Arts, Richmond, The Adolph D. and Wilkins C. Williams Fund, 71.40
PUBLISHED Gonosová and Kondoleon 1994, 74–77, cat. 18.

The two wide silver bands of this bracelet, with applied, gilded silver borders, are joined together by hinges, one of which is missing.[1] The bands are divided into three sections, each depicting an animal against a stippled background. One band contains griffins and the other, canines. Each of the animals has a different shape, indicating that they were worked individually. Niello strips emphasize their articulation. This type of bracelet was popular during the middle Byzantine era. A substantial number of examples exist, the most luxurious of them in gold.[2]

The varied textures of the reliefs, the raised borders, and the niello, as well as the silver and gilding, give the bracelet a coloristic effect. The animals are abstract in style and belong to a repertoire of forms with a long tradition in the Greco-Roman world. During the middle Byzantine period they were used to decorate metalwork and ivory objects for secular use,[3] and they are also found in contemporary Islamic art.[4]

Jewelry functioned as a status symbol in Byzantine society as much as—or perhaps more than—it does today. The gilding on this bracelet might have served to enhance the less expensive silver, possibly imitating gold.  EF

1. Gonosová and Kondoleon 1994, 74–77, cat. 18.

2. *Glory of Byzantium* 1997, cat. 174.

3. Gonosová and Kondoleon 1994, cat. 18.

4. Deppert 1995, 279.

Necklace with Cross
Pendants

Byzantine, late 5th–6th century
Gold, emeralds, sapphires, amethysts, pearls
L. 39.9 cm
Indiana University Art Museum, Burton Y.
Berry Collection, 70.56.12.A
PUBLISHED Rudolph 1995, 288–89.

This delicate necklace is constructed of five loop-in-loop gold-wire chain segments, which
are connected to one another by two pebble-shaped emeralds and two sapphires, symmet-
rically placed. The central segment has three decorative pendants. The pendant in the
middle is made of four uncut, slightly reddish amethysts strung on wire through a central
gold capsule to create the shape of a cross. Flanking the cross are two hexagonal tube beads
constructed of thick sheet gold with an openwork design of zigzag lines alternating with
continuous scrolls. Two smaller crosses made of pearls hang at the outer ends of the tube
beads. The stone or pearl that decorated the center of each of the smaller crosses has been
lost. The two trefoils that form the clasp also once held stones or pearls.

Crosses were commonly worn, most often as protective amulets. But this arrangement
of three crosses on a necklace should not be seen exclusively as the statement of a particu-
larly devout Christian; the crosses allowed a women to express her piety while adorning
herself with precious stones.   IK

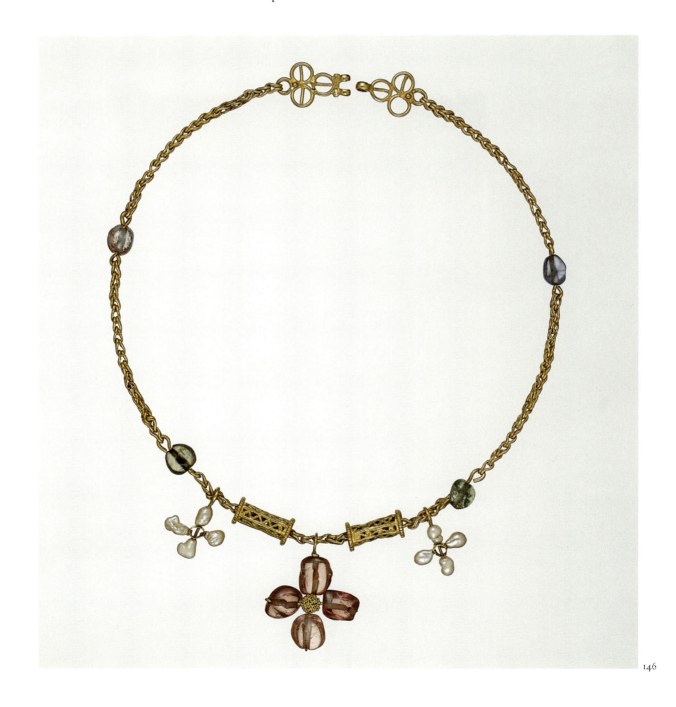

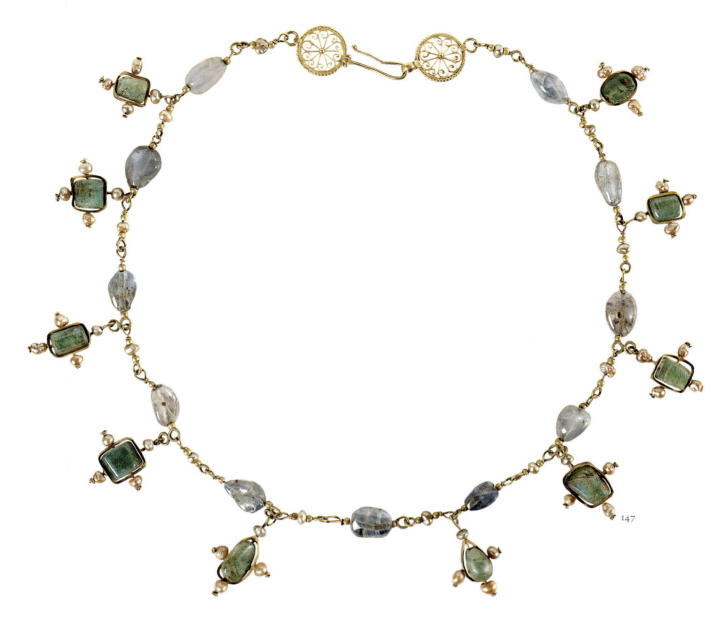

147

## 147  Necklace with Pendants

Byzantine, 6th–7th century
Gold, sapphires, emeralds, pearls
L. 47.9 cm
Worcester Art Museum, Worcester,
Massachusetts, Gift of Mrs. Kingsmill Marrs,
1925.522
UNPUBLISHED

This necklace is constructed of small segments of gold chain interspersed with pebble-shaped light-blue sapphires and small pearls. An emerald pendant hangs from each of the ten chain segments. Most likely the necklace had a central pendant, now missing, which would have hung next to the central sapphire and given a different overall impression. Each emerald pendant is vertically pierced and framed by a thin, flat band of gold with four small pearls attached. The hook-and-eye closure at the back is attached on each side to a gold openwork rosette.

This type of necklace was worn directly on the skin, close to the neck. Delicate necklaces with combinations of gold, green stones, and pearls can be seen in the Fayum portraits of the second and third centuries.[1] The addition of the cold blue tone of sapphire to this well-established combination of colors seems to suggest a particularly Byzantine aesthetic (see also cat. 146).   IK

1. Doxiadis 1995, 165, fig. 102.

## 148 Pyxis with the Judgment of Paris

Egypt, Byzantine, early 6th century
Ivory
H. 8.5 cm, diam. 9 cm
Acquired by Henry Walters, 1926, The Walters Art Museum, Baltimore, Maryland (71.64)

COLLECTION HISTORY Count G. Possenti, Fabriano, Italy; Felix collection; sale, Florence 1880; sold 1886; purchased in 1926.

PUBLISHED *Age of Spirituality* 1979, 137–38, cat. 115; Randall 1985, cat. 170.

This pyxis, its lid now missing, represents scenes from the myth of the Judgment of Paris. Desiccation of the ivory has split the box along the grain of the dentine into four parts, which were carefully repaired at an unknown date.[1] A modern core holds the pieces together.

The Judgment of Paris was a popular theme throughout the ancient Mediterranean world. Eris, the goddess of discord, was excluded from the wedding celebration of Peleus and Thetis. As an act of revenge, she tossed the golden apple of the Hesperides, inscribed "to the fairest," into the midst of the banqueters. According to the story, Aphrodite, Athena, and Hera all claimed the apple. To settle the dispute, Zeus declared that Paris, the handsome young prince of Troy, would choose among them. Paris chose Aphrodite as the fairest goddess and, in return, Aphrodite bestowed on him the love of Helen of Troy.

On the pyxis, Eris is a nude figure standing with her hand aloft, preparing to throw the apple. The four figures to the right of Eris possibly represent the Olympian gods seated around a three-legged table on which the apple has been placed. Two of the figures hold bowls, and a dog barks in the foreground. The figure on the right is possibly Hera. On the opposite side of the pyxis (illustrated), Hermes, wearing a *chlamys* (mantle) and identified by his winged cap and boots, holds the caduceus (wand) in his left hand, and extends the apple in his right, toward Aphrodite, who is nude and is twisting a lock of hair. Athena, to the right of her, wears the aegis and crown and holds a spear and shield. To the right of Athena stands Hera, fully cloaked and holding a scepter or spear. A bird, possibly a peacock, associated with Hera, stands between the two. Paris is not visible.

Pyxides like this one, frequently part of a woman's toilet, were used to store cosmetics and jewelry.[2] The subject of the decoration on this pyxis not only emphasizes the female identity of the owner, but also advertises the contents of the container—items that will make the user as beautiful as the goddess of love herself. This pyxis is one of the few extant examples of secular objects showing that classical myths were still popular in the sixth century A.D.; they remained so well into the middle Byzantine period.   DA

1. Volbach 1976, cat. 104; *Age of Spirituality* 1979, cat. 115.

2. On pyxides in general, see Kanowski 1983, 128. Pyxides were found in late antique women's graves at Dura-Europos (*I, Claudia* 1996, cat. 118 and n. 1) and Rhodes (Williams and Ogden 1994, cat. 43).

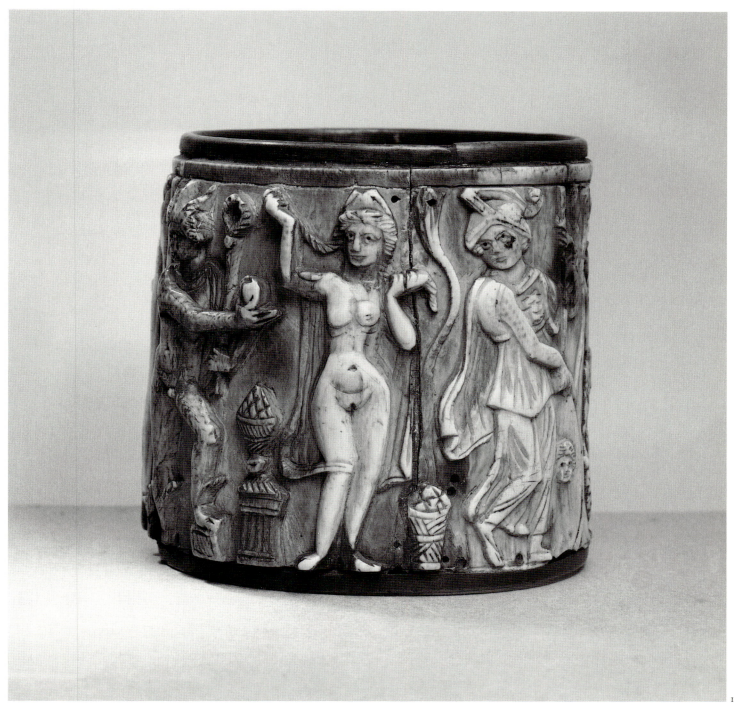

148

## 149 Hairpin Fragment in the Form of a Woman's Head

Tipasa, Algeria (?), Byzantine, 4th century
Bone
L. 2 cm, w. 1.5 cm
Dumbarton Oaks Collection, Washington
D.C., 47.1

COLLECTION HISTORY Gift of Madame
Henri Bonnet, January 1947.
PUBLISHED *DO Handbook* 1955, no. 248;
Weitzmann 1972, vol. 3, cat. 14, pl. 13.

## 150 Hairpin in the Form of Aphrodite

Egypt (?), Byzantine, 4th century
Bone
L. 7.5 cm, w. 0.6 cm
Dumbarton Oaks Collection, Washington
D.C., 48.4

COLLECTION HISTORY Gift of Mr. and Mrs.
Robert Woods Bliss, January 1948 (purchased
from Clement Pratt, Paris).
PUBLISHED Weitzmann 1972, vol. 3, cat. 15,
pl. 13.

## 151 Hairpin with Decorated Top

Late Roman, 4th century
Bone
L. 10.3 cm
Arthur M. Sackler Museum, Harvard
University, Transfer from The Peabody
Museum, Harvard University, 1978.495.114

UNPUBLISHED

Hair was a sexually charged symbol in the Byzantine world: attractive and sensuous, but, when left loose and uncontrolled, overtly erotic and potentially morally dangerous. Arranging her hair occupied much of a woman's time and attention in the course of her toilet. While women of modest means would have worn their hair simply, wealthier women could have afforded metal, ivory, and bone pins such as these, which were used in the construction of elaborate hairstyles of the sort represented by the terminal of cat. 149.[1]

Other typical designs included images of goddesses, particularly those associated with women's beauty, such as Isis or Aphrodite, as shown on cat. 150. Aphrodite was a popular subject for many toiletry and personal items, such as combs, jewelry, lampstands, and tapestries; frequently the goddess is depicted at her toilet, arranging her hair.[2] Cat. 150 shows Aphrodite covering her genitals as she emerges from her bath—a type known as Aphrodite Pudica, first established by Praxiteles in the fourth century B.C.[3]

The shaft of cat. 149 is missing, but the head of the pin is carved in the shape of a woman's head with voluminous hair. Incised diagonal and horizontal bands in the front suggest curls piled high; in the back, the flared top of the coiffure is represented by diagonal lines and supported by a knot of hair pulled tight at the back of the neck. Hairpins representing a woman's coiffure were very common.[4]

Cat. 151 is composed of two pieces of bone—one forming the shaft, the other the head—which have been incised with geometric designs. The shaft tapers asymmetrically to a point. The top third of the shaft is scored with three rings and, above these, a crosshatch of oblique lines. The head is scored with a similar crosshatch, and the very top is scored with three bands as it tapers to a slight point. When viewed from above, the three bands can be seen to form a spiral from the point of the head downward.   JF

1. In a similar hairpin, the woman's fanlike coiffure is topped by a row of points that represent the heads of hairpins (Johns 1996, 140–41, fig. 6.10).

2. See fig. 3 and Wulff 1909, 123, pl. 21, cat. 453. In another variation, Aphrodite is shown on a silver hairpin, fastening her sandal (Johns 1996, 140–41, fig. 6.8).

3. Compare Petrie 1927, 24, pl. 19, cat. 30.

4. Some examples are found in Wulff 1909, 123–24, pl. 21, cats. 454–57; Petrie 1927, 24, pl. 19, cat. 62; and Johns 1996, 140–41, fig. 6.10.

149

150

151

## 152 Hair Comb

Akhmim, Egypt, Byzantine, c. 6th century
Wood
L. 21 cm, w. 8 cm
Museum of Fine Arts, Boston, Sears Fund,
03.1628

COLLECTION HISTORY Albert M. Lythgoe
collection.

PUBLISHED *Pagan and Christian Egypt* 1941, 30,
cat. 73; *Romans and Barbarians* 1976, 208, cat.
248; *Beyond the Pharaohs* 1989, 148, cat. 58.

Hair combs were an essential element of the Byzantine woman's toilet. Many were pre-
served as grave goods, indicating their importance as intimate, personal possessions.[1]
Expensive versions of the tool were produced in ivory, while more modest examples, like
this one, were made of wood.[2] The broad teeth on the lower part were employed to comb
through the user's tresses, and the narrow teeth at the top served to smooth and refine the
hairstyle.[3] The fragile manufacture and pristine condition of this comb suggest, however,
that it was made specifically for the grave.

 The panel in the middle of the comb is decorated with an openwork design of a bird,
possibly a peacock, amidst foliage. Concentric circles decorate the bird's back as well as
the corners and sides of the surrounding frame; one circle forms the bird's eye.[4] If the bird
is a peacock, the circles running down its back may represent the "eyes" of the peacock's
feathers. Both the format of this ornamental panel and its animal motif recall the decora-
tion of contemporary textiles, drawing on natural themes of flora and fauna to adorn an
object of everyday use (for example, cats. 141 and 163). On a symbolic level, the peacock was
associated with incorruptibility and resurrection in both pagan and Christian traditions
(see cat. 138). Appearing frequently on women's toiletry items, the peacock was perhaps
invoked to preserve and rejuvenate the owner's youth and beauty.  AW

1. Rutschowscaya 1986, 26.

2. For examples of similar wooden hair combs see
Rutschowscaya 1986, 26–35, especially cats. 33–37.

3. Rutschowscaya 1986, 26.

4. The motif of concentric circles was ubiquitous
in early Byzantine art, particularly in modest objects
for daily use. For a discussion of this motif as an
apotropaic "mirror-cypher," see *Art and Holy Powers*
1989, 5–7.

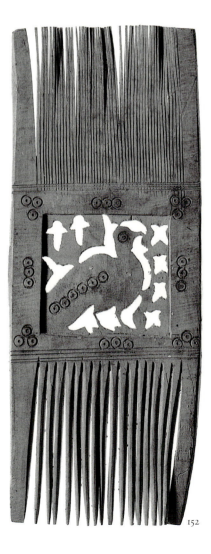

152

## 153 Spoon

Late Roman, 1st–4th century
Bone
L. 12.9 cm
Arthur M. Sackler Museum, Harvard
University, Gift of Dr. Harris Kennedy, Class
of 1894, 1932.56.45

UNPUBLISHED

## 154 Pyxis

Late Roman, 1st–3rd century
Bone
H. 8.1 cm, diam. 3.7 cm
Loan from the Alice Corinne McDaniel
Collection, Department of the Classics,
Harvard University, TL 36867.2

UNPUBLISHED

Small bone jars and spoons such as these were used in the storage and application of women's cosmetics and have often been found in domestic settings. Male writers in ancient Rome—among them Ovid, Juvenal, Pliny, Martial, and Lucian—often gave details regarding women's beautification rituals and even included recipes for certain facial masks and hair dyes. These artificial beauty aids were popular: in particular, perfume was used excessively in Rome, and a desire to protect the supply—entirely imported from Arabia—eventually prompted passage of a law to restrict its use.[1] Early Christian writers also took up the theme of feminine beauty rituals, though they were far less supportive, condemning the use of cosmetics as artificial and frivolous. From Tertullian and Clement of Alexandria as well as the *vitae* of various saints, we know that Byzantine women still penciled in their eyebrows, rouged their cheeks, and whitened their skin, despite Church leaders' criticism of these practices.[2]

Cosmetics containers like the pyxis (next page) were made in a variety of materials, including precious metals, ivory, bone, glass, and wood.[3] The luxury of some of these materials indicates how precious the objects of a woman's toilet could be. The cylinder of this container, however, is made from bone, a more modest material. The lid is attached by a bronze hinge, and there are holes for a second hinge and latch on the opposite side.[4] Even with this less costly material, the highly polished surface, the elaborate hinge, and the carefully shaped knob on the lid demonstrate the care taken with these utilitarian objects, making them purveyors of beauty in more than one sense.

The spoon is carved to a point at one end and to a flattened oval shape at the other. The oval would likely have been used to scoop a powder or ointment out of a container like the pyxis, and the other end, possibly to stir and mix powders or pastes.   JLH

1. Corson 1972, 56.

2. Ibid., 68, and *Art and Holy Powers* 1989, 181.

3. *Art and Holy Powers* 1989, 182. For an example of a wooden box of much the same type, see *I, Claudia* 1996, cat. 118. Another example of a wooden box designed in the same style showed traces of unguents,

confirming the use of these boxes as cosmetics containers (Rutschowscaya 1986, 41 and cats. 56 and 57).

4. The bronze hinge and latch are responsible for the greenish discoloration of the bone; otherwise the pyxis is in excellent condition.

153

154

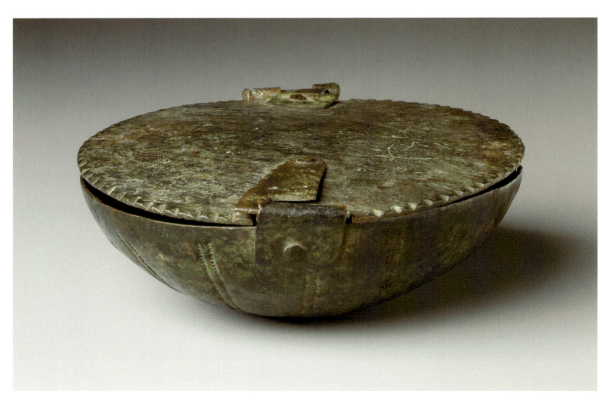

155

## 155  Toiletry Box

Egypt (?), Byzantine or Islamic, 6th or 7th
century
Copper alloy
H. 2.8 cm, diam. 7.8 cm
Arthur M. Sackler Museum, Harvard
University, Gift of the Hagop Kevorkian
Foundation in memory of Hagop Kevorkian,
1975.41.146

COLLECTION HISTORY Hagop Kevorkian
collection.

UNPUBLISHED

The dish of this container is made of a single domed sheet of metal with a geometric design punched into the surface. Although the visual effect of punching is similar to that of engraving, the jeweler used a tool with a rounded end to push the metal out rather than remove any of it. This technique is better suited to metal of such a light gauge. The lid of the box, which was attached to the dish with a hinge now broken, is a flat disc of slightly thicker metal. It was originally secured with a clasp. Its edges are decorated with regular triangular notches, and its top is lightly inscribed with circles containing a geometric six-petaled flower design.

Small boxes like this one could be used in a number of ways, including as cosmetics containers. Byzantine women, much like women in ancient Rome and Egypt, employed an assortment of cosmetics, oils, perfumes, and unguents. Some of the vials, tubes, boxes, and palettes used for storing and mixing these products preserve extensive residue. From these physical remains, and from ancient texts that debate the use of cosmetics and offer beauty advice to women, we can develop at least some idea of the toilet of Roman and Byzantine women. Ovid (43 B.C.–18 A.D.), for example, gives specific recipes for beauty aids: women used white lead or chalk to whiten their faces, black paint to accentuate and connect their eyebrows, reddish dyes to brighten their cheeks, and colored paints as eye shadow. A paste made by wetting powdered malachite would yield a satisfying green eye shadow. In hot climates, perfumed oils and unguents were used to prevent the skin from drying.[1] Similar recipes for cosmetics continued to exist throughout the Middle Ages. The eleventh-century Byzantine historian and courtier Michael Psellos reports that the empresses Zoe and Theodora tinkered with perfumes, producing their own in the women's quarters at the imperial palace in Constantinople.[2] The supplies for a woman's beauty regimen were kept in a variety of small boxes called pyxides (see cats. 148, 154), as well as in tubes and vials; these were usually made of stone, glass (cats. 156–57), or metal.[3]

The provenance of this box cannot be identified definitively. The surface design, however, seems typical of sixth- and seventh-century metalwork from the eastern Mediterranean. Several toiletry trays and bowls with handles from Egypt are decorated with similar rosettes, suggesting that this box may be of North African origin.[4]   JF

1. On ancient cosmetic use, see Corson 1972 and Ariès and Duby 1987–91.

2. Psellus 1953, 186 (6.64).

3. Corson 1972, 10.

4. Petrie 1927, 38.

156

157

## 156 Bottle

Byzantine, 4th century
Glass
H. 5.1 cm, diam. 3.5 cm
Arthur M. Sackler Museum, Harvard
University, Gift of Louise M. and George E.
Bates, 1992.256.192

COLLECTION HISTORY Collection of Louise
M. and George E. Bates.

UNPUBLISHED

## 157 Jar

Byzantine, 8th–10th century
Glass
H. 7.1 cm, diam. 6 cm
Arthur M. Sackler Museum, Harvard
University, Gift of Louise M. and George E.
Bates, 1992.256.219

COLLECTION HISTORY Collection of Louise
M. and George E. Bates.

UNPUBLISHED

Given their small size, these vessels were probably used to store precious oils or perfumes. They were items that could have been found in any Byzantine home on a woman's toiletry table. Originally the glass would have been clear, but after years of burial the surfaces have developed an iridescent patina.

In the first century A.D., Roman glass workers in Syria discovered a technique of glass-blowing that allowed them to produce glass objects more quickly and more cheaply than did previous methods.[1] As a result, glass was no longer a luxury material, and it began to be used for everyday items. The new technique, which is still in use today, spread widely, and numerous glass-making centers emerged around the Mediterranean.

Since it is not porous and does not react with liquids or oils, glass is much more practical than pottery or metal for storing perfumes and cosmetics. These little containers thus became the preferred vessels for women's makeup and other beauty supplies.   EF

1. *Glass of the Caesars* 1987, 87–91.

## 158 Tunic Fragment with Four Figures under Arches

Egypt (?), Byzantine, 7th–8th century
Wool and linen
H. 58 cm, w. 35.7 cm
Arthur M. Sackler Museum, Harvard
University, Gift of Charles Bain Hoyt, 1931.48

UNPUBLISHED

## 159 Tunic Fragment with Birds, Flowers, Lions, and Dancers

Egypt (?), Byzantine, 8th–10th century
Wool and linen
H. 45.7 cm, w. at top 36.2 cm, w. between *clavi*
22.5 cm
Arthur M. Sackler Museum, Harvard
University, Gift of Nanette B. Rodney,
1985.108

COLLECTION HISTORY Collection of Nanette
B. Rodney.

UNPUBLISHED

These textile fragments are cutouts from the front or back of two tunics. Both are tapestry weaves with a warp of natural linen and a weft of natural and dyed wool. Pieces like these, made of wool and linen and embellished with lively plant and animal motifs and mythological figures, were found in burial grounds in Egypt, where the dry climate provided conditions for natural preservation.[1]

The decoration on these two fragments is typical of the medium. Contrasting natural with purple (cat. 158) or bright multicolored threads (cat. 159), the weavers created a world of plenty—filled with animals, blooming plants, and dancing human figures. On the purple tunic, four figures—two male and two female—are shown under arches.[2] They stand with their legs crossed in the typical dancing pose.[3] The tunics of the men (second and fourth figures from left) and the scarves of the women (first and third figures) flow with the agitated step of the dance. The nudity of the women identifies the scene as one of Dionysian revelry. This tunic decoration is unusual in that the weaver has reversed the more common "dark figure" color design, leaving the four figures in the light hue of natural wool while lavishing precious purple thread on the background.[4]

Garlands in the first and third arches from the left, busts of onlookers in the second and fourth arches, and ribbons wrapped around the five Corinthian columns reinforce the celebratory mood of the scene. The pattern in the wide decorative band that runs along three sides—two longitudinal *clavi* connected by a horizontal segment—complements the theme of merriment with one of aquatic abundance.[5] The band is densely packed with a repeated motif of three rows of purple-hued fish nibbling a water plant.[6] A chain of trefoil finials with crosses embellishes the borders of this band, while a narrow band of medallions with ducks, reminiscent of a necklace, wraps around the neck. The upper left corner of this area shows signs of modern repair with fragments of the same tunic. Traces of fold lines at the waist area probably indicate where a belt was originally attached.[7]

Cat. 159 also conveys a sense of gaiety and abundance, through the use of bright threads and designs combining jewelry and flowering plants.[8] The decoration of the central area, corresponding approximately to chest level, consists of three pendants hung on a bright yellow band suggestive of gold. Each multifaceted pendant is surmounted by a blooming red rose and flanked by a motif of two birds and a basket with a similar rose. For the horizontal band terminating with the *clavi,* the weaver echoed the jewel pattern of the center by choosing as its major decorative element blue-and-red gemlike medallions with figures. The four roundels feature, from left, a lion, a Dionysian female dancer with castanets, a face in profile with blond hair, and another dancer. A pattern of a stylized flower with three pointed petals—probably a lotus—and jagged red-and-blue leaves, flanked by two green birds, alternates with the medallions. Upon close examination it is clear that the tip of the right *clavus* does not attach to the band, although it appears to be from the same tunic; it was most likely originally from the reverse side. The neck border contrasts with the rest of the decoration. A brocade of black and light threads, it is a geometric design, a chain of four crosses connected through their bent arms.

The lavish use of purple thread and the themes of celebration and aquatic abundance in the monochrome tunic (cat. 158), and the design of jewelry and blooming flowers in the

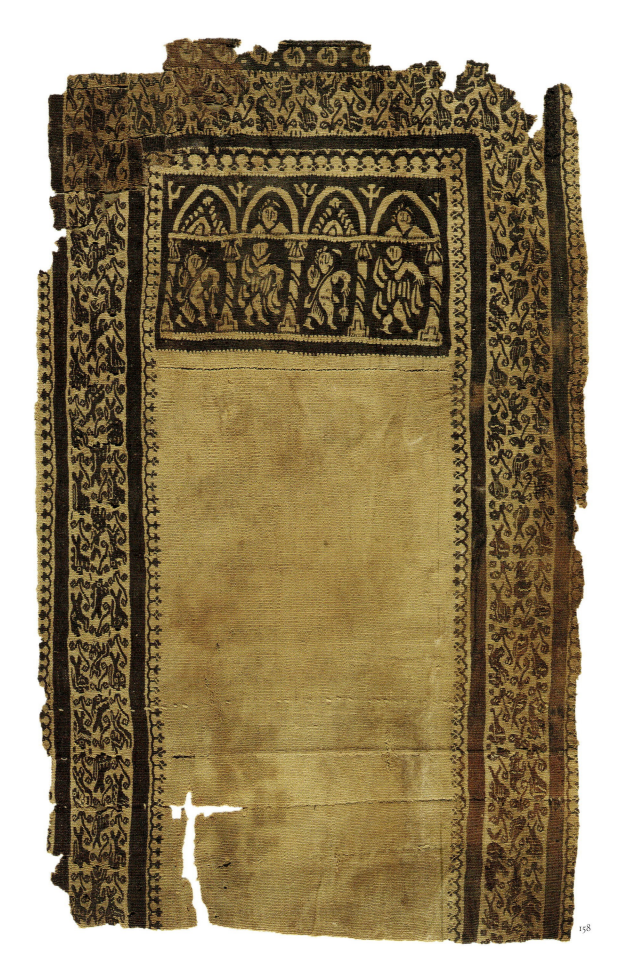

158

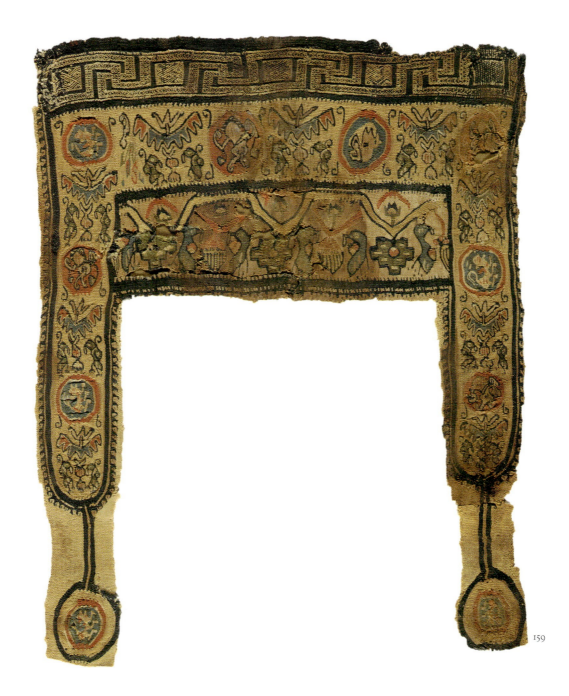

159

multicolored tunic (cat. 159), indicate the relative wealth of those who wore the garments. The somewhat small size of the fragments suggest that both these tunics were worn by women, or possibly by children.[9]  DA

1. De Moore 1993, 23, 26–27.

2. Tunics with figures under arches are numerous. See De Moore 1993, cats. 60–61, 65–66, 120, and Du Bourguet 1964, cats. C32–34.

3. See Du Bourguet 1964, cats. C32–34, D98, D134; on Dionysian dance, see *Rich Life* 1999, 90–91.

4. For the price of purple dye, see *ODB* 1991, 1756–60.

5. This probably represents the abundance of the Nile (*Rich Life* 1999, 35, 38–39).

6. The same design is found on the sleeve fragment of a tunic (Carroll 1988, cats. 52, 141, 158).

7. Compare a child's tunic with similar traces of folding and a very secular but light-on-dark design: De Moore 1993, cat. 123.

8. For other examples of a jewel-like tunic decoration, see *Rich Life* 1999, cats. B12 and C8a.

9. Judging from the high degree of stylization and the light-on-dark color scheme, which seems to be a post-sixth-century development (De Moore 1993, cats. 85, 120; *Rich Life* 1999, 88), the seventh century is the likely lower date range for cat. 158. The upper range may be established by a stylistic comparison with the *clavi* of a child's sleeveless tunic (n. 7 above) that was dated to the seventh to eighth century through radiocarbon dating. The use of outlining and the highly abstracted designs of cat. 159 indicate that this tunic was probably produced between the eighth and tenth centuries (De Moore 1993, cat. 145).

## 160  Tapestry Band with Knot Motif

Egypt (?), Coptic, 8th–12th century
Wool and linen
L. 20 cm, w. 15.5 cm
Arthur M. Sackler Museum, Harvard University, Gift of the Hagop Kevorkian Foundation in memory of Hagop Kevorkian, 1975.41.7

COLLECTION HISTORY Hagop Kevorkian collection.

UNPUBLISHED

This tapestry-weave piece probably decorated the cuff of a tunic. When the strip was wrapped around the wrist, the plain areas at the ends would have been hidden within a seam, and each of the two registers would have formed a continuous band. Geometric motifs like these are found on both men's and women's clothing.

The fragment was woven with a weft of natural and dark-brown wool on a warp of natural linen. In the geometric design, repeating rows of spades, pointing outward, appear at the top and bottom of each register. At the center of each register, a rectangle encloses a pair of knots, each of which is set in an octagon. On either side of the knots are rectangles enclosing repeating diamonds on one end and repeating X's on the other. The positions of the diamonds and the X's in the two registers are reversed. The diamonds and X's are finely rendered in a flying-shuttle technique, in which the weft is drawn freely over plain weave from one area to another.[1]

In addition to decorative appeal, the knots in the central rectangle of each register may have had protective power. Known as the Solomonic knot, this motif was thought to ward off evil spirits. Decorative elements were typically concentrated at the edges of garments, but in this case the knots may have been strategically placed at an opening of the tunic to protect the body within from malignant forces.[2]  AW

1. Tapestry-weave fragments of comparable design and technique have been attributed to Coptic Egypt and dated from the ninth to the twelfth century (Du Bourguet 1964, 615–19, esp. 615, cat. 143; Badawy 1978, 303, cat. 4.93).

2. Belief in the efficaciousness of the Solomonic knot in protecting openings is evident from its appearance in floor mosaics placed at the entrances to buildings and rooms as well as from its use in stamped impressions on the stoppers of storage vessels (Kalavrezou-Maxeiner 1985b, 95–103; *Art and Holy Powers* 1989, 4).

160

## 161 Textile Roundel with Figural Decoration

Egypt, Byzantine, 5th–7th century
Wool and linen
Diam. 20.5 cm
Arthur M. Sackler Museum, Harvard
University, Gift of Charles Bain Hoyt, 1931.46

UNPUBLISHED

This roundel of tapestry weave was probably cut from a linen shawl or tunic on which it was one of several pieces of decoration. Tapestry roundels were often sewn on the shoulders and hems of tunics. If this was the case, the figure may have been placed so as to look in the direction of the wearer's face or body.

In the early Byzantine period, Christians in Egypt dressed the dead in their finest clothes before wrapping them in shrouds for burial.[1] Most textiles like this one were found in tombs, where they were preserved by the hot, dry climate. Many of the tombs were excavated in the late nineteenth and early twentieth centuries, and the textiles were cut up and sold in pieces on the art market.[2]

This brightly colored roundel is composed of several concentric fields. The largest area contains abstracted trees and birds. In the center of the composition is a seated figure within a circle. Although highly schematic, it does appear to have a halo, large eyes, and breasts, indicating that it might be a female personification. Depicted against a red background, the figure wears a blue-and-yellow robe. Her right hand is raised and holds an unidentifiable object. Portraits of females, some bejeweled and with halos, are common on Byzantine tapestry panels from Egypt. These may be interpreted as symbols of good fortune that were intended to bring prosperity to the wearer. Since this female figure is bare breasted and surrounded by vegetation, she could be a personification of the earth, symbolizing fertility and abundance.[3]  MFH

1. The emperor Theodosios I (r. 379–95) outlawed mummification, which had long been practiced in Egypt.

2. Rassart-Debergh 1997, 37–71.

3. The style of decoration and the rendering of the figure are similar to those of a textile roundel depicting the biblical story of Joseph, dated to the fifth to sixth century and now in the Pushkin Museum of Fine Arts, Moscow. The large eyes, the *horror vacui* in composition, the abstraction, the brilliant color scheme, and the stylized borders are characteristic of Byzantine Egyptian textiles made after the fifth century.

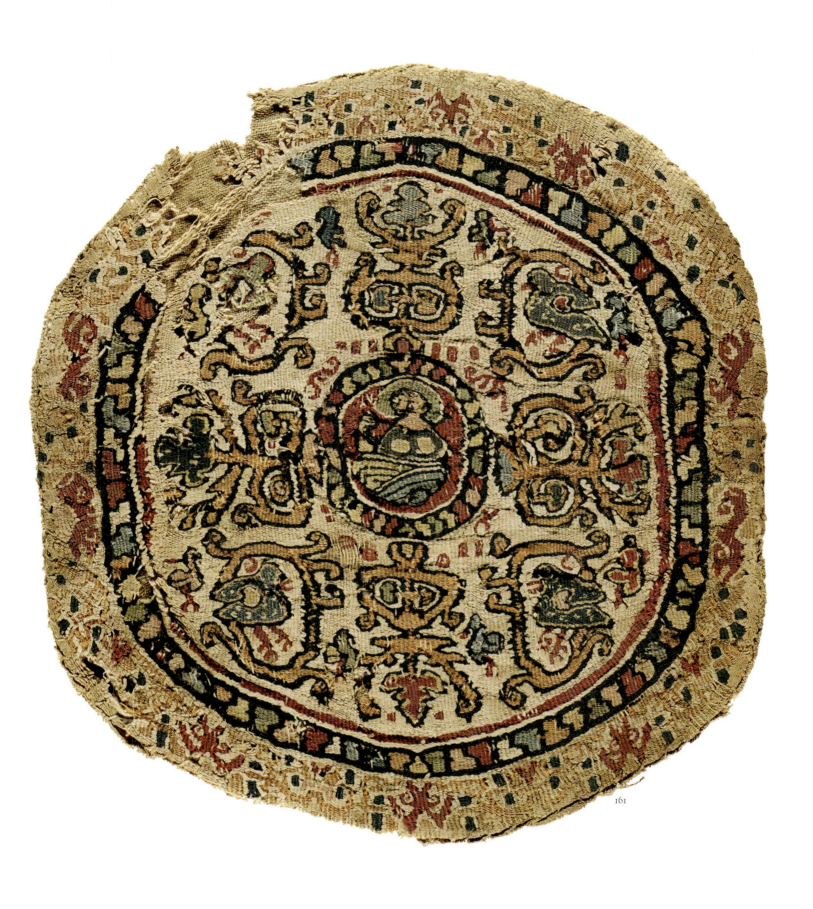

161

## 162 Tapestry Panel with Inscription

North Syria (?), Byzantine, 7th century
Wool and linen
L. 32.5 cm, w. 17.5 cm
Inscription: ΓΕΟΡΓΕΙ (for George [?])
Arthur M. Sackler Museum, Harvard
University, Gift of Charles Bain Hoyt, 1931.43

UNPUBLISHED

In each of the four smaller roundels of this tapestry panel, a nude nymph rides a sea monster, with a small darker-skinned figure in attendance. Fish swim in adjoining registers, and bands containing floral and vegetal motifs fill the remainder of the composition. This panel, originally attributed to North Syria, is similar in composition to several pieces excavated in Egypt. The Egyptian panels feature religious figures in the central roundels.[1]

The iconography in cat. 162 is not easy to understand, in part because the textile is damaged. Although much of the costume of the larger central figure has been lost, it appears to be a blue cloak with gold floral motifs. The figure holds up both hands and grasps what may be staffs or stalks of grain. Most likely it is a personification of an "endowing goddess" or, more specifically, Gaia, goddess of the earth.[2]

The inscription, above the roundel rather than within it, may not refer to the figure inside. The word is the vocative of γεωργός (*georgos*), a man who works the earth. The panel could have decorated the sleeve or front of a tunic, in which case the inscription may refer to the owner of the garment. Possibly he was called Γεώργιος (Georgios), and the choice of decoration for his tunic, with the personification of the earth, may have been intended to play off his name and his occupation. Although the tunic was possibly made for a man, the fragment depicts a female personification popular on objects used by both men and women. MFH

1. One example depicts Christ in the center flanked by scenes from his life, such as the Adoration of the Magi and the Annunciation (Kendrick 1920, vol. 3, 37, cat. 712). In another example, an alpha and an omega are embroidered on either side of Christ's head (du Bourguet 1964, 309, cat. F169.)

2. For similar representations, see Rutschowscaya 1990, 37 and 66, and *Rich Life* 1999, 164, cat. C23.

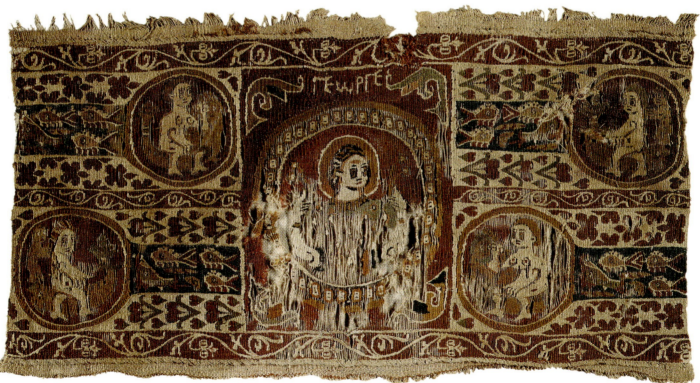

162

163

## 163 Textile Fragment Depicting a Rabbit

Egypt, Byzantine, 5th–6th century
Wool and linen
L. 18.5 cm, w. 17 cm
Arthur M. Sackler Museum, Harvard
University, Gift of Denman W. Ross, 1917.114

COLLECTION HISTORY Denman W. Ross
collection.

UNPUBLISHED

A snarling, running rabbit fills an octagon at the center of the square panel of tapestry weave within this textile fragment. Framing the rabbit on all sides are wide decorative borders containing geometric and vegetal motifs. The square of tapestry weave is surrounded by a larger piece of plain-weave linen, and the vertical slits on either side indicate that the decoration was not attached to the linen, but woven directly into the larger fabric, using the same warp. The dark purple-brown wool is common for this type of decorative weaving and contrasts with the natural-colored linen. The stains on the fabric suggest that it may have come from a burial.[1]

The playful rabbit motif would have been an appropriate decoration on a tunic, where woolen tapestry panels often adorned the hem and shoulders.[2] The panel may also have been part of a shawl, or possibly a cushion.[3] Square linen-and-wool cushion covers with a weft-looped weave border often display animal motifs.[4] The rabbit motif may have been particularly popular for home decoration as well as clothing because it carried connotations of fertility and general prosperity.[5]  MFH

1. Rassart-Debergh 1997, 68–71.

2. Ibid., 103, fig. 129. An example of such decoration is found on a child's tunic from Egypt (Kendrick 1920, vol. 1, 42, cat. 4).

3. Rutschowscaya 1990, 151.

4. For other examples, see ibid., 9, 145.

5. *Beyond the Pharaohs* 1989, 270, cat. 184.

# HEALTH

MOLLY FULGHUM
HEINTZ

## Magic, Medicine, and Prayer

Health problems considered minor today often turned into lifelong ailments in the Byzantine period, when effective drugs were lacking and surgery was risky.[1] Life was physically difficult, and women had the additional strain of pregnancy and childbearing. As the early Byzantine author Athanasios wrote:

> Most women have a hateful time in the world. They give birth in pain and danger, they suffer in breast-feeding, when their children are ill, they are ill too. They endure this without any end to their hard work. Either the children they conceive are maimed in body, or they are brought up in wickedness and plot to kill their parents. We know this: let us not be deceived by the Enemy into thinking that way of life is easy and trouble-free. When they give birth they are damaged by labor, and if they do not, they are worn down by reproaches of barrenness.[2]

In many medical texts from the period, specifically female concerns are glossed over or omitted, possibly because male doctors often did not examine women themselves.[3] Along with artifacts and images, however, a limited number of primary sources shed some light on health concerns of Byzantine women.

Under Roman law, a young girl was eligible for marriage when she reached the age of twelve.[4] This age coincides with the onset of menstruation for most girls, although the actual age of marriage was probably later. A guarantee of the bride-to-be's virginity was a prerequisite for a valid marriage, and midwives were often requested to perform tests for virginity.[5] However, the second-century physician Soranos noted that the hymen could also be broken by menstruation, if this preceded intercourse.[6]

It is not clear how women dealt with their monthly cycle, but failure to have a period was considered a serious problem, because it was assumed that the blood was retained in the body.[7] Many prescriptions for emmenagogues, or treatments that promote menstruation, survive; they usually consist of herbs to be taken orally or used as a suppository.[8] Like new mothers, menstruating women were considered unclean and were usually prohibited from taking part in the Eucharist. This rule was debated, with reference to the story of the Woman with the Issue of Blood who touched Jesus' robe—came into contact with something holy—and was healed (see cat. 165).[9] Having intercourse during menstruation, which is compared with adultery in Leviticus 18:19, was strictly prohibited by the Church, in part because it was believed to produce deformed children.[10]

The relationship between menstruation, conception, and the uterus was not fully understood during the Byzantine period. The womb was considered an enigmatic organ and was historically assigned almost magical powers. In *Timaeus*, Plato described it as a live creature that could roam all over the body.[11] Although that theory was undermined by groundbreaking medical dissections in the Hellenistic period, it was popularized again by Aretaeus of Cappadocia in the second century A.D.[12] The womb was thought capable of

causing migraines as well as erratic behavior; "hysteria" comes from the Greek word for womb, *hystera* (ὑστέρα).

Prescriptions for a "wandering womb" usually included amulets. Several surviving amulets depict the womb as an octopus-like creature with a female face and multiple arms (see cats. 166, 172, 173).[13] On the reverse of an elaborate hystera amulet made of enamel is the inscription: "[O] womb, dark [and] black, like a serpent you writhe, like a dragon you hiss."[14] Most extant amulets are made of less expensive materials, such as bronze. On the reverse of many of them is the Holy Rider motif—a saint on horseback spearing a demon who threatened pregnancy—emphasizing the connection between the womb and the risks of childbirth (see cats. 167–71). This series of amulets, dating mainly from the middle Byzantine period, differs markedly from an earlier series of womb amulets, from the later Roman and early Byzantine period. In addition to metal, amulets were often made of hematite (see cats. 165, 180), commonly known as "bloodstone" for its red coloration and thought to aid in stopping hemorrhages. These amulets depict the womb not as a snake-haired monster, but as an inverted jar. Often, a key is shown with the jar (cat. 166), as if to indicate that the jar is being locked. Such amulets were probably meant to help control heavy menstrual flow or other bleeding.[15]

Aside from medical treatment and amulets, prayer was a course of action when any type of illness or injury occurred. In a tradition passed down from ancient Greece, prayers were recited for healing specific parts of the body.[16] Supplicants who were cured would often make a donation to the appropriate church or shrine out of gratitude to God or the saint to whom they had prayed. This is exemplified in an epigram written by Manuel Philes (1275–1345), a court poet under the emperors Andronikos II and III, on behalf of the *archontissa* Irene, who was thanking the Virgin (probably the Virgin of the Zoodochos Pege, or "Life-Giving Spring") for relief of a severe headache: "Thy world-saving dew relieves/ O maiden, the pain in my head/ Which resisted the drugs of physicians. . . ."[17]

For most women, the greatest physiological event was childbirth. Byzantine women usually delivered at home, attended by a midwife, as shown in an eleventh-century miniature from a Vatican Octateuch depicting Rebecca giving birth to Esau and Jacob (fig. 23). A child's head emerges from between Rebecca's parted legs, while the newborn Esau lies on the floor before her. Like Rebecca, women are often depicted giving birth in a seated position suitable for bearing down. The periods of pregnancy and delivery were thought to be vulnerable times for both mother and child, and measures were taken to protect them. During this time, women appealed to the Virgin Mary (cats. 177–82) and saints such as Marina (cats. 184, 185) for help or wore specific amulets that were meant to turn away evil spirits.[18]

In Byzantium, procreation was the main purpose of marriage. The Church disapproved of the use of contraceptives; if a man had sex with his wife without intending to conceive a child, he was thought to be treating her like a prostitute.[19] However, the evidence that abortion occurred in Byzantium suggests that sexual intercourse took place for pleasure rather than solely for the purpose of procreation. Occasionally, sexual intercourse was prescribed by doctors; Metrodora, the author of a late Roman text on gynecology,

Fig. 23. Rebecca giving birth to Jacob and Esau, 11th century. Octateuch. Biblioteca Apostolica Vaticana, cod. Vat. gr. 747, fol. 46v.

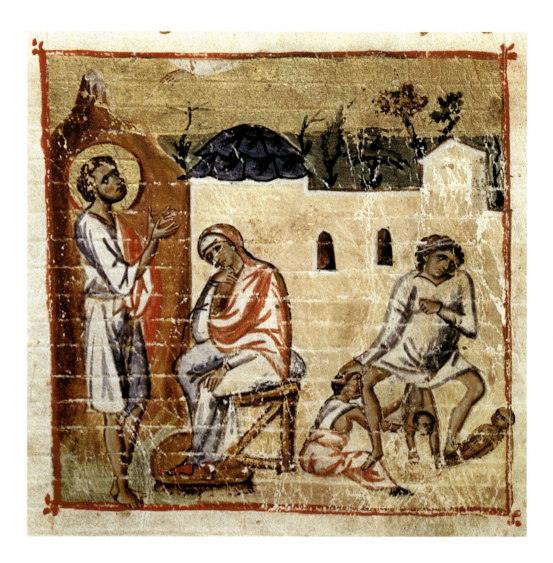

explained much female illness as the result of "natural desire" that "has remained unemployed."[20] In the eyes of the Church, the only acceptable intercourse occurred between married couples, and this was curtailed during menstruation, pregnancy, and Church fasts and festivals.[21]

The extant evidence—tools and recipes for abortifacients—indicates abortion was not uncommon, although the Church withheld its sanction. Prescriptions thought to induce a miscarriage have survived in several medical texts, including the work of Soranos.[22] From vigorous jumping to vaginal suppositories, noninvasive methods were preferred, since surgery always posed serious risks. In Paul of Aegina's *Epitome of Medicine,* the mid-seventh-century physician recommends herbal abortifacients such as myrrh, golden drop, and fern. A century earlier, Aetios of Amida described physical conditions, such as a small uterus, a narrow cervix, or a tumor obstructing the birth canal, that could lead to a dangerous pregnancy and childbirth. He indicated that women with these problems might want to avoid becoming pregnant. Aetios' list of contraceptives ranges from herbal concoctions to charms, such as "the vulva of a lion carried in an ivory container," one of his favorite prescriptions. For cases in which a pregnancy does occur and nonsurgical

methods fail to end it, Aetios describes the procedure for the physical dismemberment and removal of the fetus from the uterus. Examples of tools used for this procedure, plierlike cranioclasts and embryo hooks, were excavated at Ephesus and probably date from the fifth to seventh century.[23]

Although unwanted or unsafe pregnancies were a concern, infertility was thought to be a much greater problem. A marriage that did not produce children was considered unsound. When a woman had difficulty becoming pregnant, she often appealed to higher powers or sought the help of folk remedies (see cat. 174). The fifty-year-old empress Zoe and her new husband Romanos (r. 1028–34; see cat. 59) were unsuccessful in their attempts to produce an heir. Chronicler Michael Psellos describes the emperor Romanos' determination to exhaust all possible methods that might aid in conception:

> Even in the face of natural incapacity, he clung ever more firmly to his ambitions, led on by his own faith in the future. Hence he ignored the physical prerequisites for conception. Nevertheless, he did have recourse to the specialists who deal with sexual disorders and claim the ability to induce or cure sterility. He submitted himself to treatment with ointments and massage, and enjoined his wife to do likewise. In fact, she went further: she was introduced to most of the magical practices, fastening little pebbles to her body, hanging charms about her, wearing chains, decking herself out with the rest of the nonsense. . . .[24]

Zoe never became pregnant, probably because she had reached menopause; however, Psellos' description reveals that such extreme methods of encouraging conception were not unusual in the eleventh century.

Once a woman was pregnant, protecting mother and fetus became a central concern. Physiological problems or diseases that could interfere with a healthy pregnancy and birth were often thought to be the work of evil spirits—particularly the female demon, Gylou.

Gylou was thought to have wild, disheveled hair and the lower body of a serpent. She was based on the prototype of Lilith, the barren first wife of Adam in the Jewish tradition, and on baby-snatching nymphs from ancient Greek lore.[25] Gylou was thought to appear to pregnant women and cause miscarriages or kill newborns. A passage from the middle Byzantine text *De Daemonibus* gives a graphic description of one such encounter, as told by a man whose wife was in labor:

> Once then, when she was in childbirth, she had a very bad [attack] and became quite hysterical; having ripped off her dress, she screamed out, speaking fluently in some foreign language . . . when she had returned to her wits, I asked if she knew what had happened; she said she had seen an apparition of a demon, shadowy with windswept hair, attacking [her]. . . .[26]

The physical evidence for the belief in Gylou is a series of amulets and incantations designed to keep her in check. From the early Byzantine period, bronze or lead amulets (see cats. 169, 171) depict a half-woman, half-serpent figure with disheveled hair being speared by a rider saint, the so-called Holy Rider.[27] A sixth-to-seventh-century fresco from a chapel in Bawit, Upper Egypt, demonstrates that this popular apotropaic image also found monumental expression in a monastic context (fig. 24). The saint is sometimes identified by an inscription as Sisinnios (suggested by the Greek letters OC above the

Fig. 24. Saint Sisinnios (the Holy Rider) killing the demon Alabasdria (Gylou). Watercolor by Jean Clédat of a 6th-to-7th-century fresco. Bawit Monastery, Egypt.

Paroi Ouest. Saint Sisinnios.

Bawit rider), a Parthian soldier whose iconography is similar to that of Saint George, the rider saint who became more popular in the West. An extensive textual tradition treats Sisinnios' victory over Gylou.[28] During the same period, the sixth to seventh century, related artifacts known as incantation bowls were buried upside down under thresholds in places farther east, such as Nippur.[29] The goal of these bowls was to prevent demons from entering the house. The bowls often had a roughly sketched image of a demon at the bottom, surrounded by lines of Aramaic text that covered the interior. One text reads:

> This bowl is intended to seal the house of Gervanai, so that the evil Lilith may flee from him, in the name of "El, who has scattered" the Liliths, the male Lilin and the female Liliths, the shelanitha and the chatiphata, the three, the four and the five. Naked shall you be driven away, unclothed, with your hair loose and streaming behind your back.[30]

Besides taking these defensive measures, women appealed to the Virgin and saints for help during childbirth. The early-tenth-century *vita* of Saint Theophano (see cat. 172) reveals what might happen under severe circumstances. The saint's mother, Anna, was having a very difficult labor with Theophano and was on the verge of death. Her husband ran to a church, cited in the text as the *Theotokos tou Bassou*, and took a belt that was hanging from a column. He tied it around Anna's loins, and she gave birth without further complications.[31] This belt (ζώνη), or girdle, had probably been left in the church to be blessed by the Theotokos, the Mother of God, who was thought to help women in childbirth. While it is unclear exactly to which church the text refers, the miracle-working belt of the Virgin herself was housed as a relic in the Chalkoprateia church in Constantinople.[32]

Even if the baby and the mother survived a birth, infant mortality was a serious problem in Byzantium, as everywhere throughout the Middle Ages, possibly reaching a rate of fifty percent.[33] The demon Gylou was blamed for killing babies because, it was assumed, she could not have any children of her own and was therefore envious. The idea that envy could inflict harm is connected to the concept of the Evil Eye, also known as the Evil Eye of Envy (φθόνος). On the reverse of some of the Holy Rider amulets is a depiction of various animals attacking an eye (cats. 167, 170). Images of a malignant force being conquered were thought to ward off that brand of evil. Parents may have put the Holy Rider/Evil Eye amulet on a newborn or hung it near the baby's cradle.[34] The placenta or afterbirth was also endowed with amuletic properties; some people believed that the new baby's fortune could be read by studying it.[35]

Following the birth, the mother was considered impure. Only after forty days could she could go to church to receive Communion and a blessing, which restored her purity. Exceptions were made when a new mother was on her deathbed. The midwife who helped her deliver was impure by association and could not take Communion for seven days. These seven days following the birth were known as the *locheia* (λοχεία), or lying-in, and the mother was called the *lech*, the one who has just given birth.[36] During this week, the mother rested at home and was attended by relatives or servants. At the end of the week, there was a large banquet, and friends brought food and money and said special prayers for the mother and child.[37] The *locheia* is often evoked in depictions of holy nativities in Byzantine art, in which Mary; her mother, Anna; or Elizabeth, mother of John the Baptist, lies on a bed and is attended by servants (cats. 70, 186).

While most women probably received medical attention at home, evidence suggests that women were also treated in hospitals. Hospital records from early Byzantine Alexandria show beds designated for new mothers.[38] In twelfth-century Constantinople, the Pantokrator monastery hospital included a twelve-bed female ward and employed female physicians *(iatraina)* to attend them.[39] Frequent bathing was a common prescription there.[40] Bathing as a social activity had declined, because the Church found public bathhouses immoral and because the buildings were expensive to maintain. The spread of water-borne germs often made public baths a breeding ground for infectious disease. Luxuriously decorated bath complexes popular in the late Roman period fell into disuse in the early Byzantine period, with bathing becoming more of a controlled medical treatment than a pastime.[41]

Women's medicine did not make great advances in the Byzantine period, in part because of the overwhelming pressure of modesty. Male physicians who had the training to deal with gynecological issues in an innovative manner often left the examination of women to midwives or even to the patients themselves. Uncertainty and lack of information led women to turn to prayer and amulets for reassurance during major physiological events such as pregnancy and childbirth as well as chronic illness. More than any other area of inquiry, considering how Byzantine women tended their bodies allows us to see them as real people, with aches and pains, fears and hopes.

1. For example, chronic eye infections were very common in both men and women; see Clark 1993, 91.

2. Ibid., 91, citing Athanasios, *Life of Syncletia*.

3. King 1994, 109.

4. Rawson 1991, 27; Clark 1993, 80.

5. Clark 1993, 74–75.

6. Ibid., 74.

7. For sanitary napkins, women probably used cloths that were washed in the sea and reused; see Clark 1993, 77–78.

8. McClanan 2002, 46.

9. Brown 1987, 303. The idea that menstrual blood is unclean is discussed by Pliny (*Natural History* 28.78), who notes that contact with menstrual blood was corrosive to both plants and animals; see Aubert 1989, 431.

10. Clark 1993, 79.

11. *Timaeus* 91c; see Aubert 1989, 421.

12. Aubert 1989, 423.

13. Spier 1993, 43.

14. *Glory of Byzantium* 1997, 166, cat. 114.

15. Barb 1953, 25, pl. 1a; for additional amulets, see Bonner 1950.

16. The ancient tradition of leaving ex-votos in the shape of a leg, a breast, etc., at a shrine to Asklepios, the Greek god of healing, evolved during Byzantine times and persists in Greece today, where those who have been cured of an illness attach a small plaque with an image of a diseased body part to the frame of an icon.

17. Talbot 1994, 155–56.

18. A first-century A.D. necklace includes an amulet of the pagan deity Bes; in Roman times, Bes was considered a protector of women in childbirth (*I, Claudia* 1996, 178, cat. 138).

19. Clark 1993, 83.

20. Patlagean 1987, 619.

21. Brown 1987, 304.

22. McClanan 2002, 46.

23. Ibid., 35, 41, 46–47.

24. Psellus 1966, 65 (3.5).

25. Greenfield 1988, 182–90.

26. Ibid., 183–84.

27. Maguire 1995; Vikan 1984, 65–86.

28. See Greenfield 1988, 83–141, for different versions of the Gylou story in primary texts.

29. Hurwitz 1992, 90.

30. Ibid., 96; see also *I, Claudia* 1996, 154, cat. 96.

31. Kurtz 1898, 343–61.

32. Janin 1975, 237–42.

33. Angeliki Laiou, discussing peasantry in the fourteenth century, notes that there seems to be evidence for a "survival rate of fifty percent in the first five years of life, where a woman had to bear six daughters to ensure that one of them would survive to the age of thirty." Judging by the primary sources, the rate of infant mortality was probably the same in the middle Byzantine period (Laiou 1981, 236).

34. Russell 1982b, 540–42.

35. Koukoules 1948–57, vol. 2, part 2, 32.

36. Ibid., vol. 4, 33–34.

37. This custom may be derived from Roman rituals, which entailed fumigating the house and then feasting; see Rawson 1991, 13–14.

38. The *vita* of Saint John of Eleemon attests to a lying-in hospital for women in early Byzantine Alexandria, where a mother was allowed to rest for seven days before she went home; see Koukoules 1948–57, vol. 2, part 2, 23.

39. Miller 1985, 15, 201, 214.

40. Ibid., 145.

41. Kazhdan and Epstein 1985, 79–80; Mango 1981, 338–41; Clark 1993, 93.

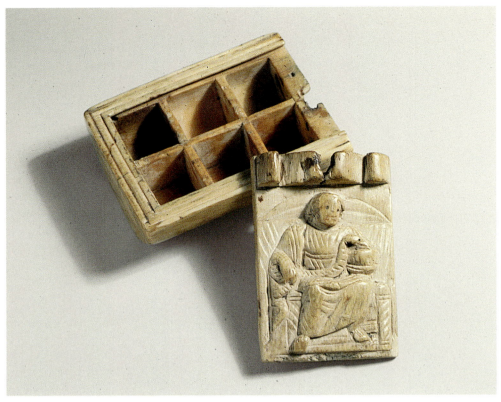

164

## 164 Medicine Box with Hygieia

Egypt, Byzantine, 6th century
Ivory
Box: h. 7.5 cm, w. 5.9 cm, d. 3.3 cm; lid:
h. 6.6 cm, w. 4.5 cm, d. (at top) 1 cm
Dumbarton Oaks Collection, Washington,
D.C., 48.15

COLLECTION HISTORY Brought to
Dumbarton Oaks May 1948; purchased from
Charles Ratton, Paris, September 1948.

PUBLISHED DO Handbook 1955, cat. 226;
Beckwith 1963, 12, and 49, fig. 24; DO
Handbook 1967, cat. 276; Weitzmann 1972, vol.
3, cat. 10, pl. 10; Cutler 1985, fig. 26; Connor
1998, appendix A, no. 56.

This container and its lid were carved from an ivory tusk; the curved base conforms to the natural shape.[1] On the lid is a carved female figure, seated frontally on a high-back throne.[2] She is Hygieia, also known as Salus, the daughter and partner of Asklepios, the god of healing.[3] A long snake slithers across her lap toward a basket she cradles in her left arm; both the animal and the vessel are common attributes of this goddess. Six compartments have been cut into the ivory block for storage of medicines, possibly in powder form.[4] A carrying handle was attached through metal hoops at the top and bottom ends of the box.[5] The owner probably carried the box around or hung it on a wall by means of a strap attached through the hoops.[6]

In the Greco-Roman world, men and women invoked and worshiped the daughter-and-father team, Hygieia and Asklepios, as givers and restorers of health.[7] The pair were patron deities of the medical profession.[8] During the early Byzantine period, with Christianity well established, images of Hygieia and Asklepios were seen less frequently, and their sanctuaries fell into disuse.[9] Of the two deities, Hygieia survived into Byzantine times, probably because her name is also the common Greek word for health. This explains her appearance on objects such as this box as late as the sixth century. More often, however, only the word ὑγίεια (health) and not the image of the goddess is found on early Byzantine objects. The inscription functions as a wish or a good omen for health. For example, a doctor could stamp ὑγίεια on medicine tablets to imbue them with additional healing force.[10] The word was often inscribed as a blessing on objects worn by women (cats. 126, 127).[11] A female deity must have been judged an appropriate god to invoke for women's medical needs.[12]   DA/IK

1. The lid, carved from a separate piece of ivory, slides into parallel channels. The lid has a slightly thicker profile at the top, which serves as a handle for opening and closing. A lock, now lost, secured the lid.

2. Kurt Weitzmann has dated this box to the sixth century based on the abbreviated style and heavy proportions of the figure, which he compares to a sixth-century pyxis in Berlin (Weitzmann 1972, 22).

3. Sobel 1990, 41.

4. Compare Künzl 1983, Abb. 43, no. 4, a similar box from the third century.

5. Now only the holes and the discoloration from the metal pins and plates are visible.

6. Weitzmann 1972, 22, cat. 10.

7. For instance, in a prayer on behalf of a sick friend: "I sadly fear that the disease has become more serious; to you, Asclepius, and you Salus, I pray that there may be none of this" (Edelstein and Edelstein 1975, vol. 1, T. 578). Asklepios is referred to as the savior who ensures that "we may see the sunlight in joy, acceptable with bright Hygieia, the glorious" (ibid., vol. 1, T. 592).

8. Only through Hygieia could Asklepios become a preserver as well as a giver of health (ibid., vol. 2, 89–90).

9. One of the latest representations of Asklepios and Hygieia together is a well-known fifth-century ivory diptych in Liverpool (*Age of Spirituality* 1979, 155–58, cat. 133).

10. Dölger 1929, vol. 1, 47; Vikan 1984, 69, fig. 4.

11. For example, rings and bracelets specifically used for the treatment of gynecological ailments include the inscription *hygieia* (Vikan 1984, 75, esp. fig. 10).

12. The second-century writer Pausanias noted the intimate association between Hygieia and women's health (Pausanias 1979, 157 and n. 65 [vol. 1, 2.6]). He observed that the statue of Hygieia at the sanctuary of Asklepios in Titane was so completely covered with locks of women's hair that it was hardly visible (Vikan 1984, 69).

## 165 Amulet Portraying the Woman with the Issue of Blood

Egypt (?), Byzantine, 10th–12th century
Hematite and gilded silver
H. 5.0 cm, w. 3.5 cm
Obv: ten lines, + KЄ H ΓVNI/ OVCA PVCH Є/MATOC ЄTI KЄ ПОΛΑ/ [ПVΘ]OVCA H KЄ ЄΔ A/ПANICA MIΔЄ/N OΦЄΛЄΘO [ЄI]CA AΛΑ MAΛ[ΛON]/ HΔЄ/A/MOVCA (After much suffering and expense the woman's bleeding not only continued but flowed rather more intensely); to left and right of standing figure, ĪC XC (Jesus Christ)
Rev: seven lines, + [Є]ΞHPAN/ΘH/ H ПHГH TO[V] VMATHCMOV AVTHC ЄNTO/ [O] NOMATI T/HC ПICTЄOC AV/TIC (The source of her bleeding dried up on account of her faith)
The Metropolitan Museum of Art, Gift of J. Pierpont Morgan, 1917, 17.190.491 (previously 17.190.46)

COLLECTION HISTORY John Pierpont Morgan, New York; Metropolitan Museum of Art, 1917.

PUBLISHED *Morgan Wing* 1925, 42; *Age of Spirituality* 1979, cat. 398; *Spätantike und Frühes Christentum* 1983, cat. 165; Spier 1993, pl. 6b.

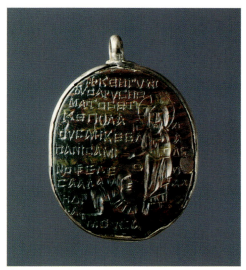

165a

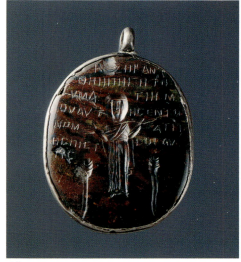

165b

This pendant consists of an oval hematite intaglio mounted in a silver frame.[1] On the obverse, a woman prostrates herself before the cross-nimbed Christ, who holds a book in his left hand and extends his right hand over her head in blessing. On the reverse an orant woman is flanked by stylized trees; her head is covered and her body is wrapped in a heavy robe. On each side of the amulet, an inscription, now corrupt, identifies the scene as depicting the healing of the Haemorrhoissa, or the Woman with the Issue of Blood. The inscription on the obverse comes from the gospels in which the story is told, Mark (5:25–35) and Luke (8:43–48).[2] According to the story, a woman who has had an uncontrollable flow of blood for twelve years surreptitiously approaches Christ in a crowd to

touch his robe. When Christ asks who has touched him, the woman falls to her knees before him, and he declares that her faith has healed her. This climactic scene is depicted on the obverse of the pendant.

The inscription on the reverse notes that the miracle took place because of the woman's strong belief in Christ. The female figure on this side is not named. A very similar figure on the reverse of a hematite womb amulet now in Poland is clearly labeled as the Virgin Mary,[3] suggesting that this amulet also may represent the Virgin as an intercessory saint sympathetic to women with menstrual difficulties.[4] The trees on either side of the orant figure may be palms associated with reproductive fertility: the date palm flourishes even in the desert climates of the Middle East and is remarkable for its fruitfulness.

From late antiquity onward, hematite, also known as bloodstone, was believed to staunch the flow of blood, and it was the choice medium for amulets related to female reproductive health and chronic menstrual dysfunction.[5] The inscriptions and imagery on this stone, like those on a related group of hematite intaglios, are intended to aid or protect female reproductive health. The figure of the Virgin would have provided overall protection of a woman's well-being.  ARG

1. Previously dated to the sixth to seventh century (*Age of Spirituality* 1979, cat. 398; *Spätantike und Frühes Christentum* 1983, cat. 166), this amulet has more recently been placed in the tenth to twelfth century based on analysis of its medium, setting, and iconography (Spier 1993, 44, n. 111).

2. The story has roots in the Old Testament (Leviticus 15:19, 25; 20:18).

3. The stone is in the Muzeum Narodowe Ziemi Przemyskiej (MP-H-1865). See Kunysz 1984, first photograph, unnumbered, with caption "Gemma Bizantyjska," and Spier 1993, pl. 5, no. 57.

4. Alternatively, the orant figure might be interpreted as the healed Haemorrhoissa herself, but no comparable representations of the Woman with the Issue of Blood in an orant position are known.

5. Vikan 1990, 156.

## 166 Chnoubis Ring with Octagonal Band

Asia Minor, Byzantine, 7th–8th century
Silver
Diam. of bezel 2 cm; diam. of band 2 cm
Inscription, on band: O KATOIKWN EN BOHΘIA (he who dwells in the help [of the highest])
The Menil Collection, Houston, X490.740

COLLECTION HISTORY John and Dominique de Menil collection, Houston.

PUBLISHED Vikan and Nesbitt 1980, cat. 43; Vikan 1984, no. 13; *Silver from Early Byzantium* 1986, cat. 92; *Survival of the Gods* 1987, cat. 52; Spier 1993, pl. 4, no. 47.

166

This ring consists of a thin, round bezel soldered to an octagonal band. A schematic oval face is incised in the center of the bezel. Six rays terminating in serpent heads emanate from the face, and a seventh, detached serpent with a looped tail is depicted below it. Several magical symbols are incised at the top edge of the bezel: from left to right, an N- or Z-shaped character, a pentagram, and an asterisk with eight rays that terminate in dots. A second asterisk of the same design is engraved at bottom right, and a hatched rectangle

appears below the face. The octagonal band is inscribed with an excerpt from Psalm 90:1: "He who dwells in the help [of the highest]."[1]

Cat. 166 is one of a corpus of silver armbands and rings, primarily from Greece and Anatolia, that bear imagery and inscriptions charged with supernatural power to protect women's reproductive health.[2] The inscription is frequently used as an apotropaic formula on jewelry, domestic doorways, and tombs.[3] Although the precise meaning of the individual magic symbols, or "ring signs," surrounding the central face is unknown, they too, had an apotropaic function.[4] Silver was associated with women, and appears to have been used predominantly for amulets.[5] The octagonal shape of a band was also believed to enhance the magical powers of a ring (see cat. 130).[6]

The gorgonic creature portrayed on the bezel is probably Chnoubis, a healing spirit of Greco-Egyptian origin commonly used in antiquity to counter ailments of the stomach.[7] By the Byzantine period, Chnoubis imagery became linked specifically to the protection of the womb. On comparative pieces, gorgonic emblems are frequently accompanied by a shortened and corrupt rendering of the Greek formula: "Womb, black, blackening, as a snake you coil and as a serpent you hiss and as a lion you roar, and as a lamb, lie down!"[8] According to an alternative interpretation, the gorgonic image is a rendering of the womb itself (see cats. 172, 173).[9]

The hatched bar below the face may be a schematic key, a symbol often found on amulets bearing uterine imagery. On a group of incised hematite gems from the British Museum a schematic key is depicted below the opening of a bell-shaped womb.[10] The key signifies the sealed state of the uterus during pregnancy and its controlled opening during childbirth. The depiction of a key in association with the Chnoubis and magical signs would have provided the wearer of this ring with security against miscarriage.[11]  ARG

1. *Silver from Early Byzantium* 1986, 265.

2. Previously dated to the sixth to eighth century (Vikan 1984, 78; Vikan 1992a; *Silver from Early Byzantium* 1986, 265), this amulet has recently been redated to the tenth century or later on the basis of epigraphical evidence and comparative material from archaeological contexts (Spier 1993, 31–33).

3. Vikan 1992a, 35.

4. Spier 1993, 40.

5. Vikan 1992a, 39; *ODB* 1991, 1898–99.

6. Vikan 1984, 76–77.

7. Ibid., 75.

8. Spier 1993, 29.

9. Ibid., 43.

10. See British Museum gems 56540, 56238, 56320, 56371 (Barb 1953, 25, pl. 1a).

11. Vikan 1984, 77.

## 167 Amulet with Holy Rider and Evil Eye

Vicinity of Nazareth, Palestine (?), Byzantine, 6th–7th century
Bronze
H. 6.1 cm, w. 3.0 cm
Obv: ЄΙC ΘЄΟC Ο ΝΙΚШΝ ΤΑ ΚΑ[ΚΑ] (one God who overcomes evil)
Rev: ΙΑШΘ CΑΒΑШΘ (Iaoth Sabaoth=Lord of Hosts)
The Art Museum, Princeton University, Museum Purchase, y1931–34

COLLECTION HISTORY Campbell Bonner, United States; Princeton University purchase.

PUBLISHED *Early Christian and Byzantine Art* 1947, cat. 326; Bonner 1950, no. 294; *Art of Seals* 1984, cat. 19; *Byzantium at Princeton* 1986, cat. 64; *Survival of the Gods* 1987, cat. 51; *Beyond the Pharaohs* 1989, cat. 104.

## 168 Amulet with Holy Rider

Byzantine, 6th–7th century
Lead
H. 4.0 cm, w. 2.7 cm
Rev: six lines, + Ο Κ/ ΑΤVΚ/ ΟΝ ЄΝ Β/ ΟΗΘΙΑ/ ΤΟV V/ ΨΙC/ Τ[ΟV] (he that dwells in the help of the highest)
University of Toronto, Malcove Collection, M82.241

COLLECTION HISTORY Lillian Malcove collection, New York.

PUBLISHED Campbell 1985, cat. 198.

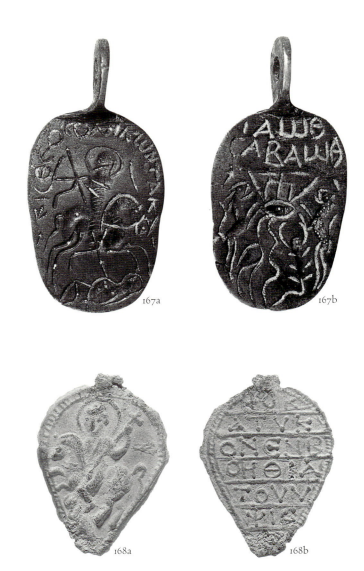

167a    167b

168a    168b

Cat. 167 consists of a crudely incised oval pendant with a suspension ring at its top. On the obverse a nimbed individual on horseback impales an anthropomorphic figure lying beneath the horse's hooves. An inscription in Greek curves along the edge of the top half of the pendant. On the reverse, a trident, a lion, an ibis, a snake, a scorpion, a leopard, and spears attack a central eye. The top third of this side is inscribed in two parallel rows of letters with the name "Iaoth Sabaoth" (Lord of Hosts; see also cat. 175).[1] The second amulet, cat. 168, takes the shape of an inverted teardrop.[2] On the obverse, a similarly nimbate male gallops on horseback toward the left. With a cross-topped staff or lance, he aims at an illegible entity rising up from beneath the horse's hooves. The reverse bears a Greek inscription of evenly spaced letters divided into seven registers that is an excerpt from Psalm 90: "He that dwells in the help of the highest." A hatched pattern rims both obverse and reverse.

These pendants belong to a large corpus of amulets portraying the Holy Rider, a mounted warrior who signifies the triumph of good over evil (see fig. 24 and cats. 169–71). Objects bearing this emblem commonly had a medical application. There are many

variations on the identity of the rider and his adversary that can be traced back to Roman times.[3] Although the rider on each of these amulets is anonymous, earlier examples of this iconography are often accompanied by an inscription identifying the rider as Solomon or Sisinnios.[4] Both of these pre-Christian heroes are reputed to have overpowered a female demon, Abyzou or Gylou, who was a lethal threat to unborn and newborn babies (see cat. 166).

The reverse of cat. 167 depicts the Evil Eye, the manifestation of envy, under attack. When set upon by vicious animals and weapons, the Evil Eye was disempowered, and an individual's security was assured. Fearing the provocation of the demon Abyzou/Gylou by the envious glance of others, pregnant women and new mothers would have been especially careful to protect themselves against the Evil Eye. The Holy Rider motif, when paired with other iconography, as it is here, served to prevent miscarriage and protect the health of mother and child during birth and shortly thereafter.

The apotropaic inscription on the reverse of cat. 168 occurs frequently on medico-magical amulets, and its biblical reference suggests that protection was called forth from all domains during a crucial passage such as that of pregnancy and birth. The Christian-ization of the Holy Rider by the cross shape of the warrior's lance in cat. 168 and by the inclusion of a nimbus around the head of the rider on both amulets further demonstrates the merging of Christian and pre-Christian forces.

Cast in lead and bronze, these pendants are two of the many amulets that would have satisfied the needs of people of modest means. A mold in the Benaki Museum, Athens, for a pendant with a shape similar to that of cat. 168 indicates that such amulets would have been mass produced.[5] At the Byzantine site of Anemourion, in southwestern Anatolia, a copper Holy Rider amulet and three other small protective devices made of inexpensive material (copper, terracotta, and shale) were discovered in small houses associ-ated with an artisans' quarter that has been dated to the mid-seventh century.[6] Found in a context with a variety of domestic objects, the Anemourion charms appear to have been common household articles.   ARG

1. *Byzantium at Princeton* 1986, 81, cat. 64.

2. Cat. 168 has previously been dated to the eleventh to twelfth century, but based on comparable amulets bearing Holy Rider imagery, a sixth-to-seventh-century date is more plausible (Spier 1993, 60–61). For comparison, see cat. 170 in this volume and an object excavated at Anemourion, Turkey (Russell 1982b, fig. 4).

3. Spier 1993, 33–39.

4. For example, a gem in the Kelsey Museum, University of Michigan, Ann Arbor showing the Holy Rider displays an identifying inscription (*Survival of the Gods* 1987, cat. 168).

5. Campbell 1985, 137, cat. 198.

6. Russell 1982b, 540, 543.

## 169 Amulet with Holy Rider and Virgin Enthroned

Eastern Mediterranean, Byzantine,
5th–6th century
Bronze
Diam. 3.5 cm
Obv: clockwise, in field, + KΙVPΙΙЄ ΒΟΗΘΙ C
(Lord, help); clockwise at edge,
+ ΑΝΙVΙϹΤΑΡΑΓ. . .ΙΙVΤΓ. . .ΙΧΡΙΓΙ
Rev: clockwise, in field, ΜЄΛΙϹΙΑϹ (Melisias);
clockwise at edge: + ϹΙϹΙΝΙΟΓ. . .Ι
ϹΙϹΙΝΝΟΓ. . .Ι (Sisinnio[s] Sisinnio[s])
Arthur M. Sackler Museum, Harvard
University, Bequest of Thomas Whittemore,
1951.31.4.1868

COLLECTION HISTORY Thomas Whittemore
collection.

UNPUBLISHED

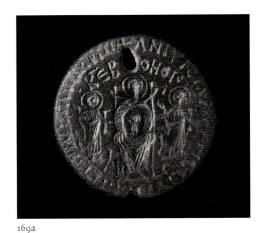

169a

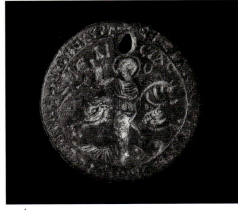

169b

This pendant sets in opposition two powerful female archetypes, one evil and defeated, the other holy and exalted. On one side the demon Gylou or Abyzou, thought to destroy human children because of her inability to have children of her own, is slain by the Holy Rider (see fig. 24); on the other side is the Virgin Mary. The she-devil lies vanquished under the horse and spear of Sisinnios, the rider saint named in the encircling inscription, whereas Mary sits enthroned, holding her divine child on her lap, and is flanked by two draped figures raising their hands toward her in a gesture of adoration.[1] The amulet imparts both specific protection from evil through the depicted defeat of the demon of child-envy, and general protection against misfortune by means of the all-powerful image of the Virgin Mary. This kind of amulet was worn either by a woman who was pregnant and wanted protection or by one who desired to conceive.

The present example is part of a group of amulets produced during the fifth to sixth century, probably in the eastern Mediterranean provinces of the Byzantine Empire (see cats. 167–68, 170–71).[2] Characteristically, it combines pagan elements inherited from the late antique magical tradition, apotropaic motifs belonging to Christian folklore (Holy Rider/Saint Sisinnios), and Christological iconography related to early Byzantine pilgrimage art.[3]   IK

1. On the legend of Gylou and Saint Sisinnios, see Perdrizet 1922 and, more recently, Greenfield 1988.

2. On this group, see Spier 1993, 61–62; Matantséva 1994.

3. For the Theotokos (God-Bearer) seated on a high-back throne with curved sides, see the sixth-century lead pilgrim ampoule from Monza (Grabar 1958). For an example of cross-fertilization between pilgrimage art and magical objects, see a sixth-century bronze amuletic armband in the Royal Ontario Museum, featuring the Theotokos, the Holy Rider, and the Women at the Tomb (*Beyond the Pharaohs* 1989, 195, cat. 107), and a bronze amulet against the Evil Eye with the Holy Rider on one side and Christ in majesty in a mandorla flanked by the Four Beasts of the Evangelists on the other side (*Art and Holy Powers* 1989, 18, and 215, cat. 134).

## 170 Amulet with Holy Rider and Evil Eye

Asia Minor, Byzantine, 5th–7th century
Copper
H. 5.0 cm, w. 4.0 cm
Rev: ΚΥΡΙΕ ΒΟΗΘΙ (Lord, help)
The Walters Art Museum, Baltimore,
Maryland, 54.2628

PUBLISHED *Beyond the Pharaohs* 1989, 192,
cat. 103.

170a

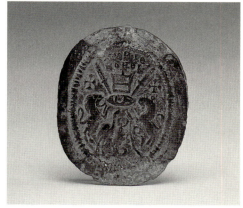

170b

These two thin copper sheets were originally joined back to back to form a double-sided oval amulet. Both are embossed with apotropaic images. On the obverse piece, within a hatched border, a nimbed Holy Rider tramples a demon beneath his horse's pounding hooves and impales his adversary with a spear (see cats. 167–69, 171, and fig. 24). A running lion is depicted below the demon and a star appears above the horse's head.[1] The reverse piece, with a similar hatched border, shows the Evil Eye at the center of a multivalent attack; ΚΥΡΙΕ ΒΟΗΘΙ (Lord, help) is inscribed at the top.[2] Lions, snakes, daggers, crosses, even an ibis and a scorpion vent their fury on this dreaded symbol of envy. Both scenes are powerful protective signs that commonly appear in various media from the early Byzantine period.[3]

A victorious mounted warrior is a general image of victory that can allude to several individuals, including Alexander the Great and Saint Sisinnios, but this figure of a rider defeating an anthropomorphic demon is most commonly identified as Solomon, the Old Testament king. The Evil Eye on the reverse piece represents the harm an envious person or demon can inflict on someone who has experienced good fortune. The animals and weapons attacking the eye render its malignant powers neutral, thereby protecting the owner of the amulet. Early Church fathers such as Jerome (347–419) warned against apotropaic devices, preferring prayer to magic, but the number of surviving amulets, armbands, rings, gems, and textiles decorated with these images demonstrates their popular appeal.[4]   DJ

1. For copper amulets with similar motifs, see Russell 1995, 40 and figs. 5, 6.

2. The term "Evil Eye" is modern. Early Greek and Latin terms for the evil eye included the Greek φθόνος (envy) and βασκανία (evil) and the Latin *invidia* (hate) (Dickie 1995, 12).

3. Vikan 1984, 65–86; Russell 1982b, 539–48.

4. Maguire 1995, 51–71.

## 171 Token with Holy Rider

Asia Minor, Byzantine, 6th–7th century
Lead
H. 3.2 cm, w. 2.6 cm
Arthur M. Sackler Museum, Harvard
University, Bequest of Thomas Whittemore,
1951.31.4.1871

COLLECTION HISTORY Thomas Whittemore
collection.

UNPUBLISHED

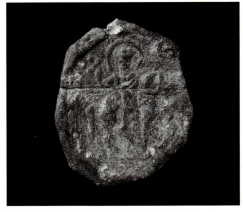

171

The obverse of this badly worn lead token is embossed with an image of the Holy Rider, and the reverse is blank. Solomon, the wise and powerful Old Testament king, was frequently portrayed as the Holy Rider, an emblem of victory over evil that embodied apotropaic powers (see cats. 167–70 and fig. 24). Mounted and holding a spear, he tramples a female demon beneath his horse's hooves. A legend from the *Testament of Solomon,* an early Byzantine treatise on magic, names the demon as Abyzou or Gylou.[1]

This image of victory over demonic powers was believed to protect its possessor from general harm, but the identity of the female demon reveals a more specific purpose for this token. When women endured a difficult labor or other problems during pregnancy and childbirth, the barren Abyzou (Gylou) was blamed for causing their trouble.[2] An amulet depicting Solomon defeating this female demon was intended to ward off her jealous interference and to protect the woman from the maladies the demon inflicted.[3] It is unusual for a female figure to assume the role of the enemy of childbirth. Customarily, female deities such as Hera, the Greek goddess of marriage and childbirth, and Christian figures such as the Virgin Mary, Saint Margaret of Antioch, and Saint Marina were protectors of pregnant women (see cats. 165, 184, 185). DJ

1. The female demon is named Gylou in the Byzantine tradition and Lilith in the Hebrew tradition.

2. *Art and Holy Powers* 1989, 26.

3. Vikan 1984, 65–86.

## 172 Hystera Amulet with Saint Theophano

Byzantine, 10th–12th century
Lead
Diam. 4.5 cm
Obv: between serpents, [✳]ѠC H ƵѠH (life is light)
Rev: left and right, H ΘЄΟΦ[ΑΝѠ] (Saint Theophano)
Arthur M. Sackler Museum, Harvard University, Bequest of Thomas Whittemore, 1951.31.4.1869

COLLECTION HISTORY Thomas Whittemore collection.

UNPUBLISHED

## 173 Hystera Amulet with Saints Helena and Constantine

Byzantine, 10th–12th century
Lead
Diam. 4.5 cm, preserved w. 2.0 cm
Obv: between serpents, [Φ]ѠC H [ƵѠH] (life is light)
Rev: ΑΓΗΟC (saint, masc.)
Arthur M. Sackler Museum, Harvard University, Bequest of Thomas Whittemore, 1951.31.4.1870

COLLECTION HISTORY Thomas Whittemore collection.

UNPUBLISHED

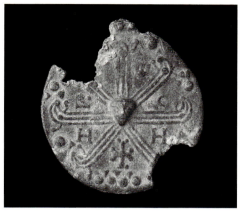

172a                    172b

173a                    173b

The obverse of each of these amulets depicts a wandering womb *(hysteron)*, which was thought to be a destructive agent. The Medusa-like motif, or stylized Gorgon's head, is a common device on middle Byzantine amulets and is often accompanied by the formula "O Womb, dark and black, like a serpent you writhe, like a dragon you hiss."[1] Individuals of both sexes could fall victim to the displaced womb, and they resorted to supernatural protection against it. *Hystera* amulets tend to associate the condition with the female demon Gylou, known from early Byzantine times, whose aggression was primarily directed against women in childbirth. The reverse of *hystera* amulets often shows Gylou being trampled and killed by a rider saint, suggesting that some of the *hystera* amulets were used to protect women in childbirth and infants.[2] Sometimes, however the reverse displays a bust of Christ, the Virgin, or a standing figure in imperial garb.[3]

The reverse of cat. 172 depicts Saint Theophano in the orant position, dressed in a tunic and a cloak fastened at the shoulder and decorated with jewels. She wears a three-pronged crown with *pendilia* (pendant ornaments), and a collar made of a double row of pearls. Another specimen, also made of cast lead, shows her in a similar manner.[4] Theophano, wife of the emperor Leo VI (r. 886–912; cat. 57), was canonized by her husband after her death in 893. She was buried in her own church in Constantinople and continued performing miracles well after her death.[5]

If some *hystera* amulets were designed to facilitate childbirth, the image of Saint Theophano was a logical choice, since her own birth was achieved through the miraculous intervention of the Virgin. According to the saint's *vita*, Theophano's mother was able to give birth only after her husband tied around her loins a belt that he had removed from a column in a church of the Theotokos.[6] It should be noted, however, that the miracles subsequently attributed to the saint's intercession, whether they were said to have occurred during or after her lifetime, do not include assisting women in difficult labor.

The reverse of cat. 173 shows an emperor-saint wearing the traditional *loros* (jeweled scarf) and a crown surmounted by a cross, and holding a *globus cruciger* in his raised right hand. He is most likely Constantine the Great, and the missing half of the amulet probably represented his mother, the empress-saint Helena (see cats. 16, 24). Between them was a depiction of the True Cross. In contrast to the representation of the *hysteron*, the image of Constantine and Helena holding the True Cross provided a powerful Christian symbol (see cat. 120).  IK

1. As on a copper and cloisonné enamel example in the Louvre (*Glory of Byzantium* 1997, 166, cat. 114).

2. Spier 1993, 44. For an earlier and different approach to these amulets, critiqued by Spier, see Vikan 1984, 75–79.

3. Spier 1993, 27 and 55; pl. 2, no. 30.

4. *Hirsch Auktion* 1999, cat. 1170.

5. *ODB* 1991, 2064–65.

6. Kurtz 1898, 2, ll. 26–35; 3, ll. 1–3.

## 174 Prayer for Pregnancy

Upper Egypt (?), 7th century (?)
Papyrus
H. 28 cm, w. 21.8 cm
Inscription, in Coptic (see entry)
The Pierpont Morgan Library, New York.
Gift of J. P. Morgan (1867–1943): 1924. MS M.662B, #22

COLLECTION HISTORY Purchased in Cairo from Maurice Nahman by Francis Willey Kelsey, 1920; brought to Rome by Kelsey and sold to Henry Hyvernat on behalf of J. P. Morgan, Jr.; John Pierpont Morgan Library, New York, 1920.

PUBLISHED MacCoull 1982, cat. 10; *Beyond the Pharaohs* 1989, cat. 108; Depuydt 1993, vol. 1, cat. 306.

The recto of this partially preserved papyrus bears a twenty-two-line Coptic (Sahidic) inscription that is a generic petition to God that his wife become pregnant.[1] The text reads:

> *Almighty Master, O Lord God: for Thou from the beginning hast made man after Thine image and after Thy likeness: Thou hast honored my striving for childbirth: Thou didst say to our mother Sarah, "[As a result of] your crying, another year and a son will be born to you," in this way yet again, behold, I too call upon Thee, Who sittest upon the Cherubim, that Thou hear my prayer today, I, N., son of N., upon this cup of wine that is in my hand, so that it may be fulfilled [?] in N., daughter of N., that Thou grace her with seed of man: And, O Lord, the one Who dost hear everyone that calls upon Him, Adonai Elohim Sabaoth, God of Gods and Lord of Lords, if [?] a man is bound with a phylactery, or if someone gives a cup and calls . . . it is from Thee that she may be forgiven [?] by redeeming love . . . I adjure Thee by Thy great Name and the sufferings which Thou didst receive upon the Cross to fulfill the words of . . . that are put into this cup in my hand.[2]*

The names of the man and the woman and their fathers are to be supplied in the positions marked "N." A cup of wine is blessed and served to the woman indicated, who is to become pregnant after drinking it. On the verso is a wine list written in Greek that is probably the earlier of the two documents.

The petition calls upon no pagan supernatural powers, but uses biblical references: Genesis 1:26, 17:16–19, and 18:10–15; and Psalm 99:1. The Genesis 17 reference relates to the

174

story of Sarah, aged ninety, to whom God promised a son. Although Sarah's menses had long since ceased, she and her husband Abraham produced a son, Isaac, an outcome beyond the boundaries of hope and human fertility. Through Isaac, Sarah became the "Mother of Nations," with kings among her descendants (Genesis 17:15). Like Abraham in the Genesis story, it is the husband who initiates this prayer. The petition reveals that not only women but also their husbands took steps to ensure successful conception. Although there are no known parallels for this prayer, Christian prayers for pregnancy were not uncommon in late antique Egypt, a trend that may reflect a low fertility rate or simply the high social value placed on childbearing and the continuation of the family line. ARG

1. The writing slopes slightly to the right and includes cursive features (Depuydt 1993, 540). The text is faded and there are some holes in the papyrus.

2. MacCoull 1982, 11–12 (punctuation modified).

## 175 Protective Tablet

Early Christian, 3rd–4th century
Gold
L. 7.6 cm, w. 2.1 cm, d. 0.03 cm
Inscription: 28 lines, ΟΡΚΙΖΩ ΠΑΝ/ ΠΝΕΥ-
ΜΑ ΚΑ/ΚΩϹΕΩϹ ΤΟΥ/ ϹΥΝΕΧΩΝ ΔΕ/
ΤΗΝ ΔΟΥΛΗΝ/ ΚΥΡΙΟΥ ΟΝΟ/ΜΑΤΙ
ΜΑΡΚΙ/ΑΝΗΝ ΑΠΟϹΤΗ/ΤΕ ϹΒΕϹΘΗΝΑΙ/
ΑΙϹΧΥΝΘΗΝΑΙ/ ΠΝΕΥΜΑΤΑ/ ΦΑΝΤΑ-
ΖΟΜΕ/ΝΑ ΗΜΕΡΑϹ/ ΚΑΙ ΝΥΚΤΕϹ ΟΤΙ/
ΕΩΟΡΚΙΖΩ/ ΥΜΕΙΝ ΤΟ ΚΠΑ/ΤΟϹ ΤΟ
ΤΟΥ ΠΑΝ/ΤΟΚΡΑΤΟΡΟϹ/ ΚΑΙ ΤΟ ΟΝΟΜΑ
ΤΟ/ ΚΡΥΠΤΟΝ ΚΑΙ Α/ΔΩΝΑΙ ΑΙΕΛΩ ΚΑΙ/
ϹΑΒΑΩΘ ΑΕΛ/ΑΤΕΙΡΑ ΚΥΡΙΕ/ΗΧΗΖΖΘ
ΛΑ/ΧΕΙΝ/ ΡΑΦΑΗΛ ΚΑΙ/ ΓΑΒΡΙΗΛ
ΑΖΑ/ΖΗΛ ϹΑΡΟΝΗΛ (I adjure every harmful
spirit that afflicts the servant of the Lord, by
name Marciane. Keep off, be extinguished, be
put to shame, [you] spirits appearing day and
night, since I exorcise you by the power of the
Almighty and by the hidden name: Adonai
and Eloai and Sabaoth and Ael, . . . Lord . . .
Raphael, and Gabriel, Azazel, Sarouel)[1]
Indiana University Art Museum, Burton Y.
Berry Collection, 71.22.125

COLLECTION HISTORY Burton Y. Berry
collection.

PUBLISHED Calinescu 1994, 33; Parca 1996, 216.

175

This thin gold sheet with an inscribed spell was probably commissioned by a woman to
ward off evil spirits that were causing her suffering. The spell is inscribed in a crude script,
probably by someone who advised on such matters and consulted a handbook of magical
formulas. The magician personalized the spell by including the client's name, Marciane.
The reference to her as a "servant of the Lord" marks her as a Christian. The spell is
designed to cast out harmful spirits by invoking the names of the supreme God—in par-
ticular by an oblique reference to his "hidden" name—and the names of various angels. It
does not, however, specify the nature of Marciane's perpetual suffering ("day and night").

Marks on the gold sheet indicate that it was rolled up and then folded. Most likely
Marciane would have worn it as an amulet, perhaps in a tubular gold case (see cat. 176)
around her neck. Spells were believed to work best when the amulet was worn close to
the body.[2]  JKS

1. Parca 1996, 216; translation edited by Ioli Kalavrezou.      2. Betz 1992, *PGM* 36.35–68 and 275–83.

## 176 Necklace with Cross and Phylacteries

Eastern Mediterranean, Byzantine,
5th–6th century
Gold, glass
L. 54.3 cm, wt. 45 g; phylacteries: l. 3.0 cm,
diam. 0.5 cm; cross: h. 3.3 cm, diam. of stone
setting 0.6 cm; clasp: diam. of roundel 1.6 cm
Indiana University Art Museum, Burton Y.
Berry Collection, 70.56.11

COLLECTION HISTORY Burton Y. Berry.
PUBLISHED Rudolph and Rudolph 1973,
188–89, cat. 153; *Art and Holy Powers* 1989, 165,
cat. 90; Calinescu 1994, 32–33, fig. 2; Rudolph
1995, 283–84, cat. 82; Parca 1996, 215–16.

A cross and two hexagonal phylacteries, or amulet cases, are suspended from a braided gold chain. The clasp of the chain consisted of two openwork roundels, one of which is now missing. The cross is formed by four conical solid-gold arms; at its center is a purple glass cabochon.[1] The phylacteries, located on either side of the cross, each contain a rolled metal sheet, as X-rays have revealed.[2] Unfortunately, we do not know the contents of these tablets. In the early Christian period either curses against demons or prayers to God were written on such tablets and worn for protection from spirits, diseases, or the Evil Eye (see cat. 175). This simple necklace displayed the Christian piety of the woman who wore it; at the same time, its cross served as a central magical device flanked by hidden but powerful invocations. The obvious material value of the necklace would have attested to the affluence of the owner.   JKS/IK

1. It is possible that this cross is not the original one, since its workmanship differs from that of the rest of the piece. However, a cross was most likely part of this phylactery necklace from the beginning. For a sixth-century gold cross of similar form, with a ruby cabochon, see *Daily Life* 2002, 404–5, cat. 508.

2. Parca 1996, 223, n. 19.

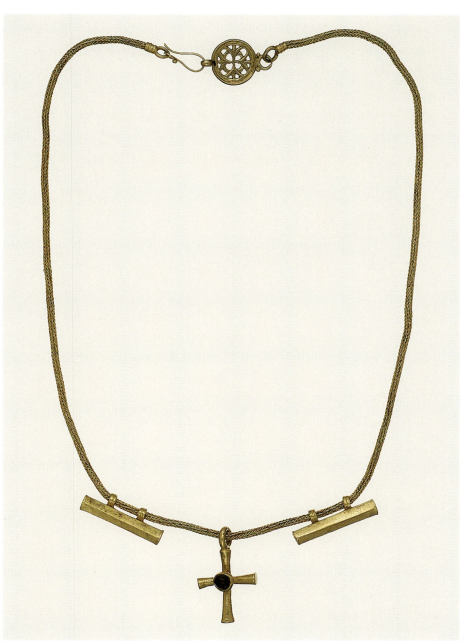

176

177

## 177 Seal Ring with Virgin and Child

Byzantine, 6th–7th century
Bronze
H. 2.6 cm, w. 2.5 cm, diam. of bezel 1.3 cm
The Menil Collection, Houston, X490.736

UNPUBLISHED

This simple bronze ring has a round bezel that depicts an abbreviated image of the Virgin with the Christ child before her chest. Only the heads of the figures, each surrounded by a nimbus, are visible. Two small crosses flank the group. The image of Mother and Child is incised so that the ring can be used as a private seal ring. Since rings were worn on a number of fingers, sizes vary, and it is not always easy to determine whether a ring was made for a man or a woman; this iconographic subject was popular with both (see cats. 22, 46, 47, 53–56).[1] The visual formula became popular on Byzantine lead seals in the sixth century, as attested by the dated examples displaying representations of the emperors Justinian (r. 527–65) and Justin II (r. 565–78; see cats. 15, 34).[2] The popularity of images of Mary was directly related to the rise of the public cult of the Virgin in Constantinople in the late fifth century.[3] This ring thus had two functions. Its physical image of the Virgin and Child protected the person wearing it as an amulet, and it served as the owner's emblem on seals.  BP

1. Cheynet and Morrisson 1994.
2. Zacos and Veglery 1972, 8, cat. 4, pl. 9.
3. Mango 2000.

## 178 Ring with Virgin and Christ

Byzantine, 11th–12th century
Gold
Diam. of band 2.28 cm
Inscription: vertical, to left of Christ, IC̅ XC̅ (Jesus Christ); to right of Virgin, Θ̅ M̅ (Mother of God)
Royal Ontario Museum, Toronto, Canada; Gift of Joey and Toby Tanenbaum; Certified by the Canadian Cultural Property Export Review Board under the terms of the Cultural Property Export and Import Act, 994.220.34.

PUBLISHED Ariadne Galleries 1988, cat. 38.

The glass medallion and the two gold rings depict the Virgin in her intercessory role with Christ—the adult Christ on cat. 178, and the infant on cats. 179 and 180. On each object the Virgin lifts her hand(s) in a gesture of appeal on behalf of the wearer, while the son responds to her request with a gesture of blessing. As the Mother of God, Mary acquired the power to intercede on behalf of humanity. It is the potency of this mother-son relationship that ensures her success; the loving child would not refuse a request from his mother.

The iconographic type showing the Virgin holding the infant Christ in one arm is known as the Hodegetria because it reproduces the iconography of a famous miracle-working icon of the Hodegon monastery in Constantinople (see cats. 51, 52). In cat. 180, the red glass-paste medallion (made of powdered glass fired at high temperatures), Mary sits on a backless throne and rests her feet on a low footstool. She holds the Child in her left arm and, with the tilt of her head and the gesture of her right hand, directs the viewer's gaze toward the infant. Christ holds a scroll in one hand and blesses with the other. A subtle dialogue of hands is thus established; each figure holds the Logos (Word of God) in one hand and makes a gesture of speech with the other. The Logos is held in two differ-

## 179 Ring with Virgin and Child

Byzantine, 11th–12th century
Gold
Diam. of band 2.4 cm
Inscription: to left of Virgin, M̅P̅ (Mother);
above Christ's head, Θ̅V (of God)
Royal Ontario Museum, Toronto, Canada;
Gift of Joey and Toby Tanenbaum; Certified
by the Canadian Cultural Property Export
Review Board under the terms of the Cultural
Property Export and Import Act, 994.220.36.

PUBLISHED Ariadne Galleries 1988, cat. 40.

## 180 Oval Medallion with Virgin and Child

Byzantine, 13th century
Red glass paste
H. 4.6 cm, w. 4.2 cm
Inscription: to left and right of enthroned
Virgin and Child, M̅P̅ Θ̅V (Mother of God)
Royal Ontario Museum, Toronto, Canada;
Gift of Joey and Toby Tanenbaum; Certified
by the Canadian Cultural Property Export
Review Board under the terms of the Cultural
Property Export and Import Act, 994.220.65.

PUBLISHED Ariadne Galleries 1988, cat. 69.

ent guises, however: Christ carries the written word in the form of the scroll, and the Virgin carries the incarnate Logos in the shape of the Child. The hands communicate an intercession spoken by the mother on behalf of the wearer and a blessing dispensed by the son.

A middle Byzantine epigram once written on an *enkolpion* (pendant reliquary) reveals how such objects were perceived (see also cat. 175). The poem reads: "As an amulet I have you in my heart, O Virgin, like a tablet with the word [*logos*] of God inscribed on it; as a shield I carry you now in front of my chest, I Theodoros Doukophnes, your supplicant."[1]

The blood-red color of the glass medallion possibly alludes to medallions with Marian images carved on bloodstone, a material that was believed to staunch the flow of blood (see cat. 165), and to the power of the Virgin to intercede on behalf of the wearer in his appeal for good health. It is thus possible that cat. 180 was used as a health-promoting amulet. All of these objects—the two rings and the glass cameo—although from different periods and with different iconographic themes, were meant to protect the person who wore them and to assist him or her in gaining access to Christ through the intercession of the Virgin. Carved in intaglio, the two rings also served as the owners' private seals.   BP/IK

1. Ἐν καρδίας ἔχων σε πλαξὶ, Παρθένε, / θεοῦ λόγον πλὰξ ὥσπερ ἔγγεγλυμμένην / ὡς θυρεόν νῦν καὶ πρὸ τῶν στέρνων φέρω / Θεόδωρος σὸς Δουκοφυὴς οἰκέτης (Lampros 1911, 22, no. 54).

178

179

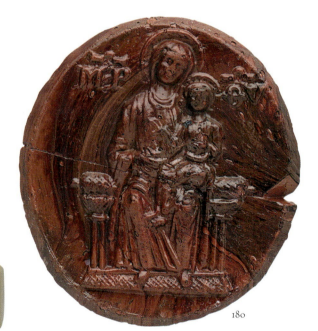

180

## 181 Roundel with Virgin's Presentation

Byzantine, 11th century (?)
Lead
Diam. 3.8 cm
Arthur M. Sackler Museum, Harvard
University, Bequest of Thomas Whittemore,
1951.31.4.1873

COLLECTION HISTORY Thomas Whittemore
collection.

UNPUBLISHED

181

The small, round lead plaque is in a poor state of preservation: it has lost a piece on its right side and its surface is worn. Still, the scene of the Presentation of the Virgin Mary in the Temple is recognizable on the front. The reverse is blank, with some scratches and other surface damage. It is not clear whether this lead medallion was a pilgrim's token or part of an amuletic pendant.

In this scene of the Presentation of the Virgin, Mary, still a child, stands before the priest Zacharias, who receives her at the entrance to the inner sanctuary. Behind her stand her parents and three maidens carrying candles (see also fig. 2).[1] The narrative is based on the Gospel of Pseudo-Matthew 4 and the Protoevangelion of James (ch. 7–8), according to which Mary's parents brought her to the Temple at the age of three in fulfillment of a vow. The Presentation of the Virgin is one of the Marian Great Feasts,[2] first commemorated in Constantinople in the late ninth to tenth century. It was a day when the emperor went to the church of the Chalkoprateia, dedicated to the Virgin, to celebrate. This type of lead token was very likely made available to participants in the feast, who could take it home as a protective amulet.

The story, about the dedication of a child to God and God's protection of children, would have been especially meaningful to parents. A medallion like this one, a small "icon" depicting the scene in the Temple, would have reassured them about their children's well-being. IK

1. Usually included in this scene is a second representation of the Virgin, seated within the sanctuary and receiving bread from a descending angel (Lafontaine-Dosogne 1964, 136–67). That part of the iconography, however, was not represented on this roundel.

2. *ODB* 1991, 1715.

## 182 Intaglio Ring with Koimesis of the Virgin

Intaglio: Constantinople (?), Byzantine, 11th century
Band and setting: 15th–16th century
Gold
Intaglio: h. 1.1 cm, w. 1.6 cm; diam. of band 2 cm
Dumbarton Oaks Collection, Washington, D.C., 56.15

COLLECTION HISTORY Sir Leigh Ashton, London; purchased from Ashton in 1956.

PUBLISHED Ross 1965, 88, cat. 123; *DO Handbook* 1967, cat. 123, pl. 63; Vikan and Nesbitt 1980, 19, fig. 41.

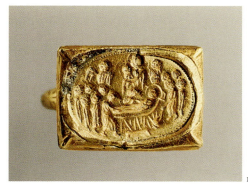

182

This ring consists of a gold intaglio, probably from the eleventh century, now in a gold setting dating from the fifteenth to sixteenth century. The small gold plaque with an oval border has been carved to depict the Koimesis (Dormition or Death) of the Virgin (see also cats. 116, 117). Although the intaglio is not in its original setting, its small size suggests that it was originally a ring, or possibly a pendant; an intaglio was intended to function as a seal.

The intaglio depicts the Virgin lying on a draped bier with her head toward the right. The twelve Apostles, mourning her death, surround her. Five stand at the head of the bier and six at the foot, where Paul touches her legs. John, at the center of the scene and on the far side of the bier, bends over her. Christ, the tallest figure, stands directly behind John, cradling Mary's soul, which is depicted in the form of a child. Two angels, one on either side of Christ, fill the upper part of the scene.

Intaglios from this period are rare. Although the Koimesis was popular as a religious subject, it was quite unusual on a seal. Among the few such seals known are one that was used by a monastery and one that belonged to Theodora Komnene, niece of the emperor Manuel Komnenos (r. 1143–80).[1] Textual sources also describe a wax seal belonging to Anna Dalassene, mother of the emperor Alexios I Komnenos, that depicted the Koimesis on one of its sides.[2] Given these examples, it is possible that an aristocratic woman had this intaglio made for her personal use as a seal, possibly when she retired to a monastery near the end of her life. The theme of the Koimesis would have been most appropriate, since it addresses death and, through the presence of the Virgin's soul in Christ's hands, manifests hope for resurrection and salvation.   IK

1. Schlumberger 1884, 25, 644; Ross 1965, 88, cat. 123.    2. Oikonomides 1985, 10.

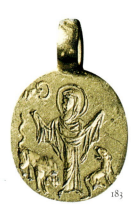

183

## 183 Oval Pendant with Thekla

Eastern Mediterranean, Byzantine,
5th–6th century
Gold
H. 2.6 cm, w. 1.7 cm, d. 0.01 cm
The Art Museum, Princeton University.
Museum Purchase, Caroline G. Mather Fund,
y1968-136

COLLECTION HISTORY Said to have been
purchased in Istanbul; museum purchase from
Mathias Komor, New York.

PUBLISHED Nauerth 1982, 16; *Byzantium at
Princeton* 1986, 91, cat. 89; Schurr 1997, 214.

A female figure stands with her arms extended in the orant position, a gesture of prayer.
The flanking animals identify the woman as Thekla. Unlike her depiction with the beasts
in cat. 68, this image shows her fully clothed and veiled, as she will appear throughout
the middle and late Byzantine period. A slight *contrapposto* stance conveys her elegance and
appeal. Her head turns slightly to her right to behold the hand of God reaching down
from above to offer her the wreath of victory for her triumph over the beasts of the arena,
vividly represented by the lions circling her feet.

Just as Thekla's prayer invoked God's protection against the beasts, the wearer of this
pendant sought the saint's intervention in her own life. Thekla's stark physical manifesta-
tion in cat. 68 and her concealing attire in this pendant both express her virginal power. In
this later image, Thekla leaves the arena behind and becomes a model for female behavior
in everyday life as well as a channel for prayer.   JKS

## 184 Double-Sided Pendant with Saint Marina

Byzantine, 13th century
Green steatite
H. 4.0 cm, w. 2.5 cm, d. 0.5 cm
Side A: vertical, to left and right, H ΑΓΙΑ
ΜΑΡΙΝΑ (Saint Marina)
Side B: vertical, to left and right, part mono-
gram, Ō ΓΡΦΤС ΔΝΙΗΛ (Prophet Daniel)
Virginia Museum of Fine Arts, Richmond.
The Adolph D. and Wilkins C. Williams
Fund, 69.41

PUBLISHED Kalavrezou-Maxeiner 1985a, 246,
no. A-53 a, b, pl. 90; Gonosová and
Kondoleon 1994, 124–25, cat. 44.

This small icon is carved with reliefs depicting Saint Marina on one side (illustrated) and
the prophet Daniel in the lions' den on the other; an accompanying inscription identifies
each saint.[1] Originally, the plaque was probably worn as a pendant. Made of steatite, a
fragile, highly valued stone, it must have had a loop and been encased in a frame partially
covering the raised border.[2] The details and facial features of the haloed figures have been
nearly rubbed away by repeated handling during prayer and by friction with the skin, a
common occurrence with stone amulets and icons worn on the body.[3]

In Byzantine *vitae*, Marina is a virginal monastic saint of great beauty, piety, and purity
of spirit (see also cat. 185). Her modesty and asceticism are reflected in her dress: the long
tunic, mantle, and *maphorion* (veil). She stands frontally with hands raised before her chest,
the left open in a gesture of prayer and the right holding a small cross signifying her
devotion, sanctity, and perhaps martyrdom. Her legs turn slightly to her right, indicating
Daniel's presence on the opposite side; he bends to his right, indicating Marina. These sub-
tle reciprocal gestures emphasize the presence of the two holy figures and activate a cycle of
invocation. Pendant icons like this one brought the wearer into continuous personal con-
tact with the holy figures depicted and promoted their protective and intercessory powers.

According to her twelfth-century Sicilian *vita*, Saint Marina's relics became "a defense

against maladies of all kinds."[4] Her powers of healing and purity are reflected and reinforced by the material of this icon; steatite was called ἀμίαντος λίθος (spotless stone) and invested with precious and curative qualities; the green color was considered beneficial to the stomach.[5] Saints Marina and Daniel are paired on other late Byzantine icons, perhaps because their *vitae* both emphasize salvation from death through faith and prayer: Marina was nearly drowned in the sea or consumed in a dragon's stomach, and Daniel, nearly torn apart by lions.[6] Although these events were possibly typological allusions to successful parturition through their references to delivery from danger, Saint Marina has more specific associations in Byzantine hagiography with healing, pregnancy, and child rearing, which made her a logical intercessor for childbearing women.[7] Perhaps a woman wore this icon for protection during pregnancy (see also cats. 167, 168, 174).[8]   EG

1. For the thirteenth-century style of steatite carving, see Kalavrezou-Maxeiner 1985a, 44–66. For other middle and late Byzantine stone and glass plaques with Marina and/or Daniel, see ibid., 242, no. A-21, pl. 83; 245, no. A-48, pl. 89; *Rom und Byzanz* 1998, 242, cat. 80; Williamson 1983–84, pl. 2A.

2. For a discussion of the stone and frames, see Kalavrezou-Maxeiner 1985a, 19, 28–30. For a double-sided plaque of similar form, also with a top loop and remnants of a metal frame on the raised border, see ibid., 244, A-42, pl. 89.

3. Ibid., 19.

4. Rossi Taibbi 1959, 105.

5. Kalavrezou-Maxeiner 1985a, 69–73, 78–85; Vikan 1984, 65–86, esp. 77–78; *Art and Holy Powers* 1989, 8, 201, 211.

6. For the complex hagiographical tradition of Marina, see Usener 1886, 3–5; De Voragine 1931, vol. 5, 113; Constas 1996, 1–12; and Rossi Taibbi 1959.

7. In the sixth-to-seventh-century Byzantine life, Maria/Marinos, the transvestite nun, is wrongly accused of impregnating an innkeeper's daughter. Instead of denying the crime, "he" voluntarily accepts punishment and raises the rejected child in the monastery (Constas 1996, 1, 9–12). In the later, Sicilian life, Marina is described as a healer of all types of illnesses (Rossi Taibbi 1959, 87, 93). Her assimilation to the late-third-century virgin saint known as Marina, Pelagia, or Margaret of Antioch, honored as the patron saint of childbirth in the late medieval West, expands Marina's role as a healing saint into the realm of pregnancy (Weitzmann-Fiedler 1966, 17–48).

8. Gonosová and Kondoleon 1994, 125, cat. 44.

184

## 185 Icon of Saint Marina

Tripoli (?), Crusader-Byzantine, 13th century
Tempera over gesso on carved wood panel
H. 22 cm, w. 16 cm, d. 1.5–2.1 cm
Inscription: part monogram, H ΑΙ/α ΜΑΙ/ΤΙΑ
(Saint Marina)
The Menil Collection, Houston, 85-57.04 DJ

COLLECTION HISTORY Eric Bradley, London;
acquired by the Menil Foundation in 1985.

PUBLISHED *Temple Gallery Icons* 1969, 4–5, cat. 1,
figs. 20–21; *Bradley Icons* 1973, cat. 78; Davezac
1988, 10–12; Folda 1992, pl. 4, figs. 99, 100.

At least three different Saint Marinas were venerated by the Byzantines: the early virgin martyr portrayed in this icon, a fifth-century Marina who disguised herself as a man to join a monastery with her father, and an eleventh-century Sicilian virgin and healer (see cat. 184).[1] Her red veil (aristocratic monastic dress, also indicating the saint's virginal status), the cross in her right hand, her left hand raised in a gesture of speech, and her frontal position identify this Marina as the virgin saint from Antioch in Pisidia, martyred in 305.[2] While Marina is frequently represented in Byzantine church mosaics and frescoes, this icon is one of a very few bust-length portrait icons of the saint and of female saints generally; more commonly, icons depict events from their lives.[3]

Recent scholarship attributes this icon to an eastern Mediterranean context on stylistic grounds. The double-barred cross in Marina's right hand is considered an allusion to the True Cross (see cat. 120), a cult strong among the Crusader states that survived in the area until the final years of the thirteenth century. The reverse-S-and-double-bar, pseudo-Kufic design framing the icon differs significantly from the plain, monochrome borders of Byzantine painted icons, but finds parallels in a group on Mount Sinai identified as Crusader icons. The raised gesso decoration of Marina's halo—which extends into the background and is also employed on her cuffs—has been interpreted as a less expensive substitute for the metal revetments found mostly on Cypriot icons. Based on these and other stylistic considerations, such as the relative two-dimensionality of the image, this icon has most recently been attributed to the Tripoli region, present-day Lebanon, an area where the cult of Saint Marina was strong.[4]

Relatively frequent and increasingly specific depictions of female saints are found in thirteenth-century icons and wall paintings from the Crusader states. This may be because of the growing responsibilities and authority of women during a time of constant war with Muslim neighbors.[5] The growing prominence and activity of women constitutes a logical context for the icon of a female martyr who provided special benefits to women. In view of Marina's popularity in the late medieval West, where she was venerated as Saint Margaret, the patron saint of childbirth, it is likely that Christian women in the Crusader states contributed to the growth of her cult by commissioning and circulating icons like this one.[6]

The small scale of this icon indicates that it would have been used for personal devotion, perhaps by a woman for whom Saint Marina had special importance, as a name saint, popular regional saint, or intercessor in childbirth.[7]  EF

1. Ross and Downey 1962, 41–44; Constas 1996, 1–12; Rossi Taibbi 1959.

2. Folda 1992, 108.

3. Mouriki 1990, 11; for Marina and other female saints in Byzantine church decoration in Greece, see Gerstel 1998, 104–11.

4. Folda 1992, 106–16. Folda thoroughly discusses the style of the icon and proposes that it was executed for a Crusader patron in the Tripoli area.

5. Hunt 1991, 113–24.

6. Anna Gonosová suggests that icons of Marina were used by Byzantine women (Gonosová and Kondoleon 1994, 125, cat. 44).

7. Byzantine women also sought access to their name saints through the inclusion of their images in church decoration, where they served as family sponsors. See Gerstel 1998, 95.

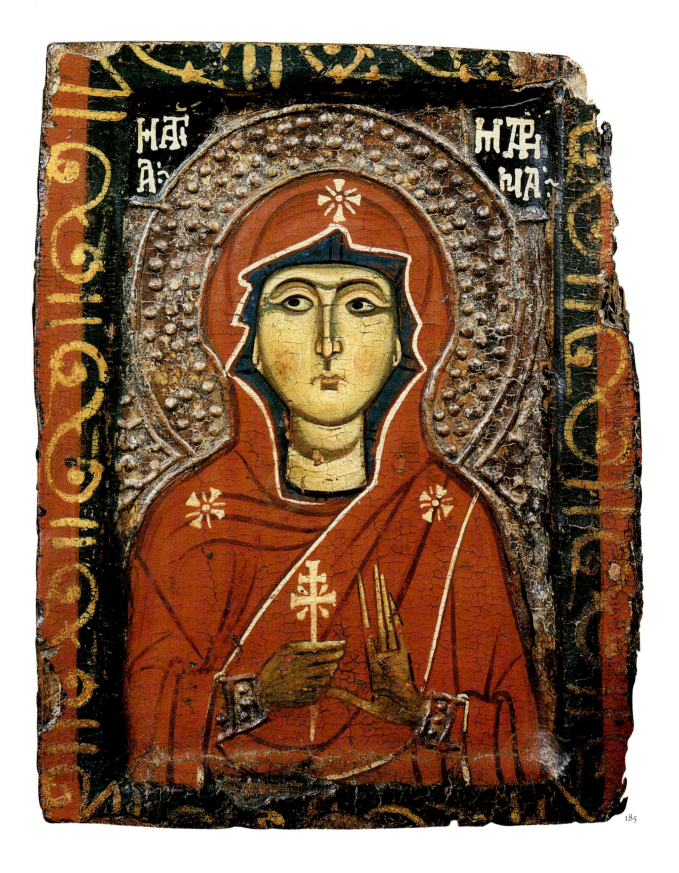

185

## 186 Bilateral Icon: The Birth of the Virgin/Saints John of Novgorod, Symeon the Stylite, and Nikita

Novgorod or Northern Province of Novgorod, Russian, early 16th century
Varnished tempera and tinted metal leaf on gesso, linen, and wood
L. 23.4 cm, w. 18.7 cm
The Menil Collection, Houston, 85-57.27a/b DJ

COLLECTION HISTORY Berthold Hintze, Helsinki; Eric Bradley, London; purchased by The Menil Foundation in 1985.

PUBLISHED *Bradley Icons* 1973, cat. 2; Davezac 1988, 59–61.

Although not found in the Gospels, the story of the Virgin's life was well known from the popular apocryphal text known as the Protoevangelion of James, where its events are described in detail.[1] In art, one of the earliest Marian cycles appears in a Cappadocian fresco dating to the late ninth century.[2] By the late Byzantine period, representations of the life of the Virgin had become codified, most notably in the thirteenth-century mosaic cycle from the Chora church in Istanbul.[3]

On this icon, the depiction of the Virgin's birth (illustrated) combines several scenes in one. Anna, Mary's mother, sits passively on a bed while one attendant brings her food and another fans her. In the lower left corner, the swaddled baby Virgin has just been bathed by nurses; one wears a white headdress, like the nurse or midwife in the Nativity of John the Baptist (cat. 70). On the right side of the image, Anna appears again with her husband Joachim, cradling the baby in their arms. In this scene, the Virgin, no longer wrapped in swaddling clothes, wears a garment, possibly of silk, that reflects light. She raises her right arm to touch her mother's shoulder, evoking representations of the Christ child, who is often draped in a similar way and holds his right hand up in a gesture of blessing.

Before the birth of Mary, Joachim was believed to be impotent. In Byzantium, childlessness was viewed as one of the worst things that could happen to a married couple. A child was essential to the well-being and stability of a "normal" family. Anna and Joachim are depicted together, with the father showing interest and concern for the child. Because of the high infant mortality rate and the risks of childbirth, neither the health of the baby nor that of the mother was taken for granted. Most births took place at home, and the seven days following were known as the mother's λόχεια, or lying-in. During this time she was cared for and given a special diet that was thought to aid lactation. At the end of the week, a banquet was held; friends came with gifts of fruit, sweets, and money. However, the new mother was considered "unclean" until forty days after the birth. She then received Communion and was allowed to move freely in society.[4]

The saints on the opposite side of the icon, John of Novgorod, Symeon the Stylite, and Nikita, were popular in the area of Novgorod.[5] Bilateral icons were often used in processions on the day of the feast they depicted; however, this icon is too small to have been used in processions (see cat. 52). Rather, it was used in the home with a selection of the family's preferred saints and the scene of the Birth of the Virgin, which might have been relevant to the household that owned it. Although of a later date, this icon represents subject matter popular in Byzantium, depicting the family, the home environment and, in particular, the careful attention shown to new mothers. MFH

1. Hennecke and Schneemelcher 1963, vol. 1, 370–88. The earliest surviving version of the text is a fourth-century papyrus (Papyrus Bodmer V); the author claims that he is James, the brother of Jesus, although the text was probably produced in the late second century.

2. Jacob 1971–73, 12–30.

3. Underwood 1966–75, vol. 4, 161–94.

4. Koukoules 1951, vol. 4, 33–34.

5. The architectural background, the delicately rendered faces, and the use of white highlights and bright coloring are typical of the Novgorod School in the late fifteenth and early sixteenth centuries (Lazarev 1981; compare no. 71).

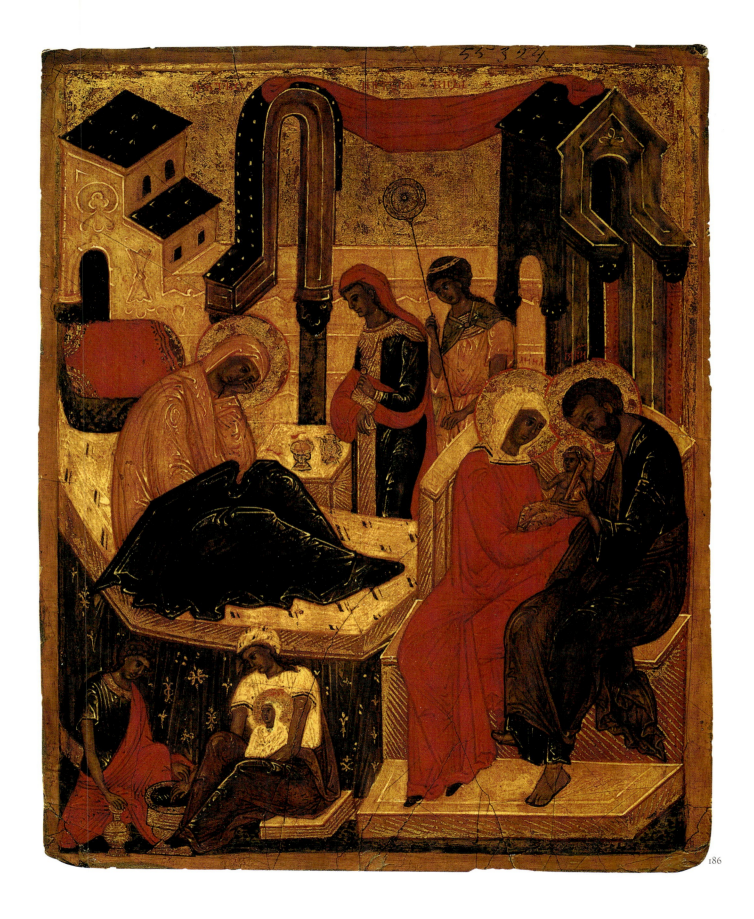

186

# Appendix: Byzantine Empresses

Names in italics indicate empresses who were sole rulers, regents, or co-rulers with adults other than husbands.[1]

* Depicted on coinage.

| EMPRESS | CIRCUMSTANCES OF ACCESSION | SOCIAL/FAMILY HISTORY |
|---|---|---|
| *Flavia Julia Helena | Elevated by son, Constantine I (sole *augustus* 324–37); *augusta* from c. 325; d. c. 329 | Former innkeeper, consort of Roman Emperor Constantius Chlorus (*augustus* 305–6) |
| *Flavia Maxima Fausta | By marriage to Constantine I (sole *augustus* 324–37); *augusta* after 306 or c. 325; d. 326 | 2nd wife of Constantine I; daughter of Roman Emperor Maximian (*augustus* 286–305); mother of Constantius II (r. 337–61) |
| *Constantia | By imperial birth, d. c. 330 | Wife of Roman Emperor Licinius (*augustus* 308–24); sister of Constantine I (sole *augustus* 324–37) |
| Anonyma | By marriage to Constantius II (r. 337–61) | 1st wife and cousin of Constantius II |
| Eusebia | By marriage to Constantius II (r. 337–61) | 2nd wife of Constantius II; daughter of consul from Macedonia |
| Faustina | By marriage to Constantius II (r. 337–61) | 3rd wife of Constantius II; mother of Constantia "Posthuma," wife of Gratian (emperor in the West 375–83) |
| Constantina (a.k.a. Constantia) | By imperial birth; made *augusta* by father, Constantine I (sole *augustus* 324–37); d. 354 | Wife of Hannibal 335–37, then Gallus Caesar 351–54; daughter of Constantine I; sister of Constantius II (r. 337–61) |
| Helena | Imperial birth; marriage to Julian (r. 361–63) | Wife of Julian; daughter of Fausta and Constantine I (sole *augustus* 324–37) |
| Charito | By marriage to Jovian (r. 363–64) | Wife of Jovian |
| Marina Severa | By marriage to Valentinian I (emperor in the West 364–75) | 1st wife of Valentinian I; mother of Gratian (emperor in the West 375–83) |
| *Justina* (regent 383–c. 388) | By marriage to Valentinian I (r. 364–75) | 2nd wife of Valentinian I; widow of Magnentius (emperor in the West 350–53); mother of Valentinian II (emperor in the West 375–92) |
| Domnica | By marriage to Valens (r. 364–78); made *augusta* at unknown date | Wife of Valens |
| Constantia "Posthuma" | Imperial birth; marriage to Gratian (emperor in the West 375–83); made *augusta* at marriage in 374? | Wife of Gratian; daughter of Faustina and Constantius II (r. 337–61) |

1. The list is selective. Dates of elevation for Eastern empresses of the fourth through eighth century are taken mostly from James 2001, 168–69, appendix 1; dates for empresses and emperors of the middle through late Byzantine period are largely based on Garland 1999, 229–31, table 1.

| | | |
|---|---|---|
| *Aelia Flavia Flacilla | By marriage to Theodosios I (r. 379–95); *augusta* 379–85 | 1st wife of Theodosios I; from aristocratic Spanish family; mother of Arkadios (r. 395–408) and Honorios (emperor in the West 395–423) |
| Galla | Imperial birth; marriage to Theodosios I (r. 379–95); made *augusta* at unknown date; d. 394 | 2nd wife of Theodosios I; daughter of Justina and Valentinian I (emperor in the West 364–75); mother of Galla Placidia (*augusta* in the West 421–50) |
| *Aelia Eudoxia | By marriage to Arkadios (r. 395–408); *augusta* 400–404 | Wife of Arkadios; daughter of Frankish general and consul; mother of Theodosios II (r. 408–50) and Pulcheria (*augusta* 414–53) |
| Maria | By marriage to Honorios (emperor in the West 395–423) | 1st wife of Honorios; daughter of general and consul Stilicho (d. 408) |
| Thermantia | By marriage to Honorios (emperor in the West 395–423) | 2nd wife of Honorios; daughter of general and consul Stilicho (d. 408) |
| *Aelia Pulcheria | By imperial birth; marriage to Marcian (r. 450–57); *augusta* 414–53 | Older sister of Theodosios II; wife of Marcian |
| *Aelia Galla Placidia (regent 423–39) | Imperial birth; marriage to Constantius III (emperor in the West 421); made *augusta* 421 at husband's accession; d. 450 | Wife of Visigothic King Athaulf, then Constantius III; daughter of Galla and Theodosios I (r. 379–95); mother of Valentinian III (emperor in the West 425–55) and Justa Grata Honoria |
| *Aelia Eudokia | By marriage to Theodosios II (r. 408–50); made *augusta* at marriage in 423; d. 460 | Wife of Theodosios II; previous name Athenais, daughter of pagan Athenian philosopher; mother of Licinia Eudoxia |
| *Aelia Licinia Eudoxia | Imperial birth; marriage to Valentinian III (emperor in the West 425–55); *augusta* 439–55?; d. after 462 | Wife of Valentinian III; daughter of Eudokia and Theodosios II (r. 408–50); mother of Placidia |
| *Justa Grata Honoria | By imperial birth; *augusta* c. 426?–49? | Daughter of Galla Placidia and Constantius III (emperor in the West 421); sister of Valentinian III (emperor in the West 425–55) |
| *Aelia Verina | By marriage to Leo I (r. 457–74); made *augusta* c. 457 at husband's accession; d. 484 | Wife of Leo I; relative of Julius Nepos (emperor in the West 474–80) and Odoacer, Gothic leader; mother of Ariadne (*augusta* 474?–515) |
| *Aelia Marcia Euphemia | By marriage to Anthemios (emperor in the West 467–72); *augusta* | Wife of Anthemios; daughter of Marcian (r. 450–57) |
| Placidia | Imperial birth; marriage to Olybrios (emperor in the West 472) | Daughter of Licinia Eudoxia and Valentinian III (emperor in the West 425–55); mother of Anicia Juliana, ecclesiastical patron and heiress of the Theodosian imperial line |
| *Aelia Ariadne | Imperial birth; marriage to Zeno (r. 474–91); made *augusta* 474? at accession of Zeno; d. 515 | Wife of Zeno, then Anastasios I (r. 491–518); daughter of Verina and Leo I (r. 457–74) |
| *Aelia Zenonis | By marriage to Basiliskos (r. 475–76); made *augusta* 475 at husband's accession; d. 476 | Wife of Basiliskos, brother of Verina; perhaps relative of Zeno |
| Euphemia | By marriage to Justin I (r. 518–27); made *augusta* 518? at husband's accession? | Wife of Justin I; previous name Lupicina, former slave |

| | | |
|---|---|---|
| Theodora | By marriage to Justinian I (r. 527–65); made *augusta* 527 at promotion of husband to co-emperor?; d. 548 | Wife of Justinian I; former circus dancer; daughter of animal keeper Akakios and dancer/actress in the Constantinople hippodrome |
| *Aelia Sophia | By marriage to Justin II (r. 565–78); made *augusta* 565 at husband's accession | Wife of Justin II; niece of Theodora |
| *Aelia Anastasia | By marriage to Tiberios I (r. 578–82); made *augusta* 578 at husband's accession | Wife of Tiberios; previous name Ino; widow of John Optio; mother of Constantina (*augusta* by 585–602) |
| *Aelia Constantina | Imperial birth; marriage to Maurice (r. 582–602); *augusta* by 585–602; elevated at husband's accession? | Wife of Maurice; previous name Augusta; daughter of Anastasia and Tiberios (r. 578–82) |
| *Leontia | By marriage to Phokas (r. 602–10); made *augusta* 602 at husband's accession | Wife of Phokas; daughter of the patrician Sergios |
| Aelia Flavia Eudokia | By marriage to Herakleios, (r. 610–41); made *augusta* 610 at coronation; d. 612 | 1st wife of Herakleios, previous name Fabia; perhaps daughter of the exarch Rogas, head of an aristocratic African family; mother of Herakleios-Constantine (co-*augustus* 641) |
| *Martina* (co-ruler 641–42) | By marriage to Herakleios (r. 610–41); made *augusta* c. 613 at marriage | 2nd wife and niece of Herakleios; mother of Heraklonas (co-*augustus* 641–42) |
| Gregoria (regent 642–before 650?)[2] | By marriage to Herakleios-Constantine (co-*augustus* 641) | Wife of Herakleios-Constantine; daughter of Niketas, patrician and general; mother of Constans II (r. 641–68) |
| Fausta | By marriage to Constans II (r. 641–68); made *augusta* at unknown date | Wife of Constans II; of Armenian origin; daughter of Valentinos Arsakuni (usurper 645); mother of Constantine IV (r. 668–85) |
| Anastasia | By marriage to Constantine IV (*augustus* 668–85), made *augusta* at unknown date | Wife of Constantine IV, mother of Justinian II (*augustus* 685–95, 705–11) |
| Eudokia | By marriage to Justinian II (r. 685–95, 705–11) | 1st wife of Justinian II |
| Theodora | By marriage to Justinian II (r. 685–95, 705–11); made *augusta* after 705?, at husband's re-accession? | 2nd wife of Justinian II; sister of the khazar khagan |
| Irene | By marriage to Anastasios II (r. 713–15); made *augusta* at unknown date | Wife of Anastasios II |
| Maria | By marriage to Leo III (*augustus* 717–41), made *augusta* 718 at son's baptism | Wife of Leo III, mother of Constantine V (*augustus* 741–75) |
| Irene | By marriage to Constantine V (emperor 741–75) | 1st wife of Constantine V; former name Čiček, daughter of the khazar khagan; mother of Leo IV (r. 775–80) |
| Maria | By marriage to Constantine V (r. 741–75); made *augusta* at marriage 750–52? | 2nd wife of Constantine V |
| Eudokia | By marriage to Constantine V (r. 741–75); made *augusta* 769, at marriage? | 3rd wife of Constantine V |

2. Herrin 2001, 24–25.

| | | |
|---|---|---|
| *Irene* (regent 780–90, restored 792, sole ruler 797–802) | By marriage to Leo IV (r. 775–80); made *augusta* 768, just before marriage | Wife of Leo IV; from aristocratic Athenian family; mother of Constantine VI (r. 780–97); sanctified for restoration of holy icons |
| Maria of Amnia | By marriage to Constantine VI (r. 780–97); made *augusta*, at marriage in 788?; divorced and exiled 795 | 1st wife of Constantine VI; from aristocratic Amnian family; mother of Euphrosyne (wife of Michael II, r. 820–29) |
| Theodote | By marriage to Constantine VI (r. 780–97); made *augusta* 795 just before marriage | 2nd wife and former mistress of Constantine VI |
| Theophano | By marriage to Staurakios (r. 811); made *augusta*, at husband's accession? | Wife of Staurakios; from Athens; relative of Irene (sole ruler 797–802) |
| Prokopia | Imperial birth; marriage to Michael I Rangabè (r. 811–13) | Wife of Michael I Rangabè; daughter of Nikephoros I (r. 802–11); sister of Staurakios (r. 811) |
| Theodosia | By marriage to Leo V (r. 813–20) | Wife of Leo V; daughter of Armenian patrician Arsaber; as widow exiled by Michael II (r. 820–29) for her orthodox religious beliefs |
| Thekla | By marriage to Michael II (r. 820–29) | 1st wife of Michael II; daughter of Anatolian theme commander; mother of Theophilos (r. 829–42) |
| Euphrosyne | Imperial birth; marriage to Michael II (r. 820–29); made *augusta* at marriage?, date unknown | 2nd wife of Michael II; daughter of Maria of Amnia and Constantine VI (r. 780–97) |
| *Theodora* (regent 842–56) | By marriage to Theophilos (r. 829–42); made *augusta* 830 at marriage | Wife of Theophilos; from aristocratic Paphlagonian family; mother of Michael III (r. 842–67) and *augustae* *Thekla, *Anna, *Anastasia; sanctified for her permanent restoration of holy icons |
| *Thekla* (co-regent with Theodora (842–56?) | By imperial birth; made *augusta* at unknown date | Eldest child of Theodora and Theophilos (r. 829–42); sister of Michael III (r. 842–67) |
| Eudokia Dekapolitissa | By marriage to Michael III (r. 842–67); made *augusta* 855 at marriage? | Wife of Michael III; daughter of court official |
| *Eudokia Ingerina | By marriage to Basil I (r. 867–86); made *augusta* 867 at husband's accession | 2nd wife of Basil I; mistress of Michael III (emperor 842–67); daughter of court official, perhaps of Scandinavian origin; mother of Leo VI (r. 886–912) |
| Theophano Martinakiou | By marriage to Leo VI (r. 886–912); made *augusta* 882? at marriage?; d. c. 896 | 1st wife of Leo VI; daughter of patrician and relative of Eudokia Ingerina; sanctified |
| Zoe Zaoutzaina | By marriage to Leo VI (r. 886–912); made *augusta* 898?, at marriage?; d. c. 900 | 2nd wife and former mistress of Leo VI; daughter of Stylianos Zaoutzes, captain of palace guard; mother of Anna |
| Anna | By imperial birth; made *augusta* c. 900 by father, Leo VI (r. 886–912) | Daughter of Zoe Zaoutzaina and Leo VI; wife of Louis III of Provence |
| Eudokia Baiane | By marriage to Leo VI (r. 886–912); made *augusta* 900?, at marriage?; d. 901 | 3rd wife of Leo VI |
| *Zoe Karbounopsina* (regent 914–19) | By marriage to Leo VI (r. 886–912); made *augusta* 906, soon after baptism of son and marriage | 4th wife and former mistress of Leo VI; from aristocratic family influential at court; mother of Constantine VII (r. 913–59) |

| | | |
|---|---|---|
| Helena Lekapena | By marriage to Constantine VII (r. 913–59); made *augusta* c. 919? at marriage? | Wife of Constantine VII; daughter of Romanos Lekapenos (r. 920–44); mother of Romanos II (r. 959–63) and Theodora |
| Theodora | By marriage to Romanos I Lekapenos (r. 920–44) | Wife of Romanos I |
| Eudokia | By marriage in 944 to Romanos II (r. 959–63); d. 949 | 1st wife of Romanos II; previous name Bertha, daughter of Hugo, king of Italy |
| *Theophano* (regent 963) | By marriage to Romanos II (r. 959–63); made *augusta*, c. 955, at marriage?; d. 976 | 2nd wife of Romanos II; then 2nd wife of Nikephoros II Phokas (r. 963–69); previous name Anastaso, daughter of innkeeper?; mother of Basil II (r. 976–1025) and Constantine VIII (r. 1025–28) |
| Theodora | By imperial birth; marriage in 970 to John I Tzimiskes (r. 969–76) | Wife of John I Tzimiskes; daughter of Helena Lekapena and Constantine VII (r. 913–59) |
| Helena Alypia | By marriage to Constantine VIII (r. 1025–28) | Wife of Constantine VIII; mother of *augustae* Zoe and Theodora (co-rulers 1042) |
| *Zoe (co-ruler 1042 with Theodora) | By imperial birth; marriage to three emperors | Daughter of Helena Alypia and Constantine VIII (r. 1025–28); married Romanos III Argyros (r. 1028–34), Michael IV (r. 1034–41), Constantine IX Monomachos (r. 1042–55) |
| *Theodora* (co-ruler 1042 with Zoe; sole ruler 1055–56) | By imperial birth | Daughter of Helena Alypia and Constantine VIII (r. 1025–28) |
| Aikaterina | By marriage to Isaak I Komnenos (r. 1057–59) | Wife of Isaak I Komnenos; daughter of John Vladislav, ruler of Bulgaria |
| *Eudokia Makrembolitissa* (sole ruler 1067) | By marriage to Constantine IX Doukas (r. 1059–67); made *augusta*, at Constantine's accession? | 2nd wife of Constantine IX Doukas; then wife of Romanos IV Diogenes (r. 1068–71); niece of Michael Keroularios (patriarch 1043–58); mother of Michael VII Doukas (r. 1071–78) |
| *Maria of Alania (Georgia) | By marriage to Michael VII Doukas (r. 1071–78); made *augusta*, at Michael's accession? | Wife of Michael VII, then Nikephoros III Botaneiates (r. 1078–81); previous name Martha, daughter of Bagrat IV, king of Georgia (1027–72) |
| *Irene Doukaina | By marriage to Alexios I Komnenos (r. 1081–1118); made *augusta* 1081, soon after husband's accession | 2nd wife of Alexios I; daughter of general Andronikos Doukas and Maria of Bulgaria; mother of John II Komnenos (r. 1118–43) and chronicler Anna Komnene, *sebaste* (b. 1083, d. c. 1153) |
| *Anna Dalassene* (regent periodically during reign of Alexios I Komnenos)[3] | Granted regency by chrysobull of Alexios I Komnenos (r. 1081–1118) | Mother of Alexios I; wife of John I Komnenos, brother of Isaak I Komnenos (r. 1057–59) |
| *Irene of Hungary | By marriage to John II Komnenos (r. 1118–43); made *augusta*, at husband's accession?; d. 1134 | Wife of John II; previous name Piriska, daughter of Saint Ladislas of Hungary; mother of Manuel I Komnenos (r. 1143–80); sanctified |

3. Although not technically an empress, Anna Dalassene had substantial official powers as a regent.

| Irene of Sulzbach | By marriage to Manuel I Komnenos (r. 1143–80); made *augusta* at marriage in 1146?; d. c. 1159 | 1st wife of Manuel I; previous name Bertha, sister-in-law of Konrad III Hohenstaufen (king of Germany 1138–52) |
|---|---|---|
| *Maria-Xena of Antioch* (regent 1180–82) | By marriage to Manuel I Komnenos (r. 1143–80); made *augusta* 1161, at marriage?; d. 1182 | 2nd wife of Manuel I; previous name Marguerite-Constance, daughter of Count Raymond of Poitiers and Constance of Antioch; mother of Alexios II Komnenos (r. 1180–83) |
| Anna of Savoy | By marriage to Alexios II Komnenos (r. 1180–83); *augusta* | Wife of Alexios II, then Andronikos I Komnenos (r. 1183–85); previous name Agnes, daughter of Louis VII (king of France 1137–80) |
| Maria of Hungary | By marriage to Isaak II Angelos (r. 1185–95, 1203–4) | 2nd wife of Isaak II; former name Margaret, daughter of Béla III (king of Hungary from 1172) |
| Euphrosyne Doukaina | By marriage to Alexios III Angelos (r. 1195–1203); made *augusta*, at husband's accession?; d. c. 1211 | Wife of Alexios III; daughter of Andronikos Doukas Kamateros (eparch of Constantinople); mother of Eudokia (wife of Alexios V Doukas, r. 1204) and Anna (wife of Theodore I Laskaris (r. 1204–21) |
| Eudokia | Imperial birth; marriage to Alexios V Doukas Mourtzouphlos (r. 1204) | 2nd wife of Alexios V; then married Leo Sgouros, ruler of Corinth; daughter of Euphrosyne and Alexios III Angelos (r. 1195–1203) |

# Empire of Nicaea (the Byzantine Empire in exile from Constantinople 1204–61)

| Anna | Imperial birth; marriage (1199) to Theodore I Laskaris (first emperor of Nicaea, r. 1204–21) | 1st wife of Theodore I; daughter of Euphrosyne Doukaina and Alexios III Angelos (r. 1195–1203); mother of Irene |
|---|---|---|
| Philippa | By marriage to Theodore I Laskaris (first emperor of Nicaea, r. 1204–21) | 2nd wife of Theodore I; from Lesser Armenia |
| Maria of Courtenay | By marriage (1219) to Theodore I Laskaris (first emperor of Nicaea, r. 1204–21) | 3rd wife of Theodore I; daughter of Yolande, Latin empress of Constantinople (sole ruler 1217–19) |
| Irene | Imperial birth; marriage to John III Doukas Vatatzes (r. 1221–54) | 1st wife of John III; daughter of Anna and Theodore I Laskaris (r. 1204–21); mother of Theodore II Doukas Laskaris (r. 1254–58) |
| Anna of Hohenstaufen | By marriage (1244) to John III Doukas Vatatzes (r. 1221–54) | 2nd wife of John III; previous name Constance, daughter of Frederick III Hohenstaufen (king of Sicily 1198–1250, emperor of Germany 1212–50) |
| Helena | By marriage to Theodore II Laskaris (r. 1254–58) | Wife of Theodore II; daughter of John Asen II (tsar of Bulgaria 1218–41); mother of John IV Laskaris (r. 1258–61) |

# Empire Restored to Constantinople (1261–1453)

| Theodora Doukaina Komnene Palaiologina | By marriage to Michael VIII Palaiologos (r. 1259–82) | Wife of Michael III; great-niece of John III Doukas Vatatzes (emperor of Nicaea 1221–54); mother of Andronikos II Palaiologos (r. 1282–1320) |
|---|---|---|

| | | |
|---|---|---|
| Anna of Hungary | By marriage (1273) to Andronikos II Palaiologos (r. 1282–1320); d. 1281/2 | 1st wife of Andronikos II; daughter of Stephen V (king of Hungary); mother of Michael IX Palaiologos (co-emperor 1294–1320) |
| Irene of Montferrat | By marriage (1284/5) to Andronikos II Palaiologos (r. 1282–1320); crowned after son's birth 1288/9; d. 1317 | 2nd wife of Andronikos II; previous name Yolanda, daughter of William VII of Montferrat; heiress to Kingdom of Thessaloniki |
| Maria of Armenia | By marriage (1296) to Michael IX Palaiologos (co-emperor 1294–1320) | Wife of Michael IX; previous name Rita, sister of Het'um (ruler of Armenian Cicilia); mother of Andronikos III Palaiologos (r. 1328–41) |
| Irene of Brunswick | By marriage to Andronikos III Palaiologos (r. 1328–41); d. 1322 | 1st wife of Andronikos III; previous name Adelheid of Brunswick–Grubenhägen |
| *Anna of Savoy (regent 1341–47, ruler of Thessaloniki 1352–65) | By marriage (1326) to Andronikos III Palaiologos (r. 1328–41); d. 1365 | 2nd wife of Andronikos III; previous name Giovanna, daughter of Count Amadeus V of Savoy; mother of John V Palaiologos (r. 1341–91) |
| Helena | By marriage (1326) to John V Palaiologos (r. 1341–91) | Wife of John V; daughter of Irene Asanina and John VI Kantakouzenos (rival emperor 1347–54); mother of Andronikos IV Palaiologos (r. 1376–79) and Manuel II Palaiologos (r. 1391–1425) |
| Irene Asanina | By marriage to John VI Kantakouzenos (r. 1347–54) | Wife of John VI; mother of Matthew Kantakouzenos (co-emperor 1353–57) |
| Maria | By marriage to Andronikos IV Palaiologos (r. 1376–79) | Wife of Andronikos IV; previous name Kyratza, daughter of Ivan Alexander (tsar of Bulgaria 1331–71) |
| Eugenia | By marriage to John VII Palaiologos (r. 1390) | Wife of John VII; daughter of Francesco II Gattilusio (ruler of Mytilene/Lesbos) |
| Helena | By marriage (1392) to Manuel II Palaiologos (r. 1391–1425); d. 1450 | Wife of John Manuel II; daughter of Constantine Dragash (ruler of Serbia, d. 1395); mother of John VIII Palaiologos (r. 1425–48) and Constantine IX Palaiologos (r. 1449–53) |
| Anna | By marriage to John VIII Palaiologos (r. 1425–48) | 1st wife of John VIII; daughter of Basil I (grand duke of Moscow and Vladimir 1389–1425) |
| Sophia of Montferrat | By marriage to John VIII Palaiologos (r. 1425–48) | 2nd wife of John VIII |
| Maria Komnene of Trebizond | By marriage to John VIII Palaiologos (r. 1425–48) | 3rd wife of John VIII |
| Theodora | By marriage to Constantine IX Palaiologos (r. 1449–53) | 1st wife of Constantine IX; previous name Maddelena, daughter of Leonardo II Tocco |
| Caterina | By marriage to Constantine IX Palaiologos (r. 1449–53) | 2nd wife of Constantine IX; daughter of Dorino Gattilusio |

# Bibliography

Note: Exhibition catalogues are listed by abbreviated title and date.

*DOP=Dumbarton Oaks Papers*
*JÖB=Jahrbuch der Österreichischen Byzantinistik*

Adler, A., ed. 1928–38. *Suidae Lexicon*. Stuttgart.

*Age of Spirituality*. 1979. Weitzmann, K., ed. *Age of Spirituality: Late Antique and Early Christian Art, Third to Seventh Century*. Exh. cat., The Metropolitan Museum of Art. New York.

Alföldi, A. 1934. "Insignien und Tracht der römischen Kaiser." *Mitteilungen des deutschen archäologischen Instituts, römische Abteilung* 50:3–158.

Alföldi, M. 1963. *Die Constantinische Goldprägung*. Mainz am Rhein.

Amandry, P. 1963. *Collection Hélène Stathatos*. Vol. 3, *Objets antiques et byzantins*. Strasbourg.

Amiaud, A. 1889. *La légende syriaque de saint Alexis, l'homme de Dieu*. Paris.

*Ancient Art New York*. 1961. Von Bothmer, D. *Ancient Art from New York Private Collections: Catalogue of an Exhibition Held at the Metropolitan Museum of Art, December 17, 1959–February 28, 1960*. Exh. cat., The Metropolitan Museum of Art. New York.

*Ancient Portraits*. 1970. *Ancient Portraits: A Show of Greek, Etruscan, and Roman Sculptured Portraits in Honor of the Seventieth Birthday of T. R. S. Broughton, Paddison Professor of Classics. Ackland Art Center, University of North Carolina at Chapel Hill, April 5–May 17, 1970*. Exh. cat., University of North Carolina. Chapel Hill, N.C.

Angelidi, C., and T. Papamastorakis. 2000. "The Veneration of the Virgin Hodegetria and the Hodegon Monastery." In *Mother of God*.

Angelova, D. 1998. The Ivories of Ariadne and the Construction of the Image of the Empress and the Theotokos in Late Antiquity. Master's thesis, Southern Methodist University.

Angold, M. 1984. Introduction to *The Byzantine Aristocracy, IX to XIII Centuries*. Oxford.

———. 1995. *Church and Society in Byzantium under the Comneni, 1081–1261*. Cambridge.

Anisimov, A. 1928. *Our Lady of Vladimir*. Prague.

*Antioch*. 2000. Kondoleon, C., ed. 2000. *Antioch: The Lost Ancient City*. Exh. cat., Worcester Art Museum, Worcester, Mass. Princeton.

Ariadne Galleries. 1988. *Byzantium: The Light in the Age of Darkness*. New York.

Aries, P., and G. Duby, eds. 1987–91. *A History of Private Life*. Vol. 1, *From Pagan Rome to Byzantium*. Cambridge, Mass., and London.

*Art and Holy Powers*. 1989. Maguire, E. D., H. P. Maguire, and M. J. Duncan-Flowers, with contributions by A. Gonosová and B. Oehlschlager-Garvey. *Art and Holy Powers in the Early Christian House*. Exh. cat., Krannert Art Museum, University of Illinois at Urbana-Champaign. Champaign, Ill.

*Art of Seals*. 1984. Root, M. C., ed. *The Art of Seals: Aesthetic and Social Dynamics of the Impressed Image from Antiquity to Present*. Exh. cat., Kelsey Museum of Archaeology, University of Michigan. Ann Arbor.

*Art of the Late Antique*. 1968. *Art of the Late Antique from American Collections: A Loan Exhibition of the Poses Institute of Fine Arts, Rose Art Museum, Brandeis University, December 18, 1968–February 16, 1969*. Exh. cat., Rose Art Museum. Waltham, Mass.

Attaleiates, M. (11th–12th century). 1853. *Michaelis Attaliotae Historia*. Edited by I. Bekker. Corpus Scriptorum Historiae Byzantinae, vol. 50. Bonn.

Aubert, J.-J. 1989. "Threatened Wombs: Aspects of Ancient Uterine Magic." *Greek, Roman, and Byzantine Studies* 30:421–49.

Babelon, E. 1897. *Catalogue des camées antiques et modernes de la Bibliothèque Nationale*. Paris.

Badawy, A. 1978. *Coptic Art and Archaeology*. Cambridge, Mass.

Bakalova, E. 1978. "La vie de Sainte Parascève de Tirnovo dans l'art balkanique du bas moyen âge." *Byzantinobulgarica* 5:175–209.

Bakirtzis, C. 1989. "Byzantine Amphorae." In *Recherches sur la céramique byzantine*, edited by V. Déroche and J. M. Spieser. *Bulletin de correspondance hellénique. Supplément* 43:73–77.

Barb, A. A. 1953. "Diva Matrix." *Journal of the Warburg and Courtauld Institutes* 16:193–238.

Barber, E. W. 1994. *Women's Work: The First 20,000 Years. Women, Cloth, and Society in Early Times*. New York and London.

Barns, J. R. 1991. *Icon Collections in the United States*. Torrance, Calif.

Barns, J. W. B., and H. Zilliacus. 1960. *The Antinoopolis Papyri*. Vol. 2. London.

Bartman, E. 2001. "Hair and the Artifice of Roman Female Adornment." *American Journal of Archaeology* 105:1–25.

Bates, G. 1968. "A Byzantine Hoard from Coelesyria." *American Numismatic Society Museum Notes* 14:67–109.

Beaucamp, J. 1990, 1992. *Le statut de la femme à Byzance (4e–7e siècle)*. 2 vols. Paris.

———. 1993. "Organisation domestique et rôles sexuels: Les papyrus byzantins." *DOP* 47: 185–94.

Beckwith, J. 1963. *Coptic Sculpture 300–1300*. London.

Belting, H. 1994. *Likeness and Presence: A History of the Image before the Era of Art*. Chicago and London.

Belting-Ihm, C. 1976. *"Sub matris tutela": Untersuchungen zur Vorgeschichte der Schutzmantelmadonna*. Heidelberg.

———. 1992. *Die Programme der christlichen Apsismalerei vom vierten Jahrhundert bis zur Mitte des achten Jahrhunderts*. Forschungen zur Kunstgeschichte und Christlichen Archäologie, vol. 4. Stuttgart.

Bénazeth, D. 1992. *L'art du métal au début de l'ère chrétienne: Catalogue du département des antiquités égyptiennes, Musée du Louvre*. Paris.

———. 2000. *L'art copte en Egypte*. Paris.

Bendall, S. 1996. *Byzantine Weights: An Introduction*. London.

Bendall, S., and P. J. Donald. 1979. *The Later Palaeologan Coinage*. Bristol.

Benko, S. 1993. *The Virgin Goddess: Studies in the Pagan and Christian Roots of Mariology*. Leiden.

Bensammar, E. 1976. "La titulature de l'impératrice et sa signification." *Byzantion* 46: 243–91.

Berger, A. 1982. *Das Bad in der byzantinischen Zeit*. München.

———. 2001. "Imperial and Ecclesiastical Processions in Constantinople." In *Byzantine Constantinople: Monuments, Topography, and Everyday Life*, edited by N. Necipoglu. Leiden, Boston, and Cologne.

Bergmann, B., and W. M. Watson. 1999. *The Moon and Stars: Afterlife of a Roman Empress*. South Hadley, Mass.

Bergmann, M. 1977. *Studien zum römischen Porträt des 3. Jahrhunderts n. Chr*. Bonn.

Betz, H. D., ed. 1992. *The Greek Magical Papyri in Translation, Including the Demotic Spells*. 2nd edition. Chicago.

*Beyond the Pharaohs*. 1989. Friedman, F., ed. *Beyond the Pharaohs: Egypt and the Copts in the Second to Seventh Centuries AD*. Exh. cat., Museum of Art of the Rhode Island School of Design. Providence.

*BHG*. 1969. *Bibliotheca Hagiographica Graeca*. 3 vols. 3rd edition. Edited by F. Halkin. Brussels.

Boardman, J. 1968. *Engraved Gems: The Ionides Collection*. Evanston, Ill.

Bondar, I. V., and T. I. Makarova. 1975. *Orfèvrerie ancienne de la collection du Musée des Trésors Historiques d'Ukraine*. Moscow.

Bonner, C. 1950. *Studies in Magical Amulets, Chiefly Graeco-Egyptian*. University of Michigan Studies: Humanistic Series, vol. 49. Ann Arbor.

Borromeo, G. 1987. "Tyche and Fortuna: The Personification of Chance and Imperial Cities." In *Survival of the Gods*.

Bouras, L. 1967. *Coptic Art*. Translated by C. Hay-Shaw. London.

———. 1982. "Byzantine Lighting Devices." *JÖB* 32:479–91.

Boyd, S. 1979. *Byzantine Art*. Chicago.

*Bradley Icons*. 1973. Peterson, T. G. 1973. *Byzantine, Greek, and Russian Icons. Image, Picture, God, Likeness: An Exhibition [from the Private Collection of Mr. and Mrs. Eric Bradley], 5–26 May 1973, University College, Cardiff*. Exh. cat., University College. Cardiff.

Brilliant, R. 1963. *Gesture and Rank in Roman Art*. Memoirs of the Connecticut Academy of Arts and Sciences, vol. 14. New Haven.

Brock, S. P., and S. A. Harvey, trans. 1987. *Holy Women of the Syrian Orient*. The Transformation of the Classical Heritage, vol. 13. Berkeley.

Broucke, P. B. J. F. 1994. "Tyche and the Fortune of Cities in the Greek and Roman World." In *Obsession*.

Brown, P. L. 1987. "East and West: The New Marital Morality." In *A History of Private Life*. Vol. 1, *From Pagan Rome to Byzantium*, edited by P. Veyne. Cambridge, Mass.

Brown, P. R. L. 1978. *The Making of Late Antiquity*. Cambridge, Mass.

Brubaker, L. 1994. "To Legitimize an Emperor: Constantine and Visual Authority in the Eighth and Ninth Centuries." In *New Constantines: The Rhythm of Imperial Renewal in Byzantium, Fourth–Thirteenth Centuries. Papers from the Twenty-Sixth Spring Symposium of Byzantine Studies, Saint Andrews, March 1992*. Saint Andrews, Scotland.

———. 1997. "Memories of Helena: Patterns in Imperial Female Matronage in the Fourth and Fifth Centuries." In *Women, Men, and Eunuchs: Gender in Byzantium*, edited by L. James. London and New York.

———. 1999. *Vision and Meaning in Ninth-Century Byzantium: Image as Exegesis in the Homilies of Gregory of Nazianzus*. Cambridge and New York.

Bryennios, Joseph the Monk. 1768–84. *Ioseph monachou tou Bryenniou ta heurethenta* [The discovered writings of Joseph the Monk Bryennios]. 3 vols. Edited by E. Boulgares and T. Mandakases. Leipzig.

Buckton, D., ed. 1994. *Byzantium: Treasures of Byzantine Art and Culture from British Collections*. London.

Bühl, G. 1995. *Constantinopolis und Roma: Städtepersonifikationen der Spätantike*. Zürich.

*Bulletin of the Fogg*. 1945. "Dumbarton Oaks Research Library and Collection." *The Bulletin of the Fogg Museum of Art* 10, no. 4:107–26.

———. 1947. "Dumbarton Oaks Research Library and Collection: Acquisitions December 1, 1946–November 1, 1947." *The Bulletin of the Fogg Museum of Art* 10, no. 6.

Buschhausen, H. 1962–63. "Frühchristliches Silberreliquiar aus Isaurien." *Jahrbuch der Österreichischen byzantinischen Gesellschaft* 11, no. 12:137–68.

*Byzance*. 1992. *Byzance: L'art byzantin dans les collections publiques françaises*. Exh. cat., Musée du Louvre. Paris.

*Byzantium at Princeton*. 1986. Curcic, S., and A. St. Clair, eds. *Byzantium at Princeton: Byzantine Art and Archeology at Princeton University. Catalogue of an Exhibition at Firestone Library, August 1 through October 26, 1986*. Exh. cat, Firestone Library, Princeton University. Princeton.

Cahn, H. A., and A. Kaufmann. 1984. *Der spät-römische Silberschatz von Kaiseraugst*. Derendingen.

Calinescu, A. 1994. *The Art of Ancient Jewelry: An Introduction to the Burton Y. Berry Collection*. Bloomington, Ind.

Calza, R. 1972. *Iconografia Romana Imperiale*. Rome.

Cameron, Alan. 1973. *Porphyrius the Charioteer*. Oxford.

Cameron, Averil. 1967. "Notes on the Sophiae, the Sophianae, and the Harbor of Sophia." *Byzantion* 37:11–20.

———. 1975. "The Empress Sophia." *Byzantion* 45:5–21.

———. 1979. "The Virgin's Robe: An Episode in the History of Early Seventh-Century Constantinople." *Byzantion* 49:42–56.

———. 1981. "Images of Authority: Élites and Icons in Late Sixth-Century Byzantium." In *Byzantium and the Classical Tradition: University of Birmingham Thirteenth Spring Symposium of Byzantine Studies, 1979*, edited by M. Mullett and R. Scott. Birmingham.

Cameron, Averil, and J. Herrin, eds. 1984. *Constantinople in the Early Eighth Century: The Parastaseis syntomoi chronikai: Introduction, Translation, and Commentary*. In conjunction with Alan Cameron, R. Cormack, and C. Roueché. Leiden.

Campbell, S. D. 1994. "Enhanced Images: The Power of Gems in Abstract Personifications." In *La Mosaïque gréco-romaine IV, Trèves, 8–14 août 1984*, edited by J.-P. Darmon and A. Rebourg. Paris.

———, ed. 1985. *The Malcove Collection: A Catalogue of the Objects in the Lillian Malcove Collection of The University of Toronto*. Toronto, Buffalo, and London.

Carr, A. W. 1997. "Court Culture and Cult Icons in Middle Byzantine Constantinople." In *Byzantine Court Culture from 829 to 1204*, edited by H. P. Maguire. Washington, D.C.

———. 2000. "The Mother of God in Public." In *Mother of God*.

———. 2001. "Threads of Authority: The Virgin Mary's Veil in the Middle Ages." In *Robes and Honor: The Medieval World of Investiture*, edited by S. Gordon. New York.

Carroll, D. L. 1988. *Looms and Textiles of the Copts: First Millennium Egyptian Textiles in the Carl Austin Rietz Collection of the California Academy of Sciences*. San Francisco.

Caseau, B. A. 1994. Euodia: The Use and Meaning of Fragrances in the Ancient World and Their Christianization (100–900 AD). Ph.D. diss., Princeton University.

Cecchelli, C. 1947. "L'anello bizantino del Museo di Palermo." In *Miscellanea Guillaume de Jerphanion*. Orientalia Christiana Periodica, vol. 13. Rome.

Chatzidakis, M. 1939–43. "Un anneau byzan-tin du Musée Benaki." *Byzantinisch-Neugriechische Jahrbücher* 17:174–206.

Cheynet, J.-C., and C. Morrisson. 1994. "Texte et image sur les sceaux byzantins: Les raisons d'un choix iconographique." In *Studies in Byzantine Sigillography*. Vol. 4. Edited by Nicolas Oikonomides. Washington, D.C.

Choniates, N. 1984. *O City of Byzantium: Annals of Niketas Choniates*. Translated by H. J. Magoulias. Detroit.

*Chronicon Paschale* (7th century). 1989. *Chronicon Paschale 284–628 AD*. Translated by Michael Whitby and Mary Whitby. Liverpool.

Chrysostom, Saint John (4th century). 1986. *On Marriage and Family Life*. Translated by C. P. Roth and D. Anderson. Crestwood, N.Y.

Clark, E. 1984. *The Life of Melania the Younger: Introduction, Translation, and Commentary*. New York and Toronto.

Clark, G. 1993. *Women in Late Antiquity: Pagan and Christian Lifestyles*. Oxford and New York.

Clement of Alexandria (2nd–3rd century). 1954. *Christ the Educator*. Translated by S. P. Wood. New York.

Coche de la Ferté, É., and O. Guistina. 1981. *L'art de Byzance*. Paris.

Comnena, A. (11th–12th century). 1967. *The Alexiad of the Princess Anna Comnena: Being the History of the Reign of Her Father, Alexius I, Emperor of the Romans, 1081–1118 A.D.* Translated by E. A. S. Dawes. New York.

———. 1969. *The Alexiad of Anna Comnena*. Translated by E. R. A. Sewter. Baltimore.

Comstock, M., and C. C. Vermeule. 1971. *Greek, Etruscan, and Roman Bronzes in the Museum of Fine Arts, Boston*. Boston.

———. 1976. *Sculpture in Stone: The Greek, Roman, and Etruscan Collections of the Museum of Fine Arts, Boston*. Boston.

Connor, C. L. 1998. *The Color of Ivory: Polychromy on Byzantine Ivories*. Princeton.

Constantine VII Porphyrogenitus (10th century). 1829. *De ceremoniis aulae Byzantinae libri duo*. Edited by J. J. Reiske. Corpus Scriptorum Historiae Byzantinae, vol. 9. Bonn.

———. 1939. *De ceremoniis: Le livre des cérémonies*. Vol. 2, bk. 1. Translated by A. Vogt. Paris.

———. 1967. *De ceremoniis: Le livre des cérémonies*. Edited and translated by A. Vogt. 2 vols. Paris.

Constas, N. P. 1995. "Weaving the Body of God: Proclus of Constantinople, the Theotokos, and the Loom of the Flesh." *Journal of Early Christian Studies* 3, no. 2:169–94.

———. 1996. "Life of St. Mary/Marinos." In *Holy Women of Byzantium*, edited by A.-M. Talbot. Washington, D.C.

Cooper, K. 1995. "A Saint in Exile: The Early Medieval Thecla at Rome and Meriamlik." *Hagiographica* 2:1–23.

Corippus, F. C. (6th century). 1976. *In laudem Iustini Augusti minoris, libri IV* [In praise of Justin II]. Edited and translated by Averil Cameron. London.

Cormack, R. 1997. *Painting the Soul: Icons, Death Masks, and Shrouds*. London.

———. 2000. "The Mother of God in the Mosaics of the Hagia Sophia at Constanti-nople." In *Mother of God*.

Corson, R. 1972. *Fashions in Makeup*. London.

*Cradle of Christianity.* 2000. Israeli, Y., and D. Mevorah, eds. *Cradle of Christianity.* Exh. cat., The Israel Museum. Jerusalem.

Cramer, M. 1964. *Koptische Buchmalerei.* Recklinghausen, Germany.

Crawford, J. S. 1990. *The Byzantine Shops at Sardis.* Cambridge, Mass.

Crowfoot, G. M., and D. B. Harden. 1931. "Early Byzantine and Later Glass Lamps." *Journal of Egyptian Archaeology* 17:196–208.

Cuno, J., M. B. Cohn, I. Gaskell, D. M. Kao, D. G. Mitten, R. D. Mowry, P. Nisbet, W. W. Robinson, and S. C. Welch. 1996. *Harvard's Art Museums: 100 Years of Collecting.* Cambridge, Mass., and New York.

Cutler, A. 1985. *The Craft of Ivory: Sources, Techniques, and Uses in the Mediterranean World: A.D. 200–1400.* Washington, D.C.

D'Ambra, E. 1993a. *Roman Art in Context.* Englewood Cliffs, N.J.

———. 1993b. *Private Lives, Imperial Virtues: The Frieze of the Forum Transistorum in Rome.* Princeton.

Dagron, G. 1974. *Naissance d'une capitale: Constantinople et ses institutions de 330 à 451.* Paris.

———. 1978. *Vie et miracles de Sainte Thecle: Texte grec, traduction, et commentaire.* Brussels.

———. 1984. *Constantinople imaginaire: Études sur le recueil des Patria.* Paris.

*Daily Life.* 2002. Greek Ministry of Culture, Directorate of Byzantine and Post-Byzantine Monuments, Museum of Byzantine Culture. *Kathemerine Zoe sto Vyzantio* [Daily life in Byzantium]. Exh. cat., Museum of Byzantine Culture, Thessaloniki. Athens.

*Dark Ages.* 1937. Worcester Art Museum. *The Dark Ages: Loan Exhibition of Pagan and Christian Art in the Latin West and Byzantine East: February 20–March 21, 1937.* Exh. cat., Worcester Art Museum. Worcester, Mass.

Darkevich, V. P. 1975. *Svetskoe iskusstvo Vizantii: Proizvedeniia vizantiisk. khudozh. remesla v Vost. Evrope X–XII v.* [Byzantine secular art: Works in Eastern Europe, 10th–12th century]. Moscow.

Davezac, B. 1988. "Spirituality in the Christian East: Greek, Slavic, and Russian Icons from the Menil Collection." Typescript of a catalogue in development, The Menil Collection, Houston.

Davis, S. 2001. *The Cult of Saint Thecla: A Tradition of Women's Piety in Late Antiquity.* Oxford.

Dawes, E., and N. H. Baynes, trans. 1948. *Three Byzantine Saints: Contemporary Biographies.* Oxford.

De Kersauson, K. 1996. *Catalogue des portraits romains.* Vol. 2, *De l'année de la guerre civile (68–69 après J.-C.) à la fin de l'Empire.* Paris.

Delbrueck, R. 1933. *Spätantike Kaiserporträts.* Berlin and Leipzig.

Demandt, A. 1986. "Der Kelch von Ardabur und Anthusa." *DOP* 40:113–17.

De Moore, A., ed. 1993. *Koptisch textiel uit vlaamse prive-verzamelingen: Coptic Textiles from Flemish Private Collections.* Zottegem, Belgium.

Denis, P. 1995/1996. "Scenes of Marriage in Byzantium." *Rotunda* 28, no. 3:18–23.

Deppert, B. 1995. "Byzantine." In *A Golden Legacy: Ancient Jewelry from the Burton Y. Berry Collection at the Indiana University Art Museum,* edited by W. Rudolph. Bloomington, Ind.

Deppert-Lippitz, B. 2000. "Late Roman and Early Byzantine Jewelry." In *From Attila to Charlemagne: Arts of the Early Medieval Period in The Metropolitan Museum of Art,* edited by K. Reynolds Brown, D. Kidd, and C. T. Little. New York.

Depuydt, L. 1993. *Catalogue of Coptic Manuscripts in the Pierpont Morgan Library.* 2 vols. Leuven.

De Ricci, S. 1912. *Catalogue of a Collection of Ancient Rings Formed by the Late E. Guilhou.* Paris.

De Ridder, A. 1911. *Collection de Clercq, Catalogue.* Vol. 1, *Les bijoux.* Paris.

De Voragine, J. (13th century). 1931. *The Golden Legend.* Translated by W. Caxton. Temple Classics. London.

De Wald, E. T. 1942. *The Illustrations in the Manuscripts of the Septuagint.* Vol. 3, *Psalms and Odes.* Princeton.

Dickie, M. W. 1995. "The Fathers of the Church and the Evil Eye." In *Byzantine Magic,* edited by H. P. Maguire. Washington, D.C.

Diehl, C. 1906, 1908. *Figures Byzantines.* 2 vols. Paris. [English: Bell, H., and T. de Kerpely, trans. 1963. *Byzantine Empresses.* London.]

*DOC.* Bellinger, A. R., and P. Grierson, eds. 1966–99. *Catalogue of the Byzantine Coins in the Dumbarton Oaks Collection and in the Whittemore Collection.* 5 vols. Washington, D.C.

*DO Handbook.* 1955. *The Dumbarton Oaks Collection, Harvard University: Handbook.* Washington, D.C.

———. 1967. Trustees of Harvard University. *Handbook of the Byzantine Collection.* Washington, D.C.

Dodd, E. C. 1974. *Byzantine Silver Treasures.* Bern.

Dölger, F. J. 1929. *Antike und Christentum.* Münster.

*DOSeals.* Nesbitt, J., and N. Oikonomides, eds. 1991–2001. *Catalogue of Byzantine Seals at Dumbarton Oaks and in the Fogg Museum of Art.* 4 vols. Washington, D.C.

Doxiadis, E. 1995. *The Mysterious Fayum Portraits: Faces from Ancient Egypt.* New York.

Drerup, H. 1933. *Die Datierung der Mumienporträts.* Paderborn, Germany.

Drijvers, J. W. 1992. *Helena Augusta: The Mother of Constantine the Great and the Legend of Her Finding the True Cross.* Leiden.

Drossoyianni, P. A. 1982. "A Pair of Byzantine Crowns." *JÖB* 32, no. 3:529–37.

Du Bourguet, P. 1964. *Catalogue des étoffes coptes: Musée national du Louvre.* Paris.

Ducas, M. 1839. *Historia Byzantina.* Edited by I. Bekker. Bonn.

Dunbabin, K. M. D. 1999. *Mosaics of the Greek and Roman World.* Cambridge.

*Early Christian and Byzantine Art.* 1947. The Walters Art Gallery. *Early Christian and Byzantine Art: An Exhibition Held at the Baltimore Museum of Art, April 25–June 22, 1947.* Exh. cat., The Walters Art Gallery. Baltimore.

Edelstein, E. J., and L. Edelstein. 1975. *Asclepius: A Collection and Interpretation of the Testimonies.* New York.

Edgar, C. C. 1905. *Catalogue général des antiquités égyptiennes du Musée du Caire*. Vol. 26, *Graeco-Egyptian Coffins, Masks, and Portraits*. Cairo.

Egeria (4th century). 1981. *Egeria's Travels to the Holy Land*. Translated by J. Wilkinson. 2nd ed. Jerusalem.

Eliot, C. W. J. 1976. "A Bronze Counterpoise of Athena." *Hesperia* 45, no. 2:163–71.

Elsner, J. 1995. *Art and the Roman Viewer: The Transformation of Art from the Pagan World to Christianity*. Cambridge, New York, and Melbourne.

————. 1998. *Imperial Rome and Christian Triumph: The Art of the Roman Empire AD 100–450*. Oxford and New York.

Emmanuel, M. 1993–94. "Hairstyles and Headdresses of Empresses, Princesses, and Ladies of the Aristocracy in Byzantium." *Deltion tis Christ. Arch. Het.* 17:113–20.

————. 1995. "Some Notes on the External Appearance of Ordinary Women in Byzantium. Hairstyles, Headdresses: Texts and Iconography." *Byzantinoslavica* 56, no. 3:769–78.

Ennabli, A. 1986. "Les thermes du Thiase marin de Sidi Ghrib." *Monuments et Mémoires* 68:1–59.

Ettinghausen, R., and O. Grabar. 1987. *The Art and Architecture of Islam, 650–1250*. New Haven and London.

Eunapius. 1952. *Philostratus and Eunapius: The Lives of the Sophists*. Translated by W. C. Wright. Cambridge, Mass., and London.

Evans, H. C., M. Holcomb, and R. Hallman. 2001. *The Metropolitan Museum of Art Bulletin* 58, no. 4: *The Arts of Byzantium*.

Ewald, B. C. 1999. *Der Philosoph als Leitbild: Ikonographische Untersuchungen an römischen Sarkophagreliefs*. Mainz am Rhein.

Fear, A. T. 1996. "The Dancing Girls of Cadiz." In *Women in Antiquity*, edited by I. McAuslan and P. Walcot. Oxford.

Fejfer, J. 1999. "What Is a Private Roman Portrait?" In *Antike Porträts zum Gedächtnis von Helga von Heintze*, edited by H. von Steuben. Möhnesee, Germany.

Finney, P. C. 1987. "Images on Finger Rings and Early Christian Art." *DOP* 41:181–86.

Fittschen, K., and P. Zanker. 1983. *Katalog der römischen Porträts in den Capitolinischen Museen und den anderen kommunalen Sammlungen der Stadt Rom*. Mainz am Rhein.

Folda, J. 1992. "The Saint Marina Icon: *Maniera Cypria, Lingua Franca*, or Crusader Art?" In *Four Icons in the Menil Collection*, edited by B. Davezac. Houston.

Foss, C. 1976. *Byzantine and Turkish Sardis*. Cambridge, Mass.

————. 1990. *Roman Historical Coins*. London.

————. 1996. *Nicaea: A Byzantine Capital and Its Praises*. Brookline, Mass.

Franken, N. 1994. *Aequipondia: Figürliche Laufgewichte römischer und frühbyzantinischer Schnellwaagen*. Alfter, Germany.

Frantz, A. 1940–41. "Digenis Akrites: A Byzantine Epic and Its Illustrations." *Byzantion* 15:87–91.

Frendo, J. D. C. 1984. "The Poetic Achievement of George of Pisidia." In *Maistor: Classical, Byzantine, and Renaissance Studies for Robert Browning*, edited by A. Moffatt. Canberra.

Freshfield, E. H. 1938. "Roman Law in the Later Roman Empire. Byzantine Guilds, Professional and Commercial: Ordinances of Leo VI, c. 895." In *The Book of the Eparch*, translated by E. H. Freshfield. Cambridge.

————, trans. 1926. *A Manual of Roman Law: The Ecloga*. Cambridge.

Gamble, H. Y. 1995. *Books and Readers in the Early Church: A History of Early Christian Texts*. New Haven.

Ganina, O. 1974. *The Kiev Museum of Historic Treasures*. Translated by A. Bilenko. Kiev.

Garland, L. 1988. "The Life and Ideology of Byzantine Women: A Further Note on Conventions of Behaviour and Social Reality As Reflected in Eleventh and Twelfth Century Historical Sources." *Byzantion* 58:361–93.

————. 1990a. "'Be Amorous, but Be Chaste . . .': Sexual Morality in Byzantine Learned and Vernacular Romance." *Byzantine and Modern Greek Studies* 14:62–120.

————. 1990b. "'And His Bald Head Shone Like a Full Moon . . .': An Appreciation of the Byzantine Sense of Humour As Recorded in Historical Sources of the Eleventh and Twelfth Centuries." *Paragone* n.s. 8, no. 1:1–32.

————. 1999. *Byzantine Empresses: Women and Power in Byzantium, AD 527–1204*. London and New York.

Gazda, E. K., and J. Royer. 1983. "Domestic Life." In *Karanis, An Egyptian Town in Roman Times: Discoveries of the University of Michigan Expedition to Egypt (1924–1935)*. Ann Arbor.

Gerontius (5th century). 1984. *The Life of Melania the Younger*. Translated by E. A. Clark. Studies in Women and Religion, vol. 14. New York.

Gerstel, S. J. 1998. "Painted Sources for Female Piety in Medieval Byzantium." *DOP* 52:89–111.

Gerstinger, H. 1965–70. *Dioscurides: Codex Vindobonensis Med. Gr. der Österreichischen National-bibliothek*. Graz.

Giacosa, G. 1977. *Women of the Caesars: Their Lives and Portraits on Coins*. Translated by R. R. Holloway. Milan.

*Glass of the Caesars*. 1987. Harden, D. B., H. Hellenkemper, K. Painter, and D. Whitehouse. *Glass of the Caesars*. Exh. cat., The Corning Museum of Glass, Corning, N.Y.; The British Museum, London; and Römisch-Germanisches Museum, Cologne. Milan.

*Glory of Byzantium*. 1997. Evans, H. C., and W. D. Wixom, eds. *The Glory of Byzantium: Art and Culture of the Middle Byzantine Era, A.D. 843–1261*. Exh. cat., The Metropolitan Museum of Art. New York.

Goldman, B. 1966. *Sacred Portal: A Primary Symbol in Ancient Judaic Art*. Detroit.

Goldman, N. 1994. "Reconstructing Roman Clothing." In *The World of Roman Costume*, edited by J. L. Sebeste and L. Bonfante. Madison, Wis.

Goldschmidt, A., and K. Weitzmann. 1930. *Die byzantinischen Elfenbeinskulpturen des X–XIII Jahrhunderts*. Vol. 1. Berlin.

———. 1934. *Die byzantinischen Elfenbeinskulpturen, des X–XIII Jahrhunderts.* Vol. 2. Berlin.

Gonosová, A., and C. Kondoleon. 1994. *Art of Late Rome and Byzantium in the Virginia Museum of Fine Arts.* Richmond, Va.

Grabar, A. 1958. *Les ampoules de Terre Sainte.* Paris.

———. 1975. "Les images de la Vierge de tendresse." *Zograf* 6:25–30.

Grabar, A., and M. Manoussacas. 1979. *L'illustration du manuscrit de Skylitzes de la Bibliothèque Nationale de Madrid.* Venice.

Greenfield, R. P. H. 1988. *Traditions of Belief in Late Byzantine Demonology.* Amsterdam.

Grierson, P. 1955. "The Kyrenia Girdle of Byzantine Medallions and Solidi." *Numismatic Chronicle,* 6th ser., 15:55–70.

———. 1963. "A Misattributed Miliaresion of Basil II." *Zbornik radova Vizantoloskog Instituta* 8:111–16.

———. 1982. *Byzantine Coins.* London, Berkeley, and Los Angeles.

———. 1999. *Byzantine Coinage.* Washington, D.C.

Grierson, P., and M. Mays. 1992. *Catalogue of Late Roman Coins in the Dumbarton Oaks Collection and in the Whittemore Collection: From Arcadius and Honorius to the Accession of Anastasius.* Washington, D.C.

Guseva, E., ed. 1995. *Baogomater' Vladimirskaya K 600 Letijv Sretenja ikonu Bogomateri Vladimirskoi v Moskve 26 Avgusta (8 sentjabrja), 1395* [The Mother of God Vladimirskaya: Toward the 600th anniversary of the meeting of the Vladimirskya icon in Moscow on August 26 (September 8) 1395]. Moscow.

Hadermann-Misguich, L. 1983. "Pelagonitissa et Kardiotissa: Variantes extrêmes du type Vierge de tendresse." *Byzantion* 53, no. 1:9–16.

Halkin, F. 1966. "La passion de Sainte Paraskève par Jean d'Eubée." In *Polychronion, Festschrift Franz Dolgër,* edited by P. Wirth. Heidelberg.

Halsall, P., trans. 1996. "Life of St. Thomaïs of Lesbos." In *Holy Women of Byzantium: Ten Saints' Lives in English Translation,* edited by A.-M. Talbot. Washington, D.C.

Hamartolos, G. (9th century). 1904. *Georgii Monachi chronicon.* Vol. 1. Edited by C. de Boor. Leipzig.

Hanfmann, G. M. A. 1964. *Roman Art: A Modern Survey of the Art of Imperial Rome.* New York and London.

———. 1980. "The Continuity of Classical Art: Culture, Myth, and Faith." In *Age of Spirituality: A Symposium,* edited by K. Weitzmann. New York and Princeton.

Hannestad, N. 1994. *Tradition in Late Antique Sculpture.* Aarhus, Denmark.

Harden, D. B. 1963. "A Romano-Syrian Inscribed Glass Flask." *British Museum Quarterly* 27:27–28.

Harrison, E. B. 1953. *Portrait Sculpture.* Princeton.

Heintz, F. 2000. "Investigating a Unique Byzantine Weight." *The Celator* 14, no. 10:26–28.

Henig, M. 1993. "Ancient Cameos in the Content Family Collection." In *Cameos in Context: The Benjamin Zucker Lectures, 1990,* edited by M. Henig and M. Vickers. Oxford and Houlton, Maine.

Hennecke, E., and W. Schneemelcher. 1963. *New Testament Apocrypha.* Philadelphia.

———. 1973. *New Testament Apocrypha.* 2nd ed. Vol. 1. Philadelphia.

Hermes Trismegistus. 1976. *Die Kyraniden.* Edited by D. Kaimakis. Meisenheim am Glan, Germany.

Herrin, J. 1982. "Women and the Faith in Icons in Early Christianity." In *Culture, Ideology and Politics: Essays for Eric Hobsbawm,* edited by R. Samuel and G. S. Jones. London.

———. 1983. "In Search of Byzantine Women: Three Avenues of Approach." In *Images of Women in Antiquity,* edited by Averil Cameron and A. Kuhrt. London.

———. 2000. "The Imperial Feminine in Byzantium." *Past and Present* 169:3–35.

———. 2001. *Women in Purple: Rulers of Medieval Byzantium.* Princeton and Oxford.

Higgins, R. 1980. *Greek and Roman Jewellery.* Berkeley.

*Highlights from Berry.* 1979. Rudolph, W.

*Highlights from the Burton Y. Berry Collection: Indiana University Art Museum, September 18–December 22, 1979.* Exh. cat., Indiana University Art Museum. Bloomington, Ind.

Hill, B. 1997. "Imperial Women and the Ideology of Womanhood in the Eleventh and Twelfth Centuries." In *Women, Men, and Eunuchs: Gender in Byzantium,* edited by L. James. London and New York.

Hill, D. K. 1952. "When the Romans Went Shopping." *Archaeology* 5, no. 1:51–55.

Hirsch Auktion. 1999. *Emil Hirsch Antiquariat. Münzen der Antike, Münzen des Mittelalters, . . . Auktion 205, September 22–25, 1999.* Munich.

Hodges, L. F. 1990. "Noe's Wife: Type of Eve and Wakefield Spinner." In *Equally in God's Image: Women in the Middle Ages,* edited by J. B. Holloway, C. S. Wright, and J. Bechtold. New York.

Holum, K. G. 1982. *Theodosian Empresses: Women and Imperial Dominion in Late Antiquity.* Berkeley, Los Angeles, and London.

Howgego, C. 1995. *Ancient History from Coins.* London.

Hunt, L.-A. 1991. "A Woman's Prayer to Saint Sergios in Latin Syria: Interpreting a Thirteenth-Century Icon at Mount Sinai." *Byzantine and Modern Greek Studies* 15:96–145.

Hurwitz, S. 1992. *Lilith, The First Eve: Historical and Psychological Aspects of the Dark Feminine.* Einsiedeln, Switzerland.

Hutter, I. 1984. "Das Bild der Frau in der byzantinischen Kunst." In *Byzantios,* edited by W. Hörander. Vienna.

*I, Claudia.* 1996. Kleiner, D. E. E., and S. B. Matheson, eds. *I, Claudia: Women in Ancient Rome.* Exh. cat., Yale University Art Gallery. New Haven.

Inan, J., and E. Alföldi-Rosenbaum. 1966. *Roman and Early Byzantine Portrait Sculpture.* London.

———. 1979. *Römische und frühbyzantinische Porträtplastik aus der Türkei: Neue Funde.* Mainz am Rhein.

Jacob, X. 1971–73. "La vie de Marie interpretée par les artistes des églises rupestres de Cappadoce," *Cahiers de l'art médiévale* 6, no. 1:15–30.

James, L. 2001. *Empresses and Power in Early Byzantium*. London and New York.

Janin, R. 1975. *Les églises et les monastères des grands centres byzantins*. Paris.

Jenkins, M., and M. Keene 1983. *Islamic Jewelry in the Metropolitan Museum of Art*. New York.

Jenkins, R. J. H. 1947. "The Bronze Athena at Byzantium." *Journal of Hellenic Studies* 67:31–33.

Johns, C. 1996. *The Jewellery of Roman Britain*. London.

Julian the Apostate (4th century). 1962. *The Works of the Emperor Julian in Three Volumes*. Translated by W. C. Wright. Cambridge, Mass., and London.

Kalavrezou, I. 1990. "Images of the Mother: When the Virgin Mary Became *Meter Theou*." *DOP* 44:165–72.

———. 1997a. "Helping Hands for the Empire: Imperial Ceremonies and the Cult of Relics at the Byzantine Court." In *Byzantine Court Culture from 829 to 1204*, edited by H. P. Maguire. Washington, D.C.

———. 1997b. "Luxury Objects." In *Glory of Byzantium*.

———. 2000. "The Maternal Side of the Virgin." In *Mother of God*.

———. 2002. "Eikones gynaikon sto Vyzantio" [Images of women in Byzantium]. In *Daily Life*.

Kalavrezou-Maxeiner, I. 1977. "Eudokia Makrembolitissa and the Romanos Ivory." *DOP* 31:306–25.

———. 1985a. *Byzantine Icons in Steatite*. Vienna.

———. 1985b. "The Byzantine Knotted Column." *Byzantine Studies in Honor of Milton Anastos*. Malibu.

———. 1985c. "The Cup of San Marco and the 'Classical' in Byzantium." In *Studien zur mittelalterlichen Kunst 800–1250: Festschrift für Florentine Mütherich*, edited by K. Bierbrauer, P. K. Klein, and W. Sauerländer. Munich.

Kalogeras, N. M. 2000. Byzantine Childhood Education and Its Social Role from the Sixth Century until the End of Iconoclasm. Ph.D. diss., University of Chicago.

Kanowski, M. G. 1983. *Containers of Classical Greece*. Queensland.

Kantorowicz, E. H. 1960. "On the Golden Marriage Belt and the Marriage Rings of the Dumbarton Oaks Collection." *DOP* 14:1–16.

Kassia (9th century). 1992. *Kassia: The Legend, the Woman, and Her Work*. Edited and translated by A. Tripolitis. New York.

Kazhdan, A. P. 1998. "Women at Home." *DOP* 52:1–17.

Kazhdan, A., and A. W. Epstein. 1985. *Change in Byzantine Culture in the Eleventh and Twelfth Centuries*. Berkeley, Los Angeles, and London.

Kendrick, A. F. 1920. *Catalogue of Textiles from Burying Grounds in Egypt*. 3 vols. London.

Kennell, S. A. H. 1991. "Women's Hair and the Law: Two Cases from Late Antiquity." *Klio* 73, no. 2:526–36.

Kent, J. P. C. 1978a. "Urbs Roma and Constantinopolis Medallions at the Mint of Rome." In *Scripta Nummaria Romana: Essays Presented to Humphrey Sutherland*, edited by R. A. G. Carson and C. M. Kraay. London.

———. 1978b. *Roman Coins*. London.

Khoury, N. N. N. 1992. The Mihrab Concept: Palatial Themes in Early Islamic Religious Architecture. Ph.D. diss., Harvard University.

Kiilerich, B. 1993. *Late-Fourth-Century Classicism in the Plastic Arts: Studies in the So-Called Theodosian Renaissance*. Odense, Denmark.

King, H. 1994. "Producing Woman: Hippocratic Gynecology." In *Women in Ancient Societies: An Illusion of the Night*, edited by L. J. Archer, S. Fischler, and M. Wyke. New York.

Kisch, B. 1965. *Scales and Weights: A Historical Outline*. New Haven.

Kitzinger, E. 1980. "Christian Imagery: Growth and Impact." In *Age of Spirituality: A Symposium*, edited by K. Weitzmann. New York and Princeton.

Kleiner, D. 1977. *Roman Group Portraiture*. New York and London.

Klingshirn, W. E. 2002. "Defining the *Sortes Sanctorum*: Gibbon, Du Cange, and Early Christian Lot Divination." *Journal of Early Christian Studies* 10, no. 1:77–130.

Koder, J., ed. 1991. *Das Eparchenbuch Leons des Weisen*. Vienna.

Kondakov, N. 1914–15. *Ikonografia Bogomateri* [The iconography of the Mother of God]. St. Petersburg.

Koukoules, P. 1948–57. *Vyzantinon vios kai politismos* [Byzantine life and civilization]. Athens.

———. 1951. *Byzantine Life and Civilization*. Athens.

Kouli, M., trans. 1996. "Life of St. Mary of Egypt." In *Holy Women of Byzantium*, edited by A.-M. Talbot. Washington, D.C.

Krauss, Samuel. 1902. "Die Königin von Saba in den byzantinischen Chroniken." *Byzantinische Zeitschrift* 11:120–31.

Krautheimer, R. 1983. *Three Christian Capitals: Topography and Politics*. Berkeley.

Kunisch, N. 1997. *Makron*. Mainz am Rhein.

Künzl, E. 1983. *Medizinische Instrumente aus Sepulkralfunden der römischen Kaiserzeit*. With contributions by F. J. Hassel and S. Künzl. 2nd ed. Cologne.

Kunysz, A. 1984. *Muzeum Narodowe Ziemi Przemyskiej: Zarys monograficzny*. [National Museum of the Przemysl Region: Monographic outline]. Przemysl, Poland.

Kurtz, E., ed. 1898. *Zwei griechische Texte über die heilige Theophano, die Gemahlin Kaiser Leo VI*. St. Petersburg.

*L'art copte*. 2000. *L'art copte en Égypte: 2000 ans de christianisme*. Exh. cat, Institut du Monde Arabe. Paris.

Lafontaine-Dosogne, J. 1964. *Iconographie de l'enfance de la Vierge dans l'empire byzantin et en occident*. Vol. 1. Brussels.

Laiou, A. E. 1981. "The Role of Women in Byzantine Society." *JÖB* 31, no. 1:233–60.

———. 1982. "Addendum to the Role of Women in Byzantine Society." *JÖB* 32, no. 1:198–204.

———. 1985. "Observations on the Life and Ideology of Byzantine Women." *Byzantinische Forschungen* 9:59–102.

———. 1986. "The Festival of 'Agathe': Comments on the Life of Constantinopolitan Women." In *Byzantion: Aphieroma ston A. N. Stratos* [Byzantium: Tribute to Andreas N. Stratos]. 2 vols. Edited by N. A. Stratos. Athens.

———. 1992. *Mariage, amour, et parenté à Byzance aux XI–XIIIe siècles.* Paris.

———. 1993. "Sex, Consent, and Coercion in Byzantium." In *Consent and Coercion to Sex and Marriage in Ancient and Medieval Societies,* edited by A. E. Laiou. Washington, D.C.

———, trans. 1996. "Life of St. Mary the Younger." In *Holy Women of Byzantium,* edited by A.-M. Talbot. Washington, D.C.

———. 2001. "Women in the Marketplace of Constantinople (10th–14th Centuries)." In *Byzantine Constantinople: Monuments, Topography, and Everyday Life,* edited by N. Necipoglu. Leiden, Boston, and Köln.

Lampros, S. P. 1911. "Codex Marc.524." *Neos Hellenomnemon* 8:3–192.

Lasareff, V. 1938. "Studies in the Iconography of the Virgin." *Art Bulletin* 20, no. 1:26–65.

Lassner, J. 1993. *Demonizing the Queen of Sheba: Boundaries of Gender and Culture in Post-Biblical Judaism and Medieval Islam.* Chicago.

*Late Antiquity to Late Gothic.* 1990. *Decorative and Applied Art from Late Antiquity to Late Gothic* [in Russian]. Exh. cat., State Hermitage Museum, Leningrad, and State Pushkin Museum, Moscow. Leningrad.

Laurent, V. 1963–81. *Le corpus de sceaux de l'empire byzantin.* 2 vols. Paris.

Lazarev, V. N. 1966. *Old Russian Murals and Mosaics.* London.

———. 1981. *Novgorodian Icon-Painting.* Moscow.

———. 1996. *The Russian Icon.* Edited by G. I. Vzdornov. Collegeville, Minn.

Lepage, C. 1971. "Les bracelets de luxe romains et byzantins du IIe au VIe siècle: Étude de la forme et de la structure." *Cahiers archéologiques* 21:1–23.

Leroy, J. 1974. *Les manuscrits coptes et coptes-arabes illustrés.* Paris.

Lévêque, A. M. M. 1997. "L'évolution de bijoux «aristocratiques» féminins." *Revue archéologique* 1:79–106.

Liddell, H. G., and Scott, R. 1991. *An Intermediate Greek-English Lexicon Founded upon the Seventh Edition of Liddell and Scott's Greek-English Lexicon.* Oxford.

Likhacev, N. 1936. "Sceaux de l'empereur Léon III l'Isaurien." *Byzantion* 11:469–82.

Limberis, V. 1994. *Divine Heiress: The Virgin Mary and the Creation of Christian Constantinople.* London and New York.

*LIMC.* 1981–97. Ackermann, H. C., and J.-R. Gisler, eds. *Lexicon Iconographicum Mythologiae Classicae.* Dusseldorf.

*Liturgie und Andacht.* 1992. Plotzek, J. M., and U. Surmann, eds. *Biblioteca Apostolica Vaticana: Liturgie und Andacht im Mittelalter.* Exh. cat., Erzbischöfliches Diözesanmuseum, Cologne. Stuttgart.

Lopez, R. 1945. "Silk Industry in the Byzantine Empire." *Speculum* 20, no. 1:1–42.

MacCoull, L. S. B. 1982. "Documentary Texts from the Pierpont Morgan Library." *Bibliographie de la Société d'Archéologie Copte* 24:10–12.

———. 1988. *Dioscorus of Aphrodito: His Work and His World.* Berkeley.

Maffry Talbot, A.-M., ed. and trans. 1975. *The Correspondence of Athanasius I, Patriarch of Constantinople: Letters to the Emperor Andronicus II, Members of the Imperial Family, and Officials.* Washington, D.C.

Magdalino, P. 2001. "Aristocratic *Oikoi* in the Tenth and Eleventh Regions of Constantinople." In *Byzantine Constantinople: Monuments, Topography, and Everyday Life,* edited by N. Necipoglu. Leiden, Boston, and Cologne.

Magoulias, H. 1971. "Bathhouse, Inn, Tavern, Prostitution and the State As Seen in the Lives of the Saints of the Sixth and Seventh Centuries." *Epeteris Hetaireias Byzantinon Spoudon* 38:233–52.

Maguire, E. D. 1997. "Ceramic Arts of Everyday Life." In *Glory of Byzantium.*

Maguire, H. P. 1987. *Earth and Ocean: The Terrestrial World in Early Byzantine Art.* University Park, Penn., and London.

———. 1992. "The Mosaics of Nea Moni: An Imperial Reading." *DOP* 46:205–14.

———. 1995. "Magic and the Christian Image." In *Byzantine Magic,* edited by H. P. Maguire. Washington, D.C.

———. 1996. *The Icons of Their Bodies: Saints and Their Images in Byzantium.* Princeton.

———. 2000. "The Cult of the Mother of God in Private." In *Mother of God.*

Makk, F. 1975. *Traduction et commentaire de l'homélie écrite probablement par Théodore le Syncelle sur le siège de Constantinople en 626.* Acta Universitatis de Attila Jóseph Nominatae. Acta Antiqua et Archaeologica, vol. 19. Opuscula Byzantina, vol. 3. Szeged, Hungary.

Malalas, J. (6th century). 1986. *The Chronicle of John Malalas.* Translated by E. Jeffreys, M. Jeffreys, and R. Scott, with B. Croke. Melbourne.

Mandel, U. 1988. *Kleinasiatische Reliefkeramik der mittleren Kaiserzeit: Die «Oinophorengruppe» und Verwandtes.* Berlin.

Mango, C. 1981. "Daily Life in Byzantium." In *16. Internationaler Byzantinistenkongress, Wien, 4.–9. Okt. 1981: Akten.* Vol. 1. Edited by H. Hunger and W. Horander. Vienna.

———. 1982. "Addendum to the Report on Everyday Life." *JÖB* 32, no. 1:247–57.

———. 1984. "The Byzantine Collection." *Apollo* 119:21–29.

———. 1986. *The Art of the Byzantine Empire 312–1453: Sources and Documents.* Medieval Academy Reprints for Teaching, vol. 16. Toronto.

———. 1998. "The Origins of the Blachernae Shrine at Constantinople." In *Acta 13 Congressus Internationalis Archaeologiae Christianae, Split-Poreč, September 9–October 1, 1994,* edited by N. Cambi and E. Marin. Studi di antichità cristiana, vol. 54. Vatican City.

———. 2000. "Constantinople as Theotokoupolis." In *Mother of God.*

Maraval, P., ed. 1971. *Vie de sainte Macrine.* Paris.

Mark the Deacon (5th century). 1913. *Life of Porphyry, Bishop of Gaza.* Translated by G. F. Hill. Oxford.

Markopoulos, A. 1989. "He Organose tou Scholeiou: Paradose kai Exelixe" [Organization of the school: Tradition and development]. In *He Katherine Zoe sto Vyzantio: Tomes kai Synecheies* [Everyday life in Byzantium: Breaks and continuities], edited by C. Angelidi. Athens.

Marshall, F. H. 1907. *Catalogue of the Finger Rings, Greek, Etruscan, and Roman, in the Departments of Antiquities, British Museum.* London.

Matantséva, T. 1994. "Les amulettes byzantines contre le Mauvais Oeil du Cabinet des Médailles." *Jahrbuch für Antike und Christentum* 17:110–21.

Matheson, S. B. 1994. "The Goddess Tyche." In *Obsession.*

Mavrogordato, J., ed. and trans. 1956. *Digenes Akrites.* Oxford.

Mavropoulou-Tsioumi, C. 1986. *The Church of Saint Nicholas Orphanos.* Translated by D. Whitehouse. Thessaloniki.

McClanan, A. L. 1997. Empress, Image, State: Imperial Women in the Early Medieval World. Ph.D. diss., Harvard University.

———. 2002. "'Weapons to Probe the Womb': The Material Culture of Abortion and Contraception in the Early Byzantine Period." In *The Material Culture of Sex, Procreation, and Marriage in Premodern Europe,* edited by A. L. McClanan and K. Encarnación. New York.

McDonald, D. R. 1983. *The Legend and the Apostle: The Battle for Paul in Story and Canon.* Philadelphia.

Metrodora. 1953. *Il Libro di Metrodora sulle malattie delle donne e il ricettario di cosmetica e terapia.* Translated and edited by G. del Guerra. Milan.

*MFA Annual Report.* 1963. *Museum of Fine Arts, Boston, Annual Report.* Boston.

———. 1966. *The Museum Year: Annual Report of the Museum of Fine Arts, Boston.* Boston.

*Middle Ages.* 1969. Ostoia, V. K. 1969. *The Middle Ages: Treasures from the Cloisters and the Metropolitan Museum of Art.* Exh. cat., Los Angeles County Museum of Art. Los Angeles.

Miller, D. 1968. "Legends of the Icon of Our Lady of Vladimir: A Study of the Development of Muscovite National Consciousness." *Speculum* 43:657–70.

———. 1995. "How the Mother of God Saved Moscow from Timur the Lame's Invasion in 1395." *Forschungen zur Osteuropäischen Geschichte* 50:239–73.

Miller, T. S. 1997. *The Birth of the Hospital in the Byzantine Empire.* Baltimore and London.

*Mirror.* 1999. Wixom, W. D., ed. *Mirror of the Medieval World.* Exh. cat., The Metropolitan Museum of Art. New York.

Morgan, C. H. 1942. *The Byzantine Pottery.* Vol. 11, *Corinth.* Cambridge, Mass.

*Morgan Wing.* 1925. Breck, J., and M. Rogers. 1925. *The Pierpont Morgan Wing.* Exh. cat., The Metropolitan Museum of Art. New York.

*Mother of God.* 2000. Vassilaki, M., ed. *The Mother of God: Representations of the Virgin in Byzantine Art.* Exh. cat., Benaki Museum. Athens.

Mouriki, D. 1990. "Icons from the Twelfth to the Fifteenth Century." In *Sinai: Treasures of the Monastery of Saint Catherine,* edited by K. Manafis. Athens.

Müller, K., ed. 1883. *Fragmenta Historicorum Graecorum.* 5 vols. Paris.

Museum of Fine Arts, Boston. 1972. *The Rathbone Years: Masterpieces Acquired for the Museum of Fine Arts, Boston, 1955–1972, and for the St. Louis Art Museum, 1940–1955.* Boston.

———. 1981. *Masterpieces from the Boston Museum.* Boston.

Nauerth, C. 1982. "Nachlese von Thekla-Darstellungen." In *Studien zur spätantiken und frühchristlichen Kunst und Kultur des Orients,* edited by G. Koch. Wiesbaden.

Nauerth, C., and R. Warns. 1981. *Thekla: Ihre Bilder in der frühchristlichen Kunst.* Wiesbaden.

Nelson Gallery Foundation. 1959. *Handbook of the Collections in the William Rockhill Nelson Gallery of Art and Mary Atkins Museum of Fine Arts.* 4th ed. Kansas City.

Nicol, D. M. 1994. *The Byzantine Lady: Ten Portraits 1250–1500.* Cambridge.

Nikolakopoulos, G. 1989. "Refléxions sur l'esthétique de la céramique byzantine." In *Recherches sur la céramique byzantine,* edited by V. Déroche and J. M. Spieser. *Bulletin de correspondance hellénique.* Supplément 43:317–26.

Nonnos of Panopolis (5th century). 1962–63. *Dionysiaca.* Translated by W. H. D. Rouse. Reprint. London.

Nordhagen, J. 1962. "La più antica Eleousa conosciuta." *Bollettino d'Arte* 47, no. 4:351–53.

Notopoulos, J. A. 1964. "Akritan Ikonography on Byzantine Pottery." *Hesperia* 33:108–33.

*Obsession.* 1994. Matheson, S. B., ed. *An Obsession with Fortune: Tyche in Greek and Roman Art.* Exh. cat., Yale University Art Gallery. New Haven.

*OCD.* 1996. Hornblower, S., and A. Spawforth, eds. *The Oxford Classical Dictionary.* 3rd ed. Oxford and New York.

*ODB.* 1991. Kazhdan, A. P., A.-M. Talbot, A. Cutler, T. E. Gregory, and N. P. Ševčenko, eds. 1991. *The Oxford Dictionary of Byzantium.* 3 vols. New York and Oxford.

Ogden, J. 1982. *Jewelry of the Ancient World.* New York.

Oikonomides, N. 1972. *Les listes des préséances byzantines des IXe et Xe siècles.* Paris.

———. 1977. "John VIII Palaeologus and the Ivory Pyxis at Dumbarton Oaks." *DOP* 31:329–37.

———. 1985. *Byzantine Lead Seals.* Washington, D.C.

Onasch, K. 1957. "Paraskeva-Studien." *Ostkirchliche Studien* 6:121–41.

Orsi, P. 1924. "Giojelli bizantini della Sicilia." In *Mélanges offerts à M. Gustave Schlumberger.* Paris.

*Pagan and Christian Egypt.* 1941. *Pagan and Christian Egypt: Egyptian Art from the First to the Tenth Century A.D., Exhibited at the Brooklyn Museum by the Department of Ancient Art, January 23–March 9, 1941, Brooklyn Museum, Brooklyn Institute of Arts and Sciences.* Exh. cat., Brooklyn Museum. Brooklyn.

Papalexandrou, A. 2001. "Text in Context: Eloquent Monuments and the Byzantine Beholder." *Word & Image* 17, no. 3:259–83.

Papanikola-Bakirtzi, D., and M. Iakovou. 1997. *Vyzantine mesaionike Kypros: Vasilissa sten Anatole & Regaina ste Dyse* [Byzantine medieval Cyprus: Empress in the East and queen in the West]. Leukosia, Cyprus.

Papanikola-Bakirtzi, D., F. N. Mavrikioy, Ch. Bakirtzis. 1999. *Byzantine Glazed Pottery in the Benaki Museum.* Athens.

Parca, M. 1996. "Gold Lamellae in the Burton Y. Berry Collection." In *Ancient Jewelry and Archaeology,* edited by A. Calinescu. Bloomington, Ind.

Parlasca, K. 1966. *Mumienporträts und verwandte Denkmäler.* Wiesbaden.

Patlagean, E. 1976. "L'histoire de la femme déguisée en moine et l'évolution de la sainteté féminine à Byzance." *Studi Medievali,* 3rd ser., 17:597–623.

———. 1987. "Byzantium in the Tenth and Eleventh Centuries." In *A History of Private Life.* Vol. 1, *From Pagan Rome to Byzantium,* edited by P. Veyne. Cambridge, Mass.

Paton, W. R., trans. 1916. *The Greek Anthology.* 5 vols. Cambridge, Mass., and London.

Paulinus of Nola (4th–5th century). 1975. *The Poems of St. Paulinus of Nola.* Translated by P. G. Walsh. New York and Ramsey, N.J.

Pausanias. 1979. *Guide to Greece.* 2 vols. Translated by P. Levi. New York.

Pelekanides, S., ed. 1973. *The Treasures of Mount Athos: Illustrated Manuscripts.* Athens.

Peltomaa, L. M. 2001. *The Image of the Virgin Mary in the Akathistos Hymn.* The Medieval Mediterranean, vol. 35. Leiden and Boston.

Penna, V. 2000. "The Mother of God on Coins and Lead Seals." In *Mother of God.*

Pentcheva, B. 2000. "Rhetorical Images of the Virgin: The Icon of the 'Usual Miracle' at Blachernai." *Res* 38:34–56.

———. 2001. Images and Icons of the Virgin and Their Public in Middle Byzantine Constantinople. Ph.D. diss., Harvard University.

———. 2002. "The Supernatural Protector of Constantinople: The Virgin and Her Icons in the Tradition of the Avar Siege." *Byzantine and Modern Greek Studies* 26:2–41.

Perdrizet, P. 1922. *Negotium perambulans in tenebris.* Strasbourg.

Pertusi, A. 1960. *Giorgio di Pisidia: Poemi.* Studia Patristica et Byzantina, vol. 7. Ettal, Germany.

Peskowitz, M. B. 1997. *Spinning Fantasies.* Berkeley.

Petitmengin, P., et al. 1981. *Pélagie la pénitente.* Paris.

Petrie, F. 1927. *Objects of Daily Use.* London.

*PG.* 1857–66. J.-P. Migne, comp. 1857–66. *Patrologiae cursus completus. Series Graeca.* Paris.

Photius (9th century). 1958. *The Homilies of Photius, Patriarch of Constantinople.* Edited and translated by C. Mango. Cambridge, Mass.

Piccirillo, M. 1993. *The Mosaics of Jordan.* Edited by P. M. Bikai and T. A. Dailey. Amman, Jordan.

*Pichon Catalogue.* 1897. Pichon, J., *Catalogue des objets antiques . . . de M. le Baron Jérôme Pichon.* Paris.

*Pilgrimage.* 1982. G. Vikan. *Byzantine Pilgrimage Art.* Exh. cat., Dumbarton Oaks Research Library and Collection. Washington, D.C.

Pintaudi, J.-E. B. R. 1985. *El-Fayyum.* Milan.

Pitarakis, B. 1996. Les croix-reliquaires en bronze: Recherches sur la production des objects métaliques à Byzance. Ph.D. diss., University of Paris I.

———. 2000. "À propos de la Vierge orante au Christ-Enfant (XIe–XIIe siècles): L'emergence d'un culte." *Cahiers archéologiques* 48:45–58.

Polemis, D. 1968. *The Doukai: A Contribution to Byzantine Prosopography.* London.

Poseljanin, E., ed. 1993. *Bogomater'. Polnoe illjus-tritovannoe opisanie eja zemnoi jizni i posvjastennyh'eja imenni chudotvornyh'ikon'* [Mother of God: Fully illustrated edition of her life and of her miracle-working icons]. 2 vols. 1909. Reprint. Saint Petersburg.

*Processional Crosses.* 1994. Cotsonis, J. A. *Byzantine Figural Processional Crosses,* edited by S. A. Boyd and H. P. Maguire. Exh. cat., Dumbarton Oaks Research Library and Collection. Washington, D.C.

Procopius (6th century). 1971. *Buildings.* Translated by H. B. Dewing. Cambridge, Mass.

———. 1981. *The Secret History.* Translated by G. A. Williamson. Reprint. London.

Prodromus, T. (12th century). 1910. *Poèmes prodromique en grec vulgaires.* Edited by D. C. Hesseling and H. Pernot. Amsterdam.

Psellus, M. (11th century). 1899. *The History of Psellus.* Edited by C. Sathas. London.

———. 1953. *The Chronographia.* Translated by E. R. A. Sewter. New Haven.

———. 1966. *Fourteen Byzantine Rulers: The Chronographia.* Translated by E. R. A. Sewter. Baltimore.

Quenemoen, C. K. 1996. "Weaving: Feminine Virtue and Economic Reality." In *I, Claudia.*

Rahlfs, A., ed. 1975. *Septuaginta.* 1935. Reprint. Stuttgart.

Randall, R. H., Jr. 1985. *Masterpieces of Ivory from the Walters Art Gallery.* New York.

Rassart-Debergh, M. 1997. *Textiles d'Antinoé (Égypte) en Haute Alsace: Donation É. Guimet.* Colmar, France.

Rawson, B. 1991. "Adult-Child Relationships in Roman Society." In *Marriage, Divorce, and Children in Ancient Rome,* edited by B. Rawson. Oxford and New York.

Reeksman, L. 1958. "La «dextrarum iunctio» dans l'iconographie romaine et paléochré-tienne." *Bulletin de l'Institut Historique Belge de Rome* 31:24–95.

*RIC.* Mattingly, H., and E. A. Sydenham. 1923–94. *The Roman Imperial Coinage.* 10 vols. London.

Rice, D. T. 1959. *Art of Byzantium.* London.

———. 1966. "Late Byzantine Pottery at Dumbarton Oaks." *DOP* 20:207–19.

*Rich Life.* 1999. Maguire, E. D. 1999. *Weavings from Roman, Byzantine, and Islamic Egypt: The Rich Life and the Dance.* Exh. cat., Krannert Art Museum, University of Illinois at Urbana-Champaign. Champaign, Ill.

Richter, G. M. A. 1971. *Engraved Gems of the Romans*. Edinburgh.

Roberts, M. 1989. *The Jeweled Style: Poetry and Poetics in Late Antiquity*. Ithaca, N.Y.

Robertson, A. S. 1962–82. *Roman Imperial Coins in the Hunter Coin Cabinet, University of Glasgow*. Vol. 5, *Diocletian (Reform) to Zeno*. Oxford.

Robinson, D. M., and E. J. Fluck. 1937. *A Study of the Greek Love-Names*. Baltimore.

*Romans and Barbarians*. 1976. *Romans and Barbarians: Catalogue of an Exhibition Held at the Museum of Fine Arts, Boston, Dec. 17, 1976–February 27, 1977*. Exh. cat., Museum of Fine Arts. Boston.

*Rom und Byzanz*. 1998. Wamser, L., and G. Zahlaas, eds. *Rom und Byzanz: Archäologische Kostbarkeiten aus Bayern*. Exh. cat., Prähistorische Staatssammlung München. Munich.

Ross, M. C. 1957. "A Byzantine Gold Medallion at Dumbarton Oaks." *DOP* 11:247–61.

———. 1959. "A Coptic Marriage Lampstand in Bronze." *The Nelson Gallery and Atkins Museum Bulletin* 2, no. 1:1–4.

———. 1962. *Catalogue of the Byzantine and Early Mediaeval Antiquities in the Dumbarton Oaks Collection*. Vol. 1, *Metalwork, Ceramics, Glass, Glyptics, Painting*. Washington, D.C.

———. 1965. *Catalogue of the Byzantine and Early Mediaeval Antiquities in the Dumbarton Oaks Collection*. Vol. 2, *Jewelry, Enamels, and Art of the Migration Period*. Washington, D.C.

———. 1968. "Jewels of Byzantium." *Arts in Virginia* 9, no. 1:12–31.

Ross, M. C., and G. Downey. 1962. "A Reliquary of Saint Marina." *Byzantinoslavica* 23:41–44.

Rossi Taibbi, G. 1959. "Vita e opere della Santa Madre Nostra Marina." In *Martirio di Santa Lucia: Vita di Santa Marina*, translated and compiled by G. Rossi Taibbi. Vite dei Santi Siciliani, vol. 2. Palermo.

Rudolph, W. 1995. *A Golden Legacy: Ancient Jewelry from the Burton Y. Berry Collection at the Indiana University Art Museum*. Bloomington and Indianapolis, Ind.

Rudolph, W., and E. Rudolph. 1973. *Ancient Jewelry from the Collection of Burton Y. Berry*. Bloomington, Ind.

Russell, J. 1982a. "Byzantine *Instrumenta Domestica* from Anemurium: The Significance of Context." In *City, Town, and Countryside in the Early Byzantine Era*, edited by R. L. Hohlfelder. Boulder, Colo., and New York.

———. 1982b. "The Evil Eye in Early Byzantine Society." *JÖB* 32, no. 3:539–48.

———. 1995. "The Archaeological Context of Magic in the Early Byzantine Period." In *Byzantine Magic*, edited by H. P. Maguire. Washington, D.C.

*Russian Icons*. 1988. Teteriatnikov, N. 1988. *Russians Icons of the Golden Age: 1400–1700*. Exh. cat., Juniata College. Huntingdon, Penn.

Rutschowscaya, M.-H. 1986. *Catalogue des bois de l'Égypte copte*. Paris.

———. 1990. *Coptic Fabrics*. Translated by A. Stephenson et al. Paris.

Rydén, L. 1982. "Style and Historical Fiction in the Life of Saint Andreas Salos." *JÖB* 32, no. 2:175–83.

———. 1985. "The Bride-Shows at the Byzantine Court—History or Fiction?" *Eranos* 83: 175–91.

Salway, B. 1994. "What's in a Name? A Survey of Roman Onomastic Practice from c. 700 B.C. to A.D. 700." *Journal of Roman Studies* 84: 124–45.

Saradi, H. 1995. *Aspects of the Classical Tradition in Byzantium*. Toronto.

Schlumberger, G. 1862. *Mélanges d'archéologie byzantine*. Paris.

———. 1884. *Sigillographie de l'empire byzantin*. Paris.

———. 1895. "Un «polycandelon» byzantin." In *Mélanges d'archéologie byzantine*. Paris.

Schneelmelcher, W. 1965. *The New Testament Apocrypha*. Vol. 2. Philadelphia.

Schrader, J. L. 1970. "An Ivory Koimesis Plaque of the Macedonian Renaissance." *Bulletin—The Museum of Fine Arts, Houston* 3.

Schurr, E. 1997. *Die Ikonographie der Heiligen*. Dettelbach, Germany.

Sear, D. R. 1974. *Byzantine Coins and Their Values*. London.

Segall, B. 1941. "The Dumbarton Oaks Collection." *American Journal of Archaeology* 45:13.

Seibt, W. 1976. *Die Skleroi: Eine prosopographisch-sigilographische Studie*. Vienna.

———. 1985. "Der Bildtypus der Theotokos Nikopoios." *Byzantina* 13:551–64.

Sendler, E. 1992. *Les icônes byzantines de la Mère de Dieu*. Paris.

Ševčenko, N. P. 1974. "Some Thirteenth-Century Pottery at Dumbarton Oaks." *DOP* 28:353–60.

———. 1991. "Icons in the Liturgy." *DOP* 45: 45–57.

Shelton, K. J. 1979. "Imperial Tyche." *Gesta* 18, no. 1:27–38.

———. 1981. *The Esquiline Treasure*. London.

*Silver from Early Byzantium*. 1986. Mango, M. M. *Silver from Early Byzantium: The Kaper Koraon and Related Treasures*. With technical contributions by C. E. Snow and T. Drayman Weisser. Exh. cat., Walters Art Gallery. Baltimore.

Simocatta, T. (6th–7th century). 1986. *The "History" of Theophylact Simocatta: An English Translation with Introduction and Notes*. Translated by Michael Whitby and Mary Whitby. Oxford.

Simon, E. 1986. *Die Konstantinischen Deckengemälde in Trier*. Mainz am Rhein.

Siviero, R. 1954. *Gli ori e le amber del Museo Nazionale di Napoli*. Florence.

Slim, L. 1996. "Venus, Toilette, and Triumph." In *Mosaics of Roman Africa*, edited by M. Blanchard-Lemée. New York.

Smith, R. R. R. 1999. "Late Antique Portraits in a Public Context: Honorific Statuary at Aphrodisias in Caria." *Journal of Roman Studies* 89:155–89.

Smythe, D. 1997. "Women as Outsiders." In *Women, Men, and Eunuchs: Gender in Byzantium*, edited by L. James. London and New York.

Sobel, H. 1990. *Hygieia: Die Göttin der Gesundheit.* Darmstadt, Germany.

Sode, C. 1997. *Byzantinische Bleisiegel in Berlin II/ mit Unterstützung durch Paul Speck bearbeitet von Claudia Sode.* Bonn.

Soren, D. 1985. "An Earthquake on Cyprus: New Discoveries from Kourion." *Archaeology* 38, no. 2:52–59.

Sotheby's London. 1931. *Catalogue of Egyptian, Greek, Roman, South American, Arabian, and Indian Antiquities.* July 27.

———. 1937. *Catalogue of the Superb Collection of Rings Formed by the Late Monsieur E. Guilhou of Paris.* November 9–12.

Sotheby's New York. 1987. *Antiquities and Islamic Works of Art with Property from the Joseph Ternbach Collection.* November 24–25.

———. 2001. *Egyptian, Classical, and Western Asiatic Antiquities. Including Property from the Collection of the Late Marion Schuster, Lausanne.* December 7.

*Spätantike und Frühes Christentum.* 1983. Beck, H., and P. C. Bol, eds. *Spätantike und Frühes Christentum: Ausstellung im Liebieghaus, Museum alter Plastik, Frankfurt am Main: 16. Dezember 1983 bis 11. März 1984.* Exh. cat., Museum Liebieghaus. Frankfurt am Main.

Spier, J. 1993. "Medieval Byzantine Magical Amulets and Their Tradition." *Journal of the Warburg and Courtauld Institutes* 56:25–62.

Spieser, J.-M. 1972. "Collection Paul Canellopoulos." *Bulletin de correspondance hellénique* 96:117–35.

Spink Auction. 1998. *Byzantine Seals from the Collection of George Zacos, Part I.* London, Auction 127. October 7.

Staatliche Kunstsammlungen Kassel. 1980. *Antiker Schmuck: vollständiger Katalog der Sammlung und der Sonderausstellung vom 31.5 bis 13.8. 1980.* Edited by F. Naumann. Kassel.

St. Clair, A. 1996. "Imperial Virtue: Questions of Form and Function in the Case of Four Late Antique Statuettes." *DOP* 50:147–62.

Steenbock, F. 1983. "Ein fürstliches Geschenk." In *Studien zum europäischen Kunsthandwerk: Festschrift Yvonne Hackenbroch,* edited by J. Rasmussen. Munich.

Stern, H. 1953. *Le calendrier de 354: Étude sur son texte et ses illustrations.* Paris.

Stornajolo, C. 1910. *Miniature delle omilie di Giacomo monaco (cod. Vat. gr. 1162) e dell'evangeliario greco Urbinate (cod. Vat. urbin. gr. 2).* Rome.

Stout, A. M. 1994. "Jewelry as a Symbol of Status in the Roman Empire." In *The World of Roman Costume,* edited by J. L. Sebesta and L. Bonfante. Madison, Wis.

*Survival of the Gods.* 1987. Brown University Department of Art and David Winton Bell Gallery, Brown University. *Survival of the Gods: Classical Mythology in Medieval Art: An Exhibition.* Exh. cat., Bell Gallery, List Art Center, Brown University. Providence.

Swarzenski, H. 1941. "The Dumbarton Oaks Collection." *Art Bulletin* 23: 78.

Talbot, A.-M. 1992. "Women." In *The Byzantines,* edited by G. Cavallo. Chicago.

———. 1994. "Epigrams of Manuel Philes on the Theotokos Tes Peges and Its Art." *DOP* 48:135–66.

———. 2001a. "Building Activity in Constantinople under Andronikos II: The Role of Women Patrons in the Construction and Restoration of Monasteries." In *Byzantine Constantinople: Monuments, Topography, and Everyday Life,* edited by N. Necipoglu. Leiden, Boston, and Cologne.

———. 2001b. *Women and Religious Life in Byzantium.* Aldershot, England, and Burlington, Vt.

———, ed. 1996. *Holy Women in Byzantium: Ten Saints' Lives in English Translation.* Washington, D.C.

———, ed. 1998. *Byzantine Defenders of Images: Eight Saints' Lives in Translation.* Washington, D.C.

Talbot Rice, T. 1963. *Russian Icons.* New York.

Tatar, M. 1987. *The Hard Facts of the Grimms' Fairy Tales.* Princeton.

Tatić-Djurić, M. 1976. "Eleousa: À la recherche du type iconographique." *JÖB* 25:259–67.

*Temple Gallery Icons.* 1969. *Annual Exhibition of Icons, 21st May–July 25th 1969.* Exh. cat., Temple Gallery. London.

*Ternbach Collection.* 1981. Merhav, R. *A Glimpse into the Past: The Joseph Ternbach Collection.* Exh. cat., The Israel Museum. Jerusalem.

Theophanes (8th–9th century). 1997. *The Chronicle of Theophanes Confessor: Byzantine and Near Eastern History AD 284–813.* Translated by C. Mango and R. Scott. Oxford and New York.

Thomas, E. B. 1987. "Eine frühbyzantinische Laufgewichtsbüste im Germanischen National-museum." *Anzeiger des Germanischen National-museums und Berichte aus dem Forschungsinstitut für Realienkunde* 1987:151–59.

Thompson, D. 1971. *Coptic Textiles in the Brooklyn Museum.* New York.

Thompson, D. L. 1982. *Mummy Portraits in the J. Paul Getty Museum.* Malibu.

Tougher, S. F. 1997. "Byzantine Eunuchs: An Overview, with Special Reference to Their Creation and Origin." In *Women, Men, and Eunuchs: Gender in Byzantium,* edited by L. James. London and New York.

Toynbee, J. M. C. 1951. "Roma and Constantinopolis in Late-Antique Art from 365 to Justin II." In *Studies Presented to David Moore Robinson on His Seventieth Birthday,* edited by G. E. Mylonas. St. Louis.

———. 1986. *Roman Medallions.* Numismatic Studies, vol. 5. New York.

Treadgold, W. T. 1979. "The Bride-Shows of the Byzantine Emperors." *Byzantion* 49:395–413.

*Treasures of Mt. Athos.* 1997. Exh. cat., Organization for the Cultural Capital of Europe. Thessaloniki.

*Trésors d'orfèvrerie.* 1989. *Trésors d'orfèvrerie gallo-romains.* Exh. cat., Musée National du Luxembourg, Paris, and Musée de la Civilisation Gallo-Romaine, Lyon. Paris.

Trombley, F. R. 1978. "The Council in Trullo (691–692): A Study of the Canons Relating to Paganism, Heresy, and the Invasions." *Comitatus* 9:1–19.

———. 1985. "Paganism in the Greek World at the End of Antiquity: The Case of Rural Anatolia and Greece." *Harvard Theological Review* 78, nos. 3–4:327–52.

Trypanis, C. A. 1968. *Fourteen Early Byzantine Cantica*. Wiener Byzantinische Studien, vol. 5. Vienna.

Turner, E. G. 1977. *The Typology of the Early Codex*. Philadelphia.

Underwood, P. A. 1966. *The Kariye Djami*. 4 vols. New York and Princeton.

Urbaniak-Walczak, K. 1992. *Die «Conceptio per Aurem»: Untersuchungen zum Marienbild in Ägypten unter besonderer Berücksichtigung der Malereien in El-Bagawat*. Altenberge, Germany.

Usener, H., ed. 1886. "Acta S. Marinae et S. Christophori." In *Festschrift zur fünften Saecularfeier der Carl-Ruprechts-Universität zu Heidelberg*. Bonn.

Van der Horst, P. W. 1998. "Sortes: Sacred Books as Instant Oracles in Late Antiquity." In *The Use of Sacred Books in the Ancient World*, edited by P. W. van der Horst, H. W. Havelaar, and L. Teugels. Contributions to Biblical Exegesis and Theology, vol. 22. Leuven.

Van Lantschoot, A. 1956. "Une collection sahidique de «sortes sanctorum.»" *Le Muséon* 69:36–52.

Vassilaki, M. 2001. "Working Drawings: Research and Study Program." *Mouseio Benaki* 1:79–86.

Vassilaki, M., and N. Tsironis. 2000. "Representations of the Virgin and Their Association with the Passion of Christ." In *Mother of God*.

Verdier, P. 1960. "An Early Christian Polycandelon from Constantinople." *Bulletin of the Walters Art Gallery* 12:2–3.

Vermeule, C. C. 1959. *The Goddess Roma in the Art of the Roman Empire*. Cambridge, Mass.

———. 1964a. "Greek and Roman Portraits in North American Collections Open to the Public." *Proceedings of the American Philosophical Society* 108, no. 2:99–134.

———. 1964b. "Greek, Etruscan, and Roman Sculptures in the Museum of Fine Arts, Boston." *American Journal of Archaeology* 68:323–41.

———. 1971. "Recent Museum Acquistions: Greek, Etruscan, Roman Gold and Silver—II: Hellenistic to Late Antique Gold and Silver." *Burlington Magazine* 113:397–406.

———. 1974a. *Greek and Roman Sculpture in Gold and Silver*. Boston.

———. 1974b. "Ten Greek and Roman Portraits in Kansas City." *Apollo* 99:312–19.

———. 1978. *Roman Art: Early Republic to Late Empire*. Boston.

———. 1981. *Greek and Roman Sculpture in America: Masterpieces in Public Collections in the United States and Canada*. Malibu and Berkeley.

Vermeule, C. C., and A. Brauer. 1990. *Stone Sculptures: The Greek, Roman, and Etruscan Collections of the Harvard University Art Museums*. Cambridge, Mass.

Vermeule, C. C., and M. B. Comstock. 1972. *Greek and Roman Portraits, 470 BC– AD 500*. Boston.

———. 1988. *Sculpture in Stone and Bronze: Additions to the Collections of Greek, Etruscan, and Roman Art, 1971–1988, in the Museum of Fine Arts, Boston*. Boston.

Vikan, G. 1982. *Byzantine Pilgrimage Art*. Washington, D.C.

———. 1984. "Art, Medicine, and Magic in Early Byzantium." *DOP* 38:65–86.

———. 1990. "Art and Marriage in Early Byzantium." *DOP* 44:145–63.

———. 1992a. "Two Byzantine Amuletic Armbands and the Group to Which They Belong." *The Journal of the Walters Art Gallery* 49, no. 50:33–51.

———. 1992b. Objects of Byzantine Daily Life in the Menil Collection. Unpublished manuscript, The Menil Collection, Houston.

———. 1995. "Icons and Icon Piety in Early Byzantium." In *Byzantine East, Latin West: Art-Historical Studies in Honor of Kurt Weitzmann*, edited by C. Moss and K. Kiefer. Princeton.

Vikan, G., and J. Nesbitt. 1980. *Security in Byzantium: Locking, Sealing, and Weighing*. Washington, D.C., and Houston.

Vinson, M. 1999. "The Life of Theodora and the Rhetoric of the Byzantine Bride Show." *JÖB* 49:31–60.

Volbach, W. F. 1976. *Elfenbeinarbeiten der Spätantike und des frühen Mittelalters*. Mainz am Rhein.

Von Heintze, H. F. 1968. *Die antiken Porträts in Schloss Fasanerie bei Fulda*. Mainz am Rhein.

———. 1971. *Roman Art*. New York.

Von Sydow, W. 1969. *Zur Kunstgeschichte des spätantiken Porträts im 4. Jahrhundert n. Chr.* Bonn.

Vostchinina, A. 1974. *Musée de l'Hermitage: Le portrait romain*. Leningrad.

Waelkens, M. 1986. *Die kleinasiatischen Türsteine: Typologische und epigraphische Untersuchungen der kleinasiatischen Grabreliefs mit Scheintür*. Mainz am Rhein.

Walker, A. 2001. "A Reconsideration of Early Byzantine Marriage Rings." In *Between Magic and Religion: Interdisciplinary Studies in Ancient Mediterranean Religion and Society*, edited by S. R. Asirvatham, C. O. Panache, and J. Waltrous. New York.

———. 2002. "Myth and Magic in Early Byzantine Marriage Jewelry: The Persistence of Pre-Christian Traditions." In *The Material Culture of Sex, Procreation, and Marriage in Premodern Europe*, edited by A. L. McClanan and K. Rosoff Encarnación. New York.

Wallace-Hadrill, A. 1996. "Engendering the Roman House." In *I, Claudia*.

Walter, C. 1979. "Marriage Crowns in Byzantine Iconography." *Zograf* 10:83–91.

———. 1995. "The Portrait of Saint Paraskeve." *Byzantinoslavica* 56, no. 4:753–57.

Wamser, L., and G. Zahlhaas. 1998. *Rom und Byzanz: Archäologische Kostbarkeiten aus Bayern*. Munich.

Wander, S. 1973. "The Cyprus Plates: The Story of David and Goliath." *Metropolitan Museum Journal* 8:89–104.

Warns, R. 1986. "Weitere Darstellungen der heiligen Thekla." *Studien zur frühchristlichen Kunst*. Wiesbaden.

Webb, R. 1997. "Salome's Sisters: The Rhetoric and Realities of Dance in Late Antiquity and Byzantium." In *Women, Men, and Eunuchs: Gender in Byzantium*, edited by L. James. London and New York.

Webster, L., and M. Brown, eds. 1997. *The Transformation of the Roman World: AD 400–900*. Los Angeles.

Weitzmann, K. 1960. "The Survival of Mythological Representations in Early Christian and Byzantine Art and Their Impact on Christian Iconography." *DOP* 14:43–68.

———. 1972. *Catalogue of the Byzantine and Early Mediaeval Antiquities in the Dumbarton Oaks Collection*. Washington, D.C.

Weitzmann, K., and M. Bernabo. 2002. *The Byzantine Octateuchs*. Princeton.

Weitzmann-Fiedler, J. 1966. "Zur Illustration der Margareten Legende." *Münchner Jahrbuch der bildenden Kunst,* 3rd ser., 17:17–48.

Wellesz, E. 1955–56. "The Akathistos: A Study in Byzantine Hymnography." *DOP* 9–10:143–74.

Wessel, K. 1965. *Coptic Art*. Translated by S. Hatton. New York.

Westermann, W. L. 1924. "The Castanet Dancers of Arsinoe." *Journal of Egyptian Archaeology* 10:134–44.

Williams, D., and J. Ogden. 1994. *Greek Gold: Jewellery of the Classical World*. London.

Williamson, P. 1983–84. "Daniel between the Lions: A New Sardonyx Cameo for the British Museum." *Jewelry Studies* 1:37–39.

Winkler, J. J. 1991. "The Constraints of Eros." In *Magika Hiera: Ancient Greek Magic and Religion,* edited by C. A. Faraone and D. Obbink. New York and Oxford.

Winlock, H. E., W. E. Crum, and H. G. Evelyn-White. 1926. *The Monastery of Epiphanius at Thebes*. New York.

Wulff, O. 1909. *Altchristliche und mittelalterliche byzantinische und italienische Bildwerke*. Part 1. Berlin.

Yegül, F. 1981. "A Roman Lady from a Southern California Collection." *The J. Paul Getty Museum Journal* 9:63–68.

Zacos, G. 1984. *Byzantine Lead Seals*. Vol. 2. Compiled and edited by J. W. Nesbitt. Bern.

Zacos, G., and A. Veglery. 1960. "Marriage Solidi of the Fifth Century." *The Numismatic Circular* 68, no. 4:73–74.

———. 1972. *Byzantine Lead Seals*. Vol. 1. Basel.

Zanker, P. 1995. *The Mask of Socrates: The Image of the Intellectual in Antiquity*. Translated by A. Shapiro. Berkeley, Los Angeles, and Oxford.

Zosimus (6th century). 1982. *New History*. Translated by R. T. Ridley. Canberra.

# Index

Aaron, Old Testament priest, 108 (cat. 48)

abortion, 165, 276–78

Abyzou. *See* Gylou

Adam and Eve, 18–19, 140, 148 (cat. 71), 215

adultery, 143, 218–19

Aelia, 89, 92

Aetios of Amida, 277–78

agriculture, 18–19, 31, 140

Akathistos hymn, 113

Akropolites, Constantine, 210

Alexander the Great, 289

Alexios, Saint, 217, 226

Alexios I Komnenos, emperor, 29, 30, 63, 68, 107, 310

almsgiving, 72, 90–91 (cat. 32)

Amazon, 48, 181–82 (cat. 97)

Ammianus, Marcellinus, chronicler, 49

*amphoriskos,* 191–92 (cat. 103)

amulets, 283–84 (cat. 165), 286–89 (cats. 167–70), 291–92 (cats. 172–73)

Anargyroi, convent of the, 73

Anastasia, 73

Anastasia, Saint, 40

Andrew the Fool, Saint, 115

Andronikos I Komnenos, emperor, 130 (cat. 61)

Andronikos II Palaiologos, emperor, 131 (cat. 63)

Anicia Juliana, 14, 71

animal motifs, 136–37 (cat. 68), 163, 164, 176 (cat. 93), 181–82 (cat. 97), 185 (cats. 99), 188–90 (cat. 102), 204 (cat. 115), 237, 253 (cat. 145), 265–68 (cat. 159). *See also* bird motifs; peacocks

Anna, empress, 40

Anna, mother of Virgin, 15, 16 (fig. 1), 304–5 (cat. 186)

Anna, Saint, 113

Anna Komnene. *See* Komnene, Anna

Anna of Epiros, 25

Anna of Savoy, empress, 73; coin with, 105–6 (cat. 45)

Annunciation, 22 (fig. 5), 30, 108 (cat. 48), 141, 147, 158–59 (cat. 83), 202 (cat. 113), 210–11 (cat. 120), 227 (cat. 130)

Anthousa and Ardabarios, chalice dedicated by, 111 (cat. 50)

Antioch, 56, 70, 71, 91, 185

Aphrodite, 37, 164, 176, 216, 237, 252; earring with, 248 (cat. 140); hairpin with Pudica, 235, 258 (cat. 150); lampstand with, 163, 198–99 (cat. 111), 234; Projecta casket with, 81, 142, 231, 233, 234 (fig. 20), 235, 237; pyxis with, 215, 256–57 (cat. 148)

Apollo, 163, 178–79 (cat. 95)

Apostles, 205–6 (cats. 116–17), 211, 213 (cat. 120), 299 (cat. 182)

Aquileia, 44

architectural frieze, 163, 165, 167 (cat. 84)

Ariadne, empress, 39, 93, 307

Arkadios, emperor, 37, 89, 90

Artemis, 17, 37, 163, 181–82 (cat. 97)

Artemisia of Philadelphia, 142

Asklepios, 282

Athanasios, writer, 275

Athanasios I, patriarch, seal of, 64–65 (cat. 22)

Athena, 37–38, 45, 113; bracelet with, 251–52 (cat. 144); bust weight, 54 (cat. 14); colossal statue of, 38, 45; as *palladion*, 38; pyxis with, 215, 256–57 (cat. 148)

Athena Promachos (Foremost Fighter), 38

*augusta,* 58–59, 86, 88–89

Augustaion, Constantinople, 44, 49, 69, 70

*autokrator,* 101, 104

Balsamon, Theodore, 164

Baptism of Christ, 202 (cat. 113), 211 (cat. 120), 227 (cat. 130)

Bardas Phokas, general, 124

Basil I, emperor, 62, 68, 69, 97, 99; coin with, 98–99 (cat. 38)

Basil II, emperor, 124; *Menologion* of, 143

baths: health and, 280; public conduct and, 146 (cat. 69); in Sidi Ghrib, Tunisia, 235, 236 (fig. 21), 237

beauty, 233–34; spiritual, 238

Bellerophon, 216, 231 (cat. 132)

belt: aid in childbirth, 93, 230; marriage, 225, 229–30 (cat. 131)

belt buckle, 216, 231 (cat. 132)

betrothal, 28

bird motifs, 185–86 (cat. 100), 260 (cat. 152), 265–68 (cat. 159). *See also* animal motifs; peacocks

birth scenes, 280; of Esau and Jacob, 15, 276, 277 (fig. 23); of John the Baptist, 15, 139, 142, 147 (cat. 70); of Virgin Mary, 15, 139, 304–5 (cat. 186). *See also* childbirth

Blachernai church, 39, 40, 73, 90, 93, 114–17

bone: hairpins, 235, 258 (cats. 149–51); needles, 152 (cat. 75–78); plaques, 163, 168–69 (cats. 85–88); spindle, 152 (cat. 74); statuette, 70, 86–87 (cat. 28); toilet articles, 234–35, 261–63 (cats. 153–55)

Pentecost, 212 (cat. 120)

performers, 139, 142, 149, 220. *See also* dancers

perfume, 200, 237, 261

perfume containers, 234, 237, 264 (cats. 156–57)

personifications: of Charis, 251–52 (cat. 143); of chastity, 70, 86–87 (cat. 28); of Church, 227 (cat. 130); of cities on coins, 45–50 (cats. 2–7); of Constantinople on ring, 50 (cat. 8); of earth, 270; of earth and wealth-bringing figures, 163; of endowing goddess, 272; of health and plenitude, 200–201 (cat. 112); Tyche of Constantinople statue, 43–44 (cat. 1)

Peter, Saint (Apostle), 134 (cat. 66), 205–6 (cats. 116–17), 213 (cat. 120)

philanthropy, 87n15, 91. *See also* patronage

Phokas, emperor, 129

Photios, patriarch, 40, 115

Phrygian cap, 200–201 (cat. 112)

phylacteries, necklace with, 237, 295 (cat. 176)

piety, 87n15, 200, 254

plates: with dancing girl, 18, 165 (fig. 16); with female rider, 17, 181–82 (cat. 97); with geometric design, 185, 187 (cat. 101). *See also* bowls

plenty, 168, 200

Ploutos (Wealth), personification, 19

polycandela, 165, 194 (cats. 106–7)

*porphyra*, imperial birthing room, 73

Porphyrios, 37, 142

Porphyrogennetos, 101

portraits: in medallions on frieze, 167 (cat. 84); of women on wood, 237, 240–43 (cats. 133–34)

portrait heads. *See* marble; sculpture

prayers, 165; cross with, 135 (cat. 67); for health, 276; icons and, 204–13 (cats. 115–20); lamp/incense burner and, 202 (cat. 113); seals with, 126–27 (cats. 55–56)

prayer corner, 165

pregnancy, 285, 290, 301; prayer for, 139, 292–93 (cat. 174). *See also* abortion; miscarriage

Presentation at the Temple, 15–16, 17 (fig. 2), 298 (cat. 181), 227 (cat. 130)

processions, 117, 118, 141, 304; crosses used in, 108 (cat. 48), 132 (cat. 65); icons used in, 120–23 (cats. 51–52)

Projecta casket, 81, 142, 231, 233, 234 (fig. 20), 235, 237

Prokopios of Caesarea, historian, 72

prosperity, 92, 177, 200, 273. *See also* Tyche

prostitutes, 67, 72, 139, 142, 143, 149, 220, 234, 235

Psalters, 15, 18

Psellos, Michael, 26–27, 30, 62, 63, 100, 103, 104, 105, 140, 236, 237, 263, 278

Ptochoprodromos, poet, 31, 219

public conduct of women, 29–30, 70, 139, 145–46 (cat. 69), 161, 235

public sphere, role of women in, 24–26

Pulcheria, empress, 37, 39, 68, 69, 71, 226; coins with, 48–49 (cat. 7); 88–91 (cat. 30)

pyxides: for cosmetics, 261–62 (cat. 154), 263; with Judgment of Paris, 67, 252, 256–57 (cat. 148)

Rebecca, Old Testament, in childbirth, 15, 276, 277 (fig. 23)

religious education, 73, 140, 162

reliquary cross, 134 (cat. 66)

Resurrection of Christ, 211 (cat. 120)

Rhea, 36

rings: with Chnoubis, 284–85 (cat. 166); marriage, 222 (cats. 121–22), 223–24 (cat. 125), 227–28 (cat. 130); openwork 249 (cat. 141); with seals, 162, 223–24 (cats. 123–24), 296 (cat. 177), 299 (cat. 182); with Virgin and Christ, 296–97 (cats. 177–79). *See also* jewelry

Roma, personification, on coins, 45–46 (cat. 2), 47–49 (cat. 4)

Romanos I Lekapenos, emperor, 100

Romanos III Argyros, emperor, 101, 129–30 (cat. 59), 278

Romanos IV Diogenes, emperor, 68

Rome, 78; Tyche of, 36–37, 43–44 (cat. 1)

Saba (Sheba), Queen of, 200–201 (cat. 112)

Sabina, Roman empress, 86

Sabine shawl in Louvre, 154

Sahidic text. *See* Coptic text

saints, 26, 141; amulet with, 291 (cat. 172); coins with, 106 (cat. 41); crosses with, 108 (cat. 48), 134 (cat. 66), 135 (cat. 67); icons with, 120 (cat. 51), 204 (cat. 115), 209–10 (cat. 119), 303–4 (cat. 185); medallion with, 136–37 (cat. 68); pendants with, 237, 300–301 (cats. 183–84); prayer to, 135 (cat. 67), 279; seals with, 65 (cat. 23), 126–27 (cats. 55–56); triptych with feast scenes, 210–13 (cat. 120). *See also specific names*

Salus. *See* Hygieia

Sarah, Old Testament, 139, 293

sculpture: marble portrait heads, 14, 69, 76–85 (cats. 24–27); in public places, 35–41, 69–70, 94; seated dancer, 149 (cat. 72); statues of goddesses, 37–39; statues of imperial women, 78, 86–87 (cat. 28); Tyche of Constantinople, 43–44 (cat. 1)

seals, 14, 40, 162–63; of Doukas family, 107 (cats. 46–47); of household, 169, 192, 223–24 (cat. 123); with Saint Theodora, 65 (cat. 23); with Virgin, 40, 64–65 (cat. 22), 107 (cats. 46–47), 124–27 (cats. 53–56)

seal rings, 162, 223–24 (cats. 123–24), 296 (cat. 177), 299 (cat. 182)

sealing containers, 162, 192, 223–24 (cat. 123)

Senate House, Constantinople, 38, 45

servants, 140, 235

sexual relationships: adultery, 143, 218–19; illicit, 29–30, 99; marriage and, 28, 143, 218–19, 276–77. *See also* concubines; mistresses; prostitutes

silk, 141, 237

silver, 183, 236–37; amulet, 283–84 (cat. 165); bowl, 183 (cat. 98); bracelet, 253 (cat. 145); chalices, 73, 110–11 (cats. 49–50); coins, 63 (cat. 21), 129–30 (cats. 59–60); dish with female rider, 17, 181–82 (cat. 97); perfume container, 237; Projecta casket, 81, 142, 231, 233, 234 (fig. 20), 235, 237; ring, 284–85 (cat. 166); seal, 124 (cat. 53); statuette of dancer, 149 (cat. 72)

Simocatta, Theophylact, 226

Sisinnios, Saint, 278–79, 288, 289. *See also* Holy Rider

Skleraina, mistress of Constantine IX Monomachos, 68, 143

Skleros, Leon, seal of, 125 (cat. 54)

Skylitzes, John, 72, 217

slaves, 140, 142

social status and adornment, 235–37, 253

Sokrates, historian, 36, 44

solidus. *See* coins

Solomon (Old Testament king), 200, 289, 290

Solomonic knot, 268 (cat. 160)

Sophia, empress, 68, 69, 71, 308; coin with, 94 (cat. 34); weight with, 57 (cat. 15)

Soranos, physician, 275, 277

Soros chapel, Blachernai church, 108, 115

Sozomenos, historian, 70

spindles, 152 (cat. 74), 162

spinning, 19, 140–41, 162; Virgin, at Annunciation, 22 (fig. 5), 30, 108 (cat. 48), 141, 147, 158–59 (cat. 83). *See also* weaving

# Illustration Credits

Photographs of all works in the Harvard University Art Museums and cats. 10, 79, and 154 © President and Fellows of Harvard College, photography by Junius Beebe III and Katya Kallsen.

Inside front cover: Adapted by Belinda Morse from Thomas Mathews, *Byzantium: From Antiquity to the Renaissance*. New York: Abrams, 1998, fig. 3, 10–11. By permission of Laurence King Publishers, Ltd.

Inside back cover: Adapted by Belinda Morse from Thomas Mathews, *Byzantium: From Antiquity to the Renaissance*. New York: Abrams, 1998, fig. 8, 19. By permission of Laurence King Publishers, Ltd. Locations of monuments are taken in part from Cameron and Herrin et al. 1984, Magdalino 2001, and Talbot 2001a, as well as: Raymond Janin, *Géographique ecclésiastique de l'empire byzantin*, vol. 3 (Paris, 1953); Elizabeth C. Koubena, "A Survey of Aristocratic Women Founders of Monasteries in Constantinople between the Eleventh and the Fifteen Centuries," in *Women and Byzantine Monasticism*, edited by Jacques Perreault et al. (Athens, 1991); George P. Majeska, *Russian Travellers to Constantinople in the Fourteenth and Fifteenth Centuries* (Washington, D.C., 1984); and Wolfgang Müller-Wiener, *Bildlexikon zur Topographie Istanbuls: Byzantion, Konstantinupolis, Istanbul bis zum Beginn d. 17 Jh.* (Tubingen, 1977).

Frontispiece: cat. 72.

Full-page details: page 12, cat. 70; 34, fig. 8; 66, cat. 28; 160, fig. 15; 214, fig. 18; 232, fig. 21; 274, cat. 165a.

Figs. 1, 4, 23 © Biblioteca Apostolica Vaticana (Vatican).

Fig. 2 From Myrtali Acheimastou-Potamianou, *Greek Art*, Athens: Ekdotike Athenon S.A., 1994, fig. 106, p. 129. By permission of the Ministry of Culture of Greece, Tenth Ephoreia of Byzantine Antiquities.

Figs. 3, 14, 15 Byzantine Collection, Dumbarton Oaks, Washington, D.C.

Fig. 5 © G. Dagli Orti, Paris.

Fig. 6 © The Metropolitan Museum of Art.

Fig. 7 By permission of Archaeological Museum, Istanbul.

Fig. 8 From *The Treasures of Mount Athos* (Athens, 1987), fig. 313. By permission of the Ministry of Culture of Greece, Tenth Ephoreia of Byzantine Antiquities.

Figs. 9, 10, 18 Biblioteca Nacional, Madrid.

Fig. 11 © Artephot/R. Percheron.

Fig. 12 From Maria Vassilaki, ed., *Mother of God: Representations of the Virgin in Byzantine Art* (Athens and Milan: Benaki Museum and Skira editore, 2000), fig. 81, p. 135.

Fig. 13 Bildarchiv d. ÖNB, Vienna.

Fig. 16 © 2002 Benaki Museum, Athens.

Fig. 17 Chrysanthi Mavropoulou-Tsioumi (1986): *The Church of St. Nicholas Orphanos*. Thessaloniki: Institute for Balkan Studies.

Fig. 19 The Cyprus Museum.

Figs. 20, 22 © The British Museum.

Fig. 21 Gilles Mermet.

Fig. 24 After Jean Clédat, *Monastère et la nécropole de Baouît*, vol. 2 (Cairo: Imprimerie de l'Institut français d'archéologie orientale, 1906), pl. 56.

Cats. 1, 11, 26, 64, 71, 132, 144, 165 ©The Metropolitan Museum of Art.

Cats. 8, 23, 47, 48, 50, 67, 97, 102, 123, 130, 131, 149, 150, 164, 182 Byzantine Collection, Dumbarton Oaks, Washington, D.C.

Cats. 12, 24, 31, 49, 72, 122, 139, 141, 152 Courtesy Museum of Fine Arts, Boston. Reproduced with permission. © 2002 Museum of Fine Arts, Boston. All rights reserved.

Cats. 13, 14, 98, 99, 100, 101, 105, 121, 125, 146, 175, 176 © Indiana University Art Museum, photographs by Michael Cavanagh and Kevin Montague.

Cats. 25, 68, 111 ©The Nelson-Atkins Museum of Art, Kansas City, Missouri.

Cats. 28, 112, 167, 183 © Bruce M. White, The Art Museum, Princeton University.

Cats. 52, 54, 73, 94, 118, 140, 168 ©The Malcove Collection, University of Toronto Art Center.

Cat. 53, 65, 128, 129, 178, 179, 180 ©Royal Ontario Museum, Toronto.

Cats. 69, 83, 174 ©The Pierpont Morgan Library, New York.

Cats. 87, 95, 126, 148, 170 The Walters Art Museum, Baltimore.

Cats. 116, 120 The Museum of Fine Arts, Houston.

Cats. 117, 143, 147 Worcester Art Museum, Worcester, Massachusetts.

Cats. 124, 127, 166, 177, 185, 186 The Menil Collection, Houston.

Cats. 135, 137, 138, 142, 145, 184 Ron Jennings ©Virginia Museum of Fine Arts, Richmond.